American Photography and the American Dream

Cultural Studies

of the United States

Alan Trachtenberg,

editor

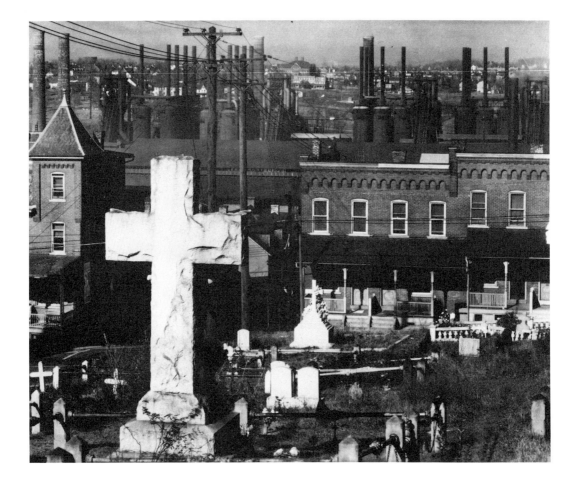

James
Guimond

American

Photography

and the

American

Dream

The
University of
North Carolina
Press
Chapel Hill &
London

© *1991 The University of North Carolina Press*
All rights reserved
Manufactured in the United States of America

The paper in this book meets the guidelines for
permanence and durability of the Committee on
Production Guidelines for Book Longevity of the
Council on Library Resources.

95 94 93 92 91
5 4 3 2 1

Library of Congress Cataloging-in-Publication
Data

Guimond, James.

 American photography and the American
dream / by James Guimond.

 p. cm.—(Cultural studies of the United
States)

 Includes bibliographical references and index.

 ISBN 0-8078-1946-8 (alk. paper).—

ISBN 0-8078-4308-3 (pbk. : alk. paper)

 1. Photography, Documentary—United
States—History—20th century.

I. Title. II. Series.

TR820.5.G82 1991

779'.9973—dc20 90-46730

 CIP

frontispiece: *Walker Evans, Cemetery, Bethlehem,*
Pennsylvania, 1936 (Library of Congress)

Contents

Foreword

The emergence of the photograph as an object of study surely strikes one of the distinctive notes in contemporary cultural studies: the photograph not only newly discovered in its plentitude of cultural and ideological implication but also as a cardinal site of cultural conflict, of contests over interpretation and meaning and over the social power of images to control not only perceptions across the lines of class and gender and ethnic identity but the perception of reality itself. The first discovery—difficult to date exactly but not unrelated to the invention of an idea of a socially combative "documentary" photography in Europe and America in the 1920s and 1930s—was simply that photographs do in fact "mean," that the image worlds they project also declaim or insinuate ideas about that world, the "reality" constructed by and as the photographic image—and that such meanings possess unfathomed public power.

From this uncovering of the arbitrary world-making work of the photograph followed another powerful insight: that photographic reality is never absolute, never a merely automatic or mechanical reflex, never free of local and immediate contingencies of presentation (where and how the viewer encounters and engages with the image)—always, in short, a "reality" overdetermined by a convergence of factors of extraordinary richness to the cultural analyst. These factors—the photographic apparatus and format, the photographer's choices and what can be deduced from them as conceptual intentions, the intertextuality of pictures' echoing and revising and canceling each other across a seemingly horizonless terrain of image exchange, the locus and mode of presentation and re-presentation, formal critical reception and canonization, informal popular reception—are perhaps finally impossible to retrieve and process and understand, yet just as impossible to avoid trying, if we seriously wish to understand photographs as the entangled historical data of ideology and culture they are.

James Guimond's *American Photography and the American Dream*

has a clear place within the large project of cultural interpretation of photographs now underway in several disciplines at once. Readers will have no trouble recognizing its place and its virtues: a plain-speaking account of selected representations of the American Dream—myth or value or ideology, a body of ideas, perceptions, symbols, predispositions to judge and interpret—that lies athwart American life. The book chooses to discuss photographers with something on their mind, mainly "documentary" photographers but also several whose category of labor is known as "photojournalism" or "art"—all such categories really terms for institutional locations and their formal determinations. Eschewing global theories of representation or efforts to propose a single critical procedure applicable to the medium as a whole, Guimond's book takes up one case after another of a particular photographic discourse that crosses boundaries of genre, style, and formalist category: the discourse of commentary, by means of photography, upon the charged and conflicted symptoms of American life known as the American Dream.

The book is political and social history as much as photographic criticism—indeed its method will be familiar as a traditional American studies interdisciplinary approach. Solidly grounded in historical event, *American Photography and the American Dream* moves freely and unselfconsciously from picture to text to context, from biography to editorial decision making to picture analysis, and in its predominantly narrative mode seeks to locate its photographic texts in a social and political relation to the propositions of the Dream. Thus the book addresses what Guimond calls "mainstream" culture. Political and aesthetic avant-garde photography is not part of the story. Organizing his story as a reconstructed debate between liberal and conservative, or Left and Right, versions of the American Dream, Guimond seeks to politicize photography, to view mainstream images as arguments about the *idea* of America: is the nation happy or discontent, true to its hegemeonic ideals of equality and opportunity (the conventional terminology of the Dream), or is it betraying them? "Obviously the Dream," Guimond writes, "has been very elastic." Its terminology and imagery have been deployed both to celebrate and to condemn, to blame the poor and disadvantaged as responsible for themselves or to side with the losers against the rich, the comfortable, the smug, and the institutions they control. The very same Dream has served to exclude and restrict and at the same time to denounce all exclusions and restrictions, to contrast realities with promises.

Yet at the center, and this is what makes the book a critique of the mainstream, lies a core notion shared by conservative celebrants and liberal (and radical) social critics alike: in Guimond's words, "The conception of America as a kind of magic environment or society that has the power to transform people's lives, the idea that the United States is not merely a new world, but a different kind of world, a unique place where the limitations, boundaries, and inequities that formerly confined the human race either do not exist or are about to disappear." This exceptionalist vision of a society governed by a rhetorical Dream flexible enough to serve alternate and even opposing social ideologies gives Guimond's book the power of a fundamental critique.

But a critique of exceptionalism as such does not hold the highest priority in

American Photography and the American Dream: photography does, and the critical
experience of socially meaningful pictures. Guimond deftly places photographs within the history of American society and politics, locates them within the dialectic of the Dream, and shows how a position toward that dialectic functions in the making of the particular versions of American reality projected by the photographs. By such maneuvers Guimond compels his readers to consider and reconsider the potency that still lies within the medium to awaken in viewers a sense of the social reality of others. Skepticism toward this notion of the practical viability of photographs in raising public and civic awareness is much in currency at the moment, but Guimond's conviction that camera images might enable us "to step out of our old ideas about ordinary realities and experience them in a fresher, more vivid way" affirms a hope rooted in an American progressivism that seems still to endure against severe odds. *American Photography and the American Dream* should reopen debates about the social power and functionality of the medium many have thought already foreclosed.

Alan Trachtenberg
Yale University

Acknowledgments

I wish to thank those people who were helpful to me. The curators of the Prints and Photographs Division of the Library of Congress, the staff of the Still Photographs Division of the National Archives, and Mr. Martin Manning of the United States Information Agency Historical Collection all generously gave me information and advice as well as access to their collections of photographic images and printed materials. Grants from Rider College and its Research and Patents Committee provided financial support for travel to those collections and helped to defray some of the costs of prints and reproduction rights. Arthur Rothstein and Jack Delano discussed the activities of the Farm Security Administration photographers with me. Jerome Liebling, William Klein, Bill Owens, and Michael Williamson provided me with prints of their works. My daughter Laura gave me helpful editorial advice. Finally, I am much indebted to Quentin Fiore, Stan Lindberg, Alan Trachtenberg, and Arlene Wilner for the encouragement they have given me to write about photography and to complete this book.

American Photography and the American Dream

Dreams
and
Documents

1

Few Americans fully realize how great their country is: how magnificent in territory; how wondrously blessed in natural advantages; how varied and great its products; how marvelous its progress, and how firm and certain its position among the great powers of the earth. . . . The immensity of the figures in the statistic tables mean little to us. . . . It is only by testing them in relation to other nations . . . and by graphic illustration, that we can comprehend them and see the nation in its true condition.

– Journalist William Jordan
describing America's industries
and natural resources in 1897

It's not the American dream anymore; it's the American nightmare.

– Filmmaker Michael Moore
commenting in 1989 on plant
closings in his hometown
of Flint, Michigan[1]

William Jordan wrote his article titled "The Greatest Nation on Earth" in 1897 in the early days of American industrialism, when productivity was equated with national power, prestige, and greatness. Published in the *Ladies' Home Journal*, one of the nation's first mass-circulation magazines, Jordan's article was filled with facts and statistics describing the extent of the country's immense natural resources, how well its industries were exploiting these resources, and how superior America's position was in comparison to Great Britain, which was considered the world's leading economic and military power at the turn of the century. "In manufacturing," Jordan wrote proudly, "the United States leads the world. . . . The yearly value of our product, as compared with that of Great Britain is in the proportion of seven to four. American workmen are the best paid in the world."

Some ninety-two years later, filmmaker Michael Moore offered a very different vision of the condition of America's industries and workmen. In his widely acclaimed and controversial film, *Roger and Me*, Moore portrayed the American Dream gone astray: the "nightmare" of the Midwest rustbelt after the General Motors Corporation began moving its assembly plants from Flint, Michigan, to countries like Mexico to lower labor costs. Like Jordan's article, Moore's film has many facts and statistics: Mexican assembly-line workers are paid seventy cents an hour; Flint lost thirty thousand manufacturing jobs over a ten-year period; by the late 1980s Flint's rat population outnumbered its human population by fifty thousand; and Flint had one of the highest violent-crime rates in the nation. Jordan wrote his article when many Americans were certain the United States was well on its way to becoming what he called it in his title—the world's "greatest nation." Moore made his film during a decade when many Americans were obsessed by the thought that their nation was no longer "number one," that Japan and Germany were surpassing it in economic power, because U.S. manufacturing skills had become so uncompetitive that it had suffered massive trade deficits for thirteen consecutive years.[2]

Jordan and Moore did have in common, however, the idea that their visions of America had to be illustrated graphically, that mere words and statistics were not enough. Jordan's article had woodcut pictures showing America's resources and its superiority to Great Britain. It showed a huge locomotive beside a tiny freighter, for 3

example, to symbolize that U.S. domestic trade was six times larger than England's foreign trade, and it displayed an eight-story factory—proudly flying the stars and stripes—next to a five-story factory to demonstrate how "Uncle Sam's manufactures" exceeded Great Britain's. Moore, even though he was a print journalist who had never made a movie, decided he needed to make a film to convey how bad things were in Flint. He assembled a crew and photographed how some citizens were trying to survive: a man was selling his blood to the Flint Plasma Company; a woman was earning ten to fifteen dollars a week selling rabbits for food (with a sign by her house saying, RABBITS AND BUNNIES—PETS OR MEAT); and a sheriff's deputy was specializing in evictions, an activity that, one reviewer commented, was one of Flint's "few growth industries" in the 1980s.[3]

Throughout this book, I am concerned with the relationship between Americans' ideas about their nation and their ways of illustrating these ideas, particularly with photographs, between 1899 and the mid-1980s. Most of the images I have selected and analyzed have several features in common. In one way or another, they are *civic* images, in the sense in which Alan Trachtenberg has used that term in his analysis of a picture by Jerome Liebling. Liebling's image shows a group of men and women in New York City's Union Square, sitting by the base of a flagpole decorated with a neoclassical bas-relief and inscribed with a quotation from Thomas Jefferson, part of which is visible in the picture: "How little do my countrymen know." Usually we associate the term "civic" with objects like flags and monuments, Trachtenberg said, but in this picture we see a more fundamental civic reality: the "city of man," the actual people who have gathered to watch a parade or some other public event. "The civic act performed by [Liebling's] picture," he pointed out, is "to expose the monument (and its notion of high civic duty) to the street—the staged ideal to the random facts gathered in and formalized by the camera lens. The picture serves up *itself* as something 'my countrymen' might know about themselves."[4] The bas-relief and Jefferson's quote give us the traditional iconography and inspirational message of idealized "high" citizenship, but the photograph, like many of those I have chosen, presents itself more humbly, as something the citizens might learn about themselves and their own lives.

Almost all of the images I study, when compared with those produced in many other kinds of photography—such as advertising, travel, fashion, and hard news—are documentary. As film director John Grierson defined the term in 1939, "documentary" films, writing, radio, and art all embody a "basic force" that is "social not aesthetic" and expresses "a desire to make a drama from the ordinary [that can be] set against the prevailing drama of the extraordinary: a desire to bring the citizen's eye in from the ends of the earth to the story, his own story. . . . I liked the idea of an art where the dramatic factor depended exactly on the depth with which [that] information was interpreted." Thus most of the photographers whose work is discussed in this book—including Frances Johnston, Lewis Hine, Walker Evans, Arthur Rothstein, Dorothea Lange, Robert Frank, and Chauncey Hare—are known as documentary photographers: they photographed distinctly "ordinary" people, like black students, child

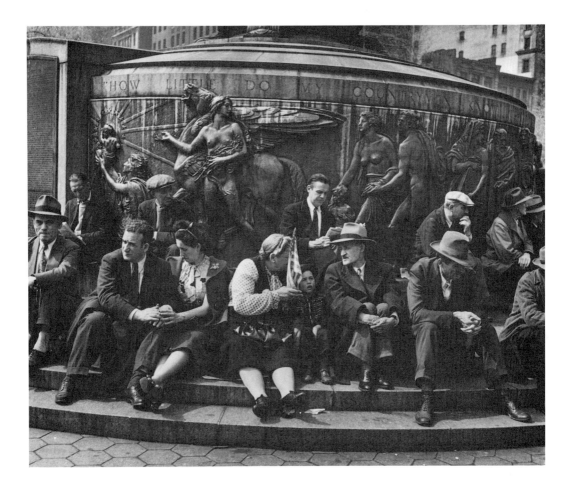

workers, sharecroppers, office clerks, and factory workers, rather than the famous people in history books, on the front pages of newspapers and the covers of magazines, and on television programs. (As Robert Frank said of a group of people he photographed, "They are . . . totally unimportant, unglamorous, unnoticed.")[5] However, I also include analyses of books, images, and photoessays by photojournalists, like Susan Meiselas, and some by art photographers, like Diane Arbus and William Klein, when their images are of relatively ordinary persons and events.

Drama implies conflict, and another characteristic the images in this book share is that they were all, in a variety of ways, intended to overcome or disprove some false, superficial, or stereotyped viewpoints about their "ordinary" subjects. The way some documentary films are edited exemplifies this process of contrasting cultural stereotypes with more realistic images. *Miles of Smiles: The Untold Story of the Black Pullman Porter*, for example, is about black men who were sleeping-car porters from the 1920s through the 1950s. Throughout the film the directors, Jack Santino and Paul Wagner, presented images from advertisements, railroad posters, and old movies that portrayed the men as "good darkies" and servants whose only desire was to please their white passenger-customers. But mixed in with these images, and contrasted with them, are

Jerome Liebling, Union Square, New York City, 1948 (Liebling, Jerome Liebling Photographs, 1982, © Jerome Liebling)

5

interviews with actual porters, who are—even though they are now retired and el-
derly—a very lively group of men. Listening to them talk at a buffet where they are
serving themselves dinner, coffee, and beer, we learn why they became porters (no
better jobs were available for black men in the 1920s and 1930s), what they felt about
racism (they bitterly resented it), and how they contributed to the civil rights move-
ment (it was a porter, E. D. Nixon, who invited Martin Luther King, Jr., to Montgom-
ery to lead the bus boycott in 1955). What is significant about this film is not only that
the images of real porters cancel out the stereotypes but also that the film's images of
the real porters seem more forceful and vivid as they interact with the false, stereo-
typed images. Juxtaposed with the clichés, the interviews become a dramatic revela-
tion of what Grierson would have called the porters' "own story," the real story of their
lives, which had to be discovered by confronting the hackneyed, superficial story that
had been imposed upon them. Sometimes a real story can be seen in a single image in
which two realities are juxtaposed—as they are in Arthur Rothstein's 1937 picture of a
black girl standing in the window of her cabin in Gee's Bend, Alabama. Our awareness
that this girl is beautiful, as well as poor, is enhanced by the contrast between her face
and the faded image of the white woman in the newspaper that faces her like a strange,
distorted mirror. Because of Rothstein's composition, we can perceive, if only briefly,
that ordinary people are worth seeing as much as the idealized or extraordinary people
whom we see in the media.[6] This process can also operate in reverse, such as when
documentary makers photograph subjects who are frequently idealized by the mass
media. Thus in Jerome Liebling's picture of Senator Henry Jackson at the 1972
Democratic Convention, we can contrast the actual, human Jackson with the grinning,
larger-than-life, political stereotype on the poster behind him. Moreover, by photo-
graphing the senator as an ordinary person on a huge, empty stage, deserted except for
his wife, Liebling has also implicitly contradicted the trite election-year vision of the
American politician as the center of attention, an animated *Time* magazine cover
surrounded by happy crowds or excited convention delegates.

Although it is not easy to define the term "documentary," enough examples of images
described as documentary have come into existence since the 1930s—when the term
began to be used by photographers like Walker Evans and Edward Steichen, by critics
like Elizabeth McCausland and Beaumont Newhall, and by filmmakers like John
Grierson—that it is possible to make some significant comparisons and note some
important contrasts.[7] First of all, even though documentary photography is sometimes
lumped with photojournalism, and even though there are ambitious photojournalists
(like Michael Williamson and Susan Meiselas) who can be considered documentary
photographers, it seems more likely that documentary photography defined itself
visually (if not verbally) in the 1930s as a contrast to hard news photojournalism, just
as documentary films were a contrast to Hollywood movies of that time. Documentary,
as Grierson said in 1939, came from "a desire to make a drama from the ordinary, . . .

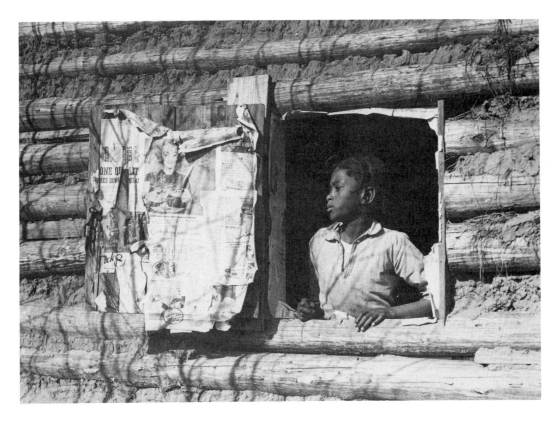

a desire to bring the citizen's eye in from the ends of the earth to . . . his own story." *Arthur Rothstein, Artelia Bendolph, Gee's Bend, Alabama, 1937 (Library of Congress)*
But most photojournalism, like commercial films and the tabloid newspapers that first started using photos in the early twentieth century, seems to be primarily a descendant of nineteenth- and early twentieth-century popular theater—melodrama, farce, and vaudeville—with its emphasis on crude excitement, broad humor, violence, and senti- mentality. Like melodrama, the great majority of hard news photojournalistic images, including many that have won Pulitzer Prizes, help ordinary people to escape from the routines of their lives by transporting them to a world filled with extraordinary events and people (crimes, fires, scandals, celebrities, movie stars, dictators, and presidents). Photojournalism also shows us ordinary people in extraordinary situations: winning lotteries or sobbing with grief, jumping out of windows or dying in gory accidents, wars, and riots. In the 1940s and 1950s, however, there was a form of semidocumen- tary, feature-story photojournalism that flourished in magazines like *Look* and *Life*, and I analyze these photoessays in some detail in chapter 5. But elsewhere in this study, I assume that commercial, mass-media photojournalism does not have much in common with documentary photography.[8]

Because documentary photographers try to present and dramatize a viewpoint about their subjects, their work is also significantly different from another genre, which I call "informational" photography, which also deals with ordinary realities but in what is intended to be a deliberately "objective," and usually rather drab, way. This type of photography—which includes legal, scientific, and motion-study photographs; 7

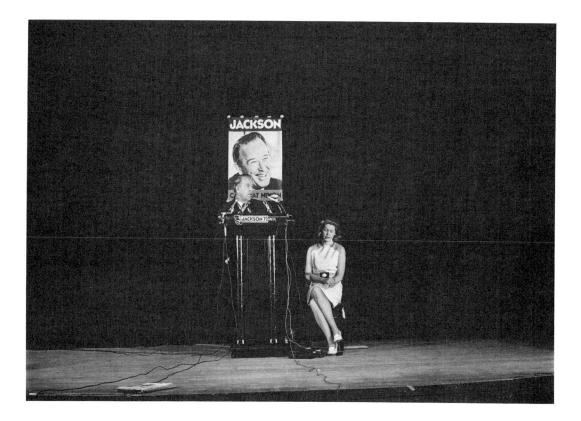

passport, police, and identification card "mug shots"; pictures of machinery, experiments, and construction sites; and the images used to illustrate catalogues, instruction manuals, and most encyclopedias and text books—can be considered "documentary" in the broad sense of that term since it does authenticate the existence of persons and things at specific times and places. But because such photographs present their subjects in what is meant to be a deliberately "neutral" manner, supposedly separated from any values, they lack the decisive emphasis on a subject's presence and the dramatization of visual qualities that characterize the "documentary style" of photographers as different as, say, Dorothea Lange and Eugene Atget. Thus a picture of a loom made for a textile machinery catalogue is an informational photograph, but a Lewis Hine picture of a small, vulnerable child standing by the same loom is a documentary photograph. Or, as Robert Frank said in 1961: "Most of my photographs are of people; they are seen simply, as through the eyes of the man in the street. . . . This kind of photography is realism. But realism is not enough—there has to be vision, and the two together can make a good photograph."[9] Because they lack what Frank would call "vision," factual photographs are considered useful, but not very interesting, visual commodities. Hundreds of thousands, perhaps millions, of them exist in the files of archives, corporations, government agencies, and photo services, where they are available to editors who use them as illustrations. But it is rare for them to be exhibited or published for their own value, and most of the men and women who made them are identified only as "photographer unknown."

In addition, even though documentary and news photographs can be used as propaganda if they are manipulated or accompanied by slanted captions, there is an important difference between documentary and propaganda photographs. Because propaganda, like advertising, is designed to manipulate most of the people most of the time, it is usually filled with all of a mainstream culture's most popular clichés and stereotypes, since these are the motifs most likely to be persuasive and effective. There are high fashion and Napoleon for the French, Wagnerian motifs for the Germans, queen and country for the British, cowboys and capitalism for the Americans, Lenin for the Russians, and so forth. "Propaganda standardizes current ideas, hardens prevailing stereotypes, and furnishes thought patterns," as Jacques Ellul has pointed out; and one of the most effective ways it can do this is by using "photos and images which have a special power to evoke the reality and immediacy of the stereotype—itself an image [that] is fed by other images. The Statue of Liberty, the Arc de Triomphe [for example] provoke immediate reactions." On the other hand, because the documentary impulse is opposed to popular conventions and clichés, documentary photography often represents, to use political terminology, a minority, or opposition, viewpoint. It is, however, the viewpoint of a "loyal opposition," whose existence is tolerated by the majority, mainstream culture and whose ideas may even, on some occasions, be adopted if they are not considered too "radical." As Edward Steichen commented on the Farm Security Administration (FSA) photographs when they appeared in the first major exhibit of documentary photography in the United States in 1938, "I do not look upon these pictures as propaganda. Pictures in themselves are very rarely propaganda. It is the use that is made of pictures that makes them propaganda. These prints are obviously charged with human dynamite [but] . . . they are not propaganda—not yet."[10]

The genre with the closet affinities to documentary is modernist, or "straight," art photography. Eugene Atget, for example, has been considered both a major documentary photographer and one of the first great modernists. Paul Strand, who was one of the most influential American modernists, was Lewis Hine's pupil at the Ethical Culture School, and later in his career he made books such as *Time in New England*, *La France de Profil*, and *Un Paese*, whose images can be interpreted as being either art or documentary photography. Walker Evans was both an excellent art photographer and a great documentary photographer when he was working for the FSA photography unit in the 1930s. Perhaps this resemblance between documentary and modernist art photography can be explained by an analogy: modernists apply the documentary impulse to the world of nature, objects, and architecture by finding fresh visions of things that have been ignored, devalued, or taken for granted just as documentary photographers present new insights about people who have been ignored, devalued, or taken for granted. As a French poet said of the images in Strand's *La France de Profil*: "This 'foreigner' is not attracted by what seems out-of-the-ordinary to foreigners and to Frenchmen. . . . His harvest as a strolling photographer is disconcerting only insofar as it places us at the very heart of *that which we no longer see*." Or as Walker Evans told a class at Harvard University in 1975, "Looking at what I was doing, most people

didn't think it was anything at all. It was just a wagon in the street or anybody, but that turned out to be what I presume to say was its virtue."[11] Despite these similarities, there are several important differences between the more formalist, "straight," photographers and documentary photographers. The former, for example, place more emphasis on geometrical forms, intricate or bold compositions, and complex lighting patterns, whereas documentary photographers are often apt to treat such matters in a more functional way because they are concerned primarily with portraying a social reality.

■

All cultures, regardless of the forms their values and ideologies are expressed in— statues in plazas, characters in literature and operas, stories in the mass media, or advertisements—have ideals and conventions that can inspire or stultify their citizens. One of the more interesting features of the American Dream is that the ideology it incorporates has rarely been taken very seriously by major American creative writers. Calderon, Racine, Dryden, and Verdi wrote some of their grandest dramas and operas about aristocrats who were destroyed by the demands of honor. Shakespeare glorified Tudor and Renaissance ideals of kingship in his history plays, and Wagner deified the stereotypical Teutonic warrior in his operas. But serious American writers have tended either to ignore the Dream or to satirize and criticize it. As early as 1820, Washington Irving ridiculed the frontier version of the Dream by making it Ichabod Crane's vision of the Promised Land, as he imagined how he could transform the Van Tassel estate into cash and invest the money in "immense tracts of wild land, and shingle palaces in the wilderness." By the twentieth century, Philip Rahv commented, the principle theme of "the modern American novel . . . from Dreiser and Anderson to Fitzgerald and Faulkner, has been the discrepancy between the high promise of the American dream and what history has made of it." As for the writers themselves, Faulkner was particularly caustic. America had "lost" its Dream, he claimed in a 1955 essay, or the Dream had "abandoned us," and the creative artist was alienated from his society because the United States "has not yet found any place for him who deals only in things of the human spirit except to use his notoriety to sell soap or cigarettes."[12]

On the other hand, the Dream has been one of the hardiest perennials in the mass media and American popular culture, and for two hundred years it has inspired editors, journalists, salespeople, and ordinary citizens, who have used the phrase (or the concept behind it) loosely and frequently as a synonym for success, prosperity, equality, economic expansion, and social mobility. In January 1984, for example, the newspaper *USA Today* celebrated the birthdate of Horatio Alger, Jr., by proclaiming that "the great American dream is alive and well," because "most of us feel we can still go from rags to riches. More than 81 percent of the adults across the USA believe that even the poorest child has the opportunity to achieve great wealth, according to a national poll conducted for *USA Today*. . . . Only 15 percent say the poor don't have the opportunity to become rich, as did those [characters] described in . . . works of

fiction by 19th century author Horatio Alger." A business associate of Polish immigrants who became successful contractors in the New Jersey suburbs said, "They're perfect examples of the American dream. . . . Most of them came over here with nothing." A movie reviewer described Brian DePalma's *Scarface* as a "retelling of the American dream as lived by a Cuban gangster who sets up shop in Miami . . . [and] equates freedom and happiness with a gaudy mansion and an icy blonde"; and the police commissioner of New York applied the phrase to juvenile drug dealers: "You can take $400 here . . . and turn it into several thousand dollars very rapidly," he said in 1986; "black kids, Hispanic kids, white kids find out very quickly that this is a nice way to achieve the American dream and become an entrepreneur."[13]

Studs Terkel published an entire book of interviews in 1980, with the title *American Dreams: Lost and Found*, in which he spoke to a middle-aged couple who had won $1 million in a state lottery in 1975 and believed that the Dream was "what we're doing right now. (Laughs.) To me, this is living. We can go golfing whenever we want to. . . . Just where but America could this have been accomplished?" But another middle-aged American—who had lost his job, his hospitalization insurance, savings account, and credit cards during the 1975 recession—was less enthusiastic when he wrote a column entitled "What American Dream?" for the *New York Times* in 1983: "It wasn't too long ago that we used to hear a lot about the American Dream. If I remember correctly, the idea evolved from the premise that what America stood for was the greatest good for the greatest number of people. I haven't heard much about that lately. . . . If we can spend $24.5 billion on defense this year . . . we can find ways to maintain services for destitute people. If we can't do this, then we'll have to face an unpleasant truth: perhaps with our penchant for disposable products, we may also have developed disposable people." But two years earlier, a writer for the *Christian Science Monitor* had celebrated the inaugural of Ronald Reagan, the nation's first movie star president, by gushing, "It's fantastic to be an American. . . . We dream the wildest dreams. Practically every American child envisions himself or herself growing up to be that semifantastic being—a star. A baseball star. A rock star. Who knows? Maybe even president. . . . Then, we don't quite make it to the Big Twinkle, we dream the dream for our children. Unlimited, fantastic room for growth—isn't that the heart of the American Dream?" And, of course, there are the advertising copywriters who use the Dream to sell Americans everything from automobiles to real estate to washing machines. "The American dream is our dream. . . . Standing behind our products . . . [is] our way of furthering the American dream," says the soothing prose of one large manufacturer's advertisement, illustrated with a picture of a ranch-style home beneath a pale pink, sunset sky: "As a maker of home appliances, Whirlpool Corporation understands how important the home is. . . . We also know that major home appliances go a long way toward making a house a home."[14]

Obviously the Dream has been very elastic, as Americans have stretched and adapted it to fit all kinds of people and historical circumstances. It has accommodated Alger's plucky newsboys, immigrants, lottery winners, drug dealers, and Miami gangsters as well as ambitious youths yearning to become rock stars or presidents. Yet

Americans also use the Dream to criticize inequality or to express fears that they may become "disposable people" who will be left to rot while their government spends billions of dollars on military budgets.

What lies behind many versions of the Dream is the conception of America as a kind of magic environment or society that has the power to transform people's lives, the idea that the United States is not merely a new world, but a different kind of world, a unique place where the limitations, boundaries, and inequities that formerly confined the human race either do not exist or are about to disappear. This belief, often described as "exceptionalism," is based on the assumption that America can never be an ordinary nation or society. Instead, to use a much-quoted phrase from John Winthrop's 1630 sermon on the *Arbella*, it is destined to be a "city set upon a hill," whose inhabitants will lead lives of exceptional virtue, free from most of the tribulations and tragedies that have afflicted past history. This concept has appeared so often and in so many forms since Winthrop's sermon in 1630 that it can be considered a salient feature of America's "corporate culture," to use a term Raymond Williams applied to literature in 1977, its "common culture of . . . meanings and values," which seems real and natural, "while the corporate culture is being lived." This common culture, Williams said, may change as elements of it disappear, take new forms, or are reinterpreted, since "there is a continual selection, and re-selection of ancestors." However, he emphasized, it "never includes the whole range of values and meanings which are active in a society" or even all of the society's "significant practices." It is only a "selection and organization of certain definite meanings and values," including ones from the past, because "a successful corporate culture . . . has to include at least some versions of the past which make sense at some depth."[15] Accordingly, what Williams called a society's "contemporary corporate culture" is actually a process of incorporation and exclusion in which the values and social practices of some citizens are repeated and included and those of others are excluded or neglected—as, for example, the values of Native Americans, black people, and women are often excluded or devalued in America's popular culture. Moreover, no successful, current version of a corporate culture is ever completely up-to-date, since it must include past versions that "make sense." As we will see later in this study, this observation applies very well to the American Dream: some older versions—such as the rags-to-riches myth and certain phrases from the Declaration of Independence—have reappeared so often in the twentieth century that they seem to be permanent, or at least perennial, components of the Dream.

Interpreted in this context, the idea of America, which came to be called the American Dream during the twentieth century, began to make sense to Puritans like Winthrop as early as 1630, and, by the late eighteenth century, had become codified and secularized. All the important rudiments of the Dream can be discerned in *The Letters of An American Farmer*, which J. Hector St. John de Crèvecoeur wrote in the 1770s and published in England in 1782. Written from the viewpoint of an imaginary Pennsylvania farmer, the first eleven letters are a good example of the Dream as a substitute for, or perhaps a reaction against, some harsh realities. Crèvecoeur, a native

of France, was a farmer in Orange County, New York. In 1778 he abandoned his family because he feared that he would be persecuted by his revolutionary neighbors. After many hardships, he arrived in England and published the *Letters*, several of which extolled the colonies as a perfect haven of equality and prosperity.[16]

In "Letter III: What Is an American?," he claimed that in North America English travelers would not see the "hostile castle and the haughty mansion" contrasted with the "miserable cabin," but instead they would discover a "pleasing uniformity of decent competence . . . throughout our habitations." "We are the most perfect society now existing in the world," Crèvecoeur wrote; and he declared that when immigrants from Europe arrived in the new world, a "surprising metamorphosis" was performed by an "invisible power" that "tended to regenerate them: new laws, a new mode of living, a new social system; here they are become men: in Europe they were as so many useless plants. . . . But now, by the power of transplantation, like all other plants they have taken root and flourished! . . . Instead of being a vagrant [the immigrant] has a place of residence . . . and for the first time in his life counts for something." America, Crèvecoeur announced, transformed the immigrant from "a servant to the rank of a master; from being the slave of some despotic prince, to become a free man. . . . What a change indeed!" After explaining this thesis in general terms, Crèvecoeur documented it by giving "the progressive steps of a poor man, advancing from indigence to ease, . . . not by virtue of any freaks of fortune, but by the gradual operation of sobriety, honesty, and emigration." He ended his sketch of the immigrant's rise to prosperity with an emphatic document—a list of the property he had acquired, including one hundred acres of land plus the value of six cows, two mares, his tools, seventy-three bushels of wheat, and the meat, flax, and wool stored in his cellar.[17]

Crèvecoeur's *Letters* were popular in Europe in the late eighteenth and early nineteenth centuries, but they were not a great success in the United States, where there was little interest in them until 1904, when a new edition was published.[18] In the meantime, however, many Americans had constructed a conservative version of the Dream that shared many features of Crèvecoeur's. They believed the United States was indeed a "perfect society" in which honesty and industry were rewarded with prosperity, and like Crèvecoeur, they illustrated this idea with examples—presidents born in log cabins, newsboys who became rich merchants, and immigrants who became millionaires. They also made this version of the Dream a part of the curriculum of their nation's common culture, an earnest lesson for Americans about what they should expect from themselves and their country. Speaking before an audience of students at a business college in Washington in 1869, for example, Congressman James Garfield said the students should not fear poverty, because "in the aristocracies of the old World, wealth and society are built up like the strata of rock. . . . If a boy be born in the lowest stratum of life, it is almost impossible for him to rise . . . but in this country it is not so. The strata of our society resemble rather the ocean, where every drop . . . is free to mingle with all others, and may shine at last on the crest of the highest wave. This is the glory of our country." Like Crèvecoeur, Garfield contrasted America and Europe to argue that the United States was not a hierarchical society, and

he used the same kind of simple metaphor to explain social mobility: for Crèvecoeur immigrants were like plants that prospered in new soil, and for Garfield the poor in America were drops in an ocean, but drops that could rise on the "highest wave." Garfield also used success stories to prove that the American Dream was a reality. But by 1869 it was no longer possible to claim that there were no miserable huts or cabins in the United States, so he incorporated poverty into the American Dream by invoking the cliché (that had already begun to be popularized by Horatio Alger, Jr.) that any poor child could become a great success. "I never met a ragged boy of the street without feeling that I may owe him a salute, for I know not what possibilities may be buttoned up under his shabby coat," he said, for "among these boys are the great men of the future,—the heroes of the next generation."* As for the failures, Garfield dealt with them briefly and briskly with another fluid metaphor, when he commented that he knew poverty could be "uncomfortable . . . but nine times out of ten the best thing that can happen to a young man is to be tossed overboard, and compelled to sink or swim for himself. In all my acquaintance, I have never known one to be drowned who was worth the saving."[19] Garfield's speech was more than mundane advice. It was, he said, "almost a sermon," and he was right, for it expressed his—and many other Americans'—devout faith in education, their nation, and the work ethic. Each of Garfield's success stories, like the ones that appear so often in newspapers, magazines, and *Reader's Digest*, can be considered a kind of secular American saint's life, illustrating the way to prosperity and redemption from poverty.

But if the conservatives have their version of the Dream, so have the liberals. Unlike conservatives, who like material success stories that prove the United States is a land of wonderful opportunities, liberals usually emphasize that America is (or should be) a land of equality and security, as well as opportunity, for all—including workers, farmers, women, and minorities. Thus when Geraldine Ferraro was nominated for the vice presidency at the Democratic Convention in 1984, she told her audience, which included many blacks and Hispanics, that she stood before them to proclaim that America was "the land where dreams can come true for all of us. . . . Our faith that we can shape a better future is what the American dream is all about. . . . The rules are fair. If you work hard and play by the rules you can earn your share of America's blessings."[20] Moreover, instead of equating instant riches or sheer wealth with the Dream, as conservatives often do, liberals specify that it is important for everyone— including "ordinary" or "common" people—to have a fair "share" of their nation's prosperity. Historian James Truslow Adams, who popularized the term "American dream" in the early 1930s in his *Epic of America*, insisted that the Dream meant that there should be "a better, richer, and happier life for all of our citizens of every rank." He explained that this idea of America as a land where *everyone* could become richer, happier, and more respected arose among America's poor people and immigrants,

*At the present time, many writers and publishers seek to avoid using language that is explicitly or implicitly sexist, and I have tried to do so in my own writing in this book. Some of the sources I quote, however, use language that suggests that the American Dream is reserved almost exclusively for men and boys. Naturally, in the interest of accuracy, I have had to preserve this language when I quote from those sources.

who had come to our shores . . . to find security and self-expression. They had

come with a new dynamic hope of rising and growing, of hewing out for themselves a life in which they would not only succeed as men but be recognized as men, a life not only of economic prosperity but of social and self-esteem. The dream derived little assistance from the leaders in America . . . [but] it was steadily and irresistibly taking possession of the hearts and minds of the ordinary American. It was his Star in the West which led him . . . in search of a home where toil would reap a sure reward, and no dead hands of custom or exaction would push him back into "his place."

Although this idea had flourished in the first half of the nineteenth century, Adams warned, it had nearly been destroyed by the plutocrats of the Gilded Age, who had concentrated the nation's wealth in their own hands and in the corporations they owned, until first Theodore Roosevelt and then Woodrow Wilson had revived the Dream during the Progressive Era. "Here . . . was the authentic voice of the great American democracy," Adams commented on Wilson's 1912 inaugural address, "here once more was the prophet speaking of the American dream, of that hope of a better and richer life for all the masses of humble and ordinary folk."[21]

Because of this concern for "humble and ordinary folk," liberals are usually more sympathetic to the nation's losers, less eager to blame them for their "problems," and less willing to believe, as Garfield did, that the best thing for the poor is to compel them to sink or swim. Instead, liberals often interpret failure, inequality, or poverty as evidence that the American Dream has not yet completely come true, or that perhaps, as Henry Wallace wrote in 1934, the "rules" of American life may need to be changed because "each generation has a different problem," and "if the rules are not changed fast enough and in the right direction, the game eventually breaks up in a riot."[22]

In contrast, conservatives usually emphasize that the American Dream can become a reality only if individuals transform themselves by conforming to certain unchanging rules or principles that will guarantee success in a capitalist society. For them, the Dream consists of "the belief . . . that people of talent in this land of opportunity and plenty" can become rich and respected if they adhere to a "well-defined set of behavioral rules," learned as early as the eighteenth century by successful Americans like Benjamin Franklin. And ever since Franklin, writing under the alias of Poor Richard, published his *Poor Richard's Almanack* and *The Way to Wealth*, many conservative believers in the Dream have been moralizers, positive thinkers, and exhorters like Horatio Alger, Jr., Norman Vincent Peale, or television evangelist Robert Schuller, who inspired unemployed autoworkers in Michigan, in the early 1980s, by shouting at them: "Don't fix the blame; fix the problem. . . . You can't hate the company for laying you off! . . . They're not giving jobs to angry people! . . . Don't exaggerate your unemployment problem! What you have is an idea problem. . . . The only difference between you and the supersuccessful is that they have bigger dreams! . . . If you are unemployed, you should look at this as a great opportunity to travel."[23]

On the other hand, it is usually the liberals who blame American institutions, as well

as individuals, for the nation's problems. Therefore, it is liberals who are willing to travel to places like Washington, D.C., or Selma, Alabama, to protest that the United States needs to make changes in its laws so that ideals can become realities and dreams can come true. In August 1963, for example, not quite one hundred years after Garfield's speech, Martin Luther King, Jr., gave his "I Have a Dream" speech to over two hundred thousand demonstrators who had come to Washington to protest against inequality, segregation, and discrimination. "When the architects of our republic wrote the magnificent words of the Constitution and the Declaration of Independence," King claimed, "they were signing a promissory note to which every American was to fall heir. This note was a promise that all men, yes, black men as well as white men, would be guaranteed the unalienable rights of life, liberty, and the pursuit of happiness." America, white America, had "defaulted" on this check, King said, but he proclaimed, "I still have a dream. It is a dream deeply rooted in the American dream that one day this nation will rise up and live out the true meaning of its creed—we hold these truths to be self-evident, that all men are created equal. . . . I have a dream my four little children will one day live in a nation where they will not be judged by the color of their skin but by the content of their character. I have a dream today."[24]

For Garfield, Crèvecouer, and other conservatives, the Dream is primarily economic, and the success stories they so often recite are linked with the assumption that America, "the most perfect society," is morally and politically superior to other nations. Therefore, they frequently contrast America with other nations they consider more static, hierarchical, or despotic. Liberals, like King, are more concerned with equality and more critical of the United States and its institutions; they often contrast the realities of life in the United States with American promises—particularly with those "magnificent words" recited on the Fourth of July, that "all men are created equal."

Even though they interpreted the Dream differently, however, King and Garfield had something in common: they were both considered embodiments of the Dream itself. Garfield, the last president born in a frontier log cabin, was the hero of a biography by Horatio Alger, Jr.; and King was portrayed as an example of the American Dream in a *Life* magazine sequence showing him as an infant, a smiling school child, a college graduate, and a winner of the Nobel Peace Prize, with this caption: "King often spoke of the American Dream. Was he not an emblem of it?"[25] Their lives may have been "emblems" of the Dream, but, ironically, their tragically similar deaths revealed a darker side of the Dream. Both were murdered by assassins, and this unpleasant coincidence suggests that, like so many other dreams, the American Dream has its nightmares, its ironies, its disasters, and its violent contradictions.

■

The present study does not try to list or analyze all of the versions and varieties of the American Dream that have been popular for the past two hundred years but rather to

discuss some of the significant ways in which certain versions of the Dream are expressed or criticized in photographs. Throughout this study, I assume that the camera is an extension of the mind, as it has been described by Gene Wise in his *American Historical Explanations*. Wise wrote that, in addition to seeing humans as political, economic, historical, religious, sexual, and psychological animals:

> We might now think of an additional conception—a picture of man as [a] *simplifying* creature, who reduces his world to size so he can communicate with it and act upon it.
>
> He does this through his power of *symboling*—which . . . is merely the ability to re-construct experience. It's the capacity to form picture representations that are something less than the full march of sensation . . . yet also something beyond those sensations. To put it another way, these pictures seem to perform two functions simultaneously for us—they both reduce our sensation of experience, and they expand it. They reduce by paring down reality . . . editing out signal from noise, focusing it down to intelligible form. But they expand reality by elevating us outside our immediate senses. We can use our picture-making power to imagine realities we've never before experienced.[26]

Photographers, editors, and curators can use film, cameras, and print technology to do literally all that Wise has described metaphorically. Distant environments and complex social realities are "pared down" and focused in images that are then ordered, selected, printed, exhibited, or published. Or, to use a slightly different metaphor from Wise's book, we can say that photographs, like all symbolic constructions, plane down realities just as pieces of wood are planed down to become manageable and to fit together in constructions.

The positive side of this process is that it makes realities that we might otherwise never be able to understand or care about seem vivid and intelligible to us. In his 1978 exhibition of American art photography, John Szarkowski proposed that photographic images could be viewed in two metaphorical ways—as mirrors or as windows. For documentary images, I would suggest a third metaphor: that photographs are also doors that enable us, if only briefly, to step out of our old ideas about ordinary realities and experience them in a fresher, more vivid way. Thus whether they show us child laborers in 1910 or dispossessed farmers in 1935, documentary images extend our sense of community with other places and persons and includes them in our consciousness and our concerns. In 1943 Ansel Adams proclaimed in a "Credo" that as soon as World War II was over "Documentation—in the present social interpretation of the term—will burst into full flower at the moment of peace. Herein lies the magnificent opportunity of all photographic history. Here is where the camera can be related to a vast constructive function: the revelation of a new world as it is born and grows into maturity. I believe that the highest function of post-war photography will be to relate the world of nature to the world of man, and man to men."[27] Unfortunately, Adams's prophecy did not come true, but his "Credo" is an eloquent statement of what photography might achieve.

The problem with photography is that it, like the mind, can plane down and oversimplify ambivalent, complicated realities by reducing them to neat packages of visual entertainment or "information." Photography may not, as Susan Sontag has claimed, symbolically reduce its subjects to "corpses,"[28] but it can pare them down until they are like the colorful porcelain statuettes of peasants in their quaint costumes that were so popular in Europe in the eighteenth century. Like those figurines, photography can give us very vivid and very superficial images of other human beings and societies. Considered in this context, the merit of documentary photography is that, generally speaking, it *tries* to be honest. As Walker Evans somewhat skeptically explained to a group of college students in 1971: "Documentary style is what we're interested in. . . . What your generation is interested in is honesty, much to your credit. You've been lied to so much that you're damned well going to have something honest for a change. This style does seem honest. It isn't always so, but it seems so. It is possible to express yourself practically, honestly, with a camera, more so than perhaps [with] other media."[29] Thanks to the achievements of photographers such as Hine, Frank, and Evans, when we look at a photograph of social significance, made in a "documentary style," we often see a serious effort to (as Wise would say) "translate vision into thing": that is, to translate an idea of what America should (or should not) be into the visual fact of a photographic image in as truthful a way as possible.

Therefore, my main assumption about the images I analyze in this book is that they are the products of a functional, rather than a decorative, art, that they are made— as Francisco Goya said of his etchings, *Los Caprichos*—with the "intention . . . to banish harmful common beliefs and to perpetuate . . . the sound testimony of truth."[30] In order to analyze these images as carefully as possible, I rely on the following methodology.

In many instances, I analyze the photographers' own comments on their work, expressed in statements and interviews. This aspect of photography has often been ignored by critics: William Klein, speaking about Roland Barthes's *La Chambre Claire*, complained that "Barthes isn't all that interested in what I see or what I've done. He's not listening to me—only to himself." I believe, however, that even though they may not be quite as articulate as critics are, photographers do have significant things to say with words as well as with images; and during the past twenty years, more of their verbal, as well as visual, statements have appeared in print. Therefore, I frequently heed what photographers say to understand what they see. Moreover, since documentary photography usually involves a social drama in which photographers may be—at least implicitly—participants as well as observers, I analyze the roles they seem to enact as they make their pictures. So, I consider the significance of the social manners of the FSA photographers, like Russell Lee, who behaved like friends and neighbors; of Lewis Hine, who acted like a spy; and of Frank, who wrote about himself that to be a photographer one must be "*un peu comme un détective*" ("a little bit like a detective").[31] In some cases, I also discuss the relevance of the subjects' attitudes, as revealed in their poses, since the people in documentary photographs usually know

they are being photographed and react to this situation by presenting themselves in various ways.

When it is relevant to do so, I analyze the formal composition of pictures: the subjects' positions, and the photographers' selections of camera angle, depth of field, lighting, and other technicalities. As Edward Weston has pointed out, photography is never restricted "to copying nature," since "an infinite number of compositions can be achieved with a single stationary subject by varying the position of the camera, the camera angle, or the focal length of the lens."[32] Documentary photographers rarely use such devices or techniques obtrusively, since they are photographing ordinary people and mundane activities, but they do use them, and sometimes significantly.

Besides the photographers' techniques and statements, I also emphasize the contents of their images, their choices (or their editors' selections) of "typical" or "significant" subjects, events, and activities. I give particular attention to the repetition of subject matter or compositions in images, and also consider the selection and arrangement of images in sequence in exhibits, photoessays, or books, either by the photographers themselves, by their editors, or by those who commissioned their work.

Another factor that is often ignored in photography anthologies or histories, but that I emphasize, is the original print context of images—the written text, or caption, that accompanies and explains a photograph. This "contribution" of print to an image's meaning is particularly important for photographers such as Hine and the *Life* and *Look* photojournalists of the 1940s and 1950s whose images were meant to be seen in integrated text-image formats.

Even though certain photographers, most notably Frank and Evans, have emphasized the "personal" quality of their photographic visions, social photographers are not poets in lonely garrets, hoping that posterity will recognize them. Therefore, I consider the general, social viewpoints of the photographers' colleagues, clients, editors, friends, and publishers and, in particular, their ideas about American society. Editors, publishers, and clients often function as intermediaries between photographers and the general public; this does not mean that photographers are always under their control but that photographers often have to cooperate with them. Hence, I discuss in some detail the viewpoints of—for example—the Hampton Institute, the National Child Labor Committee, and the editors of *Life* and *Look* magazines.

I must emphasize that the total meaning of social documentary images is not confined strictly to the intentions of the photographers or the persons who commission their work. When photographers or editors select certain images from a contact sheet, print them, and eventually publish or exhibit them, they are acting as what I call the images' immediate audience. The images they select may embody and present an ongoing social drama and a variety of social realities; and, in some cases, the photographers and their editors or clients may have a limited ability to understand and communicate that drama or those realities. After images are printed, captioned, or exhibited, their meanings may be modified or adapted by other persons—their secondary audience—who may have a different, but valid, understanding of the social

implications of the images.[33] This characteristic of social photography creates opportunities and difficulties of interpretation that do not exist for other kinds of image-making. For example, an Edward Weston art photograph of stones and roots is likely to mean the same thing to later generations that it did to Weston and those who originally appreciated it in the 1930s. On the other hand, Frances Johnston's 1899 images of black students at the Hampton Institute may have different meanings to different generations of black and white Americans because they refer to a social drama and conflicting attitudes that are still vital issues in the United States. Thus later audiences, because of insights gained over time, may understand documentary photographs differently.

Clearly, therefore, I do not accept the assumption, once widespread, that photography is an especially "transparent" or "objective" medium and that a single, unchanging, bedrock reality automatically reveals itself through photographic images. This assumption has been described as a myth, and it is significant that some important photographers have not believed in it. Walker Evans, as mentioned earlier, said that even though documentary seems honest, it is not always so. Robert Frank claimed "realism is not enough—there has to be vision"; and Lewis Hine was quite blunt when he warned an audience of social workers in 1909 that although the "average person believes implicitly that the photograph cannot falsify, . . . you and I know that this unbounded faith in the integrity of the photograph is often rudely shaken, for, while photographs may not lie, liars may photograph. It becomes necessary, then, in our revelation of the truth, to see to it that the camera we depend upon contracts no bad habits."[34]

Finally, I have selected photographers whose pictures can be related to significant versions of the American Dream and to social conflicts and issues so important or disturbing that their images appeal not only to their immediate, or original, audiences but also to later generations. As one of Dorothea Lange's friends told her about the popularity of the "Migrant Mother" picture she made when she was an FSA photographer, "Time is the greatest of editors and the most reliable."[35] Lange's FSA images continue to be published and republished almost fifty years after the Great Depression, and Lewis Hine's photographs of child workers also continue to interest and disturb people, even though there is less child labor in this country than there was when he was working in the 1910s.

I obviously do not consider these photographs as enclosed, visual artifacts that refer primarily to other photographs, to paintings, or to the photographers' private lives and obsessions. As Eugene Smith said brusquely in a 1978 interview, "I can't stand those damn shows on museum walls with neat little frames, where you look at the images as if they were pieces of art. I want them to be pieces of life!"[36] Actually, I enjoy museums, and I believe it is possible to exhibit photographs so they are not reduced to "pieces of art," but I agree with Smith that it is more important to see them as "pieces of life." Or as pieces of a dream that may help us to understand our lives better.

Frances Johnston's
Hampton Album
A White Dream for
Black People

*After the migration of the European fair-skinned races in large
numbers to other parts of the earth occupied by people of darker
colour, the adjustment of relations between the diverse races
developed a whole series of problems . . . [that] are perhaps more
acute in the United States than elsewhere, because there the
lightest and darkest races have commingled [sic], [and] because of
the theory on which the government of the country nominally
rests, that each freeman should be given an equal chance to
improve his . . . position and an equal voice in deciding political
questions.*

– Walter Francis Wilcox, "Negroes in the United States"

*The exhibit which Hampton is preparing to send to the Paris
Exposition emphasizes the importance placed by the school
authorities on the training of the Indian and Negro in the arts
that pertain to home and farm life. . . . It is part of the plan of
the exhibit to contrast the new life among the Negroes and
Indians with the old, and then show how Hampton has helped to
produce the change. . . . The value of such an exhibit lies not only
in showing to others but in making clear to the school itself what
it is doing.*

– "The Paris Exhibit"[1]

rances Benjamin Johnston's *Hampton Album* was probably one of the first attempts to use photography to document the application of the American Dream of prosperity and progress to the nation's minorities—in this case, to the blacks and Native Americans who were students at Virginia's Hampton Institute in November and December 1899, when Johnston made her images. The history of the *Hampton Album* is slightly unusual. Originally, Johnston made the pictures for an exhibition at the Paris Exposition in 1900, and a year later they were also exhibited at the Pan American Exposition in Buffalo. Afterwards, someone had them mounted and bound in a large leather photograph album in which the prints were numbered and protected by sheets of transparent paper, upon which captions were written lightly. Presumably these numbers indicate the sequence in which the prints were displayed, and the captions were the ones used at the exhibits. Critic and editor Lincoln Kirstein discovered the album during World War II in a Washington, D.C., bookstore and donated it to the Museum of Modern Art in New York. The museum exhibited Johnston's prints in 1966 and in the same year published an abridged version, which contained 44 of the 159 original plates.[2]

Frances Johnston, the woman who made almost all of the pictures in the album, was not very well known when it was published fourteen years after her death in 1952. She was, however, one of the most successful photographers in Washington, D.C., when she made these photographs (and a similar group at the Tuskegee Institute in Alabama in 1903); when she arrived at the Hampton campus, its official publication, the *Southern Workman*, proudly called her "an artist of high rank."[3] Johnston must have been pleased by this comment, since it was exactly her conception of what a photographer should be. In 1897 she had written an article for the *Ladies' Home Journal*, in which she gave other women advice about how they could become successful professional photographers and in which she portrayed her own ambitions and values quite succinctly. She admitted it would be useful for a photographer to have some technical training but emphasized that, for her, the prime requisites for a "good paying business" were "good common sense, unlimited patience . . . equally unlimited tact, good taste, a quick eye, a talent for detail . . . imagination, discriminating taste, and, in fact, all that is implied by a true appreciation of the beautiful." "In portraiture, especially,"

she wrote, "there are so many possibilities for picturesque effects . . . that one should go for inspiration to such masters as Rembrandt, Van Dyck, Sir Joshua Reynolds, Romney and Gainsborough rather than to the compilers of chemical formulae."[4]

Johnston's emphasis on the "beautiful" was a commonplace among the professional "artistic" photographers of the era who held both amateurs and "the compilers of chemical formulae" in equal contempt. What is more significant about her formula for success is the importance she assigned to the social qualities that a photographer should possess—patience, tact, and "discriminating taste," which is a social, as well as an aesthetic, virtue. It is also significant that, with the exception of Rembrandt, all of the portrait painters she admired were notable for their skill in making powerful and wealthy people look charming and gracious. They made their fortunes and reputations by painting kings, queens, dukes, and generals; and, though Johnston's camera could not do what a Van Dyck or Gainsborough painting could, she was quite successful in gaining the patronage of the American establishment of her time. In the 1890s and the early 1900s she made portraits of such notables as Mark Twain, Susan B. Anthony, and Andrew Carnegie. She made the last "official photograph" of McKinley before he was assassinated, and one of her other pictures of him was used as a model for his statue at the McKinley Monument. She photographed everyone in President Roosevelt's family, and when Roosevelt's Rough Riders uniform arrived from Brooks Brothers Johnston was there to photograph him wearing it. It was through Roosevelt's influence that Johnston was one of the few photographers allowed to join Admiral Dewey's fleet—after the battle of Manila Bay—to photograph the victorious admiral and his men. On the card he gave her, Roosevelt, who was then assistant secretary of the navy, wrote: "My dear Admiral . . . Miss Johnston is a lady, and [one] whom I personally know. I can vouch for [her], she does good work, and any promise she makes she will keep."[5]

In addition to being the portraitist of the nation's leaders, Johnston was also a capable recorder of America's works and institutions. White middle-class Americans were starting to enjoy the benefits of their nation's rapid industrialization, the exploration and mapping of its frontiers, and the exploitation of its natural resources. They wanted to see as well as to read about Pennsylvania coal mines, the Mesabi iron range, Massachusetts shoe factories, the Philadelphia Mint, the wonders of Yellowstone Park, and the glories of the Columbian Exposition (1893), the Pan American Exposition (1901), and the Louisiana Exposition (1904): which were some of the major subjects Johnston photographed for magazines like the *Ladies' Home Journal*, *The World's Work*, and *Demorest's Family Magazine*. Looking at her images of the expositions—in which America's products and inventions were displayed in grandiose, pseudoclassic temples, pavilions, and a palace of the "Mechanical Arts" surrounded by fountains, artificial lakes, and pompous statuary—it is easy to see why American visitors believed they were indeed living in what journalists and politicians had begun to call "the greatest nation on earth," whose grandeur would surely equal or surpass that of Athens, Rome, London, Paris, or Berlin. But many of these buildings, so impressive in Johnston's pictures, were really made out of a cheap compound called

"staff," a mixture of jute fiber and plaster of paris made to look like white marble. Similarly, some of the more thoughtful leaders of Johnston's era were aware that their nation was not as impressive as it looked. America needed to solve several difficult and embarrassing "problems" before it could claim to be a truly civilized nation as well as a rich and powerful one. In the West was the "Indian problem"—thousands of diseased and dispirited Native Americans had become government wards on reservations; in the cities was the "immigrant problem"—millions of poor people from every part of Europe needed to learn the English language and "American values"; and in the South was the "Negro problem"—millions of poor blacks, segregated and disenfranchised, who were not exactly living in racial peace and harmony with their white neighbors, as that region's grim lynching statistics indicated.

Considered in this context, Johnston's Hampton pictures, exhibited at the Paris Exposition in 1900, may have been meant as a tacit demonstration to the civilized world that at least some white Americans had discovered a method of educating their nation's "darker races" superior to that of the U.S. Army at Wounded Knee or of lynch mobs in Alabama and Georgia. Her pictures were used as part of the *American Negro* exhibit, which was meant to illustrate "Negro progress and present conditions" in the United States. It is rather significant that a very limited area of about twelve square feet was all the space allotted for this theme: in fact one reason that photographs were used was that they would take up very little room. Thomas J. Calloway, a young black man who was appointed a "Special Agent" of the American Commission, arranged an ingenious series of cabinets to show the materials, including the photographs from the Hampton and Tuskegee institutes and from Howard, Fisk, and Atlanta universities. The Hampton pictures, he said in a report, were considered "the finest photographs to be seen anywhere in the exposition. . . . It was the general opinion that nowhere had the photographer's lens been so eloquent and impressive in the story of a great work as was silently narrated by these photographs."[6]

When she set out to document the "great work" going on at Hampton, Johnston accepted an assignment that demanded much more tact than photographing popular subjects like Yellowstone Park or the Columbian Exposition. At Hampton, she had to dramatize a controversial racial and educational philosophy. The Hampton Institute was founded in 1868 by General Samuel Chapman Armstrong, a white man who had commanded black troops in the Civil War, as a coeducational secondary school for black freedmen. From 1878 until the early 1920s, a number of Native Americans also attended the Institute. After Armstrong's death in 1892, his philosophy of "industrial," or "vocational," education was widely identified with Booker T. Washington, Hampton's most famous and successful graduate, who founded the Tuskegee Institute in 1881. This philosophy, known as the "Hampton idea," was promoted as a panacea for the nation's racial problems after Washington made his famous 1895 "Atlanta Compromise" speech, in which he claimed that "The wisest among my race understand that the agitation of questions of social equality is the extremest folly. . . . It is important and right that all privileges of the law be ours, but it is vastly more important that

we be prepared for the exercises of these privileges. The opportunity to earn a dollar in a factory just now is worth infinitely more than the opportunity to spend a dollar in an opera-house."[7] For years, southern white leaders had been promoting the idea of a vigorous, prosperous "New South," and the Hampton-Tuskegee brand of industrial education was meant to create a different kind of black: not a groveling "good darkey," symbolized by the Natchitoches statue, but a self-respecting, hard-working farmer, artisan, or factory worker. This racial philosophy clearly was meant to disprove the contentions of bigots like Governor James K. Vardaman of Mississippi and author Thomas Nelson Page of Virginia, who believed that the Negro was a "lazy, lying, lustful animal which no conceivable amount of training can transform into a tolerable citizen" and that "the negros *as a race* have never exhibited any capacity to advance." But the Hampton philosophy was also opposed, more discretely, to the beliefs of racial liberals like John Hope, who later became president of Atlanta University. He told a black college debating society in Nashville in 1896 that "colored people" should struggle "for equality. . . . Now catch your breath, for I am going to use an adjective: I am going to say we demand *social* equality. In this republic we shall be less than freemen, if we have a whit less than that which thrift, education, and honor afford other freemen."[8]

Moreover, though Washington and his allies did not like to admit it, industrial education was relatively acceptable to white supremacists, who thought that since it was an essentially inferior kind of education it was therefore appropriate for black people. In 1913, for example, when Thomas Pearce Bailey, a southern educator, made up a fifteen-point "racial creed of the southern people," he included such maxims as "the white race must dominate," "the Negro is inferior and will remain so," "no social equality," and "no political equality"; but he also specifically claimed that "in educational policy . . . the Negro [should] have the crumbs that fall from the white man's table" and that there should be "such industrial education of the Negro as will best fit him to serve the white man."[9] Whereas white supremacists like Bailey took it for granted that the inferiority of black people was permanent and that industrial education would always be the best way to make them "fit . . . to serve the white man," Washington and his allies were careful to claim, politely, that it was only the "present condition" of black people that made industrial education so necessary. They emphasized the immediate, practical benefits of this type of education for the Hampton and Tuskegee students, which they illustrated with numerous success stories about prosperous graduates, but they also used evolutionary analogies to point out that the "Negro race" was at a certain stage in its development and that industrial education would help black people to move to higher, more "civilized" stages in the future. In a 1903 article, "The Successful Training of the Negro," for example, Washington mentioned that farm training had been given special attention at Tuskegee "because we believe that the Negro, like any other race at the same stage of development, is better off when owning . . . the soil," and he added that he did not "believe that the black man's education should be confined wholly to industrial training, nor do I advocate anything for the Negro that I would not emphasize for the Jews, Germans or

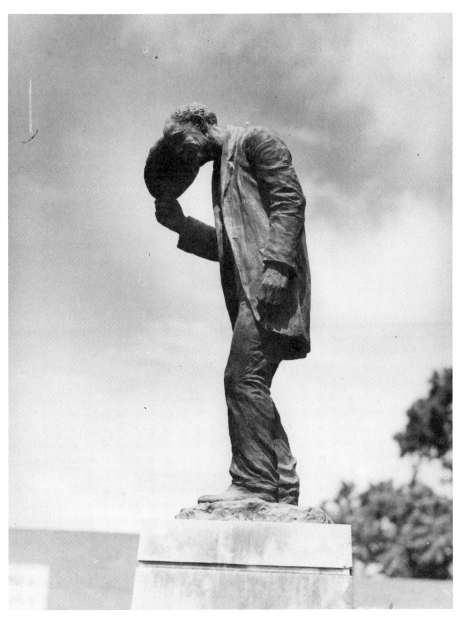

Japanese were they in the same relative state of civilization."[10] The author of a January 1899 *Southern Workman* editorial addressed to the Hampton students made the same point more harshly when he used education as a metaphor to explain the "Negro problem in this country." If we compare this problem "to a course of study," he wrote, "then at the present stage of the world's development, the white man is in college and the colored man is in the lowest grade of the primary school; and the white man demands, and justly too, that he shall successfully make all the grades below, before he enters college with him. There is but one solution to this question. . . . It is the same that the white man wrought out for himself—*development*. . . . There is no short

27

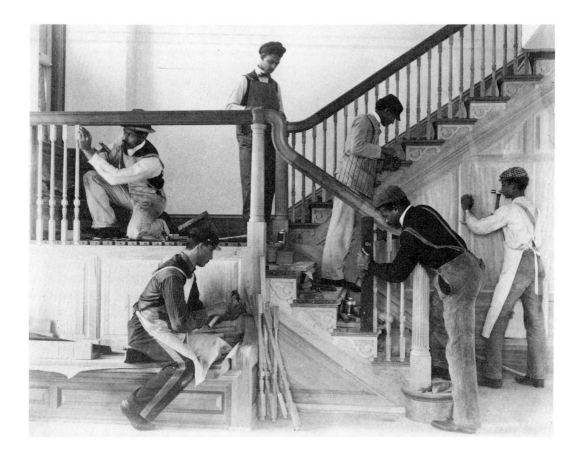

cut. . . . Step by step we must climb the rugged hill of progress." But this "stern advice" was accompanied by a promise, an invocation of the great American Dream of that era, the belief that any poor man in America—no matter what his origins or family background—could grow up to become president of the United States. Ignoring such unpleasant realities as the fact that by 1899 thousands of black men had already been disenfranchised in the South, the editorial writer proclaimed: "If we would be Lincolns, Grants, and Garfields in the White House, we must cheerfully become rail splitters, tanners, and canal boat drivers."[11]

Johnston's Hampton images dramatized that institutes's philosophy very well. In every one she presents her subjects as ideal students humbly and industriously advancing up the "rugged hill of progress." Both the contents of her pictures and their captions stress that the students are receiving a simple, utilitarian education. Many scenes are devoted to the Institute's manual trades classes in bricklaying, shoemaking, and carpentry. In the agriculture courses there are a number of classroom scenes but there are more pictures showing the students sampling milk and learning how to make butter, judge swine, and mix fertilizer. Some of the traditional academic subjects, like history, are being taught in conventional lecture rooms, and some of the sciences are being taught in laboratories; but even in many of these courses there is a heavy emphasis on the simple and the practical. A physics class, for example, is studying the

principle of "The Screw as Applied to the Cheese Press," by operating a number of little presses in a laboratory. None of the students seem restless or bored by these activities, and their keen interest strongly implies that this is exactly the kind of education appropriate for them.

Johnston's images also implied that the students had learned and were living by what at the turn of the century was called "the white man's way." Their dress is the strongest indicator of their acceptance of white culture. The children in the Institute's primary school wear full nineteenth-century Victorian regalia; the women students wear hats, bustles, and sweeping skirts even when they are observing cows in barns and pigs in farmyards; and many of the young men, particularly in the classroom settings, wear uniforms given to the Institute by the U.S. Army. As Booker T. Washington explained in *Up from Slavery,* "no white American ever thinks that any other race is wholly civilized until he [*sic*] wears the white man's clothes, eats the white man's food, speaks the white man's language, and professes the white man's religion."[12] In Johnston's images even the students' recreational activities are "white," and in her photographs of the Institute's athletic teams, musical clubs, and orchestras she arranges the students in poses that are replicas of the group photographs made at white colleges and universities—presumably to emphasize how completely the students have accepted white culture. It is also notable that in every picture in the album, students behave with the utmost Victorian propriety. Even though the classes are coeducational, the young men and women never take any interest in one another. They always seem to be totally absorbed by their lessons. Looking at them, it is easy to see how their white teachers and the editorial writer of the *Southern Workman* could have been quite sincere in saying that the Hampton students might be the Lincolns, Grants, and Garfields of their race, farming and bricklaying now so that later they, or perhaps their children, could reach the White House.

It is important to point out, however, that this version of the American Dream did not originate with the students but was imposed upon them. Despite its emphasis upon the practical and the utilitarian, the Hampton-Tuskegee philosophy began as a vision in General Armstrong's mind that he later described as a "day-dream." Armstrong had grown up in Hawaii, where his father was a missionary, and he had been very impressed by a missionary boarding school in Hilo that gave manual training and—he believed—"turned out" graduates who, although they were perhaps less "brilliant" than students from other schools, were nonetheless "more solid men." Years later, he said, when he was commanding black troops in the Civil War, he had his "day-dream" that a school like the one at Hilo would be perfect for black people: "The thing to be done was clear: to train selected Negro youth[s] who should go out and teach and lead their people. . . . To teach respect for labor, to replace stupid drudgery with skilled hands; and . . . to build up an industrial system . . . for the sake of character. . . . The missionary plan in Hawaii had not, I thought, considered enough the real need and weaknesses of the people, whose ignorance alone was not half the trouble. *The chief difficulty was, with them, deficient character, as it is with the Negro* [emphasis added]."[13]

Armstrong lived in an era when such dreams were taken seriously. The Columbian Exposition of 1893 was referred to as a "Dream City," and the Paris Exposition of 1900 was called "a veritable city of dreams and illusions." It was a time when white, middle-class Americans were apt to be particularly energetic dreamers. Writing about his parents, who were Young Men's Christian Association missionaries, John Hersey described it as "a time of wonderful optimism, of American vigor and action. Teddy Roosevelt was President. Anything seemed possible—even as the slogan of the Student Volunteer Movement for Foreign Missions, had it, 'The evangelization of the world in this generation.'" Inspired by this ambitious evangelism in 1905, his mother and father had gone from Syracuse University to Tientsin to teach the Chinese basketball and accounting as well as Western medicine, education, science, and agronomy. When he visited the United States in 1905, H. G. Wells encountered the same optimism on the Lower East Side of Manhattan. When he expressed his doubts about whether America could "assimilate" all of its immigrants, a settlement-house worker immediately insisted that the immigrants' "children make better citizens than the old Americans," and she rushed him to a model classroom at the Hebrew Alliance, where the children performed a ceremony in which they sang patriotic songs, pledged allegiance to the flag, and waved dozens of little flags as they marched around the room. Wells said "it was the most touching thing I had seen in America"; but, after he and his guide returned to the "barbaric disorder" of the ghetto "streets abominable with offal and indescribable filth," he shouted over the noise to the young woman that her nation still faced some formidable problems, like "Lynching! Child Labor! Graft!" "*We'll* tackle it!" she shouted back to him, and Wells decided that she was "a little overconfident . . . but extremely reassuring . . . I could have imagined her the spirit of America incarnate."[14]

This same optimism can also be discerned underneath the pious rhetoric of a speech made to the assembled Hampton students in 1896 by Daniel Gilman, the president of the Slater fund, a philanthropy that gave vocational education buildings to schools for blacks. "What does this assembly represent?" Gilman asked when he came to the Institute to dedicate its Armstrong-Slater Trade School Building, and he answered: "On the one hand, those who stand for the best that the white race has produced, the fruit of many generations, developed under the sunshine of freedom, religion and education; and on the other hand, those who represent the capacity, the hopes . . . of races but lately emerging from bondage or barbarism, error and illiteracy. The light-bearers are here, ready to hand to the light-seekers the torch which shall illuminate the path of progress."[15] If American missionaries could evangelize the Chinese, and settlement-house workers could change children born in Polish *shtetls* into American patriots all in one generation, then surely the nation's black people could be changed into moral, attentive, industrious, and Christian men and women who would be completely white in everything except for the color of their skins. Analyzing Gilman's speech further, one can see why he and other white Americans were so confident. They were not ordinary human beings, but "the best that the white race has produced." They were "light-bearers," Promethean beings who could "illu-

minate the path of progress" for the world's "darker races." What they had created, in
effect, was an American edition of that imperial dream expressed so eloquently by
Kurtz, the character in Joseph Conrad's 1899 novel, *Heart of Darkness*, who claimed
"that we whites, from the point of development we had arrived at, 'must necessarily
appear to [black Africans] in the nature of supernatural beings . . . [who] can exert a
power for good practically unbounded.' "[16]

In order to dramatize the belief that this dream was becoming a reality on the
Institute campus, Johnston and the persons who prepared the exhibit arranged her
images to document the process that was supposed to change the students from
degraded slaves and wild Indians into self-respecting, self-supporting Americans.
The first two pictures in the album were portraits of General Armstrong and his
successor, the Reverend Hollis Burke Frissell, who commissioned Johnston to make
the photographs. This placement of their portraits is conventional, institutional ha-
giography—since they were the Institute's founder and its current principal, it was
assumed that their images were an appropriate introduction. (Hampton Institute, one
of Armstrong's admirers claimed, was "a man incarnate—Armstrong himself, multi-
plied and in action.")[17]

Following these portraits is a sequence of three very serene "Waterfront" pictures of
the Institute, showing views of its buildings from the estuary of Hampton Roads, near
the Chesapeake Bay, which it faces. These pictures are geographically accurate, since
the Institute does have frontage on the estuary. The views, however, also create the
illusion that the Institute is surrounded by water and is, therefore, more isolated than
it really is. Looking at these images, one would never imagine that the Institute was on
the outskirts of the town of Hampton and that—as Robert Engs has pointed out—the
black community in that town had its own strong tradition of self-improvement that
sometimes conflicted with the "paternalism" of Armstrong and the Institute.[18] The
inclusion of any visual references to the black townspeople—some of whom owned
their own homes, farms, and businesses—would have contradicted the Institute's
philosophy that its students were learning everything from white mentors: this may
have been one reason that it was portrayed as such an isolated place. Seeing it in the
exhibit at the Paris and Pan American expositions, one would have imagined that it was
an island approached from the sea. This kind of illusion might be a subtle justification
of racially segregated education; that is, serene in their "separate but equal" facilities,
the students would progress toward civilization at their own quiet pace, without any
temptations, distractions, or dangers from the outside world. Considered from a
psychological or mythical viewpoint, the island illusion has some additional, archetypal
connotations. In many different cultures, islands are considered places where the
harsher laws and more mundane processes of life are not in force. Embodied in the
islands of the immortals in classical, Chinese, and Irish mythology and in the works of
Shakespeare, Gauguin, and Melville, for example, is the idea that islands are special
places where people live in blissful harmony with one another and with nature and
where wonderful transformations can occur under the direction of a benevolent
Prospero.

Indeed, following a group picture of some four hundred students sitting in the Institute's chapel, come two sequences of images showing transformations. They are cultural transformations rather than magical ones but they are still quite dramatic. First, there is a group of rather poor quality snapshots—which Johnston did not make—contrasting Native Americans who had received white educations with those who had not. Picture seven in the album, for example, is captioned, "*Without Education*: Mrs. Black Nail and Child, Sioux"; and it shows a haggard, grim-faced woman dressed in a blanket with a child on her back, standing by herself. Picture eight is entitled, "*With Education*: Kate H. McCaw and Family. / A Hampton Graduate." This image is a nineteenth-century studio family portrait showing a woman and her husband and children all dressed in white clothing. They look prosperous and healthy, and if it were not for the caption it would be easy to assume they were a dark-complexioned, middle-class family from the south of France or Italy. Other before-and-after sequences contrast the dilapidated reservation dwellings of uneducated Indians with the neat, prosperous frame house built and owned by a former Hampton student. The message is not subtle: with a Hampton education, Native Americans are respectable, self-supporting citizens; without one, they are squalid, destitute savages.

It is not certain who made these reservation sequences, but their purpose is obvious. Educating Native Americans at eastern schools was even more controversial than educating black students, and the Hampton staff collected and published all kinds of success stories, statistics, and progress reports to show that what they were doing was successful. As one Indian agent claimed, a few students could be sent East every year to schools like Hampton "to see for themselves many things impossible to be seen on the reservation, such as the uniform home comforts of civilized life, the prosperity by perseverance and economy, of the white race." The Indian pictures in the album demonstrated how completely the Hampton students had adopted "the comforts of civilized life" and had become as prosperous and persevering as any white persons.[19]

Although the visual quality of these prints was not very good, their message was considered so important that Johnston imitated them by making a similar series about the Institute's black alumni. She went into the Virginia countryside near Hampton and photographed blacks who were living in ramshackle cabins and "one mule farms," and then she made contrasting pictures of the Hampton farms and of the home and family of a middle-class black man who was identified as "a Hampton graduate." Thus in the *Hampton Album* we see the Hampton graduate at home with his family opposed to the old folks in their poor but picturesque little cabin; the exterior of the "old-time cabin," a ramshackle hut with rough shingles and a sagging door opposed to the crisp, white, two-story Hampton graduate's home (with its porch, shutters, and children in starched pinafores standing by their bicycles on the neatly mowed yard); and the "old well," a bucket on a stick surrounded by a decrepit fence opposed to "the improved well," a cast-iron pump surrounded by a strong, neat picket fence with every slat nailed firmly in place. For those who did not consider late nineteenth-century, white, middle-class propriety to be a summum bonum, these pictures of the Hampton graduate might seem stiff and self-conscious, or even a little pathetic. Lincoln

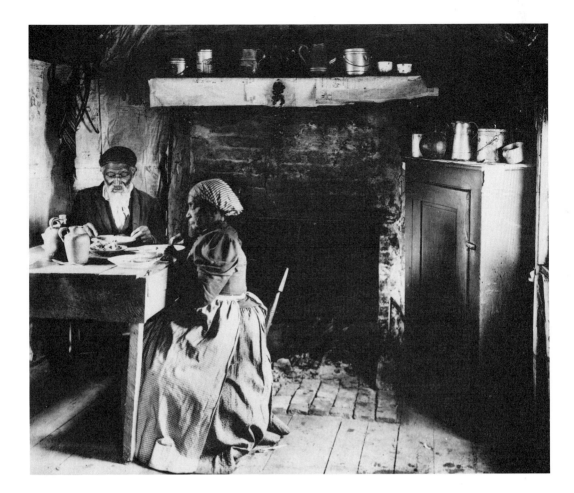

Kirstein, for example, described them in 1966 as "frozen . . . habitat groups, [that are] almost, but not quite entirely—believable. . . . There are precious few smiling faces among the prim pinafores and starched blouses; no hair ribbon is out of place; no boot unshined. . . . Without overt irony, we have . . . the white Victorian ideal [portrayed] as criterion towards which all darker tribes and nations must perforce aspire."[20]

For those who believed that industrial education was really a panacea for the nation's racial problems, however, the Hampton graduate and his wife and children were a model family, and these contrasts were an eloquent illustration of General Armstrong's philosophy. Seen together in the exhibit, the before-and-after sequences of Native Americans and blacks implicitly equated the two races; and though this idea might have made many black and Native Americans angry—for different reasons—it was very congenial to the Hampton educators, who believed it demonstrated that their kind of education was a foolproof way to correct the "deficient character" of any race that had not yet adopted the white man's culture. At Hampton, as the *Southern Workman* explained in 1899, "the Indian has received an education which was planned for [black] people who were very much in the same situation as that in which the Indian finds himself—making their first endeavors in self supporting civilized ways."[21]

Frances Johnston, "The Old Folks at Home," 1899 (Library of Congress)

33

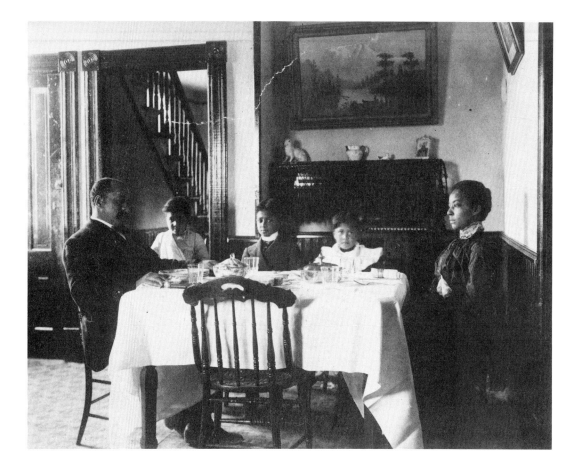

These photographs also implied that black and Native Americans were going to be changed quickly. This idea is expressed most dramatically by one of the later images in the album—number forty-three—captioned "Class in American History." (It is plate twenty-three in the 1966 edition of the Hampton *Album*.) Though this *tableau vivant* was meant to illustrate a particular class, it reveals how much the Hampton educators wanted to dramatize and document the changes they were making in their students' lives. Here we see the stereotyped Indian brave, as seen in novels, Wild West shows, Remington paintings, and Edward Curtis photographs, an heroic figure to many Americans. But in the genteel atmosphere of the Hampton classroom he is reduced to an exhibit, along with the stuffed eagle, and his fellow students observe him with the same calm attention that they direct to plants in their biology classes or to the pyramids in their class in ancient history. In his foreword to the 1966 *Hampton Album*, Kirstein described this particular image as an "odd happening," but to the Hampton educators there was probably nothing odd or ironic in this scene. For them, this was American history as they wanted their students to believe and participate in it: a picturesque past of braves in buckskins and black peasants beside their ramshackle cabins, followed by a brighter future symbolized by the Hampton graduate, Kate H. McCaw and her family, and the students themselves.

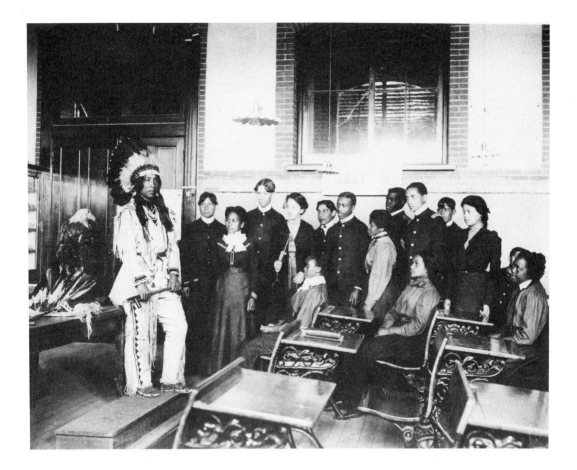

This image also reveals the extent to which the Hampton students were themselves living exhibits; not only the young man in the buckskins and feathers but also the students watching him were meant to be seen as exemplary beings. Both their appearance and their behavior, as recorded in Johnston's pictures, were intended to document how much the Hampton idea had changed their lives. As shown by "Class in American History," there were not supposed to be any visible, at any rate, intermediate stages or any compromises between the old way of life and the new one, no conversions halfway between "bondage or barbarism" and the white man's way. This emphasis upon sudden, dramatic progress implicitly places the Hampton idea within the tradition of the conservative American Dream, with its fervent faith that in America people can be transformed by sheer determination. (Or, as *USA Today* claimed over eighty years later: "Most of us feel we can still go from rags to riches. . . . Even the poorest child has the opportunity to achieve great wealth.")[22]

It is also significant that so many of the nineteenth- and early twentieth-century efforts to educate black and Native Americans were undertaken by missionary groups. Armstrong was the son of a Congregationalist missionary. When he founded Hampton much of his financial support came from the abolitionist American Missionary Association, and six of the fifteen original incorporators of the Institute were also officers

Frances Johnston, "Class in American History," Hampton Institute, 1899 (Library of Congress)

or officials of that association. Almost all of the other schools founded for blacks in the South after the Civil War were incorporated and originally staffed by white, Protestant missionaries who were deeply concerned that their students conform to strict Christian principles. Speaking about Protestant conversion experiences, particularly evangelistic ones, William James commented in 1902, in chapter 10 of *Varieties of Religious Experience*, on the importance of the "fruits for life" that were supposed to be the results of these conversions. In the lives of ordinary Protestants, James noted, such fruits were sometimes difficult to discern. "If we except the class of . . . saints of whom the names illumine history, and consider only the usual run of 'saints,' the shopkeeping church-members and ordinary . . . recipients of instantaneous conversion, . . . you will probably agree that no splendor . . . sets them apart from the mortals who have never experienced that favor. . . . Converted men as a class are indistinguishable from natural men . . . [and] there is no unmistakable class-mark distinctive of all true converts."[23] Analogously, even though the students at schools like Hampton might not have been religious converts, in the strict sense of that term, they were converts to the white man's culture and religion. White observers would have considered their genteel demeanor as equivalent to the "unmistakable class mark" that James described.

In order to maintain this demeanor, black colleges and institutes used surveillance and elaborate social codes that make Orwell's *1984* seem mild. At Hampton, "the ringing of a bell told students when to get up, go to classes, go to meals, go to work, and go to bed. Compulsory chapel services were held every day, and matrons and janitors were authorized to inspect the students' rooms" at any time. At Fisk, the women's dress code "forbade dresses made of silk or satin and required high necks, long sleeves, black hats, and cotton stockings," and the men and women students were not allowed to walk together "except at specific hours and then only with chaperones present." Tuskegee Institute "openly proclaimed its right to open and censor students' mail, and no dances were allowed until the 1930s; even then the preceptresses were given strict instructions to enforce a rule requiring that couples be separated by at least one inch of open space."[24] The students at most black schools rebelled against these codes during the 1920s, when many of the codes were modified. In 1899, though, it was still taken for granted that students would lead "Christian" lives—and that they would be observed by principals, preceptresses, chaperones, teachers, janitors, and matrons to make sure that they did so. So it is not surprising that the Hampton students showed such perfect deportment when Johnston photographed them. They were used to being closely and carefully watched.

The introductory portraits, the waterfront panoramas, and the before-and-after sequences make up the first twenty-nine pictures in the original album, about 20 percent of the total. In her remaining images Johnston made an exhaustive survey of the Institute's classes, activities, and buildings—from the boiler rooms, engine shops, and cow barns to the art classrooms, history classrooms, and physics laboratories; from the football team to the "Guitar and Mandolin Club" and the classes in sewing and dressmaking. All of these activities were meant to be seen, in sequence, as part of the Institute's "great work," as illustrations of the fruits of the students' devotion to

white culture. Presumably, these photographs were supposed to be the conclusive

evidence that would make General Armstrong's dream seem credible. Thanks to
them, his belief that vocational education could transform black and Native Americans
into white people (except for the color of their skin, of course) seemed to be a practical
process actually happening daily.

Johnston's images have a number of other significant features. As one might expect,
they are all very neat and well-organized. However, their orderliness transcends the
scrupulous cleanliness of the Institute's classrooms, students, and workshops. In
virtually every image the students are arranged in a compact group precisely yet
unobtrusively related visually to their environment and their activities. If they are
observing plants on tables, for example, all of the students are standing or sitting
beside the tables, their attention entirely focused upon the plants. None of them is
crowded, inattentive, bored, or distracted by anything—least of all by the photogra-
pher and her camera. Even when they are outside studying geology at the seashore,
mixing fertilizer, or observing farm animals, the students are always positioned in
harmonious visual patterns.

Another significant aspect of this orderliness is that it is almost never hierarchical.
In almost all of the images, the group, and not a commanding figure, forms the
pattern. The presence of teachers in the classrooms is often so unobtrusive that it is
difficult to find them, and in some cases there seems to be no teacher at all. The only
exception to this rule is in the case of an agriculture teacher, a white man who is easily
seen sitting behind his desk or standing and lecturing. In the other classrooms and
workshops, however, students study or work quietly at their tasks with little or no
direct supervision. This characteristic implicitly eliminates the issue of inferiority and
superiority, contributing to the images' utopian quality. In most cases we see the
students chiefly in relation to one another and to their work or classes; thus they
possess a tacit social equality, one of the aspects of life in the United States that black
and Native Americans were so often denied. In this particular respect, Johnston's
Hampton pictures are very different from those of a black photographer, James Van
DerZee, who made photographs of classes at the Institute a few years later. In his
pictures, the black teachers have posed themselves as authority figures who clearly are
in charge of their classrooms, the students, and the educational process. In Johnston's
images, the Hampton philosophy is the dynamic force transforming the students'
lives, but in Van DerZee's it is the teachers—the "talented tenth" described by black
leaders like W. E. B. Du Bois. Moreover, in Van DerZee's images there is direct eye
contact between the black teachers and the camera, which implies an equality with the
observer that is never present in Johnston's images.[25]

The way in which Johnston positioned herself, her camera, and (as a consequence)
the spectators, is visually and socially significant. In the great majority of her Hampton
images, she used two methods of composition: virtually all of the pictures are horizon-
tal, and in many of them the students are arranged in a row so they form a two-
dimensional plane like figures on a frieze (see photograph of Hampton students
studying insects). The students are all equally distant from the camera, and they are

also all approximately the same distance from a backdrop—a wall, a fence, or a line of trees—that encloses them in space. They are never posed against a bleak, empty space. Most of these compositions are varied with diagonal lines—particularly in the well-known picture of the students working on the staircase—but the diagonals remain within the same visual plane that contains the students. That is, there are no diagonals coming out of the students' space and into the space of the camera and the spectators. Moreover, there is always an empty, clear space, like the apron on a theatrical stage, between the camera and the spectators. This kind of visual segregation is not present in some of Johnston's pictures of white workers, such as her 1895 picture of a young woman in a Massachusetts shoe factory. In that picture the woman looks directly at the camera, and the diagonal lines of her workspace draw the observer's vision into the picture. Interestingly enough, there is also an absence of visual segregation in one of Johnston's pictures of black children, but they are children from the Hampton community—not the Institute's Whittier Primary School—and this picture did not appear in the *Hampton Album* or the 1900 exhibit. In that picture some of the children look directly at the camera, and they are posed comfortably and casually. Clearly they are interested in, but not overly impressed by, Johnston and her camera. The picture is an example of the kind of group portrait Johnston might have made at Hampton if she had not needed to illustrate the Institute's philosophy and its emphasis on Victorian decorum.[26] In contrast, it is rather significant that when Johnston photographed the Whittier schoolchildren saluting the flag she made one of the most regimented pictures in the album. Facing the flag, the children have become a miniature army of racial progress in which every arm is raised and in which there are no laggards.

"Saluting the Flag" is an example of a second kind of composition Johnston used in many of her Hampton images. In these pictures, students—and sometimes objects as well—are organized into a wedge that projects toward the camera and the spectator. This wedge comes to a point near the bottom, or slightly below the bottom edge, of the image. In some cases, the effect of a pointed wedge is accentuated even further because it is part of a vertical line. Either way, this type of composition demarcates, gives perspective to, and encloses the students' space. In her picture of the Hampton drawing class, for example, the students are seated to form a wedge that comes to a point at the student closest to the camera. The shape of the wedge is reinforced by the lines formed by the drawing boards and tripods, which come to another point slightly below the image frame, demarcating the students from the observer. The sense that the class is a closed unit is also suggested by the way the teacher's attention is focused upon the students' work. The effect is increased by the fact that the students and teachers never look at the camera, and none of them ever seems about to move toward it. Yet Johnston, her camera, and the spectators are never cut off from the students' space. It is like looking into a transparent room. We occupy the role of the privileged observer, the person who is able to see everything from a perfect vantage point with perfect clarity. We can always see and understand what is happening in Johnston's pictures, but we never have to participate in it. Our benevolent approval is all that is asked.

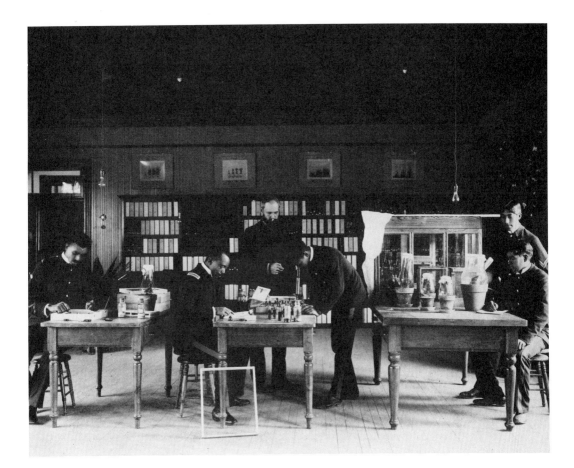

The album and the exhibit were like the guided tours given to important visitors to the Institute. Such a tour, as it was described in the *Southern Workman* in November 1899, would begin with a brief explanation of the Hampton philosophy. Then, as the author of the article wrote, one would "take a walk through the streets of this industrial village and glance at the various pursuits carried on within its limits. Coming first to the paint shop . . . the boys are getting practical experience as painters. . . . The story repeats itself again and again as we continue our inspection; in the harness shop . . . where a half dozen boys are working at the trade; on the farm where numberless boys find employment; in the tailor shop . . . in the sewing room with its score of girls diligently plying the needle . . . in all the departments where raw material is turned into manufactured goods."[27] None of the "boys" or "girls" were named in this tour, just as none of them were individualized in Johnston's images: all of them were mere emblems of racial progress. Secure in Hampton's classrooms, fields, and farmyards, the students cheerfully work at transforming themselves. And, seeing these pictures, white spectators could be transformed, too. No longer did they need to feel afraid of black people or guilty at what had happened to them after Reconstruction.

Many of Johnston's Hampton images are impressive in that they create a delicate balance between the real and the ideal, the mundane and the elegant, the aesthetic and the documentary. In her pictures, Hampton is not the bland, aesthetic never-

Frances Johnston, Hampton students studying insects, Hampton Institute, 1899 (Library of Congress)

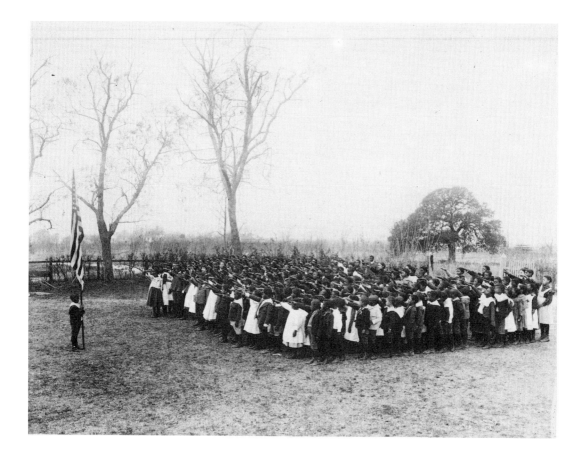

never land we see in many works by pictorial photographers at the turn of the century. Nor is it the plain, matter-of-fact realm of the ordinary seen in most of the images in textbooks and periodicals like *The World's Work*. Instead, because of the artistic skill with which she arranged the composition of her scenes, Johnston made her photographs seem more credible. Except for the relatively few pictures that now seem too stiffly and elaborately posed, she was able to imply that daily life at Hampton was serene, orderly, and detailed—educationally ideal, in short—and that the students were disciplined, patient, and attentive.

In their original context, at the Paris and the Pan American expositions, these images were meant to be emphatic documentary proof that would refute charges by white racists who claimed that black Americans were too stupid, shiftless, and immoral to become civilized people. ("I never knew niggers to invent anything but lies," a Boston lawyer wrote in his response to Thomas Calloway's request for information about black American inventors.) But when Calloway organized his exhibit for the Paris Exposition he not only had Johnston's pictures but also charts, graphs, and statistics prepared by black colleges and institutes that showed—among other things—that 350 patents had been granted to blacks in the United States, that 2,252 black students were taking industrial education courses in Georgia, that school enrollment among blacks had "increased 300 percent in 20 years," and that illiteracy had

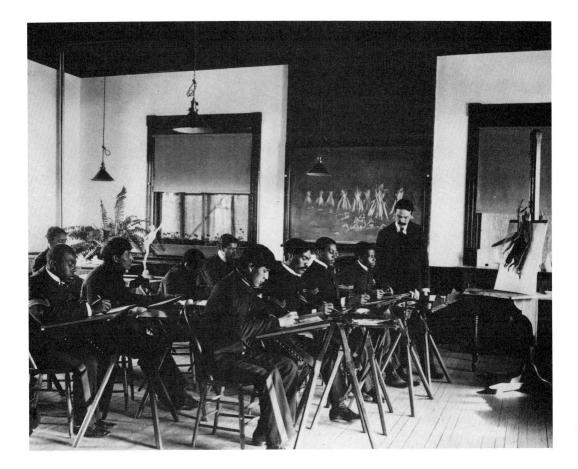

decreased "50 percent since emancipation." For, as the *Southern Workman* emphasized in a January 1900 article, the exhibit was meant to give "the nations of Europe . . . an opportunity to judge of the progress of the colored race since emancipation. An effort will be made to show the world that the Negro is 'a producer, a progressive element in the population of the United States, and a citizen becoming more and more law-abiding as educational advantages and religious agencies become more universal.' "[28]

Johnston's images were also intended to demonstrate to an uninformed, even skeptical, world that the United States was fulfilling its *mission civilisatrice*, that under the benevolent tutelage of white leaders and educators American blacks and Indians had indeed progressed during the past few decades. In the same display cabinets at the Paris Exposition that contained her photographs, racial progress was further illustrated by a series of "miniature models from life," which were considered "dramatic tableaux of real life" that could "speak to the most ignorant visitor":

No. 1 shows a family of ex-slaves just emancipated. Behind them are the woods representing the darkness of slavery, and before them a winding path leading into an unknown future. . . . Model 2 shows the father aided by the sons constructing their first rude house. . . . In scene three the Northern School Ma'am has a

Frances Johnston, Black and Native American students in a drawing class, Hampton Institute, 1899 (Library of Congress)

41

group of children under the friendly shade of an oak tree and the father stands enchanted by the scene ... in model 4 you behold him ... [persuading a neighbor to help build] a schoolhouse.... In model 5 he is welcoming the teacher to the first schoolhouse ... an old cabin.... Years pass away and in model 7 [we see] a neat white school building with glass windows and brick chimney and cheerful children ... a school over which our first bare-foot boy is now principal.[29]

This tableaux and Johnston's pictures suggested that America was progressing too, that it was solving in a single generation the difficult problems caused by the closing of the frontier in the West and the emancipation of the slaves in the South. It was now nearing its ideal of being a nation of equals in which anyone, even a black or Native American, could become a president in the White House, or at least a principal in a white school building.

It is a painful commentary on twentieth-century racial relationships that, when the *Hampton Album* was published by the New York Museum of Modern Art in 1966, some Americans responded to it not as an illustration of a historical process or as a success story but as an expression of pathetic hopes and dreams. One reviewer said that the photographs "radiate such innocence and good hope they make me want to cry." In his foreword to the 1966 album, Kirstein described the children in the "Saluting the Flag" picture as a "tiny regiment" of "quaintly hopeful ... infants." He spoke of the Institute's adult students as standing transfixed in time, like a "parable in their sturdy dreaminess, their selfless absorption in self-improvement. It is a measure of Miss Johnston's vision that she enables us to spy upon so many anonymous, long-vanished individuals, who still so vividly speak to us in public of their proper private longings for a shared social paradise.... We must know it was not, or by no means yet is, any earthly heaven. But she did capture, to an almost magical degree, the better part of an historic aspiration in its innocent and necessary striving.[30]

It would be inappropriate, though, to conclude with this recognition that Hampton was not an earthly heaven. One of the more interesting features of the 1966 edition of the album is that it says so little about what happened to General Armstrong's dream and the Hampton idea between 1899 and 1966. In a brief note at the beginning of the book, John Szarkowski mentions that "Hampton has advanced from a primarily vocational school to a fully accredited liberal arts college with ... a curriculum responsive to the intellectual and social commitments of our own day," but neither he nor Kirstein comments on how or why that change took place.

In fact, General Armstrong's philosophy that vocational education was the great panacea for America's "Negro problem" began to be ignored, criticized, and discredited by black people shortly after Johnston's photographs were exhibited at the Paris Exposition. This was true even though Booker T. Washington, Armstrong's disciple and the leading exponent of vocational education, was at the peak of his power and prestige at this time. By 1900, according to John Hope Franklin, "Washington was one

of the most powerful men in the United States. Great philanthropists and industrialists such as Andrew Carnegie and John D. Rockefeller listened to him courteously. . . . Presidents such as Theodore Roosevelt and William Howard Taft depended on him for suggestions."[31] In 1900 Washington organized the Negro Business League to promote the Hampton-Tuskegee philosophy in business and industry; in 1901 he published his popular autobiography, *Up from Slavery*; and also in 1901 Theodore Roosevelt invited him to the White House for an interview and dinner, which white southerners considered a drastic breach of racial etiquette. Yet it was also at this time that many blacks began to find at least some of the Hampton-Tuskegee philosophy unacceptable or irrelevant to their own lives. In some cases, it was exactly those aspects of the Hampton idea that were so appealing to many of Washington's white supporters and philanthropists that made it repugnant to blacks.

Thousands of black people began to "vote with their feet" by leaving the South early in the twentieth century. In his Atlanta Compromise speech in 1895, Washington urged blacks to "Cast down your bucket where you are," to remain in the South and make "friends in every manly way [with] the people of all races by whom we are surrounded." One of the most important intents of the Hampton-Tuskegee philosophy was to enable blacks to prosper and succeed in the South, despite segregation and disenfranchisement. Washington and his followers had worked hard to make this happen. An indefatigable speaker and fund-raiser, Washington traveled all over the country speaking to black and white audiences as he tried to popularize self-help and vocational education. He and his colleagues at Hampton organized conferences, including annual meetings every summer at Hampton and Tuskegee, to promote their solutions to the "Negro problem." Washington set up small satellite schools, "little Tuskegees," in which vocational education graduates taught the Hampton-Tuskegee gospel in small towns like Denmark, South Carolina, and Snow Hill and Ramer, Alabama.

By the early 1900s, however, this gospel was becoming a little archaic. C. Vann Woodward has commented that the economic philosophy behind Washington's Negro Business League came from "a bygone day. . . . It consisted of the mousetrap-maker-and-beaten-path maxims of thrift, virtue, enterprise, and free competition. It was the faith by which the white middle-class preceptors of his youth had explained success . . . [but it] never took into account the realities of mass production, industrial integration, financial combination, and monopoly." Similarly, Woodward pointed out, many of the trades taught in vocational education classes were equally old-fashioned: "blacksmithing, wheelwrighting, harness making, basketry, [and] tinsmithing . . . had more relevance to the South of Booker Washington's boyhood than to the South of United States Steel."[32] Johnston's Hampton and Tuskegee images, compared with the work photographs she made on assignments at the Mesabi iron range or at a shoe factory in Massachusetts, look not only archaic but also idealized and quaint. Even in 1900 they had a slightly nostalgic, Norman Rockwell quality. This may have appealed to white philanthropists: it reminded them of their own boyhoods in an earlier age, when the American Dream was within the reach of energetic young whites from farms and small

towns who had started their careers by learning the trades that were still being taught at Hampton and Tuskegee.

At the turn of the century, however, there were a great many blacks who did not have the luxury of learning archaic trades, and even though some of them were not very "educated" they had already decided that the action was not in Hampton, Tuskegee, Ramer, or Snow Hill, Alabama. Between 1890 and 1915 the black population of Chicago grew from slightly under fifteen thousand to more than fifty thousand people, and the majority of these migrants came from the southern and border states. In 1915, the year of Washington's death, there was a much larger exodus of southern blacks, which the Department of Labor described in 1916 as a "disturbing labor condition in the South. A great migratory stream of Negro wage earners [has been] reported as flowing out of southern and into northern states." One estimate by the *Literary Digest* in 1917 was that a total of 398,348 blacks had left the southern states, Oklahoma, and Texas between October 1916 and May 1917. Some northern blacks moved to the South during this period, but by 1920 the U.S. Bureau of the Census estimated that there had been a net gain of 692,887 blacks in the North.[33]

Another problem with the Hampton-Tuskegee Idea was that some educated blacks considered it too crass. In an age when many middle-class Americans wanted to be "cultured" as well as prosperous, vocational education was vulnerable to the charge that it was too materialistic, not academic enough. Even before Hampton was founded, a number of white schools experimented with curriculums combining work and study, and these programs were not considered very successful. In 1870, while Armstrong was still organizing Hampton, James Garfield—who was an incorporator of the Institute and a trustee from 1870 to 1875—warned him privately in a letter that they should not commit themselves too completely to industrial education "as a principle of general application," because it might be a "doctrine that we may hereafter be required to retract"; and he emphasized that he considered that kind of education acceptable for southern blacks only as a temporary necessity. "I would not, were I in your place, commit myself absolutely to the policy of manual labor . . . for the reason that hitherto all such experiments have finally failed," Garfield said,

> and for the stronger reason that very much manual labor is inconsistent with a very high degree of mental culture. . . . While I endorse this view as a general principle, I fully . . . support the labor feature of your school as the proper course at least for the present. I defend it on the ground of the peculiar and exceptional situation in which we now [in 1870] find the colored race of the South. The question is how best to lead them up from the plane of mere drudgery to one of some culture and finally of high culture. . . . The labor system is a most excellent bridge to carry them over the intermediate or transition period. . . . But I apprehend that you will find that the labor feature [will] be less and less needed as the race rises in the scale of culture, and that by and by they will require a course much nearer the ordinary college than they do now.[34]

Either because of warnings like Garfield's or because his own thinking developed in the same way, Armstrong decided by 1872 upon a compromise in which, he said, the Institute would offer vocational training, but "the academic department . . . [will be] the leading department to which all others are subsidiary." Armstrong's successor, Reverend Frissell, reversed this emphasis in 1897, proclaiming that "instead of making the industries the stepping stone to the academic department, the academic department is now made the stepping stone to the industrial and trade work." Tuskegee similarly emphasized the vocational over the academic. When the students protested during the 1903–4 term that they could not keep up with both their vocational and their academic assignments, Washington's solution in 1905 was to eliminate Bible and music study and to demand that "*every Academic Teacher is appreciably to diminish the amount of time required of his students for the preparation of his subjects.*"[35] By the early 1900s, then, Frissell and Washington elevated vocational education to the status of a "principle" that they considered more important than academic education.

The downgrading of the academic curriculum is not noticeable in Johnston's classroom pictures. Despite the exhibit's emphasis on vocational education, there are a fair number of classroom scenes in which the students are studying academic subjects, including the pyramids in Egypt and the cathedrals in France. However, the before-and-after sequence of the Hampton graduate and his family, in which there is a piano and a print of a Rocky Mountain landscape in the dining room but not a single book in sight, is a good example of the emphasis on the material rewards of vocational education. Success, as shown in these pictures, seems to be chiefly a comfortable house, clothing, and furniture. Moreover, Johnston did not photograph the Hampton graduate or his family engaging in any cultural activities.

These images imply that the Hampton graduate simply was not very interested in high culture. Other Hampton and Tuskegee alumni more explicitly expressed their disrespect for cultural education. Booker T. Washington made occasional perfunctory remarks that he did "not believe that the black man's education should be confined wholly to industrial training"; but in *Up from Slavery* he made it clear that he did not consider it good for blacks to study the liberal arts or to try to be cultured. When he first arrived in Tuskegee to start his own school, he said, white people distrusted him because they had "in their minds pictures of what was called an educated Negro, with a high hat, imitation gold eye glasses, a showy walking-stick, kid gloves . . . in a word, a man who was determined to live by his wits." And he sighed, later in the same chapter, that one of the "saddest things" that he had seen in his early travels in Alabama "was a young man, who had attended some high school, sitting down in a one-room cabin, with grease on his clothing, filth all around him, . . . engaged in studying French grammar." Some of the Hampton and Tuskegee alumni, who were vocational and agricultural education teachers, were even more vociferous in their testimonials that it was far better for them to teach blacks to plant turnips properly than it was for them to waste their time learning Latin and Greek. And in the many anecdotes he used in his writings and speeches to illustrate how successful Tuskegee students were, Washing-

45

Johnston's
Hampton
Album

ton always emphasized the practical and the material—not the cultural—benefits of education for blacks. The Reid brothers, for example, had grown up on a rented farm, but had been able to buy a number of farms, "seventeen fine horses and mules . . . thirty well-bred cows and fifty fine, healthy-looking hogs . . . [and] farming implements, including plows, mowers, rakes, harrows . . . of the latest improved Deering make."[36] Like St. John de Crèvecoeur, listing the immigrant's possessions in "What Is an American?" (his hundred acres, six cows, and two mares), Washington became a spokesman for the conservative American Dream, in which tangible, countable, material gains are considered the most important evidence of success and progress.

Despite Washington's fame and success, as his biographer Louis Harlan has pointed out, he always liked to live like a "prosperous peasant" who loved raising pigs and vegetables and hated using big words and abstractions.[37] This attitude probably helped him when he sought funds and support from white philanthropists and industrialists of the Gilded Age, who were equally uneasy with high culture and abstractions. As one of his critics commented in 1942, "Washington's teachings were . . . of his time," and he "came forth at the time when a great many other Americans whose beginnings were unpromising, but whose opportunities were greater than his, were working diligently and shrewdly . . . to make themselves gods of the very comfort and well-being . . . Mr. Washington taught Negroes to strive [for]. Incidentally, it may be noted that in a large measure Tuskegee was built and has thrived on the blessings of the gods of ease who during the Gilded Age enshrined themselves in temples of wealth and power."[38]

Although the assumption that blacks should be trained primarily to attain material success might have pleased white philanthropists, it angered some educated and cultured blacks. They resented the way in which the Hampton and Tuskegee educators asserted the superiority of vocational education in order to compete with black liberal arts colleges for funds, and they pointed out that the idea that vocational education was appropriate for *many* blacks was easily twisted by white racists into the claim that it was the only form of education appropriate for *all* blacks. "You Southern educators are all bound up with some cause or other, devotion to which sometimes unconsciously warps your opinions as to what is best for the general welfare of the race," Charles W. Chesnutt told Washington in a private letter. "You are conducting an industrial school, and naturally you place stress upon that sort of education, . . . but with the zeal of the advocate, before whose eyes his client's case always looms up so as to dwarf the other side. Unfortunately, those who would discourage the higher education of the Negro use your words for that purpose."[39] W. E. B. Du Bois publicly and much more bluntly made essentially the same criticisms of Washington in his 1903 book, *The Souls of Black Folk*. He attacked Washington's willingness to relinquish political power and voting for blacks, and claimed that "Mr. Washington distinctly asks that black people give up, at least for the present, . . . [the] higher education of Negro youth—and concentrate all their energies on industrial education, the accumulation of wealth, and the conciliation of the South." This "gospel of Work and Money," Du Bois argued, led at least indirectly to "the steady withdrawal of aid from institutions for the

higher training of the Negro," and gave blacks "only the most meagre chance for developing their exceptional men." Like many conservatives, Washington relied on success stories (including his own) to prove that the American Dream of prosperity through thrift and industry could come true, even for black people in the South, if they were "properly" educated. But in *The Souls of Black Folk*, Du Bois sternly warned that another part of the American value system, equality, was just as important as material success. Washington "insists on thrift and self-respect," he said, "but at the same time counsels a silent submission to civic inferiority" that "is bound to sap the manhood of any race in the long run." He ended his chapter on Washington by reminding his readers that the signers of the Declaration of Independence had promised mankind more than mere prosperity; and therefore, "By every civilized and peaceful method we must strive for the rights which the world accords to men, clinging unwaveringly to those great words which the sons of the Fathers would fain forget: 'We hold these truths to be self-evident: That all men are created equal.'"[40]

In a 1906 speech at Hampton, Du Bois developed his criticism of Washington into a criticism of vocational education itself. While it was true that students might need some "technical training . . . to master the present methods of living in some particular way," Du Bois insisted that it was equally necessary to allow the "most promising" students to receive "a training designed above all to make them men of power, of thought, of trained and cultivated taste; men who know whither civilization is tending and what it means."[41] Later in the summer of 1906, Du Bois organized a public meeting of the Niagara Movement at Storer College for Negroes near Harper's Ferry, West Virginia, the site of John Brown's raid. After meeting for three days and marching barefoot through the streets of Harper's Ferry to dramatize their grievances, Du Bois and the other black "radicals," including John Hope, who had just become the first black president of Atlanta University, passed a series of resolutions written by Du Bois and including this demand: "We want our children educated. . . . And when we call for education, we mean real education. We believe in work. We ourselves are workers, but work is not necessarily education. Education is the development of power."

The Harper's Ferry meeting gave Du Bois, Hope, and their allies an opportunity to dramatize their opposition to Washington, but their own Niagara Movement was not very successful. Criticized by Washington's black allies, poorly funded, and not very well organized, the Niagara Movement's leaders were not even able to return to Harper's Ferry for their annual meeting in 1907: Storer College had "experienced an 'unexpected lessening of its annual appropriation' and friends of the institution maintained it was 'injured,'" after the movement had met there in 1906.[42] Consequently, Du Bois and his allies probably would not have been able to challenge Washington and the Hampton-Tuskegee idea if not for another more bitter and volatile issue—the lynchings, terrorism, and violence used by white people in both the northern and the southern United States to force blacks to accept their status as third- and fourth-class, segregated citizens. Even though there were virtually no white people in Johnston's Hampton images, the exhibit inherently created an idealized conception of racial

relationships that was very popular with white northerners and philanthropists: a separate-but-equal educational system in which blacks would be allowed to progress toward "civilization" under the tutelage of conservative educators who would—like Johnston with her camera—benevolently approve of very limited black aspirations. Both the visual decorum of Johnston's images and the verbal rhetoric of Washington's speeches and writings suggested that if blacks were industrious enough, disciplined enough, patient and grateful enough, they would eventually get their chance to achieve the American Dream. But in the world outside of Hampton and Tuskegee there were many white people who had a very different conception of the proper way to "educate" blacks, as Johnston herself discovered in 1902 when she went to Alabama to photograph Washington at Tuskegee.

After her photographic tour of Tuskegee, Johnston went to the nearby town of Ramer, Alabama, where she was supposed to photograph a "little Tuskegee," one of the Institute's satellite schools founded by its current principal, Nelson E. Henry, a Tuskegee graduate. When Johnston arrived on the train late at night, Henry started to take her to his home outside Ramer in a buggy, but she then decided to return to Ramer and its white hotel. Two white men observed Johnston (a white woman) and Henry (a black man) leaving town together and returning an hour later and decided to punish this violation of southern etiquette. One of them fired three wild shots at Henry, who fled. Johnston escaped with the help of George Washington Carver, who had been on the train with her earlier. It was, Carver wrote to Washington, "the most frightful experience of my life . . . and for one day and night it was a very serious question indeed as to whether I would return to Tuskegee alive or not." Johnston, furious, tried to bring a suit against the two whites. She went to Montgomery to complain to the governor, and she threatened to have her friend President Roosevelt punish Ramer by firing the town postmaster, who was also the father of one of the two attackers. But the white men were not punished in any way. Instead it was Henry who had to leave Ramer and disband his little industrial school.[43] When Booker T. Washington's "The Successful Training of the Negro" appeared in *The World's Work* in 1903, illustrated with Johnston's photographs, there was no reference to the incident at Ramer. There were Johnston's pictures of Tuskegee and of "little Tuskegees" at Snow Hill and Mount Meigs, Alabama, which she visited after she left Ramer; and Washington gave a long account of Tuskegee success stories, ending with a description of the Voorhees Industrial School at Denmark, South Carolina, which had been founded by a Tuskegee woman graduate who "was greatly opposed at first by both the white and colored people, but she persevered until now all are her friends. She has three hundred acres of land, all paid for. A large central building has been erected at a cost of $3,000 . . . and a girl's dormitory to cost $4,000 . . . is in the process of erection."[44]

It was not difficult for Washington to ignore the events at Ramer, since they did not end tragically. But elsewhere in the South, and in some northern communities as well, other black people were not as lucky. Every year between the 1890s and the 1920s, dozens or even hundreds of blacks were murdered, mutilated, and burned alive by

white lynch mobs and rioters. It was also disturbing that, starting in the early 1900s, these events began to occur not only in rural areas and small towns but also in places where the white inhabitants were supposedly better educated and more "civilized." In September 1906, for example, there was a race riot in Atlanta, which was considered the most progressive city in the South, in which ten blacks and one white were killed. A few months earlier in the same year there were three lynchings in Springfield, Missouri, which H. G. Wells described with savage sarcasm after reading American newspaper accounts. In Springfield, he said, "which is a county seat with a college, an academy, a high school, and a zoological garden . . . the exemplary method reaches the nadir. Last April three unfortunate negroes were burned to death, apparently because they were negroes, and as a general corrective of impertinence. They seemed to have been innocent of any particular offense. . . . The better element of Springfield society was evidently shocked when it was found that quite innocent negroes had been used in these instructive pyrotechnics."[45]

More militant blacks were outraged at Booker T. Washington because he was unable or unwilling to protest against white lynchings and riots. In 1903, for example, Monroe Trotter, the editor of the Boston *Guardian*, disrupted a meeting of the Negro Business League in Boston, shouting a series of angry rhetorical questions at Washington and ending with the accusation, "Is the rope and the torch all the race is to get under your leadership?"[46] Perhaps some of the blame should have been placed on the Hampton philosophy, which Washington had learned so well from General Armstrong. Throughout the album, and in many of the Institute's and Washington's own writings, it was always emphasized that "the Negro problem" would be solved when blacks overcame what Armstrong called their "deficient character" through discipline. If they did this, Washington strongly implied in *Up from Slavery*, they would be rewarded with white help and friendship. Washington illustrated his point with pages and pages of anecdotes about the aid and honors he had received from white benefactors. Such a philosophy was very agreeable to white liberals and philanthropists, particularly in the North, because it absolved them of the charge that the North had betrayed or abandoned blacks by ending Reconstruction in 1877. Nevertheless, events like the Springfield lynchings and the Atlanta riots revealed that it was not enough for blacks to become disciplined. When an editorial writer for *The Outlook*, a New York periodical, claimed that there was only "one cure" for the nation's racial problems— "some method of requiring the black race to exercise self-control"—a black woman from Ohio replied that it would be better for *both* races to exercise self-control: "When for three days a white mob had control of Atlanta, attacking, maiming, and killing whomsoever it wished, provided only his face was black—I say that when this is the spectacle presented by the proud white race to a gaping world, a lecture to blacks on self-restraint becomes indeed a roaring farce!"[47]

It was not a riot in the South, however, but one in the North that was the turning point for many liberals. In August 1908 a white woman in Springfield, Illinois, claimed she had been raped by a black man. Even though she changed her testimony before a special grand jury and said that the black man was innocent, a mob of whites

tried to capture him. When they were unable to do so because the police had taken him out of town, wrote black historian John Hope Franklin, the mob

> began to destroy Negro businesses and to drive Negroes from their homes. They set fire to a building in which a Negro owned a barber shop. The barber was lynched in the yard behind his shop. . . . On the following night an eighty-four-year-old Negro, who had been married to a white woman for more than thirty years, was lynched within a block of the Statehouse. Before order was restored more than five thousand militiamen were patrolling the streets. . . . The alleged leaders of the mob went unpunished.
>
> The news of the riot was almost more than Negroes could bear. . . . Negroes were actually lynched within half a mile of the only home Lincoln ever owned and within two miles of his final resting place.[48]

Outraged by this incident, a group of northern liberals met the next February, on the centennial of Lincoln's birth, and began to organize the National Association for the Advancement of Colored People (NAACP). Some of these liberals, particularly Oswald Garrison Villard and Mary White Ovington, had been supporters of Booker T. Washington, who was formally invited to the organizational meeting because, Villard said, the organizers did not want to "show any disrespect" to him. But they also invited some of his black opponents from the Niagara Movement, including Du Bois and Monroe Trotter; and Villard warned Washington that the organizers did "not wish to tie you up with what may prove to be a radical political movement. Hence, they have not felt like urging you very hard to join the new movement."[49]

Washington understood Villard's hint and did not attend the meeting. The fact that a "radical" like Trotter was invited (even though he did not attend), the selection of Du Bois to be the only black officer of the association (and the subsequent choice of Du Bois to be the editor of the NAACP's periodical, *The Crisis*), and Villard's warning that the NAACP was "a radical political movement" were all signs to anyone who knew anything about black and white racial relationships in 1909 that the NAACP organizers were no longer willing to trust Washington and the other Hampton and Tuskegee educators to be in charge of black American destinies. For years racial liberals had supported Washington, his Atlanta Compromise, and the Hampton-Tuskegee philosophy because they thought vocational training would educate blacks, who would then be treated decently. Now they feared that southern bigots were bringing their barbarism to the North, and that "either the spirit of the abolitionists . . . must be revived and we must come to treat the Negro on a plane of absolute political and social equality or Vardaman and Tillman will soon have transferred the Race War to the North."[50]

Washington sent his spies to NAACP meetings, feuded intermittently with the new organization, and near the end of his life even began to complain a little more openly about the Jim Crow laws enacted all over the South to enforce segregation and to make it harder for blacks to travel, to buy homes and land, and to get decent jobs. But as Louis Harlan has pointed out, Washington could not bring himself to accept the

idea that blacks had to *protest* against these laws and conditions. When his secretary,

Emmett J. Scott, became a little too zealous in a campaign against unequal conditions
on railroads in 1914, Washington telegraphed him: " 'Not my idea send out any more
letters . . . over my signature. Would avoid impression of making protest but rather
making request.'. . . When Scott demurred, Washington wired again: 'Anxious not to
use word "protest"; nothing to be gained by giving that impression.' "[51] It was this
unwillingness to protest that led white liberals in the NAACP to accept the claim,
made earlier by Washington's black critics, that he did not deserve to be considered a
leader of his race and that his educational and racial philosophy was not going to
enable blacks to become more prosperous and secure. Washington was "like Nero,
fiddling while Rome burns," Villard wrote in a letter in 1914. "One right after another
is being taken away from the colored people, one injustice after another being perpe-
trated, and Booker Washington is silent. There has developed in North Carolina the
greatest menace yet, a movement . . . which will undoubtedly result in legislation,
segregating the Negro on the farm lands, thus giving the lie to Washington's advice to
his people that if they will only be good and buy land they will be let alone and will
flourish. . . . His name is getting to be anathema among the educated colored people
in the country, and he is drifting further and further in the rear as a real leader."[52]
Villard sent this letter to a white northerner whose family had contributed a great deal
of money to Tuskegee, and he sent a copy of it to Robert R. Moton, who was then
Commandant of Cadets at Hampton and one of Washington's most important black
allies.

The idea that vocational education should be the only version of the American
Dream available to blacks was so completely identified with Washington that, at least
for educated blacks, it started to disappear after his death in 1915. Washington's black
allies and associates—including Moton, his successor as principal at Tuskegee—were
not willing to carry on the battle against his critics, nor did they continue to refuse to
cooperate with the NAACP. In the summer of 1916, a year after Washington's death,
NAACP leaders invited some of his closest followers (including Moton, Emmett J.
Scott, and Fred Moore) to a conference at the summer home of Joel Spingarn, who
was chairman of the NAACP's executive committee. (Moore was editor of *New York
Age*; he had been given that post by Washington, who had also secretly given him the
money to buy out the newspaper's former publisher and editor.) A number of impor-
tant black radicals and liberals were also invited, including John Hope, Monroe
Trotter, and Du Bois; and the conference's resolutions were drafted by a committee
that included Moore, Hope, and Spingarn. The first of these resolutions—adopted
unanimously, signed by Du Bois, Scott, and the other conferees, and published two
weeks later on the front page of Moore's *New York Age*—stated that "the conference
believes that all forms of education are desirable for the Negro, and that every form of
education should be encouraged and advanced."[53]

Despite this formal truce, the two factions continued to compete with, and snipe at,
one another. Du Bois criticized Hampton, Tuskegee, and vocational education in *The
Crisis*. The two institutes competed—all too successfully, in the opinion of their

critics—with other black schools for funds. Nevertheless, after 1915 and throughout the 1920s, vocational education began to decline in importance in black schools and colleges. One major cause of this change was that, as southern states tried to upgrade their educational systems, they required that teachers, even those in black schools, had to have college degrees.[54] Since many of the vocational education graduates planned to become teachers, it was necessary for the institutes to add "Collegiate Departments" that could be accredited to offer bachelor's degrees in education. Equally important, the attitudes of blacks began to change. By the early 1920s, the Hampton Institute's vision, embodied in the picture of the Hampton graduate seated complacently in his bourgeois dining room, had become an anachronism to many black men and women, particularly those who were educated, with attitudes like those described by black philosopher Alain Locke in his 1925 anthology, *The New Negro*. As Robert Bagnall, an NAACP official, wrote in the same year, "The old Negro has passed away—a new Negro is here. He is restless, discontented, eager, ambitious. He wears the mask and smiles when he feels it to be wisdom, but he hates the mask."[55]

For many blacks, vocational education was part of that mask, and it could not be discarded immediately. But changes started to occur. Even Tuskegee added a collegiate department, and by the 1920s almost three hundred of its fifteen hundred students were in that curriculum. Robert Moton smoothly explained that, despite this development, the Institute was not departing "one iota from the principles or policies" of Booker T. Washington, that the Institute had to comply with the requirements of accreditation agencies, and that Tuskegee was not offering Liberal Arts degrees but was instead giving its students "the liberal culture which every educated man should have."[56] Events did not go as smoothly at Florida A & M, another black school. Despite its A & M status, the Florida school made only a perfunctory effort to teach vocational education; and when a new supervisor of the trades program joined forces with a white politician in 1922 to force the college to reorganize as a vocational education school, the president resigned, saying that the school should continue to make "a real effort at the *higher* education of the Negro." A new president was appointed, formerly a professor of mechanical arts, who was praised by a white newspaper as a "zealous worker" who would teach "the negro boys how to make good citizens by teaching them how to make good carpenters, blacksmiths, painters, and other practical trades." But the students boycotted classes, one-third of them withdrew from the college, and within three months three of its buildings—including the "hated Mechanical Arts Building"—were destroyed by mysterious fires. "In making his official report on these matters, the state supervisor of Negro education noted that a 'condition of rebellion bordering on anarchy' existed on campus. . . . He found solace only in the knowledge that the destroyed buildings had been covered by insurance."[57]

No buildings were burned at Hampton, but the Institute had its share of troubles during the administration of James Gregg, who succeeded Frissell in 1918 to become the school's third principal. There were difficulties with Virginia's whites, who passed laws to enforce Jim Crow laws on the campus, the students protested against being

made to sing spirituals and "plantation songs" for visitors, and there was an acrimoni-ous student strike in 1927. During all this turmoil, however, the Institute moved steadily away from the Hampton Idea. Gregg recognized that blacks had developed a "new eagerness to get knowledge, skill, culture, wealth, and all else that is suggested by the word 'progress'"; and for Hampton, progress meant the upgrading of the school's curriculum to the collegiate level. In 1920 it offered a four-year program leading to the Bachelor of Arts degree in education, and during the 1920s additional Bachelor of Arts programs and even a Masters program in school administration were added. The students pressured the Institute to raise its academic standards by com-plaining about teachers and administrators who did not measure up, such as the director of the vocational education program, who was criticized by the Student Council in 1924 because he had "little formal education and used such poor English that he was not qualified to teach."[58]

At the same time, enrollment in the Institute's college division increased rapidly. In the 1920–21 school year, twenty-one of Hampton's approximately one thousand students were in that division; by the 1927–28 school year, almost half were in it; and by 1929 no new high school students were being admitted and only remedial work was being given on the secondary level. Gregg's successor, George P. Phenix, announced in December 1929 that Hampton had begun a "new era," and that the Institute should not regret departing from Armstrong's and Frissell's philosophy of vocational educa-tion, because it had "less validity than some of us had supposed." Sometimes, Phenix warned, educational institutions might suffer from an "unwise excess of devotion" to their founders and their policies, and "this we must avoid."[59] Even at the Hampton Institute, then, vocational education was no longer seen as a cure for America's racial problems; and when W. E. B. Du Bois visited the campus in the 1930s, he believed he had the last word in his long debate with Washington and Frissell and their followers over the value of "the Hampton-Tuskegee idea of Negro education." When he saw the Institute in 1936, Du Bois said later, "behold, Hampton had become a college and was wondering what to do with her industrial equipment!"[60]

Time and history had not dealt kindly with General Armstrong's dream, but in Johnston's *Hampton Album* that dream is still intact. "Most reportage moves us chiefly to turn the page," Kirstein wrote over sixty years later; but Johnston's images still "grip us by their soft, sweet monochrome. In them, hearts beat, breath is held; time ticks. . . . Outside of Hampton there is an ogre's world of cruel competition and insensate violence, but while we are here [in the album], all the fair words that have spoken to the outcast and injured are true. Promises are kept. Hers is the promised land."[61] Less than a decade later, however, another equally talented documentary photographer would begin to confront that "ogre's world" that the Hampton educa-tors had excluded from their campus and that Johnston had not photographed as she traveled through rural and industrial America in the early 1900s. That photographer, Lewis Hine, would see the United States as something very different from a promised land.

Lewis Hine
and American
Industrialism

The American Dream at the turn of the century was literal. The reality was a nightmare. The Industrial Revolution had provided more compassion for the machines than for the humans who worked them. Life was cheap.
– Lionel Suntop, "Lewis Hine: 1874–1940"

Just think of it! This richest, greatest country the world has ever seen has over 1,700,000 children under fifteen years of age toiling in fields, factories, mines, and workshops. . . . In the worst days of cotton-milling in England the conditions were hardly worse than those now existing in the South. Children, the tiniest and frailest, of five and six years of age, rise in the morning and, like old men and women, go to the mills to do their day's labor. . . . This is the bottomest end of the scale that at the top has all the lavish spending of Fifth Avenue. . . . The foolish extravagances of the rich, . . . and the lowermost hell of child suffering are all so many accordant aspects and inexorable consequences of the same . . . way of living.
– H. G. Wells, *The Future in America*[1]

hough Frances Johnston and Lewis Hine were contemporaries and dealt with some of the same subjects, they had significantly different conceptions of the photographer's role. Johnston believed a photographer should have "unlimited tact" and was essentially a tactful, sympathetic guest whether she was photographing Theodore Roosevelt's family in the White House or the Hampton students mixing fertilizer. Her desire to present her subjects in the best possible light, socially as well as visually, can be seen in an article about coal mining that she wrote and took photographs for in 1892. Traveling by train to a "coal patch" in Pennsylvania, she was disturbed to see the Schuylkill turning into a "river of ink." When she arrived at the mine, she saw what she described as "great, unsightly frame buildings—the coal breakers—dingy with dust and smoke, ris[ing] awkwardly . . . while the small cottages and rude wooden shanties of the miners cluster drearily about the outskirts." Upon entering the mines and the miners' homes, however, she found a great deal to appreciate as well as to photograph. She was pleased to see that the miners' families had planted flower gardens by their houses; and she commented that "wherever we went [we encountered] . . . the most unfailing courtesy in simple kindly natures. . . . I was constantly offered a hospitality, were it but a cup of tea or a bite of lunch." She was pleased to learn that the miners had not been degraded by hard work but were skilled workers who possessed "an ability resulting from hard training, long experience, careful judgment, and quick wit." She observed the "choking dust and deafening clatter of machinery" in breakers where coal was separated from chunks of slate by breaker boys sitting on chutes above the falling coal, but she saw this process uncritically, as she described the boys simply as "bright-eyed youngsters. . . . It must be a specially agile bit of slate that can escape their keen vision and nimble fingers."[2]

In contrast, Hine considered himself a kind of spy who was anything but a sympathetic guest: many of the mines, factories, and mills he visited were officially breaking the law by employing the children whom he photographed. When he taught nature study and geography at the Ethical Culture School between 1901 and 1908, he entertained his students during nature walks by pretending to be a tramp or a peddler; and after he became a photographer for the National Child Labor Committee

(NCLC) in 1907, he entered factories and mills by pretending to be a fire inspector, postcard vendor, or Bible salesman. Sometimes he said he was an industrial photographer who wanted to photograph a loom, and then he would ask a child to stand by the machine so he could get a "sense of scale." He also had a notebook, hidden in his pocket, so he could secretly record the children's names and ages. When he was not allowed to enter a workplace, Hine could be even more resourceful. When the manager of a Mississippi cannery would not permit him to make photographs, he reported, he went to the plant at 5:00 A.M., "before the manager arrived, and spent some time there. They all began work that morning at 4:00 A.M. . . . I counted 20 children that seemed to be under 12 years and more came later. . . . At noon, while the manager was at dinner, I landed a row-boat at the wharf, and obtained several [more] pictures."[3]

When Hine and other reformers went to coal mines, they saw things far differently than Johnston had done on her trip to Pennsylvania. Though she admitted, for example, that the dangers of coal mining were "appalling," she found it "comfortable to know that every possible precaution is taken to guard against accident[s]." In contrast, reformers revealed statistics showing how dangerous coal mining was. For example, in West Virginia in 1907, 729 miners were killed and 245 were injured by accidents, live wires, and explosions. Johnston was reassured by her visit to the coal patch schoolhouse, where she "found the miners' children neat, cleanly, and fresh-faced"; but when reformers visited night schools for breaker boys, they found them to be "poorly equipped," with overworked teachers trying to teach "boys too weary in body and mind to profit by class-room work after a day in the breaker." Johnston was impressed by the "keen vision and nimble fingers" of the breaker boys; but an NCLC pamphlet, "In the Shadow of the Coal Breaker," ended with the story of one small boy who had been working for several years in the breaker until "his arm was caught in a belt of the scraper line." The boy was photographed alone, facing the camera so that his empty right sleeve was seen clearly by readers of the pamphlet.[4]

From the very beginning of his career, Hine photographed controversial subjects. In 1904, while he was still teaching at the Ethical Culture School, he began photographing immigrants at Ellis Island. The way that he photographed them placed him firmly on the liberal side of one of the more important disputes of the Progressive Era. In recent decades, the immigrant experience, usually symbolized by Ellis Island and the Statue of Liberty, has been one of the more sentimental aspects of the American Dream. A June 1985 advertising campaign by the *Wall Street Journal*, for example, featured old pictures of immigrants accompanied by such sentences as, "They arrived with little but their families, their clothes, and the dream of a better life," "It was called the American dream. Not because it was invented here. But because, for so many, it came true here," and "At the *Wall Street Journal*, we think the American dream is still coming true." By an unpleasant coincidence, another event in June 1985 showed that the nightmarish side of the immigrants' American Dream was "still coming true." A judge in Illinois convicted two businessmen and a foreman of murder when one of their employees inhaled cyanide on the job. "The death of worker Stefan Golab, 61,

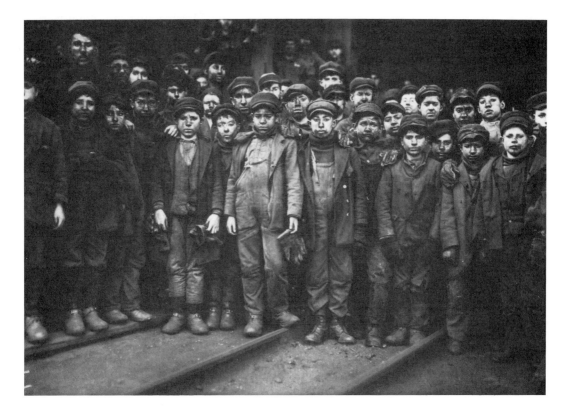

'was not accidental, but in fact murder,' " the judge ruled. The prosecutors claimed that "the company hired illegal aliens and employees who spoke little or no English so they would not complain about plant conditions or understand the hazardous nature of their work."[5]

When Hine was making his photographs on Ellis Island in the early 1900s, Americans were less sentimental about immigration. Immigrants were expected to do hard, dirty, dangerous work as well as to achieve "the dream of a better life," but many Americans could not agree on the character of the immigrants. There was a widespread belief among natives that earlier generations of immigrants from Ireland, England, or northern Europe, most likely including their own parents and grandparents, were fine people.But these "old" or "desirable" immigrants were often contrasted unfavorably with the millions of "new" immigrants who arrived from eastern and southern Europe starting in the 1890s. These immigrants—particularly the Jewish, Slavic, and southern Italian—were accused of virtually every form of moral and social depravity; and these accusations were made not only by unwashed bigots but also by well-educated and prestigious white gentlefolk. In 1892 the editor and poet Thomas Bailey Aldrich praised the United States as a "later Eden planted in the wilds," but he warned readers of the *Atlantic Monthly* that this Eden was menaced by a "wild motley throng— / Men from the Volga and the Tartar steppes, / Featureless figures of the Hoang-Ho / Malayan, Scythian, Teuton, Kelt, and Slav" who were "flying the Old World's poverty and scorn" and speaking "strange tongues . . . [and]

Lewis Hine, "Breaker Boys Working in Ewen Breaker," South Pittston, Pennsylvania, 1911 (Records of the Children's Bureau, National Archives)

Accents of menace alien to our air." Similar sentiments were advanced in prose in the *Atlantic* a few years later by General Francis A. Walker, who was chief of the U.S. Bureau of Statistics and superintendent of the Census, a professor at Yale University, and later a president of MIT. "Hungarians, Bohemians, Poles, South Italians, and Russian Jews," Walker claimed, were "vast masses of peasantry, degraded beyond our utmost conceptions." In his 1901 *History of the American People*, Professor Woodrow Wilson described these immigrants as "multitudes of the men of the lowest class . . . where there was neither skill nor energy. . . [these] unlikely fellows . . . were tolerated because they usurped no place but the very lowest in the scale of labor."[6]

Native-born Americans who opposed immigration blamed virtually everything that was wrong in late nineteenth- and early twentieth-century America—crime, slums, corruption, labor unrest, and political radicalism—on the "new" immigrants. Sociologist Edward Ross attributed even the decline in the WASP birthrate, which began in the late nineteenth-century, to the arrival of the immigrants. He claimed that children were a "burden to the [native-born] American" since "he keeps them clean, neatly dressed, and in school," but that large families were "an asset to the low-standard foreigner" because he "puts them to work. . . . William does not leave as many children as 'Tonio, because he will not huddle his family into one room, eat macaroni off a bare board . . . and keep his children weeding onions instead of at school."[7]

This was only one side of the immigrant debate, however. The other was eloquently stated by British writer Israel Zangwill's 1908 drama, *The Melting Pot*, which ended with its hero's claim that America would fuse all races and nations until they were united to "build the Republic of Man and the Kingdom of God . . . where all nations and races come to worship . . . where all nations come to labour and look forward!" Zangwill's immigrant hero was a musical genius, and—perhaps realizing that such a hero was not quite typical—the playwright added an appendix to the published edition of his play: it was an article from the *Chicago Daily News*, listing statistics showing that immigrants comprised the majority of the work force in industries like meat-packing (85 percent), bituminous coal mining (70 percent), milling (78 percent), garment making (90 percent), and leather working (80 percent). "I am the immigrant," the *Chicago Daily News* article proclaimed. "I looked toward the United States with eyes kindled by the fire of ambition and heart quickened with new-born hope. . . . I have shouldered my burden as the American man of all work." Readers of the *Atlantic Monthly* who favored a liberal immigration policy and found Francis Walker's article offensive, would have been pleased to read Kate Holladay Claghorn's more generous article, which appeared in the same periodical a few years later and predicted that the immigrants' problems could be solved by "impartial justice in the courts, honesty in government . . . a more thorough, practical, and flexible system of education, and a stricter social control." Or, if they disagreed with Professor Ross's characterization of the miserable 'Tonio forcing his children to weed onions, they could recall articles like Alice Bennett's, published a few years earlier in *Survey*, which described how successful Italian immigrants had been in Connecticut. John Carino of South Glastonbury had saved his money, bought a small farm, and sent for his family from Italy. At first,

Bennett said, all of "the family toiled early and late," but they prospered, and Carino's
two eldest children were attending school in Hartford and probably would go to college.[8]

For Professor Ross and his allies, the restriction of immigration was the great cure-all for many of America's problems. But they did not achieve this goal until the 1920s, when Congress adopted an immigration policy, based on national quotas from the 1890 census, designed to preserve the nation's "racial status quo." Before that legislation was passed, however, the nation already excluded Asian immigrants and experimented with other means, such as literacy tests, to keep out "unfit" European immigrants. As these measures were adopted, politicians, social scientists, intellectuals, and ordinary citizens energetically debated the immigrants' good and bad qualities and the best ways to "Americanize" them as rapidly as possible.

One of the noteworthy aspects of the debate was that many native-born Americans, since they spoke only English, often judged the immigrants by how they looked rather than by what they said. When Henry James visited New York in 1904 and rode on the elevated railroad, he encountered "a row of faces, up and down, testifying, without exception, to . . . alienism undisguised and unashamed." He concluded that "Face after face, unmistakably, was 'low'—particularly in the men. . . . It was difficult to say if they most affected one as promising or as portentous." Edward Ross was so alarmed by the appearance of some immigrants that he described them in the type of language that German racists used to denounce *Untermenschen* in the 1930s. "I have seen gatherings of the foreign born in which narrow and sloping foreheads were the rule," he claimed. "The shortness and smallness of the crania were very noticeable. There was much facial asymmetry. . . . In every face there was something wrong—lips thick, mouth coarse, upper lip too long. . . . There were so many sugar-loaf heads, moon-faces, slit mouths, lantern-jaws, and goosebill noses that one might imagine a malicious jinn had amused himself casting human beings in a set of skew-molds discarded by the Creator."[9]

If appearances were used to confirm prejudices, however, they were also used to verify sympathetic opinions. Frank Manny, the superintendent of the Ethical Culture School, who hired Lewis Hine to be a teacher, wanted his students to have as high a regard for the immigrants as they had for the New England Pilgrims. In 1904 he encouraged Hine to take students to Ellis Island to observe immigrants, and he helped Hine to photograph them. Manny and Hine believed such photographs would overcome prejudices. As Hine claimed in the 1930s when he applied for a Guggenheim Fellowship, "Much emphasis is being put upon the dangers inherent in our alien groups, our unassimilated or even partly Americanized citizens—criticism based upon insufficient knowledge. A corrective for this would be better facilities for *seeing*, and so *understanding*, what the facts are [emphasis added]." Seen in this context, Hine's Ellis Island pictures take on an additional significance. He does not make any effort to mitigate the immigrants' foreignness—the clothing and the faces of the people he selected often testify, as Henry James would say, to unmistakable "alienism." However, in Hine's images the immigrants are also what James called "promising," and looking

at them there is no reason to doubt that these people will make a positive contribution to American life. Thus the photographs supported a liberal immigration policy because in them Hine's subjects look like normal, alert human beings who are in no way defective or degraded.[10]

In 1911 the United States Immigration Commission completed an exhaustive study of the effects of immigration on American life. The report was very long—forty-two volumes—and contained so much contradictory evidence that the commissioners issued majority and minority reports to incorporate conflicting interpretations. Before this report was published, the editors of *Survey* published a special issue on immigration. The generally liberal attitude of this issue was introduced by an overview of the findings of the Immigration Commission by H. Parker Willis, an editorial advisor to the Commission. In spite of the difficulties immigrants had to endure, and "in spite of the social and race prejudice and other . . . conditions" that caused them to live in ghettos, Willis wrote, "the reader of the . . . reports is likely to reach the conclusion that the showing of the immigrant is on the whole a decidedly good one, all things considered." His cautious optimism was supplemented by the Hine photographs that introduced the issue. On the cover is a picture of an old woman wearing a shawl. Though her face is lined and she looks weary, the woman has a calm, dignified bearing. The frontispiece is another Hine photograph of an immigrant family with seven children. Its caption is "The Beginning of Things," and the family is alert and attractive. The father is an intelligent, capable-looking man, and the children are sturdy and bright-eyed. Seeing it, the reader would almost certainly agree with Willis's claim that immigration was a good thing for the United States.[11]

Besides showing that the immigrants were promising people, Hine's photographs also challenged the stereotyping process that characterized so many of the anti-immigrant prejudices. In many of his pictures he revealed the diversity of immigrants' personalities and temperaments, even within families and relatively small groups. One of his earliest photographs, captioned "Jews at Ellis Island" and dated "1904," shows a small group of men who are, visually at least, distinctly heterogeneous. All of them are relatively young or middle-aged, and all of them look bored. But, even though they are sitting on the same bench, they express themselves differently. One bearded young man seems the most patient; the second, more finely dressed, is stiffer and more withdrawn; the third peers wearily at the camera; and the fourth is looking ahead, presumably to see if the line is moving. They are not a generic group of people, called "Jews," who all possess the same traits. We see that they are different men who seem patient or impatient, sensitive or coarse, plain or stylish, depending on their personal characteristics.[12]

If we contrast Hine's images with Johnston's *Hampton Album*, we see that Hine's subjects have more individuality, and this impression is created not only by his selection of subjects but also by the way he photographs them. In Johnston's pictures the black and Native American students are always generic beings intended to illustrate the virtues of the Hampton philosophy, and their lack of individuality is increased by the way she visually segregates them from the observer. Hine, on the other hand, often takes his camera closer to his subjects and photographs them from a variety of

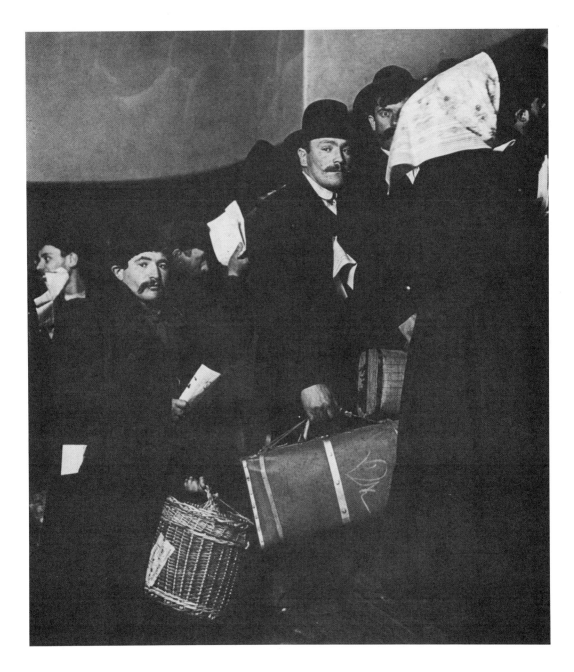

angles and distances. He seems close enough to speak to them, and they are close enough to reply. Moreover, Hine's immigrant subjects usually act as if they know they are being photographed, unlike the Hampton students, who pretend that Johnston and her camera are not present. Hine's pictures give the impression of a direct, polite social encounter between individuals who are relatively equal. There is often eye contact between the immigrants and the camera, and many of them seem to regard Hine with mild interest. Being photographed does not disturb them, and one can only assume that when they leave Ellis Island they will continue to react to America in the same alert, capable way.

Lewis Hine,
Immigrants at
Ellis Island,
1908 (Hine,
America and
Lewis Hine,
1977)

Child labor reform was not quite as controversial as immigration, but it was an equally complicated subject. Learning about the conditions under which these children lived and worked is like entering a maze of misconceptions and contradictions that is as filled with dark corridors and dead ends as the alleys, factories, mills, and tenements Hine photographed for the NCLC between 1906 and 1918.

There is, for example, a widespread misconception that child labor ended in the United States relatively soon after Hine made his NCLC photographs. In 1950 *Life* magazine published Allan Nevins's survey of twentieth-century American history, containing a Hine photograph with a caption saying: "Humanity was exploited as America grew to giant's size. This powerful picture of a forlorn child worker . . . was made in 1908 by Lewis Hine. . . . Pictures like this did much to get child labor outlawed." But even though dozens of child labor laws were passed in states all over the country during the Progressive Era, and even though children did stop working in some industries, child labor was widespread until the 1930s. Then the number of children working finally began to decline because of the depression and a variety of New Deal laws, such as the 1933 National Recovery Administration (NRA) industry codes and the 1938 Fair Labor Standards Act. (According to the 1930 census, approximately 355,900 fourteen- and fifteen-year-old children were working on farms and in industry; by 1940, that number had decreased to 210,000.) As late as 1937 the NCLC was still finding and photographing children packing shrimp in Mississippi canneries under conditions as miserable as those Hine had described in 1911. Farm Security Administration photographers Russell Lee and Walker Evans photographed children picking cotton in Texas and Alabama who seem indistinguishable from pictures Hine made thirty years earlier. Congress was still passing major, national, child labor legislation in October 1949, three months before Nevins's article appeared in *Life* magazine. Moreover, in the case of migrant farm laborers, it seems that small children will probably be working in America's fields forever. According to a 1984 appeal from the Farmworker Justice Fund, written by a farm laborer, "Every morning we get up at 5:00 a.m. We load the kids into the truck under blankets while it is still dark. We stay at the fields til 6 or 7 at night. . . . We work in all weather—cold, wet, hot. All of us work except my baby Rosa who is only two. . . . When I look at my children, they have deep shadows under their eyes, the light has already gone out of them. I don't want them to work, but they have to so we can make ends meet."[13]

Sometimes, even among themselves, reformers could not agree on the number of children who were working, legally or illegally, in America. In 1923, for example, Owen Lovejoy, secretary of the NCLC, claimed that there were at least one million children who were not receiving any education because they were child laborers; but a year earlier Secretary of Commerce Herbert Hoover estimated that "the use of child labor so far as it retards proper development and education . . . probably affects less than three hundred thousand children." Simply counting child workers was difficult because there were so many disagreements about how to categorize the children. Everyone could agree that ten- or twelve-year-old children working eight-hour or ten-hour days in canneries or mines were child laborers, but what about smaller

children who brought lunches to their older brothers and sisters and then stayed to
"help" them? These children might—or might not—be counted as working children, depending on how the laws of a particular state were interpreted. To make matters more confusing, there were many discrepancies in the laws. Thus the same city might have different minimum ages and different hours of employment permitted for boys and girls, or for factory workers and children in street trades, like news vendors; and many states had special exemptions for certain categories of children, such as the children of widows, who were exempt from various child labor regulations.[14]

Moreover, employers, parents, and even children themselves were adept at finding loopholes in the child labor laws. Children in many states were permitted to work, no matter what their age, if parents signed affidavits saying that they were the minimum age. Other states demanded "documentary" proof of the children's ages, but local officials often accepted these "documents," such as family Bibles, even when it was clear they had been altered.[15] The difference in child labor standards among different states was another problem. Employers in states with strong laws said they could not compete with companies located in states that had weaker laws. Therefore, legislators who wanted to protect their state's industries were unwilling to pass strong, consistent laws against child labor. In addition, some states had "model" legislation but failed to provide any penalties for offenders or realistic means of enforcing these laws. For example, in 1909 New York state had sixty-two inspectors and Ohio thirty-four, but Indiana had only six inspectors and no penalties for employers who hired children illegally. Also in 1909 North Carolina and South Carolina had no factory inspections at all to enforce child labor laws.[16] Starting in 1907, reformers spent years lobbying for a national child labor law that would end these inconsistencies, and they persuaded Congress to pass such laws in 1916 and 1919—but the Supreme Court declared both unconstitutional in 1918 and 1922, respectively. Further, even these short-lived national laws were weaker than laws that already existed in some states.

Sociologists, inspectors, and reformers never reached a consensus about the causes of child labor. Some blamed employers and *padrones*, the labor contractors who hired families and children to work on farms and in canneries. Others insisted that parents were at fault. It was widely believed that certain immigrant groups, particularly the Italians, put their children to work at an early age so the parents could "retire." It was also believed that there were large numbers of poor, white, "dependent fathers" in the South who lived on their children's wages. But other reformers claimed that the parents of many child laborers were so poor and so underpaid that the children had to work for the families to survive. Helen Todd, a Chicago factory inspector, said that when she asked 800 factory children about their fathers in 1909, 381 said that their fathers were sick, disabled, or dead because of industrial diseases or accidents. "The same story unfolds in every factory from most of the children. . . . 'He's got blood poisoning'; 'He's paralyzed'; . . . 'A rail fell on his foot, and it's smashed'; 'He's dead—he got killed.' He worked in the steel mills, or the stock-yards. . . . He was burned with molten metal, or crushed by falling beams, or maimed by an explosion." But Todd also pointed out that in some cases the children wished to work because it gave them status

and affection in their families and spending money for themselves. If you worked, the children told her, "You can buy shoes for the baby," "They're good to you at home when you earn money," and "You can go to the nickel show."[17]

Methodology was one way through this labyrinth. Social sciences like economics and sociology were becoming established disciplines, and reformers spent a great deal of time measuring and discussing case studies, surveys, statistics, and census and commission reports about child labor. An important reform periodical, which frequently used Hine's pictures, was entitled *Survey*; and, as Alan Trachtenberg has pointed out, a survey, "like a map, assumes that the world is comprehensible to rational understanding and that understanding can result in *social* action. It assumes, too, that once the plain facts, the map of the social terrain, are clear to everyone, then change or reform will naturally follow." Hine was well acquainted with the methodology of these studies: he had taken graduate courses in sociology at Columbia University. One of his first major assignments was to spend three months in 1907 making photographs for the *Pittsburgh Survey*—a massive, six-volume report on that city's industrial conditions. During his career with the NCLC, he worked with social workers and investigators, and he often gathered data and did the case studies that accompanied his photographs.[18]

Hine's images are usually printed in anthologies with only minimal captions. When he made them, however, his photographs were frequently meant to be closely integrated with accompanying printed texts relating them to social work methodology. In one of his "Time Exposures," for example, he photographed a group of boys and young men who worked in a mill in Massachusetts. Some of the boys looked quite young, and Hine explained the significance of their youth with the caption "Illiterates in Massachusetts." He commented in his text that the three youngest boys in the picture were Portuguese children "who could not write their own names . . . [and] spoke almost no English." Children in Massachusetts were supposed to pass a reading test before they received work permits, Hine added, "but the officers who issue permits occasionally help a child to read even the simplest English sentence." Hine's text, like the information in a survey, is as precise as possible. He says "three"—not "all" or "many"—of the boys are illiterate, and he also tells us he discovered this by asking them to write their names. In other cases, he used text and captions to give his audience information that was in the pictures but that they probably would not have noticed. One of his mill photographs from South Carolina shows a group of girls, some of them quite small, standing by a machine that looks harmless; but, as his caption points out, "The unguarded wheel and belt at the left are sinister neighbors for little girls' arms, skirts, and braids. There was no factory inspection in South Carolina." Combining images and texts enabled Hine to focus attention on exactly those facts relevant to the reforms needed to improve working conditions for children.[19]

Organizing the evidence about child labor accurately was only part of the task confronting reformers. They also had to deal with a variety of conflicting opinions regarding the related issues of whether all child labor was bad and whether it was bad

for all children. Sympathetic legislators might have agreed that small children should not do hard labor in mines or canneries, but they were also sympathetic to the claims of some employers and parents that certain kinds of work were beneficial to children or that certain kinds of children were better off working instead of attending school. Reformers tried to cut through these arguments with ideology.

In actuality, of course, child labor is not an exclusively American phenomenon and has occurred in many countries since the industrial revolution began. When capital is scarce, when machinery is expensive, and when human labor is cheap and plentiful, child labor is still one of the easiest ways to expand economies and achieve economic "miracles." Thus in England in the 1830s, mill owners were described as a "race whose whole wisdom consists in that cunning which enables them to devise the cheapest possible means for getting out of the youngest possible workers the greatest possible amount of labour . . . for the least possible amount of wages." They employed children who were "almost universally ill-looking, small, sickly, barefoot and ill-clad." During the 1950s in Italy, there were scandals about twelve-year-old boys working twelve-hour shifts in textile mills: their health was ruined, they could not attend school, and the risk of accidents was doubled because they were so tired. As recently as 1982, the British Anti-Slavery Society reported that according to government officials in Thailand there were "at least 5,000 unregistered factories in [that] country which not only employ children under 12 years with impunity, but also ill-treat them, making them work in inhumane conditions."[20]

American reformers of Hine's generation, though, rarely compared the United States with other nations. Instead, they often based their arguments on the liberal version of the American Dream, with its emphasis on equality. Even if the children were not harmed physically by their work, reformers argued, they could not become "equal" (that is, secure middle-class or working-class) citizens, if they were trapped in low-paying jobs and could not become educated or learn skilled trades. In 1913 one reformer even made up his own version of the Declaration of Independence for the working children of America. Entitled the "Declaration of Dependence," it claimed that, even though the children of America "are declared to have been born free and equal," many of them were "yet in bondage in this land of the free." John Spargo, a Socialist, developed the same idea several years earlier in a pamphlet, *Child Slaves in Free America*, when he charged that "the terrible reality of child-slavery" made a mockery of "the stately phrases of the Declaration of Independence."[21]

It was relatively easy for reformers to assert in print that working children were equal to nonworking children; but illustrating this with photographs was a challenge for Hine. On the one hand, he could not photograph children who looked "promising," like the immigrants at Ellis Island, because then it could be argued that child labor did not really harm children. In 1911 he commented bitterly, "So many times social workers have told me that photographs of happy, healthy children do not make effective appeals in our child labor work, that I am sometimes inclined to think that we must mutilate these infants in industry before the shame of it can be driven home." On the other hand, if Hine selected child workers who looked too weary and degraded, it

could be argued that they were "racially" inferior, and therefore only "fit" to work in mills or factories. As Felix Adler pointed out in 1905, there was a secret argument for child labor—"so un-American and so inhuman that I am almost ashamed to quote it"—that was told to him by a glass manufacturer who pointed to a group of young "Slav boys" working in his factory and remarked: "Look at their faces, and you will see that it is idle . . . to give them an education; they are what they are, and will always remain what they are." And the owner of a factory in Mississippi, where children were whipped "when they would not work," confided to Hine, "We don't want them [the child labor reformers] to know about this because they would not understand that it is better for these low people to be at work. They don't want school. The children who grow up and can't read and write are always better off than those who can, because as soon as they get a smattering of education they want to strike for higher wages. . . . They're just like cattle."[22]

Hine's solution to this problem was never to photograph the children so they looked "low," but instead to portray them so they appeared to be, even when they were tired, alert yet vulnerable. In this respect his pictures are significantly different from those of another reformer, Jacob Riis, who made his photographs in the New York slums in the 1890s. The people in Riis's pictures, as Trachtenberg has pointed out, "are usually downtrodden, passive, and objects of pity and horror, [but] Hine's people are alive and tough. . . . Their spirit is at odds with their surroundings. And this contradiction fills the pictures with an air of tension."[23] Riis was trying to reform New York's bad housing conditions of the 1890s—slum tenements and police lodging houses for the homeless—and his subjects often appear to be strewn about the filthy rooms of these places, part of the dirt that surrounds them. In his writings, Riis sometimes emphasized that it was the slum environment that degraded the people who were forced to live in it. But some of his other statements, particularly about certain immigrant groups, suggested that he had an opposite point of view: that it was these degraded people who were creating the miserable conditions around them. Francis Walker interpreted one of Riis's descriptions of garbage scavengers in this way and used it as part of his attack on immigrants whose "habits of life" were "of the most revolting kind. Read the description given by Mr. Riis of the police driving from the garbage dumps the miserable beings who try to burrow in those depths of unutterable filth. . . . What effects must be produced upon our social standards, and upon the ambitions and aspirations of our people, by a contact so foul and loathsome?"[24]

Some of Riis's photographic images are almost equally "loathsome," but it would be impossible for anyone to interpret one of Hine's child labor pictures that way. As Trachtenberg says, Hine's subjects are "at odds" with their environment. In his pictures the children are simple, organic, fragile figures surrounded by what seems to be infinitely complicated machinery. In his pictures of glass factories, the work environments are not only drab and dirty but also extremely cluttered, so that the children are starkly visible in the mazes of pipes, boxes, and piles of debris.

Hine showed children standing straight and tall in the midst of clutter, or he showed them working attentively—though wearily—at their jobs. The children often seem

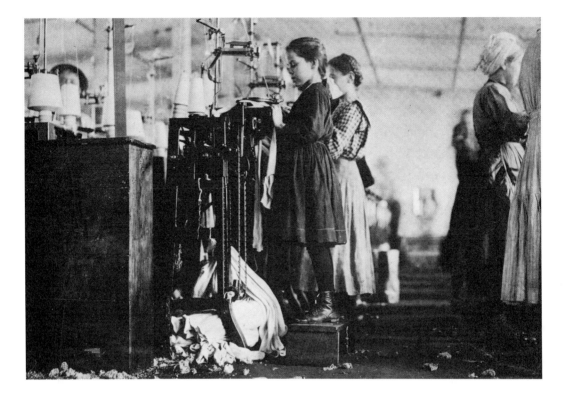

detached from their surroundings because they are staring straight at Hine and his camera with full eye contact. (In addition, because of the dim lighting in these places, Hine probably had to use a large aperture opening on his lens and a shallow depth of field, which would have made the children stand out more sharply from the dark, gloomy backgrounds.) In these frontal pictures, however, there is almost always a strong implication that this connection is only tenuous and temporary. The children stand facing the camera with a kind of frail, stiff dignity: like Manuel, a five-year-old boy whom he photographed standing in front of a "mountain" of oyster shells outside of a cannery (see below). Clearly, the children facing Hine's camera have stopped work only for a few minutes, and then they must return to the canneries, the huge iron machines, and the complicated looms that dwarf them. The expressions on the children's faces reveal their potential to become equal citizens of a great republic, but the pictures also imply that their potential will almost surely be destroyed by the work they are doing.[25] (In contrast, his positive pictures of adult workers of the 1920s and 1930s, which will be discussed later in this chapter, emphasize that the workers are in control of their work environments and that the work fulfills their capabilities.)

Lewis Hine, Girl knitting stockings in a Southern mill, 1910 (Hine, America and Lewis Hine, 1977)

Hine and the reformers also had to contend with a number of popular stereotypes, called "popular prejudices" and "national traditions," which were used to justify certain kinds of child labor.[26] The late nineteenth century was a period when immense social and economic changes were taking place as the United States became a more urban, modern, and industrialized nation. Many Americans explained or reacted to these changes with a variety of stereotypes, myths, legends, and secular faiths that

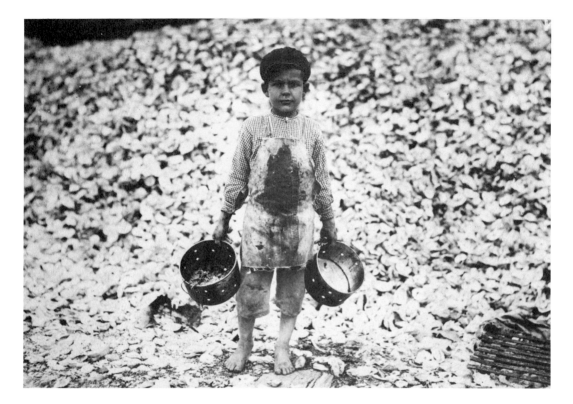

cropped up during the Gilded Age, continued during the Progressive Era, and have flourished ever since—like crabgrass in a lawn—in the nation's collective psyche, its political rhetoric, and its mass media.

After the Civil War, for example, as cities became larger and banks, industries, and railroads became more powerful, the nation's farmers began to lose the security and independence that had been extolled by Jefferson, Lincoln, Horace Greeley, and other champions of freehold democracy. They claimed—as Greeley told the readers of the *New York Herald Tribune* in 1867—that any energetic young American could "strike off into the broad, free West, and make yourself a farm . . . [and] neither you nor your children need evermore beg for Something to Do." But by 1900 35 percent of American farmers were tenant farmers, dependent on their landlords for land and credit, and "the fear that Jefferson's 'chosen people of God' would end up as peasants seemed not unfounded."[27] At the same time that the family farm was declining economically, however, it was becoming enshrined in the minds of many Americans as an iconic way of life in which hardworking farmers and their sturdy wives raised happy children who did wholesome chores while they learned the skills they would need to become the next generation of family farmers. Or, if the children did not want to stay on the farm, there were the popular stories of successful Americans that assured Americans that growing up on farms or in rural villages was a perfect preparation for success in the great world. Calvin Coolidge posed for press photographers wearing overalls and sitting on a hay wagon in the 1920s; and, as recently as the 1970s and 1980s, "populist" presidents posed for photo opportunities in blue jeans, surveying

their peanut fields and California ranches, while other actors and actresses struggled to save family farms in movies like *Country*, *Places in the Heart*, and *The River*.[28]

One aspect of this stereotype that was particularly relevant to child labor reform was the belief that farm children grew up in perfect harmony with their families, nature, and the American landscape. Inspired by such ideas, some reformers felt that agricultural work should be exempted from the category of harmful child labor. In a speech to the NCLC in 1906, Senator Albert Beveridge, who sponsored the first national child labor act, claimed the hard work he had done when he was a child had not damaged him because he had labored "in the open air, in the field . . . fragrant with the smells of the brown earth." A 1900 census report argued that in "occupations connected with agriculture [the] work of the child on the farm is essentially not injurious to health or morals, and does not necessarily interfere with opportunities for schooling."[29]

By the early 1900s, however, farming had begun to change in the United States. Many family farms still existed but there was also an increasing number of huge farms run by corporations, which brought many of the conditions of industrial work to the fields. The use of refrigerator cars and canneries made it possible for agribusinesses to specialize in single crops that had to be picked quickly by armies of migrant families, who had to travel from crop to crop as they "followed the harvest." By 1910, according to an NCLC analysis of a U.S. census report, over 260,000 children between the ages of ten and fifteen—almost 20 percent of the children working in agriculture in that age category—were classified as "working out" rather than on "home farms." Commenting sarcastically in 1911 on the conditions under which many of these children lived, Owen Lovejoy wrote about cranberry harvesting that

the farm is the paradise of our national traditions, where the cotter's Saturday night like a benediction ends the week of free and happy labor. Would that the tobacco fields, sugar beet fields, fruit and vegetable truck farms and canneries might continue to wear this bucolic halo.

Unfortunately the halo dims as we pass from one to another of those industries in which the labor power of children is profitable, and even the farm is now found in some of its activities, in league with [the] mine, store, factory and sweat-shop, in laying heavy burdens on the little child.[30]

When they investigated the conditions under which these children and their families lived, reformers discovered a type of rural existence that was the antithesis of the farm paradise that had become entrenched in popular mythology. Instead of families living in snug farmhouses, they found migrant workers living in the sheds and shacks provided by labor contractors and cannery companies. Hine photographed some of these for "Roving Children," a particularly bitter article that he published in *Survey* in 1910. "Often the quarters provided by the employers or padrone . . . lack the first requisites of proper housing," he emphasized in his text. "Sanitation is neglected and men, women and children are herded together like animals . . . Shameless overcrowding, filth and squalor are the results." As for the assumption that farm work did not interfere seriously with children's education since most of it was done in the summer,

Hine and other reformers showed that this did not apply to the migrant children: they lost months of schooling at the beginning and the end of the growing seasons and had to move into new school districts that often refused to accept responsibility for them. In one of his "Roving Children" pictures, Hine showed a small boy standing barefoot outside a shack with the caption, "In October. Wading in filthy waste around the door of a cannery shack. Should he be in school? Whose business is it to get him there?"[31]

Reformers also discovered that the belief that children did only relatively light, easy chores under their parents' supervision was not true on many farms. In the sugar beet industry, for example, children had to work long hours and perform several tiring and dangerous operations. Boys and girls who were only seven and eight years old sometimes worked from 5:00 A.M. to 7:00 P.M. in the "rush season" and from 6:00 A.M. to 6:00 P.M. on average work days. During that time, they had to pull five-pound beets caked with dirt out of the fields, put them in piles, and cut off their tops. In a single day, reformers calculated, a ten-year-old girl might be "handling from 12 to 15 tons" of beets and dirt. Moreover, the topping-off was done with a heavy sixteen-inch knife with a hook at the end of it—used to pull the beet out of the pile—and while holding the beet on one knee, so that children sometimes "hooked" themselves with the knife.[32]

Sometimes it was argued that farm and cannery work was not exploitive because children were working for their parents, who were hired by a *padrone*, rather than for a factory manager. Thus one owner of a cranberry bog claimed that children were "entirely under the direction of their loving parents." But Hine and other reformers discovered that children working in canneries and on migrant labor farms, including cranberry bogs, were exploited as harshly as the employees of any ghetto sweatshop. "When the vigilant *padrone* does not chance to be on guard," Lovejoy said, "the parents themselves urge their children [on] by curses and cuffs" to keep up with the line of cranberry pickers; and, watching children work in a cannery, Hine commented that oyster "shucking is a simple process, deadening in its monotonous simplicity, and as the bodies of the workers sway back and forth, with rhythm, concentrated on the job, one is reminded forcibly of sweatshop scenes in large cities." Instead of being cared for, children were often brutally or cleverly exploited by their parents and employers. In addition to the parents who cuffed and cursed their children to pick faster in the cranberry bogs, there were the mothers in canneries who cajoled their children, with praise or insults, to work faster. "Then there is the element of competition," Hine reported about a Mississippi cannery. "One child reaches a certain speed (which fact is freely circulated), and other children try long and hard to beat it. Often I heard it down there [in Mississippi] as I heard it in the cotton mill districts: 'She can do more work than her older sister.'" After hearing immigrant women cajole and coerce their children to work harder, Hine commented bitterly that their behavior was a "travesty" of motherhood, and their children's lives had become a perversion of the American Dream. "I have been surprised and *horrified* at the number of hours a day a six or a seven-year-old will stay and work, and to find so many parents willing and eager to keep them working. Freckled Bill, a bright lad of five years, told me that he

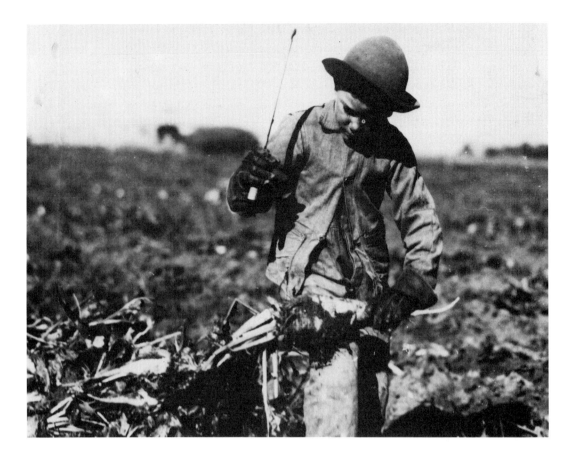

worked—and his mother added reproachfully, 'He kin make *15 cents* any day he wants to work, but he *won't do it steady.'* Think of a mother urging a boy of his age on to more work. . . . Can we call that Motherhood? Compared with real maternity, it is a distorted perversion, a travesty. The baby at Ellis Island little dreams what is in store for him."[33]

There was another ubiquitous Gilded Age myth that reformers had to contend with. In 1868 Horatio Alger, Jr., published *Ragged Dick*, a juvenile novel about a bootblack, and with it the street children of America began to become one of the more popular myths of capitalism. Horatio Alger, Jr., himself, who lived from 1832 to 1899, came from a respectable though not very prosperous middle-class family. After graduating from Harvard College and the Harvard Divinity School, he was ordained as a Unitarian minister, but he disgraced himself in 1866 when it was discovered that he was guilty of an "unnatural familiarity" with Sunday school boys. Blacklisted by the Unitarians, he fled to New York, where he seemed to have sublimated his sexual longings into good works for homeless boys—particularly those from the Newsboys' Lodging House, organized by the reformer Charles Loring Brace. (Brace also was one of the founders of the Children's Aid Society, an organization that tried to help runaways, orphans, and other homeless children.)[34]

To support himself, Alger became a hack writer and earned a modest living crank-

Lewis Hine, "Seven-Year-Old Alex Reiber Topping," 23 October 1915. Hine noted that the boy said, "I hooked me knee with the beet-knife, but I jist went on a working." (Library of Congress)

73

ing out moralistic, badly written serials, biographies, and juvenile novels—most of which were about poor boys who became respectable citizens by working hard, doing good deeds, educating themselves, and following the sententious advice they received from successful people. ("I hope, my lad," a rich man tells ragged Dick, that "you will prosper and rise in the world. You know in this free country poverty in early life is no bar to a man's advancement.")[35] After Alger's death, some of his novels continued to sell well in cheap reprints between 1900 and 1920 because, as Henry Steele Commager pointed out, they preached the same catechism of success that was popularized by best-selling writers of the time like Henry Wood, Andrew Carnegie, and the Reverend Russell Conwell. Starting in the 1930s, the rags-to-riches myth began to be described as the "Alger myth" by conservatives who recruited the Horatio Alger hero for their battles against the New Deal and, later, the "welfare state." The *New York Times Magazine* claimed in 1939 that "the papers almost every week report the success of some 'typical Alger hero' of the present." More recently, in 1982, *Fortune* exploited this myth in an advertisement that featured a reprint of one of Hine's pictures of a newsboy, accompanied by a caption proclaiming: "A lot of people think the age of rags to riches died with Horatio Alger. Are they wrong! The opportunities are out there as never before—if you have the drive and determination and guts to go after them."[36]

Many versions of this rags-to-riches myth are not, as Scharnhorst and Bales have shown, very faithful to Alger's own novels. Alger was essentially a moralist who emphasized the need for Christian charity, and his typical hero usually became a secure, middle-class employee or merchant, not a great success. Nor—as some scholars who have analyzed social and economic mobility in this country have pointed out—does this myth have much relationship to social reality. For, according to one of these scholars, virtually all of the studies of American businesspeople between 1900 and 1950 have agreed "that in every generation a disproportionate ratio of business leaders derive from either upper or upper-middle-class backgrounds."[37]

Alger's novels and the Alger myth did have in common a capability for interpreting in a reassuring way certain harsh facts of nineteenth- and early twentieth-century American life. As in many other cities in the throes of industrialism and urbanization (nineteenth-century London and Paris or twentieth-century São Paulo and Bogota) thousands of poor children and adolescents wandered the streets and worked as news vendors, peddlers, messengers, bootblacks, and flower sellers in America's cities in the Gilded Age. In New York City alone, between 1854 and 1890, Charles Loring Brace's Children's Aid Society shipped some ninety thousand "vagrant children" out for adoption to farm families in the West and Midwest. There were widespread and well-founded fears that the vagrant children who remained in the cities might grow up to become thieves and prostitutes or that their health would be ruined. "To him the gutter was America," began an NCLC pamphlet called "Street Workers." "Jack began blacking boots three years ago—at ten. He left school in the primary grade. He learned nothing. He lives in the gutter—seven days in the week—from seven in the morning until eleven or twelve at night. He rarely goes home at all. He is thirteen years old; his height is four feet."[38]

To believers in the rags-to-riches myth, however, bootblacks, peddlers, and news vendors were junior capitalists learning exactly the skills they needed to become successful. Thus newspaper publishers and editors—though they often supported other child labor reforms—defended the "street trades," which included selling newspapers; and when Beveridge introduced his national child labor bill in 1906, the *New York Sun* opposed it because "it is likely enough that many of these child laborers will grow up into capitalists and become 'too rich,' like their present oppressors." Children working in factories and mines "are often properly called 'slaves,' and their plight is regarded with pity," one reformer complained in 1912,

> but tiny workers in the streets are referred to approvingly as "little merchants" and are freely patronized even by the avowed friends of children, who labor . . . under the delusion that merely because a few of our successful business men were newsboys in the past, these little "merchants" . . . are receiving valuable training in business methods and will later develop into leaders. . . . It is extremely unfortunate that this narrow conception has prevailed, as it raises the tremendous obstacle of popular prejudice which must be broken down before these child street workers can receive their share of justice.[39]

To counteract the use of the rags-to-riches myth as a justification for child labor, the reformers collected statistics to prove that children working in the "street trades," including news vendors, were more likely to become delinquents and truants than rich capitalists. For example, a 1911 survey of boys in New York City reform schools, juvenile asylums, and houses of refuge showed that at least 60 percent of them had been street traders and many had been news vendors. Reformers also observed exactly which business skills street traders were learning and reported that the children became adept at pretending not to have change, at short-changing their customers, and at playing craps when business was slow.[40]

Children employed in other street work, particularly messengers, had more sinister opportunities. Hine noted that a Western Union boy from Wilmington, Delaware, was "14 years of age. / 9 months in service. Works from 7 A.M. to 6 P.M. / Smokes. / Visits houses of prostitution." A. J. McKelway, the NCLC's chief investigator in the South, said that in Savannah a messenger "boy of thirteen was found" who knew "the names of twenty evil resorts of that city . . . [and] the names of the women in charge of them"; and he met a nineteen-year-old in Memphis employed as a messenger for nine years, who was acquainted with "every form of sexual depravity," and "procured a card of opium for our agent and was an habitual user of the drug himself." In a photograph illustrating the "Street Workers" pamphlet, there are four "Boys in the Messenger Service" in their early teens. They look young and alert, but with them is a fifth young man, a little older, who looks quite dissolute. His hat is perched crookedly on his head, he has a faint smile, and his pose is suspiciously relaxed. From the text of the pamphlet, the reader can easily assume that he is the type of corrupted young man who has been described—and that he will probably introduce the younger boys to his vices.[41]

Obviously Hine could not take pictures of boys who were actually using cocaine or opium or engaging in "depravity," since this might have led to arrests or lawsuits. Thus he could not photograph the specific moral dangers to children in the streets in the same way that he could photograph the physical dangers that threatened children working in factories. Instead he relied on the general, emotional connotations of the children's appearances and environments. He also relied heavily on captions to make his message more specific. In one of his 1914 posters, titled "Moral Dangers," for example, he showed a picture of a boy factory worker near a saw with the caption, "Everyone knows that this is a dangerous job," followed by the claim that "street trades . . . expose children to moral dangers more deadly than circular saws." The poster was further illustrated with pictures of newsboys and a messenger boy who were, according to Hine's captions, "in the saloons late at night," playing a "midnight crap game," and "carrying notes from [a] prostitute in jail." The dark backgrounds and the empty street in the pictures connote a sense of danger, but in each case it is the caption which that conveys the disturbing information about moral dangers.[42]

In some instances, Hine showed the children in street trades doing things that, although they were not illegal, still would have disturbed middle-class persons of the time. In his 1913 picture of a young Waco, Texas, messenger, the boy is leaning on the handlebars of his bicycle and smoking a cigarette with a look of precocious sophistication. In 1910 he photographed St. Louis newsboys standing by the door of a *Post-Dispatch* branch office, next to a saloon with signs saying DRAUGHT BEER and WHIS-KIES. In another photograph, St. Louis newsboys look jaded and weary, squinting at the camera through cigarette smoke. Such boys are, as Trachtenberg said, "alive and tough," with "a worldly air."[43] To reformers, however, these were exactly the qualities that made children vulnerable. By emphasizing the worldliness of these boys, Hine was able to show that children working in street trades were morally harmed. Indeed, the fatigue and premature aging visible in the faces of some of these children make it more difficult to take the rags-to-riches myth seriously. If believers in this myth really believed these boys were "the great men of the future" who would "prosper and rise in the world," then they cannot have looked too closely at the boys who were actually on the streets of American cities.

Some of Hine's images can also be interpreted, in addition to being criticisms of relatively specific popular prejudices, as attacks on a larger and more insidious myth that spread all over the world in the late nineteenth century, wherever mills, factories, canneries, and mechanized slaughter houses began to mass-produce manufactured goods and foodstuffs. Many people took it for granted that they could enjoy and consume the products of the "machine age" while ignoring its negative consequences (production-line boredom, pollution, dangerous working conditions, occupational diseases, economic stratification, and degradation of the social and natural environment). Indeed, this myth—now called consumerism—blinds people to the entire manufacturing process. Advertisers and manufacturers regale consumers with visions of the product, not the process, through advertisements, department store displays, billboards, and trade shows. Commenting on the "exoticism" of a 1900 exposition of

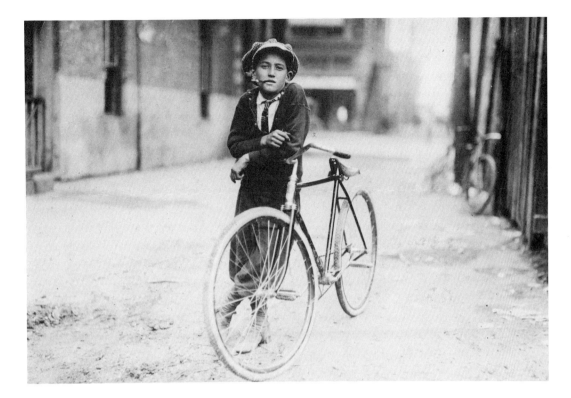

automobiles in Paris, Rosalind Williams described how, through such images and spectacles, "business provides alternatives to itself. If the world of work is unimaginative and dull, then exoticism allows an escape to a dream world [of consumption]. . . . Instead of correcting its mistakes, the city buries them under another level of technology. . . . The whole city [assumes] the character of an environment of mass consumption." She also commented that the "illusions" created by such "environments divert attention *to* merchandise of all kinds and *away* from other," more unpleasant consequences of the process of producing goods, such as colonialism and class structure. We can apply this insight to all kinds of advertising that encourages us to see products as divorced from the social and industrial systems that manufacture them and diverts our attention away from environmental damage, strikes, sweatshops, dangerous working conditions, unemployment, and other symptoms of industrial pathology.[44]

Even in the 1890s, the 1900s, and the 1910s there were a considerable number of intellectuals, journalists, writers, and reformers, including Hine, who insisted that the bad side of industrialism could not be so easily ignored. Sociologist Lester F. Ward claimed in 1893 that the wealth produced by industrialism was so unevenly distributed that "the underpaid labor, the prolonged and groveling drudgery, the wasted strength, the misery and squalor, the diseases resulting, and the premature deaths that would be prevented by a just distribution of the products of labor, would in a single year outweigh all the so-called crime of a century." Journalists and novelists like Jacob Riis, William Hard, and Upton Sinclair, writing for the muckraking magazines and books

Lewis Hine, "Messenger Boy Working for Mackay Telegraph Company," Waco, Texas, September 1913. Hine noted, "Said fifteen years old. Exposed to Red Light dangers." (Library of Congress)

77

that flourished between 1906 and 1912, revealed the brutal working conditions in tenements, steel mills, and slaughter houses. There were reformers like Frances Perkins who insisted, when she was an investigator for the New York State Factory Commission in 1912, that the politicians who wrote labor legislation actually had to meet workers and go into factories. "We saw to it," she wrote later about her efforts, "that the austere members of the Commission got up at dawn and drove with us for an unannounced visit to a . . . cannery and that they saw with their own eyes the little children [working]. . . . We made sure that they saw the machinery that would scalp a girl or cut off a man's arm."[45]

Labor reformers, union leaders, legislators, and some corporations enacted a variety of reforms that improved working conditions in some industries in the Progressive Era and the 1920s; but the most visible and public part of this movement, the muckraking journalism that had appeared in national magazines, suddenly disappeared. Between 1903 and 1912 nine magazines published exposés, but after 1912 only one of these magazines, *Pearson's*, continued to publish until World War I—all the others either went out of business or stopped publishing muckraking articles.[46] Historians have offered a variety of economic and political explanations of why this happened. In addition to these, it is equally plausible that the muckrakers' vision of American commerce and industry was driven out of the marketplace of "popular taste" by the much more benign and reassuring vision of industry provided by consumerism and advertising in newspapers and magazines like the *Ladies' Home Journal* and the *Saturday Evening Post* in the early twentieth century.

It is significant, I believe, that advertising began to flourish in national magazines and other mass media at the same time that the muckrakers were rising and falling in popularity. Charles and Mary Beard commented that, as industrial production increased in the United States in the early 1900s, "the business of selling goods employed an ever larger army of commercial officers and privates. . . . Huge areas of American social power were now occupied by huckstering shock troops . . . [who] gained an almost sovereign sway over newspapers and journals as they pushed goods . . . upon a docile herd that took its codes from big type and colored plates."[47] How the advertisers, these new "Captains of Consciousness," as Stuart Ewen called them, told consumers about products was revealing: advertisements mentioning factory work were always cited as "bad copy" in advertising manuals. Helen Woodward, a very successful copywriter, warned that if advertising writers wanted to be effective they should not even go near factories: "If you are advertising any product, never see the factory in which it was made. . . . Don't watch the people at work. . . . Because, you see, when you know the truth about anything, the real, inner truth—it is very hard to write the surface fluff which sells it." In 1938 *Printer's Ink* summarized the development of advertising this way: first, advertisements "told the name of the product," then, the "specifications . . . were outlined. Then came [an] emphasis upon the uses of the product. With each step the advertisement moved farther away from the factory viewpoint and edged itself closer into the mental processes of the consumer."[48] Thus, instead of showing how factories or mills and their workers transform raw materials

into manufactured products, advertising shows the glossy, idealized products entering
the lives of consumers and transforming them into the happiest people on earth—the
smiling, satisfied folks who beam at us with shining eyes and glistening teeth every day
from millions of television sets, magazine pages, and billboards.

Hine was aware that advertising constituted a kind of competition with the mes-
sages that he and other reformers wished to communicate, but he seemed to have
considered advertising a competitor whose methods could be emulated. In a 1909
speech on "Social Photography," which he gave at a conference on social work, he
emphasized that social photography had to be so honest it could "stand as evidence in
any court of law"; but he also speculated on how reformers might adapt some of the
techniques of advertising to serve their own purposes. The public, he argued, needed
to "know what its servants are doing, and it is for these Servants of the Common Good
to educate and direct public opinion. We are only beginning to realize the innumerable
methods of reaching the great public. I wonder, sometimes, what an enterprising
manufacturer would do if his wares, instead of being inanimate things, were the
problems and activities of life. . . . Would he not grasp eagerly at such opportunities to
play upon the sympathies of his customers as are afforded by the camera[?]"[49] A
decade later, in the 1920s, Hine actually did advertising photography; however, in
the early 1910s he seemed to have been interested chiefly in adapting (or subvert-
ing) advertising motifs to communicate ideas that were the antithesis of most adver-
tisements.

In the period around 1909, when Hine was speculating on this subject, the rela-
tively small number of advertisers who used photographic images in their advertise-
ments often used pictures of children. Moreover, in a few cases, these photographs
were accompanied by captions and texts that gave them a vaguely "documentary" kind
of authority. Grape Nut Flakes and the Eskay's and Nestle's baby food companies used
pictures of healthy children to persuade consumers their products helped "Growing
Children Develop Sturdy Bodies and Bright Brains." Eskay and Nestle also used
pictures of babies who were identified as if they were subjects of documentary case
studies. "Charles F. O'Connell of Danville, Illinois," was the chubby, "finely devel-
oped, sturdy boy [who] was raised on Eskay's Food," said a 1910 advertisement in the
Ladies' Home Journal; a few pages later in the same issue, Nestle's had a picture of an
equally healthy "Baby DuFais" of Cleveland, Ohio, accompanied by the warning,
"Your Baby's Life Depends Upon Its Food." This concept was developed with excep-
tional thoroughness in a 1910 Quaker Oats advertisement that reveals a good deal
about the mentality of the Progressive Era, including some of its prejudices. On the
left side of a full-page advertisement were photograph-like drawings of two sour-
faced, poorly dressed youngsters looking away from the viewer as if ashamed of their
miserable condition. On the other side of the page were three alert, neat, well-
dressed, youngsters staring right at the viewer. "How Much of This Difference is Due
to Oatmeal?" asked the advertisement, which claimed that Quaker Oats had "can-
vassed hundreds of homes [with children] like these—the wan and anemic, the red-
cheeked and strong—the capable and the deficient," to discover: "Among the homes

of the ignorant in our largest city . . . not one home in twelve serves oats. The children's breakfast consists of coffee and bread. . . . The average child of the tenements is nervous. It matures underdeveloped, and exhibits the lack of mental and physical power. . . . The ranks of the incompetent are largely recruited from these homes of the underfed." In contrast, "On the boulevards," said Quaker Oats, "in the homes of the educated, the prosperous, [and] the competent, seven out of eight regularly serve oatmeal." And in one corner of the page it also had a photograph of a slum tenement with the caption, "Where Children Never Taste Oatmeal."[50]

From Hine's point of view, the meaning of such advertisements was that healthy, prosperous children were being associated with manufactured foods. At the same time, he was learning how, in other industries, the manufacturing process was harming children's health. Hine prepared a pamphlet and a series of posters combining these themes for a 1914 conference exhibit, *The High Cost of Child Labor*, in which he used pictures of miserable child workers as negative advertising images. These posters are clearly fashioned after popular advertising formats, but they attack the central theme of consumerism and advertising—that the manufacturing process is irrelevant to consumers, who are only concerned about the cost of a product and how it will benefit them.

Hine's version of the before-and-after type of advertisement was a poster contrasting a smiling, healthy "Normal Child" with a weary-looking "Mill Child," accompanied by the caption, "Would You Care to Have Your Child Pay *This* Price?" In another poster he adapted the popular advertising claim that new products mean a better way of life by contrasting "old" industrial methods in coal mines and glass factories, which depended on child labor, with "new" methods that made children unnecessary. Photographs of breaker boys in a coal mine and helpers in a glass factory contrasted with pictures of machines and the captions: "No Boys Needed / Better Work Done" and "Child Labor Abolished / and the Work Done Better." Hine also turned the emphasis on low prices and economy, which characterize so many advertisements, against the industrial process by claiming that "Industry Saves at Society's Expense." When industry paid children "lower wages than adults," he argued, it first made the children pay with stunted lives, ignorance, disease, and a tendency to criminality; then it made society pay for the hospitals, courts, and jails needed to provide for the children whose lives had been warped by child labor.[51]

Consumerism and advertising implicitly ignore the manufacturing process and explicitly glorify products, which are invariably presented as shiny, new, and exciting. Hine, though, was deeply concerned by the condition of the weary children he photographed, who were being worn out, sometimes literally, by their work. In South Carolina in May 1912, he photographed a thin, weedy young man accompanied with the note, "Human Junk. Roy Hammett. Spartenberg, S.C. . . . A product of the mill. 'Ben workin for 10 yrs. Began when I was 6 yrs. old for 5¢ a day. Lately I was workin for $1.25 a day but got to spittin blood and had to quit.'" Hine returned to this theme in his poster, "Making Human Junk," which bitterly satirized the claim that underlies most advertising—that industry transforms the material world into valuable products

that make our lives richer and better. He showed how children who were "Good
Material at First" entered factories and became a "product"—"Human Junk" with
"No Future and Low Wages."[52]

As his "Making Human Junk" poster shows, Hine used photography to break
through the facade of advertising to show the destructive, "pathological" side of the
industrial process. He claimed in his 1909 speech on "Social Photography" that the
photographer could transport his audience into the children's work environments by
showing actual working conditions in vivid, memorable pictures that have emotional
appeal—sometimes accompanied by appropriate written texts, "Take the photograph
of a tiny spinner in a Carolina cotton mill," he said, "as it is it makes an appeal.
Reinforce it with one of those social pen-pictures of Hugo's in which he says, 'The
ideal of oppression was realized by this dismal servitude.' With a picture thus sympa-
thetically interpreted, what a lever we have for the social uplift. The photograph of an
adolescent, a weed-like youth, who has been doffing for eight years in another mill
carries its own lesson. . . . Whether it be a painting or a photograph, the picture is a
symbol that brings one immediately into close touch with reality."[53]

Advertising valorizes products by idealizing them and picturing them in idyllic
social and natural environments. In contrast, Hine wanted to bring his audience into
"close touch" with the manufacturing process. This goal probably influenced the
visual strategies he used to compose his photographs. As Ronald Hill wrote, he
developed "a vision, an iconography of seeing," which was distinctively his own.[54]
Thus his images frequently create the effect that we have entered a closed world,
along with the photographer, for a glimpse of a hidden reality. Often, in these pictures,
the children's poses seem tentative and fragile, as if the noise of the machinery has
only momentarily stopped. The fragile quality of many of Hine's compositions be-
comes more noticeable when one contrasts them with Johnston's *Hampton Album*.
Both photographers took viewers on "tours" of unfamiliar places. Johnston always
maintained a consistent, discrete distance between her camera and her carefully posed
subjects, whereas Hine was continually moving into and through his subjects' work
and home environments. He photographed people from different distances and an-
gles, showed them standing in groups and then isolated as individuals; or he first
photographed a distant view of a building, then a middle-distance view, then an
interior shot as he moved into a shack or mill to discover more about the children
whose names, ages, and lives he was recording with his camera and scribbled notes.
Moreover, unlike the visually segregated students in Johnston's pictures, whose lives
cannot "touch" ours, the working children in Hine's images are not confined to their
own visually enclosed spaces where they can be observed in a detached way. As Judith
Gutman pointed out, "In so many Hine photographs one finds movement threatening
to spill over and force its way out of the plane that encompasses it."[55] In many of his
images, for example, there are people sitting or standing at the sides, so that parts of
their bodies are obscured or invisible, or there are people at the edges who are in the
act of walking into or out of the frame while Hine's subjects stand still in the center.

Hine also had a tendency to position his camera so that it seems to pull viewers into

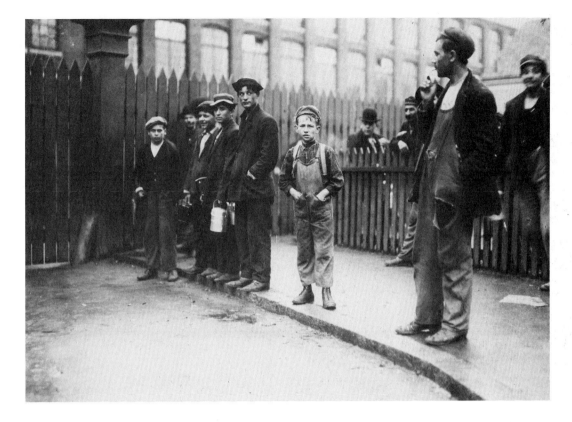

the frame of his vision in factories, mills, and tenement sweatshops. The straight lines in his pictures are often strong diagonals that slope toward the lower right or, more rarely, the lower left side of the picture. The visual effect of these diagonals is to draw our vision into the image and toward the subject, suggesting that we can enter as well as observe. In some cases the sense of being drawn in is reinforced by Hine's narratives and captions. In one of his oyster cannery investigations, for example, he specifically invited his readers to "come out with us to one of these canneries at three o'clock some morning. Here is the crude shed. . . . Near the dock is the ever-present shell pile. . . . It is cold, damp, dark. . . . See those little ones over there stumbling through the dark."[56]

One of the most important motifs in Hine's iconography was his use of doorways and windows. "Factory windows, whose height . . . gives scale to the figures, are invariably closed," Hill commented; and "factory groups stand in front of the doorway leading into the dark factory interior, signalling the crime of forcing children, who should remain outside playing, into the darkness of the workplace."[57] Many times there were probably legal, as well as visual, reasons for photographing these children by doorways. Showing them waiting at the doorway of a mill early in the morning, for example, indicated that they actually worked there: a manager might have refused to allow Hine to enter the building to take photographs. In addition, posing the children in doorways gave his pictures a greater visual focus and a sense of scale.

On a deeper psychological level, doorways have additional connotations. In particu-

Lewis Hine, "Boys Going to Work in Warren Mfg. Co., Warren, R.I." "Plenty of youngsters here," noted Hine. (Library of Congress)

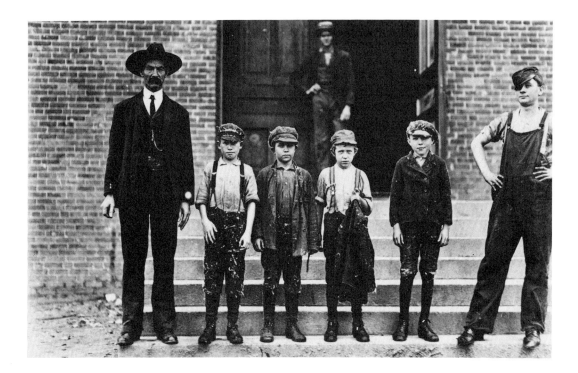

lar, they are often associated with what Arnold van Gennep called "rites of passage"—rituals intended to cause "a change of condition or a passage" from one stage of existence to another, such as the change from adolescence to adulthood or from life to death. Moving from one condition to another is symbolized very well by moving from one space to another, and the moment of change is often signified, in rituals, by passing through a gate or doorway. "The door is the boundary between two stages in life, so that in passing under it a person leaves the world of childhood and enters that of adolescence."[58] Hine's photographs and texts frequently suggest that when the children passed through the doorways they were transformed downward. Alert, promising children became "human junk." But at the same time his photographs draw us into the children's world—and in this respect his photographs are analogous to doorways—and give us the opportunity to be transformed upward, from indifferent or apathetic consumers who do not know or care about workers to concerned citizens who would support the reforms needed to make the children's lives better.

■

Mr. Hine has a prejudice against the phrase "art photographer." Nor is he, in any sense of the word, a commercial photographer. The effect of a picture as a compositional study does not interest him consciously. Its value as a survey of a human phase of industry is what he is after. . . . Into all his work Mr. Hine gets an interpretive angle. Indeed, he terms himself an "interpretive photographer." A picture which has beauty without significance means little to him.

– Excerpt from a 1926 interview with Lewis Hine[59]

The final two decades of Hine's career as a photographer were, in many respects,
pathetic years, yet they also included some important successes and honors. Though he continued to do special assignments and projects for the NCLC and the *Survey Graphic* throughout the 1920s, he resigned from his post as a staff photographer for the NCLC in 1918 because the directors of the organization wanted him to do more investigative work and he wanted to do more photography. After a year spent photographing refugees and postwar conditions in Europe in 1918 and 1919, he became a free-lance industrial photographer who worked for a variety of clients, such as Western Electric, Vacuum Oil, Sloan's Liniment, the Milbank Foundation, the Amalgamated Clothing Workers Union, and—during the depression—the Tennessee Valley Authority and the Works Project Administration. These assignments did not pay well, and Hine was in severe financial straits during the 1930s. His mortgage was foreclosed in 1938, though he was allowed to live in his home and pay rent until his death in 1940. During the mid- and late-1930s he applied twice for Guggenheim Fellowships and was turned down both times. The Carnegie Corporation would not give him a grant to do a study of American craftspeople, and Roy Stryker refused to hire him as a photographer for the Resettlement Administration. (Stryker did, however, help to arrange for a major exhibition of Hine's work in 1939.) On the other hand, Hine received a fair amount of recognition and honor during the 1920s and 1930s. His photographs were exhibited at the National Art Club (1920), the Art Director's Club (1924), and the Advertising Club (1928) in New York, and at the Russell Sage Foundation (1929). The Art Director's Club awarded him a medal for photography; and Rexford Tugwell, Thomas Munro, and Stryker selected a large number of his adult work pictures for their 1925 textbook, *American Economic Life*. Hine's own 1932 book for adolescents, *Men at Work*, was chosen by the Child Study Association as its outstanding children's book of the year. And, in the last few years of his life, he was praised by critics like Elizabeth McCausland and Beaumont Newhall, and by younger photographers in the Photo League. Hine may have been poor, and he certainly did not receive the recognition he deserved, but at the time of his death, according to Arthur Rothstein, he "had become the most eminent social documentary photographer of his time" because he "had demonstrated a profound belief in the power of the photograph to educate and its ability to make people realize the values of life."[60]

Hine's adult work pictures of the 1920s and 1930s, particularly as summarized in *Men at Work*, created a positive vision of American industrialism that complemented the earlier, negative vision seen in his child labor images. His initial motivation for making these adult work photographs was fairly clear. As early as 1909, when he was making some of his most harrowing child labor pictures, he also emphasized in his speech on social photography that "Apart from the charitable or pathological phases of social work, what a field for photographic art lies untouched in the industrial world." He claimed there was an "urgent need for the intelligent interpretation of the world's workers, not only for the people of today, but for future ages." He followed this comment with a long, revealing quotation from George Eliot in which she called for an art that would picture workers as well as angels. "Do not impose on us any esthetic rules which shall banish from the reign of art those old women with work-worn hands

... those rounded backs and weather-beaten faces that have bent over the spade and done the rough work of the world." In the 1920s Hine was photographing stevedores, railwaymen, and factory workers—not farmers—but clearly his goal was to inculcate respect for people who were doing the "rough work of the world."[61]

Despite his good intentions, however, there has been controversy about the meaning and value of his adult work pictures. Rothstein, for example, interpreted them as being examples of " 'positive documentation' [in which Hine] expressed an optimistic confidence in the dignity of the worker and an affirmation of industry. For Hine, the American worker was a heroic figure, one who should take great pride in his or her craft." In contrast, Gutman criticized Hine for making images that seem, at least tacitly, to approve of the mechanization and dehumanization "that American technological society imposed on an older industrial order. . . . What makes Hine's machine photographs so upsetting for us today is that they show us how the machine, and not the person, saw life. . . . What makes some of us want to throw these photographs aside . . . is that they show us how a person became an arm of the machine, how the machine was the vital living element in the photograph and the [human] arm or face just an extension of its life."[62]

When Hine's adult work pictures are considered in the context of the other ways in which industry was visualized by artists and photographers during his era, it can be argued that their significance is more complex than either of these interpretations allow. From the early 1900s through the 1930s, for example, there was a popular genre of industrial art that was a kind of sooty romanticism. In photography this romantic vision of industry was expressed by Alfred Stieglitz in "The Hand of Man," his well-known 1902 image of a locomotive in a freight yard; by Alvin Langdon Coburn in his 1910 Pittsburgh industrial landscapes; and by Margaret Bourke-White in her pictures of unskilled workers in *Fortune* in 1931. Essentially the same vision of industry is seen in drawings and paintings by Joseph Stella, Arthur Covey, Frank Brangwyn, and Gerrit Beneker. There is a great emphasis in these pictures on the smoke, light, dust, and drama of the industrial process, and the workers, if they are visible in the images, are usually large muscular men whose coarse feature are seen in intense chiaroscuro. "Day and night, a veritable inferno of electric heat burns on," intoned the text of a *Fortune* advertisement for grinding wheels. It is illustrated by a woodcut of a Covey painting showing a muscular worker beating on a smoking cauldron with a sledge hammer, as "the clay-like mineral . . . becomes the potent Norton abrasive . . . serving the world in grinding wheels." This vision of industry was emotional, and often self-consciously heroic, but Hine would have questioned whether it was an intelligent interpretation of industry.[63]

When Hine was beginning his career as an industrial photographer in 1920, a reporter for the *New York Evening Post* pointed out the difference between the industrial pictures made by an "art photographer," like Stieglitz, and those made by Hine, whom he called a "sociological photographer." Stieglitz's "The Hand of Man," he wrote, was essentially "an adoption of principles employed by Whistler in some of his etchings. The subject is comparatively nothing . . . and the treatment [of the subject is]

all." Although Hine, the reporter speculated, might have some of the same "instincts
as an artist," his intentions were essentially didactic rather than expressive. He wished "to show the meaning of the worker's task, its effect upon him, and the character of his relation to the industry by which he earns his living." Hine's goal was to make a series of images to be presented in the factories themselves "in photographs or lantern slides . . . both to the workers and the managers . . . of the significance of industrial processes and of the people engaged in them."[64] The romantic vision of industry was mainly an expression of the artists' and photographers' own feelings of awe and excitement as they observed processes that seemed mysterious and "infernal" to them; but to Hine—who understood more about industry—these processes were a series of tasks performed by specific workers trained to take part in the complex process behind the drama of industry.

For Stieglitz, the locomotive was essentially an icon of power signifying human dominance over nature, but to Hine the operations of railroads were complicated patterns of human and mechanical operations, whose human side was a terra incognita to be explored and communicated. Hine's 1921 photoessay for *Survey*, "The Railroaders: Work Portraits," started with pictures of the more visible actors in the railroad system (an engineer, conductor, and brakeman) and then included the more obscure but equally important workers such as signal maintainers, levermen, linemen, machinists, pipe fitters, laborers, and air-brake inspectors. His captions explained how important these people were and extolled their responsibilities with metaphors and analogies. He called the leverman, who controlled track signals, "the demi-god of the road as he touches his magic levers, to permit the trains to run safely into the terminals," and he emphasized that even the humble laborer with oil can and brush was needed to make the trains run safely. "Tracks are like babies, needing continual attention. Rust and dirt are track diseases to which this man must apply oily medicaments to make the electric switches click into position to prevent calamity."[65]

Hine's work portraits also differed from the romantic vision in that, judging from his captions and the way he photographed his subjects, he had a considerable amount of respect for unskilled as well as skilled workers. Although romantics might glorify the strength of unskilled workers, they also showed a certain lack of respect for them. In the 1920s and the 1930s, unskilled American industrial workers were mostly immigrants. A 1930 *Fortune* article, illustrated by Bourke-White photographs, called them "Jigs . . . Hunkies . . . Dagos . . . [and] Kikes," and said that "the great mass of the unskilled are not, in a certain and very common sense of the term, 'American' at all. Fifty to eighty per cent of them are foreign-born. And of the remaining 20 to 25 per cent, an enormous number are Negroes and members of those European races which maintain their exotic and foreign character." The men in Bourke-White's pictures may have impressive muscles, but most of them do not look very intelligent. They stare at her camera or gape at nothing in particular, and she photographed them so that they seem to be taking no interest in their jobs.[66]

On the other hand, the most consistent characteristic of the men and women, skilled and unskilled, in many of Hine's work portraits is their concentration. As

Johnston did in her Hampton pictures, he showed his subjects calmly and intently peering at their tools and machines and emphasized the orderliness of their work through pictures that are carefully lit and simply, though meticulously, posed. In a 1926 interview, Hine said that "the great problem of industry is to go a step beyond merely having the employer and employee 'get along.' The employee must be induced to feel a pride in his work." He then indicated one of his own photographs, a picture of a man standing between two huge fly wheels, and commented, "That man is not just an attendant for that machine. Upon his adjustments, his care, his watchfulness depends the efficiency of the mechanical energy you see there."[67]

Because of his belief that workers could learn to appreciate their jobs more and do them better, Hine's work images are virtually antithetical to another form of industrial photography—the commercial, anonymous, public relations photographs of machines and assembly lines that began to appear around 1900. It is impossible to know what these commercial photographers felt, but F. Jack Hurley described the effect their images conveyed when he pointed out how well they expressed the feelings of Sinclair Lewis's Babbitt. Babbitt, Hurley noted, "was not entirely a figment of the novelist's imagination." Salesmen like him really existed in the 1910s and 1920s, and they "commissioned pictures like these, paid out good money for them. . . . When Lewis wrote about Babbitt fondling the shiny new fixtures in his bathroom or reveling in the odor of a new car, he often used the term 'worshipful' to indicate the depth of his character's feelings. . . . When Americans looked about themselves at their new cities and their huge industries, capable of tremendous output and amazing production speed . . . it seemed a very fine thing to be a part of the cult of the machine."[68] In large industries, Babbitt's counterparts, the public relations people, were the intermediaries between these industries and the public. The photographs they commissioned, in Hine's era as well as our own, were indeed worshipful. The uniformity of these public relations pictures is also notable. Whether from Detroit in the 1900s or Asia in the 1980s, they exhibit a visual logic and adhere to conventions as consistent as, say, the rhyme scheme of an Elizabethan sonnet. The assembly lines in these pictures are always immaculate and perfectly orderly. Whether they feature a 1943 Douglas airplane factory in California or a Sony tape recorder factory in Osaka in 1984, all activity in these pictures, human or mechanical, is reduced to cool, geometrical neatness. Complexity is synonymous with productivity, but nothing ever looks cluttered or rushed. Workers, if they are present at all, are always expressionless gnomes. Usually faceless or seen in profile, they tend their machines, making the simple motions needed to keep the larger and more complicated machine of the assembly line running smoothly. Machines, these public relations pictures imply, virtually run themselves. The images create the impression that the Spanish scholar Américo Castro summarized so succinctly when he remarked, as he watched a freight train in New Jersey roll by, "Aquí el hombre no es nada" ("Here man is nothing.").[69] The impression that humans are either unimportant or irrelevant is also implied by the convention that machines, particularly if they are large and impressive, must always be photographed as objects complete in themselves, finished, impressive, and awesome. Miniscule

workers may stand by them, exactly as humans stood by cliffs or waterfalls in nine-
teenth-century landscape pictures and for the same purpose—so the viewer can
appreciate the sheer size of the awesome object, apparently designed and created by
some superhuman intelligence. The public relations vision of industry and technology
was not confined to the work of photographers hired by private corporations. Indeed,
some of the anonymous photographers the federal government hired in the 1930s and
1940s were as worshipful toward the "cult of the machine" as any Babbitt.

Considered by themselves, these factual pictures of machines and factories do not
convey any definite ideological meanings beyond a commitment to technology. They
illustrated the supposed efficiency and productivity of any social or political system
that wanted to demonstrate its faith in mechanization and modernization. In the actual
contexts in which these photographs often appeared during the 1920s and the 1930s
in the United States, however, they often glorified the executives and managers of
corporate capitalism and big business. Arthur Pound's 1936 book, *Industrial America*,
for example, a typical pro-business work of the period, extolled the policies and
operations of twelve large, successful corporations in major industries like steel, paper,
food-processing, building supplies, automobiles, and tires. All of these corporations
were notable, in Pound's opinion, for their "enlightened" attitudes toward the public
and their employees. They were managed "not by bluff captains of industry but by
educated men accustomed to looking on all sides of the complex problems presented
to them. . . . They accept the fact that their employees have a stake in their enter-
prises; they meet their men when and as occasion demands, not as enemies, but as
cooperators."[70] But the claim that employees were cooperators is belied by Pound's
text, which deals solely with the executives' decisions, and also by his illustrations.
Each chapter is illustrated with public relations pictures of factories and assembly
lines, presumably supplied by the corporations themselves, in which the machines
either stand alone or are attended by faceless men and women who look more like
"machine tenders" or "human robots" than cooperators. The managers and execu-
tives are represented in each chapter in standard, shirt-and-tie studio portraits in
which they look out at the reader from full-face or three-quarter-profile poses. In the
chapter on the Continental Can Company, for example, management is represented
by a full-page, full-face studio portrait of Oscar C. Huffman, the president of the
company. Company operations are illustrated by two pictures of huge, intricate ma-
chines and one of a glistening mountain of stacked cans, and by an aerial view of one
of the company's forty-two factories. In none of these pictures is there a single human
being visible anywhere.[71]

This same vision of American industry was presented monthly in *Fortune*, which
began appearing in 1930. Occasionally the magazine did publish a specific article on a
subject like the American worker, but its usual approach to industry was, like Pound's,
the corporate case study. These studies were usually well-illustrated with studio
photographs of executives (or reproductions of their boardroom portraits), aerial views
of mines and factories, and informational pictures of large machines running them-
selves or attended by small, insignificant men and women. Also like Pound's book,

these articles suggested that America's managers and executives were almost solely responsible for the productivity and efficiency of their industries and not, as Hine believed, that it was the industrial worker's care, watchfulness, and adjustments that made factories function properly.

In the early 1930s *Fortune* also popularized a kind of industrial photography that was self-consciously modernistic and artistic. When they planned the magazine in 1929, Henry Luce and his editors seem to have intuited that, underneath their staid exteriors, thousands of their fellow American managers, executives, and engineers yearned to consider themselves adventurers, explorers, and conquistadors; they designed *Fortune* to satisfy that yearning. The magazine treated capitalism and industrialism in the same dramatic way that the movies presented romance and *National Geographic* pictured geography. "Business takes *Fortune* to the tip of the wing of the airplane and through the depths of the ocean," claimed the magazine's sales prospectus. "It forces *Fortune* to peer into dazzling furnaces and into the faces of bankers. *Fortune* must follow the chemist to the brink of worlds Columbus never found." The Young and Rubicam advertising agency expressed an equally romantic vision of *Fortune*'s contents. "You have taken what are sometimes called 'prosaic business' and 'sordid industry'—you have viewed them with imagination . . . and behold, we thrill at the pages you lay before us. No longer is business a column of figures or work a daily

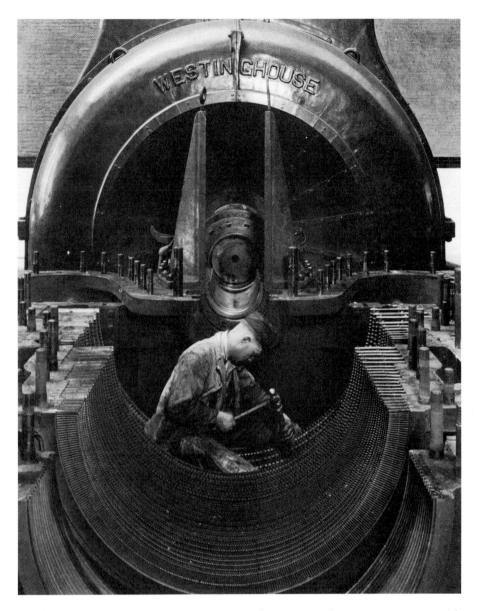

grind. Here is epic enterprise, a panorama of romançe, adventure, conquest—with beauty in factories and derricks."[72]

Modernist photography was a particularly appropriate style for finding the beauty in factories and derricks. Earlier, during the 1920s, a few Americans had begun to understand and appreciate cubist and abstract art; and pioneer modernist photographers like Paul Strand, Ralph Steiner, Charles Sheeler, and Edward Weston made images of machinery, automobiles, factories, and steel mills in which machine parts, pipes, wheels, and buildings formed cubist and abstract patterns. Margaret Bourke-White, who studied art and photography in New York in 1921 and then became a commercial photographer in Cleveland, discovered that modernist pictures of buildings and industrial subjects pleased her commercial clients. Her photographs of Otis

Lewis Hine, "In the Heart of a Turbine" (Hine, Men at Work, 1932)

91

Steel were used to illustrate its annual report in 1927, and in 1929 Henry Luce hired her to do industrial assignments and portfolios for *Fortune* (perhaps partly because it would seem appropriately adventuresome to have such photographs made by an ambitious young woman who was daring enough to aim her camera at blast furnaces and executives' faces).[73]

Fortune presented with reverent respect the aspects of industry that Charlie Chaplin satirized so brilliantly in *Modern Times* in 1936. Bourke-White's *Fortune* pictures follow all the conventions of industrial public relations photography—intricate patterns, large machines running themselves, insignificant workers—but she also used a variety of modernist techniques such as exotic camera angles, high contrast lighting, and rhythmic, abstract patterns to make these subjects look more grandiose and melodramatic. Dwight Macdonald, who worked with her on a glass factory assignment, summed up her forte when he said, "She made even machines look sexy."[74] Or, to be a little more precise, she made the machines seem far more dynamic than they look in conventional industrial photographs. In particular, her modernistic techniques, like extreme camera angles and high contrast lighting, added a visual novelty to her subjects and gave them an additional emotional impact. (Movie directors use some of the same devices to add suspense and excitement to thrillers.) Despite these techniques, the basic implication of her industrial photographs is essentially the same as conventional industrial pictures: machines are large, vast, and intricate, but they run by themselves or with a minimum of supervision by insignificant workers.

Presumably Hine was well aware of these features of commercial industrial photography. One of the ruses he used to get into workplaces when he was a photographer for the NCLC was to pretend to be an "industrial photographer making a record of factory machinery." He was also probably aware of Bourke-White's style and techniques. He defended his own type of industrial photography in a 1933 letter, arguing "that the design registered in the human face through years of life and work, is more vital for purposes of permanent record, (tho it is more subtle perhaps) than the geometric pattern of lights and shadows that passes in the taking, and serves (so often) as mere photographic jazz."[75]

Hine's emphasis on the presence and importance of faces in his pictures is the most significant difference between his and commercial photographers' visions of industry. Hine's *Men at Work* shows us that we cannot subtract workers from industry and imagine that machines and industries control themselves. Instead, as Hine emphasizes in "The Spirit of Industry," his credo at the beginning of his book, "Cities do not build themselves, machines cannot make machines, unless back of them are the brains and toil of men. We call this the Machine Age. But the more machines we use the more do we need real men to make and direct them. . . . I will take you into the heart of modern industry . . . where the character of the men is being put into the motors, the airplanes, the dynamos upon which the life and happiness of millions of us depend." He further suggests that the spirit of industry is really dependent on the human spirit: some of his captions stress how responsible workers are for the quality and precision of their work. Describing a welder concentrating intensely on his work

in an airplane factory, for example, Hine points out not only that the man is welding the airframe but also that "the slightest flaw would mean a smash-up."[76] The absence of faces in so many of Bourke-White's pictures implies that the spirit of industry is massive, automatic, flawless and implacable—a power beyond mere human control. Hine's images, however, humanize industry.

Hine and Bourke-White photographed some of the same subjects (power stations, railroad machine shops, and skyscrapers) and in virtually every image there is the same difference in viewpoint. His Empire State Building pictures are focused on the workers, either heroically outlined against the sky high over Manhattan or concentrating intently on their jobs; but the three Bourke-White pictures of the Chrysler and Empire State buildings that appeared in *Fortune* are all low-angle shots in which the buildings soar upward heroically and no workers are visible. Similarly, her images of a Niagara-Hudson power plant, published in *Fortune* in 1931, show two massive machines—a line of giant generators and parts of a giant turbine—functioning without any humans present. (Presumably to imply who was responsible for all this power, *Fortune* also supplied eleven little shirt-and-tie studio portraits of power company executives.) Hine's pictures of a turbine factory, made in 1921 as part of a photoessay on "Power Makers" for *Survey*, show skilled workers assembling huge turbines and transformers. We know that these men are important parts of the power-making process because, as in "In the Heart of a Turbine," they are exactly in the center of the images. This implication is reinforced, when the same picture appears in *Men at Work*, by the caption, "In the Heart of a Turbine," which emphasizes that human skill is vital even in the electrical-power industry (which most people consider virtually automatic).[77]

The ostentatious modernism of Bourke-White's photographic style makes her vision of industry seem more up-to-date than Hine's. In at least one important respect, however, her viewpoint was relatively dated and his revealed a better understanding of industry as it actually existed in the 1920s and 1930s. Stuart Chase, in his 1929 analysis of American industrial conditions, *Men and Machines*, pointed out that technology had already begun to make certain work skills redundant, and that the productivity of American industry and agriculture had increased by some 15 percent between 1919 and 1927 while the number of workers had declined by approximately 7 percent. Moreover, Chase said, this process was taking place not only in what he called the "old hand skills," like smithing and stone-working, but also in assembly-line work. Mass production and automatic machinery were "relentlessly substituting machines for machine-tenders." A year later, in an article published in *Fortune*, Chase studied this development in an analysis of the operations of the A. O. Smith Company and concluded that "the automatic function in industry is steadily gaining ground, displacing machine-feeders, and nut-screwers by skilled designers, inspectors, dial-watchers. A large number of so-called [human] robots gives way to a small number of workers with reasonably intelligent and independent jobs."[78]

Hine's *Men at Work* emphasized exactly this type of worker, the skilled industrial worker, in pictures of structural steel workers, machinists, and mechanics who had—

as he said in his captions—"Special Skills," and were the "Makers" of tires, airplanes, skyscrapers, turbines, and transformers. Yet Bourke-White, the editors of *Fortune*, and commercial photographers almost totally ignored the existence of the skilled industrial worker and consistently visualized factory workers as machine-tenders or "robots," or showed what Chase called "the automatic function in industry" as a completely mechanized process in which machines ran themselves.

Hine's moralistic emphasis on the work ethic, his claim in the credo of *Men at Work* that workers put their "character . . . into the motors, the airplanes, and the dynamos" that they manufactured was rather old-fashioned. As we shall see later in this study, advertisers and public relations people often expressed a very modern (yet also romantic) faith in technological "miracles" and "wizard" scientists who were going to create a utopia in which machines, appliances, "wonder drugs," and chemicals would eliminate poverty, disease, and drudgery. In contrast, Hine's viewpoint was expressed by "The Sons of Martha," a Kipling poem that introduced the 1926 interview (illustrated by his photographs of workers), which appeared in *The Mentor*, a magazine for young people. Kipling adapted the biblical story of Martha and Mary to industrialism as he said of the workers:

> It is their care that the gear engages;
> It is their care that the switches lock.
> They do not preach that their God will rouse them
> A little before the nuts work loose.
>
>
>
> Wary and watchful all their days
> That their brethren's days may be long in the land.
>
>
>
> And the sons of Mary smile and are blessèd—they know the
> Angels are on their side.
> They know in them is the Grace confessèd, and for them are
> the Mercies multiplied.
> They sit at the Feet—they hear the Word—they see how truly
> the Promise runs.
> They have cast their burden upon the Lord, and—the Lord He
> lays it on Martha's Sons![79]

In Kipling's parable about twentieth-century work, the Sons of Martha are factory, construction, and railroad workers, and the Sons of Mary are middle-class consumers who enjoy, but do not appreciate, their "brethren's" efforts. Like Kipling's poem, Hine's adult work photographs are an earnest attempt to create a synthesis between nineteenth-century values and twentieth-century industry by showing the importance of workers, particularly skilled workers, in an industrial society. Whether he portrayed a powerhouse worker tightening the bolts on a dynamo, a structural steel worker with a rivet gun, or a machinist with a micrometer, Hine composed his captions and adult

work images to reveal that these American "Sons of Martha" were responsible for the

efficiency, quality, and safety of the machine age and its products.

Hine, with his prejudice against the phrase "art photographer" and his view of modernism as "mere photographic jazz," was not much interested in being an aesthetic pioneer or a stylistic innovator. As Trachtenberg pointed out, however, there was one aspect of photography—"the relation of the text to the image in the constitution of the photographic communication"—in which Hine was an innovator and in which "the full range, power, and complexity of [his] work still awaits rediscovery." In this area Hine understood problems and achieved solutions that other photographers, editors, and theorists did not confront until years later.[80]

It was not until the 1930s, for instance, that European artists and intellectuals like Bertold Brecht and Walter Benjamin began to understand that straight photographs, "simple reproduction[s] of reality," might not express anything important about that reality. A simple photograph of the Krupp works or some other factory, for example, "reveals almost nothing about these institutions" (such as "the reification of human relations . . . in industry"), and therefore it was necessary for photographers to *build something up*," to construct "something artistic" about these subjects by using captions and photomontages. Without captions, Brecht said in a 1934 comment that applies very well to Bourke-White's *Fortune* portfolios, photography would "become more and more subtle, more and more modern, and the result is that it is now incapable of photographing a tenement or a rubbish-heap without transfiguring it. Not to mention a river dam or an electric cable factory. . . . What we must demand from the photographer is the ability to put such a caption beneath his picture as will rescue it from ravages of modishness and confer upon it a revolutionary use value."[81]

Hine's politics were more moderate than Brecht's and Benjamin's, and he probably would have preferred to apply a term like "reform value" to his pictures, but as early as 1909 he had achieved a similar insight that photographs needed to be seen as parts of larger, constructed realities. He emphasized the importance of captions in his 1909 lecture on "Social Photography," in which he pointed out that it was possible to reinforce the emotional appeal of a picture of a child worker by adding a "social pen picture," such as a quotation from Victor Hugo, which would interpret the image so it would become "a lever for social uplift." Hine's mechanical metaphor is important, since it implies that a photograph is a tool that can change society after it is "sympathetically interpreted" by the caption or text attached to it. Thus the image alone is incomplete. It will not perform its full function if it is seen without an appropriate caption.[82] In the NCLC brochures containing his photographs, these captions are often brief, factual explanations NCLC officials probably added from Hine's notes. But the "Time Exposures by Hine," which he composed for *Survey* for several years, almost always contain a mixture of factual and descriptive details that make the images more effective. A February 1914 piece about canneries in Pass Christian, Mississippi, for example, includes a picture of a cannery and three prose items entitled "Three Bits

of Testimony for the Consumers of Shrimp and Oysters," implying that these captions are bits of information that the reader can consume like bits of shellfish. But the information in these bits is not at all appetizing. The first is Hine's report about how he made his picture in February 1911 at a Pass Christian cannery where the children got up as early as 3:00 A.M. and were taken to work by a padrone, "who told me: 'Ef day don't get up, I go and git 'em up.'" Then comes an extract from a January 1914 newspaper account of President Woodrow Wilson's visit to Pass Christian, where he "saw children 7 and 8 years old, working their ten-hour shift in steam and blustering wind, their little hands sore and bleeding from the action of the acrid juices. . . . The President started to take a walk through the oyster packing plant, but a whiff of the noisome steam struck him and he retired back to the motor car." Finally, there is a sober, factual report by an NCLC investigator who visited the canneries in Pass Christian in the same month Wilson did and discovered fifty violations of Mississippi's age laws and forty-five violations of its hours laws.[83] The three captions not only corroborate each other by showing how different observers discovered the same violations; but each also contributes its own more disturbing information: that the children started work at 3:00 A.M. and that the smell of the cannery was noisome. Hine's picture for this piece is not disturbing. It is a middle-distance view of a shed, showing children and adults shucking oysters at tables, but the additional information in the text makes the total photographic communication far more vigorous than the picture would have been alone, or with a simple, factual caption.

Hine was also aware of how to combine photographic images in montages so that they interact to create visual messages. Nineteenth-century photographers like Oscar Rejlander used concealed montages, or "trick" photographs, to create images resembling representational paintings, but overtly political montages were not widely used until the 1920s. Russian modernists and German artist John Heartfield considered them a particularly "direct and successful way . . . of re-educating, informing, and persuading people."[84] As early as 1914, however, Hine used relatively simple montages in his "Time Exposures" for didactic purposes: "Hiding Behind the Work Certificate" is one of them. It is a particularly clever juxtaposition of a photograph of a work permit that is placed in front of a picture of three small boys so that they are literally hiding behind it. Hine explains in his caption that the certificate, made up by a Georgia official, stated that a certain child worker was ten years old even though the official had recorded elsewhere that the boy "was *under* ten years of age." After explaining how he photographed the document, Hine acknowledges that none of the children standing behind the certificate is the boy in question (apparently Hine had not been able to photograph him) but that they are other working children from the same town. The montage illustrated one process by which poor parents and "kindly" officials circumvented the laws. Moreover, by combining the images of the children with the certificate, he contrasted the reality of child laborers with the falsity of the work certificate. He also indirectly demonstrated the need for investigating and photographing child labor conditions instead of relying on all-too-fallible records or the good intentions of local officials.[85]

The photoessay was not officially invented until the late 1920s, when the editors of German magazines like the *Berliner Illustrierete Zeitung* and the *Münchner Illustrierete Presse* began sending their photographers out to take sequences of pictures to be cropped, edited, and combined with texts and captions to form narrative patterns.[86] As early as 1910, however, Hine experimented with this format in "Roving Children" and "The Construction Camps of the People," two assignments that appeared in the January issue of *Survey* and dealt with canneries and with the camps erected for immigrants who were working on a canal in New York state. Both articles begin with relatively long, explanatory texts accompanied by heavily cropped pictures (of children or workers) that are "bled" onto the page. These glimpses of people and conditions make the texts more lively and integrate them with images but, since they are only fragmentary, external views, they increase the reader's desire to see more. Then, particularly in "Roving Children," the article on canneries, Hine follows these fragmentary images with full photographs, two to a page, of the workers standing by or sitting in their company shacks, usually by doorways or windows. These views, mostly exterior shots, bring the reader a little closer to the subject, while their captions raise the issues of bad housing conditions and inadequate education for workers' children. "Twenty-four people were reported sleeping in this [basement] room," is the dry comment on a cluttered room that looks like it could hold five or six persons comfortably. "Idle Children," says another caption, "What preparation are they getting for citizenship? . . . There are no playgrounds for these children, no supervision, no schools, no sanitary decencies." Hine ends the sequence with a final, emphatic, full-page, interior picture of two small girls sitting on a cot in a filthy room. The room is cluttered and squalid, and for the first time in the sequence, Hine's subjects have full eye contact with the camera. They look right at us as we read about the "room eight feet square, one end used for sleeping and the other as a wood shed and storeroom. Parents away at work; no school: nothing to do all day. What is the state of New York doing to prepare these children for their place in life?"[87] This sequence is as well done as, for example, the early photoessays that appeared in *Life* in the 1930s. Hine gave readers the information they needed to understand the situation; he moved them from external, fragmentary views of the subject to larger, more complete views; and he concluded with a strong interior shot that, with its indignant caption, visually brought readers in at the same time that it challenged them to become more concerned.

Common to all of these textual innovations is Hine's understanding that a photograph can become a part of something that is *made* by a craftsperson or skilled worker rather than something that is simply *taken* by an innocent (or predatory) eye and displayed as a sign of visual sensitivity or artistry. It is this aspect of his images that constitutes their relevance to a society that may be even less aware than Hine's society was of the conditions under which manufactured goods are produced. Hine's photographs were, and still are, a significant corrective to the consumerism that is so ubiquitous in the mass media, whether the popular magazine of the early 1900s or last night's television commercial bursting with dancing automobile buyers and junk food devotees. "The United States lives by what is made in the factory," a critic commented

in 1982 on Lee Friedlander's *Factory Valleys*. "In actuality and in dream[s], the product rules the nation. Each day trillions of photographs appear glorifying and selling what people working in factories produce."[88] One idea that virtually all of these images suggest, in Hine's generation as well as ours, is that industrialism and the machine age benefit everyone and make all our lives richer, happier, and more exciting. But Hine's child labor images remind us that this age has its victims as well as its beneficiaries, its pathetic "human junk" as well as its stores crammed with shiny new machines, toys, and appliances. His adult work pictures of the 1920s can also help us to understand the equally important idea that the quality of a product depends not only on machines but also on the qualities of the people who control them. As Hine wrote at the beginning of *Men at Work* in 1932, "Machines cannot make machines, unless back of them are the brains and toil of men," and "The heart of modern industry [is] . . . where the character of the men is being put into the motors, the airplanes, the dynamos upon which the life and happiness of millions of us depend. . . . The more you see of modern machines, the more may you, too, respect the men who make them and manipulate them."

The
Signs of
Hard Times

We were in a small town and [Russell Lee] saw a little old lady with a little knot of hair on her head. He wanted to take her picture, but the woman said, "What do you want to take my picture for?" . . . He turned to her and said: "Lady, you're having a hard time and a lot of people don't think you're having such a hard time. We want to show them that you're a human being, a nice human being, but you're having troubles."

"Well," she said, "All right. You can take my picture, but I've got some friends, and I wish you would take their pictures, too. Could you come and have some lunch with me today?" We stayed all that day and that night had supper. She invited four or five women over and Russell took pictures.

– An incident in Minnesota in 1937,
 as recalled by Roy Stryker

"Excellent work. Enlarge the project and take more pictures. Very Fine use of public funds."

"They could be better. Please save our tax money for something more useful."

"Excellent and vivid portrayal. Far better than reams of the written word. Have never witnessed more clear depiction of things as they are."

"Teach the underprivileged to have fewer children and less misery."

"If the newspapers don't print these—can you get them before the public in some other manner?"

"Every comfortable person who objects to the present Administration's efforts to help the poor in [the] city or country should be made to look at these splendid pictures until they see daylight."

"As pictures O.K. but a false impression is given of American farm conditions. Typical of the New Deal bunk at taxpayers' expense. However, F.D.R. and the whole gang is about washed up, Thank God, and a majority of Christians in the U.S.A."

"Touched me to the point where I would like to quit everything in order to help these stricken people."

"They're exceedingly lousy."

"These pictures are great. They speak a thousand words to especially enlighten people who have never seen much farm life— and do not believe such conditions can exist."

"An excellent illustration of the necessity for Social Justice . . ."

"Well, we've got a big army and navy haven't we?"

"I am two weeks in this country. I have my first papers. I am a German Civil Engineer. I hope to help. Vos mit ich kann."

– A selection of written responses from persons who saw the FSA exhibit at The International Photographic Salon, Grand Central Palace, New York, 1938[1]

t is easy to believe, especially if one has seen some of the most famous FSA photographs—Dorothea Lange's "Migrant Mother" and her pictures of Okies on the road, Russell Lee's close-up of an old farm woman's gnarled hands, and Walker Evans's images of Alabama sharecroppers—that the FSA photographers were a band of good neighbors with cameras, who photographed poor Americans so that their fellow citizens would support the New Deal and help them. Some people, like the German civil engineer, clearly did respond to the FSA's images in that simple, direct, humanitarian way. But as some of the other, more cynical, responses ("New Deal bunk") to the Grand Central Palace exhibit suggest, the FSA photographers' relationship to what is now called America's "depression culture" was complicated.

Americans were confused and divided in the 1930s. Some of them looked at the Grand Central Palace exhibit and saw the need for social justice, and others looked at the same pictures and believed that the government was wasting their tax dollars or that what the "underprivileged" really needed were lessons in birth control. One of the few things that virtually all Americans did agree on in the 1930s was that the country was indeed suffering from "hard times." As a young man who could afford to travel in Asia was informed by his parents in 1932, "We're all having the worst 'hard times' in human memory. . . . Better off for you to stay in China for a while, especially if you have something worthwhile you can do there." The situation was summarized particularly well by S. K. Ratcliffe, an English editor. In June 1931, after analyzing unemployment statistics, relief measures, and the American political situation, he concluded that one of the most drastic effects of the depression was psychological. "The great overturn has wrought an immense change in the American mind, and perhaps most of all in the collective business mind," he said.

When Mr. Coolidge retired from the presidency the American people were enjoying a sense of power and well-being such as no nation in the modern world had approached. American prosperity was a commanding reality; it was rare to find an American citizen who was prepared to express a serious doubt as to the permanence of the structure of [the American economic system]. And—more

101

significant still—the theory that America had opened the road to plenty, discovered the secret of continuous prosperity, and abolished the cycle of good and bad trade, was carried from the Rotary Club and the Chamber of Commerce into the colleges; it was being adopted as the new orthodoxy. . . . Of all this, needless to say, nothing whatever is now to be heard. The shock of the depression has been terrific, overwhelming, and there does not exist in any country so widespread a spirit of perplexity, concern, and self-criticism. [2]

The material prosperity of the United States in the 1920s increased for a number of reasons: the enormous influx of capital from Europe during World War I, which allowed American investors and industrialists to exploit their own and other countries' natural resources more vigorously; the increasing efficiency of the automobile and other mass-production industries through labor-saving machinery; the abundant supply of cheap foods from America's farms, which gave even poorly paid urban workers the disposable income they needed to buy cheap, standardized, industrial products; and the increasing use of advertising and easy credit to sell these products. One of the more important effects of this prosperity was the tendency, in much of the nation's popular media, at least, to treat people in big business as culture heroes who were responsible for "the world's highest standard of living." The small-time Babbitts back in the Rotary Clubs might be fair game for satirists like Sinclair Lewis; but, according to Stuart Chase, by 1929 leaders of big business had "ousted the philosopher, teacher, statesman, editor and preacher" as "spiritual leaders" and "entrenched themselves as the dictators of American life and habits."[3] A coalition of millionaires, owners and managers of major manufacturing industries, and communications and media "magnates," they were supposedly younger, better educated, more efficient, and more intelligent than their predecessors, the bad old robber barons of the Gilded Age. Their powers were summarized in November 1929 by a writer for the *Magazine of Wall Street*, who said that the stock market crash of the month before should not cause undue alarm since "this generation has conquered the air and annihilated time and space. The young leaders of our business world have brought the nation to its current high position in international commerce and business. They have developed a banking system which has withstood the trials of a market cataclysm and our business structure is amply buttressed to meet its aftermath."[4]

Business leaders, as this quote suggests, enjoyed a collective personality cult, but cults have a tendency to focus on particular individuals, and during the 1920s many admirers of big business were very impressed by Herbert Hoover and his efforts to create what he called, in his 1928 presidential campaign, a "New Day" and a "New Era" in American life. Like most presidents, Hoover was as much a symbol as an actual human being. Before the depression, he seemed to be, as Robert S. McElvaine wrote, "the perfect embodiment of the American Dream."[5] His life story, before 1929, could have been written by Horatio Alger, Jr. He was orphaned at the age of nine, worked his way through Stanford, and went on to become not only a successful mining engineer but also a millionaire. He managed mines in exotic places like Australia and

China and then became director of the American Relief Administration, which, in Europe, "restored communications, conquered epidemics, moved millions of tons of food and other supplies, and overcame tremendous obstacles created by the British and French" after World War I. (American business leaders demonstrate the superiority of their methods to the Old World.) According to his admirers, he also used "food as a weapon to stem the Bolshevist tide" by helping to overthrow a Communist government in Hungary and a Socialist government in Finland. (American capitalists defeat the forces of world revolution.) As secretary of commerce between 1920 and 1928, Hoover promoted himself as a moderately progressive or liberal alternative to old guard Republicans by supporting such causes as child labor reform and the growth of American multinational corporations, particularly glamorous businesses like airlines and communications. Like the business executives who benefited from his programs, Hoover was well acquainted with the latest developments in communications and the media. He employed his own little corps of professional public relations experts and advisors, and he competently cultivated a number of influential editors and writers, like Mark Sullivan and William Allen White, who became his admirers and supporters. In 1928 his public relations team made a special movie about him from old war and flood relief film clips, entitled *The Master of Emergencies*, and distributed it to be shown at Republican organizations.[6]

Campaigning for the presidency that year, Hoover was a walking anthology of statements expressing the American Dream. Though he was not a liberal, he tried to gain liberal support by repeatedly stressing his belief in "equality of opportunity" as the "right of every American—rich or poor, foreign or native-born, irrespective of faith or color." But he put even more stress on America's prosperity and its superiority to other nations, two of the most common conservative motifs of the Dream. In his acceptance speech, he made his famous claim—often quoted by Democrats after 1929—that "We in America are nearer to the final triumph over poverty than ever before in the history of any land. The poorhouse is vanishing from among us." In the final, long address of his campaign in St. Louis, Missouri, he gave a particularly optimistic speech in which he said America was different from and better than other nations because it had a unique social, political, and economic system whose founders had been guided by "Divine inspiration." He claimed the United States had created "a new economic system" that would "steadily lift the standard of living of the whole people," and he strongly implied that his own activities as secretary of commerce had helped to "mitigate the violence of the so-called business cycle. . . . No one suffers more from these periodic hard times, with their hideous unemployment, decrease in wages, and bankruptcy in business, than both labor and the farmers. Time forbids a discussion of the intricate problems . . . and the remedies . . . [but] the proof of their effectiveness lies in the fact that we have had a far longer period of stability in industry and commerce, far greater security in employment, and larger buying power for farm products than ever before in our history."[7] Not until forty years later, during the Tet offensive in Vietnam, did an American leader's dreams collide quite so violently with reality. An English writer, A. Fenner Brockway, traveling in the United States in the

winter of 1933 and seeing a Hooverville in St. Louis, believed that America was indeed different from other industrial nations—but not in a positive way. "In the depth of the American winter, on a day when a stabbing icy wind pierced the thickest overcoat, I saw the unemployed living on wastelands, in shacks put together from old boxes (wood and tin), bits of old motor cars, bits of corrugated iron, bits of cloth. I saw them lining up nearly three sides of a block waiting in a queue for soup. I saw them scrounging over refuse heaps like flies crawling over a dung hill. Even in India I had not seen destitution more horrible or humiliating."[8]

What Brockway saw in St. Louis was what the FSA photographers were trying to communicate in their photographs in the Grand Central Palace exhibit—bleak, squalid, total poverty—people without homes, without jobs, without food, and without hope. Throughout the 1930s other Americans described what Brockway and the FSA photographers had seen: John Steinbeck, in *The Grapes of Wrath*; critic Edmund Wilson, in his 1930 and 1931 reports on the nation's poor in the *New Republic*; and journalist Lorena Hickok, in descriptions of the conditions she found in North Dakota in November 1933:

> Yesterday I visited one of the "better-off" families on relief. In what was once a house I found two small boys, about two and four years old, running around without a stitch on save some ragged overalls. No stockings or shoes. Their feet were purple with cold. . . . The kitchen floor was so patched up—with pieces of tin, can covers, a wash boiler cover, old automobile license plates—that you couldn't tell what it might have looked like originally. Plaster falling off the walls. Newspapers stuffed in the cracks around the windows.
>
> The mother of those children—bare-legged, although she wore some sneakers on her feet—is going to have another baby in January. IN THAT HOUSE.[9]

On the other hand, there were many other Americans throughout the 1930s who preferred to see different, more cheerful realities. Moreover, since restoring "confidence" was often considered a kind of public service, the purveyors of optimism could justify their activities on patriotic as well as commercial grounds. One of the most important features of the classic, hard-times FSA images—the kind that were shown at the Grand Central Palace exhibit—is that they were opposed to a great deal of the popular culture of the 1930s.[10] As Ludwig Lewisohn commented in 1932 in a discussion of the popularity of "pseudo-romantic" fiction in the United States and the popularity of naive social reforms like Prohibition, "With this flight into illusion, with this inability to face facts, we must constantly reckon in the history of American civilization. . . . At any cost we must be optimistic, at any cost unresigned to the changeless elements of man, of nature, and of human life. We must be optimists and we must be right."[11]

This optimism, and the illusions that sustained it, however, did not come bubbling out of the facts of American reality like water from some pristine spring. Like so many other aspects of life in the United States during the 1930s as well as in later decades,

many of these illusions were consumer products, and it is not difficult to analyze their forms and their functions—and to see how different they were from the FSA photographers' images. Dos Passos's grim pronouncement in *The Big Money*—"All right we are two nations"—not only applies to the rich and the poor, the powerful and the powerless. It also applies to the ways middle-class Americans were willing to perceive their nation. Some read Dos Passos's novels and James T. Farrell's *Studs Lonigan*, others read Dale Carnegie's *How to Win Friends and Influence People*. Some acknowledged the soup kitchens and bread lines in the Bowery, others saw only debutante balls and shows at Radio City Music Hall. For some, life in the 1930s meant Lange's "Migrant Mother," and for others it meant Shirley Temple in *Rebecca of Sunnybrook Farm*.

Optimism was considered a profitable commodity and was promoted not only to sell products but also to "cure" the depression. "What this country needs is a good big laugh. . . . If someone could get off a good joke every ten days, I think our troubles would be over," Herbert Hoover announced early in 1931. Many of the business leaders who controlled the nation's mass media seem to have agreed with him. George B. Hill of the American Tobacco Company, for example, personally selected the music played on his company's Lucky Strike radio hour and "insisted that the dance music have strongly marked rhythms, rapid tempos, and crashing noise. Such music gave people confidence, he said. It was an antidote to the Depression."[12] Hollywood, as many commentators on the depression have pointed out, was another great source of optimism. As Will Hays, president of the Motion Picture Producers and Distributors, proudly explained in 1936, "No medium has contributed more greatly than the film to the maintenance of the national morale during a period featured [*sic*] by revolution, riot and political turmoil in other countries. It has been the mission of the screen, without ignoring the serious problems of the day, to reflect aspiration, optimism, and kindly humor in its entertainment."[13]

In the 1930s only a few Americans made films, like King Vidor's *Our Daily Bread* and Paul Strand's *The Wave*, emphasizing the need for any sort of collective social action. (Even then, Vidor had a great deal of difficulty raising the money to finance his film, and Strand made his in Mexico.) Far more popular, and profitable, were the sentimental, conservative, populist movies of the period in which the good, small-town capitalists of America helped one another and the idle rich, big-city snobs—who tried to humiliate or exploit the good guys—were either defeated or converted to more humanitarian values in the films' happy endings. In one of the most popular of these films, Frank Capra's 1936 *Mr. Deeds Goes to Town*, Longfellow Deeds, a young man from a small town in Iowa, inherits a fortune and goes to the big city, where the cynics and snobs try to persuade him to give his money to an opera. But after a poverty-stricken, demented farmer tries to shoot him Deeds decides, despite the opposition of the city-slickers who try to have him declared insane, to give his fortune to small farmers so they can buy farms. With a little imagination, *Mr. Deeds Goes to Town* can be interpreted as a liberal, New Deal parable in which Deeds, like the FSA, gives the

little farmers of America the land they need to survive. It can just as easily be interpreted, though, as a conservative fantasy in which the old, voluntary relief efforts that Hoover promoted so strenuously are carried out by a generous millionaire.[14]

In contrast, in many of the FSA's classic images of the depression—like Rothstein's famous "Dust Storm"—it is not only the desolation of the land that is disturbing but also the isolation of the people. Even the family does not seem intact. The mother is not in sight, and we can see only the farmer and his two little sons running toward their bleak storm shelter. An entire decade's fear can be read in Lange's caption for her 1937 picture of a woman crouching beside her baby and an old, stalled car by U.S. 99 in California: "Broke, Baby Sick, and Car Trouble!" No one else is in sight, and the woman, looking away from the photographer, is staring down the road. Waiting for her husband to return with help? And what if he does not return?[15]

The Hollywood musicals of the period were just as optimistic as the sentimental comedies, though in a slightly different way. As Gerald Mast pointed out, the plots of these films, particularly those made in the early 1930s and choreographed by Busby Berkeley, "never tried to be believable." The real sources of their optimism were the "grandiose and grotesquely imaginative patterns" of Berkeley's dances, which created the illusion of unlimited energy both frenetic and perfectly synchronized.[16] Many of the FSA photographers' hard-times images show the grim faces and stooped bodies of people who are exhausted and worn down by hard work or, if they are unemployed or migrating, haggard with anxiety. But in the musical comedies of the early 1930s we see and hear those same qualities of American popular culture that a writer analyzed very well in a 1982 *Partisan Review* article. Commenting on listening to Linda Ronstadt records and seeing *Superman* and television shows like "Kojak" and "I Love Lucy" in Africa, she wrote, "Hearing American-made rock music or seeing reruns of television shows in this context, one is immediately struck by the sheer energy of it all—the amplified, frenetic electronics, the endless car chases and escapades. . . . No wonder we are perceived as having a power far beyond what we actually possess."[17] It is precisely this energy that helped to make Hollywood musicals and big band jazz so popular in the depression, as well as later. They entertained anxious, powerless people with the illusion that they had escaped into a fantasyland in which everyone wore tuxedos and evening gowns, no one ever stopped smiling, and the dancing and music went on and on.

Americans also had the American Dream itself to cheer them up during the depression. Even though Herbert Hoover and big business were not as popular as they had been in the 1920s, their conservative version of the Dream continued to flourish in popular guidebooks to success, inspirational biographies, and fiction in magazines like *Liberty, American Magazine*, and the *Saturday Evening Post*. After reading hundreds of these works, Charles Hearn concluded that the rags-to-riches, get-rich-quick idea was almost as ubiquitous in the 1930s as it had been earlier in the century. "Clearly a large number of people were not yet ready to give up their image of America as a Horatio Alger paradise where anyone willing to make the effort could find success and happiness. On the popular level, the bitter experience of the Depression did not deal

the death blow to the capacity for dreaming, the idealistic faith in the future, the extravagant expectations that Americans have been noted for. To judge from the popular literature of the period, the capacity to dream suffered much less than the capacity to face reality and to distinguish legitimate hopes from puerile illusions." Another notable feature of these works, Hearn emphasized, was that so many of them were "transparently didactic stories" that expounded such themes as "the importance of ambition, industry, and self-help . . . with a deadly seriousness worthy of the most propagandistic proletarian novel."[18] At the same time, the frontier version of the American Dream was an extremely popular subject in history books written and murals painted during the depression. In fact, even the phrase "the American Dream" was popularized by a 1931 history book—James Truslow Adams's *The Epic of America*—that glorified the frontier as being the origin of the American Dream and of most of the nation's virtues and values. (According to Allan Nevins, Adams fought to have the book titled *The American Dream*, but was overruled by his publisher "on the ground that book buyers would never pay $3 for a 'dream.' ")[19]

Written in London in only five months, between October 1930 and March 1931, *The Epic of America* received excellent reviews. It was a Book-of-the-Month-Club selection, and it went through ten printings by the spring of 1932. Even though he wrote his book over three thousand miles away from the breadlines and Hoovervilles of what was left of his nation's industrial civilization, Adams understood very well what it was that many Americans wanted to learn about themselves in the early 1930s. As one of his fellow historians told him, "You have written a book that should be recommended—nay, imposed—by every teacher as necessary reading for his students."[20] *The Epic of America* placed most of the blame for what was wrong with America, including the depression, on speculators and leaders of big business. Adams was particularly critical of the great industrialists and capitalists, whom Teddy Roosevelt castigated as "malefactors of great wealth," because they made social and economic equality impossible. During the Gilded Age, Adams claimed, "the rights of man in the Declaration of Independence had collided with the new doctrine of the divinity that doth hedge a capitalist if he is big enough. To such men [the robber barons], the American dream was drivel." He criticized certain aspects of American frontier life for being "almost unbearably narrow," lonely, and monotonous; but he placed far more emphasis on his belief that the frontier had been a great positive force in the nation's history. It had created "that American dream of a better, richer, and happier life for all our citizens of every rank, which is the greatest contribution we have as yet made to the thought and welfare of the world." On the frontier, Adams said, everyone had been free to work for a better life, and "hard work became transmuted into a moral virtue and leisure into evil." In addition to inspiring the work ethic, the frontier had inspired the revolution and the settlement of the West. It became "the voice of the early Americans who had been promised 'life, liberty, and the pursuit of happiness' by Thomas Jefferson," Adams said. He claimed that, even though the frontier was officially closed in the 1890s, the Dream continued to inspire the populist and progressive political movements in the twentieth century and would very soon

again lead the common people to reform their nation. "Ever since we became an independent nation, each generation has seen an uprising of the ordinary Americans to save that dream. . . . Possibly the greatest of those struggles lies just ahead of us at this present time."[21]

This inspirational vision of rural and frontier America was expressed in many murals painted in post offices and federal buildings between the mid-1930s and 1943 as part of a New Deal patronage program for artists. The design of the murals had to be approved by representatives from local communities, and artists had to redesign their work if there were objections: the final murals represented the "collective taste of the citizens of the community, together with the individual taste of the artist."[22] Above all, as Karal Marling points out, both artists and communities in the late 1930s had a taste for lots of good hard work. "In the logging camps, the steel mills, the factories, and the mines of Mural America, people threw themselves into their work with grateful abandon. In vast tracts of Mural America, nobody looked for work, waited for a job or fled west on the roof of a boxcar . . . because everybody could pick up the tools and do the job at home." In the grim America outside the murals, Marling reminds us, were the Americans that Dorothea Lange photographed on U.S. 66 in Oklahoma, during a decade when "on any given day . . . two million refugees were roaming the country, riding the rods, hitching rides, looking for work." But in the murals prospectors were finding the ores that would make their towns prosper (as in Kellogg, Idaho, and Chisholm, Minnesota), black farmers were hauling their cotton to bustling cotton gins and warehouses (as in Leland, Mississippi), and white farmers were harvesting bountiful crops (as in Spencer, Indiana, and Bridgeport, Ohio, and Seneca, Kansas) or clearing land to plant more acres (as in Mercer, Pennsylvania). In Paris, Arkansas, the townspeople were led by a newspaper editor and a congressman to protest that the work in Joseph Vorst's sketch for their town's mural—a tenant farmer pushing a manual plow by a ramshackle cabin—was not inspiring enough. Vorst defended his work on the grounds that he "made that sketch from life during my recent visit to Paris and it *is* authentic." But after he visited Arkansas again and talked to a "committee of local citizens, including the Postmaster, Editor, and Banker," Vorst revised his design to conform to what was considered "authentic" in Paris. The final mural featured a bustling, modern stock-breeding farm, a coal mine, and a busy cotton gin. Every building in the mural, as Marling notes, is "spanking new, freshly painted, and soundly roofed." Even the humblest field hands "wear neat, presentable overalls," and "of the fourteen figures shown in the painting, thirteen are intensely busy."[23]

John Steuart Curry, one of the nation's best-known and most popular painters in the 1930s, carried this vision of America to its idyllic extreme in murals about rural and frontier life. *The Movement of the Population Westward*, his mural in the Justice Building in Washington, D.C., shows burly, stalwart pioneers striding heroically toward the setting sun as they lead a procession of covered wagons. His 1938 *Land Rush* mural in the Department of the Interior depicts a horde of settlers rushing into the Oklahoma Territory on horseback, covered wagons, buckboards, and even high-wheel bicycles, while in the background a steaming locomotive rushes across the horizon—presum-

ably pulling cars filled with even more settlers. To his admirers, Curry's idealized rural landscapes were "hallowed ground," the icons of a national religion. One of his rural paintings, an art critic wrote in 1935, disclosed "a powerful spirit born of America, inspired by America and dedicated to American ideas and ideals. . . . [It is] historical in that it mirrors our contemporary will to believe in ourselves."[24]

The FSA photographers' hard-times images, considered in the context of the nation's mass media and popular culture, were resolutely opposed to the optimistic illusions, dreams, myths, and inspirations so popular during the 1930s. If such cultural phenomena as Capra's films, Adams's *The Epic of America*, and Curry's murals are "historical," in the sense that they expressed Americans' "will to believe" in themselves, the FSA hard-times photographs were historical in the very different sense that they communicated the conditions under which poor Americans lived and the effects the nation's hard times had on actual men, women, and children. After seeing these images at the Grand Central Palace exhibit in 1938, art critic Elizabeth McCausland commented:

> After the usual diet of the art world—cream puffs, eclairs, and such—the hard, bitter reality of these photographs is the tonic the soul needs. They are like a sharp wind, sweeping away the weariness. . . . In them we see the faces of the American people. The American people which lives under the threat of unemployment, hunger and eviction. We see the farmers, the sharecroppers, the homeless migrant agricultural workers, the children who suffer from malnutrition, the whole families whose homes are part of that dreadful substandard "one-third of a nation."
>
> In these photographs we might see also (if we were completely honest and fearless intellectually) the face of ourselves. For, if the past decade has taught us no other thing, it has showed that the vaunted economic security of the prosperous citizen is no more secure than the marginal life of the depressed millions.[25]

■

The style and techniques of the FSA photographers' hard-times documentary pictures did not originate from any single source or policy. Officially, the group was known as the Historical Section of the Information Division of the Resettlement Administration (later renamed the Farm Security Administration), a New Deal agency organized by Rexford Tugwell, one of the original members of Roosevelt's "brains trust." Tugwell, who had been an economics professor at Columbia University in the 1920s, was one of the more controversial people, and the Resettlement Administration (RA) was one of the more controversial agencies, in the New Deal. At a staff meeting in July 1935, Tugwell "predicted that the agency would be highly vulnerable to attack, that it would be closely watched by its enemies, and that its leaders had better prepare their defenses against internal conflict and external attack." He was right. Virtually every policy that his agency formulated or implemented was denounced as "commu-

nistic," "socialist," "impractical," or a "waste of money." Nevertheless, since hundreds of thousands of destitute American farmers were either roaming the roads or in danger of losing their farms, Tugwell did not run a timid agency. By June 1936 the RA's efforts in "rural rehabilitation" had been extended to 536,302 farm families, reaching more than two million people, and the agency spent 60 percent of its budget, approximately $95 million, on assorted programs, loans, and grants for poor farmers.[26] Under the circumstances, it was logical for Tugwell to hire Roy Stryker, one of his colleagues at Columbia, to organize an Historical Section to photograph the good work his agency was doing in "rural rehabilitation" and in setting up experimental farms and running camps for migrant workers. During the eight years it was in existence, the FSA photography unit made plenty of pleasant, uncontroversial, informational photographs of these subjects, which were not particularly different from the thousands of pictures produced at the time by other government agencies, corporations, and photo services like Ewing Galloway. They were considered "documents" in the 1930s because they dealt with factual subjects and were used for educational and publicity purposes. But, as Edward Steichen pointed out in his review of the Grand Central Palace exhibit, besides "producing this kind of 'tweedle dum' and 'tweedle dee'" photography, the FSA photographers also made "human documents" that many visitors to the exhibit found disturbing; "these documents told stories and told them with such simple and blunt directness that they made many a citizen wince."[27]

Roy Stryker, the administrator of the photography unit, was not much interested in the technical side of photography, but he did have what John Vachon called a "half-formed concept" of what should be photographed. Photographers were starting to use terms like "documentary" and "documentary style" for certain kinds of images; and when Stryker began to recruit his photographers in 1935 he believed "it might be appropriate to gather together a collection of photographs of all aspects of American rural life, with [an] emphasis on what had gone wrong: deforestation, soil erosion, migrant fruit pickers, and hungry children." Moreover, the years he had spent growing up on farms and ranches in the West and teaching economics to undergraduates at Columbia had given him a great deal of information about American agriculture, which he imparted to the photographers in long briefings in Washington and in shooting scripts which he sent to them when they were on their travels. Just to be on the safe side, he also made them read vast amounts of J. Russell Smith's *North America*, an encyclopedic, one-volume survey of the continent's economic geography. While he was at Columbia in the 1920s, Stryker coauthored Tugwell's and Thomas Munro's 1925 textbook, *American Economic Life*. His contribution was to find visual materials to illustrate the book, and in the course of doing that he learned something about social photography from Lewis Hine, who provided him with many of the book's illustrations.[28] It was probably from his experience of working with Hine that Stryker learned the value of emphasizing details that, even though they might seem insignificant and shabby, revealed the quality of peoples' lives. It was Stryker, Arthur Rothstein said, who "made me aware of the fact that it was important, say, to photograph the corner of a cabin showing [an] old shoe and a bag of flour . . . and it was important to

show a window stuffed with rags." Finally, Stryker imparted a certain amount of useful skepticism to his photographers regarding any illusions they might have about their country or the optimistic clichés flourishing in its media. "He was a kind of friendly and effervescent tyrant," Vachon recalled, "from whom I heard, for the first time in my life, that the American economic system had some imperfections, that the Negro hadn't been freed by Abraham Lincoln, and that it wasn't necessarily true because you read it in the *Saturday Evening Post*."[29]

In addition to teaching his photographers, Stryker learned from them. Vachon believed that of the main, original group of photographers Stryker hired (Evans, Rothstein, Lange, and Carl Mydans—who was replaced in 1936 by Russell Lee), Lange, Evans, and the artist Ben Shahn had the strongest influence on him during the formative stages of the photography unit. Shahn was an unofficial member of the unit. He was hired by a different branch of the RA to make posters and paintings, but after he went on a field trip with a camera the pictures he brought back were so good Stryker put them in his file. Shahn worked with Diego Rivera on the Radio City Music Hall murals and was a member of the left-wing artists group, Art Front. He helped Stryker understand that it was not enough to photograph factual "conditions" clearly and carefully: the photographer also had to try to show the effects they had upon human beings. Looking at a picture of bad farm land, for example, he explained, "You're not going to move anybody with this [picture of] eroded soil—but the effect that this eroded soil has on a kid who looks starved, this is going to move people."[30]

Walker Evans, one of Shahn's friends, was probably the member of the group who knew the most about the kind of photographic modernism that had begun to appear in America and Europe in the 1920s, but was still not well-known outside of avant-garde artistic circles. By the early 1930s he had seen Eugene Atget's architectural photographs and the work of Ralph Steiner, one of the first American street photographers; and he had been very impressed by Paul Strand's extremely forceful and incisive modernist images in a copy of Stieglitz's *Camera Work*. "I came across that picture of Strand's blind woman and that really bowled me over," Evans wrote to a friend in 1929. "That's a very powerful picture. . . . That's the stuff, that's the thing to do."[31] Strand's images are notable for their intense clarity, his technique of composing his images so that they are filled with sharp, hard, concentrated detail. Even before he started working for the FSA, Evans had begun making some powerful images of his own—notably a series of portraits of dockworkers and coal handlers made in Havana in 1932, which have the same direct eye contact and grim forcefulness that characterize his more famous portraits of sharecroppers in Alabama in 1936.

Dorothea Lange also influenced the unit early in its development with many of her best-known, most explicitly compassionate images of migrant farm workers and sharecroppers. Lange began her career in the 1920s as a rather conventional portrait photographer. She was associated with the West Coast modernist "Group f.64" in the early 1930s, but even before she joined the FSA photography unit in 1935 she had begun photographing the rural poor with great emotional commitment and concern. As she said later about the circumstances under which she made "Migrant Mother" in

1936, "Had I not been deeply involved in my undertaking on that field trip, I would not have had to turn back [and visit the migrant labor camp]. What I am trying to say is that I believe this inner compulsion to be the vital ingredient. . . . If our work is to carry force and meaning to our view, we must be willing to go all out." It is in her images that we perceive most directly the sense of commitment that characterized the New Deal; Roosevelt's phrases, like "the forgotten man at the bottom of the economic pyramid," and "I see one-third of a nation ill-housed, ill-clad, ill-nourished," were not the usual American political clichés, but a stimulus for concern and action, a determination not only to "see" the poor people of the United States, but to do something to make their lives better and more secure.[32]

Though it is important to recognize the contributions of Stryker, Lange, Evans, and Shahn to the FSA documentary style and technique, it is more important to realize that they also functioned as a group and interacted with one another. When they were in Washington, they saw each others' prints and learned techniques and approaches. When new photographers—like John Vachon, Gordon Parks, Jack Delano, and Marion Post Wolcott—joined the unit, they could see and learn from their predecessors' earlier work. Thus, within a relatively short time, the FSA photographers created a documentary tradition of their own, which is most identifiable in their hard-times images.

First of all, as a group trying to show what had gone wrong with America, the FSA photographers had an aversion to the conservative, big business clichés about American economic life that continued to flourish in the 1930s along with the sufferings of the depression. They expressed this attitude most clearly in the deliberately ironic photographs they made of certain billboards that were part of what *Life* magazine called a "propaganda campaign" by the National Association of Manufacturers (NAM) in the 1930s.

The most famous picture of the NAM billboards was made by Margaret Bourke-White, who was not an FSA photographer: she photographed a line of poor black people waiting for relief food in front of a NAM billboard that showed a prosperous, middle-class, white family riding in their car. The billboard slogans said WORLD'S HIGHEST STANDARD OF LIVING and THERE'S NO WAY LIKE THE AMERICAN WAY. Bourke-White's picture appeared in the 15 February 1937 issue of *Life* magazine as part of a news story about a flood in the Ohio River valley, and the black people were flood victims waiting outside a relief agency in Louisville, Kentucky. Bourke-White's image was intended to illustrate the flood conditions only, not the depression, and the magazine's caption for her full-page picture ended with a mild comment that, since more relief was needed, "It was going to take a lot of money to restore the American standard of living in . . . the Ohio Valley." On the other hand, the FSA photographers were quite assiduous in their pursuit of NAM and other big business propaganda billboards, and their irony was more deliberate. According to Arthur Rothstein, they considered the Manufacturers' clichés about the American standard of living so absurd—at a time when millions of Americans were suffering from the depression— that they treated the billboards as fair game for visual ironies.[33] Rothstein photo-

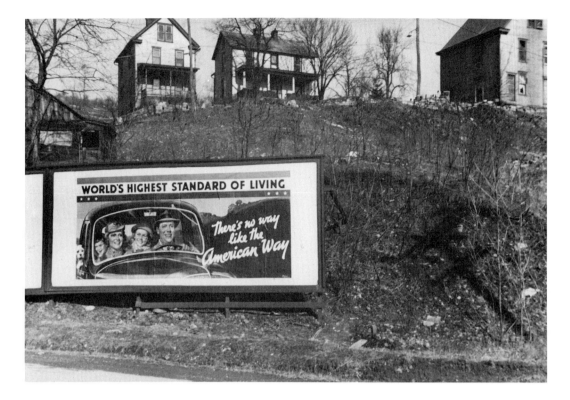

WORLD'S HIGHEST STANDARD OF LIVING

There's no way like The American Way

graphed a NAM billboard in a weedy lot in Birmingham, Alabama, at the same time Edwin Locke,
Bourke-White did, and Edwin Locke photographed another one (see illustration NAM bill-
above) in the same month near Kingwood, West Virginia, which shows three run- board near
down houses perched on a hill overlooking the billboard. In January 1938, Russell Lee Kingwood,
photographed a WHAT HELPS BUSINESS HELPS YOU billboard on Fourth Avenue in New West
York City, next to another billboard advertising a Broadway show, saying HOORAY FOR Virginia,
WHAT?, so that the two slogans are neatly juxtaposed. In 1940 John Vachon made 1937
photographs of two NAM billboards in Dubuque, Iowa, one of which is being read by (Library of
a migrant worker with a bundle on his back. Dorothea Lange seems to have had the Congress)
keenest eye for these billboards. In addition to finding three of them with different
messages on U.S. 99 in California in 1937, she photographed a WHAT HURTS BUSI-
NESS HURTS ME billboard (with a picture of a pouting baby) standing over the shacks of
a squatter camp near Porterville, California, in 1938; and she photographed Southern
Pacific billboards (NEXT TIME TRY THE TRAIN—RELAX) in 1937 and 1938 on Califor-
nia roads where migrant workers were trudging by on foot and where families like the
one Shahn photographed in 1935 ("A Destitute Family") were camping in their
jalopies underneath billboards to try to escape from the wind and cold.[34]

Seen in this new, ironic context, the middle-class family in the NAM billboards
seems very smug and indifferent. Secure in their little car and in the American way of
life, they appear to be totally oblivious to the depression all around them. In Lange's
Southern Pacific billboard image, this indifference is shown by the railroad passen-
ger's position and closed eyes. Of course you can smile and relax, Lange's image 113

*Ben Shahn,
"A Destitute
Family,"
Ozark
Mountains,
Arkansas,
1935
(Library of
Congress)*

implies, if you are riding through life asleep to the miseries around you. Her image, therefore, is also a satire on consumerism and the many advertising campaigns that encourage middle-class people to think only of their own comforts, even during times when millions of other people are homeless and hungry. (It is also significant that—like many other "emotional" advertisements of the same period—the NAM billboards were drawn in the bland, cheerful style used for Dick-and-Jane primary school readers. The people have the same chubby cheeks and inhabit the same Dick-and-Jane world of smiling daddies, pretty mommies, cheerful pets, and grinning children—always two to a family—which is the antithesis of the grim realities in the FSA photographers' images of migrant mothers, haggard fathers, and dirty children living in sharecropper's shacks and migrant labor camps.)[35]

In a 1978 analysis of Bourke-White's picture of the Louisville NAM billboard, John Walker pointed out that, even though she might not have consciously intended it, there are a number of ideological implications present in her image: the middle-class whites seem to "dominate" the black people; and the NAM image reinforces such values as patriarchy (the father commanding his car and family), the nuclear family, and "dependence on technology."[36] In 1937, however, the NAM billboards suggested other, more specifically political, implications. The NAM began to attack the New Deal in 1935. "The N.A.M. Declares War," warned a *Business Week* article about the Manufacturers' 1935 convention, which was devoted mainly to angry criticisms of the New Deal. In the late summer of 1936, the NAM launched an ambitious newspaper advertising campaign (with headings like "What Is Your America All About?," "American Standards of Living," and "America's Tomorrow") designed to refute "New Deal

114

orators, Townsendites, Coughlinites, Socialists, and Communists."[37] Even though the advertisements were not ostensibly political, they were scheduled to appear in thousands of newspapers all over the country at regular intervals from the end of August until the end of October: exactly the same time that the 1936 election campaign was taking place.

Despite the opposition of the NAM, as well as the U.S. Chamber of Commerce, the Liberty League, and many newspapers, Roosevelt won a substantial reelection victory in 1936 (60.8 percent of the ballots cast and 523 of 531 electoral votes). When the Manufacturers met again in December 1936, they spoke as if they intended to cooperate with the New Deal, "to make any changes necessary to complete harmony [sic] with national thought."[38] But, at the same time, the NAM was steadily increasing its activities and expenditures for "public relations" from $36,500 in 1934 to $793,043 in 1937. (In 1935 and 1936, respectively, these figures were $112,659 and $467,759.) According to Alfred Hirsch, a journalist writing in the *Forum* in 1938, the NAM was

Dorothea Lange, Southern Pacific Railroad billboard near Los Angeles, California, 1937 (Library of Congress)

spending this money not only on sixty thousand American Way billboards but also on a news service, two recorded radio programs, a movie (*Let's Go America*), which was distributed free to movie theaters, and a campaign to place NAM "educational" materials in school libraries and to bring speakers to high school assemblies.[39] In the case of the billboards, the NAM obviously decided not only to sell its American Way "message" like cornflakes or cigarettes but also to rely on the same chicken-in-every-pot consumer version of the American Dream that had been so ubiquitous during the 1920s. It was, in effect, the American Dream of Hoover's "New Era," minus Hoover. Thus, by photographing these billboards in the way they did, the FSA photographers pointed out that Americans had discovered other, grimmer realities since 1929: that, in the words of Elizabeth McCausland, they had learned "that the vaunted economic security of the prosperous citizen is no more secure than the marginal life of the depressed millions," that the American middle classes did not really exist on their own island of prosperity, as the NAM portrayed them.

In addition to giving the FSA photographers opportunities to express what they thought of big business and its clichés about America in the 1930s, their photographs of the NAM billboards probably helped them to clarify their awareness of what documentary photography should do and how it could be different from propaganda. In his review of the Grand Central Palace exhibit, Steichen reasoned that the FSA images were not "propaganda" because they were different from "Russian Official Photographs" of the same period, in which "the Soviet is represented as the home of fine, healthy, vigorous boys and girls . . . [and] lineups of tractors or automobiles giving the impression of miraculously synchronized high speed production." He then implied that the NAM's American Way images were equivalent to Russian propaganda because they also illustrated an idealized national reality, whereas the FSA photographs revealed discrepancies between their nation's ideals and its real conditions: "As a matter of fact, the whole tenor of these Soviet photographic [images] would seem to strive to get under a caption such as is presented on the 'World's highest wage' poster on page 48 which proclaims 'There is no way like the American way' [a 1937 Lange image of a NAM billboard standing on a weedy sandbank in California]. Then cast your eyes on the F.S.A. picture above this poster—a picture of a share cropper's residence and children." In other words, the Russian and NAM pictures were propaganda because they presented an idealized reality as if it had been achieved, whereas the FSA pictures emphasized the ironic distance between the ideal and the reality.[40]

While photographing the NAM billboards, the FSA photographers were developing their own visual techniques for contrasting, in a documentary style, American clichés with American realities. Steichen made this connection when he contrasted Lange's image of a NAM "poster" (actually a billboard) with a nearby photograph of a sharecropper's shack in the same exhibit, but by 1938 several FSA photographers had begun to make such connections within single photographic images, just as they had done in their NAM billboard pictures.

Selecting and framing two kinds of facts within the same image, Arthur Rothstein believed, could achieve a "third effect": an implicit comment on social conditions.[41] In

Rothstein's own 1937 picture of the bootblack, for example, the fact that the subject is an old man contradicts the inherent optimism of the Disraeli quote, which becomes ironic in the context of the image. The fact that the man is not some kind of hobo who could be blamed for his own lack of success but a neat, well-organized person with a vest and sports coat, who has carefully painted and arranged his chair and box, also contributes to the irony. Rothstein composed the picture so that all of these details are clearly visible and juxtaposed with the bank's sign. It is also important to realize that, whereas propaganda is designed for crude emotional effects (usually indignant anger or simple affirmation), Rothstein's documentary image encourages a complex range of emotional responses. For example, we feel respect and pity for the bootblack because, despite his efforts to be respectable, he has obviously been waiting a long time for his "opportunity," which probably will never arrive. He also does not look like the kind of person who needs "Travel Checks" to protect his funds.

There are also a good many FSA hard-times images in which facts are composed to tell a "story" in which causal relationships are implied. Soil erosion, for example, was a major problem in the depression; it caused both poverty and floods. When Walker Evans went to Mississippi, Stryker asked him to "put quite a little effort in getting us good land pictures, showing the erosion, sub-marginal areas, cut-over land. These should be taken whenever possible, showing the relationship of the land to the cultural decay."[42] Evans made a series of pictures in March 1936, near Jackson and Oxford, showing eroded land and gullies, and then he made an additional series, in Tupelo, in which he photographed eroded land near unpainted, ramshackle houses with sagging walls and porches. Rothstein made a similar photograph in Alabama, in which there is not only an unpainted house but also a listless young farmer leaning against it and staring at a bare, eroded hill obviously too barren to be farmed.[43] But the most pathetic of the FSA photographers' soil erosion pictures is Post Wolcott's 1938 photograph of a bleak, shabby farmhouse in North Carolina, in front of which we see eroded land and two children walking toward the camera, one of them with the terribly bowed legs caused by rickets. In all of these images, the photographers connected the social and environmental causes with the human consequences of rural poverty by composing their images so that factual connections are dramatized.

In contrast, when Margaret Bourke-White—who became a popular photojournalist in the 1930s—photographed poor sharecroppers for her book *You Have Seen Their Faces*, she dramatized her subjects in a very different way. Traveling through the rural South in 1936 accompanied by her husband, writer Erskine Caldwell, Bourke-White often used melodramatic camera angles and lighting, but she rarely showed people in relation to their environments. For example, she photographed farmers from low camera angles so that they were dramatically outlined against the sky, but the land they farm is not even visible. She also made extreme close-ups of many of her subjects, particularly when they had grotesque or misshapen features, to heighten the emotional impact of her images. In addition, as Bourke-White went through the South, she photographed every cliché that was popular in the newspapers, movies, and popular fiction of the era: women in poke bonnets and gingham dresses, indolent

blacks, "white trash" sharecroppers, flood victims, chain gangs, and people with
missing teeth and grotesque features. Caldwell's text, which accompanied Bourke-
White's images, was sympathetic to the poor blacks and whites of the region (he
blamed most of their troubles on greedy landlords), yet many of the photographs and
captions were so insensitive they could have been used to justify all kinds of middle-
class prejudices. An image of a rather presentable, poor, white family, for example, has

118

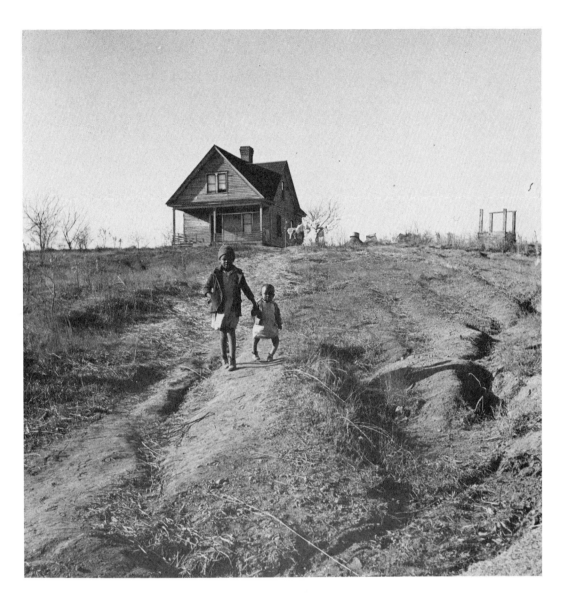

the caption, "Every month the relief office gives them four cans of beef, a can of dried peas and five dollars, and the old lady generally spends a dollar and a half of it for snuff." (Why bother with money for people on relief?) A caption reading, "I think it's only right that the government ought to be run with people like us in mind," is accompanied by a picture of an elderly white couple so ugly and degenerate that it could be interpreted as an argument for poll taxes. (Who would want to let these "white trash" vote?)[44]

Many of the farmers and their families in the FSA photographs were just as poor as those in *You Have Seen Their Faces*, but the FSA photographers almost invariably photographed their subjects in a more dignified and respectful way. For decades many prosperous Americans believed that the economic system dispensed a kind of justice as well as goods and services; hence, it was easy for them to blame the poor for being poor. During the Panic of 1893, the president of the University of Wisconsin warned

Marion Post Wolcott, Farm with eroded land near Wadesboro, North Carolina, 1938 (Library of Congress)

119

students that they should not assign the "wrong causes" to the suffering going on in America at the time, because "In a vast number, if not a majority of the cases, suffering has come from improvidence, from extravagance, or from dissipation."[45] The same ideas were still in existence during the depression, but the FSA images showed that American farmers really were poor—that they obviously were not extravagant people who wasted their money on dissipation. Anyone looking at Russell Lee's picture of the four small children of an Iowa tenant farmer eating a "Christmas dinner" of corn bread and "a sort of thin soup" in a room with rough, unpainted board walls, would have realized that stories about rural poverty were not New Deal "propaganda," that these farmers really did need help if they and their families were going to survive. ("These pictures are great," one of the visitors to the Grand Central Palace exhibit wrote. "They speak a thousand words to especially enlighten people who have never seen much farm life—and do not believe such conditions can exist.")[46] Moreover, unlike Bourke-White's images, many of the FSA photographs seem to have been made in ways that counteract, or at least undermine, the negative stereotypes that portrayed the rural poor as *Tobacco Road* freaks or shiftless ne'er-do-wells. "To my knowledge," Stryker later claimed, "there is no photo in the FSA collection that in any way whatsoever represents an attempt by the photographer to ridicule his subject, to be cute with him, to abuse his privacy, or to present him as [a] cliche."[47]

Most significantly, the FSA photographers seemed to have avoided photographing people who looked noticeably strange or grotesque. As Russell Lee told the old woman in Minnesota in 1937, "We want to show them that you're a human being, a nice human being, but you're having troubles." The photographers' subjects may look very poor—the men wear overalls, the women sometimes wear sack dresses, and the children may be dirty and half-naked—but at least they look like human beings. It is also noticeable that, though the subjects quite often appeared anxious or weary, they seldom were photographed either when they looked very excited or when they looked dull-eyed and apathetic. Also, the camera distances and angles that Lee and the other FSA photographers used are relatively normal, and the way that the people look at the camera implies a casual social equality. Even sharecroppers in their shacks or standing by their jalopies were allowed to pose themselves in an informal but presentable manner. When Lange photographed people on the road or on their farms, for example, "she would explain who she was and why she was there, and talk about the weather or the crops or any nearby children. . . . She would answer any questions the people had and ask them questions in a direct, friendly way, equal to equal. She would ask if she could take their picture to remember the meeting and for the government. If the people said no, she didn't press. If they said yes, she would continue chatting. . . . As she took pictures . . . she continued asking neighborly questions."[48]

It is also significant that the FSA photographers sometimes selected situations that would show rural Americans trying to improve their own, or their children's, lives. This is particularly obvious in the pictures that Lee, Rothstein, and Post Wolcott made of rural schools in Kentucky, Texas, and the South in the late 1930s and that John Collier made of an Hispanic school in New Mexico in January 1943. The school-

rooms, by middle-class, urban standards of the time, are scarcely better than shacks; the one in New Mexico is so cold that the teachers and many of the children are wearing coats, and the partition separating the two classrooms is made of rough planks. But in all of these images the teachers are serious and dedicated, the children are poor but clean, and—particularly in Post Wolcott's Kentucky photographs—they seem eager to learn. The black people in Lee's Texas and Louisiana pictures and Rothstein's Arkansas photograph are even worse off, materially, than the whites or Hispanics. They do not have schools or blackboards, yet they are trying to teach one another, and the children are attentive and respectful. Both Lee and Rothstein emphasize a subtle but significant juxtaposition of middle-class signs and values with facts of rural poverty. For example, a young black woman uses a stick instead of a pointer, and a black man uses planks for a chalkboard, yet both of them take their responsibilities as adults and teachers very seriously. In another picture that Lee made of the same black woman in Transylvania, Louisiana, she stands in the doorway of her shack, a typical, "underprivileged" FSA client, the "wife . . . of a Negro sharecropper who will benefit" from a resettlement project; but standing in front of her homemade blackboard, trying to teach her children to read, she symbolizes the desire of poor black people to improve themselves and their children.

These images contradict the negative, middle-class stereotypes that rural blacks, whites, or Hispanics are poor because they are "ignorant," "illiterate," or "racially inferior." Instead, as an Alabama journalist commented in a 1939 article in the *Survey Graphic*, which was illustrated by one of Lee's pictures, these images were an indictment "of race discrimination in education—a failure of democracy with economic, social and political repercussions throughout our national life."[49] This idea was further emphasized by the caption for Lee's image: "Because there is no school, this half literate mother does her best for her children at home." In other words, the blacks are not to blame for this situation, but it is America in general, and the southern states in particular, that have failed to provide black people with schools. In the context of the 1930s, photographs like these also implicitly invoked the liberal version of the American Dream, as they presented a positive view of their subjects as people who were capable of working, mentally as well as physically, to improve themselves.

Another important quality in some of the FSA photographs was expressed very well by Dorothea Lange in a comment on Walker Evans. "There is a bitterness. . . . There is an edge, a bitter edge to Walker—that I sense—and it is pleasurable to me. I like that bitter edge."[50] This "edge" expresses a kind of quiet anger mixed with sorrow, a sense that some of the things that were wrong with America were never going to become right. The New Deal and the FSA might have helped some people, like the FSA clients, to better their lives; but the millennium had not arrived in America, and the FSA photographers showed this very clearly in some of their images. These are not, however, melodramatic "protest" images, like many of Riis's slum photographs and some of Bourke-White's pictures are. Instead, they are carefully composed, well-lit, informative, understated images in which every detail is an indictment.

We can see this "bitter edge" in Lange's 1937 pictures of black sharecroppers

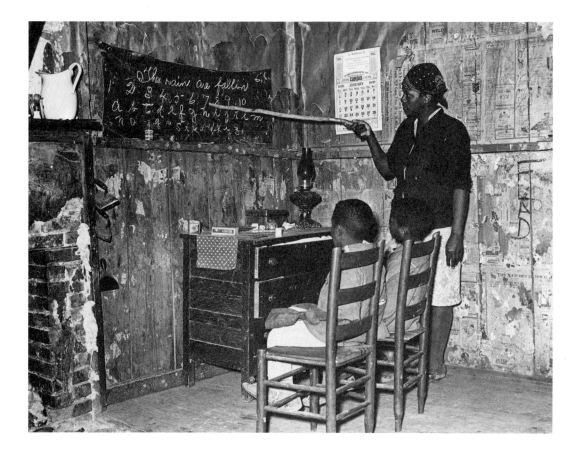

Russell Lee,
"A Negro
mother
teaching her
children the
numbers and
alphabet in
her home,"
Transylvania,
Louisiana,
1939
(Library of
Congress)

hoeing fields in Georgia and Mississippi. In each image, thin, ragged people—Steichen called them "scare crows"—stand as if tied to the bleak land by their hoe handles, outlined against flat, distant horizons. The land, like their labor, seems endless, without a tree, fence, or building in sight. A sequence of two pictures in Lange's *American Exodus* of "Tenant Farmers without Farms" in Texas in 1938, is equally bitter in a quiet way. Apparently waiting to be hired for day labor, or perhaps to rent farms, the six men are posed standing in a line in the first photograph. They are all relatively young white men; all of them look strong and hard-working; and all of them are serious, clean-shaven, and dressed in presentable overalls or work clothing. In the second photograph, made a half hour later, the same six men are still waiting, but now they are all crouching or sitting—and each of them looks a little grimmer, a little more anxious and vulnerable.[51]

This bitter edge appears in many of Evans's and Rothstein's pictures of industrial subjects. Evans, in one of his best-known photographs (of a stone cross overlooking graves, houses, and steel mills in Bethlehem, Pennsylvania), used a special lens—which had the same effect as a telephoto lens—to narrow the depth of field so that the whole scene is like a bleak cemetery with the houses compressed between the mills and the graveyard. In one of his less-known pictures—a very carefully composed image of a junkyard in a field—the cars seem so angular, cluttered, and alien that they

contaminate the landscape. In thousands of other American images of technology and automobiles, particularly those in advertisements and illustrations, the machine is a symbol of power or a delightful possession that gives people access to nature by enabling them to go easily to scenic places; but in Evans's picture, technology's domination of nature is oppressive and ugly. His photograph of the company housing erected by a steel mill in Birmingham, Alabama, deliberately emphasizes its regimentation. Not only are all the houses alike and set in straight lines but also their outhouses stand in line, each in its barren, empty, little backyard.[52]

Rothstein made an equally bleak picture of company housing for miners in Birmingham. He photographed slums that stood in front of steel mills in Ensley, Alabama; he made photographs of coal-mining towns in Illinois, in which the tipples loom over the drab, little houses; and—in Westmoreland County, Pennsylvania—the coal tipple of an abandoned mine stands over the tombstones in a small cemetery. But Rothstein's grimmest industrial landscapes are the ones he made in the West in the spring and summer of 1939. In his May 1939 picture, a Meaderville, Montana, copper mine has created a completely sterile landscape; the houses are pressed between the mines and the junk in the foreground, and beside the highway in the distance there are the usual billboards, presumably advertising the usual delightful products of American industry (see Rothsteins's "Copper mine and miners' homes"). Rothstein's brilliantly composed image of Butte, Montana, which he made in June 1939, is even harsher. Beneath a cloudy, overcast sky, the angular shapes of the mine equipment and tin sheds, the trucks and steam shovels, all loom over and encroach on the precarious living space a family has tried to create in their yard—a little lawn, two pine trees, clothes drying on a line. In one corner of the picture, a child sits on a curb looking at the trash and debris all around her. In photographic images of the 1930s and 1940s, which idealized industry, mines and their surroundings were seen as elegant abstractions, usually from distant aerial views, and machinery functioned in splendid isolation, efficiently turning out the shiny products that would make everyone's lives richer and better. But in Rothstein's and Evans's images, industry is associated with drabness, junk, death, and squalor; and, as in Lange's images of sharecroppers and tenant farmers, there are no hints that these conditions will ever change for the better.[53]

Rothstein and Evans expressed their viewpoints in these industrial pictures by composing their images very carefully. But at other times the FSA photographers expressed bitter realities through a simple emphasis on the grim or sad facts of American life that they happened to notice. Traveling through the Upper Peninsula of Michigan in 1937, for example, Russell Lee saw barren, cutover swamps being sold as farm land, and he photographed the sign advertising it as CHOICE FARM LAND FOR SALE that stood in a field filled with stumps and second-growth timber. When John Vachon photographed a 1940 shantytown on the edge of a city dump in Dubuque, Iowa, he picked a tar paper shanty whose owner had decorated it with a sign advertising a housing development: NEW AMERICAN HOME OPEN TO THE PUBLIC. Ben Shahn went to Morgantown, West Virginia, during a strike, and photographed a deputy guarding not a factory or a mine but a grocery store; he photographed the man from

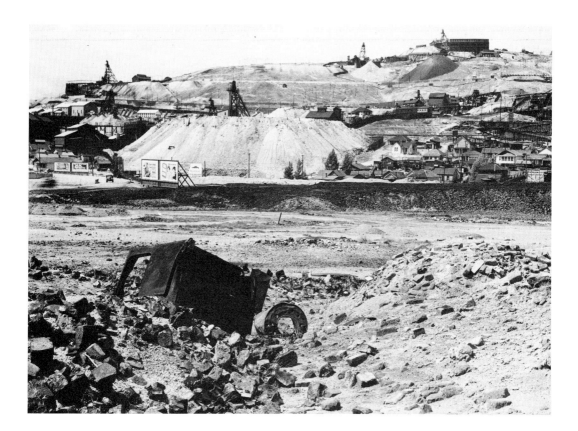

Arthur
Rothstein,
Copper mine
and miners'
homes,
Meaderville,
Montana,
1939
(Library of
Congress)

the back to emphasize his fat buttocks and his revolver—a sinister but humorous comment on how the prosperous people of Morgantown protected themselves against the hungry ones.[54]

It is also significant that many of these FSA images were not specifically related to the depression. As they traveled around the country taking the pictures that Stryker needed for his file showing "what had gone wrong" with rural America, the FSA photographers noticed and photographed other things that were still going wrong: regimentation, ugliness, blighted environments, fraud, inequality, and repression. In other words, they were becoming social critics and using their photographs to express their viewpoints.

Mixed in with these criticisms of American life in the FSA file, however, are many rather pleasant, affirmative pictures. After seeing Edward Steichen's 1962 exhibit of FSA hard-times photographs, *The Bitter Years* (which was essentially a reprise of the 1938 Grand Central Palace exhibit), Stryker "was disappointed that Steichen had not selected any of what he called 'the positive pictures.' 'Steichen's approach,' he said later, 'was to show misery in its finest hour. . . . The [view]point was "The Bitter Years" and that is what was shown.' "[55] The "positive pictures" include a fair number of FSA images of poor, rural Americans who were trying to improve their lives. The subjects of these photographs were FSA clients, people who had received loans or other help from the FSA. Their pictures might, therefore, be considered propaganda,

but, if so, it was very mild propaganda. The photographers did not try to show that the
FSA clients became middle-class citizens or that their lives were drastically changed for the better by the New Deal. Indeed, in what is probably one of the best-known pictures of FSA clients—Lee's photograph of a couple sitting by their radio in Hidalgo, Texas—the couple's own efforts to look more prosperous and middle class than they really are makes them seem pathetic and a little comic. Though they have managed to furnish their living room with certain middle-class amenities (a painting on velvet of an eighteenth-century scene and a huge radio) and though they have posed themselves like people in a *Saturday Evening Post* advertisement, they are obviously plain country people; and since this is an honest, documentary photograph it contains the tell-tale signs of their recent poverty—their battered, worn-out shoes and a huge hole in one of the man's socks.[56] Images like Rothstein's pictures of Mr. and Mrs. Andy Bahain of Kersey, Colorado, are considerably more typical. Lee photographed the Hidalgo people surrounded by the appurtenances of 1930s consumerism, but the Bahains proudly posed themselves standing by a huge tree and holding the crops they raised themselves—potatoes, corn, tomatoes, and a watermelon. Whether intended or not, the symbolism of the Bahain's picture is touching and convincing: an American farmer and his wife have survived droughts, hard times, and the depression and are now enjoying the results of their own hard work on their own land. Jack Delano's 1941 photograph of a black man—an "FSA borrower" in Greene County, Georgia, who is playing an accordion—is another convincing image of FSA success. Even though the man's house has an unpainted plank floor and whitewashed plank walls, it is neat and clean, and there are curtains in the window.

Corn and tomatoes in Colorado, curtains in the windows of a black farmer in Georgia—these small signs of prosperity are very different from the Dick-and-Jane, consumer version of the American Dream visualized in the NAM billboards. These pictures of the FSA clients are probably the FSA photographers' modest, frugal, but quite genuine version of the Dream; their illustrations of the kind of security possible for some poor Americans during the depression—thanks to a little help from their friends Franklin and Eleanor Roosevelt, Rexford Tugwell, Roy Stryker, Dorothea Lange, Arthur Rothstein, Russell Lee, Jack Delano, John Vachon, Marion Post Wolcott, and Walker Evans. It was the American Dream as it was expressed by George and Lennie in Steinbeck's *Of Mice and Men*—"a little house and a couple of acres an' a cow and some pigs and . . . a big vegetable patch and a rabbit hutch and chickens," or by a sign Lange photographed in California in 1937: A LITTLE FARM WITH POULTRY, FRUIT AND VEGETABLES—YOU ARE SAFE.[57]

The FSA file also contains many positive pictures of places and people that were photographed simply because the photographers found them interesting—not because they were FSA clients. The photographers were not just, as one book later called them, "Crusaders with Cameras." They were also travelers in a large and complicated country who were seeing and discovering many interesting, amusing, and enjoyable things. John Vachon was particularly eloquent about the joys of being an FSA photographer. "In western Nebraska I had my first glimpse of a part of the world

I came to love, the ecstatically magnificent Great Plains," he wrote about his first field trip in October of 1938.

> I got inside dozens of farm houses (what a wonderful job I had: how else could I have ever been in a farmer's house in Red Willow County?), and I photographed the whole family sitting down to dinner. And there were the towns! I was twenty-four years old, and this was America before the Holiday Inn. Seneca, Kansas, had a hotel with a huge balustraded and polished staircase rising out of the lobby. I went to a church supper in the basement of the Methodist church. I saw ladies

quilting. . . . In North Platte, Nebraska, I met an ample forty-five-year-old blond lady who played the piano in a bar. Her name was Mildred, and she said she was a retired whore from Wichita. I told her I was a talent scout from Broadway, and her picture is in the File.[58]

Though these pictures represented the photographers' personal tastes and experiences to some extent, there also were certain patterns and a cultural significance to what they appreciated in the United States in the late 1930s. In particular, they seemed to have had an affinity for what might be described as American *ways* of living that were different from the bland, homogenized American Way celebrated on billboards. Their positive pictures usually contained images of regional cultures or eccentric, individual behavior; they usually celebrated work, not consumption; and they often emphasized the preindustrial, or "pioneer," qualities of life that still existed in many parts of the United States in the late 1930s. The NAM's images advertised a manufactured world, but the FSA photographers seemed to have been particularly interested in people who still produced homemade, handmade things. It was, in effect, that hotel in Seneca, Kansas, with its balustraded and polished staircase, versus the Holiday Inn; it was homebaked, whole wheat bread versus that bland, pulpy white bread sold in supermarkets all over the country.

As Warren Susman pointed out, the 1930s was a period when many Americans were particularly sensitive to the idea of culture as being a way of living rather than a fixed ideal or standard inherited from the past. Because of books like Robert and Helen Lynds' 1929 *Middletown* and Ruth Benedict's 1934 *Patterns of Culture*, they learned that "culture" did not necessarily have to refer to the "highest achievements . . . of intellect and art through history," but that it might refer to what Robert Lynd described as "all the things that a group of people inhabiting a common geographical area do, the ways they do things and the ways they think and feel about things, their material tools and their values and symbols."[59] The American middle-class culture of the 1930s, for instance, was characterized by the ownership of automobiles and radios, subscriptions to *Reader's Digest*, *Time*, and the *Saturday Evening Post*, and enthusiasm for "Amos and Andy" and baseball. Inevitably, this American Way dominated the mass media and advertising. But these allegiances were only one particular set of "values and symbols," and during the 1930s some thoughtful Americans were interested in the values and behavior of other cultures that existed in both the United States and foreign nations.

Stuart Chase's *Mexico: A Study of Two Americas* was published at the same time as Adams's *The Epic of America* and was almost as popular (11 printings between August 1931 and October 1932). Instead of giving his readers the usual sombrero-and-siesta stereotypes, Chase used the Lynds' *Middletown* and anthropologist Robert Redfield's *Tepoztlan* to contrast the ways of life that existed in Muncie, Indiana, (the Lynds' model for Middletown) and the Indian village that Redfield studied and Chase himself visited briefly during a trip through Mexico in 1930. Analyzing his own impressions and these two books "for a . . . serious study in comparative civilizations," Chase

contrasted the two cultures not to praise one at the expense of the other but to understand both better. "One can compare item by item the work habits, play habits, religious habits; the food, houses, clothing, education, social organization of two communities . . . a whole world apart," he wrote. The one (in Mexico) "is still following the leisurely pattern of the handicraft age, with many cultural traditions from the greatest indigenous civilization which the Western Hemisphere produced; the other is firmly locked into the culture of the machine age, deriving most of its traditions and *mores* from the Eastern Hemisphere." The people of Tepoztlan had a very low standard of living, by industrialized Middletown's standards, Chase acknowledged. They had no telephones, bathtubs, or movies—but they had less mental illness, anxiety, and unemployment. And their culture still possessed its traditional crafts: the people could "put their hands to almost anything, fashion it, repair it, recreate it. Their popular arts, their weaving, pottery, glass work, basketry, are as authentic and delightful as any the modern or the ancient world has seen."[60]

The FSA photographers approached their subjects in a way that was essentially similar to Chase's, because in 1936 Stryker had given them all a shooting script based on suggestions made by Robert Lynd "for things which should be photographed as American Background." Many of Lynd's and Stryker's categories inherently stressed that different regions and economic classes of American citizens would have different ways of living. Backyards, wall decorations, and street scenes, for example, could all be photographed "as an index to . . . different income groups." The rural and ethnic cultures the FSA photographers saw were not as isolated or as alien as the Mexican village that Chase visited, but the photographers seem to have found them almost equally fascinating. Like Chase, they seemed to be particularly interested in relatively traditional crafts, tools, and occupations.[61]

It would be impossible to describe all of the subjects that fascinated the photographers, but there were certain significant patterns and personal preferences. Blacksmiths, for example, seemed to be one of their favorite subjects; Rothstein, Post Wolcott, and Collier photographed them at work in places as different as Vermont, Mississippi, and New Mexico. Rothstein, who grew up in New York City and graduated from Columbia University, was particularly interested in ranching and sheep herding in the West; his photographs of cowboys and sheepherders in places like Montana contained so many pristine skies that the other photographers joked that he "specialized in cumulus clouds." Vachon loved to photograph farming and ranching in Nebraska and the Dakotas. Evans seems to have been fascinated by folk art and what would now be considered vernacular architecture, and he made dozens of images of small, rural Southern churches, hand-painted signs, and nineteenth-century carpenter Gothic houses.[62]

The FSA photographers also had keen eyes for humorous, odd, and eccentric aspects of the "American Background." This is particularly noticeable in their images of hand-painted signs, including ones with picturesque misspellings, which they collected from all over the country. Lee, for example, met a man and woman in Louisiana who were "traveling evangelists, still preaching the gospel and sharpening

knives to pay for expenses after 25 years on the road," and he made a picture of them *John Collier,* and their cart—which they pushed on foot—with its message, REPENT YE SHALL ALL *Jr., Black-* PERISH and JESUS IS COMING SOON. The most elaborate example of these folk signs *smith shop,* was photographed near New Orleans by Vachon. He found a farmer named Emile *Peñasco, New* Riche, who made a series of large, hand-painted signs proclaiming his autobiography *Mexico, 1943* and his side of a dispute with officials who had refused to pay him for damages to his *(Library of* property in a 1927 flood. Presumably pleased that Vachon was interested in his hand- *Congress)* painted narration, Riche painted another sign, with an image of Vachon and his camera on it and the caption: I AM TAKING THE PHOTOGKA OF DEPRESSION ANP STARVATION AT ONCE. (This was perhaps the only time that one of the FSA photographers was the subject of an image by a subject.)[63]

It is important to realize, however, that these images did not contradict the hardtimes photographs, but represented the amusing, vital, or worthwhile aspects of cultures or regions. In fact, in many instances the photographers made both kinds of photographs on the same assignments. Thus Evans might photograph the desperate poverty of tenant farm families in Alabama and then photograph rooms in their cabins for their aesthetic interest. Rothstein photographed Montana landscapes to emphasize their beauty, but he also photographed Butte and Meaderville to show how they had been blighted by copper mines and smelters. Collier and Post Wolcott made positive 129

photographs of blacksmiths at work in New Mexico and Mississippi but also photographed substandard schools in the same areas.

In some instances the FSA photographers' interests in different cultures and other ways of life were searches for alternatives to the physical dreariness and moral squalor that characterized so much of life in the "civilized," machine-age America and Europe of the 1930s and the early 1940s. Evans's images of small-town houses and rural churches in his *American Photographs*, Lee's pictures of Pie Town, New Mexico, in 1940, and Collier's 1943 images of a rural Hispanic family are affirmations that contradict the sense of hopelessness W. H. Auden expressed in his poem, "September 1, 1939." He bitterly described the 1930s as "a low dishonest decade" when "waves of anger and fear / Circulate over ... the earth, / Obsessing our private lives" and "blind skyscrapers use / Their full height to proclaim / The strength of Collective Man."[64] The FSA photographers found some American places and people whose lives were not yet dominated by the "blind skyscrapers" and their power to control ideas, tastes, and feelings; and when they had the opportunity to photograph these subjects, they did so with great enthusiasm.

Evans seemed to have the most conscious distaste for the world of collective humanity, and he expressed this distaste quite clearly in his 1938 *American Photographs*. In 1934, a year before he joined the FSA, he was planning do a picture book about what he disliked in America. "The right things can be found in Pittsburgh, Toledo, Detroit (a lot in Detroit, I want to get in some dirty cracks, Detroit's full of chances).... People, all classes, surrounded by bunches of the new down-and-out.... Automobiles and the automobile landscape.... Architecture, American urban taste, commerce ... the street smell, the hateful stuff, women's clubs, fake culture, bad education, religion in decay."[65] Though it is possible to interpret the sequences of images in *American Photographs* in various ways, one of the most obvious aspects of his book's organization is that it is divided into two separate, carefully demarcated parts; Part One has most of the "hateful stuff." Several of his FSA hard-times images are in this part, and it also contains some fairly harsh urban scenes in New York and Havana and a number of chaotic, squalid interiors. There are a good many street photographs, and many of the people in these pictures look anxious or tense: four middle-aged, middle-class New Yorkers sitting on a bench in the Bronx and glaring in different directions at the world around them; a young couple in a roadster staring anxiously at the photographer; and a middle-aged American Legionnaire in Pennsylvania looking suspiciously at the camera. If, as Kirstein claimed, this part is the "physiognomy of a nation," then it is a tense, anxious nation filled with contradictions and disintegrations.[66] The sequence of the images—which was deliberate, according to Kirstein—is not based on chronology or geography, and often seems consciously intended to be jumbled and unsettling. Considering the images as "pairs," the first image often seems to be eroded or disintegrated by the one immediately following it. For example, an intense portrait of an old black man in Cuba, his face seamed by age and work, is followed by an image of a minstrel show poster filled with silly racist stereotypes—blacks strumming banjos, stealing chickens, and waving

razors. Part One ends with a series of three hard-times pictures, which Evans did not do for the FSA: a ruined Louisiana plantation house and two squalid pictures of unemployed men and derelicts on South Street in New York City.

Part Two presents a more serene and positive view. It begins with a series of images of industrial and factory towns dominated by row and company housing (the regimented world of "Collective Man") but then escapes to a long concluding sequence of images of individualistic, serene, and even elegant buildings in rural areas and small towns, and in New Orleans. The oppressive sense of regimentation that characterizes the company towns at the beginning of Part Two is replaced by a sense of delightful diversity as Evans discovers all kinds of buildings, each of which has its own subtle virtues. The result is a visual pastoral symphony, which Kirstein described eloquently as Evans's celebration of "the continuous fact of an indigenous American expression . . . whether in sculpture, paint or architecture: that native accent we find again in Kentucky mountain and cowboy ballads, in the compositions Stephen Foster adapted from Irish folk-song and in contemporary swing-music."[67]

We see this same appreciation of a vernacular and indigenous American culture, outside the mainstream of urban and industrial life, in Lee's 1940 photographs of Pie Town, New Mexico, which were published as a photoessay in *U.S. Camera* in 1941. Many of the inhabitants of Pie Town, a community of 250 families, were refugees from the Dust Bowl who arrived in New Mexico in 1935 and had the good luck—or the good sense—to try homesteading instead of migrant work in California. Most of the homesteaders arrived "without any money," Lee said. "Usually they brought their kids, their personal belongs, some furniture, and some family heirlooms, in cars that barely made the grade." But settled families helped newcomers get started. Everyone worked hard and cooperated, a point Lee emphasized heavily throughout the photoessay; and by 1940, Pie Town had a church, a farm bureau, a school in the farm bureau building, a literary society, square dances, and community sings and picnics.[68]

Pie Town, however, did not have a very high "standard of living." The community was very isolated. Its main contact with the outside world was a Plymouth sedan that functioned as a daily stagecoach. It was sixty-five miles from the nearest railroad, twenty miles from a doctor or telegraph, and ten miles from the nearest telephone. Most of the people Lee photographed worked tremendously hard and had few, or no, luxuries visible in their homes. "It isn't an easy life we've got here," one farmer told Lee, and because of the short growing season "we don't have too much to do with. We came without money, we've had to grub and clear our land. . . . But we don't go hungry, that's one thing."[69]

Before they arrived in New Mexico, many of the homesteaders were sharecroppers and renters. But given land, even desert land, they showed that they could recreate pioneer living conditions and "values." ("For the first time in their lives these people own their land and they feel they've a future here," one of them said.)[70] Pie Town, Lee wrote, was "unique because it is a frontier town very much after the pattern of frontier towns a hundred years ago: a photographic survey . . . was particularly important because to some extent it . . . enables Americans of today to understand the pioneers

who have pushed westward for more than three hundred years, doggedly, ingeniously, humbly, and yet heroically, conquering a continent, making it fruitful for generations to come. . . . We could picture the frontier which has unalterably molded the American character and make frontier life vivid and understandable."[71] However, unlike many of the 1930s painters who portrayed frontier life in post office murals, or the Hollywood directors who depicted it in movies, Lee was not concerned with the "simplicity," the violence, or the excitement of frontier life but instead with the complexity of its development.

In particular, his pictures of the Pie Towners at work sought to show the different stages of the process through which they became more settled, comfortable, and secure. Some homesteaders, the newest arrivals, lived in dugouts, others lived in log cabins, and "old-timers" lived in sizable houses made of sawed boards. Lee was able to photograph, in great detail, all the stages of building a dugout and the ways in which log cabins were constructed. In addition, he photographed different kinds of agricultural tools, which ranged from the eighteenth to the twentieth centuries in their technology. "In the early days we made our own farming tools," an old settler told Lee. "We've made our own plows; constructed harrows by driving spikes through piñon poles tied together. We used burros a lot for power." Lee photographed one homesteader, Jack Whinery, who still plowed walking behind a plow he made by hand, which was pulled by two burros. Another homesteader, Faro Caudill, was still clearing land by "grubbing" out rabbit bush with a pickax, but Caudill planted his fields on a two-wheeled riding plow pulled by two horses. Behind this plow was a block of wood which, as it dragged over the ground, smoothed the soil after planting; Lee carefully photographed this homemade device, presumably to show Caudill's ingenuity. Two other farmers, who were not named, used a cut-down truck as a tractor to pull their plow—one drove the truck while the other sat on the riding plow. (In his *U.S. Camera* caption for this picture, Lee commented, "pioneering requires ingenuity and cooperation.") But George Hutton, Jr., another Pie Town farmer, had a new tractor that could plow, plant, and cover two furrows of beans at a time. This particular development, from Whinery's homemade plow to Hutton's modern tractor, also illustrated, though Lee did not emphasize it, how relatively fragile the frontier way of life was, how its culture and values could be diminished by the "progress" represented by Hutton's tractor. That tractor, manufactured by a factory in Michigan or Illinois, made many skills and much ingenuity redundant. Hutton was "one of the few farmers in this section who farms with a tractor," Lee said in his notes. But seeing how well that tractor fits into the American Dream of productivity and progress, we wonder how much longer the Pie Towners continued to rely on burros and horses for power, how much longer they needed to rely on ingenuity and cooperation to help one another, and how much longer it would be before Pie Town had electricity and replaced its all-day community sings with radios and record players. [72]

As these Pie Town pictures indicate, the FSA photographers were very interested in cultures that were alternatives to the mainstream, middle-class American way of life of the 1930s, but they did not photograph these subjects in a simplistic, nostalgic, or

Russell Lee,
Faro Caudill
planting
beans, Pie
Town, New
Mexico, 1940
(Library of
Congress)

static way. Instead, like Lee, they seemed to be intrigued by the complexities and the social dynamics of the communities they photographed.

One of the best ways they could show the mixed, changing qualities of American life was by photographing billboards, posters, and signs. Stryker pointed out that signs were interesting to documentary photographers because they revealed "contrasts" and

"mental attitudes." Thus Lange illustrated one of her chief interests, the increasing mechanization of rural life, with an image of a dilapidated ox cart going past an Alabama Ford garage and its billboard saying ALL SIGNS POINT TO FORD V-8. Post Wolcott was amused by, and photographed, the mixture of the sacred and the secular on a pine tree in Greene County, Georgia. It had commercial signs for GREEN SPOT ORANGE-ADE and INTERNATIONAL FERTILIZERS tacked to its trunk beneath a carefully hand-painted, wooden sign asking, DOST THOU BELIEVE ON THE SON OF GOD. Lee, traveling through a small oil town in New Mexico, managed to photograph a group of signs advertising a wonderful jumble of cultural attitudes and interests all on the same sandy, vacant lot: OIL LEASES AND ROYALTIES, CHURCH OF GOD 1 BLOCK, PENTECOSTAL CHURCH 4 BLOCKS, and a commercial poster for a movie called "White Zombie."

Evans's images often seem to have the clearest emphasis on the aesthetic qualities that could be perceived in the odd mixtures existing between different eras and aspects of American cultures in the 1930s. In many cases he seemed fascinated by scenes and buildings that expressed casual, almost surrealistic, juxtapositions of different historical periods and attitudes. In 1936 in Charleston, South Carolina, for example, he photographed the grimy storefront of a building housing the Plenge Chemical company, decorated with assorted pseudoclassical architectural decorations and pasted over with posters for a circus. Fifty miles away, in Beaufort, South Carolina, he photographed another building with signs proclaiming that it was an art school and a fish company, sold fruits and vegetables, had a public stenographer, and that GENERAL LAFAYETTE SPOKE FROM THIS PORCH 1824. His 1935 picture of the interior of a West Virginia coal miner's house emphasized the juxtaposition of a handmade rocking chair constructed of bent saplings with commercial posters—advertising a Coca-Cola Santa Claus and graduation gifts from a Rexall drug store—that the miner used to decorate his house. The unknown craftsperson who made the chair is not in the picture, but that person's way of life is represented by the chair and contrasted with the modern values symbolized by the commercial posters. Such images may not have illustrated hard times particularly well, but they did express—as well as any photographs can—the strange mixtures of times, activities, and cultural influences that mingled and jostled with one another in the FSA photographers' America.[74]

■

As these images imply, times change; and so did the FSA Historical Section. Considered strictly as a government institution, Stryker's photography unit was not exactly a long-term success. When the Farm Security Administration was organized in 1937, it was inspired by a sense of idealism as well as urgency. In his special message to Congress urging it to establish the agency, Roosevelt warned, "The American dream of the family-size farm, owned by the family that operates it, has become more and more remote. The agricultural ladder, on which an energetic young man might ascend from hired man to tenant to independent owner, is no longer serving its purpose."[75] Moreover, this rural version of the American Dream was based not only on the

likelihood that farmers could own their own land but also on the assumption that this possession of land would make them free and independent citizens. As a nineteenth-century New England poet claimed about his native state, Connecticut,

> 'Tis a rough land of earth, and stone, and tree,
> Where breathes no castled lord or cabined slave;
> Where thoughts, and tongues, and hands are bold and free,
>
> .
> They love their land, because it is their own,
> And scorn to give aught other reason why;
> Would shake hands with a king upon his throne,
> And think it kindness to his majesty.[76]

Russell Lee, Signs in an oil boomtown, Hobbs, New Mexico, 1940 (Library of Congress)

For many Americans one of the most disturbing aspects of the farm crisis, which started in the 1920s and continued throughout the 1930s, was that all over the country poor farmers, drought victims, tenant farmers, and sharecroppers, in addition to living in terrible poverty, were losing their independence. According to Edwin Embree, writing in the *Survey Graphic* in 1936, the two million tenant families (over 8.5 million people) farming cotton in the South were living in "conditions bordering on peonage. . . . Economically they are at a bare subsistence level; mentally and morally they

are dependents, without control over their own destinies, with little chance for self-respect or the exercise of individual responsibility." Many of these tenant farmers were also second-class citizens because they could not vote—either because they were black or because they could not afford to pay poll taxes. In 1936 and 1937 it still seemed possible that these conditions might change, and Embree outlined an ambitious program based on "the suggestions advanced almost unanimously by students of farm problems, southern statesmen and government officials," which would have resettled landless farmers if "the federal government [would] . . . buy up huge acreages of farm lands now in the hands of insurance companies, land banks and others, and distribute this land in small plots of minimum size required to support farm families." Besides this massive land reform effort, Embree proposed that the government could set up service agencies to give homesteaders advice, seeds, and fertilizer, and it would also set up a variety of "carefully directed types of communities," including cooperative farm colonies.[77]

Though the Resettlement and Farm Security administrations did make some modest efforts to give land to homesteaders and to establish farm colonies and cooperatives, and though Stryker's photographers dutifully photographed those efforts, they were considered too expensive and much too controversial to be attempted on a large scale. By 1939 Paul Taylor, who was Dorothea Lange's husband and one of the nation's leading agricultural economists, admitted that because of mechanization and low crop prices it would be impossible to keep many poor farmers on the land. "It is plain that with advances in agricultural techniques, the country requires fewer farmers. . . . The real opportunity for large-scale absorption of the displaced [farm families] must lie in the direction of industrial expansion, not in crowding them back on the land where already they are surplus." In fact, as Taylor and Lange tacitly admitted in *American Exodus*, some of the the FSA's own policies contributed to the "displacement" of the nation's poorest farmers, the sharecroppers: the agency gave loans and payments to landlords, who used the money to mechanize their farms and replace the tenants with tractors. "In '34 I had I reckon four renters and I didn't make anything," one Oklahoma landlord told Lange. "I let 'em all go. . . . I bought tractors on the money the government give me and got shet o' my renters. . . . I did everything the government said—except keep my renters. The renters have been having it this way ever since the government come in. They've got their choice—California or WPA [Works Project Administration]."[78] Back in Washington, some FSA administrators continued to battle for "the small farmer issue." The "lowest third" of the American farm population was not going to be abandoned entirely, but it was gradually accepted that a large number of these farmers and their families would end up living in cities and working in industries. To phrase the matter more cynically, the overseer would be replaced by the factory foreman, the sharecropper's shack by the ghetto tenement, and the plantation commissary by the neighborhood pawnshop.

The FSA photography unit might have been able to respond to this change in a constructive way and survive. Reading between the lines of Howe's sympathetic April 1940 article in the *Survey Graphic*, which was presumably based on interviews with

Stryker and his staff, it is clear that the unit had already begun to shift away from the
hard-times photographs that dominated the 1938 Grand Central Palace exhibition.
Though, Howe said, the FSA photographers' first objective was still "to tell people,
through pictures, about the great human problem . . . of giving a decent break to the
lowest third of our farm population," they had adopted another aim of making "a
photographic record of rural America—a visual account of how America's farmers
live." He described the unit's new aims, such as a plan to photograph various food-
processing and retail operations affecting farm life, the exploration of techniques to
use photography as a "tool for social research," the use of FSA images to illustrate
books, and a plan to provide colleges with sets of photographs for economics and
sociology courses. It also is clear from the FSA picture files that by 1939 and 1940 the
photographers themselves were working on some important social issues not directly
related to rural poverty. The file contains pictures of substandard schools, Rothstein's
images of industries and their effects on the social and natural environment, and Lee's
1941 photographs of ghetto housing in cities like Chicago. Howe's article expressed
constructive criticisms—that the pictures often needed better "caption material" and
that some of them would be more effective if they were presented like photoessays in
picture magazines—but it ended with a cautiously optimistic statement implying that
the unit might survive because it "vividly demonstrated the value of the camera as [an]
instrument of government."[79]

Three years after Howe wrote this article, however, the FSA photography unit was
disbanded, and Stryker left government service to organize a public relations photog-
raphy project for Standard Oil of New Jersey. Probably the most important single
reason for this change was World War II. One month after Howe's article was
published in 1940, the Germans invaded the Low Countries and France, many more
Americans began to believe that the United States would inevitably be drawn into the
war, and conservatives began to attack New Deal agencies like the FSA as "non-
essential" to rearmament or the "war effort." "Under the influence of the American
Farm Bureau Federation and the Cotton Council, two organizations that represented
the interests of the large commercial farmers," F. Jack Hurley wrote, senators and
congressmen like Kenneth McKellar, Harry Byrd, and Everett Dirksen began to
attack the Department of Agriculture and the FSA and to demand huge cuts in their
budgets. McKellar, for example, blamed the FSA for "promoting 'socialized medi-
cine,' excessive spending on travel and publicity, wasting funds on 'no-account people'
and refusing to liquidate 'useless and dangerous resettlement projects.' " For good
measure he also claimed that the head of the FSA was "not far removed from being a
Communist." Congress battled all though the summer of 1942 over appropriations for
the Department of Agriculture and the FSA. The administrators of these agencies
began to struggle with one another over money and reorganization plans, and in
September of that year Stryker asked to have the photography unit transferred to the
government's propaganda agency, the Office of War Information (OWI). (Earlier in
1942 he already began to "loan" photographers to the OWI for specific projects.)[80]

Even before he asked to have the Historical Section assigned to the OWI, however,

Strykcr began to dilute the unit's documentary principles. It is true that several of the photographers who are most frequently associated with the FSA's hard-times images (Evans, Lange, and Rothstein) left the unit between 1937 and 1940. As Howe pointed out, though, the photographers who joined the unit between 1938 and 1940 (Vachon, Delano, and Post Wolcott) had studied the pictures of the earlier photographers, particularly Walker Evans and Ben Shahn;[81] the FSA files contain many images by them almost as bleak and bitter as the classic hard-times photographs exhibited at the Grand Central Palace in 1938. (For example, there are Vachon's 1940 pictures of bad housing in Dubuque, Iowa, Post Wolcott's 1939 and 1940 pictures of plantation and migrant worker families, and Delano's 1940 pictures of FSA clients and farm workers.) Moreover, the captions on many of these pictures indicate that the photographers were well aware that the New Deal, the FSA, and the WPA had not yet ended the nation's hard times and that many Americans were still suffering from disease, poverty, substandard housing, and bad schools.

By the autumn of 1940, Stryker asked for a very different kind of picture of American life. In a September 1940 memo to Delano, who was leaving for a field trip to New England, Stryker told him to watch out for "Autumn" pictures and "emphasize the idea of abundance—the 'horn of plenty' and pour maple syrup over it—you know: mix well with white clouds and put [it] on a sky-blue platter. I know your damned photographer's soul writhes, but to hell with it. Do you think I give a damn about a photographer's soul with Hitler at our doorstep? You are nothing but camera fodder to me." Delano said he considered this memo an example of Stryker's sense of humor and did not take it too seriously. At any rate, even when he and the other FSA photographers were making their hard-times pictures they occasionally made what they called "America the Beautiful" pictures when they saw attractive landscapes.[82]

By early 1942, however, when the United States was at war, Stryker gave his photographers even more specific directions about the reassuring propaganda pictures that he wanted. He ended a long February 1942 memorandum listing the photographs of industry and agriculture he needed with a demand:

> People—*we must have at once* [emphasis Stryker's]:
> Pictures of men, women and children who appear as if they really believed in the U.S. Get people with a little spirit. Too many in our file now paint the U.S. as an old person's home and that just about everyone is too old to work and too malnourished to care much what happens. (Don't misunderstand the above. FSA is still interested in the lower income groups and we want to continue to photograph this group.) We particularly need young men and women who work in our factories, the young men who build our bridges, roads, dams and large factories. . . . More contented-looking old couples—woman sewing, man reading . . . coming from church; at picnics, at meetings.[83]

The FSA photographers had documented harsh realities about the depression in the 1930s that were not clichés and that genuinely disturbed many people. Now, despite his claim that the FSA was still interested in the lower income groups, Stryker asked

them to make images that were essentially propaganda, to illustrate popular, reassuring clichés about America: that there were plenty of young men available to work in factories and build bridges, that old people were contented and secure, and so forth.

This situation became worse after the unit came under the control of the OWI, and Vachon later commented bitterly that "We photographed shipyards, steel mills, aircraft plants, oil refineries, and always the happy American worker. The pictures began to look like those from the Soviet Union."[84] The extent of this change is illustrated by Vachon's own, March 1943 image of a Gulf Oil billboard. Three years earlier in Dubuque, he made ironic photographs of the NAM billboards, but his 1943 image shows the Gulf billboard beside a substantial, middle-class house, illustrating what was called the "defense motive" in advertising; that is, corporations' efforts to sell their products through an appeal to patriotism. It was indeed, as the Gulf sign said, TIME TO CHANGE.

The increasing use of FSA images for propaganda purposes is also shown by the changes in their main exhibits. The 1938 Grand Central Palace exhibit consisted of hard-times images that contradicted the NAM's claims that American was so prosperous and successful. In 1941 the FSA's exhibit, shown at Rockefeller Center, was called *The Way of a People*, a slogan very similar to the NAM's. The exhibit was filled with optimistic images showing that the United States was strong, healthy, and prosperous—and implying that all this strength could be transformed into military might. The 1942 *Road to Victory* exhibit, as one would expect of a show coming right after Pearl Harbor, was fervently patriotic. It was shown at the Museum of Modern Art and mounted by Steichen, who was a lieutenant commander in the navy. It consisted of combinations of enlarged FSA images (all very positive), and navy publicity pictures of fighter planes, bombers, and warships.[85]

Even though the FSA photographers' images, arranged and captioned appropriately, could be used for propaganda purposes, the photographers themselves did not seem very interested in making the hard-core propaganda pictures so popular in the American mass media during the war. For instance, when Russell Lee and Dorothea Lange were assigned to photograph the Japanese-Americans interned in camps in the West in 1942, they were extremely sympathetic to the Japanese and portrayed them as such decent people and loyal Americans that their pictures look like an indictment of the U.S. government's actions: this was so even though both of them were working for the government at the time—Lee as a member of the FSA, and Lange as an employee of the War Relocation Authority. Lee photographed two Japanese-Americans respectfully holding an American flag in their camp in Idaho. Lange photographed a Japanese-American schoolchild saying the Pledge of Allegiance in San Francisco; one of her pictures was used to illustrate a pamphlet printed by a Quaker group that opposed the internment of the Japanese-Americans, much to the annoyance of the military authorities in charge of the camps.[86]

Nor, despite his earlier, patriotic memos about "camera fodder," did Stryker seem to be happy administering a photo service for propaganda pictures. The Selective Service began to draft his photographers, he fought with the other OWI administra-

John Vachon, Billboard with oil company advertisement, New Orleans, Louisiana, 1943 (Library of Congress)

tors, and he became convinced that the OWI wanted to "dismember" the FSA files that he had built up. After winning a final bureaucratic struggle to save the FSA prints and negatives by placing them under the control of the Library of Congress, he resigned from the government in September 1943 and began working for Standard Oil.[87]

■

Despite the relatively short life span of Stryker's photography unit as a government agency, the long-term contribution of the FSA photographers to photography was extremely important. No one, with the possible exception of Lewis Hine, did more to make documentary photography a significant visual media. It is quite possible that, if the FSA photographers had not exhibited their hard-times photographs at the Grand Central Palace in 1938, documentary photography—in the United States, at least—might still be confined to the drab informational and public relations pictures illustrating textbooks and gathering dust in the files of corporations and government agencies. But this contribution did not reach fruition for nearly two decades, because documentary photography suffered an eclipse during the 1940s and the 1950s. As Howe and Hurley pointed out, in the late 1930s and the early 1940s not only newspapers and

magazines published the FSA photographs, but authors and editors also began to use them to illustrate serious books such as Archibald MacLeish's *Land of the Free*, Herman Nixon's *Forty Acres and Steel Mules*, Lange and Taylor's *American Exodus*, Agee and Evans's *Let Us Now Praise Famous Men*, Sherwood Anderson's *Home Town*, and Rosskam and Wright's *Twelve Million Black Voices*.[88] But the use of these photographs stopped during World War II, when American photography began to be dominated by photojournalism. Magazines were filled with dramatic combat and propaganda pictures and, after the war, with equally dramatic images of atomic bomb explosions, concentration camp corpses, war crimes trials, and the beginnings of the cold war. Moreover, the media, instead of drawing attention to the problems of ordinary people, were busy emphasizing how such people could contribute to the war effort. When the war ended, these media were filled with images of a devastated Europe and Japan, which made the United States' problems—such as strikes, racial tensions, and the housing shortage—seem relatively mild.

The nadir of the FSA photography unit's reputation came in 1948, when *Life* magazine regaled its millions of readers with a two-page spread illustrating conservative Indiana Senator Capehart's claims that the FSA wasted $750,000 of the government's money on "silly" and "ridiculous" pictures. The article mentioned that the FSA photography unit also produced "some excellent documentary work" during the depression, and it praised a dull picture of a New England church as a "sample of better FSA work" that was "useful in propaganda work abroad during the war." But *Life* illustrated the story with a series of trivial pictures selected by Capehart, and it did not include any of the "excellent documentary" images. When the American Society of Magazine Photographers denounced *Life*'s portrayal of the FSA in an editorial in its newsletter, one of the magazine's staff members apologized, claiming that any "criticism, such as it was, was by implication directed at Senator Capehart," and that any file as large as the FSA file "will have some turkeys in it."[89] But the letter did not explain why the magazine printed so many "turkeys" to illustrate Capehart's criticisms; nor did it explain why *Life* relied on the senator for its selection of FSA prints at a time when two of the original FSA photographers—Walker Evans and Carl Mydans—were on the staffs of *Fortune* and *Life*.

Moreover, in the late 1940s it began to be unpopular and even risky to criticize the American way of life or the country's domestic and foreign policies, except for partisan political purposes. Persons who did that were frequently accused of being subversives, fellow travelers, or Communists. Drama critic Harold Clurman commented in 1961 that, during the 1950s, America was "prosperous and relatively strong; it was sinful to rock the boat; that is, to do anything that might weaken our confidence or prestige as a world power. . . . McCarthyism became the chilling emblem that frightened and froze us into a tense dumbness. We dared never suggest—no matter what the provocation— that we were not living in the best of all possible worlds. If a peep of protest issued from your lips, you were thought a crank or a neurotic, if not actually subversive."[90] For the photographers, the clearest warning came in 1947, when the Photo League was placed on the attorney general's list as a subversive organization. Even though the

League was defended against this charge by its leaders and members, which included eminent photographers like Strand, Lange, Eugene Smith, Edward Weston, Barbara Morgan, Eliot Elisofon, and Ansel Adams, it was disbanded in 1951 because many of the other photographers were afraid of being blacklisted.[91]

In such a political and cultural atmosphere, there were very few editors or agencies who would risk publishing or sponsoring photographers who wanted to deal with controversial subjects or with "what had gone wrong" with America. Marion Palfi, a documentary photographer, assigned herself during the late 1940s and the 1950s to photographing the same types of subjects that the FSA and the Photo League photographers did in the 1930s and the early 1940s: abandoned children in public institutions, racism in Georgia, the problems of elderly people, and the consequences—all of them bad—of the government's policy of "terminating" Indian reservations and making their inhabitants enter mainstream white culture. Even though Palfi was a capable and courageous photographer, no private foundations or government agencies would give her any support, no one would exhibit her images, and no one would publish them until 1971, when Lee Witkin managed to arrange an exhibit and publish an exhibition booklet entitled, appropriately, *Invisible in America*.[92]

By the 1960s, however, more Americans were again brave enough to confront images of poverty in their nation. In 1962 the FSA photographers were the subjects of a major retrospective, *The Bitter Years*, organized by Steichen at the Museum of Modern Art in New York. The show was widely praised: the prestigious Swiss photography magazine, *Camera*, devoted an entire issue to the FSA; the works of individual photographers were shown in exhibits and published in books and monographs; Stryker and the photographers were interviewed; and the FSA became the subject of a number of valuable studies by historians and critics of photography like F. Jack Hurley, William Stott, and Robert Doherty. In one of the best appreciations of the photography unit since Steichen's and Howe's 1938 and 1940 comments, Doherty recognized and summarized the significance of the FSA photography unit in *Camera* in 1962: "Candid honest documentation of life in a country, by the government of that country, is something seldom encountered. The inclination to rationalize the ills of an individual, a group, or a nation is far more prevalent than frank admission of reality. When documentation of the [condition] of a nation is executed . . . on the scale of the Farm Security Administration Project . . . it ranks of great importance in the history of photography."[93]

The photographers themselves were able to use what they learned from one another and Stryker to create successful careers for themselves in photography and communications after the FSA Historical Section was disbanded. Rothstein became director of photography, first at *Look* magazine and then at *Parade*. Evans became staff photographer at *Fortune,* and after he retired from that position he taught at Yale. Despite severe health and family problems in the 1940s, Lange returned to photography in the 1950s, when she did two important photoessays for *Life,* and she was the subject of a Museum of Modern Art retrospective. Delano worked on the Standard Oil project for Stryker, then went into television documentary production and became

director of the government's television service in Puerto Rico. Vachon also worked for

Standard Oil and then for *Look*. Lee did documentary photography on coal miners after World War II, then did free-lance industrial photography and taught photography at the universities of Missouri and Texas. Evans, Vachon, and Lange received Guggenheim Fellowships.[94]

Despite these achievements and honors, several of the FSA photographers had difficulty making the hard-times documentary photographs that they did so brilliantly in the 1930s. If they did that type of photography, they did not receive much encouragement or support. When Russell Lee was living and teaching in Texas in 1960, for example, the University of Texas was delighted with his proposal that he make a photographic tour of Italy. He received a grant of $1,000 toward his travel expenses, and 150 of his photographs were published by the University's *Texas Quarterly* in 1961. On the other hand, when he decided that it would be worthwhile to make a major photographic study of the "living conditions and health problems" of Spanish-speaking people in Texas in 1950, he received a small grant from the University and traveled to several Texas cities, including Corpus Christi, where "he found a physician . . . who allowed him to go along on his daily rounds through the 'barrios.' . . . The living conditions reminded Lee of the worst situations he had encountered back in the depression." But it seems that this study, Hurley wrote in 1978, "has never been published," and "one is led to speculate that the Texas power structure still had use for cheap 'bracero' labor in 1950 and was able to exert enough pressure on the University of Texas" to make sure that Lee's pictures remained unseen.[95]

Lee's solution to this problem was, in effect, to use the income he received from his teaching and free-lance industrial photography to subsidize his documentary photography. He made photographic studies of the conditions in Texas state institutions for the elderly and the criminally insane and for a small news magazine, *The Texas Observer*, even though the *Observer* only paid him five dollars per print used, because he felt "what the hell, I mean, it was work that just had to be done." He made a photographic study at a center for retarded children in Austin, printed the pictures at his own expense, and arranged an exhibit for the school because, as he explained to Hurley, "I just did this sort of thing on my own because these people had no funds to compensate a photographer."[96]

The case of Walker Evans's career after he left the FSA is sadder and more complicated. On the one hand, he seemed to be the FSA photographer most concerned that his photographs not be considered "propaganda" or "political." When he accepted his appointment with the Historical Section, he made a note to himself. "Mean never [to] make photographic statements for the government . . . this is pure record not propaganda." He told an audience of Harvard students many years later, "I do have a critical mind...but I am not a social protest artist, although I have been taken as one very widely. . . . You're not—and shouldn't be, I think—trying to change the world . . . saying, 'Open up your heart, and bleed for these people.' I would never dream of saying anything like that. . . . I believe in staying out, the way Flaubert does in his writing." As this comment indicates, Evans was fascinated by Flaubert, and he

believed he unconsciously incorporated many of the novelist's aesthetic ideas and techniques into his own work.[97] It seems possible that he wanted to be a photographic Flaubert, a seemingly disengaged, objective artist who rigorously criticized his society's illusions yet never "lowered" himself to the status of a "protest" artist.

On the other hand, judging from some of his statements in talks and interviews in the 1970s after he retired from *Fortune*, Evans had some strong social feelings. He left the United States and became an expatriate in France in 1926 and 1927, he said, because "at that time, America was scandalously materialistic and really fascist, and so awful that we just had to get the hell out of it. . . . I was really anti-American at the time. America was big business and I wanted to escape. It nauseated me. . . . It was a hateful society, and that embittered all people of my age. . . . [The Wall Street Crash] was certainly coming, and that awful society damn well deserved it. I used to jump for joy when I read of some of those stock brokers jumping out of windows!"[98] Traveling in the South for the FSA probably was very stimulating for Evans because it gave him a vision of a reality (he called it "old" or "regional America") that was an alternative to big business and the country's mainstream culture in the 1920s. "I was dedicated to making pictures with that camera," he later told an interviewer about his work in the South. "I couldn't stop doing it. . . . I had to do it. And I was terribly excited by all sorts of things that I saw, and attracted naturally, almost by heritage and by birth, to regional America."[99]

After he left the FSA in 1938, Evans did free-lance work for several years and in 1943 joined Time-Life, Inc., first as a writer for *Time* magazine and then, in 1945, as the only full-time photographer on the staff of *Fortune*—a magazine read by many stockbrokers and filled with idealized images of big business and portraits of executives, rather than sharecroppers. Interestingly enough, it was *Fortune*'s editors in 1936 who commissioned Agee and Evans to go to Hale County, Alabama, as part of a series of documentary studies of ordinary Americans, to research and photograph the subjects that later became *Let Us Now Praise Famous Men*. (They found Agee's prose and Evans's images too disturbing to publish, even in the depression.) After Evans became the magazine's staff photographer in 1945, he did not make any more disturbing or hard-times images until 1961, when he made "People and Places in Trouble," a portfolio of strong, concise, black-and-white pictures of unemployed people in the eastern United States who were living "in pockets of new unemployment and old poverty." In the interval between 1945 and 1961, he did a great many other portfolios for *Fortune*, which are quite bland and often dull. Since many of these dealt with architecture, it is possible to be charitable and say that he was trying to be an American Atget, since—like Atget—he often photographed old buildings and sites about to be demolished.[100]

A less charitable and more psychological interpretation of Evans's work of the 1940s and the 1950s, including his *Fortune* portfolios, would point out that—contrasted to the magnificent pictures that he made in Hale County in 1936—these later pictures could easily be entitled, "The Alienated Photographer." Starting in New York in the early 1940s, he began photographing people on subways with a hidden camera,

and he made a similar series in downtown Detroit in 1946, in which unidentified people, all seen from the same angle, marched past his camera, unconscious of the fact that they were being photographed.[101] In the 1950s people disappeared almost completely from his images. The government buildings of "Imperial Washington" (1952), the railroad stations of "The U.S. Depot" (1953), the chairs and desks in "Vintage Office Furniture" (1953), the old factories of "These Dark Satanic Mills" (1956), and the old buildings in lower Manhattan in "Downtown, A Last Look Backward" (1956) are all totally empty—except for a few shiny automobiles in a parking lot in "Imperial Washington" and one tiny man who is barely visible by a bridge in that portfolio. In a decade when his contemporaries (Strand, Lange, Lee) were photographing Frenchmen, Egyptians, and Italians in their homes and villages, Evans was photographing America from train windows in "The Right of Way," and the logos on old boxcars in "Before They Disappear." Evans could still make good modernist art photographs, and in 1955 he did "Beauties of the Common Tool," a series of studio pictures of ordinary tools. It was the sort of conventional, rather antiseptic modernist photography that Strand, Sheeler, Steiner, and Albert Renger-Patzsch did in the 1920s. Considered as a comment on what had happened to Evans's own creativity, a handwritten note he made about this 1955 portfolio is one of the sadder confessions by an American artist. "Time and again a man will stand before a hardware store window eyeing the tools arrayed behind the glass; his mouth will water; he will go in and hand over $2.65 for a perfectly beautiful special kind of polished wrench; and probably he will never, never use it for anything." Perhaps Evans also revealed his feelings about himself and what happened to his talents since he and Agee were in Alabama together when he met a younger photographer in 1955. "I once came to see Walker at the office at *Fortune*," the other photographer recalled. "It was when Agee had died. . . . Agee was his best friend, and I remember him just sitting on his desk in front of a window and looking down on Rockefeller Center . . . and he just sat there and he cried. . . . He came up to Nova Scotia about three years ago [in 1972]. . . . I took him to all the old houses—the people live just like in the thirties or forties in the States, and he was overjoyed. He photographed and photographed. And I liked to see him so happy . . . but at the same time, I felt that I wouldn't want to do that when I'm older."[102] The younger photographer who saw Evans crying in his office was Robert Frank—but that is another story and another chapter.

Unlike Evans, who almost entirely gave up making hard-times photographs until he did his "People and Places" portfolio in 1961, Dorothea Lange made a serious effort in the 1950s to bridge the gap that existed between the FSA documentary tradition and the mass-media photojournalism that dominated American photography in that decade. In the early 1950s Steichen began planning his 1955 *Family of Man* exhibit, which was, among other things, an attempt to create a synthesis between photojournalism and documentary photography. Thus he relied heavily for advice on Lange, on photographer Homer Page, who was one of Lange's close friends, and on his assistant, Wayne Miller, who spent months selecting pictures from *Life*'s huge files. The resulting exhibit was dominated by photojournalism (*Life* was the largest single source of

pictures), but there were some prints from the FSA, including nine of Lange's; this may have encouraged her to try to make her own compromise between the concerns of the documentary tradition and the demands of the 1950s photojournalism market-place.[103]

The results of her efforts were mixed. Her 1955 *Life* photoessay about poor, rural people in western Ireland was quite successful. The idea that foreigners might be poor but decent people, even though they did not drive Buicks or shop in supermarkets, was quite acceptable in the mass media of the 1950s. *Life*'s editors printed Lange's images of farmers, schoolchildren, and craftspeople in a fairly long and well-designed photoessay. When they discovered that Lange and her son, who accompanied her, had not recorded all the names and clearances they needed, the editors sent two research-ers to Ireland to find the people she photographed and collect the necessary infor-mation.[104]

The photoessay on Utah's small-town Mormons that she and Ansel Adams did for *Life* in 1954 was less successful, even though Maitland Edey later included it in *Great Photographic Essays from Life*. Lange and Adams were close friends, they collaborated on several earlier photographic projects, and they had an idea, which can be deduced from some of *Life*'s text, that might have led to an impressive photoessay. Adams could photograph the "splendid but forbidding" Utah mountains and deserts near the three Mormon towns, and Lange could show how the people survived and created their own way of life. Unfortunately, Adams's images were a little too splendid for *Life*'s presses; as Edey admitted, the magazine could "not begin to do justice" to his pictures, so it used only seven of them and twenty-seven of Lange's.[105] Her contribution could have been—like Lee's photographs of Pie Town—a substantial photoessay showing how pioneer conditions, skills, and work habits were surviving in the twentieth-century in a harsh, isolated environment. But *Life*'s editors arranged and captioned her pictures so they illustrated a common cliché: adopting mainstream American culture brings progress and prosperity, but the past remains as a nostalgic tourist attraction.

Life neatly stereotyped the three towns according to the degrees to which they supposedly adopted mainstream, "worldly" American values, and presented them in sequence. Toquerville, the town that changed the least, was presented as a kind of cemetery, pretty but almost empty because, though it had a "strong and enduring vision of Zion," it did not have a bank, movie house, motel, or neon signs. The second town, Gunlock, was presented in a more lively way since, as *Life*'s captions empha-sized, it was changing and being "assimilated" into the rest of the United States. The men had begun to go to nearby St. George to work for wages. St. George, the third town, "has taken up worldly ways," *Life* claimed, as it stressed the presence in the town of loan companies, motels, a drive-in movie theater, and tourists. Its representative citizen was a Mormon gentleman who was the town's "merchant, churchman, [and] owner of the town's first motel." "The Tourists Take Over Main Street," said another caption, with what may have been irony: the photograph shows a troop of people walking past a supermarket whose window signs advertise all the usual brand name products (Mazola Oil and Pillsbury Pancake Mix) advertised in *Life*. In other words,

now that the Mormons are a tourist attraction, what they have to offer are the exotic

delights of Mazola Oil and the Stardust Motel's neon sign. Nowhere in the photoessay
were Mormons doing any of the farming or work that enabled them to "wrest a living
from the desert" before the motels arrived—except for small pictures of a shovel and a
man's legs, a woman peeling corn, and another woman holding mason jars. Adams
commented later that he and Lange gave the magazine " 'very handsome' material, but
'as so often occurred with such projects . . . it suffered from over-editing and loss of
emotional drive.' "[106]

During 1956 and 1957, Lange also completed the photographs for two other
photoessays intended for *Life*, but not published. This was not unusual in itself, since
the magazine commissioned and paid retainers for many more projects than it could
publish, and its files were filled with unpublished photoessays. In Lange's case,
however, it may have been significant that she did not make stereotyped images. In
1955 she did a photoessay called "Public Defender," about a young Alameda County,
California, Legal Aid lawyer and his penniless clients. She hoped that it would be
published by *Life* for a May 1956 issue on Law Day. In her pictures she showed that
the lawyer was concerned about the rights of his clients, even though most of them
were poor people and petty criminals, and that he took their trials very seriously. As
one would expect, when she photographed the defendants Lange "showed the same
respect for their dignity" that she showed for "the dispossessed of the thirties." [107]

Life never published "Public Defender." Instead, in the fall of 1957, it published
"The Qualities of Justice," a group of essays about the American legal and police
system, as part of a series on "Crime in the U.S." One of these photoessays dealt with
Legal Aid and petty criminals. Unlike Lange, however, *Life* separated the Legal Aid
lawyers from their clients, treating them separately in an essay illustrated by a group
picture of the New York City Legal Aid staff. The magazine then, in a separate article,
presented the nation's poor criminals en masse, in a remarkably squalid manner.
" 'Revolving Door' Court," a tabloid tour of the "lower depths," was the sort of thing
that journalists in London, Paris, and New York had done for decades to entertain
their middle-class readers. *Life* illustrated it not with photographs but with dehuman-
izing, messy drawings made in courtrooms, which presented the criminals as sleazy
grotesques. The captions gave only the most superficial kind of tabloid, police court
data. ("A legless man arrested in Detroit for drunkenness, assures the judge, 'If you let
me go I'll never be here again.' He has a record of 51 previous arrests, 45 for being a
'drunk person.' He got 10 days.")[108] Even though *Life* solemnly noted that these "two
million cases" dealing with the "also-rans of society" every year were "a major national
problem," it implied that these criminals were not worth much serious attention or
concern, which is the opposite of what Lange conveyed in "Public Defender."

In the last photoessay she tried to do for *Life*—which was interested enough to pay
her a thousand-dollar retainer—Lange photographed the destruction of the fertile
and prosperous Berryessa Valley, which was flooded to be a reservoir for California's
growing suburbs. Aided by a young photographer named Pirkle Jones, Lange re-
corded every stage of the valley's destruction: the gathering of the final crops; the sale

and auction of farmers' homes and belongings; the demolition of buildings; the clearing of stumps, trees, and brush by giant bulldozers; and even the disinterment of bodies from graveyards, to be re-buried on higher ground. The final pictures presented frightening images of desolation. One is of a terrified horse pawing the barren ground and another shows a monstrous bulldozer tearing the land into dust. It was a vision of a fruitful world that became as desolate as the terrible dustbowl photographs that Rothstein made in Oklahoma and Kansas in the 1930s, but this desolation was caused by "progress," not drought.[109]

After they received Lange's and Jones's prints, *Life*'s editors prepared a layout, but instead of printing it they ran "articles on storms and floods . . . for several issues, and [then] the editors decided there had been 'too many articles on water.' " The Berryessa Valley photographs were shelved. The magazine's stories on floods and storms enabled them to stay safely within the cliché that the relationship between people and their environment is a struggle in which nature is the menace threatening human life and property—a much more conventional and less disturbing idea than the insights implied by Lange's and Jones's study. *Aperture* published the Berryessa prints in 1960 as a photoessay with the title, "Death of a Valley." Minor White's introduction to it was an accurate and intelligent interpretation of the images and events and contained some perceptions that would not have appeared in *Life*: "Under the swelling pressure of a skyrocketing birth rate, places for people to live and water for crops and factories has become critical . . . Bulldozers are only slightly slower than atomic bombs . . . [and] the nature of destruction is not altered by calling it the price of progress. To witness population inflation of such proportions that ways of life are uprooted, fruiting trees sawed down, productive land inundated, and bodies already buried forced out of the ground is to realize that as life teems so does death. And that man is the active agent of both."[110]

After Lange's death in 1965, Eugene Smith, one of the best and most idealistic magazine photographers of his time, wrote an elegy for her in *Popular Photography*. He praised Lange's "Public Defender" and "Death of a Valley," and said it was "a downright crime . . . that the largest and most influential publications of our time have made so little use of her reportorial ability, that they have realized so little from her reportorial accomplishments."[111] It was an elegy not only for Lange personally but also for her efforts to create an honorable synthesis between the insights of serious, documentary photography and the exigencies of mass-media photojournalism. By the time she died, a later generation of documentary photographers who had been inspired by the FSA photographers were finding new ways of reaching an audience—and *Life* magazine was not one of them.

The American Way
of Life at Home and
Abroad

The intention to communicate and inform, and to bring the world to you in some new narrative form for almost no expense, to buy a magazine for 10¢, was a fantastic thing. It's like looking at television now. Looking at television doesn't cost you any money. . . . You can be entertained twenty-four hours a day, subsidized by the advertisers. The advertisers subsidized the [picture] magazines; for 10¢ you could get this world of photography brought to you.

– Cornell Capa in a 1977 interview

Photography, magic eye and faithful mirror, toy and instrument in the hands of modern man, conquers the world!

– Gevaret film advertisement in a
 brochure publicizing the
 Family of Man exhibit, ca. 1955[1]

As documentary photography declined in significance, particularly in the popular media, a different kind of photography flourished and became influential during the 1940s and 1950s. During that period, millions of Americans learned about their own country and foreign nations through the eyes and minds of editors, photographers, and journalists employed by a few news agencies and magazines such as *Life*, *Look*, the *Saturday Evening Post*, and *Colliers*. In particular, *Life* and *Look*, the two picture magazines, enjoyed such influence and prestige that according to Dora Hamblin the photographers from *Life* sometimes considered themselves "God the Photographer" and behaved accordingly toward their subjects. Gordon Parks asked a Danish military commander, "Please move your army two steps back for a better composition," and Ralph Morse told an American admiral, "I know it's expensive to move a whole fleet, but the ships are placed so we can't see the new plane maneuvering among them." One photographer decided to take a picture of bulls from a silo and insisted they be marched up a hillside, in formation. When Eliot Elisofon did a farm story in Nebraska, he planned shooting scripts like a movie director, ordered his assistants to have the required farmers, tractors, and other equipment waiting for him at 11:00 A.M. and then, when he arrived late, would announce, "the great Elisofon is here."[2]

Perhaps the most elaborate, and expensive, example of the cooperation the picture magazines could receive from their subjects occurred in 1956, when the air force assembled three dozen airplanes at an airfield in Florida. A *Life* photographer wanted to photograph them flying in formation from another plane hovering overhead. Since the planes flew at different speeds, it took three days and ten "fly-bys" before the photographer was satisfied. The cost of this single image, to taxpayers, was estimated at $300,000 for the jet fuel alone, but most of *Life*'s readers would not have realized the picture was subsidized by taxes and advertising, and they probably were delighted to see this awesome illustration of "air power" from such a divine, or at least angelic, perspective. The Deity referred to in Genesis may have "created the heavens and the earth," but He had not "packaged" His creations to be observed and consumed cheaply and easily. By the 1950s "God the photographer" corrected this oversight and gave readers beautifully organized, privileged visions of a whole "world of photogra- 151

phy." For a cost of only dimes and quarters, which was what *Life* cost at newsstands from the 1930s through the early 1960s, readers could indeed believe the camera was a magic eye enabling them to imagine they were seeing and conquering the world.[3]

Though photographers from *Life* and *Look* often traveled abroad, their magazines were filled with hundreds of pages of advertising by many of the nation's largest corporations; hence, one of their most important subjects was America itself. Millions of readers saw photoessays devoted to subjects like the American economy, the American woman, leisure in America, new "miracle" industries and technologies, the American military, and the U.S. teenager. The tone and message of many of these photoessays were expressed by a *Look* editor in 1955. "America is still the most exciting country in the world," he claimed. "It is changing faster than even Americans expect." The editor emphasized that certain good qualities of the nation's life had not changed: "Americans are still the friendliest, most informal, unsuspicious . . . people I know"; and they were "still in a hurry . . . working hard and playing hard." He went on to describe the changes taking place, most of which were for the better. Americans were moving more and becoming more "standardized," but this had its benefits, he said, since the " 'sticks' are no more, and the rubes and hillbillies are almost extinct." Everyone was watching television, becoming more cultured, buying more, and having more children. ("Culture is busting out all over," said the editor. "The nation is crawling with babies.") Behind these social and cultural changes was an economic change that greatly interested *Life*, *Look*, and their advertisers: "America's living standard has never been higher. Things they can't afford to dream about abroad are within everyone's reach over here. So you can't pay for the new split level. Who cares? In Los Angeles they offer you the "no down" [payment] plan. You move in without paying a cent. . . . I remember when minks and Cadillacs were emblems of affluence. Today, you need a Jaguar or Thunderbird to make an impression. And the pattern of prosperity is nationwide. . . . Thanks to production miracles and installment buying, Americans are acquiring at 35 the things they used to work for until they were 65."[4]

Americans were not the only ones who had the opportunity to learn about themselves and their country. During the 1950s the same vision of America was promoted all over the world by the journalists, photographers, and government officials who produced brochures, exhibits, and pamphlets distributed to millions of foreigners by the United States Information Agency (USIA). Photojournalism became, to use phrases from the 1950s, a "mirror" and a "showcase" for middle-class Americans because it enabled them to see their virtues reflected in magazines like *Life* and *Look* and also to exhibit the same virtues to others abroad. In fact, in some cases the same images were used both at home and in foreign countries. Eugene Smith's pictures of a hard-working country doctor, for example, appeared in *Life* magazine, where they demonstrated the virtues of volunteerism and the American medical profession, and also in *Amerika*, the illustrated magazine the USIA sent to Russia. Similarly, a 1947 *Life* picture of an Oklahoma farmer, his wife, and seven children—standing chest-deep in a wheat field to show how prosperous Dust Bowl farmers had become after World War II—also appeared in *What Is America?* and *Progress on the Land*, a book and

a brochure distributed by the USIA. The latter illustrated how the United States government had "been extraordinarily generous" and arranged "farm loans," "crop loans," and "ceiling prices" for farmers.[5]

There were a few moderately significant differences between the two picture magazines. *Life*'s images and photoessays often were more showy and visually assertive than *Look*'s. "A great picture is not merely seen," one of *Life*'s editors claimed. "It demands an emotional response." Virtually every issue of the magazine contained one or more big, glossy pictures meant to surprise, awe, shock, or delight readers. Some of *Life*'s photoessays are also notable for their heavy use of innuendo—a tendency that might have been encouraged by the magazine's proximity to *Time*, whose writers often resorted to this device. *Life*'s editorial comments were brash and assertive, and when they discussed subjects like the American way of life they were often chauvinistic and rather defensive. For example, when certain novelists dared to criticize the United States in 1955, the editors berated them for not appreciating the virtues of "the most powerful nation in the world. It has had a decade of unparalleled prosperity. It has gone further than any other society in the history of man toward creating a truly classless society. Yet it is still producing a literature which sounds sometimes as if it were written by an unemployed homosexual living in a packing-box shanty on the city dump while awaiting admission to the county poorhouse."[6]

Look was a calmer magazine and considerably more liberal than *Life*. Instead of railing at novelists, its editors and writers were more inclined to acknowledge that there were problems in the United States, particularly among its minorities, and to offer brisk, constructive solutions. The layouts of *Look*'s photoessays were less showy than *Life*'s, and its editors liked to use smaller, more subtle pictures instead of the "big picture" (impressively staged, full- or double-page spreads) favored by *Life*. By American standards of the time, *Look* had better taste and considerably more "class" than *Life* did. The USIA publications were, if anything, even more optimistic than the magazines. They tended to imply that the United States had already solved (or was about to solve) the social problems that occasionally troubled the editors of *Look* or, more rarely, the editors of *Life*.[7]

Despite these differences, both the magazines and the USIA publications expressed essentially the same message, which is summarized by the term that Michael Schudson applied to American advertising, "Capitalist Realism." This kind of realism, like Russian "socialist realist art, simplifies and typifies," Schudson said; it presents "lives worth emulating. It always has a message. . . . It always assumes that there is progress. It is thoroughly optimistic, providing a solution . . . for any ill or trouble it identifies."[8] In *Look* this optimism was particularly salient in the Reverend Norman Vincent Peale's column. When one reader asked him if he believed "we will meet and know our loved ones in Heaven," Peale responded, "The life beyond will be as filled with love and beauty and every good thing as is the here and now. . . . God is good to us here. He will be good to us there." *Life*'s editors could be equally positive. Perhaps the apogee of their optimism was the 1959 special issue on leisure, in which they acknowledged that, though America had not yet lived up to its full potential, it had the

"unprecedented" opportunity to create a civilization that "ought to be freer and bolder than the Greek, more just and powerful than the Roman, wiser than the Confucian, richer in invention and talent than the Florentine or Elizabethan, more resplendent than the Mogul, prouder than the Spanish, saner than the French, more responsible than the Victorian, and happier than all of them together."

Many of the USIA's publications seem to have been inspired by Max Millikan's and Walt Rostow's influential 1957 *A Proposal: Key to an Effective Foreign Policy*. "The United States is now within sight of solutions to the range of issues which have dominated its political life since 1865," Millikan and Rostow claimed. "The farm problem, the status of big business in a democratic society, the status and responsibilities of organized labor, the avoidance of extreme cyclical unemployment, social equity for the Negro, the provision of equal educational opportunity, the equitable distribution of income—none of all these great issues is fully resolved; but a national consensus on them exists within which we are clearly moving forward."[9] Obviously such a successful nation, which was about to solve all of its own problems, could solve other nations' problems as well, and their book dealt with how America could use foreign aid to achieve exactly that goal.

Despite all this optimism and idealistic rhetoric, which caused editors and photojournalists to work hard at "showcasing" and idealizing the nation's virtues, photojournalism itself (including much of that which appeared in *Life* and *Look*) was a visual genre with some rather humble antecedents and a number of ambivalent—almost schizophrenic—qualities. "Respectable" journalism was published and edited by such eminent Dr. Jekylls of the American media and political establishment as Gardner Cowles, Jr., and Henry Luce, who printed the columns, memoirs, and histories of people like Bishop Fulton Sheen, the Reverend Norman Vincent Peale, Winston Churchill, and John Foster Dulles. But another kind of photojournalism, usually euphemistically referred to as "sensational," seems to have been edited by a Mr. Hyde, who had less genteel tastes. God the Photographer's diabolic counterpart reveled in pictures of death, violence, cruelty, and destruction. This dual nature of photojournalism was summed up by German philosopher Erich Kahler's comments on the format of *Life* magazine in the 1940s. After quoting Ernst Junger's description of photography as "an unfeeling and invulnerable eye," Kahler criticized the "callousness" of the mass media, which mixed advertising with atrocities, and added that the worst examples of this attitude were popular magazines like *Life*, which not only recorded

the crassest details of horror scenes, accidents, suicides and catastrophes . . . but, beyond that, it advisedly intermingles these appalling pictures with displays or advertisements of sumptuous comforts and merry carousing.

Here we can find Chinese children dying of hunger alongside a display of . . . clothes for children costing around $120.00. . . . Here we see vultures fattening on Indian corpses . . . and pictures of Nazi doctors working on human guinea pigs, while on the following pages we may find an elaborate picture story on a billionaire's club in Florida or a "house to swim in" in Palm Springs. . . . It is

hardly possible to enumerate all the offenses against human sensibility and taste which these visual records contain.[10]

Both sensationalism and the more respectable kinds of photojournalism started to become popular in the late nineteenth and the early twentieth century, when newspapers and magazines began to be illustrated by mechanically reproduced photographs. Readers of these picture magazines and newspapers were described, in a British context, by the English editor Tom Hopkinson. He believed this audience was created by the spread of mass education and literacy, which "produced a mass audience which could read, but in many cases no doubt only with difficulty. However, they could certainly follow pictures, and were eager for something better suited to their tastes than the stolid periodicals of the Victorian times. For such an audience the popular 'picture tabloid' was exactly right, and its price, one halfpenny, was just right for their pockets."[11] One salient feature of these illustrated newspapers and magazines, as Hopkinson indicated, was that they were usually very inexpensive: therefore, they had to have mass appeal and/or be subsidized by a large volume of advertising. They appealed to an audience that enjoyed other inexpensive twentieth-century media such as movies, radios, newsreels, records, and (finally) television, which also communicated mainly with images or sounds rather than with words.

Despite their popularity, however, these new media were remarkably unpopular with many philosophers, intellectuals, and creative writers. Hamlin Garland in 1930 stated sadly, but fairly precisely, that earlier in the century the editors of mass-circulation magazines began to study "the appetites of the millions and not the tastes of the cultivated few. . . . Editing became more and more a process of purveying . . . an appeal to shopgirls [and] tired businessmen." Similarly, in his 1929 novel, *I Thought of Daisy*, Edmund Wilson satirized the mass media through his characterization of a cynical advertising writer who boasts to a tabloid editor, "You'd never believe what the boobs will consume till you actually commence to feed 'em. You can make 'em do anything, buy anything! All you need is a gaudy picture and an idiotic phrase." The equally cynical editor agrees, "You can't lay it on too thick—the more maudlin and preposterous it is, the better they seem to like it."[12]

The mass media possessed another quality, however, that probably contributed greatly to their popularity. They all, through the use of new technologies, gave their audiences a strong sense of immediacy—or at least the illusion of immediacy—that increased the power of their emotional effects. One of the more important media stories of the 1920s, for example, was the death of Floyd Collins, a trapped Kentucky cave explorer. He was interviewed by a radio reporter "who had crawled through the shifting sand himself, adding his own sense of terror to that of the buried victim," as he reported his "frightened prayers and entreaties."[13] Similarly, as Hopkinson said of twentieth-century picture magazines and newspapers, their photographic images allowed "the man in the street" to come "into direct visual contact with the world in which he lived. His horizon was lifted beyond his street . . . without the intervention of any visualizing artist. . . . Through the photographs in his daily newspaper he came to

know what the important men and women of his time . . . looked like. He formed some impression of foreign countries and their ways of life. . . . At the same time he derived a new enjoyment from the excitement of sporting events and the splendour of great occasions. *He was no longer one of the mass who had always been excluded* [emphasis added]."[14]

But even if seeing these images made ordinary people feel included in a larger world, what they saw was usually quite selective. First, because of their formulaic quality, certain kinds of realities were invariably featured more than others because there was a better "market" for them. Celebrities, for example, were always "news-worthy" and often had their pictures in magazines, whereas factory workers were almost never "news"—except when they were on strike and fighting with police. Sometimes these magazines showed ordinary people in feature stories that superficially resembled documentary studies; however, unlike documentary work, these images of ordinary Americans were almost invariably reassuring, and they were presented to illustrate popular stereotypes about patriotism, progress, gender roles, and the joys of consumerism. Moreover, the editors of some magazines (like *Life* in the 1930s and much of the 1940s) usually avoided news and feature stories about controversial issues. *Life* "could not afford to make a statement on a segregated South, violent crime and political corruption," Clare Booth Luce acknowledged in an interview, because "we understood that the magazine was an escape for an audience that didn't have time for problems. Even during [World War II] the idea of patriotism and national unity drew the minds of *Life* magazine['s] readership away from the Detroit race riots, the narcotics ring in Harlem and the wartime profiteering scandal hearings in Washington. If such situations were too heavily harped upon, *Life* could very well have been rejected by its subscribers."[15]

The most successful new publishing ventures packaged their "products" most briefly and simply: this was evident in the United States by the mid-1930s and was another reason that the print mass media were selective and superficial. The most profitable magazines and newspapers made smaller and smaller demands upon the reader's attention span, intellect, and literacy. By the time he and his family started *Look* in 1937, Gardner Cowles, Jr., decided that "the public, generally speaking, won't read long columns of type in any newspaper or magazine explaining heavy-weight, important public problems," and that the most successful new publishing ventures (like *Reader's Digest*, *Time* magazine, and tabloid newspapers) all "condensed their contents more than their predecessors." The public, it seemed, did not want much thinking or complexity; it wanted short, snappy, entertaining news items rather than "long columns of type." The popularity of *Life* and *Look* showed that it also wanted plenty of vivid, exciting pictures.[16]

Another influence on magazine editors and publishers was their need to please advertisers.[17] The best way to do this was to have large circulation numbers. This meant, particularly in the late 1930s when *Look* and *Life* were getting started, not only that the editors avoided "heavy-weight, important public problems" but also that they were extremely partial to what one critic called "old stuff, tried and proven": photo-

journalistic genres like sports, violence, sex, animals, and cute babies. Two of these genres, violence ("sensationalism") and sex ("cheesecake"), are especially revealing about the values of magazine editors and audiences.[18]

The portrayals of "national character" so popular in American magazines and books during the 1940s and 1950s often emphasized that Americans were a "friendly" people who loved "decency" and "fair play," and that they were "aggressive" only in self-defense.[19] Yet, during this same period, some of the most popular news photographs were violent and contained, as Kahler pointed out, "the crassest details of horror scenes, accidents, suicides, and catastrophes." When they started their magazines in the 1930s, the editors of *Life* and *Look* were quick to exploit this taste for the violent and the macabre, and they particularly emphasized pictures of victims of violence. When Luce and his editors were making up the prospective issue of *Life* in 1936, they went through some five thousand pictures that were available to magazines during a single week. Among the ones they selected "were those of a lynching, brutally captioned 'Nigger Hunt,' [and] a murderer strapped in the death chair." The early issues of *Look* were designed to appeal to the same tastes, and when that magazine's circulation reached one million, the *New Republic* described it as a "morgue and dime museum on paper. . . . We can think of no reason why *Look* should not go to a circulation of ten millions—if the supply of corpses holds out." Once *Look*'s popularity was established, however, its editors published relatively few violent images and began emphasizing the feature and celebrity stories, sports, and "social problem" photo-essays that were its staple ingredients during the 1940s and the 1950s. *Life*, on the other hand, continued to publish violent news pictures throughout the 1940s. In 1946 one of its editors told Luce, in an in-house memo, that their magazine's huge circulation was due to "the kind of sensational reporting that only *Life* produces. We're all sensation mongers. . . . Let's make plenty of provision for book larnin' and gracious living but let's see that it is wrapped around some good solid sensations."[20]

How do Americans reconcile their love of violence with their self-image as decent, friendly people? Herbert Gans commented that the United States is "in many ways a violent society, permitting all kinds of violence against foreigners, minorities, and deviants, which is duly reflected and publicized by factual and fictional media fare."[21] That is, violence is acceptable both in American society and in its mainstream media (either as news or entertainment) primarily when it is directed against "outsiders"— people who are not considered "friends" and do not belong to the country's white, middle-class majority. Thus outsiders—whether they are Native Americans, blacks, Asians, or (more recently) Arabs and Central Americans—are often treated as designated victims, people whose sufferings and corpses can be photographed and packaged as "sensations" for the media.

When *Life* magazine's violent pictures are analyzed from this perspective, many of them fit Gans's criteria so well that it seems clear that a kind of protocol was followed, presumably by both photo agencies and editors. In addition to pictures of accidents and disasters, there were many pictures of violence to foreigners, people from "darker races," and/or members of American minority groups. In late December 1936, for

example, *Life* published one of the more extreme examples of callous bad taste. Following immediately after a reverent article on the "Life of Jesus Christ" published for the Christmas season, the editors presented two pages showing Chinese Communists being beheaded or shot by Chiang Kai-shek's police. "Here (left) is the executioner, marching out with 'sword of justice' to decapitate a Red," said one caption. "Note the horror on the spectator's face as he looks down at the severed head, and the cruel smile on the executioner's [face]." And in February 1938, *Life* showed a picture of the corpse of a Kansas City black man, photographed so readers could see his face ("Negro killed in row over $10"). When accident victims and dead or dying black people, foreigners, and Asians were not in the magazine, *Life*'s readers had to be satisfied with pictures of animals being killed, as in "A Dying Moose Makes a Great Hunting Picture."[22]

This protocol governed not only who could be seen as victims of violence but also how they could be seen. Readers looked directly at the face of the dead black man in Kansas and saw the Spanish Republican soldier in Robert Capa's famous picture as he was falling backward at the instant the bullet struck him, but the three dead American soldiers in an equally famous *Life* World War II picture are all lying quietly on a New Guinea beach. They are photographed from an angle, no wounds or blood are visible, and their faces are obscured by their helmets. A similar protocol seems also to have governed the magazine's captions. It might have been unpleasant for *Life*'s readers, or its editors, to acknowledge openly that they enjoyed looking at dead or dying people, and therefore the captions often have a deliberate numbness or pseudo-objectivity— as if they were comments by a lecturer describing a laboratory experiment. "Robert Capa's camera catches a Spanish soldier the instant he is dropped by a bullet through the head," the magazine commented. One of the captions for its 1936 Chinese execution pictures advised readers to "Note the pistol's kick, the body's slump as the executioner sends his bullet ploughing through the head of this captured Chinese Communist."[23]

Just as violence was implicitly controlled through the selection and editing of pictures, so was sexuality; an equally careful protocol governed *Life*'s "cheesecake" pictures. Naturally, like most editors during the 1930s and afterward, *Life*'s editors never allowed pictures that hinted that women possessed pubic hair or nipples— thanks to the efforts of photographic retouchers.[24] But, apparently, overt displays of eroticism—in the manner of Manet's *Olympia*, for example—were forbidden. Such images would have suggested that women were aware of their sexuality and consciously willing to enjoy or exploit it. Sexually assertive women appeared in the mass media only as jokes (as in Mae West's self-parodies), or as castrating villainesses (as in *films noirs* like Billy Wilder's 1944 *Double Indemnity*). Even the mildly erotic "How to Undress in Front of Your Husband," an early photoessay Luce published over the objections of his editors, caused such a commotion that nothing like it was ever repeated. Instead, *Life* specialized very frequently in pictures of nubile young acrobats, movie starlets, cheerleaders, and ice skaters who always managed to be leaping or jumping, so that *Life*'s readers could get an excellent view of their thighs and panties.

Models and starlets cavorting at swimming pools or in the ocean surf were just as popular. Perhaps the best example of how well *Life* exploited the conventions of this genre without endangering its status as a "family magazine" was the cover of the 3 January 1938 issue. Ice skater Sonja Henie was photographed, as she turned with one leg in the air, from such a low angle—the photographer must have been lying on the ice—that readers saw up into the crotch of her panties. Elsewhere in the same issue, readers saw two more pages of Henie ice-skating, two pages of Marlene Dietrich and her famous legs, nightgowns modeled as evening dresses, and a news picture of a young woman, a United Autoworkers picket in Kansas City, being hauled to a paddy wagon and photographed as her skirt fell. A week later, a photoessay, "Hollywood Keeps Fit," featured French actress Danielle Darrieux doing exercises in a bathing suit; later in that issue there was a full-page picture of the severed head of a Chinese man executed when the Japanese captured Nanking.[25]

These photojournalism genres, still popular with tabloid newspapers, reveal the extent to which editors changed photography not only into what Ernst Junger called "an unfeeling and invulnerable eye" but also into a pseudo-innocent eye that enabled readers to enjoy the pleasures of voyeurism without considering themselves voyeurs. However, *Life*'s "cheesecake" pictures also raise an issue relevant to certain other, more "respectable" kinds of photoessays. Commenting on André Rouillé's *Le Corps et son Image*, Michel Melot pointed out that many photographs can be categorized according to three codes, which reveal different relationships that can exist between the subject, the photographer, and the audience. In portraits, the code is imposed by the subject to create "the image one wishes to make of oneself . . . the individual 'propaganda' image . . . an ideal and synthetic self." The second category or code includes the bodies of women in pornographic pictures and photographs of police suspects and convicts: "dominated peoples assembled in artificial scenes by ethnographers or the army, the sick and the monstrous." These people are seen as objects posed according to the photographers' rules. A subcategory of this code includes many pictures made in the documentary style, in which the rules are not imposed but instead are openly agreed upon by the photographer and the subject—such as, for example, the tenant farmers who cooperated with Evans and Lange in the 1930s. The third code is more subtle. It involves a complicity between the subject, photographer, and audience to pretend that there is no code at all governing the behavior of the people in the image; as a result, the photographer is able to create "the effect of the real."[26]

This third code applies perfectly to *Life*'s "cheesecake" and starlet pictures. The women pretend to be amusing themselves, not posing for a photographer. This same complicity, on a larger scale, also existed in many photoessays about how ordinary, middle-class Americans lived and behaved. In order to photograph people in their own homes, in restaurants, or at parties, photographers had to use large amounts of flashbulbs and floodlights. They could be extremely demanding in pursuit of the "perfect" picture. Hamblin described their visits to private homes as "assaults" that would take three days to complete, rather than the "couple of hours" originally



requested. Photographers persuaded their subjects "to chop down trees ... move fences, paint walls, [and] put on their Sunday clothes when it was only Tuesday." Nevertheless, the picture magazines resolutely maintained the illusion that their photographs were not "staged"; presumably the subjects themselves understood that they had to look natural if they wanted to appear in the magazine. It seems that this principle was so well-established by 1938 that, when one *Life* photographer went through a steel mill, he noticed that as soon as "steelworkers noticed his camera, they'd assume highly dramatic poses." Another photographer, taking pictures at a San Antonio high school, was amazed at the students' sophisticated cooperation. "They didn't pose; they didn't look at the camera; they behaved naturally."[27] In other words, people already knew, from seeing picture magazines, how they were supposed to look when they were "on camera." Further, picture magazines could afford to pay photographers to spend days or even weeks photographing their subjects, and they could make hundreds or even thousands of pictures to be culled to a few dozen, well-composed, "natural" pictures for the final photoessay.

Adding to this implicit flattery was an additional sense of social and visual order created by the editing of the photoessays. Activities, places, or institutions that were well-regarded by the middle class and that represented its values—such as schools, hobbies, sports, small towns, civic ceremonies, military academies, and colleges—were invariably seen in a flattering way. (Magazines often dealt only with the non-academic side of college activities, such as social life and sports.) People were neatly grouped according to well-recognized social and age categories, with a heavy emphasis on the jolly, the hearty, the provincial, and the wholesome. In December 1940, for example, *Life* published one of its "Visits" photoessays. Staff photographer Bernard Hoffman went to Franklin, Indiana, to do a photoessay about "A Small Town's Saturday Night."[28]

Presumably because they agreed with the attitude toward American small-town life expressed by Warren Harding twenty years earlier ("There is more happiness in the American village than in any other place on the face of the earth.") the editors were emphatically upbeat in their introduction. They claimed they were showing readers one of "America's great institutions," a "joyous native phenomenon," in which "nearly everybody is neatly dressed, good-natured and chatty. Nearly everybody toots his auto horn at acquaintances and stops to visit with friends. . . . A tingling electric excitement fills the gasoline-scented streets. The whole town quivers with life and light and sound . . . Here, 22 miles south of Indianapolis, [the photographer] found a perfect Saturday-night setting: a bustling main street, an old-fashioned Court House . . . a small local college full of handsome youngsters, a fertile countryside full of friendly farmers." Since *Life* wanted a perfect Saturday night, and one they considered typical, the photographer did not select a town still blighted by the depression; and for the main subject of his photoessay he selected Glen Dunn, a prosperous farmer who was not at all like the poor farmers the FSA Historical Section had photographed. Dunn owned a fairly new Plymouth sedan and a 250-acre farm that had electricity, a telephone, big barns, and fifty head of cattle. In town, Dunn had his hair cut, his wife

and daughters shopped at the dime store, the smaller Dunns went to see a movie, and the older sister enjoyed a ten-cent soda at a drugstore with her boyfriend. In the remaining two pages, *Life* showed other, equally pleasant activities in Franklin: the 4-H band; college students in their "hangout" near the campus where "boys and co-eds 'coke,' smoke, date, and dance"; high school students in their "hangout; Nick's candy kitchen;" a new bowling alley; and, finally, the town's lover's lane at night.

Thanks to the cooperation of the Dunns and other Franklin citizens, the entire photoessay looks quite "natural"—including the picture of the children in the movie theater, which must have been made with a whole battery of flashbulbs or floodlights on the row of children facing Hoffman's camera. Besides creating this "effect of the real," the photographs are arranged in a sequence that has an implicit visual order. First, there is a crowd shopping on main street, to imply the town's prosperity; then a close-up of a group from that crowd, the Dunn family, arranged in an afternoon/early evening/night sequence; then the final two pages on other Franklin citizens, ending with the late-night picture of lover's lane. In addition to this visual orderliness, there is also an inherent social order. Everyone in Franklin, in the photoessay, has his or her proper place—even the college and high school students have separate "hangouts." A naive intimacy is conveyed by the captions, filled with trivial facts and a few bits of slang: for example, the Dunns's daughter's boyfriend was named Mayo Heath and was "the math shark at Franklin". This orderly accumulation of details and images creates an impression of totality, a sense that the reader is learning all about Franklin, and many other American small towns as well. But a skeptic might comment that this impression is rather naive. After all, *Life* did not show any of Franklin's citizens enjoying a poker game, a night at a pool hall, a mixed drink, or even a beer in a local bar. What *Life*'s readers wanted, it seemed, was a stereotyped village that confirmed their nostalgic beliefs about small towns in which no one is bored, poor, or lonely; and the magazine's photographer and editors—like Norman Rockwell in his *Saturday Evening Post* covers—gave them exactly that kind of town.[29]

■

This willingness to see ordinary Americans and their middle-class institutions and culture in such a positive way was encouraged by the surge of sentimental, conservative populism that took place in the late 1930s and during World War II. Earlier in the 1930s there had been the more radical populism of Huey Long's Share Our Wealth program, whose two goals, as summarized by the *New Republic* in 1935, were to " 'give every man, woman and child in the United States five thousand dollars,' with a home, a job, a radio and an automobile. . . . The other [objective] is to prohibit great fortunes."[30] Relatively radical populism, like Long's, encourages "the people" to oppose "the interests:" the millionaires and the established elites and "their" institutions—banks, railroads, and the prestige press. Conservative populism is based on the more comforting idea that these established institutions can become the collective, democratic embodiments of the ordinary "little people" and their values, if a few

idealists band together against the cunning "interests"—just like Jimmy Stewart and his admirers triumphed over the corrupt politicians in Frank Capra's 1939 *Mr. Smith Goes to Washington*. Conservative Populists like to ignore or de-emphasize the differences or conflicts between social or racial groups and to concentrate on themes or "values" that unite them, such as nationality, love of home, and family. Above all, conservative populism is emotional and patriotic, the perfect "creed" to link diverse groups in America—some of which may have different or even conflicting interests—into a nation united against foreign enemies.

Conservative populism took many forms. Academics and intellectuals produced books and articles about quintessentially American ideas and values such as "Democracy" and the "American Creed." "What really stirs our hearts and minds is our set of ideals and values," one sociologist wrote in 1944, and "our respect for certain symbols which convey these ideals to our attention (the American flag, for example)."[31] There were many other symbols and expressions of populism in the popular and mass media. In music, there was John LaTouche and Earl Robinson's "Ballad for Americans," which was sung by Paul Robeson on a national radio network in 1939, published in *Fortune* and *Newsweek*, and sung as a kind of anthem at the 1940 Republican convention. On Broadway, there were dramas like Rodgers's and Hammerstein's 1943 *Oklahoma!*, and in painting, there were Norman Rockwell's enormously popular *Four Freedoms*, which were *Saturday Evening Post* covers. At the movies Americans could see Frank Capra's sentimental populist films during the 1930s, William Wyler's 1946 *The Best Years of Our Lives*, or John Ford's 1940 film version of *The Grapes of Wrath*, which ends with the surviving Joads in their jalopy chugging toward the rising sun as Ma Joad proclaims: "We're the people that live. Can't nobody wipe us out. Can't nobody lick us. We'll go on forever. We're the people." In poetry, there was Sandburg's *The People Yes*, and in politics there was Henry Wallace's attempt to internationalize populism with his "Common Man" speeches, one of which ended with the declaration that "the world is one family." Even *Fortune* magazine, which Marshall McLuhan once described as "managerial Grand Opera," expressed the mood of the times in February 1940, when its editors temporarily restrained their passion for big business executives and devoted a special issue to "The United States of America." It was filled with pictures of all kinds of common men and women and their children. The organization of large corporations was represented by a "Management Chart" entitled ONE BIG FAMILY and illustrated by cute cartoon figures representing everyone from the president of the company to workers and clerks—a vision of American industry that might not have amused union organizers of the time.[32]

Photographic images—whether they were seen in museums (Edward Steichen's *Road to Victory*), in books (Caldwell and Bourke-White's *Say, Is This the USA?*), or in magazines (*Fortune*, *Look*, and *Life*) were virtually a perfect media for visualizing this kind of populism; eventually it achieved its visual apotheosis in 1955 in Steichen's immensely popular *Family of Man* exhibit, which was seen by hundreds of thousands of Americans and millions of foreigners. It was exhibited first in New York at the

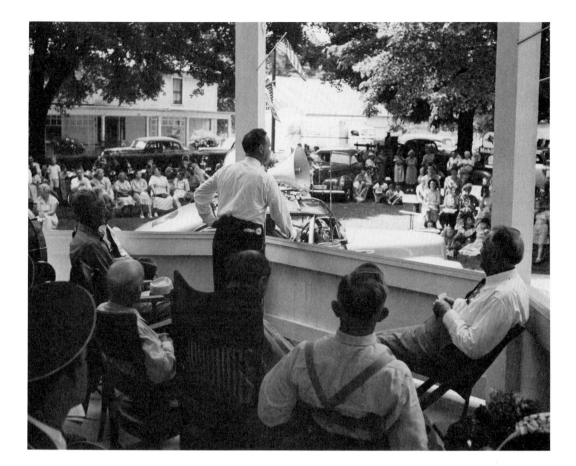

Museum of Modern Art and then was sent abroad by USIA to eighteen foreign countries. Purged of any overtly chauvinistic elements, the *Family of Man* proclaimed that here was how Americans saw the world and invited others to see it: one vast family sharing the same experiences (procreation, birth, work, worship); troubled by the same fears and problems (poverty, war, death); and delighted by the same joys (love, family life, parties, festivals). As Roland Barthes commented in his analysis of the exhibit, the *Family of Man* stressed exoticism and diversity by showing infinite variations in people's "skins, skulls, and customs"; but then "from this pluralism, a type of unity [was] magically produced," because "man is born, works, laughs and dies everywhere in the same way."[33]

Small-town Fourth of July, Belleville, Ohio, 1949 (National Archives)

During the late 1930s and throughout the 1940s, the American media frequently used photographs to illustrate populist themes celebrating the triumph of national unity over diversity. Editors could select individual pictures from a wide range of American groups and regions to create a sense of diversity, but could then group them in thematic patterns that united them. This implied that all Americans could transcend their differences and join together to achieve common goals. In effect, such groupings were the conservative equivalents of nineteenth-century French paintings,

like Delacroix's *Liberty Leading the People* and Jean Victor Schnetz's *Combat de Hotel de Ville*, in which all social classes—from the haute bourgeoisie in top hats to artisans in their smocks—rush to the barricades, united by their passion to defeat tyranny.

The messages of these conservative, populist works are fairly simple. There are not any forgotten or "no-count" people in America, since here everyone can speak up. Our experiences "count" for something. Americans are decent folks who do not want to exclude anyone, bully anyone, or force them to "sink or swim," like some of their parents might have done back in the bad old days of Gilded Age capitalism. Such ideas were not significantly different from the New Deal, the Popular Front of the mid-1930s, or the progressive beliefs of the early twentieth century. But in those versions of populism it was frequently emphasized that "the people" might have to struggle for their rights against selfish tycoons, bosses, "economic royalists," or robber barons. In contrast, conservative populists assumed that these rich and powerful individuals were eager to join "the people" and be united with them. "The tycoon is dead," asserted Max Lerner in 1957, quoting from *Fortune* magazine; and throughout the 1940s and 1950s the media abounded with stories of the tycoon's successors: public-spirited, unselfish managers and executives who were concerned with the country's general welfare, willing to let workers join unions, and eager to work for a "dollar-a-year" in Washington during World War II or as high-level civil servants and cabinet members in the 1950s. Therefore, since "the people" did not have any domestic opposition, they could all unite against *foreign* enemies—the Germans and Japanese in World War II, and then the Russians and the Chinese after the cold war started.[34]

Conservative populism obviously had a good deal in common with the liberal version of the American Dream, with its emphasis on equality, but another important ingredient was needed, a kind of socioeconomic yeast, to encourage the belief that all of these common men and women could rise and transform themselves and their nation into the bustling, prosperous, capitalist utopia projected in the mass media during the late 1940s and the 1950s. That ingredient was a revival of the vigorous optimism about American industrialism, which flourished in the 1920s and which Barry Karl called "messianic materialism:" the belief that America could cure all of its own problems, and the world's, by increasing its industrial production and "spreading prosperity." Probably the best known expressions of this idea in the 1920s were Herbert Hoover's New Era speeches, in which he claimed, "We in America are nearer to the final triumph over poverty than ever before in the history of any land"; but liberal economists Rexford Tugwell, Thomas Munro, and Roy Stryker were even more eloquent in their 1925 textbook, *American Economic Life and the Means of Its Improvement*. Surveying the American economy, they were a little perplexed by its inequalities. "We have both prosperity and poverty," they brooded. There were "classes who live in no fear of want, who are assured that a good livelihood will result from their economic efforts," at the same time that other Americans lived "in constant fear that, in spite of their best efforts, somehow calamity will descend upon them. A period of mysterious business depression that closes mills and factories, the introduc-

tion of some new machine or process . . . old age, accident—all have a frightful power over their lives." But this situation was only temporary, they decided, since industrialism had placed the United States "within striking distance of an economic order where the means of well-being shall be established for all," and they justified this prophecy with an analogy from the Book of Exodus. Americans, they wrote, were "like a chosen people on a dividing ridge between the desert, through which we have just come with pain and struggle, and the promised land, in the hope of which we have been sustained. . . . We stand facing the desert, thinking desert thoughts . . . [mumbling about] the sins and sorrows of a homeless folk, when we might run like children . . . down into grassy, well-watered valleys, privations forgot, hearts full of an opulent tomorrow."[35]

Such optimism could not be justified so easily during the depression, when hundreds of thousands of Americans were literally, not metaphorically, "homeless folk"; but it still persisted in the minds of some of the nation's planners, managers, editors, and executives. In the late 1930s it was revived in the iconography of the 1939 World's Fair, with its "World of Tomorrow" visions of unlimited economic, social, and technological progress. The World's Fair, *Life* magazine announced in July 1939, was "a stirring conglomeration of today's world, a boast by America about America for Americans." Its industrial exhibits, prepared by corporations like General Motors and General Electric, showed Americans an "opulent tomorrow" in which they would drive shiny new automobiles, live in clean, perfectly planned cities, and be served by technological marvels like talking appliances and household robots.[36]

Commentators have often noted how ironic it was that the international vision of peace and harmony of the World's Fair was contradicted by World War II, which began four months after it opened; however, they have ignored the way in which the war indirectly encouraged the *national* vision of a perfectly organized, capitalist utopia. After September 1939, many American planners, economists, managers, and executives correctly realized that, first, "preparedness" and, then, war spending would revitalize industry, stimulate the economy, and end the depression. In October 1941, Adolf Berle, Jr., an assistant secretary of state and a member of Roosevelt's original "Brains Trust," published an article in *Fortune*, in which he assumed that the United States would enter World War II and that "a long, hard, bloody road [had] yet to be travelled," but that the real challenge for American managers and planners in government, large corporations, and universities would be to organize the nation's *postwar* economy. If this was successful, Berle predicted, "We shall have an opportunity to create the most brilliant economic epoch the U.S. has yet seen." It would be "entirely feasible to make the country at once more prosperous and more free than it has ever been. We shall have in our hands the tools by which we can create a greater measure of economic justice, without sacrificing any of the essential freedoms. The country will have set up mechanisms for production on an unparalleled scale. Far from being bankrupt, we shall be richer in productive power than any economic system hitherto known."[37]

A key feature of this new prosperity was that it would be created by cooperation

between the government and big business, with some help from the universities for good measure. It would plan the economy (thus pleasing liberals and New Dealers on the left) yet retain "essential freedoms" (thus satisfying conservatives and Republicans on the right). It would deliver "economic justice" for the general population as well. In other words, as the publication of Berle's article in the nation's leading business magazine signaled, the conflict between the New Deal and big business—symbolized by the FSA photographers' irreverent pictures of the NAM billboards—was over. The country's managers, bureaucrats, professors, experts, and executives set out to construct the great consensus supposed to prevent any future depressions or hard times, to solve all the nation's economic and social problems, and to make ideologies irrelevant.

One key feature of this consensus was that it assumed the country would become so prosperous, and be so well-managed, that everyone's American Dreams could come true. If the United States chose to do so, the editors of *Fortune* wrote in May 1942, it could create a postwar world in which "there need be no serious postwar depression and certainly no unemployment," and there could be "almost unlimited opportunities for the profit-seeking individual and a vastly higher standard of living for all people."[38] Thus for conservatives the expansion of industry during and after World War II would mean that, once again, America would be a "land of opportunity" in which there would be "almost unlimited chances for profit-seeking" individuals to get rich; and at the same time liberals could believe that they were going to complete the New Deal and give everyone "a new democratic world" in which all people everywhere would have "a decent standard of living, including a job, good housing, recreation, and health, unemployment, and old age insurance."[39]

By the 1950s this confidence became codified and more overtly ideological. Editors and experts began to claim that the country's social, political, and economic system had "evolved" or transformed itself into what Peter Drucker said was a new kind of industrial society that went "beyond capitalism and socialism" because it was "a new society transcending both." A variety of terms were coined to describe this New Era (to use Hooover's phrase) of American life, but one of the more significant was "People's Capitalism," a phrase adopted in 1956 by the Advertising Council and the USIA for an exhibit illustrating American growth from 1776 to the 1950s. This exhibit, set up in Washington, D.C., for seven months and then sent to tour Asia, Europe, Africa, and Latin America, demonstrated, among other things, how the United States had changed. It contrasted, for example, a replica of a log cabin with an actual "modern, steel prefabricated five-room house, including all the modern labor-saving devices." The basic iconography of this exhibit was in the tradition of the conservative American Dream, which extolls the virtues of farm children who go from log cabins to the White House. This conservative motif was amended by a liberal emphasis on the way in which the exhibit was meant, according to the Advertising Council, to show "an economic system under which a very large percentage of the people own the means of production and under which workers fully share in the results of increased output through higher wages and more abundant goods at lower prices."[40]

Old-style capitalism, the experts and editors admitted, often benefited only a
relatively small number of wealthy industrialists and their families, who possessed a "ruthless preoccupation with profits" and amassed huge fortunes while "the general welfare was neglected" and "workers were over-worked and under-paid." But now, the experts and editors insisted, America had people's capitalism, "Man's Newest Way of Life," a qualitatively different kind of economic system that—"far from creating progressive poverty—has spread wealth even more widely" among all Americans. Or, as historian Allan Nevins claimed in 1950 in *Life* magazine, World War II "was, in some ways *our* finest hour." Cooperation between government and business enabled the United States to realize its full potential as an industrial power "in a prodigy of production . . . that eclipsed our wildest dreams" at the same time that it restructured American society, as "the pioneering spirit of social adventure . . . won successive and solid triumphs over the divisions and injustices that plagued the society of 1900. . . . [The] result has been the widest, the most decent and just distribution of the greatest production of goods in the world's history."[41]

The proponents of people's capitalism explained the good fortune of workers during the 1950s by reviving the paternalistic "Fordism" theories of the 1920s (and also some public relations advertising of the 1930s and 1940s) that *Fortune* described in 1931 as the "new capitalism" and the "Doctrine of High Wages." The key tenet was that large corporations like Ford and General Electric no longer hired their employees as cheaply as possible and then fired or laid them off during hard times. Instead, said *Fortune*, they treated their workers as "employee-consumer partners," paying them high wages and giving them other benefits that increased their "purchasing power and consumption." "The American worker is valuable to the boss not only as a man who produces goods in his factory. He is valuable also as a customer," said a 1950s USIA pamphlet about "Consumer Capitalism." Another pamphlet was illustrated by a picture of an actual worker-consumer in a supermarket with his family, with the caption: "One of the primary goals of the economic system in the United States is to provide plentiful consumer goods for the well being of all the people. Here a brickmaker and his family shop at a well-stocked grocery store."[42]

Above all, this consensus version of the Dream was filled with reassurances that now all Americans could count on their government to protect them in poverty or hardship. "Practically everybody in the country, regardless of political party, now assumes that if a depression threatens us, the government *must* step in to try to prevent it," historian Frederick Allen wrote in *Life* in 1953. "And furthermore . . . the government *must* see that people do not suffer inordinately as a result of hard times."[43] But in order to do this, to keep all these "employee-consumers" working, and to make sure that the corporations employing them continued to be profitable, government and corporate planners believed that it was essential to increase consumption, to maintain wartime levels of production. In 1942 the Committee for Economic Development asserted that a 30 to 40 percent increase in consumer spending would be needed to maintain the postwar economy "at acceptable levels," and in 1946 the Federal Reserve System Board of Governors called for a "rise of forty to fifty percent above pre-war

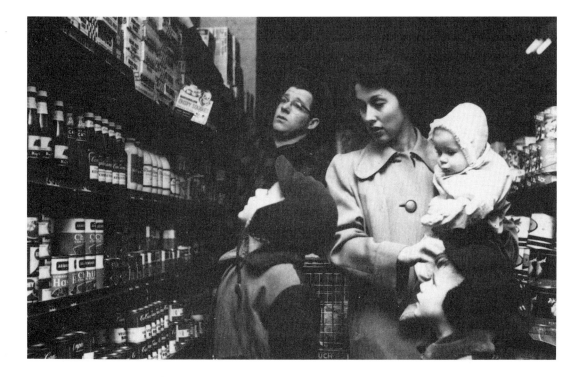

A worker
with his
family in
grocery store,
Shanesville,
Ohio, ca.
1954. Used
as an
illustration
for the
brochures
"American
Capitalism"
and
"Capitalism
in America:
An Indone-
sian View."
(National
Archives)

levels."[44] George Lipsitz pointed out that, to do this, it would be necessary to change the way many consumers thought about themselves and their country. "For Americans to accept the new world of 1950s consumerism, they had to make a break with the [recent] past," he wrote. "The depression years had helped generate fears about installment buying and excessive materialism, while the New Deal and wartime mobilization had provoked suspicions about individual acquisitiveness. . . . Depression era and wartime scarcity had led [Americans] to internalize discipline and frugality."[45]

If this insistence on discipline and frugality was a stereotyped reaction to American life, a "depression mentality" as it was called at the time, then the flamboyantly optimistic advertising and photoessays of the 1940s and 1950s expressed a documentary impulse—a desire to replace an excessively pessimistic viewpoint of the American economy with a more "realistic" and optimistic one. It must be pointed out, however, that this impulse was not disinterested: increased advertising would be needed to increase consumption, and this was clearly very much in the interest of advertising agencies, editors, and publishers, including the editors and publishers of picture magazines.

The editors of *Life* were particularly keen on increasing consumption when they raised their advertising rates in 1947 and their salespeople started to have trouble competing with other magazines. "The big manufacturers of consumer products . . . were still dubious about increasing their advertising appropriations" in the late 1940s, Robert Elson commented. Many executives were raised in the depression "and still had vivid memories of it; they were not sure that postwar prosperity would last." To dramatize the nation's "new economy," Time-Life, Inc., made up a show, entitled *The New America*, with a multiple-camera projection system allowing them to show full-

color slides on five giant screens. A team of photographers produced "a series of . . .
panoramic pictures that showed not only the natural glories of the United States but how dramatically the country had expanded since the war—the new factories, the prosperous and exploding suburbs with their schools and shopping centers. The message was clear: the country was confident and had money to spend."[46]

Even before Time-Life created this inspirational slide show, however, the magazine's editors started to produce photoessays with the same message. They put one together called "Dreams of 1946," in which they claimed that in that year "few dreams a man can have seem too improbable." They helped to encourage their readers' dreams with pictures of a slick new "dream car" designed by Raymond Lowey; a female model posed by "A Woman's Dream in 1946," a display that included "about $1,000,000" worth of gowns, mink coats, and emerald and diamond necklaces; a male model posed in hunting gear surrounded by rubber boats, golf clubs, bows and arrows, and other sports equipment ("A Man's Dream in 1946"); and *Life*'s pièce de résistance: a centerfold of a family with three small children standing by their new house in the country, with a Chrysler convertible, new appliances, a television set, lawn furniture and mower, pots and pans, and a $48,500 helicopter hovering overhead.[47]

Of course, *Life* and *Look* published many other photoessays that were not so crassly materialistic and whose general subject matter, how ordinary Americans lived, was similar to that of photoessays made in the late 1930s and the early 1940s. But these earlier photoessays, like the one about Franklin, Indiana's, Saturday night, probably functioned as reassurances to middle-class readers that their way of life was surviving the depression, despite any bad news they might have heard about Okies in California or violent strikes in Detroit and Flint. After World War II, however, photoessays often proclaimed that this way of life was not merely surviving but rapidly expanding and improving. It was this emphasis on progress and change, always for the better, that related them to the Dream and its faith that the United States is a nation with an extraordinary power to transform itself and the lives of its citizens.

When the cold war began, an additional documentary impulse was supplied by the belief that the American media needed to overcome the stereotyped ideas that some foreigners had about the United States. Thus a *New York Times* byline said explicitly that the Advertising Council–USIA *People's Capitalism* exhibit was "Sent Overseas to Combat Red Falsehoods" and was intended "for competition . . . with international communism." However, even foreigners who were not "Reds" sometimes had stereotyped views of the United States that were not as favorable as they might have been. After living and traveling abroad for eight years between 1946 and 1954, William Attwood said many foreigners believed in a "set of clichés" they derived from statements by American politicians, what they read and saw in the media, and the behavior of "slaphappy tourists." Among the clichés Attwood considered inaccurate were claims that "Americans are materialistic. They are too busy chasing the almighty dollar to appreciate the finer things of life, such as culture," and "Americans are immature and overbearing—like spoiled brats . . . who think they have a right to push other people around."[48]

What better way to dispel these notions than to publish photoessays filled with

images and examples illustrating how truly progressive, cultured, and democratic ordinary Americans were back in their hometowns? Consequently, Attwood's article in *Look* stressed how friendly, and not overbearing, Americans were, and pointed out, "Culture is busting out all over." "In town after town, we found amateur drama societies, symphony orchestras, [ballet dancers], art groups, and sculpture classes." Similarly, in 1947 *Life* magazine published a special Fourth of July issue that included a photoessay about Omaha, Nebraska, "An American City's Dream," claiming there was a "healthy ferment in American life" not only for a better town but also for a "better world." When all of Omaha's plans and dreams were carried out, *Life* suggested, "Omaha will be a far better place to live in. So, although few Omahans are now thinking in such terms, will the world. For this little example of American democracy in action will do much more for the historic democratic ideal than a thousand flights of Fourth of July oratory."[49]

■

By the late 1940s, the picture magazines and their photoessays were considered inspirations for Americans and foreigners more valuable than the usual patriotic oratory. Instead of mere words, photographs of real people and places promoted an American way of life that was an embodiment of American "ideals and values." Finally, at least in the picture magazines and propaganda pamphlets, Americans would become a "chosen people" and enter that "promised land . . . of milk and honey" that Tugwell, Munro, and Stryker described in 1925, or that efficient, immaculate "World of Tomorrow" constructed at the 1939 World's Fair. Moreover, it was also implied that all Americans seemed to be sharing in the nation's prosperity together, buying the same new appliances, laughing at the same television shows, and sharing the same wholesome "American" attitudes.

The *Twelve Photographers Look at US* exhibit held at the Philadelphia Museum of Art in 1987 reveals, on the other hand, that the United States is a very heterogeneous country. The people in Thomas Arndt's photographs of North Dakota farm families, for example, are so different from those in the bars of Nan Goldin's New York City series, *The Ballad of Sexual Dependency*, that they seem to be from different planets. Nicholas Nixon's pictures from poor city neighborhoods, mainly in the Midwest and South, and Larry Fink's rural Pennsylvania people, seem to have equally little in common with Bruce Gilden's Coney Island subjects, even though a sociologist might consider them all to be from the "working class." Barbara Norfleet's *All the Right People* pictures of rich Eastern and Southern families are images of a caste whose values, features, and mannerisms have nothing in common with the other subjects. Within its own context, moreover, the *Twelve Photographers Look at US* exhibit expresses a genuine pluralism; none of the subjects is presented as more important or more significant than the others, and none is presented as more "American" than the rest.[50]

The American way of life pictures and photoessays made for *Life*, *Look*, and the USIA in the 1940s and the 1950s, however, are notable for their homogeneity:

virtually everyone in them is white, middle class, and a member of a small nuclear family. The fathers of these families invariably hold full-time jobs and provide most or all of the family income; the mothers are housewives or have part-time jobs; the children are cute and well-mannered. The houses, except for farmhouses, are usually new and in the suburbs or in small towns (never old houses in big cities), and the people always had at least one fairly new car. These families closely resembled the people who had appeared in advertisements since the 1920s, the families in children's elementary school textbooks, and, above all, the happy families in the NAM billboards. For, like those families, these were specifically and insistently portrayed as being identical with America and its way of life. There was, however, one important difference. As the Professional Photographers of America in 1927 emphasized in a publicity campaign directed at advertisers, photographs could "mingle romance and reality . . . with a captivating charm that leads to bigger, quicker sales," yet they "are not discounted as the fanciful dream of an artist" would be.[51] So, even though the families in *Life*, *Look*, and USIA publications were presented with the same relentless optimism and charm as the ones in the NAM billboards, the messages conveyed seem more authentic because they are photographs, not drawings.

The favorite subjects of these visions of American reality were happy families. Analyzing them as they appeared in photoessays and USIA pamphlets, it is clear why they were so cheerful. First of all, they never seemed to contain any of the people (the infirm, the unemployed, the bankrupt, or the alcoholic) who sometimes make actual family life difficult. Indeed, according to the doctrines of people's capitalism, virtually the entire social and economic system of the United States was designed specifically to guarantee that families remained happy, prosperous, and secure. In their introduction to their special issue on "U.S. Growth" in 1954, for example, the editors of *Life* claimed the entire "trillion-dollar U.S. economy" was a machine "geared to one job— feeding, housing [and] defending the U.S. family." A brochure produced by the Board of Community Relations of Buffalo, New York, was even more specific about what Americans could expect from a "good community," which they defined as one in which "every family can obtain safe and attractive housing . . . in which every family has adequate protection from disease and injury, and resources to see its way through the cost and strain of serious illness. . . . A community in which everyone has the opportunity to earn an adequate living for the family and assurance of help if unemployment comes. Safety on the job and security for the breadwinner are essential parts of the security of the family." And, as if to emphasize how important an expanding industrial economy was to family life, this part of the brochure was illustrated by a picture of a man in work clothes with his wife and three children facing a billboard, put up by Ford's stamping plant in Buffalo, proclaiming: APPLY HERE TODAY / SKILLED— UNSKILLED—PRODUCTION / HELP WANTED / FORD MOTOR CO.[52]

On the job, at least in picture magazines and USIA publications, American workers never had to contend with speed-ups, dangerous working conditions, or unpleasant bosses. Instead, they always worked in clean, orderly factories where they attended production lines on which the work seemed, in the photographs, leisurely and not at

all difficult. At home, there was a heavy emphasis on leisurely, not-very-strenuous suburban activities and hobbies such as gardening, watering lawns, and building things like lamps and boats from prefabricated kits.

Also, virtually none of these families, particularly the ones in the picture magazines, seemed to belong to minority groups. They never had to worry about being "undesirable." Any religious or ethnic differences were consistently downplayed or ignored. (For example, Jews never wore yarmulkes and Roman Catholics never carried rosaries in photoessays about American economic and social conditions. Such details might appear in photoessays devoted to those religions, of course, but not in ones in which the people were seen as generic Americans.) *Life* magazine's elaborate special issues on subjects like the nation's economy and "America's Assets," which came out approximately once a year in the 1940s and 1950s, had a lily-white vision of America that was especially revealing and consistent. In fact, a foreigner whose knowledge of the United States was derived from these issues would have been surprised to learn that this country had millions of citizens who were, as some people now say, "persons of color."

In *Life*'s July 1947 special issue on "This Pleasant Land," the only black people in the main photoessays were a small group barely visible in a picture of tourists at the

Jefferson Memorial in Washington. The only blacks who appeared in the January
1950 issue on "American Life and Times: 1900–1950" were four men on a boat in an old picture that was part of a nostalgia photoessay. There were no blacks or other "persons of color" in the magazine's November 1946 tenth anniversary special issue; nor were there any in its 1951 "America's Assets" issue. The twelve "Great American Churches" in that magazine, chosen by a poll of one hundred thousand ministers, all had white ministers and congregations. Even more remarkable, the photoessay in the same issue praising General Motors implied—by omission—that all of that corporation's employees were white. Nor did *Life*'s 1954 "U.S. Growth" issue contain any pictures of blacks or other minorities. Therefore, compared to those magazines, the 1955 special issue on American food almost seems integrated. In a photoessay about an agribusiness there are five black men picking squash in a field, and if one looks very carefully at a picture of the Manhattan Chock Full O' Nuts restaurant in an "America Eats Lunch" photoessay, one can see three black waitresses and two black customers surrounded by hundreds of whites.[53]

Middle-class white people—whether they were farmers raising America's food, handsome young pilots defending its freedom, engineers and scientists building its "Wondrous Weapons" and discovering new cures, executives managing its great corporations, or just ordinary families buying its consumer goods—were identified in these photoessays with the nation's prosperity, fertility, power, and intellect. In contrast, black people, Puerto Ricans, Native Americans, and other minorities, when they appeared at all, were usually segregated in photoessays devoted to "America's Problems," and which described their "plight" and "poverty."

Almost everything about white families was seen with that reverence "for all that commends itself . . . as the right, the good, and the true," that, in Will Herberg's words, characterized the attitude of middle-class Americans toward their way of life in the 1950s. One of the subjects treated most reverently by the media were these families' new suburban houses. "Owning one's own home" was identified—particularly by real estate developers—as the American Dream; and pictures of middle-class families in *Life*, *Look*, and USIA publications often mentioned that these "typical" middle- or working-class people were homeowners or home buyers. Photoessays about these new houses and the way they were built never mentioned quality; they emphasized instead how cheap they were, how quickly they were constructed, and how families from coast to coast were buying them. A *Life* photoessay about standardized houses with "precut and preassembled parts," built by the members of the National Association of Home Builders, for example, stressed that the houses sold for as little as $15,000, and that they were built in Ohio, Oklahoma, Indiana, Texas, Kansas, Colorado, Pennsylvania, and Louisiana in as little as six weeks.[54]

Virtually everything about these houses was extolled as "better," "attractive," or "cost-saving," but the rooms in them praised most fulsomely were their "modern" kitchens filled with the latest appliances, just as the kitchens at the 1939 World's Fair had been. These kitchens were emblems of the supposed raison d'être of American capitalism and large corporations: slavish devotion to the happiness of middle-class

Suburban living, Levittown, Pennsylvania, 1954 (National Archives)

women, who were considered their best customers. "Suffrage for women did vastly less to 'liberate' them than the labor-saving devices that filled America's homes in this half century," Allan Nevins wrote in *Life* in 1950. "Women [have] never had it so good," William Attwood claimed in *Look* in 1955, because even though the "servant class" had vanished in most parts of the country, appliances and "the packaged foods of 1955" replaced "yesterday's cook and upstairs maid." And Richard Nixon made essentially the same claim in 1959 in his so-called "kitchen debate" with Premier Nikita Khrushchev, when he said one of the benefits of capitalism was that appliances like washing machines made "things easier for our women."[55]

The fact that the United States government sent a ranch-style house as an exhibit to Moscow, and that Nixon used its kitchen as a symbol of the virtues of capitalism, suggests that these kitchens were not merely emblematic; they were also iconic. For, like certain wonder-working statues of the Virgin Mary in Europe, they could demonstrate their powers in times and places of crisis. The kitchen sent to Moscow was the best known, but a kitchen sent to Berlin earlier was perhaps an even better example of the American way of life in action; it was staffed, presumably for demonstration purposes, with actual American women who prepared foods made with actual American ingredients.

According to advertisements and photoessays, the source of much of the American way of life was the nation's large corporations. Only a decade earlier many Americans regarded big businesses with a certain amount of distrust, or even hostility. THIS IS YOUR COUNTRY DONT LET THE BIG MEN TAKE IT AWAY FROM YOU, said a carefully hand-lettered sign that Dorothea Lange photographed next to the air pump at a California gas station in 1937. In *The Epic of America*, James Truslow Adams said the oligarchies that ran the nation's large corporations were enemies of the American Dream and their companies were "dinosaurs" that should become extinct. Labor leaders claimed many big businesses were run by "soulless" executives who exploited

"Modern" American kitchen and dining area, with built-in appliances, selected for the American National Exhibition in Moscow, 1959 (National Archives)

175

their workers with bad working conditions and low wages; and, of course, some Americans believed that big businesses, along with Herbert Hoover, caused the depression and later prolonged it because of their opposition to the New Deal. To counteract such hostility, even before the 1930s, some large corporations started to court the goodwill of the public through public relations advertising, which portrayed them as benevolent organizations concerned with community welfare and the health and safety of their workers. As industries expanded after World War II, so did their public relations campaigns. Between 1944 and 1964 the number of public relations firms in the United States increased from one hundred to fifteen hundred, as "corporate-made movies and corporate-employed speakers told schoolchildren and Rotary clubbers about America's great manufacturing enterprises. Boy and Girl Scouts, little leaguers, and other wholesome youth groups became the beneficiaries of local corporate charity. . . . The annual company reports to stockholders became glossier, artier, more dazzling. . . . Companies began including big colored pictures, cartoons, comic strips, [and] phonograph records."[56]

The corporations' own efforts to make themselves "well-liked," to use one of Willy Loman's favorite phrases, were supplemented by the editors of magazines like *Life*. In their 1953 special issue on "The American and His Economy," they included three major photoessays as filled with enthusiastic prose and arty, colored pictures as any annual report. "The Reign of Chemistry" was an eleven-page blurb for the Monsanto Company of St. Louis, with photographs by Eugene Smith and two pages of colored cartoons. A "$15,000 'Trade Secrets' House" photoessay had six pages praising the beauties of the ranch-type homes built by the National Association of Home Builders, which culminated in a full-page picture of a young family smiling happily as they inspected their new house in South Bend, Indiana. These smiling consumers were supplemented, later in the issue, by two pages about "The Company of Smiling Employees," a photoessay filled with beaming workers, union officials, and managers who all, a caption said, were wearing "Crown Zellerbach smiles" because that corporation was "succeed[ing] with 'human relations.' "[57]

Big business was also thought capable of transforming anything into cheap, useful products, thanks to their new technologies, and of bringing prosperity to all regions of the country. "Chemistry makes Gulf Coast a land of fantastic promise," was *Life*'s headline about petrochemical companies in Texas and Louisiana that transformed soggy coastal plains into "a great chemical empire" that produced "a thickening stream of products . . . nylon, synthetic rubber, fertilizers, alcohols, refrigerants," and were surrounded by "scores of neat new towns" built for the companies' employees. And, to add a human image to illustrate how the lives of individual Americans were affected, *Life* included a picture of a grinning young engineer named Joe Parish who at only "33 is a top executive in one of the world's biggest chemical plants."[58]

This view of large industries as benevolent organizations was in harmony with a shift in American middle-class attitudes that began after the depression, when many small businesses had gone bankrupt, and after the 1940s, when many people were grateful to have jobs with any size or kind of company. When William Attwood

interviewed young Americans in 1954 and 1955 for *Look*, he noticed that many of
them did not want, or were afraid, to start businesses because they wanted economic security. "I'm looking over some offers from big firms," a college senior told him. "I want to get married and enjoy the good things of life while I'm young. In a big company you're safe. They take care of you." The popularity of this attitude was revealed by a 1954 opinion research survey, published in *Look*, which stated that among Americans who considered big business "good for the nation" the most important reason was that "big business provides many jobs." Ninety percent of the respondents agreed with this statement, and it was the most important "pro-business factor" in the poll.[59]

In addition to providing Americans with prosperity, jobs, and smiles, big business also was the source of a plethora of new products in the 1950s, many of which the mass media and advertising described as "marvelous" or "miraculous." "There's New Magic Every Mile in NASH—the World's Finest Travel Car," boasted a 1956 advertisement illustrated with a picture of a new car photographed, appropriately enough, in Disneyland. Any product, no matter how humble, could be described in such terms. The Armstrong linoleum company promised its customers "the miracle of plastics at a low, low cost! . . . a new floor in minutes."[60]

There were no doubts in the minds of many writers, editors, and executives during the 1950s that humanity in general and Americans in particular were about to enter a millennium of better living created by new technologies and research. Even very complex or dangerous scientific developments could be transformed, they said, into safe, helpful products. By far the most elaborate public relations campaign for a new technology was "Atoms for Peace," which was organized by the government, large corporations, and the media to popularize nuclear energy. Magazines promised "Atom Power for Homes in Five Years," and discussed "How to Make Money out of the Atom," or they described "Atomic Miracles We Will See," and how "Leashed A-Bombs Do Tricks for Atomic Tamers."[61] The Eisenhower administration promoted nuclear energy as a kind of magic act in 1954, when the president participated in a ceremony to begin construction of the first American atomic power plant in Shippingport, Pennsylvania. Standing in a television studio in Denver, Eisenhower waved a radioactive "wand" over a counter. This, in turn, transmitted an electric signal to Shippingport, where it activated an automatic power shovel to scoop up dirt. "A Wand Wave, a New Era," *Life* announced, and said that the president "transformed the bright hope for atomic power peaceably used into a solid certainty."[62]

Writers and editors described this transformation with almost ritualistic references to, or photographic images of, atomic bomb explosions, followed by immediate promises that this dangerous energy could be transformed into what a *National Geographic* article called "Man's New Servant, the Friendly Atom." Behind the "guarded doors" of buildings in Oak Ridge, the writer said, "I saw atomic energy being put to work. . . . That same morning newspaper headlines had told of tests of new, more terrible atomic weapons. But here I watched unfolding the brighter, happier story of how atomic energy is building a better world," because at Oak Ridge "the terrific power that

explodes atomic bombs has been tamed and harnessed for countless peaceful tasks." *Look* magazine published photographs of Hiroshima devastated by the 1945 bomb explosion, followed by an article on "The Utopian Promise of the Peacetime Atom." It described "some of the fantastic promises of the atom . . . miracles within our reach," such as atomic ships and airplanes; central atomic heating for homes and office buildings; "cancer a thing of the past; diseases reduced to the vanishing point; teeth that do not decay. . . who is to say that atomic research and atomic power cannot give us the life of abundance and happiness that the atomic pioneers have promised?"[63]

"The Atomic Revolution," a comic book produced by the USIA, was equally utopian. It had a drawing of a garden city with trees, streets, cars, and immaculate buildings, covered with a huge dome and surrounded by snow. This scene, the comic book explained, was the future in Antarctica, since "within the atom is the promise of a new age in which we will have complete control over our environment." Experts and scientists like David Sarnoff and John Von Neumann were similarly optimistic as they predicted that "atomic batteries will be commonplace long before 1980," and "a few decades hence energy may be free—just like the unmetered air—with coal and oil used mainly as raw materials for organic chemical synthesis."[64]

Magazines and USIA brochures also had a variety of current "miracles" to present to mid-1950s America—particularly radioactive isotopes, which were already used for many kinds of medical, industrial, and agricultural research. As they showed scientists using these isotopes, the editors sometimes tried to illustrate how easily atomic technology could be domesticated. In 1956, for example, *Look* did a three-page photoessay on how a physiologist from the Brookhaven Laboratory and his family were raising and eating "atomic food" (vegetables that were irradiated to retard spoilage). Every picture included one of the physiologist's small children, looking at cabbages in experimental plots, romping through a greenhouse, or visiting a laboratory where the physiologist's son was looking at a tube filled with oats grown from irradiated seeds. Obviously, if scientists were willing to feed "atomic food" to their families, then nuclear energy was not dangerous. The final picture in the story was a photograph of the physiologist's son going to bed with his teddy bear and his souvenir radiation tag from the laboratory.[65]

In many cases atomic technology was photographed in highly scientific environments, like laboratories filled with strange machines and attended by intense scientists; but another, almost equally common, visual motif in the "Atoms for Peace" photoessays and pamphlets was the mixing of the mundane with the technically exotic, as in the *Look* photoessay. Presumably, this emphasized that atomic "miracles" took place not only in universities and guarded laboratories but also in the ordinary world. A picture from a government experimental farm at Beltsville, Maryland, which was using isotopes to measure fertilizer use, showed two technicians wearing masks and gloves and one carrying a strange kind of "gun" that was not explained. Yet only a few feet away another worker is sitting on a conventional tractor and not wearing any kind of special protective mask or clothing, implying that scientists do not face any serious danger when working with nuclear energy.

These institutions—the family, big business, and technology, along with the military—were the cornerstones, or core, of the American way of life as it was presented and visualized in magazines and USIA publications. A number of other, peripheral groups also were presented in an equally optimistic fashion during the 1950s, either as present or future participants in that way of life or as problems that were soon going to be solved because, as Millikan and Rostow claimed in 1957, a "national consensus on them exists within which we are clearly moving forward."[66]

During the late 1940s and throughout much of the 1950s, it was generally taken for granted that these problems, whatever they were, would be solved quickly and without any great difficulties. According to the consensus theories about American society popular at the time, one of the most important features of that society was its avid desire for change, reform, and progress. "Another misunderstanding of us . . . is that we are fighting some sort of rear-guard action in defense of the status quo," one editor participating in a 1951 roundtable complained, and then said Americans insisted "in every respect there must be better ways of doing everything."[67]

The social and economic condition of black Americans was on virtually all of the editors' lists of the country's problems between 1945 and the mid-1950s. The relatively mild Civil Rights and Fair Employment acts of the New Deal and World War II, the Harlem and Detroit race riots, the publication of studies like Gunnar Myrdal's *An American Dilemma*, and criticism by foreign liberals and leftists forced the editors to confront the truth that virtually all black Americans were second- or third-class citizens; and many of them set out, some more bravely than others, to scold, educate,

Agricultural experiment using radioactive isotopes to measure the amount of phosphorous absorbed by corn plants, Beltsville, Maryland, ca. 1954. Used in the pamphlet "Atomic Power for Peace." (National Archives)

and cajole their fellow white citizens. In 1945, for example, the editors of *Look* published both a book (Wallace Stegner's *One Nation*) and a photoessay attacking discrimination, in which the prejudice against black people was emphasized heavily. The photoessay began with a large picture of a Ku Klux Klan cross-burning ceremony, followed on the next page by a shocking news photograph of a middle-aged black man, his face covered with blood, being helped by two young white men. "Prejudice . . . means violence—last resort of vigilante action and terror against our 'second-class citizens,' " the caption warned. It then explained that the black man had been stoned during the Detroit race riots. After this disturbing, emotional beginning, the photoessay became calmer as the editors discussed the nature of prejudice and showed how it was directed against other groups—such as Jews and Mexican-Americans—in four smaller pictures facing the picture of the wounded black man. After a brief analysis of the causes of prejudice, they gave six rules (one, for example, asked Americans to "give the minorities a chance") to help "combat discrimination." This advice was accompanied by two large, emotionally positive pictures of racial harmony: a middle-aged, well-dressed, black, woman teacher in a schoolroom with white students ("Equal opportunities will lift the blight from the lives of minorities"), and a Los Angeles classroom filled with smaller children of many races singing "God Bless America," accompanied by a caption pointing out that children "have no natural aversion to other races." Hate and disorder were replaced by harmony as the editors forcefully, yet reasonably, pointed out how Americans could meet the "challenge" by following a few simple guidelines and relying on their nation's school system.[68]

Arthur Goodfriend's *What is America?* offered conservative solutions to America's racial problems when it was published in 1954. Using his own biography as a case study in national values, Goodfriend wrote that he had grown up in a multiracial, multiethnic neighborhood in which all of the boys became educated and successful. But one of his friends, Bob, had a little more difficulty, even after he graduated from an architectural school, because he was black. "Negroes had come a long way from slavery, but many doors remained shut. Bob shrugged. 'I'm going west. I'll take any job and build a up little capital. Then I'll open an architect's office.' " This version of the American Dream ("Go West") worked as well for Bob as it would have for any white person. Goodfriend reported that Bob became a success in California, where his houses were winning acclaim, and he said that Bob had written to say he could "design a house for workers with advantages once enjoyed only by the rich. The slums are doomed. So is the notion that people must work in drab, uncomfortable factories, offices, and shops."[69]

William Attwood, too, was optimistic about racial progress in 1955 in *Look* magazine and in his book, *Still the Most Exciting Country*. One of the clichés foreigners believed about the United States, he complained, was that "Americans are hypocrites. They preach democracy to other people, but deny equal rights to their Negro citizens." To disprove this, Attwood compiled a series of anecdotes proving to his satisfaction that only elderly Southerners were prejudiced. "Bigotry, or prejudice . . . shows up today in almost direct proportion to the age of the person. . . . Try to find a

white Southerner under twenty-five who has adopted the racial prejudices of his elders as his own. It is not easy." He ended his analysis of racism with an indignant attack directed not at white Americans' attitudes but at foreign critics. He thought it was "high time . . . Asian and European editors and commentators updated their U.S. files. For the big news in America today is no longer the plight of the Negro. The big news—bigger than yesterday's lynchings—is how far he has come and how fast he is moving toward full equality with his fellow Americans."[70]

The editors believed that racial relations were improving rapidly, and they found and emphasized many other kinds of progress. In particular, they believed cities all over the country were changing for the better as the prosperity of the late 1940s and the 1950s revived not only the "messianic materialism" of the 1920s but also the boosterism of that decade. "The great news about America . . . is that it has regained something very precious that it almost lost in the '30s—the capacity to dream," *Life* said in its 1947 photoessay about Omaha, Nebraska. "Americans again are pursuing the kind of community dreams that enabled them . . . to turn a nation of farmers and shopkeepers into the world's greatest industrial power, and the kind of individual dreams that have transformed farm boys into presidents and carpenters into inventors." Applying this Horatio Alger, Jr., version of the Dream to a city rather than to individuals was not difficult. During the depression, Omaha's concerned citizens had to watch their city "stagnate" (just as some of Alger's heroes had to endure poverty), but now that it was prosperous they could make all kinds of dreams come true, and their city would be "bigger and better, cleaner and more healthful." Omaha was "bursting with civic plans," *Life* said, and it showed four boards and commissions posed with their plans for a new rail terminal, an auditorium, a bigger airport, and better sanitation.[71]

Look's vision of the nation's cities and their problems in the 1950s was humbler but fully as confident. Every year the magazine published a photoessay about cities receiving awards from the National Municipal League because they had improved themselves by attracting new industries, cleaning up slums, lowering crime rates, reforming city governments, or opening new schools. As the name for these awards—"All-America Cities"—indicates, they were intended to be models for other towns, and *Look*'s descriptions of these cities were briskly didactic. "Is your city a good place to live?" the magazine asked in 1954. "Hundreds of American cities are not. They are being strangled by corruption, inefficient government, poor schools, and crime. . . . But hundreds of other cities are good places to live in today. Though these cities once had the same problems, they met them squarely." In 1955 *Look* emphasized that the awards were based mainly on "citizen effort," the extent to which ordinary citizens made improvements by becoming concerned. Any "American community—if it becomes indignant enough and determined enough—*can* stem graft, choke creeping blight, root out bumbling inefficiency, [and] make streets safe for women and children."

These photoessays were illustrated with pictures showing citizens' efforts. Certain neighborhoods in Chicago, for example, were trying to clean up slums in 1955, and

Look showed a group of middle-class volunteers inspecting a trashy lot while, in the foreground, an official tacked up a sign: THIS BUILDING IS IN A DANGEROUS CONDI- TION. Canton, Ohio, had been "a city of ill repute … [where] gamblers, dope peddlers, clip-joint owners and vice lords operated in complete defiance of the law." Then citizens elected a new city government, a new public safety director closed down the clip joints and brothels, and six of the city's civic leaders posed proudly for *Look* in front of the "city's old red-light district, where 48 bawdy houses once operated" before vigorous prosecution closed them.[72] Characteristic of all these civic success stories was their absence of any comments upon larger regional, social, or national issues—which would have been referred to as "interdependence" in the 1930s. Events happening in Washington, D.C., or even in state capitols, which might well have affected their citizens' lives, were not mentioned; the entire emphasis was on independence, on how communities could better themselves solely by their own efforts.

Perhaps the best example of how America's problems could be turned into success stories in the 1950s was Puerto Rico. Even though the United States took possession of the island in 1898, Puerto Rico never enjoyed anything remotely resembling the American way of life. During the 1920s, Raymond Carr commented, it was treated as a political and economic "nuisance" by the federal government, "by 1930 it had become a problem," and, as the depression continued and per capita income sank from $122 to $86 between 1929 and 1933, it became "a disaster area, the 'poorhouse of the Caribbean.'" "There is today more widespread misery and destitution in Puerto Rico than at any previous time in its history," Secretary of the Interior Harold Ickes said in 1935. When FSA photographer Jack Delano arrived at the island in 1941 to document living conditions there, he saw rural poverty worse than anything he had seen among sharecroppers in the deep South, and conditions in city slums were worse than those in any mainland city.[73]

Rexford Tugwell, who was governor of the island from 1941 to 1945, tried to bring the New Deal there; but when Congress cut Puerto Rican relief to thwart Tugwell's "socialist" plans and German submarines cut much of the shipping to the island during World War II, some of the island's poor people actually began to starve. The Chavez Commission, sent by the Senate to investigate in 1943, decided that the island's problems were "unsolvable." (After the war hundreds of thousands of Puerto Ricans seem to have agreed with this judgment as they emigrated en masse to the mainland.) *Life* magazine, which did a photoessay on Puerto Rico after the Chavez report was issued, was indignant. "The pictures above and those on the following pages are a shocking disgrace to the U.S," it said in a text printed below a picture of "El Fanguito," one of the worst slums. "While millions of young men are fighting to clean up the Axis and to create a better post-war world, the cesspool of Puerto Rico had been festering in our backyard for over 40 years. If Americans cannot straighten out the relatively small mess of this small island, how can they expect to bring order out of chaos in the rest of the big world?"[74]

After World War II, Luis Muñoz Marin, the first elected Puerto Rican governor,

and his party, the Populares (PPD), decided that industrialization was the only way the island could escape from poverty. They launched a program called "Operation Bootstrap" to encourage mainland investors through low-cost loans, factory buildings erected by Formento (the Puerto Rican development agency), generous tax concessions, and access to "a 'docile' labor force requiring wages considerably below those of workers on the mainland." During the 1950s the program was a success. Even though there was still widespread unemployment and sixty thousand Puerto Ricans were emigrating to the mainland every year, industrialization created an urban middle class and drew hundreds of new employers to the island. Moreover, the investments in education and health services made earlier in the 1940s by Tugwell and the PPD increased life expectancy by one-third and doubled elementary school enrollments. By 1954 *Life* referred to the expansion of the Puerto Rican economy as a "miracle"; and in 1956 it helped Muñoz Marin celebrate the opening of the four-hundredth new factory by sending Gordon Parks to photograph "the island's homemade transformation from a scabrous slum into a shining showcase of the rewards won through a partnership of Puerto Rico with the mainland U.S." *Life* emphasized before-and-after images to dramatize the island's "transformation." Thus on one page there was Parks's 1949 picture showing "Coki" Lozano—a nine-year-old slum child ("a sullen-faced ragamuffin")—posed by a shack whose porch was filled with other dirty, ragged, or naked children. Facing it was a 1956 picture of the same boy, now a clean, neatly groomed adolescent, with a caption explaining that he had become "a different boy against a different background," since now he lived with his family and three sisters in a clean, inexpensive, government-owned housing project in a San Juan suburb. Behind him, his sisters were posed in the doorway of the apartment, all wearing white dresses and all as neatly groomed as their brother. Unfortunately, *Life* had to admit, the boy dropped out of school. He was unemployed, but he hoped to find work in a factory. The juxtaposition of his old life in the slums with his new one in the suburbs was a persuasive illustration of how Puerto Rico was "transformed" by industrialization and what Edward Carr called Muñoz Marin's "welfare capitalism."[75]

Parks and the *Life* reporters were not the only outsiders to be invited to the 1956 Operation Bootstrap "fiesta." Muñoz Marin was photographed with four young Indian women in saris, with a caption explaining they were part of a group of three hundred foreign students from countries receiving Point Four American aid, who were transported to Puerto Rico for the celebration. Clearly, since Puerto Rico was transformed from a slum to a "showcase" through its partnership with the U.S. government and large corporations, it would be useful to publicize this message in poor nations everywhere—which is exactly what the USIA did. Puerto Rico's "limited natural resources are unable to support the overpopulated island," and the result was poverty, one pamphlet pointed out; but now "Puerto Rico is alive with hope. . . . Puerto Rico's industrialization program demonstrates the means whereby other countries may accelerate their development . . . [by] implementing the Point Four Policy. . . . The path is still uphill [in Puerto Rico]. But in the climb, a new spirit of energy and pride is emerging."[76]

These illustrations of Puerto Rican progress echoed—verbally and visually—earlier versions of the American Dream, particularly as embodied in Frances Johnston's Hampton pictures and certain statements in the *Southern Workman*. The *Workman* claimed the Hampton-Tuskegee philosophy of vocational education would transform black and Native American students into prosperous, middle-class citizens by showing them how to "climb the rugged hill of progress," and USIA employed the same metaphor when it described Puerto Rico's "uphill climb" to prosperity. There was the same emphasis on neat, selected success stories illustrating claims for large-scale social progress. Johnston made before-and-after sequences contrasting the cabins of rural blacks with the middle-class house of a Hampton graduate. Parks's "Coki" Lozano pictures in *Life* created the same kind of contrast. USIA publications showed ordinary Puerto Ricans posed in front of their new, public housing projects, or eating dinner in their kitchens, just as Johnston had shown the Hampton graduate and his family at their dining room table. Johnston's images were used to show the world, at the 1900 Paris Exposition, how successfully America was dealing with its black and Native American inhabitants; and the images of Puerto Rico made by Parks and the USIA photographers were used in essentially the same way. The United States may have changed in many important ways between the Progressive Era and the 1950s, but there were some significant continuities in the mentalities of its policymakers— particularly when dealing with poor people and the "darker races," whether they were in Virginia in 1899 or in Puerto Rico in 1956.

■

By the 1950s the American way of life was expanding and extending itself everywhere, according to USIA publications and the mainstream press. This belief led not only to a new faith in the "messianic materialism" and boosterism of the 1920s but also to a renewal of the kind of optimism H. G. Wells observed in 1905 when he met the earnest young woman who taught Americanism at the Hebrew Alliance. As they strode through the filthy streets of a Lower East Side slum, the woman responded to Wells's challenge that America had not solved "the barbaric disorder about us." She shouted back, "*We'll* tackle it!" She was, Wells decided, "the spirit of America incarnate"—"bright and courageous and youthful, [but] a little overconfident."[77] The same observation could have been made of many other young Americans fifty or sixty years later—except that by then the young woman (or her male counterpart) might have been briskly striding through a street in Saigon, Tehran, or Rio de Janeiro. And in the 1950s or 1960s she might very well have been followed by reporters and photographers from *Life*, *Look*, *National Geographic*, or USIA, taking notes and snapping pictures to show how America was bringing prosperity, democracy, and progress to yet another poor country.

Since so many American experts, editors, and policymakers seem to have believed sincerely that middle-class Americans were in the process of transforming their own nation into a good society, or even a great one, it was inevitable that they would try to

export their dreams and way of life to deserving foreigners. Thus on the first page of their 1957 *Proposal*, which they subtitled *Key to an Effective Foreign Policy*, Rostow and Millikan claimed the United States could use foreign aid to increase "the awareness elsewhere in the world that the goals, aspirations, and values of the American people are in large part the same as those of peoples in other countries" (Our dreams, ideals, and values are essentially the same as yours.) and to develop "viable, energetic, and confident democratic societies through[out] the Free World" (You need social and economic systems like our own.).[78] In fairness to American editors and policymakers of the period, however, it should be emphasized that their overconfidence was encouraged by some of their successes in World War II and the years following it. In western Europe in particular, the Marshall Plan was considered an impressive demonstration of how well Europeans could use American aid to revitalize economies that had been devastated by the war. Even more impressive was the way in which the Japanese accepted the occupation of their nation and the eagerness with which they embraced certain American values. In 1947, for example, General Douglas MacArthur, who was then ruling Japan, addressed the readers of *Life* in a special Fourth of July issue on the subject of the exportation of America's spiritual values. "Our experience in the Philippines and in the more recent reformation of Japanese life," the general claimed, offered unmistakable proof that the "tenets" of Americanism were "no longer pecu-

Gonzalo Crespo Duran and his family in their apartment in the Las Casas Housing Project, built by the Puerto Rico Housing Authority, ca. 1949 (National Archives)

liarly American but now belong to the entire human race. . . . Given the opportunity to take root in one society they will flourish and grow [there] as surely as they will in any other society."[79] A skeptic might have commented that Japan and also Germany probably were special cases, since conditions in Hiroshima and Berlin in 1947 were sufficient arguments for many Japanese or Germans to be adaptable to new values; but in the 1940s and 1950s such skepticism would have been swept aside by the patriotic assumption that the changes occurring in Japan and Germany were endorsements of the American way of life.

In the late 1940s and throughout the 1950s and 1960s, however, policymakers and editors also believed that modernization—or, as the process was also called, Americanization, development, industrialization, and Westernization—was a global panacea for virtually all nations and societies, which would enable them to achieve the kind of economic growth that was taking place in the United States. Moreover, since the United States was competing with the Russians, who were just as eager to modernize poor countries—also known as underdeveloped, or Third World, nations—American editors and policymakers were determined to show the world that they could fulfill the pledge John Kennedy later articulated so eloquently when he promised that his nation would help "those people in the huts and villages of half the globe struggling to break the bonds of mass misery . . . for whatever period is required—not because the Communists may be doing it . . . but because it is right."[80]

During the 1950s and the 1960s, the mainstream media and USIA publications were eager to find "showcase" examples to demonstrate to foreign nations how American-style development, or modernization, was ending poverty, "backwardness," and "mass misery" in Asia, Africa, and Latin America. When the pictures in these photoessays are examined carefully, however, one difference emerges that makes them significantly unlike equivalent photoessays and images made at the same time in and for the United States: the conservative populism, so endemic to 1940s and 1950s mainstream photojournalism, in the form of illustrations of the idea that ordinary people can be a dynamic factor in improving their own lives. There were no foreign equivalents of the citizens of Omaha with their blueprints, the smiling employees of Crown Zellerbach, the citizens of *Look*'s "All America Cities," in photoessays about underdeveloped countries during this period.

Instead, readers were likely to see pictures of anonymous, generic groups of foreigners and/or peasants welcoming an American politician or being instructed by an American teacher, soldier, or expert. Additionally, and perhaps even more significantly, the reader might be confronted with a big, emphatic picture of Ngo Dinh Diem or the Shah of Iran, accompanied by a caption or text proclaiming that *he* was America's "friend" and that *he* was transforming his nation and its citizens to provide a better way of life. Either way, it was tacitly assumed that the peasants and/or foreigners were not able to shape their own lives and destinies in the same way that the citizens of Omaha, Nebraska, or Canton, Ohio, could. Frances FitzGerald summarized this attitude in a 1979 article on Iran. Until the revolution in that country was well under way, America's "foreign policy establishment—both policy makers and journalists—

had confined the discussion of Iranian politics to the person of the Shah himself. What

was the Shah like as a man? What did he say last week? The assumption behind this discussion was that the Shah was the only person who counted in Iran."[81]

Heavy emphasis on rulers and "strong" leaders inherently contradicted the official, public rhetoric of American foreign policy, which was filled with phrases like "democracy," "freedom," and the right of all citizens to "participate in government." "We [Americans] have always been, as we should always be, the despair of the oppressor and the hope of the oppressed," John Foster Dulles eloquently assured the readers of *Life* in 1952. In 1941 Henry Luce prophesied that the United States was going to be a "Good Samaritan . . . the powerhouse of the ideals of Freedom and Justice."[82] However, this emphasis on strong leaders and dictators was in harmony with certain regional, and less-publicized, aspects of American foreign policy. It was consistent, for example, with the United States' own relatively discrete, de facto imperialism, which it had practiced for decades in Latin America, the Caribbean, the Philippines, and parts of China. Earlier in the twentieth century, American aid was called "dollar diplomacy"; and the people and the means used to enforce it were not notable for their concern for democracy or for their humanitarianism. "I spent 33 years and four months in active service as a member of . . . the Marine Corps," Major General Smedley Butler (retired) wrote in 1935,

I helped make Mexico . . . safe for American oil interests in 1914, [and] I helped make Haiti and Cuba a decent place for the National City Bank boys to collect revenues in. I helped in the raping of half a dozen Central American republics for the benefit of Wall Street. . . . I helped purify Nicaragua for the international banking house of Brown Brothers in 1909–12. I brought light to the Dominican Republic for American sugar interests in 1916. I helped make Honduras "right" for American fruit companies in 1903. In China in 1927 I helped see to it that Standard Oil went its way unmolested. . . . Looking back on it, I feel I might have given Al Capone a few hints. The best *he* could do was to operate his racket in three city districts. We Marines operated on three *continents*.[83]

Ostensibly, of course, places like Nicaragua, Haiti, Honduras, and the Dominican Republic were sovereign states with their own flags, elections, governments, and postage stamps; in actuality they were scarcely more than American protectorates or satrapies. In the late 1920s and the 1930s the United States began a more discrete practice of this "informal" regional imperialism. Direct interventions, like those carried out by General Butler, were avoided; native police forces or National Guards were trained to replace the marines; and local Capones, like Somoza in Nicaragua, Ubico in Guatemala, and Batista in Cuba, were trusted to keep their countries safe for American interests. Popularly known as the "Good Neighbor Policy," this new system of control was bipartisan; it was started by Hoover and continued by the Roosevelt administration. Roosevelt, like Hoover, accepted dictators in Nicaragua, Guatemala, Honduras, and El Salvador, and, as Walter La Feber pointed out, as long as these "regimes maintained order and protected private property, they were perfectly accept-

able. They accomplished for less cost what the marines had been trying to do for more than thirty years."[84] During the 1930s, however, these policies were applied with certain saving inconsistencies. Mexico was allowed to nationalize its oil industry in 1938, and the United States did not promote a Mexican equivalent of Somoza to stop the process, and America tolerated Pedro Aguirre Cerda's popular-front, left-wing government in Chile from 1938 to 1941. There was also, during the Roosevelt years, a certain cynicism and hard-headed realism about these dictators, which was expressed very well by the president's mot about Somoza: "He's a son-of-a-bitch, but he's our son-of-a-bitch."

Nevertheless, although they were supporting dictators like Somoza and Batista, American statesmen were also making some of their most idealistic statements—as in the Four Freedoms and the Atlantic Charter—about bringing freedom and democracy to the whole world and ending the imperialism that, when it was practiced by Europeans, they considered quite wicked. This contradiction was papered over by ceremonies in Washington and the tendency of the mainstream media to ignore, to rationalize, or to sanitize the bad behavior of right-wing dictators who were considered America's "friends" or "good neighbors."[85] By the late 1930s, a protocol emerged that Thomson, Stanley, and Perry later compared to that of imperial Ch'ing China. "Barbarians were expected to draw near the throne in Peking . . . bearing ritualistic gifts, and in exchange would be rewarded with imperial benevolence," they wrote; and this "benevolence meant not only lavish gifts from the palace but, inevitably, access to Chinese merchants and markets. . . . Lest this system seem exotic, recall that Americans . . . developed their own international rituals of mutual benefit . . . the ceremonial journey to Washington by the Asian, African, or Latin American head of state; the offer of tribute in the form of renewed verbal pledges to the 'Free World'. . . and perhaps the offer of military base rights; and finally the full benevolence of the American ruler, manifested in the form of . . . that welcome increased flow of military and economic aid."[86] In many cases, the ritual included an address to Congress and/or the National Press Club, and trips to New York to visit bankers and other powerful people. Photography seemed to be an essential part of this protocol; foreign rulers—whether they were democratic or dictatorial—were invariably photographed with important Americans. Consequently, when the "Strong Man of Cuba," Fulgencio Batista, came to Washington in 1938, *Life* printed pictures of him beaming beside a grinning American general. Batista, the magazine explained coyly, "was something very like a dictator," but "everybody in Washington was surprisingly cordial to him" and his visit was a "brilliant success." He "promised to give Cuba a real constitution and free elections" and said "the armies of the Americas should have the sole purpose of 'guaranteeing democracy.' " A year later it was Nicaraguan President Anastasio Somoza Garcia's turn to be met at Union Station by Franklin Roosevelt, Mrs. Roosevelt, most of the Cabinet, and Chief Justice Hughes. Somoza and Roosevelt were photographed together for *Time* magazine and captioned "Two American Presidents," which suggested an equality between the freely elected leader of the world's largest democracy and one of the hemisphere's sleaziest dictators. In its brief description of

Somoza's career, *Time* did not mention any of the more unpleasant details, such as his

responsibility for the murder of Augusto Sandino in 1934; instead, it blandly said that he came to power by "run[ning the former President] out of the country," and having "himself elected President in due Constitutional style." When Somoza addressed a joint session of Congress, one Congressman from Wisconsin was rude enough to refer to him as a "dictator," but three weeks later Somoza was given $2 million in credit from private and federal banks, and American technical advisors and managers moved in to help run the banks and railroads that the dictator and his family exploited for their own profit.[87]

When World War II ended and the cold war began, American policymakers and the mainstream media continued to follow essentially the same kind of policies in relation to the rulers of Third World nations. There were, however, some modifications and adaptations. As the English and French began dismantling their empires in the Middle East, Africa, and Asia, there were many more Third World nations to attract the attention of American generals, policymakers, and multinational corporations. Motivated by the fear of communism, and also by opportunism, diplomats and policymakers rushed around the world setting up alliances and handing out aid to any rulers who would rent the United States bases and/or sell their nations' natural resources inexpensively to American corporations. The mainstream media cooperated by vilifying uncooperative or left-wing governments, like Mossadegh's in Iran and Arbenz's in Guatemala, and either ignoring or praising "cooperative" right-wing regimes, no matter how brutal or undemocratic they might be. The criteria were that the dictators had to claim to be anti-Communists, rent bases to the American military, and/or allow American companies to operate profitably in their domains. As a result, William Dorman pointed out, the American media's news coverage often followed an ideological double standard for deciding what was newsworthy in Third World nations. Economic failures, human rights violations, and the abusive treatment of minorities were often reported and emphasized in the media when they occurred in "countries that oppose[d] U.S. interests"; but similar events in America's "client regimes" usually were ignored entirely or buried on the back pages of a few newspapers.[88]

A second development was that the media campaigns on behalf of cooperative foreign governments became more elaborate as their rulers (or their American "handlers") adopted more sophisticated public relations techniques to sell themselves to Congress and the American public. Photographers still made the obligatory pictures of foreign leaders and American politicians grinning at one another and shaking hands in Washington, but additional photographs showed that these rulers were not aloof, ruthless tyrants but friendly, likable people who shared many of the same values as Americans (even though they sometimes might have to take "stern measures" when they were dealing with Communists or their own unruly citizens). For instance, when the Shah of Iran visited the United States in 1949 he was photographed eating a hot dog at a Georgetown football game, visiting an elementary school classroom in Arizona, and listening to a women's glee club at the University of Michigan. When Ngo Dinh Diem visited Washington in 1957, he was not only photographed, for *Time*,

wearing a Vietnamese mandarin's gown and smiling at President and Mrs. Eisenhower but he also had his picture taken as he rode up Broadway in a convertible, smiling and waving at spectators just like an American politician.[89]

Other media opportunities could be arranged to show that these rulers were popular with their own people. *Life* magazine ran a major photoessay on Vietnam in 1957, which featured a big picture of a smiling, confident Diem striding through a village in South Vietnam surrounded by happy children waving South Vietnamese flags. The *U.S. News and World Report* showed him riding in a jeep surrounded by cheering villagers under the headline, "Indo-China: Another Place Where Reds Are Losing. Strong President, U.S. Aid Tip Balance for West." In the same way, when *Life* visited Iran in 1966, it presented a large picture of a smiling Shah, posed en famille with his lovely Empress Farah and their two small children. The caption asserted that he was such a "genuinely popular monarch" that his "23 million subjects feasted, danced and prayed" for seven days and nights to celebrate the twenty-fifth anniversary of his regime.[90]

The American media and the USIA publications rarely gave many specific details about the economic deals, the military alliances, and the diplomatic treaties their nation made with regimes ruled by dictators. Instead, they often explained these relationships in simpler, more emotional terms, suggesting that these leaders and their subjects were America's friends. One of their favorite ways of doing this was to publish pictures of visiting American politicians surrounded by nameless but friendly foreigners obviously pleased to shake the politicians' hands and smile back at them. Wendell Willkie popularized this practice in 1943 with his around-the-world series of state visits, during which he not only interviewed national leaders like Chiang Kai-shek but also was able—as he emphasized in his best-seller, *One World*—to meet and talk with "ordinary people," like a veiled woman in Baghdad, a carpet weaver in Iran, a Russian factory worker, and Chinese soldiers.[91] During the 1950s and 1960s a very popular foreign policy and media ceremony was the vice presidential visit to a series of allies and satrapies in which Nixon, Johnson, or Humphrey—and sometimes their wives as well—were photographed beaming at selected smiling foreigners. The implications of these grins and hugs were obvious: Americans were cheerful, friendly people who wanted to help the citizens of Iran, El Salvador, Nicaragua, or Vietnam simply because they *liked* them, and the foreigners reciprocated. When politicians visited very important allies who were receiving large amounts of aid, these ceremonies could be impressive imitations of American political rituals, including motorcades, huge cheering crowds, and lots of hand-shaking. When Vice President Johnson visited Iran in 1962, for example, *Time* described him as going through Tehran "as though he was running for Shah—and if the warmth of his welcome was an indication, he might be able to get the job. . . . Three times Johnson . . . [hopped] out of his car to grasp all the outstretched hands within reach. . . . The crowds responded with the highest praise they knew: *'Javid Shah!'* (Long Live the King!)." Later the vice president visited a village near Tehran where, surrounded by police and photographers, he spoke to the

villagers about their "problems"; and *Time*, paraphrasing Dale Carnegie, said his visit to the Middle East had "the simple aim of keeping friends and influencing people."[92]

In addition to claiming that rulers like the Shah were America's friends, editors and policymakers had a number of other rationalizations for giving aid and loans to them. The most important of these was anticommunism, but modernization was almost as important a justification. Supposedly, rulers were modernizing their countries, promoting education and industrialization and ending poverty, "backwardness," and "underdevelopment." Despotic allies and satraps who did not bother to go through the motions of modernization, like Somoza and his peers in Central America, were almost entirely ignored by the mainstream media.

According to the social scientists who promulgated these theories in the 1950s and 1960s, modernization was a complicated change from simple rural societies to complex urban societies in which a "series of transitions" would occur "from primitive, subsistence economics to technology-intensive, industrialized economics ... from closed, ascriptive status systems to open, achievement-oriented systems ... from religious to secular ideologies, and so on." Non-modern societies or nations were stereotyped as dominated by "traditional people [who] typically cling to [the] old way

President Ngo Dinh Diem visiting a village in South Vietnam, 1955 (National Archives)

191

of doing things . . . accept hierarchical power relationships, and usually depend upon subsistence agriculture"; whereas modern nations relied on "advanced technology, sophisticated organizational skills . . . hard work, and . . . complex visions of the future."[93] Translated into the language and symbols of American culture, modernization had much in common with the American Dream promulgated since the 1920s. There was the same strong emphasis on education, work, and technology. Phenomena like the 1939 World's Fair, books like Morris Ernst's 1955 *Utopia 1976*, or *The Fabulous Future: America in 1980*, compiled by the editors of *Fortune* in 1956, were fine examples of "complex visions of the future"; and the U.S. government and large corporations like Standard Oil or General Electric were obviously the products of "sophisticated organizational skills." According to development experts, modernization meant the transformation of nations from societies that barely subsisted into ones characterized by abundance. Because of the development of technology in modernized societies, one expert claimed, it was possible "for the first time in the history of mankind . . . to anticipate that adequate food, shelter, education, and medical care can eventually be made available to everyone and that want can be abolished forever," a claim even more ambitious than Herbert Hoover's 1928 campaign promise to abolish the poorhouses of America.[94]

In the mainstream media and USIA publications, however, this whole complicated process was usually portrayed in simpler terms. First, there often were covert suggestions that modernization had to be controlled by "strong," pro-American foreign leaders who could provide "stability" and keep their countries away from communism. In addition, throughout the 1950s and the 1960s there was a frequent, overt emphasis on how the modernization process needed to be carried out with American aid and "know how." During that time, the United States derived substantial military and economic benefits from its involvements with foreign nations. By 1952, for example, the air force had 131 bases overseas, over twenty of which were so secret that their locations could not be published, and the navy also had dozens of bases all over the world.[95] American companies sold weapons to countries receiving U.S. military aid; oil companies like Gulf, Mobil, Standard Oil, and Texaco had gained access to enormous oil reserves, particularly in Venezuela and the Middle East; and multinational corporations had profitably invested millions of dollars in foreign subsidiaries. But the mass media and USIA publications rarely commented on these benefits and profits, as they instead chose to stress the generosity of Americans as individuals and as a nation. One of the most frequent motifs in foreign news photographs and USIA publications in the 1950s and 1960s was the generous American—soldiers helping foreigners to "resist communism," and civilians working for the Point Four program, the Agency for International Development (AID), or the Peace Corps to bring progress and modernization to poor nations.

The purpose of this generosity was summed up by the text of a *National Geographic* photoessay on the Peace Corps, which said that a husband and wife who served in Ecuador "left cleaner streets, a stronger community spirit, [and] friends for the United States." But along with this emphasis on friendship there was also an unacknowledged but implicit suggestion in many of these photographs that the Americans were much stronger, wiser, and more capable than their foreign friends. The Americans usually look more significant, dynamic, or important than the foreigners. Part of this impression comes from the fact that many North Americans are physically larger than people from countries in Asia and South America, but contributing to this impression were the scenes that photographers and editors selected, the camera angles, and the compositions, which were arranged so that the Americans were prominently visible. Women and children were often shown receiving advice or aid from Americans, and relatively young Americans were often shown teaching and directing older foreigners who were, in effect, their pupils. In the USIA pamphlet, *Partners in World Progress*, for example, the Indian agricultural officials in the picture of the maize production project are much older than two of their advisors from the United States. In these pictures, the Americans were always the teachers, experts, mentors, and trained soldiers and the foreigners were students, novices, or recruits. The Americans were the doctors and nurses, while the foreigners were their patients. Moreover, in the captions, usually the Americans had names and individual identities, while the foreigners were groups of undifferentiated "villagers," "recruits," or "schoolchildren."[96]

A final, important tenet of modernization was that it occurred in countries that cooperated closely with the American government and multinational corporations. This point was made very clearly in a 1954 *Life* photoessay on Venezuela, which began with a lush, full-color, double-page photograph of an affluent Caracas suburb, accompanied by a colorful text emphasizing that this prosperity had been achieved because the Venezuelans were selling their oil and iron ore to the United States. "Until 10 years ago," *Life* said, Caracas "drowsed in colonial charm—a place of perpetual spring, of bird sellers and guarded señoritas who were courted through barred windows. Then a great gush of oil from a fabulous pool brought Caracas suddenly alive. New pastel-colored apartment buildings, offices and stores sprouted. . . . The boom which rebuilt and repopulated Caracas is also revamping Venezuela's entire economy. . . . The big chunks of capital and cadres of technicians needed to extract these raw resources were coming from the U.S. [which] now has its biggest foreign investment ($2 billion) in Venezuela."

It was equally clear from *Life*'s report that this "boom" was not accompanied by democracy, since Venezuela had been ruled by a military dictatorship since 1948, and this fact did not much trouble either *Life*'s editors or American investors. Indeed, their comments on the current dictator—Marcos Pérez Jiménez—were quite approving. Underneath a picture of Pérez, the magazine said that, under his "firm rule," Venezuelans had "freedom to spend." It emphasized that "for the host of U.S. entre-

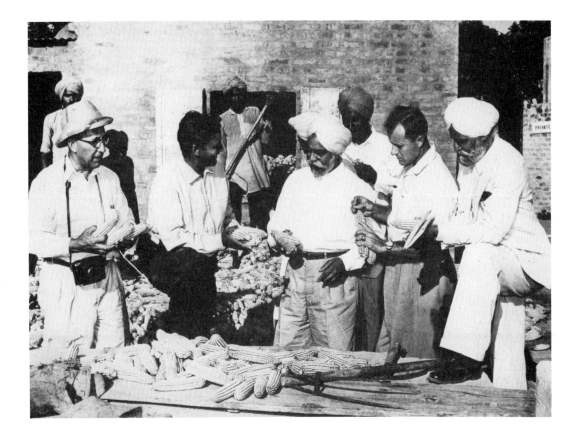

preneurs who have found booming Venezuela a lucrative outlet for their wares," Pérez's "dictatorial rule . . . has some definite advantages . . . under his firm hand the currency stayed rock stable and strikes were eliminated. The new prosperity has enabled many Venezuelan workers . . . to replace their rope-soled sandals with shoes, buy canned goods in new supermarkets and satisfy a craving for chicken and ice cream." Surrounding the picture of Pérez were other photographs showing how this new prosperity changed Venezuelans into new consumers: there were a full-page picture of three men, their backs to the camera, carrying a television set ("an expensive G.E. model") into a workers' barrio to watch a "U.S.-style panel and give-away programs," and a small picture of boys looking at a newsstand display of American comics, including Raton Miguelito (alias Mickey Mouse), translated into Spanish.[97]

Time, in 1967, was even more euphoric about Iran. Thanks to the Shah's "Revolution from the Throne," the whole country was "being shaken by a two-pronged revolution—social and industrial—that is bringing to the mass of its people [their] first real taste of prosperity," the magazine claimed.

> Across the huge land . . . great factories are springing up everywhere. . . . A railroad is stretching out across the treacherous Dasht-i-Kavir Desert. . . . A giant dam now irrigates the rolling grainlands below Shush. . . . Along the Caspian seashore, the highways are clogged with . . . trucks hauling a record cotton

U.S. Technical Cooperation experts and Indian officials inspect the results of an experimental maize project. Used in the brochure "Partners in World Progress," ca. 1959. (National Archives)

195

crop to market. The beaches bounce with bikinis, and teenagers in Teheran have joined the Transistor Generation. The ancient, withered men of Yezd are being taught to read . . . 15 million peasants have been transformed, almost overnight . . . from feudal serfs into freeholders. . . . Iran's economy is growing at the rate of 12% a year, and the per-capita income of its 26 million people has nearly doubled. . . . The country, which once depended on U.S. aid ($1.7 billion since World War II) . . . now stands proudly on its own feet. . . . Gone are the swarms of U.S. advisers . . . who once inhabited every government ministry. . . . Their places have been taken by Iranians.

The "man responsible" for all this modernization and progress, *Time* enthused, was "Mohammed Reza Pahlevi, 47, Shahanshah (King of Kings) . . . and absolute ruler of his nation." It extolled his reforms, such as land reforms and literacy campaigns, for more than three pages and devoted one seven-sentence paragraph to a sanitized description of his politics. It said, for example, that parliamentary elections were "arranged as to give the Shah's . . . Party an overwhelming majority of the seats."

These mild caveats were far outweighed by *Time*'s effusive praise for the Shah's achievements and a six-page portfolio of color photographs entitled "A Realm Transformed," documenting how thoroughly he had modernized his nation: "Old-fashioned" water canals were contrasted with modern, automatic irrigation systems; 1946 and 1967 aerial views of Tehran were juxtaposed to show how the city had grown; a river gorge was shown before and after the Mohammed Shah Pahlevi Dam was built; tractors were photographed near oxen to illustrate increasing agricultural prosperity; and a final pair of pictures showed huge pipelines leading to an oil jetty in the Persian Gulf and an automobile assembly line that produced "Iran's own automobile, the new four-door $1,900 Peykan."[98]

Many of *Time*'s readers might not have known a great deal about where Yezd or the Dasht-i-Kavir desert were, even if they studied *Time*'s helpful little map, but the manner in which the editors presented Iran might have seemed rather familiar— perhaps because it was essentially the way the United States itself was presented in the media in the 1940s and the 1950s. There were the same kinds of statistics illustrating rapid economic and industrial growth, the same dramatic transformations of nature by dams and irrigation, the same anecdotes documenting social progress and economic prosperity everywhere in the country, and a similar emphasis on modern industries like automobile factories. The aspects of Iranian life that did not fit in with these stereotypes—the fetid slums of South Tehran, the Islamic "fundamentalism" (as it would later be called), the greed and corruption of the royal family, the torture and political oppression carried out by SAVAK, the Shah's secret police—simply were ignored by (or unknown to) editors, journalists, and photographers from *Time*, *Life*, and other mainstream publications.

These photoessays also resembled photoessays made in the United States in their assurance that middle-class Americans, their leaders, or their foreign surrogates and imitators were in control of everything they chose to do. Back home in the United

States, ordinary middle-class people improved their hometowns, their "wizard" scientists leashed the atom, "public-spirited" large corporations created new jobs for "smiling" workers, and government experts managed the economy. It was not surprising that some foreigners assumed that the American Dream of the 1950s was a recipe for success that would enable them to control events and transform their own nations in a few years, or decades, into countries as successful and prosperous as the United States. For example, the Shah of Iran—who assured *Time*'s foreign news editor that he read his magazine every week—informed an Egyptian journalist in the mid-1970s that he planned to have "the standard of living in Iran in ten years time to be exactly on a level with that in Europe. . . . In twenty years time we shall be ahead of the United States." The *National Geographic* quoted a similar claim by the Shah that "in ten years we will be another France or Germany. . . . I can assure you it is no exaggeration: Our young people will inherit a different country."[99]

■

"In any given picture, there are something like four authors. There's me—I make the decisions. I push the button. But there's also reality. Reality is incredibly forceful and talkative and says a lot of things. It always has a chance for revenge. The camera . . . does something very specific as well: It changes what it sees. And then there's the viewer, the people who look at the pictures. It's a collaborative venture [emphasis added]."
– Gilles Peress, photographer and author of *Telex Iran*[100]

Though some of the American-way-of-life photoessays and USIA publications made in the late 1940s and the 1950s may have been inspired by the documentary impulses I mentioned earlier—to dispel foreigners' "clichés" about the United States and to give Americans more confidence in their nation's economy—the editors quickly made this way of life into one of the more ubiquitous and stereotyped versions of the American Dream and the national identity. In the process, they often seemed to assume "reality" was a ventriloquist's dummy that could be manipulated to say, in one photoessay after another, that America was a capitalist utopia inhabited by nothing but smiling, constructive people. The photographs selected to illustrate this stereotype made it seem so eminently true—and the texts and captions accompanying these images were so enthusiastic and yet plausible—that many reasonable viewers might have been persuaded that this stereotype was the whole truth. Unfortunately, as early as the mid-1950s reality began to take its revenge: the stereotype began to be contradicted by hard news stories and images appearing on television, in newspapers, and even in magazines.

In 1954 and again in 1955 the Supreme Court ruled that segregated schools were illegal. Many white Americans—first in the South and later in the North as well—reacted to this "threat" to what they considered their way of life by resisting federal court orders and attacking black people. Southern states passed dozens of laws to

preserve segregation. They put schools under the control of governors, repealed attendance laws, and gave police the power to prevent blacks from entering schools. Even worse, in 1955 three black men were lynched in Mississippi, and a fourteen-year-old black boy from Chicago, Emmett Till, was kidnapped and murdered because a white woman said he whistled at her and asked for a date. The belief, advanced by optimists like William Attwood, that only elderly Southerners were segregationists, was demolished in 1956, less than a year after Attwood's article appeared in *Look*. Mobs of white youths resisted school desegregation in Clinton, Tennessee, by attacking black people and policemen trying to restore order. "All across the country, Americans were shocked at the news from Clinton and particularly by the pictures of angry youths attacking automobiles containing terrified blacks who feared for their lives as the youths smashed in the windows, slashed the tires, and jumped up and down on the car tops and hoods. Peace was not restored until the Highway Patrol and National Guard moved in . . . seven M-41 tanks and three armored personnel carriers."[101] In 1957 the Clinton response to integration was repeated, on a larger scale, when the state of Arkansas tried to prevent the integration of Little Rock Central High School, and President Eisenhower had to send in U.S. paratroopers to disperse mobs and prevent riots. For the rest of the 1950s and throughout the 1960s the mass media presented a new and unpleasant stereotype of ordinary Americans that contradicted the populist cliché that they were a friendly, helpful people. (As Roland Barthes asked sarcastically, "Why not ask the parents of Emmett Till, the young Negro assassinated by the Whites[,] what *they* think" of *The Family of Man* exhibit?)[102] Instead of the friendly folks who had appeared in so many *Life* and *Look* photoessays, people all over the world saw television images and news photographs of white Americans attacking blacks; white adults jeering and shouting obscenities at black children in school buses; governors and state officials barring schoolhouse and university doorways; National Guardsmen and army soldiers, armed with rifles, escorting black students or confronting mobs of white demonstrators; buses burning on highways; civil rights workers and demonstrators attacked by white mobs, policemen, water from fire hoses, and guard dogs; and, in 1964, a Mississippi sheriff and his deputy (Lawrence Rainey and Cecil Price of Neshoba County) grinning broadly at their trial for murdering three civil rights workers.

These events and images also damaged the illusions, held by some editors, that the popularity of the media meant it had the power to change attitudes, and that Americans were so willing to support reforms and progress that all they needed was some scolding from journalists and presidents. Most of the nation's mainstream media supported school integration or strongly condemned violent opposition to it in their editorials. The photographs that illustrated news stories and photoessays about the opposition to integration often presented extremely negative viewpoints toward segregationists and the police who arrested civil rights demonstrators. But, instead of being shamed by such criticisms, white mobs sometimes attacked reporters and photographers, and white police arrested them on trumped-up charges. When *Life* sent reporters and photographers to Little Rock in 1957 to do a photoessay called "A Historic

Week of Civil Strife," they came back with pictures of a black photographer, Ramon
Williams, being shoved by whites in a crowd, and a four-picture sequence of a black
editor from Memphis, Alex Wilson, being attacked from behind by whites. He was
knocked to the ground and kicked in the chest while the crowd screamed, "Go home,
you S.O.B. nigger," and the police standing nearby did "nothing to protect Wilson or
to jail his attackers." Ironically, three of the white people who were arrested at Little
Rock happened to be two *Life* photographers and a reporter, who were jailed for
"inciting a disturbance" after they were attacked by white rioters.[103]

A less well-known series of events, that occurred to the subjects of one of *Life*'s
photoessays, was another revealing example of how complicated and difficult it was for
blacks to achieve equality. In 1956 *Life* published an ambitious, five-part series about
segregation. The series was relatively "fair" in that Southern whites were allowed to
present their viewpoint in detail and were not portrayed as racist monsters. (*Life*
included a picture of a white man bringing flowers to the grave of a black man who had
been his employee.) But the overall message was that segregation was wrong, and this
idea was conveyed most clearly in the fourth installment, a case study of the effects of
segregation and discrimination on three generations of a black family, the Thorntons,
who lived near Mobile, Alabama. The photoessay suggested that the Thorntons were
excluded from the benefits of the American Dream even though they practiced the
virtues and followed the rules associated with it. The Thorntons were hardworking,
for example, and according to the Dream people who work hard are sure to "get
ahead" in this country, or at least their children will be successful; but *Life* emphasized
that even though eighty-two-year-old Albert Thornton looked back "on a life of
tremendous toil," his rewards for that labor had been "small," and when he took his
grandchildren for walks he saw that "the status of the Negro [was] little better than it
was when he was a child." Education was another important aspect of the American
way of life, and four of Thornton's children went to college and became teachers, but
they did not receive the rewards that white graduates took for granted.[104]

Life used one of these children—the Thorntons' daughter, Allie Lee Causey, a
school teacher who was married to Willie Causey, a hardworking farmer and woodcut-
ter—to illustrate how segregation prevented blacks from enjoying the same middle-
class standard of living that white people did. Even though the Causeys had two
incomes, they lived in an "unpainted, disintegrating" house, cooked on a wood stove,
and did their laundry in an iron pot over a bonfire in the yard. Mrs. Causey taught in a
country school, which was heated by a wood stove and did not have any plumbing. *Life*
did not portray the Thorntons or Causeys as bitter or angry about segregation, but it
did emphasize the pathos of their situation. One picture showed Mrs. Thornton and a
granddaughter looking at clothing on white mannequins in a store window. The
caption said, "They look long, buy carefully because of limited funds." Facing this
picture was a photograph of six small black children standing by a chain-link fence and
watching white children in a "white" playground they could not enter.

Five years earlier, *Life* had published a sympathetic portrayal of a poor, hardworking
black Southerner, Maude Callen (the subject of W. Eugene Smith's "Nurse-Midwife"

photoessay), who had to deliver babies in a country church while she dreamed of "having a well-supplied clinic." Maude Callen's dream came true, thanks to Smith and *Life* magazine—readers sent her $29,000 to build her clinic.[105] But Smith's photoessay did not mention segregation, and Callen did not express any opinions on that dangerous topic. *Life* quoted Allie Causey, on the other hand, saying that "segregation is on the way out," and "integration is the only way through which Negroes will receive justice. We cannot get it as a separate people. If we can get justice on our jobs, and equal pay, then we'll be able to afford better homes and good education." When the whites in the Causeys' town read this in *Life*, they ostracized the black family. There was no violence, but store owners refused to sell them food, gas station attendants refused to sell Causey gas for his truck, and Mrs. Causey was criticized by the local school board and lost her teaching job. *Life* sent a correspondent to try to "straighten things out," but he quickly learned he could do almost nothing to help or protect the Causeys, as he sat "night after night . . . in an Alabama cabin and listened to terrified people trying to decide where to go." Instead of receiving contributions from readers to improve Mrs. Causey's school, *Life* had to give the Causeys money to move to a different town. Mrs. Causey, though, was not qualified well enough to get a teaching job there, the marriage broke up, and Willie Causey moved back home, hoping that eventually he would be forgiven by the whites.[106] Because of *Life*'s "good intentions"—and the naïveté of its editors—the Causeys' efforts to have their little share of the American Dream had turned into a nightmare.

In the 1960s another American Dream turned into a nightmare. News stories and images from Vietnam contradicted the stereotyped vision of the United States as a generous, constructive nation whose foreign policies and economic aid were intended to save Third World nations from oppression and from what John Kennedy called "the bonds of mass misery." To be sure, there were still pictures of American politicians beaming at foreigners, and there were thousands of Peace Corps volunteers, and other idealistic Americans, still helping poor nations build schools and improve farming methods. As the war became increasingly violent, however, this could no longer stand as the essential—or even as a very important—truth about America's policies or national character.

Thousands of academics, intellectuals, poets, writers, and ordinary citizens began to disagree with the 1940s and 1950s consensus that the United States was a "Good Samaritan" nation, bringing prosperity and the blessings of modernity to humanity. In 1967, for example, Martin Luther King, Jr., declared that America had become "the greatest purveyor of violence in the world today."[107] In 1970 Oscar Cargill published an essay, cynically entitled "Gift to the World," in which he analyzed American foreign policy according to the classic criteria for imperialism outlined in John Hobson's 1902 *Study*, and concluded that the "United States since World War II" fulfilled Hobson's criteria "much more completely than did Great Britain." Hobson had argued that nations acquired empires in order to invest surplus capital abroad, and Cargill pointed out that the U.S. foreign aid program could be considered "not solely beneficent," but a device to "relieve the glut of capital and inflation" after World War II. Hobson

had said that empires were outlets for surplus population, and Cargill claimed that
America's "stationing of troops abroad fulfills another test of imperialism. How many troops have we had stationed in Germany, France . . . England, Spain, and Turkey since World War II? How many in South Korea? Vietnam? What would have been the effect on our economy of returning them all at once?" Finally, Hobson had argued, "imperialism had produced a class of parasites dependent on its perpetuation"; and Cargill asked rhetorically, "Is there not a sense in which much of the army officialdom of the United States is parasitic and dedicated to perpetuating the policy of 'containment'? And what about the Central Intelligence Agency? . . . Pity prevents us from placing the Peace Corps among these organizations."[108]

Other Americans might be less moralistic than King was, or less well-read in theories of imperialism than Cargill was, but they were just as disturbed by the sheer violence and destructiveness of the war. As a CBS news commentator said after watching marines raze the Vietnamese village of Cam Ne and set fire to its huts with Zippo lighters, "This is what the war in Vietnam is all about. The Vietcong were long gone. . . . The action wounded three women, killed one baby, wounded one Marine, and netted four old men as prisoners. . . . There is little doubt that American fire power can win a military victory here. But to a Vietnamese peasant whose home means a lifetime of backbreaking labor, it will take more than Presidential promises to convince him that we are on his side."[109] Nor were these Americans reassured by statements from soldiers and government spokespersons that justified such actions, claiming that huts were "tactical installations," that it was proper to kill peasants' cows, pigs, chickens, and ducks because they were "VC support units," or that destroying entire villages was necessary so they would be "saved."

Indeed, the naive amorality of such euphemisms and rationalizations was highlighted by certain images that were reproduced in one media after another—newspapers, television, picture magazines—with an almost obsessive frequency after the Tet offensive in early 1968: wounded American marines dragged by their comrades through ruins; wounded Americans, covered with blood and bandages, waiting to be taken to field hospitals; AP photographer Eddie Adams's picture of Colonel Nguyen Ngoc Loan shooting a bound "Vietcong suspect" in the head at point-blank range; a screaming, naked nine-year-old girl fleeing from a napalm attack while South Vietnamese soldiers walked by her; and bloodstained corpses of Vietnamese women, children, and babies strewn in an irrigation ditch after American troops massacred them in a village called My Lai. Inevitably, such images caused some Americans to doubt the wisdom and the morality of their nation's "involvement" in Southeast Asia.[110]

In actuality, these images were not much more violent than the "sensational" news photographs that had appeared so often in *Life* and in tabloid newspapers in the 1930s and 1940s. In particular, Adams's picture of Colonel Loan shooting the nameless "Vietcong suspect" in the head was not much more violent than *Life*'s 1936 pictures of Chiang Kai-shek's police executing Chinese communists, or than Capa's famous picture of the Spanish militiaman sprawling back from the impact of a bullet. But after

the Tet offensive began in 1968, it did not take much imagination to relate these violent images from Vietnam to American military "actions," or to the dead and wounded Americans described or seen on other pages or segments of the same media. Violence, in effect, became something that could no longer be controlled: it was no longer directed only, or chiefly, at the world's "darker races," foreigners, criminals, or other designated victims. Confronted with the breakdown of this protocol, editors, journalists, and other Americans reacted to the violent images in their media more emotionally. Thus *Life* published Adams's picture, nearly a month after it was taken, not as a big picture (like Capa's in 1937), but as a tiny one only a few inches square. Nor did it give it a caption like Capa's, inviting readers to appreciate Adams's timing in photographing the subject at the instant of death. ("Robert Capa's camera catches a Spanish soldier at the instant he is dropped by a bullet."). Instead, *Life* surrounded Adams's picture with a full page of columnist Shana Alexander's anguished musings. "What are the rules of war?" she asked. "What are the special rules of guerrilla war? What constitutes a terrorist? . . . Who are the Vietcong? Who is the 'enemy' in South Vietnam? How can you tell friend and foe? Who was the man?"[111]

Two months later, in May 1968, the editors of *Look* went a step beyond anguished rhetorical questions. After publishing an eloquent portfolio of Catherine LeRoy's Vietnam photographs showing "The Wounded" (a close-up of a bloody, bandaged American), "The Dead" (the decaying corpse of a North Vietnamese soldier), and "The Ravaged" (a woman holding a child with a bandaged head), the editors declared these pictures were not "published . . . to shock you into realizing that war is hell. We've all been shocked before, in our living rooms, watching violent death on 24-inch screens." The pictures were meant "to remind you of some things many Americans seem to have forgotten: that people and nations make mistakes; that people and nations can learn from their mistakes. . . . The Vietnam War has been a mistake, destroying something precious in the word 'America.' " The editors went on to argue that the violence of war contradicted the idealistic vision, which many Americans still held in the 1960s, that their country's "genius lies not in war but in peace. . . . So let us learn to be useful to the world without trying to be its policeman. . . . Let us work strenuously to create an international environment where all can flourish. Millions of Americans would like nothing better—students, teachers, Peace Corps volunteers, technicians, businessmen. This band . . . backed by the moral force and example of America, can help bring prosperity and build friendship and understanding all over our impoverished and endangered planet."[112]

Implicitly present in *Look*'s antiwar editorial was the realization that the United States could not have two national identities. It could not be the "world's policeman," causing death and destruction, and at the same time be a kindly teacher, bringing prosperity, friendship, and understanding to an "impoverished and endangered planet." Senator William Fulbright articulated this idea more fully in 1966, when he argued that the war affected "the internal life of the United States in two important ways: It has diverted our energies from the Great Society program . . . and it has generated . . . a war fever in the minds of the American people and their leaders."

Fulbright knew that some people claimed the nation had the economic resources to wage a war in Asia while it created a Great Society at home; but, even so, the senator said,

> It is already being demonstrated that we do not have the mental and spiritual resources for such a double effort. Politicians, like other people, have only one brain apiece.... The President simply cannot think about implementing the Great Society at home while he is supervising bombing missions . . . nor can the American people be expected to think very hard or do very much about improving their schools and communities when they are worried about casualty lists.... My own view is that there is a kind of madness in the facile assumption that we can raise the many billions of dollars necessary to rebuild our schools and cities and public transport and eliminate the pollution of air and water while also spending tens of billions to finance an "open-ended" war in Asia.[113]

The belief among Americans that their nation had one common Dream, and that it possessed the resources to make it come true, had been essential to the optimistic, consensus version of the American Dream of the years between 1945 and the mid-1960s. As Fulbright's analysis indicates, the war in Vietnam destroyed that consensus as Americans began to wonder how they could pay the spiritual and economic costs of being the world's police force, which had turned out to be so expensive, and at the same time be able to fight poverty, rebuild cities, stop pollution, and deal with all the other problems confronting their nation. Indeed, in the winter and spring of 1961, well before the war in Vietnam had become a serious matter, Walker Evans—even though he was still a staff photographer at *Fortune*—came out of his retirement as a documentary photographer and made an extended trip through Appalachia and the industrial heartland of the eastern United States. The portfolio of his pictures, which was published in *Fortune*, was very different from the images of industrial America that usually appeared in that magazine or in other mainstream media. Entitled "People and Places in Trouble," Evans's 1961 photographs were almost as bleak and disturbing as those he made twenty years earlier for the FSA. They were signs that yet another American Dream that had flourished in the 1940s and 1950s was in trouble.[114]

The
Great American
Wasteland

6

*Now to me the most exciting discovery which we have stumbled
into . . . is the extraordinary power of the photograph to
dramatize and lend fresh interest, news interest, to the good,
which . . . I may define as the normal and calm as distinct from
that which is disruptive or fantastic. . . . True, we make great
efforts to keep close to the news in the conventional sense of the
word—but the photographic angle on the news [in* Life] *is just as
apt to be [a] dramatization of the pleasant as it is of the
unpleasant proceedings of the human race.*

– Henry Luce, "The Photograph and Good News," 1937

I want to photograph what is evil. . . . I feel like an explorer.

– Diane Arbus, comments to Lisette Model
 and Seymour Krim, 1958, 1959

I saw the book [Life Is Good and Good For You in New York] *as a monster big-city* Daily Bugle, *with its scandals and scoops, that you'd find blowing in the gutter at three in the morning. . . . The photographers I knew mostly were Walker Evans, Weegee, maybe Riis and Hine. For me photography was good old-fashioned muckraking.*

– William Klein to John Heilpern, 1981

Un peu comme un détective.

(One must be a little bit like a detective.)

– Robert Frank, commenting on himself in 1983[1]

uce's comment may seem rather ingenuous, or even hypocritical, compared to the actual contents of *Life* during the 1930s and 1940s, which had so many "sensational" pictures of executions, corpses, and war victims; but, of course, in *Life* most of these "disruptive" experiences happened to foreigners, Asians, or black people, and even in those decades Luce's magazine always had room for "good news" about white, middle-class Americans and their institutions. Moreover, by the mid-1950s many issues of *Life* and *Look* were filled, cover to cover, with nothing but good news about the nation's economy and prosperity—all illustrated with pictures of the satisfied consumers, happy families, grinning young people, and smiling workers who inhabited what *Life*'s editors called, in 1947, "This Pleasant Land." But at almost precisely the same time, in the middle and late 1950s, that reality was beginning to take its revenge on the American way of life, and just as events in Little Rock and later in Vietnam were beginning to expose the dark side of the nation's dreams, some photographers began taking their revenge, too.

The most important of these photographers were William Klein, who photographed his New York City pictures in 1954 and 1955 and published them (in France) in his 1956 book, *Life Is Good and Good for You in New York*; Robert Frank, who used a Guggenheim Fellowship to tour the entire country in 1955 and 1956 to make the pictures for his 1958 (Paris) and 1959 (New York) editions of *The Americans*; and Diane Arbus, who first began to be noticed as a serious photographer when she published a portfolio of six pictures in *Esquire* magazine in 1959, and when her pictures were included in exhibitions at the Museum of Modern Art in New York in 1965 and 1967.*

As their comments and images indicate, Klein, Frank, and Arbus did not share Luce's vision of photography. Unlike photographers from *Life* and *Look*, their photographs did not flatter white, middle-class Americans. Nor did they have any desire to play "God the Photographer" by taking grandiose pictures of navies, airplanes, huge

*Despite strenuous efforts, the author has been unable to obtain permission to reprint photographs by either Diane Arbus or Robert Frank, which is why the work of William Klein alone is represented visually in this chapter. The work of Arbus and Frank—including most of the photographs discussed here—is well known nevertheless and is available for readers who wish to see it in the photographic collections by Arbus and Frank cited in the bibliography.

factories, or fields full of bulls and tractors to illustrate the nation's power or its miraculous productivity. ("I wanted the view anybody can see," Frank said, "just what goes on every day.")[2] They had no interest in the photojournalistic techniques, so popular in the picture magazines of the 1950s, that transformed movie actresses, politicians, and foreign dictators into screen goddesses, world statesmen, and "leaders of the free world." Instead, they transfigured photography itself into a far more personal and daring medium, and in the process they also changed and helped to reestablish documentary as an important form of photography—several years before it was "officially" revived in New York by the Museum of Modern Art in its 1962 *Bitter Years* retrospective of the FSA photographers.

Photojournalists who played "God the Photographer" for the picture magazines from the 1930s through the 1960s had to function as efficient cogs in large media machines well-lubricated with money and corporate prestige. They had to follow shooting scripts and coordinate their work with publication deadlines, airline and hotel reservations, editors, researchers, and reporters. Their subjects often had to perform in elaborately staged and lighted tableaux choreographed so readers could imagine they were participating in great news events or seeing ordinary people in spontaneous, real life situations. Then the images had to be shipped back to New York to be selected, arranged, and captioned by editors and designers to convey messages pleasing to publishers, advertisers, and millions of subscribers. Obviously, under such a system there was a great emphasis on being a good technician and a cooperative team player, and there were few or no serious opportunities for spontaneity or any kind of critical thinking. As Irving Penn said about 1950s advertising and fashion photography (which placed an equal emphasis on teamwork, meeting deadlines, and producing "marketable" images), "Having to always produce a publishable result forces you to play it safer than you'd like to, because the result must be publishable. In journalism, and even more so in advertising photography, the unforgivable sin is to come out of a sitting without something that can be put on the printed page. That's worse than banality."[3]

In contrast, Klein, Arbus, and Frank were great risk-takers who did their best work alone, following their own creative compulsions and obsessions. Klein subtitled his New York book, *Trance Witness Revels*. Remembering the eight months in 1954 and 1955 when he made these pictures, Klein said he felt like he was " 'Superman!' . . . Well, anyhow, my own man—I hope. I was taking pictures for myself. I felt free. Photography was a lot of fun for me. . . . Choosing a location, maybe a symbolic spot, the light and perspective—and suddenly you know the moment's yours. . . . Someone lurking in the background, a shadow, a reflection, posters, traffic, junk. 'Hold it! Don't move! Hey look this way!' . . . I had only one camera to start with. Secondhand. Two lenses. No filter, none of that. . . . I was in a big hurry. Once I got used to everything in New York I knew the trance would wear off. So I took pictures with a vengeance." Similarly, some of Arbus's friends said that when she started making her pictures of "evil" subjects for *Esquire* she threw herself into "an almost constant state of euphoria" for four months, as she rushed about New York in cabs or on a bicycle, weighed down with cameras. Two of them remembered seeing her coming out of the subway at 2:00

A.M., "running up from the station, eyes sparkling, not at all tired. I've never seen anyone work so hard." Anne Tucker described Frank in the 1950s as having "immersed himself in a world of people seeking to change jazz, literature, and art as he was trying to change photography. Spontaneity was a vital tool; they revered risk taking"; and another photographer called him "the kind of artist who is reaching so far beyond his grasp that he has grown accustomed to the feeling of being in over his head and would be uncomfortable if he were in total control, which is one of the things I admire most about him."[4]

Clearly this type of photography was radically opposed to the corporate and editorial control exercised by the picture magazines. In their 1936 prospectus for their new magazine, *Life*'s editors claimed that, hitherto, pictures had been taken and published "haphazardly," and "therefore, they are looked at haphazardly. . . . [But] the mind-guided camera . . . can reveal to us far more explicitly the nature of the dynamic social world in which we live."[5] This usually meant, in practice, that the editors' minds controlled the photography process, as they made up shooting scripts and selected images, and therefore it was their viewpoints that determined how the "social world" could be seen in photoessays.

Arbus's and Klein's rebellion against this system was visibly present in their images, but Frank went a step further. Not only were his pictures iconoclastic, but he also openly justified his rebellion in a "Statement" published in the *1958 U.S. Camera Annual*, along with a portfolio of his prints. "I do not anticipate that the on-looker will share my viewpoint. However, I feel that if my photograph leaves an image on his mind—something has been accomplished," Frank wrote. "It is a different state of affairs for me to be working on assignment for a magazine. It suggests to me the feeling of a hack writer or a commercial illustrator. Since I sense that my ideas, my mind and my eye are not creating the picture but that the editors' minds and eyes will finally determine which of my pictures will be reproduced to suit the magazines' purposes. . . . Mass production of uninspired photo journalism and photography without thought becomes anonymous merchandise."[6]

Both Frank and Arbus could have had relatively conventional careers in photography. Frank served his apprenticeship in Zurich, doing the meticulous, technically exact work always associated with Swiss commercial photography. He worked for *Harper's Bazaar* when he arrived in New York from Switzerland in 1947, and he was described as a "poet with a camera" by a writer for *U.S. Camera* in 1954 and by *Life* magazine in 1952, when he won second prize in the "Young Photographer's Contest." He did freelance work for the *New York Times*, *Fortune*, *Look*, *Esquire*, and *Glamour*. Seven of his pictures were published in Edward Steichen's *Family of Man* exhibit. Steichen (then photography curator of the Museum of Modern Art), Walker Evans, Alexy Borodovich (art director of *Harper's Bazaar*), and Alexander Lieberman (art director of *Vogue*) recommended him for his Guggenheim Fellowship. So, Frank probably could have had a career much like Steichen's in the 1920s and 1930s—combining commercialism with "poetic" art photography—if he wanted to. Arbus worked with her husband Allan for many fashion magazines from 1946 to 1957, and after she separated from him she supported herself and her daughters (though not very successfully) as a free-

lance photojournalist who did some relatively conventional magazine assignments. But, instead of making the pleasant, technically conventional photographs of the surface features of American life, which were the forte of the picture magazine photographers, she (as well as Frank and Klein) set out to photograph more hidden, subtle, or disturbing realities. She wanted to explore what she called "evil," or—in her daughter's words—"forbidden," subjects. Klein called himself an old-fashioned muckraker hunting for "scandals and scoops," and Frank considered himself as being like a detective. It is significant that in popular movies and fiction the detective is almost invariably portrayed as someone with a special ability to see through the "normal and calm" surface appearances of things, and to interpret these appearances to reveal the underlying guilts, fears, motives, and crimes; similarly, these photographers explored the darker sides of reality so sedulously excluded from the picture magazines during much of the 1950s.[7]

There was, of course, a whole ugly side of American politics and culture not entirely hidden during the 1940s and 1950s, which suggested that there were some unpleasant forces simmering in the nation's collective psyche. There were the sinister political fantasies of the John Birch Society and the dirtier doings of politicians, like Joe McCarthy and Richard Nixon, and their henchmen, like Roy Cohn. There were the men's "adventure" magazines illustrated by drawings of muscular, blonde gestapo thugs torturing voluptuous maidens, and there were Mickey Spillane's sadomasochistic misogynist fantasies (thinly disguised as sadomasochistic anti-Communist and antigangster fantasies). There were lurid *films noirs* and melodramas, like Lang's *The Big Heat* and Sirk's *Written on the Wind*, about vicious criminals and degenerate nouveaux riches Texans. And there were the millions of copies of comic books so violent they were considered menacing to the mental health of the nation's children. These symptoms of social malaise were almost entirely off-limits for the picture magazines and their photographers. Indeed, in 1955 the editors of *Life* reviled certain novelists who dared to depict the darker corners of American reality, describing them as "unemployed homosexual[s] living in . . . a shanty on the city dump while awaiting admission to the county poorhouse."[8]

Nevertheless, despite the menace of McCarthyism and the risk of enraging the editors of influential magazines during the 1950s, there were still writers willing to criticize the United States and its way of life. In 1952 the *Partisan Review* sponsored a symposium dedicated to the theme that intellectuals and writers no longer needed to feel alienated or "disinherited" from the United States, since "we obviously have come a long way from the attacks of Mencken . . . and the Marxist picture of America in the thirties as a land of capitalist reaction." Just in case the writers needed a role model, the editors provided them with a quote from Edmund Wilson's 1947 *Europe Without Baedeker*, in which Wilson offered his "optimistic opinion that the United States at the present time is politically more advanced than any other part of the world. . . . We have seen in the past fifty years a revival of the democratic creativeness which presided at the birth of the Republic . . . [and] a remarkable renascence of American arts and letters." Some of the symposium participants agreed with this, but several others attacked American society and culture as vigorously as any Mencken or

1930s Marxist. Leslie Fiedler paraphrased Marx: "A hundred years after the *Manifesto*, the specter that is haunting Europe is—Gary Cooper! Vulgar, gross, sentimental, impoverished in style—our popular sub-art presents a dream of human possibilities to starved imaginations everywhere." Norman Mailer declared "straightaway that I am in almost total disagreement with the assumptions of this symposium. . . . Everywhere the American writer is being dunned to become healthy, to grow up, to accept the American reality, to integrate himself. . . . Is there nothing to remind us that the writer does not need to be integrated into his society, and often works best in opposition to it?" Although theologian Reinhold Niebuhr admitted Russia was "a ruthless and intransigent foe, whose calumnies against us are . . . shockingly beside the point," he felt this did not excuse Americans for becoming "engaged in such a perpetual liturgy of self-congratulations about the vaunted . . . achievements of the 'American Way of Life' that we not only make ourselves odious to the world, but also rob ourselves of the political wisdom required to wield power. . . . Appeal to the courts is of less moment than individual courage in every relationship of life. What is wanted is the courage and the ability to resist the tide . . . to defeat the fools with the weapons of both scorn and laughter."9

It must have been encouraging for writers and intellectuals that they were the heirs to a well-established tradition of criticizing, or laughing at, mainstream American values, which could be traced back to Mark Twain, Frank Norris, Randolph Bourne, Van Wyck Brooks, Sherwood Anderson, Sinclair Lewis, John Dos Passos, and John Dewey, as well as to Mencken and the Marxists. Photographers had no comparable tradition in the 1950s. Instead, they had—if they knew the work done by Riis, Hine, the FSA photographers, and the Photo League—a tradition of what can be described as issue-oriented criticism; that is, criticism of specific social problems, usually from the standpoint of how middle-class America failed to live up to its own values or how it excluded worthy people from the prosperity and equality they needed to enjoy the American way of life. Before Klein, Arbus, and Frank, however, there was no clear, definite tradition of using photography to criticize American society and its values in general terms.10

Since they did not inherit a critical tradition, Klein, Frank, and Arbus created their own. In each case, because they were such strong individuals, the contents of this tradition were somewhat different, but there were a number of significant similarities. In all three photographers' work there were elements derived from American photojournalism and popular culture (or reactions against it); other elements derived from European visual culture and photography; and, finally, there were elements from past documentary photographers—mainly from Evans but also, for Klein, probably from Riis and Hine as well.

■

Robert Frank's links to European culture seem the most obvious, since he was born and raised in Switzerland and received his training as a photographer there, until he moved to New York when he was twenty-two years old. His link to past documentary

work is also clear; he acknowledged in 1958 that Evans, along with Bill Brandt, was onc of thc two "photographers [who have] influenced me," and in certain respects his book *The Americans* is an act of homage to Evans's *American Photographs*.[11] It is important to realize, however, that in Frank's work a European sensibility interacted with the American documentary approach to produce a new kind of photography that was more than a simple hybrid.

From the outset of his career, Frank was a street photographer, and European street photography has certain characteristics that can be appreciated in contrast to the American version. In particular, the Europeans generally have a sharper eye for social distinctions and subtleties. This is seen, for instance, by comparing Weegee's New York photographs of the 1930s with Brassaï's pictures of Paris in the same decade. Both specialized in photographing criminals, street people, transvestites, and other "night hawks" (to use Edward Hopper's excellent phrase). Weegee's images are mostly very brief, melodramatic encounters on city streets, whereas Brassaï's often show the same kind of people drinking, talking, and relaxing in the bars, night clubs, and dance halls where they are part of a functioning, though slightly clandestine, social environment. They are not exotic "others" who momentarily surface from the "underworld" to be captured in the glare of the photographer's flash. Brassaï's subjects possess social environments and insignia in a way that Weegee's do not; and, equally important, Brassaï could count on an audience that appreciated these social signs and distinctions—whether they were the curls of a prostitute's hairdo, or the rakish tilt of her pimp's cloth cap.[12] Both Helen Levitt and Robert Doisneau, in their daylight street photography, made many pictures of children, but Levitt's are all generic "kids" playing in the streets, usually in slum neighborhoods that also look rather generic. Doisneau sometimes photographed his children in more social settings, such as schools, and it is usually fairly clear whether the children are from the working class, lower middle class, or middle class. The specific city or suburban neighborhood they inhabit is usually distinctive, too.

Similarly, it is instructive to contrast Frank's *The Americans* with Evans's *American Photographs*. Frank's book conveys a far more social vision of the country. The final twenty-two images in *American Photographs* are a sequence of buildings, signs, and architectural details in which no humans whatsoever are present, and Evans included fewer pictures of people in social or family groups; but Frank included pictures of street crowds, political conventions, funerals, parties, people drinking in bars, gambling, attending commencement exercises, and riding in streetcars and railroad club cars. These were exactly the subjects that Evans rarely or never photographed, even though he used a 35mm camera (as well as a view camera) during the 1930s and did some street photography during that decade. When Evans went to Detroit for *Fortune* in 1946, he photographed isolated people walking by a hidden camera; when Frank went there nine years later, he photographed people riding together in cars, a crowd of factory workers at a drugstore lunch counter, and men working on an assembly line. Both Frank and Evans exploited the format of the photographic book to express diversity, but it is significant that, whereas Evans used his sequences chiefly to show

the regional and architectural diversity of 1930s America, Frank used his sequences to show social diversity. Thus, in *The Americans*, Frank's picture of a crowd of working-class children in a New York candy store is followed by a photograph of three rich children sitting in a car in a "Motorama" exhibit in Los Angeles—apparently practicing for the future, when they will be able to survey the world from a limousine. His picture of three middle-aged men conspiring in a New York-to-Washington express train is followed by a picture of a young movie actress displaying herself at a Hollywood movie premiere—a juxtaposition that implies a good deal about the different ways men and women gained power in the 1950s, and afterwards, in American society.[13]

Their ambition was one of the principal things that Frank and Evans had in common. "The physiognomy of a nation is laid on your table," Lincoln Kirstein said in 1938 about Evans's *American Photographs*. When Frank applied for a Guggenheim Fellowship in 1954—with Evans's encouragement—he admitted that "the photographing of America is a large order," but he still insisted he was going to make "a broad, voluminous picture record of things American past and present . . . the visual record of a civilization."[14] However, in the seventeen years between Evans's publication of his book and the time when Frank bought a Ford Business Coupe and started to photograph "the American nation in general," the meaning and purpose of what William Stott called the "I've seen America" tradition had changed considerably. During the early- and mid-1930s, it was used by writers and photographers trying to discover a "real America" beyond the glib generalizations and clichés produced by New York editors and Washington politicians. In 1933, for example, Sherwood Anderson wished that Herbert Hoover could have "come away from the Presidency for a few months" to "ride about America with me . . . talking man to man with workers, men out of work, country merchants, country lawyers, bums, small capitalists . . . with Americans just as they are." When Margaret Bourke-White accompanied Erskine Caldwell on the trip that resulted in *Now You Have Seen Their Faces*, or when the FSA photographers surveyed farm conditions for Roy Stryker, they were trying to show, in images rather than words, what Americans really were like. These tours could convey liberal or even moderately radical ideas; but by the early 1940s, as Stott pointed out, the "I've seen America" survey had become a cliché used mainly by "conservative" documentary writers, whose conversations with ordinary Americans always expressed the same patriotic idea—that the United States was a wonderful place certainly worth defending. An expression of the conservative populism described in the last chapter, this affection for "Americanness" was rarely defined or analyzed but could be appreciated in the same patriotic, sentimental way that Americans saluted the flag or listened to Kate Smith sing "God Bless America." *Life* and *Look* magazines expressed this feeling visually in many issues, but particularly good examples of it appeared in *Life*'s 1947 "This Pleasant Land" and William Attwood's *Still the Most Exciting Country* (originally published in *Look* in 1955).[15] Facts and images about America could be recorded or photographed verbatim and shipped back to New York, where editors melded them into the chauvinistic books and photoessays so prevalent in the 1940s

and 1950s. It was possible to leave out bad news from the provinces, as *Life*'s editors did in their special issues about America's national identity. Or, in the case of *Look*, its editors preferred to present unpleasant facts as social problems that would be solved with a little time, good will, and more education.

Frank made his Guggenheim Fellowship tour of America at almost the same time that Attwood did his reporting for *Look*, but Frank inverted the "I've seen America" genre to convey loneliness, anxiety, ambiguity, skepticism, and alienation. After all, Frank's picture of a lonely young man with a haggard face sitting at a cafeteria table covered with plates of half-finished food and empty soda bottles was just as much a truth of American life as the jolly "*Life* Goes to a Party" photoessays in so many issues of that magazine. His picture of a black nurse holding a white baby in a South Carolina hospital said as much, in one image, about the complexity and contradictions of American racial relationships as *Look*'s earnest photoessays.[16] His images of smug, fatuous politicians on reviewing stands, or cunning ones wheeling and dealing at the 1956 Democratic convention, expressed more about the nation's political system than the mass media was able to say about it—either in the 1950s or later.

As Diane Arbus sometimes emphasized in conversations and interviews, she was raised in a particularly affluent and sheltered section of American society. When she was growing up in New York in the 1930s and 1940s, her family operated Russeks, a Fifth Avenue department store that specialized in furs and expensive clothing for women. Many people would have considered the early part of her life a particularly fine example of the American Dream: she lived in a huge apartment on Central Park West; she was educated at good private schools and camps where the teachers encouraged her to be creative; and when she married her teenage sweetheart, Allan Arbus, her family gave the young couple the commissions and contacts that provided them with an entry into the very competitive field of fashion photography in the late 1940s. Arbus, however, seems to have considered this life confining. "For eight years I've been exploring, daring, doing things I'd fantasized about in my sheltered childhood," she told *Newsweek* after her 1967 New York exhibition opened at the Museum of Modern Art. "I'm a little foolhardy rushing in to explore all these freaky things, but dangers of violence—rape, murder—are more moving and less frightening than making a living at fashion photography."[17]

One of the significant aspects of Arbus's development as a photographer was that she gained much of her vision of "evil" or "forbidden" subject matter ("freaky things") from European visual and literary culture. Of course, American popular culture has never been averse to dealing with freaks, eccentrics, marginal people, and bizarre events—as the profits amassed by P. T. Barnum, horror movies, and the magazines sold at supermarkets indicate ("Two-Headed Baby Slays Mom," "Elvis Abducted by UFOs"). In American popular culture, however, freaks and eccentrics are almost always seen as objects of pity or horror, or they are exploited for their entertainment value in a circus or carnival environment. The latter approach was quite popular in mainstream photojournalism during the late 1930s and the 1940s. In 1938, for example, *Life* magazine did a photoessay on California in which it contrasted the

"pleasant, moderate, sensible" northern part of the state with "absolutely screwy" Southern California, which it described as well-stocked with eccentrics and gullible addlepates. The editors then filled several pages with pictures of eccentrics like Peter the Hermit, a Dr. Newman who lived in a tree and was "the prophet and lone member of his own cult," and "Jack ('F. D. R.') Young [who] was once told he looked like Franklin Roosevelt. Now he rides around looking like F. D. R. and having his picture taken." As one would expect from a magazine which so often praised middle-class normalcy, *Life* ridiculed and exploited individualism in its more bizarre forms, although its attitude was usually condescending and good-humored. The eccentrics cooperated by posing for the magazine's photographers, which implied that, far from defying mainstream society, they were delighted by the chance to entertain it. During the 1940s, this basic approach was followed in both *Life* and *Look* magazines in a minor but definite genre, the "screwball" photoessay. For example, a *Life* photoessay portrayed opera singer Lauritz Melchior as a "screwball" in a picture of him in his dressing room wearing the massive corset he needed to support his back during four-hour performances of Wagnerian operas. When she was working as a commercial photographer, Arbus did a number of "screwball" photoessays for magazines: for *Nova*, she did photographs of people who thought they looked like Queen Elizabeth and Winston Churchill; for *Glamour*, she presented soothsayers; and for *Harper's Bazaar*, she showed a tattooed man who called himself "Jack Dracula," another man who said he was the hereditary ruler of the Byzantine Eastern Roman Empire, and a third "Personality" who wore an Uncle Sam suit and claimed to be the "youngest 80-year-old man in the world."[18]

Arbus's images in these magazine photoessays were not particularly disturbing—or interesting. From the European photographer Lisette Model and the works of the German artist George Grosz, however, she absorbed a more radical and disturbing approach to eccentric and grotesque subjects, which shows in her images that were in exhibits and published in her 1972 Aperture monograph. Model and Grosz, like many twentieth-century European avant-garde artists, saw such people not as entertaining or pathetic individuals, but rather as morbid, human symptoms of social disorder, corruption, and malaise. European surrealists thought they possessed some kind of mysterious, irrational creativity. Either way, the Europeans did not view grotesque subjects as mere objects of amusement, pathos, or horror in the way that the American mass media did. Model's late 1930s portraits of gamblers and parasites on the French Riviera were entitled *Why France Fell*, and Grosz's works of the 1920s, with their lurid, violent subjects and iconography, were clearly meant to be seen as emblems of the decadence of the Weimar Republic. It was to Model that Arbus went for photography lessons after her marriage to Allan Arbus ended and she was trying to start a new career for herself. (The relationship between Arbus and Model was probably more a novice-mentor than a conventional student-teacher relationship. Bruce Davidson later said, "God, those two women had a strong bond! . . . [It] reminded me of a mother and daughter.") Earlier, Dorothy Thompson had taken Arbus to the Metropolitan Museum of Art to see works by Grosz, who became Arbus's favorite artist. She

particularly liked his works that emphasized lechery and gluttony. In the 1960s Marvin Israel introduced Arbus to the bizarre and irrational side of the European literary avant-garde. He encouraged her to read Franz Kafka's stories and Louis Ferdinand Céline's *Death on the Installment Plan*.[19]

Model's images of bizarre or grotesque people, which she made in Europe, have a crude, matter-of-fact monumentality. Unlike the subjects of horror films, most of her subjects do not seem particularly threatening; nor do they seem pathetic or ingratiating, as were the eccentric subjects of the "screwball" photoessays. Usually fat, and frequently ugly, Model's subjects simply exist in her images as if they were statues—a characteristic emphasized by the way that Model photographed many of them in harsh sunlight so that the shadows of their wrinkles, warts, and folds of flesh are heavily accentuated. Arbus achieved some of this same inert monumentality in certain images of grotesque subjects that she exhibited.

There is, however, one important difference between her grotesque images and Model's. Model photographed most of her European subjects with relatively little background around them in the picture frame; Arbus often used Evans's "documentary style" to make close-ups of her grotesque subjects, or she photographed them from a middle-distance perspective to include some of the street or domestic environment—very much as Evans and the FSA photographers often did. Whereas the backgrounds in the FSA pictures were almost always sharp and significant (to indicate ethnic or economic conditions, for example) Arbus usually included nondescript, tacky, or cluttered environments. She used the phrase "mangy woods" to describe a nudist camp: it can be applied to a great many of the domestic, street, or natural environments she included in her pictures. If she shows a street in New York, it is likely to be a drab, "mangy" street with bits of trash and paper. If her subject is a transvestite in a room, it is likely to be a depressing, impersonal room, probably in a cheap hotel. If Arbus photographed her subjects in dark places, their separation from the environment is emphasized by flash lighting, which isolates them in a harsh, ominous glare—a technique she probably copied from Model, who used it to photograph people in Bowery bars, and from Weegee, who also used it in bars and street scenes at night.

Evans's "documentary style" often gave a certain amount of dignity to his subjects, but Arbus's pictures rarely convey any of the dignity he emphasized. Moreover, his FSA photographs, when exhibited or published in *Let Us Now Praise Famous Men*, for example, appeared in contexts that gave a clear explanation (extreme poverty) for his subjects' haggard or bizarre appearances. In contrast, many of the grotesque subjects of Arbus's exhibition images exist in a kind of visual limbo in which there is no context to explain how or why they look so different from "normal" people. Instead, they simply appear in her images, like hallucinations. Indeed, as Arbus herself said, in a slightly different context, "It's a little bit like walking into an hallucination without being quite sure whose it is."[20] We can only surmise that these people, like Herman Melville's character Bartleby the scrivener, inexplicably *prefer* to be grotesque or different from the rest of the human race.

In effect, one of the most disquieting effects of many of her images is the extreme
sense of alienation they convey. A key aspect of the American Dream presented in the picture magazines of the 1950s, on the other hand, was that virtually all Americans were seen as parts of a huge network of entities, institutions, and communities that nutured and encouraged them to become healthy, normal citizens. Whether they were members of families shopping in supermarkets, citizens of friendly towns, smiling employees of large corporations, fans cheering for their sports teams, or voters chanting "I Like Ike," the Americans in the picture magazines were almost always people who *belonged*, cheerfully and voluntarily, to a society that made them happy and prosperous.[21] No one ever simply stood or sat by themselves, staring inertly into space or glaring angrily at the camera, like some of Arbus's subjects do. Her vision of American society is so consistent in this respect, and so radically antithetical to the American Dream, that some critics interpret her images as possessing, on an intuitive level, a "social-political . . . message." Halla Beloff, for example, compared Arbus to August Sander, the German photographer who set out to make a visual "portrait" of his nation in the 1920s and 1930s. Arbus, Beloff claimed, "would make her point by showing us a sub-set of the North American urban population, who demonstrate in actuality the quality of the American Dream. She did this by seeking out the transvestites, the wrinkled blondes, the murderous child, the isolated nationalist; and by photographing them with great exactitude. Then we would see what the American Way of Life was really like."[22]

William Klein's inheritances from European and American visual cultures mingled in the mid-1950s when he returned to New York after living for six years in Europe, where he studied art, established himself as a painter, and married a Belgian woman. On the one hand, he grew up in New York, surrounded by that city's jangled, frenetic visual environment of flashing lights, neon signs, skyscrapers, traffic, violent comic books, and the blaring tabloids that Klein later said had been the models for his first book of photographs. ("I saw the book as a monster big city *Daily Bugle* . . . that you'd find blowing in the streets at three in the morning. . . . I could imagine my pictures lying in the gutter like the New York *Daily News*.") Yet Klein also spent much of his precocious adolescence in the Museum of Modern Art, which was then one of the most important outposts of European modernism. He saw Von Sternberg's *Blue Angel* "endlessly" at the museum, which one of his friends later described as "our second home . . . [where] we would soak up *everything*—not just the paintings, but design, photographs, movies. It was central to our lives . . . talking intensely about D. W. Griffith and the Dadaists, Fritz Lang and Le Corbusier." When he was in his early twenties, Klein studied in Paris under the French modernist Fernand Léger, whom he later praised as "a great artist who told us that galleries were dead, easel painting was finished . . . who'd gone his own way against all the Parisian fads and fashions of the time. . . . Léger had another way of looking at life around him, and I could relate to it. He wanted us to get out of studios into the streets, or link up with architects. . . . He wanted us to be *monumental*. And we tried. His references weren't the Nineteenth Century painters . . . we all knew. His focus was on the monumental frescoes of

Masaccio, Piero della Francesca, Cimabue. . . . After a few weeks with Léger, I left to try to find my own way. He was the only contact I've had with formal training of any kind. He opened my eyes."[23] Yet Léger lived in the United States during World War II; he visited the country three times for extended visits during the 1930s; and he commented on how he believed America's visual culture influenced his painting. "In this country . . . there is an increased sense of movement and violence. . . . I prefer to see America through its contrasts—its vitality, its litter, and its waste," he wrote in 1946. "What has come out most notably . . . in the work I have done in America is in my opinion a new energy—an increased movement within the composition."[24]

When one looks at Klein's photographic images with this mélange of transatlantic influences in mind, it is clear he shared Léger's fascination with the monumental and also agreed with his advice that art should get "into the streets" and deal with violence, movement, waste, and litter—but the sense of monumentality is most significant. Not only are most of Klein's pictures big—some of them in his 1982 Aperture book are 13″ × 19″ double-page spreads—but also the people in them often seem crammed into the images and about to burst out of them. Many of the figures in Klein's photographic images seem larger than life, just as the figures in a Léger, Cimabue, or Piero della Francesca mural seem larger than life. But the contents of Klein's images are significantly different. Léger's paintings, even the "violent" works he made in America during World War II, have a sense of balance, and some of them even have a sense of hard-won serenity. Though Léger might have appreciated the "litter" of New York, he did not include any of it in his paintings, particularly the ones in which his dignified, monumental, stylized human figures seem to float in backgrounds where he has tamed the jarring, discordant rhythms of modern life. Similarly, in Piero della Francesca's painting, *The Battle between Heraclius and Chosroes*, even the violence of the battle is dignified, though its participants are attacking each other with great vigor.

The violence and movement in Klein's images, however, are notably undignified. Some of his subjects stare at the camera with coarse, mask-like expressions. Others contort, twitch, and gesticulate like the figures in American action movies, comic books, and crime and sports pictures in tabloid newspapers. (Later, in the 1960s, Klein made two films: *Mister Freedom*, a violent parody of American comics and action movies, and a film on Muhammad Ali.) Klein's subjects seem further debased by the deliberately blurred, "grainy," high-contrast look of many of his images, which was an imitation of the appearance of tabloid news photographs. "The kinetic quality of New York, the kids, dirt, madness—I tried to find a photographic style that would come close to it," he later told John Heilpern. "So I would be grainy and contrasted and black, I'd crop, blur, play with the negatives. I didn't see clean technique being right for New York."[25]

Klein's determination to show the dirt of New York fitted in perfectly with his interest in documentary photography, mentioned earlier, which included an interest in "Evans, Weegee, [and] maybe Riis and Hine."[26] Riis, in particular, frequently selected scenes filled with dirt, squalor, and litter, to show the need for cleaning up slums. But in Riis's pictures one expects to see dirt and squalor, because slums are usually dirty.

Klein, even though he made a fair number of his New York pictures in poor neighbor-
hoods, also seems to have been determined to show that he could do his "good old-
fashioned muckraking" photography on Fifth Avenue in 1954 as well as Riis had done
his muckraking on the Lower East Side and in the Bowery in the 1890s.[27] To be sure,
Klein's middle-class subjects do have cleaner faces, better teeth, and better clothing
than his slum people do, but even his pictures of these middle-class New Yorkers
often express a misery and cultural squalor that is just as depressing and disturbing. In
his picture of a crowd of businessmen by Rockefeller Center, for example, the men
wear expensive topcoats but their faces are rigid with tension or have coarse, heavy
features; the crowd of women he photographed near Gimbels are obviously from the
middle class (many of them are wearing corsages) but they have ugly, haggard faces
and wear sunglasses that make them look like giant insects. Klein also made many
unflattering pictures of specific groups. His pictures of the St. Patrick's Day Parade
and the fans at a Dodgers game, for example, are so remarkably unpleasant that they
could not possibly have been printed in any mass-media newspaper or magazine: their
publication probably would have caused thousands of New Yorkers to cancel their
subscriptions.

■

Only two weeks after he arrived in New York in 1947, Robert Frank told his parents in
a letter that, though American society had certain virtues, "there is only one thing you
should not do, criticize anything. The Americans are extremely proud of their coun-
try!"[28] Klein and Frank (and Arbus also, though perhaps less intentionally) deliber-
ately broke this rule with gusto. One of the most important features their images have
in common is the open or implicit iconoclasm they expressed toward the American
way of life as it existed in the 1950s. "I was at last coming to terms with . . . the city I
thought had excluded me. I never felt part of the American Dream," Klein said about
his arrival in New York in 1954 after six years of living in Europe. "I was poor as a kid,
walking twenty blocks to save a nickel carfare. Most of the city seemed foreign to me,
hostile and inaccessible, a city of headlines and gossip and scandal. And now I was
back with a secret weapon—a camera. I thought New York had it coming, that it
needed a kick in the balls."[29] During a 1975 interview, Frank was equally explicit
about his feelings toward *Life* magazine, that weekly anthology of the American
Dream and way of life in the 1950s. When he made his Guggenheim Fellowship
photographic trip, which resulted in *The Americans* twenty years earlier, Frank said, he
was influenced by a "tremendous contempt" for Luce's magazine, because "I wanted
to follow my own intuition and do it my way, and not make any concession[s]—not
make a *Life* story. That was another thing I hated. Those goddamned [*Life*] stories
with a beginning and an end."[30]

Arbus's iconoclastic feelings—more intuitive and less explicit—took the form of a
disturbing, corrosive sense of irony. Everybody had some kind of "flaw," she told one
of her classes at the Rhode Island School of Design; there was always what she called

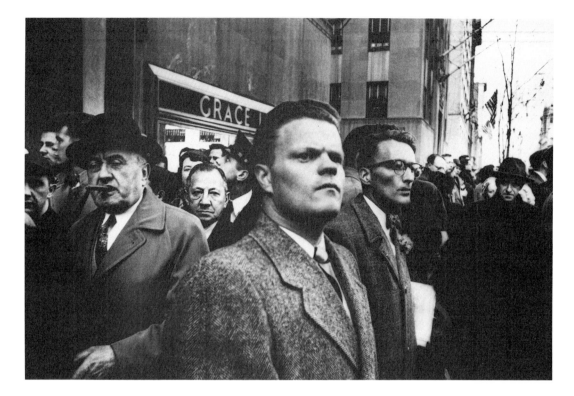

William
Klein, Fifth
Avenue,
Rockefeller
Center, 1954
(Klein, Life Is
Good and
Good for You
in New York,
1956, ©
William
Klein)

a "gap between intention and effect. I mean if you scrutinize reality closely enough, if in some way you really, really get to it, it becomes fantastic. . . . Something is ironic in the world [because] . . . what you intend never comes out like you intend it." Describing a visit to a nudist camp, she commented, "After a while you begin to wonder. I mean there'll be an empty pop bottle or a rusty bobby pin underfoot, the lake bottom oozes mud in a particularly nasty way, the outhouse smells, the woods look mangy. It gets to seem as if way back in the Garden of Eden after the Fall, Adam and Eve had begged the Lord to forgive them and He, in his boundless exasperation had said, 'All right, then. Stay. Stay in the Garden. Get civilized. Procreate. Muck it up.' And they did."[31] The picture magazines of the 1950s, on the other hand, depicted reality in the United States with an enthusiasm that was the opposite of irony. The editors printed photoessay after photoessay showing how well life in the United States conformed to the desires of its citizens and the plans of its executives, scientists, experts, and leaders. In their photoessays, to adapt Arbus's analogy, the human race had returned to a shiny new Eden, with all of the latest appliances and technological conveniences. What was so unsettling about some of Arbus's documentary style images was that she photographed both nudists and ordinary Americans in the same disturbing way; she always found the flaw, the empty pop bottle and the smelly outhouse. To those accustomed to the optimistic populism of the picture magazines or to Steichen's 1955 *Family of Man* exhibit, such images could only seem very "sick" or insulting. "The subjects of Arbus's photographs are all members of the same family, inhabitants of a

220

single [idiot] village," Susan Sontag observed tartly. "Only, as it happens, the idiot village is America."[32]

Just how unsettling the iconoclasm and irony of Arbus's, Klein's, and Frank's images could be to mainstream Americans was revealed by the dramatic—and very negative—first reactions that some editors and museum visitors expressed. When three of Arbus's images were first shown at the Museum of Modern Art in 1965, Yuben Yee, one of the museum's librarians, had to come in early every morning to wipe the spit from them. Yee later said, understating the matter a bit, "People were uncomfortable—threatened—looking at Diane's stuff"; Arbus herself was so uncomfortable, when she heard about the spitting, that she left town for several days. Alexander Lieberman, then the editor of *Vogue*, liked Klein's early New York pictures even though they had a "violence I'd never experienced in anyone's work. . . . [It] was a wonderful iconoclastic talent, seizing what it saw." According to Klein, however, other editors were less complimentary, and in the 1950s he could not find an American publisher for his New York pictures: "Everyone I showed them to said, 'Ech! This isn't New York—too ugly, too seedy, too one-sided.' They said, 'This isn't photography, this is shit!' "[33]

Frank's book, *The Americans*, enraged some of the editors of *Popular Photography* so much they passed it around their offices in a kind of poll and published the results in a group review. Two of the six editors had positive, though grudging and qualified, responses; the other four editors were almost totally negative and reviled Frank with a variety of mostly ad hominem criticisms, saying he was "a joyless man who hates the

William Klein, Near Gimbel's Department Store, New York City, 1954 (Klein, Life is Good and Good for You in New York, 1956, © William Klein)

221

country of his adoption . . . a liar, perversely basking in the kind of world and the kind of misery he is perpetually seeking," with a vision "too often marred by spite, bitterness, and narrow prejudice." "If this is America . . . then we should burn it down completely and start all over again. . . . It is obvious that Mr. Frank had 1934 eyes and blinders on when shooting," one of them complained, and others said, "the shots he grabbed show a warped objectivity," or that *The Americans* was "a sad poem for sick people. . . . Frank uses the same approach that distinguishes [Jack] Kerouac and his kind in their writing efforts. You will find the same studious inattention to the skills of the craft, the same desire to shock and provide cheap thrills."[34]

We can better understand why Frank's, Klein's, and Arbus's images were so disturbing if we contrast them with other pictures of the American way of life that appeared in picture magazines, USIA brochures, and the work of Magnum photographers like Burt Glinn, Wayne Miller, Eve Arnold, Cornell Capa, and Dennis Stock in the 1950s. (The Magnum photographers were more independent than those working for *Life* and *Look*, but they made their images for essentially the same market—and the recent collection of their pictures, *The Fifties: Photographs of America*, is a good, accessible anthology of 1950s mainstream photography.)[35] Klein's, Frank's, and Arbus's pictures represent excellent examples not only of iconoclasm but also of what an anthropologist might consider "symbolic inversions"—playful yet deeply serious transgressions of cultural order, which Victor Turner described as expressing the "freedom to enter, even to generate, new symbolic worlds. . . . Freedom to transcend structural limitations, freedom to play with ideas, with fantasies, with words . . . and with social relationships . . . [and to] release potentially creative powers . . . either to criticize or buttress the dominant values of [a] culture."[36]

In the mass media of the late 1940s and the 1950s, one of the most ubiquitous symbols of cultural order was the middle-class nuclear family. According to this stereotype, the right, best way to grow up was in a family in which little girls looked like dolls and little boys played cowboy; then they became adolescents whose role models were cheerleaders, Pillsbury bake-off winners, football players, and crew-cut infantrymen, sailors, pilots, and marines; then they fell wildly in love, married young, bought houses in the suburbs, and had plenty of cute children. This vision of human happiness appeared in advertisements, picture magazines, movies, and politics (Dick and Pat Nixon vs. Jack and Jackie Kennedy).

Even Diane and Allan Arbus made a modest contribution to this stereotype in 1947, when they photographed themselves for a *Glamour* series called "Mr. & Mrs. Inc.," which were case studies of seven young couples who had achieved "togetherness" in their careers in the arts, sciences, and business. The Arbuses, said *Glamour*, "found their forte in photography. They've known each other since their early teens, married young, and arrived at their chosen work only after sampling other careers. While Allan was working in advertising, he came into contact with fashion photographers. . . . His enthusiasm converted Diane and they were soon planning, taking and printing pictures almost on a 24 hour a day basis. They began to specialize in fashions, [and] established their own studio."[37] In one of the photographs accompanying the article,

the Arbuses posed together with a camera: Allan with his hand on the shutter cable release and staring right at the viewer with full eye contact, Diane looking down demurely at the camera viewfinder. In another picture, Diane posed elegantly feeding their daughter, Doon, her baby food, while wearing a long dress and high heels, presumably to show that her busy schedule had not impaired her femininity. Actually, as Bosworth points out, Arbus was usually only the "stylist" in the studio—in charge of fixing the models' hair, make-up, props, and accessories—Allan did most of the actual photography. Later, in the mid-1960s when she was doing some free-lance commercial photography for *Harper's Bazaar*, Arbus did a series of portraits of married couples ("Fashion Independents on Marriage"), which contained all the conventional gender stereotypes—the wives touch, cling, and snuggle against the husbands; and the men stare boldly straight at the camera, whereas the women tilt their heads submissively.[38]

After Arbus rebelled against her role of stylist in 1957, and when she was making images in a documentary style, families were one of her more important subjects—but she deliberately selected strange or eccentric families. In Arbus's vision, as Sontag pointed out, "every couple is an odd couple."[39] Her images present ironic contrasts between the social form of her subjects (they are families or have some sort of family relationship) and their actual appearance, which conflicts with conventional ideas about what a family should look like. In her 1970 picture, "A Jewish Giant at Home with His Parents in the Bronx, N.Y.," the "giant" son towers over his middle-aged parents, and they stare up at him like children confronting a monster in some morbid fairy tale. She photographed nudist families, mostly fat and middle-aged, at a New Jersey camp in 1963, and another nudist couple with an equally fat teenaged daughter at a camp in Pennsylvania in 1965. Wearing clothes from Sears Roebuck, which would match the furniture in their camp house, the New Jersey couple would look like any ordinary, lower middle-class, late middle-aged American couple, but their nakedness beautifully contradicts this idea, particularly since they are both so plump. In Washington Square Park in New York, also in 1965, Arbus photographed a young couple identified as "A Young Man and His Pregnant Wife," in which not only is the man black and the woman white but also the woman seems distinctly taller than the man because of her bouffant hairdo. Moreover, the man is tilting his head in the "submissive" pose that women often assume in advertising images.

Another mark of the mass media's devotion to the family in the 1950s was their interest in pleasant or "cute" rituals in which children performed for their parents and other relatives. Magnum photographer Wayne Miller, for example, photographed eighth-grade graduation ceremonies and small children singing and reciting in Sunday school in California and Kansas in 1957 and 1950. But, when Arbus photographed this type of ritual in 1967, she picked a particularly silly one—a "Diaper Derby"—and she made close-ups of the sobbing losers, so that the babies look more like monsters than human beings. One of the more sentimental stereotypes of the "togetherness" genre was the picture of a family with its new baby. Eve Arnold in 1955 photographed a Long Island young mother kissing her husband, who is sitting in a

rocker holding their new infant and surrounded by all the marks of suburban afflu-ence—a nursery with a view of the lawn, a new cocker spaniel puppy, cut flowers in a vase, and a Raggedy Ann doll; Arbus's photograph of a "mother and child" in 1971 was of a thin, middle-aged woman sitting on an old couch and holding a tiny baby monkey dressed like a human infant.[40]

On at least one occasion, Arbus photographed a "typical," affluent, upper-middle-class family—the Tarnapols of Westchester, Connecticut. Tarnapol was a successful agent and publisher in the music business. He and his wife were in their mid-thirties, physically trim, and lived with their three small children in a suburban home with a spacious yard. In the 1950s, gathered around their pool or barbecue pit and photographed for an advertisement or picture magazine photoessay, the Tarnapols would have been portrayed as perfect examples of the American Dream—relaxed, cheerful, and smiling. In Arbus's picture, which was published in the London *Sunday Times Magazine* in 1968 and later in her Aperture monograph, she subtly but completely subverted every feature of that Dream. Mr. and Mrs. Tarnapol, wearing their bathing suits, posed for Arbus lying in chaise longues, and she stood facing their feet so that—in the photograph—their bodies are foreshortened. Mrs. Tarnapol's blonde hair looks artificial, like a wig, and her expressionless face seems hard and haggard. Her husband lies with one hand covering his face in what seems to be a gesture of shame or disgust. Behind them, one of their children stares down into a small wading pool. The Tarnapol's lawn looks vast and formless, with toys scattered around it; the woods behind the yard seem "mangy," like the ones at the nudist camp; the sky is overcast; and the entire scene seems laden with alienation and anxiety—like a scene from a film in which one of the characters is about to have a nervous breakdown.[41]

In addition to parodying or subverting families, Arbus also sought out subjects who did not fit mainstream American life and values, such as a Mexican dwarf, Russian midgets, carnival freaks, transvestites, and a hermaphrodite. In a 1966 unpublished essay, she claimed that seeing such people in a dime museum on 42nd Street was a magical, exciting experience, like going into another world, reached by descending "somewhat like Orpheus or Alice or Virgil, into the cellar." Surprisingly, one of the most significant features of her pictures of these subjects is how drastically unmagical they are. Using Evans's documentary style and harsh lighting, she continually empha-sized the sheer, drab ordinariness of these subjects' environments. In the photographs of the transvestites, the resulting effect is extremely ambivalent: her subjects try to transform themselves into another sex by wearing slips, nylons, and garters, yet at the same time they are surrounded by an external reality that resists the transformation process. When she photographed transvestites at drag balls, she often seemed to pick out men with such coarse features that they could not possibly look like women—they exist in a sexual limbo in which they look masculine despite their efforts to transform themselves with wigs, feathers, mascara, and lipstick.

On the other hand, when Brassaï photographed gay men and women in Paris in the 1930s, he went to gay bars and nightclubs in which his subjects seemed at home. At

drag balls he photographed good-looking lesbians and gay men who posed for him quite happily because they were obviously—and justifiably—proud of their makeup and costumes. Brassaï's subjects subvert or rebel against the cultural order (which is one of the functions of a real carnival) and establish a different order in their own milieu, at least temporarily. It might have been a bit decadent, but it was also witty and charming. Brassaï, emphasizing the positive aspects of his subjects' appearances, signaled his own tolerance of their behavior as an alternative way of living. Years later, he described one of the drag balls he photographed with good-humored appreciation: "These middle-aged nellies in their finery and their glad-rags would utter piercing shrieks, join hands, and dance wildly together. There were no indiscreet onlookers here to make them feel uneasy. No threatening opprobrium from "normal" men, no humiliating female disdain, no inquisitorial vice squad surveillance. . . . On that night, the 'love that dares not speak its name' said it loud and clear, shouted it from the rooftops." Arbus, through her choice of subject matter and and her portrayal of families, obviously rebelled against the gender stereotypes of the American Dream of the 1950s. She photographed gays and transvestites with such an emphasis on the ugly and the sullen, however, that it is difficult to believe she had much respect and tolerance for them, and some of the photographs she made of feminists in the late 1960s were not only ugly but remarkably hostile as well.[42]

Unlike Klein and Frank, Arbus seems to have been ambivalent, or perhaps even defensive, about her rebellion against the American way of life. This may explain her comments in a 1967 *Newsweek* interview, in which she acknowledged that she knew she had "incredible power in my closet" (an interesting choice of language); then she explained she did not mean "power to do harm—just the feeling that I've captured people who since have died and people who will never look that way again. The camera is cruel, so I try to be as good a person as I can to make things even." Yet she loved the thrill, the adrenalin charge, of photographing "evil" or "forbidden" subjects and subverting mainstream values, as she told her students. "Freaks was a thing I photographed a lot. It was one of the first things I photographed and it had a terrific kind of excitement for me," and "Everything is so superb and breathtaking. I am creeping forward on my belly like they do in war movies." But at the same time she also wanted to be considered a "good person" and to blame the camera for being "cruel."[43]

From this point of view, it is significant that one of her kindest, most sympathetic portraits was of Iva d'Aquino, a Japanese-American woman who became infamous as "Tokyo Rose" when she made propaganda broadcasts for the Japanese government during World War II. In the text Arbus wrote to accompany d'Aquino's portrait, which was published in *Esquire* in 1969, she strongly implied that d'Aquino had not really been guilty of treason—that she had been stranded in Japan at the beginning of the war, that she had befriended American prisoners of war because, d'Aquino said, "it was manna from heaven to be among people who thought and felt as I did," and that she had been convicted of treason because she was "a symbol." After serving a few years in jail, she was released, and her lawyers petitioned for a presidential pardon.

Arbus ended the interview with a quote implying that d'Aquino had forgiven America for causing her so many difficulties: " 'I could have done without all this,' she says smiling, 'but it's a lot of water under the bridge now.' "[44]

Arbus photographed d'Aquino standing in her living room in Chicago, where she managed a gift shop. The room is not luxurious enough to be considered an example of the American Dream in the 1950s or 1960s, but it is comfortable, clean, and orderly, and d'Aquino stands smiling and relaxed in the middle of it. Unlike so many of Arbus's subjects, she does not look tense, angry, or like a zombie; and nothing in the room looks squalid, dirty, or distorted. Arbus's picture and text might be interpreted as an indirect, rather pathetic autobiographical statement. Here was a woman who, seemingly, had attacked America, had been guilty of disloyalty, and had been hated by many Americans—but it was all due to bad luck and a series of cruel misunderstandings and mistakes. She really was a "good person" who had not meant to harm anyone. In reality, she probably was more a victim than an enemy of America and its way of life, but few Americans were able to accept such an interpretation of either Iva d'Aquino's or Diane Arbus's lives and careers.

Clearly there was nothing ambivalent about William Klein's contempt for the American way of life—at least as it was lived in New York City in the mid-1950s—when he made the images he published in his 1956 book, *Life Is Good and Good for You in New York*. In contrast to Arbus's iconoclasm, directed mainly at the private and domestic elements of the American Dream, such as gender roles and the family, Klein's attacks were aimed more at the public and civic aspects of that cultural order.

Klein designed his book himself, and entitled its first section "Family Album." That section contains very few pictures of nuclear families, however, since it expresses the concept of the city as a civic "family," and also—by implication—parodies the melting-pot myth that had become a popular, urban version of the Dream by the 1950s. In Arthur Goodfriend's 1954 *What Is America?*, for example, the Horatio Alger, Jr., myth was incorporated with the melting-pot myth as Goodfriend described himself growing up in a generic, working-class, multiethnic, urban neighborhood in which all the boys learned to be successful Americans by playing the same games and sports, going to the same schools, and absorbing the same "values" from movies and organizations like the Boy Scouts. "We, sons of Italians, Africans, Germans, Hungarians, Russians and Chinese, became cowboys and Indians," Goodfriend claimed. "At home each family clung to its old ways. [But in] the street they mingled, each striving to speak a common tongue." Ethnic diversity was transformed into national unity as the boys learned American teamwork and "brotherhood in action" by playing baseball together, which was illustrated with a picture of a team of boys, including blacks and whites, walking with their arms around each others' shoulders. Thus, instead of suffering the "class warfare" or ethnic strife that occurred in other nations, Goodfriend saw American cities as places where people from all races, classes, nations, and religions could mingle and transcend their respective origins to become parts of the same "team," or "family," in which they would participate in the same vigorous capitalist economy and all become equally successful.[45]

Klein invoked the melting-pot myth in the "Family Album" of his book, but mainly
to subvert it. He designed two pages of this section to look like the pages of an actual family album, with small oval and rectangular pictures on a black background, but he also suggested that this was a civic "family" by including photographs to represent many of New York's different classes, and ethnic and religious groups: Asian-American businessmen in suits, a beggar waving his hat, black people, Jewish women holding a B'nai B'rith banner, two Roman Catholics holding a picture of the Virgin Mary, a row of middle-class kids dressed up in coats with fur-trimmed collars, and poor children dressed in ragged clothing. Here we all are, Klein implied, rich and poor, young and old, Asians, blacks and whites, Jews and Catholics, all mingling together—except that he also included, beneath suit-and-tie images of two businessmen, a surreal picture of three grinning, mechanical Mr. Peanut mannequins wearing black top hats and turning the cranks on peanut roasters. Who are these men? The founders of the Planter's Peanut Company? What can they and the Mr. Peanut mannequins possibly signify? Klein doesn't say; he only inserts this bizarre image into his "Family Album" as if to suggest that the concept of the city as a "family" is really a joke.

This interpretation seems reasonable when one looks at the other pictures in the "Family Album." In them, Klein emphasizes how discordant and different New Yorkers are from one another. There is a picture of a young white couple, with the man in an army uniform and wearing medals, posed by a stone eagle in a park; it faces a picture of a black couple, also dressed-up, posed in front of a slum storefront. The lighting in the two pictures and the poses of the couples are so different they seem to inhabit two different worlds. An image of a husky young man clowning in front of a bar, hoisting a midget smoking a pipe onto his shoulders, faces an image of a smiling young man in blue jeans who is pretending (?) to mug a middle-aged man in a suit. A black man dressed in an archaic costume of Waspish respectability—top hat, morning coat, striped trousers, pince-nez—poses by a church in several pictures, and in one of the pictures a young black girl crouches to shout at the camera. The other groups of people who appear in this section are almost as "odd" as some of Arbus's couples and families. In one famous Klein image, a poorly dressed woman points what appears to be a toy pistol at a small boy's head at the same time that she gently holds the boy's hand; this picture faces one of a man at a baseball game holding his son's neck so that it looks as if he may be about to choke him. The final image in the section shows three young men talking casually while around them small children in Halloween masks appear like disembodied monsters. The City's diversity has turned into a chaos of disparate, and frequently disturbing, images—concluding with an image of Halloween masks, as if to imply that in this "family" the monstrous and the bizarre have become casual and commonplace.

Klein's iconoclastic pictures were notable also, as Alexander Liberman pointed out, for their violence.[46] Two of his images are particularly famous for this quality: one is of a scowling, angry boy pointing the muzzle of his cap gun directly at the lens of the camera, and the other, mentioned above, is of the poorly dressed woman holding a toy

gun against a boy's head. Of course, there was plenty of violence in the movies, comics, and tabloid newspapers during the 1950s, but in these media violence always originated from evil others: gangsters, Nazis, Asian and Russian Communists, wicked women, bad cowboys in black hats, and monsters from outer space who attacked innocent, peace-loving Americans. These stereotypes prevailed until the 1960s, when attacks on civil rights workers, the Vietnam War, and a number of political assassinations finally forced some Americans to recognize that the United States was a "violent society" and that its fascination with guns and games like "cops and robbers" might not be quite so harmless after all.

Klein anticipated this awareness by almost a decade in a section of his book entitled "Gun," which began with a picture of a newsstand rack stuffed with copies of the tabloid *Daily News*. Part of the headline and part of the front-page news picture are visible. The headline says "Gunma," and the picture shows a group of policemen carrying a body. Presumably, the full headline is something like "Gunman Kills Cop," or perhaps "Gunman Slain," and the picture shows policemen carrying one of the victims, or perhaps the gunman himself. In tabloids like the *Daily News*, violent people are stereotyped as evil others, gangsters or psychopaths, who attack society because of their own malevolent natures. In Klein's book, New Yorkers learn violence from their society—if not at their mothers' knees, then in the streets, where they play with guns. Thus his gunman headline picture is followed not by pictures of adult gunmen but by four pages of images of children aiming or carrying toy guns—three of which are aimed right at Klein and his camera lens. In one picture a small boy, scarcely more

than a toddler, carries a toy double-barreled shotgun, and in another picture a toddler in a stroller brandishes a cap pistol.

In addition to the violence of these gun pictures, many of Klein's other images are filled with emotional violence. To paraphrase Jean-Paul Sartre only slightly, in these pictures, hell is other New Yorkers—pushing, jostling, bumping into, ignoring, or glaring at one another. In one picture, for example, a black man in a suit, tie, hat, and overcoat frantically shouts at pedestrians on a busy street in Times Square. He carries an American flag and a Bible, plus signs with religious messages: THE WAGES OF SIN IS DEATH BUT THE GIFT OF GOD IS ETERNAL LIFE. MY SUBJECT TO ALL PEOPLE IS PRAY. Except for a small boy who stares at the black man, the passersby try to ignore him as they walk by, smoke cigarettes, or stare at Klein and his camera. The black man's anger and frustration as he tries to make these sinners listen to him are palpable—and so is the tightly controlled indifference of the people around him. In another picture a fat car salesman stares malevolently at the camera through the plate glass window of his showroom. Another shows marchers in a St. Patrick's Day parade, carrying a giant rosary and looking at the photographer with a kind of weary hostility, or at least annoyance, as they march down Fifth Avenue.

There is also what might be called the aesthetic violence of Klein's New York crowd scenes. Only some of the people in his pictures are distinctly ugly, but all of them look rushed, hectic, and nervous. Nowhere is there a visual note of charm or grace. Walker Evans made similar pictures of crowds in Chicago in 1946, and one of Frank's pictures in *The Americans* ("Canal Street—New Orleans") has a rushed, alienated quality. But virtually all of Klein's pictures are like this, and one is reminded of the Swiss editor and photographer Gotthard Schuh's "shocked and haunted" response to *The Americans* in 1957—a response that applies as well or even better to Klein's book than it does to Frank's. "No smile, no flower, no vegetation, no beauty, but only tormented, stolid human faces set about with machinery," were in the images, Schuh wrote. "I do not know America, but your pictures frighten me. . . . Never have I seen so overpowering an image of humanity become mass, devoid of individuality, each man hardly distinguishable from his neighbor, hopelessly lost in airless space. A dour mass, crafty and aggressive."[47]

Klein also accentuated the City's crass consumerism. There are commercial signs, billboards, and posters in many of his images, and most of them look silly or ironic. On one side of his blurred picture of two children dancing beside a drab street in Queens, for example, half of a Ballantine Ale billboard is visible: it is a holiday greeting from the brewery, with an image of people riding in a sleigh through a snow-covered, rural landscape. This banal pastoral image looks over a weedy, trash-strewn lot; on the other side of the image automobiles rush by, and in the center two children do a blurred, manic dance. One of the most popular icons of "People's Capitalism" in *Life* and the USIA brochures was the happy family pushing their loaded supermarket cart, but in one of Klein's images, four flabby, middle-aged women with puffy, unhappy faces seem barricaded behind their carts in a checkout line. In other Klein pictures, a laughing white woman on a billboard advertising cigarettes seems about to jam her

lighted cigarette into the neck of a young black woman standing in front of the billboard; a middle-aged man with a blank grin on his face stares at the camera from behind the neon letters of a RHEINGOLD EXTRA DRY beer sign in a tavern window; an ingratiating, middle-aged saleswoman in a dime store, heavily made-up, leans toward the camera to show a customer a can of "cleaner," and beside her a poster urges, DO IT YOURSELF.[48]

Products in advertisements are almost always seen as integral parts of clean, orderly, or pristine environments, whereas in Klein's images advertisements for the same products (or their logos) become integral parts of a grimy, debased, urban environment that is even more blurred and distorted by his grainy, wide-angle photographic techniques. Further, in the innumerable versions of the American Dream appearing in advertisements, products like beer, Coca-Cola, and cigarettes are valorized by association with pleasant-looking scenes and relaxed, smiling people; and it is always implied that the product, whatever it is, will enter our lives and make us just as cheerful. In Klein's images, this relationship becomes inverted: the products, symbolized by their advertising posters and billboards, visually invade and dominate the spaces in which his New Yorkers exist, and the City's consumer plentitude turns into a nightmare. Indeed, in one of his most powerful and disturbing images, Klein photo-

graphed a group of men sitting behind a plate-glass window in a luncheonette. Their faces and bodies seem chopped, broken-up, and disfigured by the tangled images from the street that are reflected on the plate-glass, and by the signs in the luncheonette windows. Messages like HOME STYLE BROWNED BEEF STEW . . . 95¢ and BREADED VEAL CUTLET TOMATO SAUCE VEGETABLE & POTATO . . . $1.05, reflected images of cars on the street, and reflected business signs from the other side of the street have all become, symbolically, more important than human beings, and dominate their lives.

Pictures like this one suggest the kinship that exists between Klein's and Lewis Hine's images, which otherwise seems rather unlikely, since Klein did not photograph any people doing physical work in his New York book. In many of Hine's pictures of factories and glassworks, he showed how the children were debased by their cluttered work environments, and Klein achieved an analogous effect by the way he photographed New York's consumer environment. Many of his images imply that the City's frenetic insistence that everything must have a price—its ubiquitous brand-name billboards, signs, posters, and neon lights—produce the trashy, harassed people who rush by his camera. Also, just as Hine composed child-labor posters to show how children were exploited for profit, Klein arranged sequences in his book to show how women were exploited commercially by sexism.

Of course, advertisers frequently used sex to sell their products in the 1950s, but they usually did this with innuendo and a little "good taste." Klein arranged his images so that the crassness of the connection was inescapable. In one double-page spread he juxtaposed a picture of a graffiti, "I need," scrawled on a brick wall, with a picture of a

William Klein, Eighth Avenue Luncheonette, New York City, 1955 (Klein, William Klein: Photographs, 1981, © William Klein)

231

record store window filled with record jackets. Four of the records are entitled "I Love" and illustrated with pictures of a voluptuous model who is, on one cover, fondling her own breasts. (The music on one of these records is by "Norrie Paramor and his Orchestra.") Strewn below the soft-porn "I Love" records are a sign, 12 INCH LONG PLAYING 99¢, and a pile of recordings by Gershwin, Rachmaninoff, and Beethoven, which suggests both how cheap and how eclectic the tastes of the City's music lovers were. In another double-page spread, Klein juxtaposed a picture of silly, sexist, men's ties with cartoons of women printed on them (on sale in a tourist shop), with a facing picture of four voluptuous, smirking chorus girls wearing elaborate gowns and silly little hats. Like the cartoons on the ties, the "chorines" are comic parodies of sexuality, dressed up so tourists can gape at them.

Also iconoclastic was the overt emotional violence of Klein's photographic response to what he saw in New York. What he was looking at offended him, and he "shot" back with his camera, as if he wanted to force his subjects to see how squalid and second-rate they looked. Frank could be just as tough in his view of America, as John Heilpern wrote, but—compared to Klein, who was violent and personal—he was cool, wry, and "distant." Instead of standing back and maintaining his aesthetic distance, Klein rushed into crowds, "attacking them like a *paparazzo*," so that the people in his pictures seemed to be plunging toward the camera—an effect heightened by his use of a wide-angle lens that bent and distorted the scene.[49]

Robert Frank's reaction against the American way of life was just as strong as that of Klein and Arbus. "I am photographing how Americans live, have fun, eat, drive cars, work, etc.," he wrote to his parents in Switzerland during the winter of 1955 in the midst of his Guggenheim tour. "America is an interesting country, but there is a lot here that I do not like and that I would never accept. I am also trying to show this in my photos."[50] However, his iconoclasm was more comprehensive than that of the other two photographers, because he was more ambitious. Klein and Arbus attacked or parodied salient parts of the American Dream and way of life, such as the family and consumerism. But Frank, as Ian Jeffrey commented, was concerned with the "idea of America" itself. Through the title of his book (not merely *American Photographs*, but *The Americans*), through his references to American places "redolent of glamour, of a heroic past and an optimistic tradition," and through his repeated allusions to flags and other national icons, Frank made it clear that he was portraying a nation. This determination to make a forceful, unflattering portrait of a society was so ambitious that—as Hugh Edwards, of the Chicago Art Institute, pointed out—it put Frank not only in the company of Walker Evans but also in the company of many serious American writers. "I feel your work is the most sincere and truthful attention paid the American people for a long time," Edwards told Frank in a 1960 letter. "Although so different and not stemming from them, it may be kept in the company of Frank Norris, Sherwood Anderson, Hart Crane, John Dos Passos and Walker Evans and these are the best in American expression in the time I can remember." Frank did this, moreover, not by photographing the obvious political leaders, natural wonders, and cheerful folks (that were appearing in all those *Life* photoessays he hated), but by discover-

ing the significance of the tacky, nondescript, scruffy bits of reality that most middle-class Americans ignored or thought of as ephemeral or totally insignificant at the time. For he was, as editors from *Life* and *U.S. Camera* said earlier in the 1950s, a "poet with a camera."[51]

Frank's briefer but almost equally eloquent photographic portrayals of other societies before he photographed *The Americans* contributed to his development as an artist. His early 1950s images of Paris, for example, compare favorably with those of Robert Doisneau, who was probably the best Parisian street photographer of the period; and his picture of a group of grim-faced former Resistance leaders, carrying wreaths and striding down the Champs Elysées directly toward his camera during a memorial service illustrates very well the emotional and intellectual milieu of the Fourth Republic—the era of Camus, Sartre, de Beauvoir, and *littérature engagée*. Frank's 1952 images of eastern Spain and Majorca are as barren and bleak as those in Juan Goytisolo's documentary descriptions of Almería in southeastern Spain in his *Campos de Níjar* and *La Chanca*; and some of Frank's images of Barcelona and Valencia express the exhaustion, the somber squalor, and the poverty of Franco's Spain almost as well as José Camilo Cela expressed them in *The Hive*, which was one of the best—and bleakest—Spanish novels of that era. In London, either by coincidence or because he had read T. S. Eliot's poem, Frank made many images of bankers in 1952 and 1953 that are as expressive as the famous lines in *The Waste Land*.

> Under the brown fog of a winter dawn,
> A crowd flowed over London Bridge, so many,
> I had not thought death had undone so many.
> Sighs, short and infrequent, were exhaled,
> And each man fixed his eyes before his feet.
> Flowed up the hill and down King William Street,
> To where Saint Mary Woolnoth kept the hours
> With a dead sound on the final stroke of nine.

Indeed, Frank even photographed a group of bankers entering a doorway below a statue of an angel with an upraised sword, so it looks like the angel is about to give them a "final stroke" as they pass from the "unreal City" into some land of the completely dead.[52]

But bankers are not the only inhabitants of Eliot's poem, and London and Valencia are not the only wastelands in the world. In one of the best early analyses of *The Waste Land*, Edmund Wilson commented that the sterile people in the poem had their actual equivalents everywhere, because of the "rise of the middle-class which has brought a commercial-industrial civilization" to both Europe and America, so that "the desolation, the aesthetic and spiritual drouth, of Anglo-Saxon middle-class society oppresses London as well as Boston. The terrible dreariness of the great modern cities is the atmosphere in which 'The Waste Land' takes place—amidst this dreariness, brief, vivid images emerge, brief pure moments of feeling are distilled; but all about us we are aware of nameless millions performing . . . interminable labors . . . people whose

pleasures are so sordid and so feeble that they seem almost sadder than their pains."[53] Frank grew up in a middle-class, Jewish society in Zurich, but he must have found some of the same kind of "drouth" there because, as he later told an interviewer, "I think what I learned as I grew up was all negative. I didn't want to be a businessman, to make more money, to buy a better house. . . . Our relatives were all concerned with the same thing. There was a silent struggle, who will come out on top, make the most money." It is revealing that, when he was a boy, Frank might have believed that the United States was a different or better kind of society, since "he slept under a portrait of Franklin Delano Roosevelt, which he had cut from a newspaper and hung above his bed. An article about Roosevelt's New Deal policies and their relationship to the concept of democracy was taped to the picture."[54]

There are no images of Roosevelt or references to the New Deal in *The Americans*. But, in cities all across the United States in 1955 and 1956, Frank discovered thousands of equivalents for the "nameless millions" Wilson described; and this discovery was totally opposed to the "idea of America" promoted in the mass media of the era, that this nation was supposed to be the great, fertile exception to the material, aesthetic, or spiritual poverty that might afflict other countries.

All the 1950s signs of American democracy, prosperity, popular culture, and success are in *The Americans*—the flags, cars, jukeboxes, cowboys, teenagers on dates, motorcycles, television sets, political conventions, movie and television actresses. Seen in "real life," however, through the lens of Frank's Leica, without the flattering techniques and selectivity of the picture magazines, these icons of the American national identity all seem disappointing or debased. Cowboys in the mass media during the 1950s, for example, were still rugged, masterful young men whether they were performing in Hollywood movies, posing at rodeos for *Life*, or working on ranches for *Look*'s photographers.[55] In *The Americans*, however, one cowboy stands by himself, a lonely figure under a glaring fluorescent light in a bar in Gallup, New Mexico; a rodeo cowboy leans against a trash can on a littered street in New York City; and another rodeo cowboy, seen relatively close up in Detroit, turns out to be an unattractive young man with a bad complexion, who is smoking an ugly cigar.

Frank's images of automobiles were similarly disrespectful. During the 1950s, the nation's well-known "love affair with the automobile" reached orgiastic proportions. Earlier, during the depression and World War II, many Americans were unable to buy cars because they were too poor or because production was severely rationed. During the 1950s, though, some people could buy all the new cars they wanted, and the automobile companies responded with extravagant public relations and advertising campaigns echoed by the picture magazines in their annual "new model" feature stories. "The Great American Automobile . . . epitomizes the Great American Dream," *Look* told its readers in 1957; "more than any other material possession, [it] sets you and the American way of life apart from all the world's peoples. To their wondering, hungering eyes, your automobile is the symbol of your power, the proof of your prosperity."[56] Also symbolic were the annual General Motors "Motorama" exhibits—photographed in 1953 by Dennis Stock for Magnum—in which bands of

awed consumers stared worshipfully at floodlit, futuristic "dream cars" like pilgrims visiting a shrine or cathedral.

The 1950 Ford Business Coupe Frank used on his Guggenheim tour did not fit this iconic stereotype very well—it was already five years old when he bought it—and neither do his pictures of automobiles in *The Americans*. Throughout the book, he showed automobiles associated with people and scenes that would never have been allowed to appear anywhere near the "new models" in advertisements and picture magazines. In his image of the General Motors "Motorama" exhibit, he photographed three rich children sitting in one of the model cars, their faces already hardened by precocious boredom and arrogance. In Butte, Montana, he photographed a slovenly, middle-aged woman in her car with a sullen child staring out of the window behind her. He showed a bench full of decrepit old people in St. Petersburg, Florida, staring at nothing in particular while a shiny new Pontiac whizzed by on the street behind them. In a public park in Ann Arbor, Michigan, he made a wonderful parody of a pastoral love scene when he photographed teenagers in bathing suits necking and petting in the grass by a parking lot, surrounded by Packards and Buicks glistening in the same afternoon sun that makes the park's trees seem hazy and romantic in the background.

Frank also used sequences in *The Americans* to make some very unpleasant connections between automobiles and other realities. The St. Petersburg picture of the old people on the bench, for example, is immediately followed by a picture of a "Covered Car—Long Beach, California." Following the picture of the old people and the Pontiac, the image of the mysterious, shrouded car suggests that the old people are about to die. Then, to complete the connection between cars and death, Frank followed the Long Beach picture with one showing the results of a "Car Accident—U.S. 66, between Winslow and Flagstaff, Arizona": three men and a woman stand over two corpses shrouded by a blanket or tarpaulin, lying on the shoulder of the road.[57] In the background, a weedy, barren field, a drab ranch-style house, and a few flimsy outbuildings are as bleak a vision of death in a wasteland, witnessed by strangers and a passing photographer, as any image in a modern poem, film, or novel. Another accident scene, marked by three crosses beside "U.S. 91, Idaho," is followed by a picture of Detroit autoworkers on a Ford assembly line. Instead of the immaculate, orderly assembly lines in the USIA brochures and the picture magazines, Frank's is real—blurred, hectic, crowded, and grimy. And, since it immediately follows the image of the three crosses, the sequence implies that the workers are dying as they manufacture the cars that kill people.

As these examples indicate, many of the iconoclastic effects in *The Americans* are created by the sequence of images, as well as by the images themselves. This was not a new development for Frank, since he always had a tendency to think of photographs in sequences. *Harper's* hired him in 1947, when he showed Brodovich a sequence of photographs in a handmade book called *40 Fotos*, and later he gave friends similar handmade picture books. In 1952 he had a book of photographs designed for him—with the title, *Black, White and Things*—in which he gave symbolic meanings to the

contents of the images. Frank considered Funerals, beggars, and bankers, for example, "black," whereas children, parks, and families were "white."[58] *The Americans* makes significant use of public, civic symbols—particularly the flag—to invoke the "idea of America"; then Frank contrasts that idea with his perceptions in the images he made during his Guggenheim tour.

In his first plan for the book, Frank said later, he considered putting the pictures "together in three sections. I started each section with [a picture of] an American flag, and each section began with no people and then came to the people."[59] In other words, he would first invoke the idea of America with flags and then juxtapose this idea with harsher, documentary realities. In this way, the book's overall pattern probably would have been a relatively simple series of movements from brief invocations of the American Dream to drab or disappointing images of the country. Instead, Frank rearranged the flag images in *The Americans* to create groups of iconoclastic sequences related to the various meanings that Americans attach to their flag as a symbol of their nation and society.

In 1985 Frank praised a catalogue of his pictures, saying that what he liked about it was that it was "just like the Photographer, concept after concept": this phrase describes how he arranged *The Americans*.[60] The opening sequence, which has the most flags in it, invokes the concept of democracy. It starts with two of the best-known pictures in the book: the first is of two women standing in windows watching a parade in Hoboken, New Jersey. One woman's face is in the shadow of a shade and the other woman's face is partly covered by an American flag that has blown across the top of her window. The flag has become, visually, a mask. What lies behind that mask is revealed in the book's second image: a group of sleazy old politicians in top hats and overcoats, identified as the "City Fathers—Hoboken, New Jersey," standing on a reviewing stand draped with striped bunting (which continues the flag motif). The next image is of a man at a "Political Rally—Chicago" (the 1956 Democratic Convention), and it shows that American politics on the national level may not be any more impressive than they are in Hoboken—the man stands on a parapet with his arms raised, like a cheerleader, his mouth open in an idiotic shout, a blurred picture of Adlai Stevenson taped, or strung, across his chest. Frank has photographed him from below, so he seems to be kneeling—a grotesque parody of the shouting, cheering crowds of enthusiastic delegates and candidates who appear on television, in newspapers, and in picture magazines. (An example is Magnum photographer Burt Glinn's picture of Estes Kefauver, Harry Truman, Adlai Stevenson, and Lyndon Johnson with their arms upraised at the same 1956 convention.)

The second flag sequence, which follows a few images later, starts not with a flag but with a military image—a noncommissioned officer in a too-tight uniform walking with his wife on a street in Savannah, Georgia. This is followed immediately by a brilliant, satiric image called "Navy Recruiting Station, Post Office—Butte, Montana." Through an open doorway, Frank photographed an office with a flag on the wall, and below it, a pair of feet in well-shined shoes propped on top of a desk. Obviously, it is not a busy day for Butte's navy recruiter, and his office has many of the

accouterments of bureaucracy—a pen set, file cabinet, in-and-out wire baskets, scotch-tape dispenser, and desk calender—rather than any heroic military trappings. The presence of the flag and a recruiting poster JOIN THE NAVY / ASK ME ABOUT IT invokes the concept of patriotic militarism; but, juxtaposed with the picture of the paunchy sergeant coming just before it, Frank's image reveals how well the American military had adapted to its position as a privileged garrison class in the 1950s after the Korean War ended. (In contrast, as one would expect, the picture magazines showed soldiers, sailors, and pilots as lean, keen-eyed, handsome young men who were commanded by alert, handsome, gray-haired generals and admirals.)

The third flag sequence is particularly interesting. It shows a big, slightly faded flag, with a patch on one side and a tear in one edge, hanging over a group of people who casually walk by or under it—presumably at some kind of community picnic or ceremony, since two girls carry balloons, and the caption identifies it as "Fourth of July—Jay, New York." This is one of only two images in the book that is dated, and the date is significant. The Fourth of July is the national holiday dedicated to the Declaration of Independence and the proposition that "all men are created equal"; but immediately following the Jay, New York, picture is Frank's image of a definitely segregated New Orleans trolley. The first three windows are occupied by whites, but there are black people looking out of the last two windows, including a large, black man who seems to be staring at the photographer with a pathetic appeal. Years later, Frank said he was not thinking about segregation when he made that particular picture, only that the black people at the back of the trolley looked more dignified to him than the whites did. His placement of this image in a sequence coming immediately after the Fourth-of-July picture from Jay, New York, however, strongly suggests that when he composed *The Americans* he was contrasting the nation's liberal pretensions with the actual racial practices of the 1950s, which included segregation in places like New Orleans.[61]

In the final flag sequence in the book, Frank returned to the topic of politics. This sequence begins with his famous satiric picture of a tuba player at a 1956 political rally, his face hidden by the bell of his instrument, standing under a flag bunting so that the bunting seems to rise like a huge mushroom or a cartoon caption from the instrument. Following that picture is a photograph of the shop window of a tuxedo rental agency in Washington, D.C. A headless dummy wearing a tuxedo stands in the window, and taped near the dummy is a poster with a picture of President Eisenhower on it. It looks as if Eisenhower's head belongs on the dummy but has become separated mysteriously from its torso. Following that is a picture of a television studio in California, showing a blonde actress smiling on a television set and, simultaneously, on a monitor at the other side of the room. Like the politician in the previous picture, the actress has become a media commodity whose actual personality, if any, is a marketable image. By implication, politics has become the realm of mindless people (the tuba player), of decapitated dummies (Eisenhower in the tuxedo shop window), and of smiling faces on television screens (the actress).[62]

Not all of Frank's images and sequences are related to politics and the ironies of

American society. Despite his critics' angry charges that he was a "joyless man" who produced a bitter book, many of Frank's images and sequences possess considerable wit. In a few instances, the wit was good-humored—for example, in a sequence in which an image of a pregnant woman standing by a tree in a Michigan park is immediately followed by a picture of a man sleeping by a tree in a Cleveland park, photographed so that the tree trunk seems to rise from the man's hips like a giant phallus. More often, however, Frank's wit expressed sharp psychological and social insights, frequently tinged with a certain amount of pity or compassion. As Walker Evans noted in the *1958 U.S. Camera*, "Frank, though far, far removed from the arid pretensions of the average sociologist, can say much to the social critic."[63]

Frank's pictures of isolated figures in *The Americans*, for example, are frequently juxtaposed with one another or with pictures of crowds or groups, so that the loneliness of the isolated people is accentuated. At a Yale commencement in New Haven, an old man wearing a white hat has one hand clapped to his head in a gesture of weariness while a crowd of graduates in black gowns troops by him, ignoring his existence. ("For older people who do not have much $, it is terrible here," Frank told his parents in a 1947 letter.)[64] Immediately following this image, Frank placed a picture of a black baby crawling on a cushion on the floor of a cafe in South Carolina, with no adults in sight, tended only by a jukebox. The old man and the baby are of different races and ages, yet they are united by the ways in which they are neglected.

Socially, Frank's vision of the United States in the mid-1950s was exceptional for its range and diversity. Mainstream journalists like William Attwood of *Look*, who were interested almost exclusively in the middle classes, might claim that "Americans are getting to be more like one another. Mobility and television are doing it."[65] But *The Americans* shows that a photographer interested in exceptions and contradictions to standardization could find them without much difficulty. In particular, Frank showed an unusual sensitivity toward the existence and the individuality of the Americans who were most often ignored or most heavily stereotyped in the mainstream media of the period. Consequently, *The Americans* has far more pictures of black people than any of *Life*'s late 1940s and early 1950s special issues on the national identity, analyzed in the previous chapter. His pictures of waitresses, rich women at a charity ball and cocktail party, a young woman running an elevator in Miami, a black woman sitting in a field by herself, or the black nurse holding the white baby in the South Carolina hospital show a greater variety of American women than usually existed in *Life*, *Look*, and the Magnum photographers' images, which consisted mainly of stereotyped images of housewives, adolescents in bobby sox, politicians' wives, starlets, and Pillsbury bake-off contestants.[66] Moreover, as mentioned earlier in this chapter, Frank used sequences to accentuate differences in American regions, cultures, races, and social and economic classes. For example, his image of two romantic white teenagers hugging each other in the Reno City Hall are followed by a picture of a hard-faced, thirty-year-old black couple sitting on their glistening Harley-Davidson motorcycle; his "classic" American-way-of-life 1950s picture of a Detroit drive-in movie is followed by an

image of a mysterious black man in a white robe and skull cap, carrying a white cross and kneeling by himself in prayer on the bank of the Mississippi River at Baton Rouge.

Clearly, Frank's America was not the folksy, homogeneous, "classless society" portrayed in so many picture magazine editorials and photoessays. Armed with his Guggenheim, his Leica, and his 1950 Ford, he created his own alternative vision of the United States as a big, complicated nation in which there were many ways of life, not simply an American way or Dream. Moreover, despite the nasty ad hominem attacks of critics, Frank's vision could not be dismissed—as *Life* dismissed the writings of certain novelists in 1955—as the product of someone whose conception of America had been confined by his wretched existence.[67] Instead, Frank traveled from New York to South Carolina, Florida, New Orleans, Texas, California, Nevada, Montana, and back through the Midwest to New York. He exposed almost eight hundred rolls of film and made over twenty-seven thousand images. He photographed rich people at charity balls, cocktail parties, and Miami Beach hotels, and poor- or working-class people in New York, Detroit, and Butte. He saw autoworkers in factories, black people at funerals, cowboys in bars and rodeos, politicians in Washington, Hoboken, and Chicago. He photographed the nation's jukeboxes, taverns, television sets, and people riding in sedans, convertibles, and trains. His photographs were (as Edmund Wilson wrote earlier about *The Waste Land*) "brief vivid images" in which "pure moments of feelings are distilled." Frank's ambition was extraordinary, and so was his achievement and influence. As Hugh Edwards, the photography curator of the Art Institute of Chicago, told him in May 1960, just after *The Americans* was published in the United States, there already was a "steady demand" for the book in the Institute's bookstore, and copies of both the Paris and the New York editions were placed in the print study room, where "they have been enthusiastically received by the many young photographers who come here to look at the prints in our collection."[68]

■

Unlike the FSA and Photo League photographers, Arbus, Klein, and Frank never worked together or had a common agenda, and the iconoclastic stages of their careers in the 1950s and 1960s were relatively brief. Arbus committed suicide in 1971, a little more than a decade after she began working as a serious photographer. Klein went back to France, where he published his New York book in 1956, and later he did equally scathing urban portraits of Rome and Tokyo, and a sensitive, rather gentle book of Moscow pictures. ("We're not completely *brut*, you know," as he told John Heilpern.) But most of his energies were devoted to painting and a career as a fashion photographer, which ended when he satirized fashion photography in a film called *Qui êtes-vous, Polly Maggoo?* He has directed commercials for French television, documentary films, and experimental films—most notably his "comic strip, political fable," *Mister Freedom*, which satirized American, Russian, and Chinese ideologies so vigorously that the French government was offended and threatened to expel him from

France. Despite these troubles, by the 1980s Klein achieved a veritable expatriate American's dream of a Left Bank apartment in Paris, a studio in Montparnasse, and a country house in the Loire Valley. In addition, a bar in Paris was named after his movie's model-heroine, Polly Maggoo, and when the French government tried to ban *Mister Freedom*, Sartre and other French intellectuals signed and circulated a petition of protest. As Klein ironically commented, "I did do all right in Paris!"[69]

After finishing *The Americans*, Frank, despite his angry "Statement" in the *1958 U.S. Camera* annual attacking editors and the commercialization of photography, worked for the *New York Times* and a number of magazines—*Esquire, Glamour, Harper's Bazaar,* and *House and Garden*—from 1957 through 1963. ("Unfortunately one has to make a living," he told Eugene Smith in 1952.)[70] In 1958 he made a series of pictures from New York City buses, which were, he announced, his last "personal project." He said that, as he assembled these images, "I knew and I felt that I had come to the 'end' of a chapter. And in it was already the beginning of something new."[71] The "something new" was filmmaking, and during the 1960s Frank gradually gave up still photography to make a number of experimental films and work as a cameraman or editor on several others. In 1969 he moved to Nova Scotia, continued to make films, lectured at colleges, and gave occasional interviews in which he had to explain (over and over) why he stopped doing still photography: new printings of *The Americans* were published at that time, and his reputation as a photographer was soaring. "Dear Ed," he wrote to a friend in an undated letter, "I'm famous[,] now what?" The letter is on a page from a bookkeeper's ledger, and at the bottom Frank wrote "TOTAL" next to a blank space.[72] In the mid-1970s, however, he began doing still photography again—extremely intense, personal, lyrical works, usually with multiple images and words written on them (or scratched into the negatives). With his friend Rudy Wurlitzer, he made a commercial feature film, *Candy Mountain*, which is a surprisingly good-humored, unpretentious, beautifully photographed road movie. As its title suggests, the film can be interpreted as dealing with a contemporary version of the American Dream—its main character, Julius, is a mediocre New York rock musician and small-time hustler. Julius's "dream" is to arrange a contract with Elmore Silk, a guitar maker who has stopped making guitars and has mysteriously disappeared. Bankrolled by a smarter hustler, Julius sets off in search of Silk and discovers him living (like Robert Frank) in Nova Scotia. "When they finally meet, Julius says to Elmore, 'I don't understand, you've got guitars stashed all over the place and you don't want to sell. I'll do it for you.'

'It's over,' Elmore replies. 'That's all. What's done is done. I don't look back. I don't look ahead. That's all I have to say about it. There's always the open road out there, son. It's better than a dead-end street.' "[73] The American Dream of getting rich quick—by selling someone else's talent in this case—confronts the artist's need to renew creativity and escape from stagnation. In *Candy Mountain*, the artist wins. Silk sells some of his best guitars to Japanese investors, and he and Julius burn the rest, in the film's climactic scene, in a trash can by the ocean during a storm. Of course, Silk's reference to the "open road" can be interpreted as a reference to yet another version

of the Dream, but it is a version dedicated to creativity and purged of greed and materialism—which may be why *Candy Mountain* ends in Nova Scotia rather than in the United States.

In the meantime, young photographers of the 1960s and 1970s could learn from Frank—and from Klein and Arbus as well—a new, alternative type of photography that competed strongly with the more traditional photojournalism, art, and documentary photography.

American art photography of the 1950s was dominated by the Stieglitz, Strand, Weston, and Adams tradition of the perfect print, the sharp, previsualized image that captured what Weston called "supreme instants"—moments when light, form, and the photographer's techniques were in such perfect harmony that a formally "beautiful" picture was created. In contrast, Klein and Frank showed that images made much more recklessly, or intuitively, could be just as memorable. "In photography I was interested in letting the machine loose, in taking risks," Klein explained in 1981. He was interested in "exploring the possibilities of film, paper, printing in different ways, playing with exposures, with composition and accidents. It's all part of what an image can be, which is anything." If dark, grainy, "dirty" images made spontaneously with a wide-angle lens could have as much of an impact as pristine, uncropped, previsualized Weston prints filled with delicate nuances of tones and details, then—as Klein would say—"Why not?"[74]

Klein, Frank, and Arbus demonstrated that documentary photography could be much more "visionary," or "personal," than it had been in the past. As Walker Evans commented in a 1971 conversation, Frank "developed a style which I call the documentary into a further statement. What he's done since he has something to say—is say it. It's a personal message with him. . . . What we conscious photographers now think of as documentary has a personal style to it," even though this personal element was clothed in a "guise of objectivity." Frank, who did not seek to appear objective, became "more personal and said more."[75]

The reason for this "guise of objectivity" probably was related to the close relationship that existed between photographers like Hine, Evans, and Lange and the social sciences, such as economics and sociology, which consider "subjectivity" a deadly sin to be avoided whenever possible.[76] For the earlier documentary photographers, who were trained in the social sciences or were trying to emulate their methods, photographs were facts meant to verify case studies and illustrate surveys so that reforms could be made. Conversely, even though Frank, Klein, and Arbus were all influenced by earlier documentary work, they took a distinctly casual interest in "factuality." Arbus's comments on her subjects were mostly statements about how exciting she found them or how "terrific" it was to meet and photograph them. Klein's only bow to "factuality" in his New York book is a one-page parody of a guide book, containing irrelevant statistics, historical jokes, and wisecracks: "The New-Amsterdamer was drunk practically all year long, disobeyed city ordinances and was politically corrupt. Must be something in the air."[77] Frank, as Anne Tucker pointed out, was "inattentive to facts," often misdated his photographs, and commented, in one of his films, that

"the truth is somewhere between the documentary and the fictional, and that is what I try to show. What is real one moment has become imaginary the next." It can be argued, however, that the best work done in the documentary photography tradition has always had a strongly personal, "imaginary" (or creative) element, and that Hine's, Lange's, and Evans's images often were quite effective when exhibited or printed in contexts with little or no "factual" background. What may matter as much, or more, than "factuality" is the degree of intensity and commitment that the photographer applies to a subject. As Frank commented in his *1958 U.S. Camera* "Statement," "Above all, I know that life for a photographer cannot be a matter of indifference. Opinion often consists of a kind of criticism. But criticism can come out of love . . . it is always the instantaneous reaction to oneself that produces a photograph."[78]

Klein, Frank, and Arbus also challenged the illusion of objectivity (or the "effect of the real") that dominated prestige photojournalism during the 1940s and 1950s. When Arbus's images were exhibited at the Museum of Modern Art in 1967, Richard Avedon exulted because she had "taken photography away from the sneaks, the grabbers, the generation created by *Life*, *Look* and *Popular Photography* and returned it to the artist."[79] Avedon's comment, also relevant to Klein and Frank, can be applied to many picture magazine photographers, but perhaps the most important of the "sneaks" he had in mind was Henri Cartier-Bresson, the doyen of serious photojournalists in the 1950s. The subject of special portfolios in *Life*, exhibits at the Museum of Modern Art, and essays by critics like Lincoln Kirstein and Beaumont Newhall, Cartier-Bresson was praised for his "objectivity," his ability to capture "decisive moments," and his ability to abnegate himself by avoiding "the intrusion of idiosyncrasy, of his own accidental personality," so that he was able to get "close to [his subjects], to their private identities." "His portrait subjects are not shot," Kirstein claimed; "they get themselves taken at tactful intervals, by eavesdropping or absorption."[80]

Using Cartier-Bresson's techniques, photographers were supposed to be able to efface themselves so they could snap "the shutter in that one decisive moment when the scene before [them] suddenly comes to life."[81] Because of this obsession with decisive moments, as Victor Burgin commented, photographers regarded themselves as hunters going "after significant moments, like so many rabbits in a wood to track down, shoot, and carry home"; but, after photographers like Frank began publishing their pictures, "photographers knew there were no significant moments. It is we who give them significance."[82] Frank and Klein considered subjectivity an asset, and they both criticized Cartier-Bresson for making images that lacked that quality. "I've always thought it was terribly important to have a point of view, and I was also sort of disappointed in him [Cartier-Bresson] that that was never in his pictures," Frank said at a symposium. "He traveled all over the goddamned world, and you never felt that he was moved by something that was happening other than the beauty of it, or just the composition. That's certainly why *Life* gave him big assignments. They knew he wouldn't come up with something that wasn't acceptable." Klein was equally unimpressed by what he called the "Henri Cartier-Bresson strictures." "You're not to

intrude or editorialize, but I don't see how that's possible. . . . I loved and hated New
York. Why shut up about it?," he told John Heilpern; "I liked Cartier-Bresson's
pictures . . . but I didn't like his set of rules. So I reversed them. I thought his view that
photography must be objective was nonsense. Because the photographer who pre-
tends he's wiping all the slates clean in the name of objectivity doesn't exist. . . .
Cartier-Bresson chooses to photograph this subject instead of that, he blows up
another shot of the subject, and he chooses another one for publication. He's making a
statement. He's making decisions and choices every second. I thought, if you're doing
that, make it show."[83]

Other picture magazine photographers sought to achieve Cartier-Bresson's "objec-
tivity" by giving readers privileged glimpses into their subjects' "private identities." In
1948, for example, *Life* photographer Leonard McCombe spent weeks following a
young New York career girl through every minute of her daily routines. He arrived
every morning at her room, followed her in the streets, at her office, with friends, and
on dates, until she became "so accustomed to McCombe's presence that he was all but
invisible." He photographed her at her job, yawning, crying, arguing with her room-
mate, and even taking a bath (a back view, since this was 1948).[84] Given that much
time, patience, and film almost any competent photographer could produce some
"decisive moments," and readers could feel that they were involved and really cared
about the subjects of photoessays.

Naturally, ambitious politicians, movie stars, and other notables were alert to the
publicity value of "inside" coverage and were eager to cooperate with photographers,
as well as with print journalists and, later, television directors. Thus, during the 1950s,
Magnum photographer Elliott Erwitt photographed Professor Henry Kissinger beam-
ing over a pile of Harvard students' papers; Burt Glinn photographed John Kennedy
huddling with advisors at the 1956 Democratic Convention, Henry Cabot Lodge
chanting "I Like Ike" at the 1956 Republican Convention, William de Kooning
drinking with friends in his studio, and Eddie Fisher chatting with Elizabeth Taylor;
Eve Arnold photographed Oral Robert meditating, with a Bible prominently clasped
to his chest, and Joan Crawford at a Pepsi-Cola board meeting, with Pepsi bottles
prominently displayed on the table; Cornell Capa photographed Richard Nixon hard
at work writing a campaign speech in a hotel room and Governor Nelson Rockefeller
telling jokes to his aides and cabinet officials in Albany. According to editor John
Morris, John Kennedy was particularly "sophisticated" about photography and
"started a policy of inviting photographers like Cornell Capa and others sort of behind
the scenes to give a candid feeling. . . . This was a new dimension in presidential
coverage, when you saw the kids under the desk, and Mrs. Kennedy wheeling a baby
carriage."[85] These images conveyed the idea that America was a land without secrets
or mysteries, a place where the famous and the powerful were happy to be observed
working, praying, and wheeling baby carriages.

Klein, Frank, and Arbus (in her exhibit pictures) refused to create the illusion that
their photographs revealed any special, "privileged" information about the people they
photographed. Indeed, Klein and Arbus often went to the opposite extreme and

confronted their subjects, who glared at the camera hostilely or defensively. Klein claimed he wanted to "make photographs as incomprehensible as life itself." Arbus once cryptically remarked: "What I'm trying to describe is that it's impossible to get out of your skin into somebody else's." She also was fascinated by people wearing masks and often photographed her subjects when they had blank, zombie-like expressions.[86]

Frank's emphasis was on the sheer ordinariness of his vision, and it is very instructive to contrast his pictures of the 1956 Democratic Convention with those made by Burt Glinn for Magnum. Glinn photographed John Kennedy and his fellow politicians from the vantage point of a participant in their conference, thus creating the visual illusion that we can all participate in high politics. Frank photographed a similar conference, in which a politician in sunglasses is waving his cigar, from behind the back of one of the participants: the viewer sees mainly the back of the man's suitcoat, and the faces of the other politicians are hidden or expressionless.[87] Presumably a deal is being made, but Frank—like millions of other people—really does not know what it is; for in his photograph, as in actuality, the powerful do not take ordinary people into their confidence. "I wanted the view anybody can see," Frank told *Newsweek*. This meant, as Jean-Claude Lemagny wrote, that the photographer "acknowledges all the unfinished, blurred, dirty, ill-defined things that make up the fabric of what we can see. He does not set himself up as the master of what should be seen and what should be admired. He is on our side, like each one of us, alone in the crowd."[88]

Such a view obviously is the antithesis of "those goddamned [*Life*] stories with a beginning and an end" that Frank hated. It is also the antithesis of the American Dream of a friendly, open, democratic society in which "We, the people" are masters of our own nation and fates, live in a middle-class reality in which everything is neat, clean, and perfectly defined, and trust editors, politicians, journalists, and photographers to tell us, in perfectly composed "decisive moments," what is admirable and significant.

After
the
Fall

If you expect to be supplied with beautiful and reassuring pictures which do not raise any problems in your minds . . . don't rely on me. The kind of literature which settles all the hard issues of life in a few hundred pages belongs to the kind of activity generally known as utopia. *Nothing is so dangerous as utopia. It lulls people to sleep and when they are awakened by reality, they are like sleep-walkers on the top of a roof—they suddenly find themselves tumbling down to the ground.*

– Louis Aragon, speaking to a meeting of
 Young Communists in France, 1959

When I was young—it was just before the Great Depression—this was a very unpleasant society in the sense that if you weren't interested in commerce and business . . . there was no place for you. You had to make one. . . . That was a good thing for many artists, I think, because they didn't have any sense of guilt about not being in business or Wall Street. . . . They couldn't get in if they wanted to. There was no place for them. You may come to know that first hand yourself! It looks as though there is that sort of thing around the corner. It [another depression] may produce another good bunch of artists, which is all I'm interested in. Really, I feel rather stony hearted about it, but . . . I don't care very much whether this country prospers or not. I don't want to lead the world or be part of that machinery.

– Walker Evans, speaking to a group of
 Harvard students in April 1975[1]

By the time Aragon gave his speech, some thoughtful Communists had already lost faith in their ideology's capability to create a utopia, after Nikita Khrushchev revealed, at the 20th Party Congress in 1956, that Stalin and his colleagues were guilty of horrendous crimes. At approximately the same time, events in places like Clinton, Tennessee, and Little Rock, Arkansas, forced thoughtful Americans to worry about how well their society was realizing its utopian pretensions. During the 1960s, magazines like *Life* and *Look* were still illustrated with many pages of "beautiful and reassuring pictures," but there were other events—riots in the black ghettos of Los Angeles, Newark, Detroit, and Washington, D.C.; the Tet offensive in Vietnam; several major political assassinations; and more civil rights violence—that awoke Americans from their utopian slumbers. Many events during the 1970s and 1980s also disrupted the nation's utopian dreams.

During those decades, the United States had to contend with the humiliating collapse of the South Vietnamese army, which American military advisors and mentors supposedly had trained to "resist communist aggression"; an oil embargo, energy crisis, and "double digit" inflation; the near-disaster at Three Mile Island, which demolished the dream that atomic energy could be "tamed" to become a cheap and reliable source of power; and the Watergate, Abscam, and Contragate political scandals, one of which—Watergate—was so scrofulous that for the first time in the nation's history a president had to resign in disgrace (and be pardoned by his successor so he would not be jailed). In addition to these debacles, there was the Iranian revolution and the "hostage crisis" in Tehran; the biggest stock market crash in the nation's history; the worst economic recession since the 1930s, and the worst "hard times" in American agriculture since the Great Depression; an assortment of big business scandals and cover-ups (Johns Manville, the Dalkon Shield, the Ford Pinto, insider trading on Wall Street), which revealed that twentieth-century executives were not really any less greedy or more concerned with the public welfare than nineteenth-century robber barons had been; the worst technological tragedy involving an American corporation (the Union Carbide disaster at Bhopal in India); the worst ecological disaster in the nation's history (the Exxon oil spill in Valdez); the restructuring and "deindustrialization" of the economy, which caused millions of working- and middle-

class Americans either to lose their jobs or to accept lower pay and poorer working conditions; colossal trade and budget deficits; and the world's most spectacular aerospace tragedy—the 1986 explosion of NASA's Challenger space shuttle—which occurred on live television in front of millions of children who were watching because a schoolteacher was included in the shuttle crew as the first "civilian in space." The cumulative effect of these disasters on Americans' sense of their nation's identity and destiny was expressed by an anguished analysis of the Challenger explosion on the front page of the *New York Times*. Entitled "Space Agency Image: A Sudden Shattering," the *Times* article said that, before the explosion, NASA

> symbolized all that is best in American technology and American technological management.
>
> The Pentagon and its military contractors might manufacture costly weapons that did not work. Other industries might produce a frightening nuclear accident at Three Mile Island, a chemical disaster in Bhopal, India, electronics that could not compete with the Japanese or automobiles that needed to be recalled. . . . But NASA seemed above such mundane shortcomings. The agency projected an image of almost superhuman technical and managerial proficiency. . . computerized at the cutting edge of technology. . . .
>
> All that is beginning to change.[2]

In the meantime, other significant changes were taking place in American society and values. Walker Evans's 1975 prophecy turned out to be quite accurate: the 1970s and 1980s definitely saw a return to the values of that "unpleasant society" that Evans despised, during the 1920s, because of its greed and crass commercialism. Symbolically, this change was signaled early in 1981, when the White House staff dusted off a portrait of Calvin Coolidge and gave it a place of honor in the Cabinet Room to inspire President Ronald Reagan and his administration. They emulated Coolidge's tax cuts as well as his "get-government-off-our-backs" attitudes and his "help-the rich-first-and-let-the-rest-trickle-down" economic philosophy. Coolidge was the patron saint of big business in the 1920s, when he ran the country according to his most memorable precept, "The business of America is business"; and in the 1980s the nation's government was equally sympathetic to big business and its need to be as profitable as possible.[3] The concept of the United States as a potential Great Society, popular in the 1960s, was replaced by the reality of the Great Greed of the 1970s and 1980s. "Greed is fashionable, and restraint is out of style," a British academic who taught in the United States reported to his countrymen in 1987. "At a recent conference in Boston on 'The American Dream,' not a single paper that I heard deviated from the convention that the dream has nothing to do with freedom or democracy, and everything to do with living standards. In the annual opinion poll of entering college students this academic year, 70 percent gave as their reason for entering college 'to make more money.' . . . Questioned about their essential goals in life, 73 percent of new students chose 'being very well off financially' . . . while the proportion of students who have ambitions to do 'something creative' with their lives has sunk to 10

percent." For skillful, ruthless practitioners of this version of the Dream, it was the best of times. Manhattan, Miami Beach, and Beverly Hills were glutted with what one critic described as the "flotsam of a floundering empire" composed of rich, expatriated "Arabs, Iranians, Eurotrash, [and] Pacific plutocrats," along with native-born "Wall Street wheelers; arbitragers, money-marketers, conglomerators, high-rollers and . . . drug importers, fashion dictators, cultural king-makers, and development czars," all cruising the streets in fleets of exotic cars from Axis countries and "eating $60 lunches of nouvelle *chazzerei*."[4] Obviously, in this latest "New Era" of American life, there would be few temptations or opportunities for good documentary artists like the ones Evans had in mind to become incorporated into such an unpleasant society.

On the other hand, documentary photography flourished in the United States when there were significant fissures, or discrepancies, between the American Dream and actual living conditions; and in the 1970s and 1980s such fissures were numerous. One of the more salient features of these decades has been the increasing inequality that exists between different classes and races in America. "The great American dream of a vibrant, dynamic prosperous society in which the poor get less poor even as the rich get richer lies shattered," one foreign journalist commented on the fact that the 1950s media vision of the United States as a classless society was replaced by a flood of statistics indicating that now it was a nation in which the rich got richer while the poor got poorer and the middle classes stagnated. Reviewing one such table of statistics in 1988, the editor-in-chief of the *U.S. News & World Report* complained that it stunningly documented a "growing *inequality* in American life," which was "counter to our ideals. . . . Most of our citizens have not benefited from recent U.S. prosperity. Not only has the gap between rich and poor grown; the gap between the rich and the middle class has also grown. . . . The consequences of this are revealed most strikingly in the lives of millions of middle class families. Many cannot afford a college education for their children without financial assistance. Most younger families cannot afford to buy homes."[5] Yet many Americans still felt that their country possessed (or was supposed to possess) a social and economic system meant to be fair or to promote equality.

According to the tenets of "People's Capitalism" and other consensus visions of American society held by liberals and moderates in the 1950s, economic growth was supposed to mean that everyone would become more prosperous; but by the 1980s, it was recognized that the United States possessed a permanent "underclass"—millions of poor people, and their children, who were remaining in poverty even when the rest of the population prospered. "The facts regarding the poor and the near poor are truly appalling," economist Robert Hamrin wrote in 1988.

Despite the expenditure of hundreds of billions of dollars to "wage war on poverty" and despite healthy growth rates in the majority of years in the past two decades, the poverty rate in 1986—13.6 percent—was essentially the same as the rate in 1967. . . . What is particularly disturbing is that the poor and the near-poor have been basically shut out from sharing in any of the fruits of economic

growth [in] this decade: from 1980 to 1986, the bottom 40 percent of the population had an increase of income of just $199, while the top 40 percent . . . had an increase of $4,418 and [the] richest 10 percent had an increase of $10,339. This, in turn, led to a very dubious record being set in 1986: income inequality was at an all-time high in America. . . . 11 percent of Americans (over nine million households) had no net assets or negative net assets in 1984 . . . [and] the typical white household [had] a net worth twelve times as great as the typical black household and eight times as great as the typical Hispanic household.[6]

Supplementing these statistics were frequent, vivid contrasts between extreme squalor and extreme affluence, which could be observed in regions and cities throughout the country. In Washington, D.C., homeless men slept on heating grates a few yards away from the stretch limousines whizzing by on the city's boulevards. In New York City, travelers saw bag ladies and derelicts lying sprawled or huddled in wheelchairs in Grand Central Terminal, Penn Station, and the Port Authority bus terminal, inches away from affluent commuters rushing back to their suburbs. Similarly harsh inequities could be discovered elsewhere. "Rise in Poverty is Grim Side of Minneapolis Boom," a writer for the *New York Times* observed in 1988, puzzled by the fact that—even though Minneapolis had enjoyed "six years of rapid expansion"— infant mortality rates had increased between 1980 and 1986, and 31 percent of the children in the city's schools came from families receiving welfare assistance. The *U.S. News* in 1986 printed a picture of unemployed men standing in line at an office of the Texas Employment Commission, next to a column of text describing how a Dallas socialite had given a party for 3,700 guests, who had feasted on "800 pounds of shrimp, 1,000 pounds of chicken, 4,000 pizzas and 200 baby lambs . . . 744 cases of liquor," and 7,500 bottles of wine and champagne.[7]

The liberal-moderate consensus of the 1950s and 1960s was based on the belief that capitalism in the United States had evolved to become a higher, better, and more humane socio-economic system in which the economy would almost automatically eliminate inequality and poverty and the government would prevent the "hard times" and suffering that took place in the 1930s. By the 1970s and 1980s, however, it seemed that the United States had *devolved* socially and politically to an earlier, nastier, form of capitalist society in which many citizens—perhaps a majority of them—did not really care much if the country had new recessions (or even depressions), as long as they were selective recessions. That is, they were not troubled as long as their own living standards did not decline, or as long as most of the "hard times" were suffered by other people.[8]

If the liberal version of the Dream did not fare well in the 1970s and 1980s, the conservative version had its troubles too. Ever since the eighteenth century, when St. John de Crèvecoeur listed the immigrant's possessions in his *Letters of an American Farmer*, conservatives have promoted essentially the same bootstrap version of the Dream, in which success is synonymous with hard work, thrift, and material accumu-

lation. In 1953, for example, in his *What Is America?*, Arthur Goodfriend claimed that
one of the great causes of the nation's prosperity was the influence of Benjamin Franklin's *Poor Richard's Almanack*, with its homilies about plain living and prudent saving. If the "moneyless" wished to fill their purses, for example, Poor Richard advised that "two simple rules well observed will do the business. First, let honesty and labor be thy constant companions. Second, spend one coin every day less than thy clear gains. . . . Embrace these rules and be happy." During the Great Greed of the 1970s and 1980s, even rich and middle-class Americans often felt themselves to be, if not "moneyless," at least a little short of the ready cash needed to maintain the American way of life. Instead of following Poor Richard's rules, however, they went on a mammoth consumption, tax-cut, and credit binge. During the period between 1976 and 1985, the aggregate level for consumer loans and mortgage debts tripled as consumer credit soared from $242 billion to $668 billion, while mortgage debt increased from $483 billion to $1,400 billion. In the meantime, between 1973 and 1986, the rate for personal savings sank from 8.6 percent to 3.8 percent; and the United States had the lowest rate of savings of any major industrial nation.[9]

For decades, conservatives applied Poor Richard's rules to federal spending and bewailed every deficit as a national disaster. But in the 1980s, even though they had Calvin Coolidge's portrait to inspire them, the conservatives managing the nation's economy managed to double the national debt to $2 trillion in only five years, from 1981 to 1986. (It took the nation one hundred and ninety-one years to accumulate the first $1 trillion of debt.) As deficits and the interest payments on them increased by colossal sums, the United States began to borrow more and more from foreigners at the same time that it also developed huge trade deficits with countries like Japan. By borrowing and buying so much from foreign nations, America transformed itself from a creditor to a debtor nation with extraordinary speed. As recently as 1981, foreign nations owed America $141 billion more than it owed them; but by the end of 1986, the nation's *negative* credit balance was $264 billion, and by 1987 it was approximately $400 billion. "In other words," as former Treasury Secretary Peter Peterson commented, in only six years the United States "burned up more than $500 billion, net, by liquidating our foreign assets and by borrowing from abroad. . . . What does the future hold for a nation that is borrowing such sums from foreigners?" One answer to this question appeared on the front page of *USA Today* in 1988, when it warned that America was "selling off real wealth"; it discovered that foreigners owned 46 percent of the prime real estate in Los Angeles, 39 percent of the best property in Houston, 12.5 million acres of American farmland, and $1.3 trillion in government securities. "So there we have it," Peterson wrote in 1987, just before the stock market crash, "a conservative Republican Administration that promised us a high-savings, high-productivity, highly competitive economy, with trade surpluses, and gave us instead a torrid consumption boom financed by foreign borrowing, an overvalued currency, and cuts in private investment, with debt-financed hikes in public spending and huge balance-of-payment deficits."[10]

The significant changes in American reality that took place during the 1970s and

1980s—many of them for the worse—were not limited to specifically liberal or conservative values and policies. Many of these changes also affected the optimistic consensus, or "bipartisan," assumptions about life in the United States. Indeed, a pessimist could compose a great many before-and-after photoessays contrasting conditions in the United States in the 1980s and in the 1950s: they would be antitheses of the optimistic before-and-after sequences that Frances Johnston made of the Hampton Institute or that Gordon Parks made for *Life*, documenting how mainland industry transformed Puerto Rico from a tropical slum into a prosperous industrial community.

Back in 1951, the word "homeless" usually referred to foreign refugees, not American citizens. For example, *Life* published a photoessay by Dennis Stock, entitled "New Home for the Homeless," about displaced persons arriving in New York from refugee camps in Europe. In those days it was taken for granted that the American Dream meant that all Americans, not only rich people, could buy comfortable houses for themselves and their children. In the 1980s, the same magazine published Mary Ellen Mark's "A Week in the Life of a Homeless Family," and its subject was a family of four native-born Americans in which the parents were unemployed for two years in Colorado, then moved to California and lived for five weeks in shelters, cheap motels, and their 1971 Buick. Homelessness was becoming an ubiquitous American phenomenon: the *Philadelphia Inquirer* was concerned that "more young women and children [are] joining the ranks of the homeless"; and the *New York Times* published an article, "A High Tide of Homelessness Washes over City Agencies," illustrated with a picture of a couple and their three children living in a welfare hotel. A *New Republic* pundit argued that the nation needed to build "asylums" for the homeless, particularly the mentally ill homeless, because "it is not our aesthetic but our moral sensibilities that are most injured by the spectacle of homelessness. The city, with its army of grate dwellers, is a school for callousness. . . . To expose [the ordinary citizen] hourly to a wretchedness far beyond his power to remedy is to make more insensitivity a requirement of daily living." Moreover, by the late 1980s, decent housing had become so expensive in some parts of the country that many middle-class citizens had begun to fear that they (or their children) could not afford homes. "What we're talking about is the shredding of the American dream," the governor of New Jersey said in 1988. "We have always believed in this country that if you worked hard enough and saved, you'd have a home. . . . Well, it's not there any more."[11]

Owning a home was only one part of the American Dream of the 1950s. It also included a secure job, and by the 1980s millions of Americans began to fear what Jesse Jackson called "economic violence." These were well-founded fears of losing jobs because of plant closings, mergers, foreign competition, deindustrialization, and the "restructuring" of the American economy. In the 1940s and 1950s, the picture magazines and USIA brochures featured images of smiling workers, the cheerful beneficiaries of "People's Capitalism," who worked for large corporations, like steel and automobile companies. "In a big company you're safe. They take care of you," one young man told William Attwood in 1955; and in 1960, sociologist Seymour Lipset announced that in the United States the "fundamental political problems of the industrial revolution have been solved" because "workers have achieved industrial and

political citizenship."[12] Walker Evans revealed the fragility of this "industrial citizen-

ship" in his "People and Places in Trouble" portfolio for *Fortune* in 1961,[13] but the
full impact of the technological and economic changes that caused America to aban-
don many of its heavy industries was not widely recognized until the late 1970s and
the early 1980s. A series of huge corporations—Chrysler, U.S. Steel, Allis Chal-
mers, International Harvester, General Motors, Wheeling-Pittsburgh, and Bethlehem
Steel—went bankrupt and/or "restructured" by closing down plants, foundries, facto-
ries, and mills all over the country, but particularly in "Rust Bowl" areas such as
Detroit, Flint, and the Mahoning and Monongahela valleys.

Visiting Homestead, Pennsylvania, in December 1984, a reporter for the *New York
Times* returned to the vocabulary of the Great Depression to explain, "with hard times
fasten[ing] on the steel industry, and fiercely holding on, much has changed. . . . This
is not a land from Hallmark cards or Norman Rockwell's paintings, but . . . [from the]
photographs of Walker Evans and Dorothea Lange." Strictly speaking, the reporter
was a little inaccurate because Evans and Lange mainly photographed poor share-
croppers and migrant farm workers, not unemployed industrial workers. But in a
larger sense he was correct. In the 1930s, the American economy had more farmers
than it needed, and many of them, and their families, suffered destitution and ended
up in places like California, where some of them eventually found industrial jobs
during the 1940s; in the 1980s, America's industrial workers suffered the same fate,
except that now they were supposed to find niches in the "service economy," which
was supposedly booming in the Sun Belt. Also disturbing to some Americans was the
fact that these new "hard times" affected not only ghetto people but also white people
who subscribed to all the mainstream values. "These are people who did everything
right," a union official in Youngstown, Ohio, told Dale Maharidge. "They went to
college. They went to church. They bought into the system. Now what? This is a
depression. You used to be able to live the American Dream. With corporations, it's all
'Gimmie, gimmie, gimmie.' They want a profit *now*. They don't care about people."[14]

If steel towns in the 1980s resembled pictures made by FSA photographers in the
1930s, then cities like Chicago and New York could sometimes be compared to Jacob
Riis's images of the Lower East Side in the 1890s. In the late 1940s, *Life* used cities
like Omaha to show the world how capitalism and democracy enabled middle-class
Americans to turn their "community dreams" into realities; and during the 1950s,
Look's "All-America Cities" showed other towns how to become "good places to live
in." This positive stereotype was destroyed in the 1960s by the riots in many inner-city
ghettos; and, by the 1970s and 1980s, the media were filled with almost totally
negative stereotypes about the poorer sections of American cities. Particularly blighted
areas, like the South Bronx in New York, became national symbols of urban devasta-
tion in the 1970s, and by the late 1980s this negative stereotype sharpened and
focused almost entirely on the inner city's violent criminals and drug dealers. The
painful lives of hundreds of thousands of other city people, trying to survive in
neighborhoods with grossly inadequate schools and hospitals, terrible municipal ser-
vices, and little or no police protection, were largely ignored as the mass media ranted
and raged about drugs, gang wars, and homicide counts. The fear, hatred, and

alienation that the middle class felt toward their nation's large cities was expressed vividly by a 1989 *U.S. News* article that compared conditions in the nation's ghettos with those in Lebanon. "This time the firefights are taking place on our own territory," the magazine said, "within the hearts of our major cities. Every day there are haunting pictures of the dead being carried off in body bags, of angry grieving families . . . of dilapidated buildings, of armed gangs and wounded children, of burned-out cars and the flash of gunfire." A "new civil war" was taking place, the magazine claimed: "From Gangland Los Angeles to Murder Capital Washington, D.C., city after city now tolerates its own Beirut, a no man's land where drug dealers shoot it out to command street corners." One man, who moved to Washington, D.C., from the South Bronx, said about shootings and homicides in his neighborhood: "To a guy who came here from New York City, this was like an American dream. . . . Then it shattered."[15]

As the analogies to Lebanon suggest, Americans also had new fears, nightmares, and stereotypes about foreign nations during the 1970s and 1980s. *Time, Life*, and other mainstream media of the 1950s and early 1960s were illustrated with some negative stereotypes of Communists and unfriendly nationalist leaders, like Mossadegh of Iran, but they, and USIA publications, also contained many positive images showing how well the United States was making friends and bringing security and prosperity to the rest of the world: grateful Europeans receiving Marshall Plan assistance; Asian recruits being trained by American military advisors; crowds of Central Americans, Asians, and Iranians shaking hands with vice presidents; peasants learning new farming techniques from AID officials. These docile foreign stereotypes were almost entirely displaced in the media during the 1970s by hordes of negative images—cowardly or incompetent South Vietnamese soldiers, arrogant Arab oil sheiks, cunning Asian entrepreneurs, Central American revolutionaries and death-squad killers, Libyans, Iranians, "unreliable" European allies, "evil empire" Soviet leaders and KGB spies, and, above all, the masked terrorists whose activities were reported in obsessive detail every time they attacked (or were rumored about to attack) Americans.

Moreover, during the 1950s and 1960s, the mainstream media contained positive stereotypes of "strong man" rulers whose countries were considered friendly because they cooperated with American interests. During the 1970s and 1980s, presidents and policymakers continued to befriend and recruit supposedly cooperative tyrants and dictators—Vietnamese and South Korean generals; Portuguese fascists and imperialists; Greek colonels; Chinese Communists; Brazilian, Chilean, Uruguayan, Argentinian, and Central American oligarchies and military juntas; the Shah of Iran and the military rulers of Pakistan and Indonesia; Marcos in the Philippines; the Duvaliers in Haiti; South African racists; and even—after the Vietnamese invaded Cambodia—Pol Pot and his Khmer Rouge mass murderers. Despite the complaints of liberals and the modest efforts of a few politicians, like President Jimmy Carter, to implement "human rights" policies, all of these oppressors were U.S. allies at various times.[16] However, befriending these dictators, many of whom were extremely vulnerable, corrupt, and/or incompetent, did not really make America more powerful or secure. A large number of them were either assassinated or deposed in the 1970s and 1980s—much to the consternation of their patrons and admirers in Congress, the mainstream

media, the Central Intelligence Agency, and the Pentagon. Indeed, by the 1980s, the
new strong-man stereotype was likely to be a picture of a glum-faced dictator at an airport as he prepared to go into exile, or a description of his assassination and funeral in a news story, accompanied by discrete remarks mentioning how disturbing his demise was to "American officials."[17]

In 1941, when the United States had just started to play its role as a world power, Henry Luce enthusiastically proclaimed that his nation would be a "Good Samaritan ... the powerhouse of the ideals of Freedom and Justice," and in 1945 Walter Lippmann praised Franklin Roosevelt for leading "this country out of the greatest peril in which it has ever been to the highest point of security, influence, and respect which it has ever attained."[18] During the 1950s, these ideas became codified into a stereotyped vision of the United States as a powerful but very generous and friendly nation; but, during the 1970s and 1980s, many American politicians, media people, and ordinary citizens reacted to foreign events with furious outbursts of rage and xenophobia, which reached a peak in the mid-1980s. Indeed, anyone who read *1984* and observed the American media at that time might have concluded that certain parts of that book, such as the "two-minute hates," were accurate prophecies about the United States. In Orwell's novel, the members of Oceania's ruling party go into two-minute paroxysms of fear and anger when they are exposed to telescreen images of the arch-villain Emmanuel Goldstein. "Behind his head on the telescreen marched the endless columns of the Eurasian army," until Goldstein's face melts "into the figure of a Eurasian solder who seemed to be advancing, huge and terrible, his submachine gun roaring." One need only substitute Mu'ammar Qaddafi or the Ayatollah Khomeini for Goldstein, and a scowling Russian soldier or Middle Eastern terrorist for the Eurasian soldier, and one could easily portray the contents of many American television programs and magazine articles of the mid-1980s. At the same time, in movies like *Delta Force*, *Rambo*, and *Rocky IV*, macho heroes "blew away" hordes of foreign enemies or beat them into pulp, while prestigious press journalists and editors unraveled paranoid conspiracy theories that Bulgarians, incited by the KGB, tried to kill the Pope. The mayor of New York called the United Nations a "cesspool," and the nation's pundits and foreign policy officials complained vociferously about "unreliable" European or Pacific allies if any of them dared to contradict American opinions or did not cooperate with U.S. policies. When New Zealand refused to allow American ships carrying nuclear weapons in its harbors in 1985, for example, a Defense Department official described it as "a piss-ant little country south of nowheresville," and congressmen and the American media called New Zealand's citizens "mutton-headed," "ostriches," and "Soviet stooges."[19] It was all very colorful and exciting, but these were scarcely the reactions one would expect from Good Samaritans, or from a respected and influential nation.

With all the hard times and bad news appearing in the mainstream media, it might be argued that documentary photography had become redundant. Who needed a Lange

or an Evans if the *New York Times* and television news programs were doing stories about the homeless, bankrupt farmers, and unemployed steelworkers? Who needed a Lewis Hine to document child labor and illegal "street trades" when *Time* magazine published stories about 13-year-old drug dealers and *Newsweek* contained articles about homeless adolescent prostitutes on city streets? A careful look at these media stories, however, reveals that the need for documentary "artists" is just as strong now as it was in the 1910s or the 1930s.

Despite all the bad news that appeared in the mass media in the 1970s and 1980s, their *overall* mood was often not too depressing, since the bad news was frequently leavened by outbursts of frenetic optimism and chauvinism. Clearly, Americans wanted to "feel good" about themselves and their nation in the 1970s and 1980s, and editors and politicians were happy to oblige them. "The capacity of the American media to conjure up an instant myth, to glamorise the mundane and sanctify the profane should never be underestimated," one British journalist noted in 1987. "There is something about the American mood and something in the mechanism of public opinion which is like a pendulum, ready to swing from confidence to despair [and back again] . . . with bewildering speed." Thus bad news about the homeless, disasters in the Middle East, or atrocities in El Salvador could be overwhelmed by the 1986 "Miss Liberty" ceremonies, the 1984 Olympics in Los Angeles, the destruction of the Berlin Wall, the Grenada and Panama invasions, or the bombing of Libya, which induced moods of optimism and euphoria expressed quite well by the *U.S. News* in its description of the 1986 Statue of Liberty centennial celebration:

> It was wild, it was extravagant, it was at times even a bit tacky. But it was American all the way.
>
> *Only in America* is a legend known to all the world—and small wonder. We are a people on a pinnacle, gone giddy with our greatness. On the Fourth of July . . . we swept ourselves to new heights with our love for our land and our lore. . . . In freedom's name, we filled the skies over the Statue of Liberty with 40,000 skyrockets. We filled New York Harbor with the wind-billowed sails of 265 tall ships, and filled our ears with oratorical gusts from numberless celebrities.[20]

Major hard-times documentary statements, like the FSA photography unit's 1938 Grand Central Palace exhibit, had a single main message meant to persuade ordinary citizens (or at least some of them) that America had to make major changes if it wanted to improve the living conditions of millions of its citizens. In contrast, the almost manic-depressive mixtures of optimistic and pessimistic messages in the mainstream media of the 1970s and 1980s often seemed to be designed (whether deliberately or unconsciously is no matter) to induce a confused stasis: there are homeless people sleeping in the streets but the stock market is "booming," and there are terrorists attacking the United States but "America is standing tall"—so why risk any significant changes?

In addition, the harshness of much of the bad news in the mass media was diluted or trivialized by the format of the media—an effect most pronounced in television news

programs. By the early 1980s, Cecelia Tichi commented, television stations all over

the country adopted the same format of "jolly news teams" who "connected the filmed
reports" of bad news "with scripted conversational cheer" and banter. Very often,
Tichi noted, "the impact of very serious news reporting is weakened when the
subsequent story is pointedly frivolous. [Thus a news special] suggested recently that
Chicago's Cook County Hospital has become a medical dumping ground for the poor.
It was a powerful report of extreme human misery and exploitation, but [it was]
immediately followed by scenes of trained dogs."[21] If dog acts and other "feel good"
stories did not cheer up audiences, there were the commercials filled with dancing
consumers and jolly jingles, and the cheerful sports reporters and witty weather
people who ended broadcasts with jokes about tomorrow's forecast.

The emotional effects of the bad news that mainstream newspapers and news
magazines purveyed were often dissipated by little touches of optimism and reassur-
ance that appeared even within hard times news and feature stories. The *New York
Times* reporter who compared the scenes he saw in the Monongahela Valley with
Evans's and Lange's 1930s photographs ended his article with anecdotes showing how
the unemployed steelworkers and their families were still able to celebrate Christmas
despite the hard times they were enduring, and *Life*'s photoessay about a week in the
life of a homeless family ended with the good news that the family found an apartment,
managed to make a deposit on it, and moved in. Neither of the parents had a job by the
end of the photoessay, but they received a $4,500 loan to learn job skills at a technical
college, and both of them were doing well in their classes—so an optimistic reader
could assume that, though the plight of the American homeless was certainly sad, it
was not too devastating.[22] (A different family, in which the parents did not get a loan or
find an apartment, might have given readers a different feeling about homelessness,
but *Life*'s editors did not publish a photoessay about that kind of family.)

Another significant difference between documentary work and the mass media is
that the former tries to be systematic and comprehensive. Hine and the FSA photog-
raphers sought to communicate as many of the causes and consequences of child labor
and rural poverty as possible. In contrast, the mass media are almost invariably more
simplistic and more selective in their reporting because they concentrate so heavily on
the most emotional or "sensational" aspects of subjects. In mass-media articles about
the homeless, for example, there is a heavy emphasis on pathetic details. Every
November, when cold weather arrives and shelters need to be expanded, there are
news and feature stories about the "plight of the homeless," illustrated with pictures of
people at soup kitchens and accompanied by anecdotes and interviews with the
homeless people themselves or with shelter personnel. However, according to one
professor of urban planning, who made a study of articles about homelessness in four
major newspapers in 1986, at most only 10 percent of these articles made any
references to the reasons why people became homeless, and then it was mentioned
only in passing.[23] A related reason for this superficial quality is the media's tendency
to compartmentalize social problems, presenting them as isolated, separate crises,
each with its own anecdotes, its own set of pathetic victims, and its own group of

experts who are interviewed. In actuality, a social problem like homelessness is related to many other issues, such as the increasing poverty of the "working poor," local and national housing policies, the disappearance of inexpensive housing, deindustrialization, and landlord greed. But most articles on homelessness ignore these complex or disturbing connections by suggesting that the homeless are mostly "voluntary" vagrants, addicts, or former mental patients. In foreign news, the mainstream media reports are often naive because they give virtually none of the historical background that might enable readers to understand news stories intelligently. Stories about Iran, for example, rarely mention the likelihood that some of that nation's xenophobia might be inspired by the fact that it has been bullied and manipulated by foreign imperialists (the Russians and British until the 1940s and by the Americans from 1953 until the 1979 revolution).

Moreover, mainstream journalism, including photojournalism, is often superficial not only because it does not analyze its subjects adequately but also because it is rushed and impersonal. Documentary photography, particularly after the example set by Klein and Frank in the 1950s, is often strengthened by the photographer's personal involvement with the subject; but editors often do not want this kind of involvement because it can make a photographer more independent and less productive than editors would prefer. Bill Owens, for example, made several documentary books in the early 1970s and expected that these books would give him an entry into photojournalism, which he imagined would be a more profitable and prestigious field. But, when he finally received an assignment from *Newsweek* to photograph Sun Belt cities in the mid-1970s, Owens was ordered to stop photographing what interested him and to bring in images that would fit the stereotypes *Newsweek* wanted. "If you don't get this straight, *you* are going to be in deep trouble," the editor informed him. "We need you to show some of the good life ... people swimming, vacationing, shopping, carousing and generally having a good time." Also, because *Newsweek* wanted these images fast, Owens had to work under "a crazy pressure ... to photograph all of Houston, Texas or Phoenix, Arizona in three days. What can really be said or shown about a city in three days? Only the Chamber of Commerce view." Finally, the editors cropped Owens's pictures and selected only the ones they liked. He later complained, "on such assignments, one has to do what the editors require ... they have final control. . . . Cropping the photos negated my style, and thus the essay lacked my photographic 'look.' I was homogenized and reduced to fit *Newsweek*'s style."[24]

Also, documentary photography generally tries to be honest; but a great deal of mainstream journalism in the 1980s, particularly when it dealt with foreign nations, was heavily biased. Commenting on how the American government tried to manipulate the media during the Vietnam War, Walter Cronkite warned in 1982: "Today . . . we may be in for more of the same. I do not intend to liken El Salvador to Vietnam in any way . . . except in this: that official reports and explanations often are woefully unconvincing, transparently wrong, and in conflict with reports from experienced and reliable American reporters on the scene. And we already are hearing echoes of that earlier battle between press and officialdom. The reporters are 'naive,' 'romantic,'

'leftist.' ... Yes, we've been down this road before."[25] To a considerable extent, however, this battle also took place within the American press and media establishment. Many people in the media were quite willing to follow the politicians and policymakers down the same road that led to so many illusions about China in the 1940s, Vietnam in the 1960s, and Iran in the 1970s. Indeed, in some cases, the same magazines that earlier over-praised Chiang Kai-Shek, the Shah of Iran, and Ngo Dinh Diem showed an equal enthusiasm for cooperative Central American politicians like José Napoleón Duarte of El Salvador; and the same media that promoted "Vietnamization" in the early 1970s were equally optimistic in the mid-1980s about the prowess of the mercenaries hired to overthrow the Nicaraguan government or the military capabilities of El Salvador's American-trained battalions. If "experienced and reliable reporters" did not bring editors the right kind of news, then inexperienced or gullible "special correspondents," often accompanied by photographers, could take tours under the guidance of American officials.

Further, the United States, by the 1970s and 1980s, had become an "information society," a culture whose middle-class citizens are exposed to virtually continuous barrages of facts, propaganda, ideas, statistics, charts, graphs, advertisements, messages, crises, lies, theories, slogans, warnings, complaints, trivia, and human interest stories, usually illustrated by photographs or other kinds of images. In a cultural context such as this, in which "reality" is reduced to a stream of split-second glimpses, sound bites, and glib facts, it is difficult to believe that the relatively drab image of a homeless woman or a frightened Salvadoran peasant really means much more than the glowing, color-coded advertisement for an automobile or personal computer likely to appear on the next page of a news magazine or the next commercial break on a television program. Commenting in 1981 on Susan Sontag's many theories of photography and her complaints about the proliferation of photographic images, William Klein agreed that "we're drunk with images. She's sick of it. I'm sick of it. Everybody's sick of it. But we're often moved by old amateur photographs because they aren't concerned about theories of photography or what a picture must be. They're just photographs."[26] Klein's comment sounds casual, but it contains an important insight into the continued relevance of documentary photography: such photographs—plain, direct, forceful pictures that are sometimes not so very different from the amateur photographs Klein mentions—move us and allow us to concentrate on important realities.

In many respects, the documentary photography of the 1970s and 1980s is a fusion of approaches and attitudes that existed in earlier work, mainly from the 1930s and 1950s. Like the FSA photographers, the "good artists" Evans mentioned in 1975 photograph socially significant subjects and call attention to America's shortcomings. This strong social orientation may have been due to the influence of the FSA photographers, whose work became widely known in the 1960s, but it is just as likely that in

some cases this kinship was due to changing economic and social conditions. That is, as more Americans began to suffer the kinds of hard times that existed during the Great Depression, it was reasonable that some photographers would adopt some of the practices and attitudes that characterized 1930s documentary work.

Although the photographers of the 1970s and 1980s rarely express the strong, or even defiant, individualism that Frank, Klein, and Arbus did, they resembled them in certain ways. Like those photographers, they were strongly self-motivated in their choices of subjects, and they did not depend on any organized, institutional shooting scripts or support for their efforts (which is just as well, since, during the 1980s, the U.S. government was scarcely likely to hire any Roy Strykers to arouse sympathy for the poor or to criticize mainstream institutions). Instead—again, like Klein, Frank, and Arbus—some of these photographers did commercial work or mainstream photo-journalism to support their "personal work," though some of them also received grants from institutions like the Guggenheim Foundation and the National Endowment for the Arts. Finally, like Klein and Frank, they had a strong interest in having "final control" (to use Owens's term) over their personal documentary work, and this caused them to rely on books as their main avenue of expression. This last development may not have been very profitable for them, but it does reveal the increasing sophistication and sensitivity that many photographers now have about the presentation of their images—and their determination to present these images in the most accurate and responsible manner.

As Owens pointed out after his unhappy experiences with *Newsweek*, "There is a basic and important difference between doing a magazine story and creating a book. With the book, one has the time to produce it in a proper fashion and the pressure of work comes from within," rather than from editors.[27] The "proper fashion" also implies that by putting their images into books photographers have more control over the documentary process. They can select their subjects, create their own shooting scripts, and collaborate with one another or with writers if they want to—as Michael Williamson worked with Dale Maharidge on *Journey to Nowhere*, for example. When their books are edited and published, photographers can have a considerable influence on which pictures are selected, how they are printed, and the sequences in which they appear. They also can have more influence over the texts that accompany their images—such as autobiographical statements, journalistic accounts and narratives, chronologies, captions, explanations, and even maps. Thus the contexts in which documentary photographs appear, which formerly were controlled by project administrators or by editors, are increasingly likely to be controlled by, or at least influenced by, the decisions of the photographers themselves.

Also, because these photographers often select their own subjects, there is considerable diversity in their work. Underlying this diversity, however, there is a recurrent tendency, which can be discerned in all good, strong documentary work, to challenge or ignore the stereotypes that flourish in the mainstream mass media. What that media often idealizes, the documentarians are likely to see ironically or critically. What the mass media usually ignores or treats as insignificant, they are likely to emphasize.

What the mass media treats as isolated, or separated from mainstream society, they are
likely to see as connected, or symptomatic.

Bill Owens's documentary and photojournalistic work of the 1970s is a good example
of the differences that can exist between mainstream photojournalism and documen-
tary photography in dealing with a subject like the suburban American Dream.
Commenting on a slightly earlier version of that "good life," Ingrid Sischy said
perceptively, about the images that Dan Weiners made for *Fortune in* the 1950s, that
"almost everyone in them is under a spell—the spell known as the American
Dream."[28] Sischy's comment applies perfectly to the Sun Belt photoessay that
Newsweek's editors created with Owens's images for their 1976 special issue on the
American bicentennial. In that issue, published for the Fourth of July, the editors
acknowledged that the bicentennial had been dampened a bit by Vietnam, Watergate,
and the recession and inflation of the mid-1970s, but they avoided using words like
"mistake" or "failure." They claimed that the United States was an "unfinished
nation" whose people spoke "to the ongoing resilience of what used to be called the
American Dream. They live for the most part in material plenty and believe it to be the
reward of hard work. . . . We are, the novelist John Cheever says, a nation 'haunted by
a dream of excellence.' We have not yet despaired of making the dream come true." As
one of the editors told Owens, more bluntly, "We need you to show some of the good
life."[29] Sure enough, elsewhere in the issue, and particularly in Owens's Sun Belt
photoessay, readers could see what *Newsweek* meant by "excellence" and the "good
life." The photoessay opens with a picture of a nubile California blonde in a sun suit,
draped over the hood of a car and staring at Owens's camera. Behind her, an attractive
brunette also stares at the camera from behind her reflecting sunglasses. In virtually
all of the pictures on the following two pages—described by the editors as "Civiliza-
tion and its contents"—everyone is happy, tanned, and smiling: there are two young
women in bikinis jumping into a swimming pool, two elderly "happy campers" smiling
beside their trailer, a woman grinning as she eats at a fast-food restaurant, a blonde
in a tight dress "boogieing at Rosie O'Grady's Goodtime Emporium in Orlando
Florida," and an attractive brunette getting out of her car at a posh Houston country
club. Sun Belt architecture is represented by a luxurious Phoenix mansion with its
swimming pool and gardens and by shiny, soaring skyscrapers in Houston. Thanks to
the pressure they put on Owens, and their ability to select and crop his images, the
editors produced an updated version of the American Dream photoessays that *Life*
and *Look* loved to publish in the 1950s—a panoramic view of the country from coast to
coast, filled with pretty girls, fun in the sun, and rampant consumerism. (On the other
hand, Owens decided his *Newsweek* pictures looked like "postcard photographs" and
"everyone liked the photo essay but me.")[30]

 The people in Owens's book, *Suburbia*, are still under the "spell" of the American
Dream. They live in California suburban communities where, according to Owens,
"everyone . . . lives 'the good life,' which means having attractive homes, high paying
jobs, swimming pools and shiny cars."[31] But, instead of idealizing this "good life" as

Newsweek's editors did, Owens wanted to make a "documentary project" that would be "a visual/anthropological view of America"; therefore, he used a "documentary style" as plain and direct as any picture made by Walker Evans or by an anthropologist lining up "natives" in front of their huts. Seen from that perspective, as just another culture rather than as a *summum bonum* of human achievement, the American Dream becomes considerably more comic and more ironic.

On the cover of the book is an image that invokes the spaciousness, the material affluence, and the mobility so often associated with the Dream since the 1950s: a wide-angle picture of a split-level home with a boat and a camper in the driveway. Owens introduced his pictures by explaining briefly that his work as a photographer for a local newspaper enabled him to meet people who "enjoy the life-style of the suburbs. They have realized the American Dream. They are proud to be homeowners and to have achieved material success." One turns the pages expecting to see images from *Life*, but instead Owens's first picture of people is a definitive parody of suburbia: a chubby little man and his plump wife stand over their barbecue grill. The wife is grinning like a model in a toothpaste advertisement, and the husband, wearing a chef's hat, drapes his pudgy hand over his wife's shoulders in a wonderfully comic expression of macho possessiveness amplified by his explanation of how they divide barbecue duties: "Sunday afternoon we get it together. I cook the steaks and my wife makes the salad."[32]

One of the most significant features of Owens's approach to his subjects was that it was the opposite of Arbus's. She hunted out subjects like nudists and transvestites, whose images would reveal a "forbidden," alternative America behind the American way of life of the 1950s and 1960s. Owens, on the other hand, let many of his subjects select themselves. He advertised in a local newspaper that he was "working on a photographic project about suburbia. I would like to photograph your home, your children, pets, or whatever."[33] Therefore, the people in his pictures identified them-selves not only as suburbanites but also as suburbanites who wanted to be photo-graphed as such. One of the most important things about the barbecue man and his helpmate is that they are trying so hard to look "suburban." Like virtually all the other people in Owens's book, they still believe in the Dream of the 1950s—lots of steaks, boats, cars, bicycles, kids, motorcycles, Tupperware parties, and squeaky-clean kitch-ens filled with all the latest appliances. Rather than finding the best camera angles and waiting for the decisive moments that would enable these people to look like the ones in the picture magazines and advertisements, Owens photographed them in a system-atic, sociological manner that Roy Stryker would have loved. In every picture we see the people surrounded by their belongings or in relationship to one another in ways that reveal their values—but always in a crisp, no-nonsense documentary style.

The interaction between Owens's documentary style and his subjects' efforts to look like the stereotypes they have seen in magazines and advertisements creates an ironic *frisson* throughout the book, the main effect of which is an accentuation of the role-playing endemic to middle-class life. One couple even posed themselves in front of a painting of paper doll cutouts and announced: "You assume the mask of suburbia

for outward appearances and yet no one knows what you really do." (Or, they might have added, what you really feel or really think.) Instead of trying to penetrate this mask to find hidden or forbidden realities, as Arbus tried to do, Owens simply let his subjects act out their "life-styles" in front of his camera, and instead of commenting directly on them he simply added captions that were, as he said in the foreword to the book, "what the people feel about themselves."

One effect of the deadpan irony that pervades *Suburbia* is that it makes almost everything Owens's subjects do appear to be in a kind of visual quotation marks. When they meet people or face his camera, Owens's subjects grin as broadly as possible, showing lots of teeth, to indicate they are "friendly." When they go to parties and drink, they are obviously having lots of "fun," and when they pose with their "material plenty" (to use *Newsweek*'s term), they smile complacently or broadly to show how "satisfied" they are with themselves and their cars, boats, and houses. Many of the women seem to be trying to look younger, more chic and stylish than they really are; but, since they are not models and Owens was not a fashion photographer, some of them—like the woman showing the Tupperware—look more bizarre than fashionable. Moreover, much of their furniture and other furnishings are made of ersatz materials—plastics, veneers, and polyesters that are painted, coated, or woven to look like brick, wood, or natural fabrics—and visually echo the sense of superficiality that characterizes many of the facial expressions and comments. (The artificial Christmas trees, the giant, "antique" plastic keys used as wall decorations, the Old Tyme Taverne signs purchased at K-Mart and used to furnish family room bars, are all in *Suburbia*.)

When *Suburbia* is compared with the American way of life images and photoessays published in *Life*, *Look*, and USIA pamphlets in the 1950s, the most noticeable difference is a sense of diminishment. *Life*'s and *Look*'s middle-class Americans were always presented as parts of larger contexts, as examples of the successful American economy, or of how new appliances "liberated" women from drudgery. In contrast, Owens's people exist within their own physically spacious but culturally parochial environment. The people in *Look*'s All-American Cities, for example, "cleaned up" slums and corrupt local governments, but the Californians in *Suburbia* had more modest goals. Thus a woman pushing a sponge mop over an already-clean bathroom floor told Owens, "I put it off until I can't stand it anymore. The rottenest job in the whole house is cleaning the bathroom," as if this task was a major challenge to her. One of the men informed Owens that "the best way to help your city government and have fun is to come out on a Saturday morning and pull weeds in a median strip," which is the caption for a picture of a group of men and boys crouching by plants in the middle of an empty road. Seen through Owens's wide-angle lens in a matter-of-fact documentary way—without the careful selection of images, the flattering lighting, and the enthusiastic texts commissioned and composed by editors—the American way of life is considerably less impressive than it was in the picture magazines.

Owens's book also presents a different vision of suburbia's overall pattern. One of the dominant themes of the Dream, which was extremely salient in the 1950s, was *growth*. The U.S. economy, productivity, industries, and military might were all de-

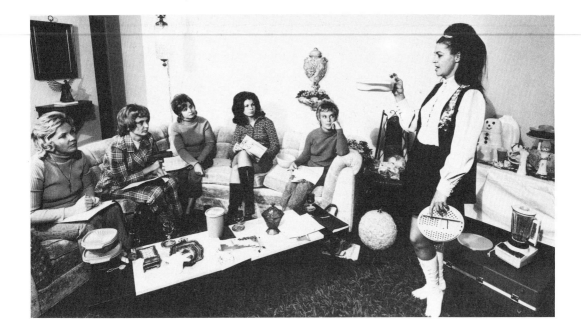

scribed enthusiastically in the mass media as "booming," "expanding," or even "exploding"; and the nation's new suburbs were prime examples of rapid, vigorous growth. At first glance, *Suburbia* seems to be within that tradition, but when it is studied more closely we see an important difference.

The suburbs of the 1950s picture magazines were eloquent proof that the United States had transformed itself from the poverty and stagnation of the Great Depression to the affluence and security of the 1950s. In Owens's book, a different transformation occurs. After his short preface, in which he explains to the reader that his book is about people who "have realized the American Dream," Owens includes a page of dedications, in which he thanks his wife and a friend for their "understanding and support." Then he adds: "And to the people of the Livermore Amador Valley. It's your book." Below this dedication is a picture of an old wooden cistern standing in a field of wildflowers: an implicit suggestion of the valley's rural past, of the time before it became a suburb. In the remainder of the book, Owen suggests how this opening image—half-natural and half-agrarian—was transformed by the people of the valley into the driveways, streets, and houses of their suburban society.

Owens's original title for the book was *Instant America*, and the transformations he depicts are very rapid ones.[34] Instead of showing how these changes create a brighter, happier way of life, however, several of his early image sequences reveal a change from barren vacancy to affluent banality. The process starts with the picture of a half-finished house on a parched lot (see "Instant America," below). Photographed by Owens on an overcast day, the house, with bricks littering the yard, already looks like a ruin, even though we know it is new because of the sign proclaiming that it is being built "expressly" for someone named Edwards. This image is followed by a photograph of a family putting in an instant lawn, "planting" six-foot rolls of sod that they have purchased. ("My wife and son helped roll out the grass. In one day you have a

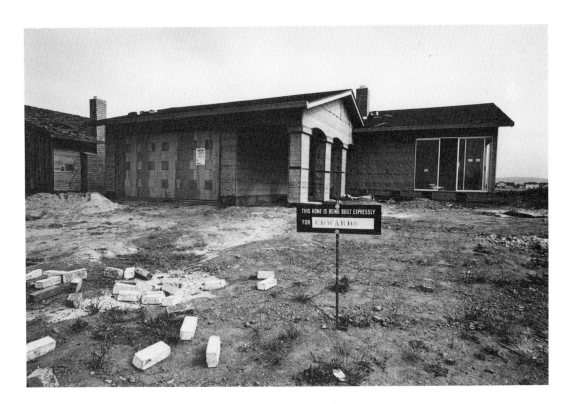

front yard.") On another page, a young married couple pose in an empty room in one picture and in a room full of furniture in another, with a caption explaining how they lived for a year without any living room furniture, because "we wanted to furnish the room with things we loved." The furniture in the second picture is new and plush but not very impressive, and in one corner there is an artificial Christmas tree. Like so many of the other interiors Owens photographed, the room does not reveal bad taste or good taste but rather a pleasant, manufactured mediocrity. In many of his photographs this quality is increased by a super wide camera angle (that Owens presumably used to get more of the rooms' furnishings into his pictures) that "flattens" the dimensions of spaces: we see a world that is visually, as well as socially, shallow.

Bill Owens, "Instant America" (Owens, Suburbia, 1973, © Bill Owens)

Moreover, many of Owens's portraits of the valley's people imply that all this material growth has not been accompanied by an equivalent cultural or psychological growth. Throughout the book are pictures of middle-aged people and whole families whose expressions resemble those in eighth-grade class pictures; that is, everyone—including the parents—look like happy, well-fed twelve-year-olds who know that they are supposed to smile ("Say cheese!") when a camera is pointed at them. Indeed, in a few of his pictures, the smaller children—or even the babies—look more mature than the adults. This sense of visual homogeneity is reinforced by the cultural homogeneity. Everyone in it is white, except for one young black woman who says she enjoys the suburbs but misses "black cultural identity for my family. . . . Here the biggest cultural happening has been the opening of two department stores," and an Asian-American family who said that, because Chinese food was not available, "on Saturday we eat hot dogs." Most of the white people face the camera with expressions of complacent

265

optimism notably lacking any sense of complexity, sophistication, or self-doubt. Clearly, for them, the "good life" that they saw in so many advertisements came true, and they were proud to have achieved it.

Owens's own attitude is more problematical. On the one hand, he did not patronize his subjects or see them in the heavily ironic manner that Frank, Klein, and Arbus might have. But on the penultimate pages of his book he placed two pictures, without captions, that suggest that he saw the growth of the suburbs and their way of life as something other than a blessing. On one page is a bulldozer ripping up an old vineyard, and facing it is another picture of the old cistern in the field of wildflowers, which appeared at the beginning of *Suburbia*. This image of the cistern, however, is larger than the earlier one, and now we can see that it is threatened by a road and a line of suburbs advancing toward it as well as by the bulldozer on the facing page. At the same time, we can now see better that the cistern and field of wildflowers and grasses are beautiful. In fact, the cistern photograph is the only really beautiful picture in the book, the only image of anything that seems genuine or natural, and this beauty is about to be destroyed. The expansion of the suburbs, and the ersatz way of life they represent, is causing the loss of something valuable; and Owens, placing these two images together so near to the end of his book, steps outside of the suburban American Dream to criticize it.[35]

Having discreetly made that point, Owens ended the book by presenting himself in the role of the "objective" photographer as a cool, noncommittal technician. His final image is a slightly ironic self-portrait, a picture of his reflection in a suburban powder room mirror, his face hidden by his camera. An accompanying caption lists the technical details of his photography—the cameras he used, the film, the strobe and flash units, the name of his printer. As the couple who posed by the painting of the paper doll cutouts said earlier in the book, "You assume the mask of suburbia . . . yet no one knows what you really do."

Like Owens, Chauncey Hare often used a wide-angle lens and a strong, precise documentary style, but in virtually every other respect his attitudes and his approach were antithetical to Owens's. Owens was a meticulous craftsman who sometimes visited his subjects six or even ten times, until he found exactly "*the* interesting photograph" he wanted. Hare took it for granted that usually there would only be "one picture for me in a place," and he rarely made more than two photographs of the same subject. Owens presented himself as a relatively "objective" technician in *Suburbia*, and referred to his feelings about the subjects of that book only obliquely; but Hare was extremely "subjective" in his documentary work, an angry and outspoken polemicist, and he introduced both of his books—*Interior America* and *This Was Corporate America*—with long, autobiographical statements explaining himself and his feelings in great detail. For reasons he did not explain, Owens approached his suburban subjects living the American Dream of the 1950s and 1960s as something of an outsider who considered himself an anthropologist; for Hare, that Dream was an intensely personal matter because, for two generations, his family lived it.[36] His father

was born in a house that "was little better than a chicken coop," but received a small scholarship, worked his way through college to become an engineer during the depression, and by the mid-1950s was the manager of a DuPont electrochemical plant that employed fifteen hundred people. Chauncey seemed destined to follow the same path, but more easily. "To be white, male . . . with a new wife and an engineering degree . . . was just about the best thing that a person could be in 1956," Hare wrote about himself at the beginning of *Interior America*, which was published in 1978. "The Russian launching of Sputnik was only a year away, and it would send America rushing pell-mell into many technological races: aerospace, computers, plastics. . . . President Eisenhower elevated engineering from a well-paying profession to an act of patriotism. In that graduating spring more than twenty years ago, I possessed all the credentials of the American dream as we then knew how to dream it. . . . To all appearances, I was a young man who marched to the right drummer." Indeed, if *Life* had photographed Standard Oil rather than Monsanto and Union Carbide for its idealized visions of the chemical industry, Hare might have been one of the engineers in the photoessays. Or, if he had gone to work for a company near Livermore, California, and if his marriage had not failed, he might have been one of Owens's suburban subjects.[37] Instead, as Hare's allusion to Thoreau's "drummer" indicates, he rebelled and became a documentary photographer, composing two books that are indictments of large corporations and government bureaucracies.

Ever since World War II, most large corporations communicated with the rest of the country mainly by producing advertisements glorifying consumption.[38] In contrast, Hare was deeply concerned with the effects of the processes of production on individuals and American society, and much of his first book, *Interior America*, is a visual indictment of the consequences of industrial production as it existed in the United States between the 1950s and the 1970s. In his introduction to that book, he said he was "deeply moved by the humanity of the documentary work" of Walker Evans and Russell Lee.[39] Interestingly, *Interior America* picks up documentary photography almost exactly where Lee and Evans left it in the late 1950s and early 1960s: Lee was photographing poor Mexican-Americans in Texas and Evans was making his "People and Places in Trouble" photoessay for *Fortune*. Like Lee, Hare worked from a deep, personal sense of concern and commitment, and, like Evans, he tried to photograph the grim lives of people living outside of the American Dream. Evans's "People and Places" photoessay sought to go beyond the traditional FSA-sociological perspective of primarily depicting the material conditions of American life for reform purposes: he tried to make photographs that would reveal moods and psychological realities. "They speak with their eyes," Evans wrote about the people in that photoessay. "People out of work are not given to talking much about the one thing on their minds. You only sense, by indirection, degrees of anger, shades of humiliation, and echoes of fear. . . . Unemployment, let alone poverty, has to be lived to be understood and felt. This is the realm of chronic indigestion, incipient stupefaction of the will, and hardening of the spirit. The real state of mind of the jobless cannot be read about in . . . sociologist prose, or in the Government Report. The plain, non-artistic photograph may come closer to the

matter, which is sheer personal distress."[40] It was, once again, that "bitter edge" of Evans's sensitivity, which Lange had spoken of, except that now Evans's bitter sympathy was directed toward people who were internally victimized by the conditions of life in industrial America rather than toward sharecroppers who were living in material misery because of the nation's 1930s agricultural crisis.

Hare's career as a documentary photographer was triggered by his encounter in 1968 with the kind of person Evans might have photographed for his "People and Places" photoessay—Orville England, a disabled Standard Oil employee who was injured in an industrial accident, "eased into retirement with a small pension, no disability [pay], and with the bulk of his own medical bills to pay." England was victimized by Standard Oil's corporate bureaucracy rather than by unemployment, but photographing him and his home gave Hare the "confidence" he needed to photograph other people in a way that would reveal the drabness and alienation that he experienced, personally and emotionally, as a Standard Oil employee.[41] In effect, Hare went a step beyond Evans and Lee by trying to show the "sheer personal distress" that was not related to a definite, relatively external cause, like unemployment or racism, but was instead an important but unrecognized feature of the industrial system that has dominated American life for much of this century.

A few of the pictures in *Interior America* that Hare made in industrial sections of Ohio can be related relatively easily to the FSA photographers' techniques. In one of them, made in Mingo Junction, an elderly black man sits slumped on a broken-down porch glider, his head bowed toward a steel mill seen in the town's skyline a few blocks away. According to Hare, the black man, who had one arm, reminded him of his own grandfather, whose leg was crippled in a Monongahela Valley steel mill, and became for him an emblem of "modern industrial casualties," a symbol of the destructive side of American industry. Such an image is essentially very similar to the pictures of the blighted people and eroded environments that Evans, Rothstein, and Post Wolcott made in Alabama, Montana, and North Carolina in the 1930s.[42]

Pictures like the ones from Mingo Junction, which directly connect industry with desolation, are rare in *Interior America*. Rather, Hare usually emphasized a more indirect indictment. He began the book with a benign picture of an elderly man and his dog standing on the porch of a small, two-story house in Steubenville, Ohio, which he made in the direct, head-on documentary style Evans used to photograph country churches in *American Photographs*. The house is the type of trim, unpretentious working- or lower-middle-class house seen on the outskirts of hundreds of American towns. It is in good repair, though the paint is a bit faded, and it has shrubs and a neatly trimmed lawn decorated with a bird bath, wagon wheel, and flamingo. It is not difficult to imagine this picture in a 1950s USIA brochure praising the comfort and security enjoyed by workers in the United States. In such a brochure, however, the elderly man would have been smiling; the man in Hare's picture looks sad and a little wary.

In *Interior America*, the Steubenville picture functions as a symbolic facade: the remaining pictures in the book, which are mostly interiors, show a uniformly bleak, depressing vision of American domestic culture. These images, Hare said in his

introduction, revealed to him that there was "severe alienation in this country": there are middle-class people, looking as if they have been stuffed by taxidermists, in stuffy, old-fashioned living rooms; lower-middle-class adults staring like zombies at television sets; working-class men and women stagnating in tiny apartments, drab rooming houses, and flophouses; plus plenty of pictures of empty, desolate small-town hotel lobbies, hallways, and restaurants.[43] These images are the "evidence," which is explained by the personal "testimony" of Hare's autobiographical introduction to the book: if we read his account of how sterile and frustrating his engineering work for Standard Oil was, we should understand, by implication, how industrialism has produced the sterile, alienated culture we see represented in *Interior America*, from West Chester, Pennsylvania, and Wintersville, Ohio, to Oakland, California.

Hare's second book, *This Was Corporate America*, was a logical outgrowth of his first. It follows that, if the workplace is the cause of much of the distress afflicting "interior America," this distress should be visible in work environments. *This Was Corporate America* is not a tidy book. It has an introduction that is even more combative and personal than the *Interior America* introduction was, illustrated by personal snapshots of Hare and some of his friends. This is followed by two loosely organized sequences of images of workers at Standard Oil (at Hare's own refinery) and at government offices (a Social Security center in Richmond, California), followed by two shorter sequences of pictures made at Silicon Valley electronics firms and on the San Francisco rapid transit system (BART). Finally, there is an "Afterword" by Judy Wyatt, a psychotherapist who treats workers for job stress and alienation, explaining the relevance of Hare's vision of American workplaces. A few of the images have captions consisting of Hare's polemical and didactic comments, but many have no explanations, and none of the pictures are titled.

Needless to say, Hare did not see Standard Oil in the way that *Life*'s photographers and editors saw companies like Monsanto and Union Carbide in the 1950s. For them, refineries and petrochemical factories were Emerald Cities of glistening pipes and catwalks ruled by benevolent wizards—one such photoessay was even titled "The Reign of Chemistry"—that were scientifically transforming raw materials into new products for the nation's consumers. The subtext of these photoessays was that the size, complexity, and technological sophistication of such places also transformed America into a "world power" with "productivity" and "energy."[44] Instead of these grandiose visions, Hare's images show us a sterile, mundane corporate bureaucracy in which most of the workers are confined in offices, control rooms, and laboratories. Virtually all of these people look like managers, engineers, and skilled technicians who are, presumably, well-educated, well-trained, and well-paid. Yet most of them appear to have been changed into apathetic or discontented drones surrounded by dials and gauges, files, piles of paperwork, and reports. Above all, the Standard Oil workers seem isolated from one another, each in his or her own cubicle, an impression epitomized by Hare's enigmatic portrait of one engineer in a stained lab coat who stares at the camera through a glass wall while another man pores over *his* work in *his* office, totally oblivious to what is happening a few feet away from him.

Hare's vision of the Social Security offices is just as bleak, since those offices are organized according to the same "corporate" principles that rule Standard Oil. (The main difference between working for the federal government and working for a large corporation, Hare commented, is that the "government employees work as hard and are paid less.")[45] There is also, as one might expect, more paper confining the people who work in Social Security, since it is an organization that produces information rather than a tangible product, like oil. In addition, though Hare does not mention this, the people in his Social Security images seem more individualistic and try to "humanize" their bleak little work stations and cubicles. Several are surrounded with plants, and one man with a beard has a virtual forest around his desk. A black woman has a picture of her baby near her desk, and another one has hung an inflated, plastic teddy bear above her desk, which wears a t-shirt with "Hug Me" printed on it. Whether these little "human" touches seem pathetic or optimistic depends on one's perspective.

Hare's images of the Silicon Valley work environments are even bleaker and more sterile. In fact, he was unable to complete the project because he could not take "inspired photographs" while working at a meaningless job he took at the Environmental Protection Agency to survive economically.[46] His BART pictures are of riders, mainly men but also a few women, most of whom appear to be middle-aged, middle-class managers and businesspeople. In the mainstream media of the 1980s, particularly in business magazines, these were the people praised as the "tough" managers who were competing more strenuously to create a "meaner, leaner," more productive America so the "home team" could win its trade wars with other nations or enemy

270

corporations. In the background of one of the BART pictures there is even an advertisement for a business magazine showing ferocious-faced managers in three-piece suits carrying attaché cases as they leap over hurdles, accompanied by the slogan, "When the competition gets tough . . ."[47] In Hare's images, however, practically all of these people look tense, driven, repressed, and painfully "uptight," an effect accentuated by the way he photographs many of them standing or sitting near people who are younger and more relaxed-looking.

Despite its grim contents, *This Was Corporate America* is a more hopeful work than *Interior America*. The mood of the earlier book was stagnant and, in certain respects, stoic. The idea of a better world, which was supposed to be created by industrialism, is dead for the people in *Interior America*—just as it was dying for the people in Evans's "People and Places in Trouble" photoessay—but the only "solution" in most of Hare's *Interior America* images is to sit in one's living room staring at a television set. *This Was Corporate America* is more urgent and desperate, yet more optimistic. On its title page are two juxtaposed images—a drawing of a man jumping out of a skyscraper window and, next to it, a picture of Hare standing by a shoreline with his arms raised in an exultant pose. Inside the book we learn that the suicide was an unnamed "government clerk" who leaped to his death from a nearby building a few months after Hare began working for the EPA, and the picture of Hare was made when he performed an intuitive, spontaneous ritual when he knew that his father was dying, which he called "releasing my father." An image of the clerk's self-destruction (because of "fears, loneliness," and "difficulties adjusting to [a] new job") is juxtaposed and contrasted with self-renewal (Hare accepts the loss of his father and more responsibility for his own fate.)[48] Elsewhere in the book, Hare explained that its title referred to a time, centuries in the future, when the Standard Oil refinery he once worked at would be a kind of museum where guides would explain to tourists that what they were seeing "once *was* corporate America." He used the "past tense . . . in order to underline my belief that we are leaving the old world behind. Corporate America is part of the past—deterioration is clearly visible in many of [my] photographs." Symbolically, Hare photographed the blank exterior of the megalithic Richmond Social Security building when its flag was flying at half-mast.[49]

Seen from that perspective, the tense, middle-class San Franciscans in the BART series at the end of the book are additional omens of change: even the managers and beneficiaries of this system find it unbearable. Hare was pleased when someone stole one of his prints from an exhibit at the San Francisco Art Institute. The man in his picture, Hare said, was an "elderly and successful" businessman, and the image was accompanied by a caption from Charles Reich, saying that such men needed hugs rather than more "status symbols" like Cadillacs. Perhaps, Hare speculated, the picture was stolen by a student because it "spoke to him about his father's predicament." He placed this picture at the end of *This Was Corporate America*, presumably to celebrate his ability to communicate with others through his images. This image, by itself, also can be interpreted, however, as an expression of severe doubt as well as loneliness. Seen this way, it seems strangely similar to many of the FSA pictures of

troubled dispossessed farmers in MacLeish's 1938 *Land of the Free*. In that book, the
FSA images were accompanied by a free-verse "sound track," composed by Mac-
Leish, expressing the doubts about the future of rural America that were created by
the Great Depression: "We don't know. . . . We wonder whether the great American
dream . . . is behind us now. . . . We can't say. / We aren't sure. . . . We wonder / We
don't know / We're asking."[50] For Hare—and perhaps for the man in his BART
image—industrial, corporate America is beginning to be "behind us now."

Hare and Owens both approached their subjects from documentary starting points as
they sought to make systematic studies of a culture (Owens's *Suburbia*) or a major
social problem (alienation in Hare's books). The other two photographers who are
analyzed in this chapter, Susan Meiselas and Michael Williamson, are photojournal-
ists who saw their subjects, at first, as "news," but went on to create hybrid works that
combined the best features of photojournalism and documentary photography. Both
Meiselas's *Nicaragua* and Williamson and Maharidge's *Journey to Nowhere* contain
images conveying the sense of immediacy that characterizes good photojournalism,
yet they present these images with the intelligence and passion that are characteristic
of the best documentary work.

Meiselas's subject—the Nicaragua ruled by General Anastasio Somoza Debayle—
was not, before the late 1970s, a promising place to visit for any photojournalist who
wanted to sell his or her pictures to North American magazines and newspapers. Until
that time, Nicaragua, along with most of Central America, was one of the places in the
world most consistently ignored by the mainstream media, for reasons not difficult to
decipher.

Central America is a region that has been heavily influenced by U.S. policymakers
and large corporations, like the United Fruit Company, since the beginning of the
twentieth century. A disturbing number of its political and economic realities, how-
ever, were (and still are) flagrantly at odds with several of the most cherished tenets of
the export model of the American Dream: one of these is the belief that the United
States is a benevolent "Good Samaritan," bringing prosperity and freedom to poor
and oppressed nations. Liberal members of the media had good reason to ignore the
region, since many Central American rulers were, in the words of Harrison Salisbury,
"fascist and neofascist thugs." Yet, some of the most vicious of these thugs came to
power with the tacit consent of such eminent liberals as Franklin Roosevelt and Adolf
Berle, Jr. Moreover, most of these Central American dictators—unlike, for instance,
the Shah of Iran—did not bother to modernize their nations to any serious extent or to
cultivate the support of high-level liberal politicians and journalists. At the same time,
conservatives had little motivation to mention these nations frequently or in any detail
in their newspapers and magazines, since one of the region's very few democratic
governments—that of Jacobo Arbenz Gúzman, who was elected president of Guate-
mala in 1950—was overthrown in 1954, due to the zealous efforts of the CIA and
such eminent conservatives as Dwight Eisenhower, John Foster Dulles, and Henry
Luce, whose magazines functioned as propaganda bureaus for the CIA and the State
Department.[51] In addition, despite the fact that some of the region's most repressive

governments had cooperated very closely for decades with large North American corporations, very few of their citizens enjoyed the blessings of prosperity and social progress that *Life*, for example, described in its photoessays about Puerto Rico during "Operation Bootstrap," or about Venezuela, which it described as a "New Latin Boom Land" during Marcos Pérez Jiménez's "firm rule."

By the early 1970s in Nicaragua, for example, over 50 percent of the population had 273

incomes of less than ninety dollars *per year*, 80 percent of the houses had no running water, 59 percent had no electricity, and 49 percent had no sanitary facilities. Out of every 1,000 babies born, 102 died, and the Somoza family owned 23 percent of the country's arable land. At approximately the same time in El Salvador, the top 10 percent of the country's landowners owned 78 percent of the arable land; 38 out of every 100 children died before the age of five; and rural and urban unemployment averaged approximately 35 percent, though it was "higher in the agricultural off-season."[52]

When a revolution began in Nicaragua in the late 1970s, however, North American magazines were willing to publish the same sort of exciting, or "sensational," pictures that they published earlier about the Spanish civil war, World War II, and Vietnam. Meiselas was a capable and courageous combat photographer, but instead of simply becoming another Robert Capa or David Duncan, she did considerably more. She published a documentary book of her Nicaraguan pictures, which is far more intelligent and serious than any of the photoessays or collections of combat pictures published so far in this century.

Her book is divided into two significantly different parts. The first half is a long sequence of color images that show, chronologically, three stages of the Nicaraguan revolution. Images one through twenty-two are a series of pictures of social, economic, and political conditions dated "June 1978" and entitled "The Somoza Regime"; images twenty-three through forty-six present the September 1978 insurrection, when the revolution began; and images forty-seven through seventy-one, dated "June–July 1979," show the "final offensive" by the FSLN (Sandinista National Liberation Front), which ended when Somoza flew to Miami and his National Guard troops fled to neighboring countries.

This last part of the book contains a fair number of conventional combat pictures, but the perspective of Meiselas's *Nicaragua* is far different from that of the usual books and news articles that pour out of New York when a crisis or revolution occurs. Instead of the usual introduction by a North American expert, explaining the significance of the events occurring in the foreign country, the last section of Meiselas's book is introduced by a page of quotations, translated into English, taken from Nicaraguans' comments on the Somoza government and the origin of the revolution. These are followed, on another page, by Meiselas's own dry comment: "Nicaragua. A year of news, as if nothing had happened before, as if the roots were not there, and the victory was not earned. This book was made so that we remember."

News, as Meiselas's comment implies, is usually presented with a minimum of history and a maximum of combat pictures, which reduce revolutions to a few riots, demonstrations, and pitched battles. In contrast, her pictures present the social reality that preceded the Nicaraguan revolution: a squalid, muddy, country crossroads with a few shacks standing in the rain and a pig sniffing at the mud; a small, sweating worker loading one-hundred-pound sacks of grain aboard a ship while a fat overseer watches him; a man chopping sugar cane; a woman washing clothes in a sewer in a Managua slum; and a uniformed maid caring for rich children at a country club. These are the

"ordinary" Central Americans who do not appear in the North American media, except when they are corpses or when they appear in a crowd to cheer a visiting U.S politician.

What it is that holds this social system together is suggested by another series of pictures showing Somoza getting out of a limousine and surrounded by body guards. This is followed by a picture of his son, the head of the "Elite Infantry Training School," surrounded by new graduates of the school who are drinking Schlitz beer—a U.S. Army tradition imported to Nicaragua. The Schlitz beer cans are not the only details in this image that remind us of certain North American military attitudes. Somoza's son is large and looks Caucasian, and his troops are mostly Indians and mestizos: smaller, darker men. This picture recalls other photographs made a decade earlier in Vietnam, when the picture magazines published photoessays showing Green Berets and other American advisors with South Vietnamese troops. In those photo-essays, it was always taken for granted that the Green Berets were helping the Vietnamese to "resist Communist tyranny," but, in *Nicaragua*, it is clear that these troops will be enforcing tyranny, the Somoza family's tyranny over the rest of the population. Just in case the Nicaraguans have any doubts about this matter, one of the pictures in the sequence (image eleven) shows National Guard recruits with shaven heads walking past a huge poster of Somoza in full uniform glaring out at us (exactly like Big Brother in *1984*), a perfect example of the modern tyrant ruling by fear and repression. Image twelve shows two middle-aged National Guardsmen with brutal, leathery faces staring down at Meiselas as she takes their picture. The implication is that the young recruits walking by the Somoza poster in image eleven have been transformed into the callous, sinister men in image twelve. Meiselas exposed the dark side of the policies followed by the United States in Central America, which were so often ignored or sanitized by the mainstream media since the 1930s. Instead of helping a poorer, smaller nation to become more prosperous and democratic, North American influence (implied by the picture of the younger Somoza with his "Elite" troops) created a dictatorship that ruled by terror and repression.

Just how brutal that repression could be is shown by image fourteen—a picture of a half-burned, dismembered corpse on a hillside overlooking an idyllic landscape of hills and a lake. The corpse's legs, hips, part of its charred backbone, one arm, a hand, and a few other scattered bones are visible. The rest has been burned or torn apart.

In the mainstream U.S. media of the early 1980s, such an image might have been a stimulus for editorial qualms about "human rights" or the horrors of "dirty wars," as journalists tried to rationalize their government's (or, in some cases, their magazines' and newspapers') support for dictatorships that murdered, tortured, or "disappeared" people. In *Nicaragua*, this image stimulates something more. Image fifteen, on the page following it, shows a graffiti painted on the house of a Somoza supporter in Monimbo: DONDE ESTE NORMAN GONZALEZ QUE CONTESTE LA DICTADURA JRN ("Where is Norman Gonzalez? The dictatorship must answer. JRN.") We cannot know what "JRN" refers to. Presumably it is a clandestine political group, but the graffiti's message is clear. To someone in Monimbo, Norman Gonzalez was a real

human being, not just a phrase about a "human rights violation." Somoza's dictator-
ship has aroused the rebellion that culminates in the revolution shown in *Nicaragua*.

On one level, many of the images in that book can be read as a series of cycles of
armed resistance and vicious repression in which the resistance gradually is victorious
as the FSLN revolutionaries become strong enough to defeat Somoza's National
Guard. However, a closer reading shows that Meiselas also added additional political
dimensions to her subject by including many images that go beyond the stereotyped,
picture magazine tradition of showing battles mainly as if they were real-life Holly-
wood combat movies. The Nicaraguan revolution, Meiselas's images suggest, involved
many segments of the country's population, as well as the battle-hardened revolution-
aries, who do not actually appear until midway through her book (images thirty-eight
and thirty-nine, and fifty-two through fifty-eight). The revolution she shows also
included the crowds carrying FSLN and Nicaraguan flags at funerals for slain stu-
dents and workers (images nineteen through twenty-one); the adolescent boys wear-
ing masks and bandanas to protect their identities as they fought the Guard with
pistols, old rifles, and homemade contact bombs (images twenty-three through
twenty-seven, fifty, and fifty-one); the poor- and middle-class citizens who sheltered
and supported the armed revolutionaries though they knew Somoza's troops and air
force would attack their neighborhoods in retaliation (images fifty-three, fifty-four,
and fifty-seven through sixty).

One of these groups—the young boys, or muchachos, wearing masks, scarves, and
bandanas—has a special significance. In the North American, European, and Mexi-
can traditions of political iconography, it is taken for granted that the artist will show
the faces of revolutionaries ennobled by their resistance to tyranny: Washington
crossing the Delaware in Leutze's painting, the victorious citizens storming the barri-

cade in Delacroix's *Liberty Leading the People*, Lenin making speeches to crowds of
workers in Soviet paintings, Zapata with his troops in Rivera's mural. The same was
expected of combat photography during World War II and the Korean War, when U.S.
magazines were filled with images of stern-faced generals, admirals, infantrymen, and
sailors defending America against tyranny. In Somoza's Nicaragua in 1978, on the
other hand, tyranny was still in power; and the boys in Meiselas's pictures had to
conceal their identities—or it was very likely that they would suffer the same fate as
the burned, dismembered corpse. As Meiselas herself commented later, "The Nica-
ragua picture on page fourteen especially shows what most Americans don't know
about the situation—yes, most of these images are about death and yes we want you to
look at them."[53]

The well-armed revolutionaries who appear a little later in *Nicaragua* had better
weapons and camps in the mountains, and could appear without masks. However,
Meiselas photographed them with a sensitivity and even a sense of humor that makes
them very different from the leftist, Che Guevera stereotypes popular with some
liberals in the 1960s. Many of the FSLN fighters were women, for example, and
Meiselas showed one of them teaching the other how to fire a revolver. This image
may seem a little comic until one considers the Carmen Miranda-Chiquita Banana
stereotypes of Latin American women that flourished in the mainstream North
American media—or until one considers what would have happened to these women
if they were captured by Somoza's National Guard. (Would Carmen Miranda have
joined the FSLN?) In one of Meiselas's most famous pictures, she showed a FSLN
revolutionary playing a clarinet while waiting at a barricade for a counterattack. These
revolutionaries, Meiselas implies, are complete human beings, not the stereotypes
who usually appear in the mass media, which depicts them as all good (if they are pro-
American), or all bad (if they oppose American imperialism).

What is also significant about the FSLN revolutionaries in *Nicaragua* is the amount
of support they received from many of the ordinary citizens who appear in Meiselas's
images. In one picture (image fifty-four) the people are middle class enough to have
stepped out of Owens's *Suburbia*, yet they seem proud to be bringing food and water to
the Sandinistas waiting at their barricade in Managua for an attack by the National
Guard. In other photographs, made in "liberated" cities or neighborhoods, there are
women and children who are obviously nervous or frightened—in image fifty-nine
they wait near a bomb shelter they have dug in the street—but in these pictures the
revolutionaries are the people's protectors.

The nature of this kind of popular revolution is further explained and documented
in the second part of the book, which consists of a section called "Captions/
Texts/ Chronology" following the color images. This section, brilliantly designed by
Susan Mitchell, repeats all of Meiselas's images in sequence, but now they appear as
small black-and-white pictures on the margins of the pages. The text on each page is
drawn from a wide range of documents and excerpts from interviews made by Mei-
selas and edited with the help of French journalist Clair Rosenberg. Like Meiselas's
images, these texts are notable for their range and sensitivity. A few are historical: a

Susan Meiselas, "Woman instructor teaching marksmanship to woman volunteer" (Meiselas, Nicaragua, 1981, © Magnum Photos, Inc., and Susan Meiselas)

U.S. Department of State bulletin; statements by Augusto Sandino, the nationalist revolutionary who was murdered on Somoza's orders in 1934; a 1977 letter from the country's Episcopalian bishops to Somoza protesting the "state of terror," the "arbitrary arrests," and the tortures, rapes, and summary executions performed by his army; and a 1978 CBS television interview with Somoza. Other statements are from what might be called the "official" FSLN revolutionaries like Ernesto Cardenal, Eden Pastora, and Sergio Ramirez. However, many of these interviews are from the "ordinary" people who appear in Meiselas's pictures, the people who rarely are mentioned in the usual history books or the television news programs: a taxi driver, a nun, housewives, a civil servant, a shoemaker, a construction worker. Just as these ordinary people mingle with the FSLN revolutionaries in Meiselas's images, so also their stories mingle with the words of Cardenal and Ramirez, implying the unity developing between the revolutionaries and many Nicaraguans.

These ordinary people's comments often add a great deal of meaning and emotion to Meiselas's images, for even when they do not describe exactly the same events that appear in her pictures, they do reveal what similar people might feel during similar experiences. Image twenty-nine shows one of Somoza's aircraft bombing the city of Estelí in 1978, and—in the "Captions/ Texts/ Chronology" section of her book—it is accompanied by an excerpt from an interview with a Matagalpa housewife, who described the bombing in her town:

> We crouched down, looking for somewhere to hide, and my stomach churned, my whole body shook, just looking at the beast flying over us.
> The Guardsmen in the town told the planes where to fire—which street, which house. We heard all the conversations over the radio. They said, "The hospital's ours, the barracks are ours, the rest is just meat. Exterminate them!"
> When they described a house—say, it was such and such a color—we knew there were *compañeros* there, so we'd send someone to warn them immediately.

Without this quotation, Meiselas's image is scarcely more than a drab blur showing a tiny airplane in a sky full of smoke, but combined with the text, it becomes what Steichen would have called a vivid, powerful "human document."[54]

Both of these parts of Meiselas's *Nicaragua* follow the same explicit, historical chronology; however, they also have an analogous, parallel development that can be considered an implicit process of visual and social revelation. An exhibit of images from the book was entitled *Demaskings* and the metaphor applies very well to this process.[55] In the first half of the book, the revolutionaries in the color images literally "demask" themselves and show their faces as they gain power and confidence in their struggle against Somoza and the Guard. In the second half of the book, the experiences and feelings of ordinary Nicaraguans are "demasked" as they emerge from the insignificance and powerlessness imposed on them by the Somoza regime.

In some respects, therefore, Meiselas's book also documents a political process that opposes the American Dream as it was applied to poor foreign nations after World War II. Even in the most generous versions of that Dream, as it was promulgated by

picture magazines and USIA brochures during the 1950s and 1960s, it was taken for granted that the poorer, darker peoples of the world could improve their lives only by gratefully accepting "reforms" initiated by their "strong man" leaders or by humbly accepting the tutelage of military advisors, Agency for International Development bureaucrats, and Peace Corps volunteers from the United States, who would teach them what *Look* described as "how to do things the American way."[56] Either way, this philosophy did not contain the possibility that students, taxi drivers, housewives, and shoemakers would revolt against their pro-American leaders and try to establish governments independent of North American approval, aid, and advice. However, it must also be remembered that by the early 1980s, when Meiselas published her book, the Dream was not working very well in many parts of the United States either.

Meiselas's *Nicaragua* portrays a reality largely unknown to many North Americans because it was almost totally ignored—and, more recently, is frequently misrepresented—by the mainstream media. Michael Williamson and Dale Maharidge's *Journey to Nowhere* is a study of several subjects—the new American "underclass," deindustrialization, and homelessness—that appear frequently in that media, but usually in a superficial, stereotyped way. Their book also represents a significant return to the "hard times" documentary tradition of the 1930s. Williamson dedicated the book, in part, to "all the Farm Security Administration photographers who documented the last depression so well," and he has great respect for the work of Walker Evans and Russell Lee.[57] But Williamson's interest in Evans and Lee is more than an homage to elder artists; it is also a recognition of certain very important changes that began in America in the 1970s and became painfully noticeable between 1982 and 1984, when he and Dale Maharidge, a print journalist who wrote the text, researched and composed *Journey to Nowhere*.

In 1977, as the recessions of the 1970s became more severe, DaCapo Press published a reprint of Archibald MacLeish's *Land of the Free*, with a new introduction by A. D. Coleman. MacLeish's book was no longer a "period piece," as it might have been earlier, Coleman pointed out, because "as a nation we seem to have come cyclically to a stretch of our own history which is similar in many ways to the time in which *Land of the Free* was created [1938]. . . . We, too, are living in a depression. . . . If we are willing to pry up the thin veneer of our times and look beneath, it is not difficult to recognize the imminence of that powerlessness and dispossession which has run like a river throughout the American experience." By the early 1980s, it was no longer necessary to "pry" to find the conditions Coleman mentions, and in 1982 an intelligent editor of the Sacramento *Bee* suggested to Dale Maharidge that he might do a story about hoboes—not the old-time, traditional hoboes who rode the nation's rails for decades—but "jobless middle-class people," called "new timers," who had become hoboes as they searched for work. Maharidge realized that such a story should be illustrated with photographs, and he recruited Williamson. Together they began riding freight trains in California and meeting "people who had worked hard all their lives but now could not beg a job. It hit us hard. We saw something, but weren't sure

what. . . . Something big was happening to America, and we'd only caught a glimpse."

Gradually they realized that, though these homeless, unemployed people came from all over the country, much of the problem seemed to emanate from the "heartland" of industrial America in Michigan, Pennsylvania, and Ohio. They went to Youngstown, Ohio, to begin their journey since they realized they needed to "understand the decline of the industrial core of the nation" to learn "what causes formerly middle-class people to wind up living on the street."[58]

Chapter 2 of *Journey to Nowhere*, which is about Youngstown and entitled "The Rust Bowl," is a devastating study of the death of an American Dream. Just as the FSA photographers recorded a crucial stage in the death of the rural American Dream in their "Dust Bowl" pictures, Williamson and Maharidge recorded an important stage in the decline of industrial America. Almost every image in this chapter of their book is an inversion of motifs from 1940s and 1950s mass media. Instead of the glistening production lines and glowing blast furnaces in *Life*'s hymns to American "productivity," Williamson photographed the "dead hulk" of Youngstown Steel and Tube's Campbell Works, the ruined interior of the Brier Hill steel mill, and the wreckage of U.S. Steel's Ohio works, which was dynamited and looked very similar to the ruins in Europe at the end of World War II. Instead of main streets clogged with prosperous shoppers, he photographed the desolate, nearly abandoned streets of downtown Youngstown, a theater with a huge "For Sale" sign on it, and a furniture store with "Going Out of Business" signs in its windows. Instead of smiling workers shopping in supermarkets, like the ones in USIA brochures, he photographed, and Maharidge interviewed, former steelworkers who had lost their homes because they could not pay their mortgages. They met men who were laid off and angry and frightened that their mills might be the next ones to close. A Republic Steel millwright told them, "We're supposed to be the best country in the world! Why can't we have better? . . . The companies want to pay less wages. When you make minimum wage, you invest in bread and bologna. . . . I can't afford a new car. I'm scared to spend $100. . . . The mill is run by a steam engine built in 1908. It's very crude. When something breaks, we make the part. . . . I blame the companies. . . . They should have re-invested."[59]

As the millwright's comments remind us, industries like the steel industry were a crucial part of the twentieth century American Dream because they produced not only prosperity but also pride and power. "Youngstown steel traveled the world," Maharidge wrote; it "was used in the gates of the newly opened Panama Canal. Youngstown steel helped win World War I and World War II when the mills worked round the clock to produce metal for tanks and bombs. . . . When the second great war ended, Youngstown steel helped build the prosperity which followed." Now the mills were abandoned and dynamited, and as one ex-worker said bitterly, "What Hitler couldn't do, they did it for him."[60]

In most newspapers during the 1980s, these grim realities were dealt with in a neat, sanitary, rather abstract manner. Headlines announced a plant or mill closing, accompanied by a round number of jobs lost ("GM to Close Framingham Plant. . . . 3,700 to be put out of work"), followed by the usual brief announcement from a corporation

spokesperson giving the usual reasons for the closing ("profitablity," "foreign competi-tion"). There might be a few unhappy remarks from local union officials, and occa-sionally a few snippets of interviews with actual workers. There were relatively few follow-up stories; but sometimes, a little later, advertisements, like this one from a Michigan newspaper in 1988, would appear—"ATTENTION PERSONNEL MANAGERS: Due to the streamlining of our . . . operations, many skilled men and women have been laid off indefinitely. In an effort to help these individuals in gaining full time employment, we have implemented a company operated placement program. If you are searching for good, experienced applicants . . ." Next to this advertisement was one from a fast-food restaurant chain, which suggested the kind of employment opportunities that were available for skilled workers: "Hardee's / We're out to win you over. / Job Going Nowhere / Here is your opportunity."[61] Men and Women who had been elite members of America's industrial work force—lathe operators, grinder operators, and quality control inspectors—were being forced into low-paying "ser-vice" jobs; but to most editors in the 1980s these people were rarely important enough to be photographed, interviewed, or mentioned in any detail.

In *Journey to Nowhere*, Maharidge presented some statistics he received from Youngstown area officials—that child abuse increased by 21 percent, suicides in-creased by 70 percent in two years, a mental health clinic was receiving four thousand calls a month for help, up to fifteen hundred people a week were going to one Salvation Army soup line, and the number of burglaries, robberies, and assaults doubled "in the few years following the plant closings," even though the area's population declined.[62] Williamson and Maharidge, however, like the FSA photogra-

phers of the 1930s and like Lorena Hickok, Edmund Wilson, and a few other

journalists of that decade, tried to discover the human reality behind the "official"
statistics. They found a new exodus from industrial America just as disturbing as that
earlier exodus from rural America that occurred during the Great Depression.

During World War II and the 1950s, the immense expansion of American industry
brought prosperity to virtually all regions of the country, but, as these industries
declined or collapsed in the 1970s and 1980s, hundreds of thousands of unemployed
working- and middle-class people had to leave communities like Youngstown and
search for work elsewhere. Maharidge and Williamson documented how painful,
demeaning, and exhausting this search could be. They interviewed and photographed
dozens of "dispossessed" Americans who were forced into the underclass and fled to
places like Texas, Colorado, and California in search of work in the early 1980s. In the
process of doing this, Maharidge and Williamson challenged a number of stereotypes
flourishing in the mainstream media.

The media almost never connect subjects like homelessness and deindustrializa-
tion, but treat them as separate compartments of news having no relationship to one
another. In contrast, Maharidge and Williamson documented the painful, logical
realization that, if thousands of factories and homes were abandoned in the industrial
Midwest, the people in them were going somewhere else; and, if they did not find jobs
in these new places quickly, they were going to be living on the road and sleeping on
the streets, in their cars, or in shelters. Talking to these people, they learned many
details of life in the underclass rarely mentioned or emphasized in the mainstream
media: what happens when an old car breaks down, what it is like to ride a freight train
in the winter in Colorado during a snowstorm, how difficult it is to sleep in a shelter
for the homeless, what it is like to hoe cotton for ten hours and earn a total of $4.04
(after "deductions"), how much food a person can buy after selling a pint of blood
plasma, and how much someone can earn collecting aluminum cans for a recycling
center (about seventy-five cents a day).

Further, Maharidge and Williamson also challenged the stereotyped assumption
that the underclass is composed mostly of people who either do not deserve or are not
lucky enough to get their slice of the American Dream. According to this assumption,
people in the underclass are too lazy, too criminal, or too addicted to drugs or alcohol
to work hard and become prosperous, secure citizens. Or, according to a less moralis-
tic and punitive stereotype, the underclass consists of people who are unlucky enough
to have been born black or Hispanic or Appalachian, to be illiterate or mentally ill, or
to have grown up on welfare and a "culture of poverty" that prevents them from
achieving the Dream.

Maharidge and Williamson discovered that many of their subjects, on the other
hand, were white, mainstream, middle-class citizens who lived that Dream until their
lives "shattered" because of recessions and plant closings. "You lose the TV. And you
accept that," said one man, who lost everything twice, first in Grand Rapids and again
in Atlanta. "You lose the car. And you accept that. Then you cut down on the
groceries. And you accept that. Then you lose the house. That's too much. It's like a

cancer. It eats you up." They devoted two chapters to one young white man, whom they called Don, who was a college graduate and had a wife, three children, and his own business before he went bankrupt in a recession, his wife and children left him, and he tried to commit suicide. "I grew up having everything. . . . I thought [being] poor meant you didn't want a job," he told Maharidge and Williamson in a St. Louis mission. "It's one thing to be poor and stay poor. It's another thing to be middle class and go down. It hurts like a son of a bitch. . . . Friends I went to high school with made fun of me because I went to college and graduated. But when things were good, I was looked up to. . . . I was proud as a peacock. By the time I went down, my neighbors were out of work, too. One guy got down and left his family. And this was suburbia! I had eight thousand dollars in the bank. That's bubble gum when it starts going." Merely being willing to work, and work hard, was not enough. Maharidge and Williamson met dozens of homeless men and women who were eager to work and could not find jobs anywhere—even in places like Denver and Sun Belt states like Texas and Arizona, whose economies were supposedly "booming." Near El Paso they met a man and woman in their sixties, grandparents who owned and lost a small hotel in Kansas. Now they were hitchhiking through Oklahoma, Texas, New Mexico, and Arizona trying to find jobs and failing. "I wants [sic] to work, dammit! That's the Gospel," the man told them. "We've never been on welfare. We've never gotten food stamps. Nothing is beneath us. We'll wash floors. We'll clean shit bowls. . . . We don't need much. Just a place to stay."[63]

Maharidge and Williamson also discovered that, even when poor people did find jobs, they could not quickly climb out of the underclass. In Houston, they met and photographed two men, both named Jim, who lived under a bridge. One of the Jims found a job at the Houston Astrodome, but only for four hours a day, two or three days a week, and it did not pay him enough to afford a "real apartment." In a park in the same city, they met a family, originally from Michigan, who were living in tents because they could not pay the rent on their apartment after the father, a welder, was laid off from a well-paying job in the oil fields and took a minimum-wage job in a welding shop.[64]

Like Russell Lee and the other FSA photographers, Maharidge and Williamson were sympathetic to their subjects and tried to show that they were decent people who needed some help. As Russell Lee told the old woman in Minnesota in 1937, "You're having a hard time and a lot of people don't think you're having such a hard time. We want to show them that you're a human being, a nice human being, but you're having troubles."[65] They also, like the FSA unit, tried to be comprehensive and to record as many of the causes and consequences of the "hard times" as possible. Just as Dorothea Lange and Paul Taylor, for example, went through the Southwest in the 1930s to learn more about exactly why the "Okies" were migrating and about the conditions they encountered in California, Maharidge and Williamson traveled to places like Youngstown and Texas to learn as much as possible about the new underclass. They also made a side-trip to Mexico to show how and why millions of desperate Mexican nationals were driven North because of their country's collapsing economy.

Of course, Maharidge and Williamson could not do the quantity of work that the FSA photography unit did, since there were only two of them, but they compensated for this limitation by often becoming personally involved with their subjects and by undergoing some of the same hardships. They rode freight trains with hoboes and hoed sugar beets beside Mexican nationals and unemployed construction workers. They gave Don, mentioned earlier, some of their own money so he could rent a cheap room in Denver for a month while he searched for work. Maharidge acknowledged, "What of the hundreds of other Dons walking around Denver? We were powerless to help them." They drank beer and played pool with the welder in Houston, and bought him and his family the food for a decent meal instead of the usual bologna sandwiches for dinner. By photographing these people, trying to help them, working with them, and recording their experiences in the book, they were able to make a very eloquent documentary study of what it was like to be among people who were cut out of the American Dream of the 1980s.[66]

There is, however, one important aspect of the FSA unit's work that is not present in *Journey to Nowhere*. Lee, Rothstein, and the other FSA photographers photographed FSA "clients," like the Andy Bahains of Kersey, Colorado, who achieved a modest, frugal, depression-era version of the American Dream. But by the 1970s and 1980s, thanks to the Great Greed, that version of the Dream was passé in American mainstream culture and the mass media; and politicians like Walter Mondale, who tried to revive the New Deal ethos, were badly defeated when they ran for high office. So, instead of meeting people like the Bahains, Williamson photographed people whose lives were an unpleasant contrast to the dominant, get-rich-quick Dream of the 1980s. In Arizona, he saw a Mercedes Benz sedan passing a man walking down the road with a plastic bag of scavenged aluminum cans on his back. The man driving the air-conditioned car worth $40,000 is only twenty feet away from the man walking in the Arizona sun (with his bag of cans worth seventy-five cents), but socially they are in two different nations. In Denver, Williamson photographed the city's skyline at night, glowing like a magic city in the dark, with the light from a bonfire in a hobo jungle in the foreground. In Houston, he showed the two Jims in their "apartment" under the Smith Street bridge while construction cranes completed a new high-rise building one block away from them, which probably would be occupied by expensive offices or condominiums.

Maharidge called Houston a "mirage." It looked like an impressive city to a "visitor with a fat wallet," who would see that "skyscrapers covered with acres of glass and steel dot the horizon. . . . The streets are spacious, clean; men and women in smart clothes bustle between office buildings." But he invited his readers to go

behind the skyscrapers, over to the Star Hope Rescue Mission. . . . There, hundreds of men sit on street curbs—their faces buried in their hands. . . . Watch police cruise slowly past. Watch the cops return and glare. . . . Breathe a sigh of relief when they move on, only to stop and arbitrarily question two other men. Watch, if you can, when the cops beat their heads bloody with nightsticks for no

Michael Williamson, Men living under bridge in Houston, Texas (Maharidge and Williamson, Journey to Nowhere, 1985, © Michael Williamson)

reason, then haul the two off to jail. . . . Watch a mother and father come begging for help with their son. Dad is dressed in old U.S. Marine clothes. Mom holds her forehead . . . towing the toddling boy, barely old enough to walk. Watch them slink off. . . . Leave the mission area and drive around. Notice the outcasts scavaging [*sic*] for . . . food in dumpsters.

Get out of your car. Walk in the little valley formed by Buffalo Bayou, a river

286

looping around downtown: its waters reflect the images of those beautiful mil-
lion-dollar skyscrapers.[67]

In addition to these signs of social conflict and inequality, Maharidge also recorded
some of the less brutal but nevertheless mean-spirited ways in which middle-class
people and institutions harassed and demeaned their poorer fellow citizens. Texas
made it illegal to sleep under bridges or on the steps of buildings; Los Angeles passed
laws forbidding people to sleep in cars; and a city commissioner in Fort Lauderdale
urged that garbage be sprayed with kerosene or insecticide, because "to get rid of
vermin . . . you cut off their food supply." Maharidge described Phoenix as "the town
in the sun that hates the poor," because it passed laws declaring that garbage was city
property and could not be scavenged, rezoned neighborhoods to evict missions and
soup kitchens, and made it illegal to lie down or sleep on city property.[68]

So, not surprisingly, that "bitter edge" that Dorothea Lange perceived in Walker
Evans's images is also present in *Journey to Nowhere*, and it also is accompanied by
some explicit anger: the Ohio millwright who blames the companies for making him
work in a steel mill with a 1908 steam engine, a Vietnam combat veteran who owns a
.357 Magnum handgun and warns that though he would not steal money he would
steal food to feed his children, a Northerner who described Texas hospitality this way:
"If you're here on vacation, you're a Yankee. If you're looking for work, you're a
damned Yankee. If you find work, you're a fucking damned Yankee."[69]

The book ends with images of despair, mixed with a little bit of very mild optimism.
On one page, there is a large picture of Fred, a laid-off forklift operator from Chicago
who came to California to find a job and failed to. Sitting next to the tracks in Fresno,
Fred buried his head in his arms in a gesture of exhaustion and despair, and his picture
is accompanied by a caption identifying him and adding, "When asked where he might
be in the coming months," Fred mumbled, "'I might be right here.'" Facing this
picture is a photograph of protesters in sleeping bags at a federal building in Sacra-
mento with a hand-painted sign: 2 MILLION AMERICANS HAVE BECOME LITTER ON THE
STREETS.—HOMELESSNESS. A NATIONAL DISGRACE. Like so many other marginal mi-
nority groups in the United States since the 1930s, the homeless, and people who
sympathize with them, have begun the slow, frustrating process of protesting the
conditions that afflict them and trying to shame their fellow citizens into supporting
some kind of change. The final image in the book is of a San Francisco newspaper
headline—"12 Million Jobless: Enough!"—which shows that the mainstream media
has begun to show more interest in problems like unemployment and homelessness.[70]

The overall impression of *Journey to Nowhere*, however, is summed up by its title.
Like Fred, many of Maharidge's and Williamson's subjects are going "nowhere,"
either literally or metaphorically. The Dream of an industrial America so powerful,
humane, and well-organized that no one would suffer "hard times" again is as dead as
many of the steel mills that helped to create it. In the meantime, since *Journey to
Nowhere* was published, the amount of unemployment in the nation has declined, but
that river of "powerlessness and dispossession," which A. D. Coleman perceived in

1977, continues to flow. Plant closings still occur, and estimates of the number of American homeless people—particularly young people and families with children—continue to rise. Further, the concept of powerlessness applies to middle-class Americans and their institutions as well: when a "national disgrace," such as homelessness, cannot be solved for years, or decades, it is increasingly difficult to believe that a society really does have the power to improve itself in a significant, substantive way. As Jonathan Kozol wrote about homelessness in New York City in 1988 (three years after *Journey to Nowhere* was published), "What startles most observers of the homeless is not simply that such tragedies persist . . . but that almost all have been well documented and even the most solid documentation does not bring about corrective action." Of course, Kozol acknowledged, task forces have been appointed, press events have been scheduled, studies have been made, and experts have proposed programs costing large sums of money. But "when, after a year or so, we learn that little has been done and the problem has grown worse," Kozol argued, "we tend to feel not outrage but exhaustion. . . . The truth is that we do not know what we want to do with these poor people. We leave them, therefore, in a limbo."[71] Leaving people to waste their lives in a limbo of poverty and homelessness does not fit in with anyone's idea of the United States as a successful, dynamic nation able to solve its own social and economic problems, much less those of the rest of the world.

EPILOGUE

After looking at Williamson's images in *Journey to Nowhere* and reading Kozol's comments on the homeless, one is tempted to indulge, very briefly, in some ironic optimism. Perhaps the fact that these images and comments were published, respectively, by a major press (Doubleday), and in the *New Yorker* is a sign that middle-class Americans will become a little more realistic about their own and their nation's limitations. Perhaps, one is tempted to speculate, we will have fewer utopian illusions that, because of some sentences Thomas Jefferson wrote two hundred years ago, America is a society in which everyone really is treated "equally" or that, because of some novels Horatio Alger, Jr., wrote a hundred years ago, it is a place where anyone can become rich if they are willing to work hard. Then, freed from such dreams, perhaps we will devise more effective solutions for our nation's problems.

Such optimism, however, is easily dispelled by the sheer enormity of the nation's problems and the low quality of many of the remedies so far suggested or attempted. The homeless have been a "national disgrace" for almost a decade, but no one seems to know what to do with them, except to open more soup kitchens and to house them in squalid shelters and welfare hotels. Deindustrialization and plant closings have been going on for more than a decade, but the main solution for this "restructuring" of the economy has been to try to retrain industrial workers for "high tech" jobs (which many of them will never get) or to send them to places like Florida and Texas to search for low-paying service jobs (which they may lose in the next recession). Nor, turning to

a problem that obsesses the mass media, do American policymakers really seem to know what to do about terrorism, particularly in the Middle East, except to send expensive fleets of warships steaming around the Persian Gulf and the Mediterranean and to demand that airlines buy scanning devices that cost almost $1 million each, to detect hidden bombs like the one that blew up Pan Am Flight 103 over Scotland in 1988.[72] Neither do policymakers and editors seem to have any good ideas about what to do with the "poor people" of Central America when they rebel against their native oligarchies and against "Yanqui" imperialism, except to send aid and weapons to right-wing death squads and mercenaries and then to complain timidly about "human rights violations" when those weapons are used to terrorize and murder innocent people. Further, many Americans seem unwilling to understand or confront alienation in their nation's workplaces, which Chauncey Hare documented, beyond setting up testing and/or counseling programs for employees who become so demoralized that they resort to drugs or alcohol to help them stagger through their workdays. No one seems to have any intelligent ideas for dealing with the affluent banality, the sheer cultural mediocrity, that Bill Owens photographed in *Suburbia*, except to whine about the decline of "cultural literacy" and to berate school systems for not teaching more "classics," or a "respect for excellence."

Other problems are similarly costly and intractable—pollution and toxic waste, the so-called "drug war," the Savings and Loan "bailout" debacle, the AIDS epidemic, third-world debt crises, and America's own trade and budget deficits. Under these circumstances, it is not difficult to understand why many Americans prefer to know about these subjects only superficially. And now it is remarkably easy, in our present culture, to retreat to an alternative reality that is well "supplied with [those] beautiful and reassuring pictures" that the poet Louis Aragon disparaged in 1959—the world of media images, which is available twenty-four hours a day, seven days a week, on television screens, newsstands, videos, movie screens, and in shop-by-mail catalogues and advertisements—that all claim to make everyone's dreams come true quickly and easily.

It may be, however, that the escapism and superficial stereotypes that constitute most of this media world will help to create and sustain that "bunch of good artists" Walker Evans called for shortly before his death in 1975. Several decades earlier, in 1940, Lionel Trilling analyzed V. L. Parrington's contribution to the nation's intellectual history, pointing out that what animated many of Parrington's works was his awareness of how difficult it was for many Americans to confront reality; therefore, Trilling said, "Parrington still stands at the center of American thought about American culture because . . . he expresses the chronic American belief that there exists an opposition between reality and mind and that one must enlist oneself in the party of reality."[73] Trilling, writing in the 1940s, considered this concern for reality to be excessive, because it led Parrington and his followers to disparage intellectual writers like Henry James and to overvalue drab realists like Theodore Dreiser. But presently, the American taste for realism—exemplified by the popularity of novelists like Dreiser—has long been superseded by a ravenous appetite for stereotyped fantasies,

wishful thinking, and instant mythologies in which colorful facts and images are manipulated to express the collective mind of this country's mainstream, mass media culture. The "opposition between reality and mind," which Trilling described, once again has become a serious conflict, and one that will exist for a long time. Vast quantities of entertaining "feel good" news programs and magazine articles, fantasies, and propaganda certainly will continue to be produced by television networks, mainstream media journalists, editors, and politicians. But, hopefully, some Americans will still seek to discover and communicate the genuine, complex conditions of this nation's life that lie behind or outside of these stereotypes; if they do, documentary photography will continue to be one of the more important ways in which Americans may enlist in the "party of reality."

Notes

CHAPTER 1

1. Jordan, "The Greatest Nation on Earth," p. 7. Michael Moore speaking in an interview, "A Self-Taught Film Maker Creates a Comic Hit," *New York Times*, 28 Sept. 1989, quoted by Purgavie, "Flint's Bizarre Story," p. B6.

2. Klawens, "Films" (review of Moore's *Roger and Me*), pp. 505–6. Hamrin, *America's New Economy*, pp. 178–84. Moreover, as Hamrin points out, there have been declines in the "real wages" paid to many American workers since the 1970s, particularly in the wages for young workers, which "plummet[ed] 30 percent . . . over the 1973–1984 period" (pp. 410–14).

3. Jordan, "The Greatest Nation on Earth," p. 7. Klawens, "Films," p. 506.

4. Alan Trachtenberg, "Introduction," in Liebling, *Photographs*, not paginated. The full quote from Jefferson is: "How little do my countrymen know what precious blessings they possess and which no other people on earth possess."

5. Grierson, "Documentary Film," pp. 121–22, 124. Frank quoted in Editors of Time-Life Books, *Documentary Photography*, p. 172.

6. Rothstein said that these juxtapositions of "two contrasting images of the same subject" (or images from two different value systems) in a single image were intended deliberately "to create a new meaning," or what he called a "third effect." Telephone interview, Feb. 1985. See chapter 4, below, and Rothstein, *Documentary Photography*, pp. 31, 39.

7. Edward Steichen used the term in his review of the 1938 FSA exhibit, "The F.S.A. Photographers," in Newhall, *Photography*, p. 267. Evans spoke of "documentary in style," and "typical documents" in a 1 Nov. 1935 memo to Roy Stryker. Evans, *Walker Evans at Work*, p. 113. See also Newhall, "A Backward Glance," pp. 1–6. Newhall, "Documentary Approach," pp. 3–6. McCausland, "Portrait of a Photographer," pp. 502–3.

8. For additional comments on photojournalism, see Guimond, "Toward a Philosophy," pp. 760–62. Bill Owens, *Documentary Photography*, p. 10.

9. In 1938 Steichen distinguished between what I have termed informational and documentary photographs when he said that the latter (by the FSA photographers in the Grand Central Exhibit) were "human documents," and the former were " 'tweedle dum' and 'tweedle dee' document[s]" whose subjects were "piles of this, stacks of that, . . . boxes, bales, and timber, pictures of Politician A congratulating Politician B, etc." Edward Steichen, "The F.S.A Photographers," in Newhall, *Photography*, p. 267. For good examples of informational images (and some documentary and propaganda ones), see Exhibitions Staff, National Archives and Records Service, *The American Image*. Frank is quoted by Edna Bennett, "Black and White," p. 22.

10. Ellul, *Propaganda*, pp. 163, 164. As Ellul points out, successful propaganda very

often contains some elements of truth, a few convincing facts; and what better way is there to prove that one's propaganda is factual and therefore "true" than by illustrating it with photographs? (p. 53). Edward Steichen, "The F.S.A Photographers," in Newhall, *Photography*, p. 269. In fact, Steichen himself used FSA pictures for propaganda purposes in his 1941 exhibit, *The Road to Victory* (see below, chapter 4).

11. Claude Ray, quoted in Strand, *Paul Strand*, p. 165. Evans quoted in Travis, *Walker Evans*, p. 5. What seems notable about architectural documentary photographers, who were modernists, is that they so often photographed places and buildings that had lost all economic value and were about to be destroyed. Atget, for example, photographed buildings in Paris that were about to be torn down in the 1900s, and Evans did the same thing in the United States during the 1950s.

12. Rahv, *Literature and the Sixth Sense*, pp. 268–69. William Faulkner, "On Privacy," in Faulkner, *Essays*, p. 75. In addition to the authors Rahv mentions, a brief list of the more important twentieth-century writers who have criticized or satirized the American Dream and/or dreamers includes Arthur Miller, Eugene O'Neill, Ralph Ellison, Sinclair Lewis, Norman Mailer, and Nathanael West. For a study of writers whose works can be considered criticisms of the Dream, see Madden, *American Dreams, American Nightmares*.

13. "We Still Believe," p. 1. Mintz, "Complaints," p. 1. Persico, Review of *Scarface*, p. 18. "N.Y. Officials," p. A6.

14. Terkel, *American Dreams*, pp. 324–25. Furey, "What American Dream?," p. A21. Maddocks, "It's Fantastic," p. 19. Whirlpool Corporation ad, p. 102.

15. Raymond Williams, "Literature *in* Society," pp. 33–35. For an application of this concept to the field of American Studies, see Gunn, *The Culture of Criticism*, pp. 165–66.

16. Philbrick, *St. John de Crèvecoeur*, pp. 23–27.

17. Crèvecoeur, *Letters*, pp. 60–99.

18. George Washington thought the *Letters* might "afford a great deal of profitable and amusive [*sic*] information," but he was concerned that Crèvecoeur's portrayal of America was "embellished with rather too flattering circumstances"; and in 1856 the Duyckinck brothers criticized him in their *Cyclopaedia of American Literature* for looking at "homely [scenes of] American life" with too much "fanciful enthusiasm." Philbrick, *St. John de Crèvecoeur*, p. 162.

19. Garfield, *President Garfield on Education*, pp. 326–32.

20. Ferraro speech quoted in Drew, "A Political Journal," p. 66. For obvious reasons, politicians often blur the differences between these two versions of the Dream so they can appeal to both conservative and liberal voters. Thus Ferraro invoked hard work, a conservative motif, in her liberal speech; and Herbert Hoover was adept at leavening his conservative ideas with liberal rhetoric about "equality." (See the beginning of chapter 4, below.)

21. James Adams, *The Epic of America*, pp. vii, 68–69, 363. When he wrote the *Epic*, Adams was a liberal of the Progressive Era, or Populist. During the depression, he became more prosperous (in part because the *Epic* sold very well), and by the late 1930s he was an anti–New Deal conservative.

22. Wallace, *New Frontiers*, p. 39.

23. Trask, "Fitzgerald's *The Great Gatsby*," p. 197. Schuller is quoted by Moore, "Tough Times Last," p. 753.

24. Martin Luther King, Jr., "I Have a Dream," in Linkugle, *Contemporary American Speeches*, pp. 362–66.

25. "I've Been to the Mountain," p. 80. Alger, *From Canal Boy to President*.

26. Wise, *American Historical Explanations*, pp. 11, 19. For the scholarship behind Wise's thinking, see p. 21.

27. Szarkowski, *Mirrors and Windows*. Ansel Adams, "Credo," in Newhall, *Photography*, pp. 255–56. On the other hand, Adams did not approve of the FSA photographers' efforts to communicate social realities during the 1930s. Peeler, *Hope Among Us Yet*, pp. 87–88.

28. Sontag, *On Photography*, pp. 7, 14–15.

29. Evans, "Walker Evans, Visiting Artist,"

in Newhall, *Photography*, p. 320.

30. Gassier and Wilson, *Francisco Goya*, p. 129.

31. Klein, *Photographs*, p. 18. Frank, "Robert Frank," no pagination. See chapter 6, below. Halla Beloff speculates on the subject of the photographer's role in her *Camera Culture*, pp. 27–48.

32. Edward Weston, "Photographic Art," in Petruck, *The Camera Viewed*, p. 96. See also Whelan, *Double Take*.

33. How an image is re-visioned in new or different contexts sometimes can involve political and ethical questions. Susan Meiselas, for example, is not disturbed when her pictures of the Nicaraguan civil war are used in new contexts by the Nicaraguans, but she is troubled and angered by the way some of them have appeared in the North American media. Snyder, "Mixing Media," pp. 33–36.

34. For expressions of the idea that photography is a "transparent" medium, see the critics Copeland quotes in his "Photography and the World's Body," pp. 176–78, and my discussion of Henri Cartier-Bresson in chapter 6, below. For an example of the attacks on this "myth," see Craig Owens, "The Discourse of Others," pp. 68–71. For Owens and other postmodernist critics, the myth of photographic objectivity is part of a larger "crisis in representation" that is related to the decline of a modernist worldview, which they believe has dominated our culture since the Enlightenment and the beginnings of modernity. See also Wallis, *Art After Modernism*, pp. xiii–xiv. Solomon-Godeau, "Beyond the Simulation Principle," pp. 83–99. Frank quoted in Edna Bennett, "Black and White," p. 22. Evans, "Walker Evans, Visiting Artist," in Newhall, *Photography*, p. 320. Hine, "Social Photography," p. 357.

35. Dorothea Lange, "The Assignment I'll Never Forget," in Newhall, *Photography*, p. 263.

36. Smith is quoted by Hill and Cooper, "Camera-interview, Eugene Smith," p. 42.

1. Wilcox, "Negroes in the United States," p. 346. "The Paris Exhibit," p. 8.

2. John Szarkowski, "Acknowledgements," in Johnston, *Hampton Album*. Lincoln Kirstein, "Foreword," in Ibid., pp. 4, 5.

3. "Hampton School Record," p. 498.

4. Johnston, "What a Woman Can Do," p. 6.

5. Note from Roosevelt and photographs mentioned in this passage are found in Daniel and Smock, *A Talent for Detail*, p. 58.

6. Calloway, "The American Negro Exhibit," p. 75.

7. Washington, *Up from Slavery*, p. 149.

8. Vardaman and Page quoted in Gossett, *Race*, pp. 275–81. Torrence, *The Story of John Hope*, pp. 114–15.

9. Bailey quoted in Woodward, *Origins of the New South*, pp. 355–56.

10. Washington, "Training of the Negro," p. 3743. This article was arranged in essentially the same format as the Hampton exhibit: first there were panoramic views of the Institute, then pictures of Booker T. Washington and his staff, and then a photographic tour of different educational activities.

11. "Self Help and Self Activity," p. 6.

12. Washington, *Up from Slavery*, p. 81.

13. Armstrong, "From the Beginning," pp. 2–6.

14. Hersey, "A Reporter at Large," p. 46. Wells, *The Future in America*, pp. 148–51.

15. Gilman, "A Study in Black and White," p. 5

16. The quotation from Kurtz's "report" to the International Society for the Suppression of Savage Customs is near the end of chapter 2 of Joseph Conrad's *Heart of Darkness*. This report concludes with, as Marlow (Conrad's narrator) emphasizes, "a valuable postscriptum" that was "scrawled evidently much later, in an unsteady hand, . . . 'Exterminate all the brutes!' "

17. The comment on Armstrong is from H. P. Douglass, *Christian Reconstruction in the South*, quoted in Brownlee, *Heritage of Freedom*, p. 28.

18. Engs, *Freedom's First Generation*,

pp. 134–60. For an analysis of Armstrong's attitudes toward black people and their relationship to the "Hampton Idea," see Anderson, *The Education of Blacks*, pp. 35–50.

19. The Indian agent is quoted in *Ten Years' Work for the Indians*, pp. 79–80. Lonna Malmsheimer has analyzed the use of before-and-after photographs by the Carlisle School in her " 'Imitation White Men.' " See also "The Paris Exhibit," pp. 8–9; and Guimond, "The 'Vanishing Red,' " pp. 242–48.

20. Lincoln Kirstein, "Foreword," in Johnston, *Hampton Album*, p. 10.

21. "Co-education of Races," p. 3.

22. See above, chapter 1.

23. William James, *Religious Experience*, pp. 193–94.

24. These descriptions of the schools' social codes are from Wolters, *The New Negro*, pp. 235, 37, 46, 142. There is also a good analysis of the codes at Hampton in Engs, *Freedom's First Generation*, pp. 149–51.

25. Van DerZee's pictures of Hampton classes are in Van DerZee, *The World of James Van DerZee*, pp. 25–27.

26. The Lynn and Hampton community pictures described in this paragraph are in Daniel and Smock, *A Talent for Detail*, pp. 52, 103.

27. Brown, "Hampton School Record," pp. 439–40.

28. The statistics and a description of their sources are in Calloway, "The American Negro Exhibit," pp. 75–79. The quote regarding the purpose of the exhibit is from "The Paris Exhibit," p. 9.

29. The description of the tableaux is from Calloway, "The American Negro Exhibit," p. 77.

30. Cohen, "Innocent Eye," pp. 45–48. Lincoln Kirstein, "Foreword," in Johnston, *Hampton Album*, p. 11.

31. Franklin, *Three Negro Classics*, p. xi.

32. Woodward, *Origins of the New South*, pp. 365–67. Moreover, as Franklin has pointed out, Washington "did not seem to grasp fully the effect of the Industrial Revolution upon the tasks that had been performed by the hands of workers for centu-

ries. . . . Many of the occupations that Washington was urging Negroes to enter were disappearing almost altogether. As training grounds for industrial workers, the curriculums and the institutions urged by Washington were not at all satisfactory" (*From Slavery to Freedom*, p. 289). Johnston's Mesabi pictures are in Daniel and Smock, *A Talent for Detail*, pp. 44–48.

33. Johnson and Campbell, *Black Migration*, pp. 65, 73–78.

34. Garfield letter to Armstrong, 27 Sept. 1870, in Leech, *The Garfield Orbit*, p. 267.

35. Wolters, *The New Negro*, pp. 230–31. Harlan, *Booker T. Washington*, p. 148.

36. Washington, "Training of the Negro," pp. 3743, 3750. Washington, *Up from Slavery*, p. 92, 94.

37. Harlan, *Booker T. Washington*, p. 202.

38. Farrison, "Booker T. Washington," p. 315.

39. Chesnutt letter to Washington, 21 Nov. 1910, quoted in Render, *The Short Fiction of Charles W. Chesnutt*, p. 53.

40. Du Bois, *The Souls of Black Folk*, in Franklin, *Three Negro Classics*, pp. 246–47, 252.

41. Du Bois, *The Education of Black People*, p. 14.

42. Torrence, *The Story of John Hope*, p. 151. Franklin, *From Slavery to Freedom*, p. 327. Rudwick, *W. E. B. Du Bois*, p. 108.

43. Daniel and Smock, *A Talent for Detail*, pp. 116–17.

44. Washington, "Training of the Negro," p. 3751.

45. Wells, *The Future in America*, pp. 188–89.

46. Harlan, *Booker T. Washington*, p. 44.

47. "Racial Self-Restraint," p. 309. Clifford, "The Atlanta Riots," p. 564.

48. Franklin, *From Slavery to Freedom*, p. 326.

49. Harlan, *Booker T. Washington*, p. 361.

50. William Walling, "Race War in the North," quoted in Franklin, *From Slavery to Freedom*, p. 328.

51. Harlan, *Booker T. Washington*, p. 419.

52. Villard letter to Roger Baldwin quoted in Harlan, *Booker T. Washington*, p. 427.

53. "The Amenia Conference of 1916," in Aptheker, *A Documentary History*, pp. 130–35. "The Amenia Conference," p. 1.

54. Wolters, *The New Negro*, pp. 140, 233. See also Anderson, *The Education of Blacks*, p. 258.

55. Robert W. Bagnall, "Negroes in New Abolition Movement," in Aptheker, *A Documentary History*, p. 498.

56. Wolters, *The New Negro*, pp. 141–42.

57. Ibid., pp. 195–202.

58. Ibid., pp. 232, 233, 248.

59. Ibid., pp. 233, 274–75.

60. Du Bois, *The Education of Black People*, p. 15.

61. Lincoln Kirstein, "Foreword," in Johnston, *Hampton Album*, p. 11.

CHAPTER 3

1. Suntop, "Lewis Hine," p. 75. Wells, *The Future in America*, pp. 111–12, 114–15.

2. Johnston, "What a Woman Can Do," p. 6. Johnston, "Through the Coal Country," pp. 256–66.

3. Walter Rosenblum, "Foreword," in Hine, *America and Lewis Hine*, p. 13. The quote from Hine's report is in McKelway, "Child Labor in Mississippi," National Child Labor Committee, pamphlet no. 169, p. 17. (Citations from these pamphlets will be identified hereafter as NCLC, followed by the pamphlet number.)

4. Johnston, "Through the Coal Country," pp. 265, 266. Clopper, "Child Labor in West Virginia," NCLC 86, p. 7. Lovejoy, "In the Shadow of the Coal Breaker," NCLC 61, pp. 13–15. The Clopper pamphlet has photographs credited to Hine. The pictures in the Lovejoy pamphlet are not credited and may have been taken by another photographer.

5. *Wall Street Journal* ad, p. 7. "Bosses Murdered Worker," p. A11.

6. Thomas Bailey Aldrich, "Unguarded Gates," in Carlson and Colburn, *In Their Place*, p. 316. Francis Walker, "Restriction of Immigration," p. 828. Woodrow Wilson, *History of the American People*, 5:212.

7. Ross, *The Old World*, p. 303. See also Francis Walker, "Restriction of Immigration," pp. 824–25.

8. Zangwill, *The Melting Pot*, pp. 185, 197. Claghorn, "Our Immigrants and Ourselves," p. 548. Alice Bennett, "The Italian as Farmer," p. 58.

9. Henry James, *American Scene*, pp. 125–26. Ross, *The Old World*, p. 286.

10. Naomi Rosenblum, "Biographical Notes," in Hine, *America and Lewis Hine*, p. 17. Hine is quoted in Walter Rosenblum, "Foreword," in ibid., p. 10. Verna Curtis, *Photography and Reform*, p. 32. This connection between the Pilgrims and later immigrants was also emphasized by Felix Adler, who was the founder of the Ethical Culture Society and one of the organizers of the NCLC. See his *Moral Instruction of Children*, pp. 240–43.

11. Willis, "Immigration Commission," pp. 571–78.

12. This image is in Hine, *America and Lewis Hine*, p. 69. For other pictures of immigrants, see pp. 29, 30, 43, 98.

13. Nevins, "The Audacious Americans," p. 82. Trattner, *Crusade for the Children*, p. 224. Letter from Farmworker Justice Fund, Nov. 1984. The 1937 NCLC picture is in MacLeish, *Land of the Free*, p. 12. A recent, disturbing change in the American economy is that the kinds of child labor Hine documented—for example, in sweat shops and in "street trades"—are returning. See Kilborn, "Playing Games," pp. 1, 46. Freitag, "Thousands of Children," p. B1.

14. Herbert Hoover, "Child Labor: Important Thrift Problem," in Johnsen, *Selected Articles*, p. 326. Owen Lovejoy, "Relation of the School to Occupational Life," in ibid., p. 157.

15. Felt, *Hostages of Fortune*, pp. 171–72, 22–24. See also Hine, "Hiding Behind the Work Certificate," p. 691.

16. Clopper, "Child Labor in Indiana," NCLC 91, p. 15. McKelway, "Child Labor in the Carolinas," NCLC 92, pp. 3, 11.

17. Mangold, *Problems of Child Welfare*, p. 325. Helen Todd, "Why Children Work," in Johnsen, *Selected Articles*, pp. 143, 135.

18. Alan Trachtenberg, "Ever the Human Document," in Hine, *America and Lewis Hine,* p. 126. Naomi Rosenblum, "Biographical Notes," in ibid., pp. 17–18.

19. Hine, "Illiterates in Massachusetts," p. 69. McKelway, "Child Labor in the Carolinas," NCLC 92, p. 14.

20. E. P. Thompson, *English Working Class*, pp. 329, 348. Milani, "Letter to Dom Pierre," p. 176. Pilger, "Frogmarched into Slavery," pp. 10–12.

21. McKelway, "Declaration of Dependence," p. 43. Also quoted in Trattner, *Crusade for the Children*, p. 7. Spargo, *Child Slaves*, p. 1. Or, at the opposite side of the political spectrum, Herbert Hoover made the same argument in 1922, when he said the "supreme ideal of America" was "that there should be an equality of opportunity for every citizen" but there was "no equality of opportunity where children are allowed by law and compelled by parents to labor [during] the years they should receive instruction." Herbert Hoover, "Child Labor: Important Thrift Problem," in Johnsen, *Selected Articles*, p. 326. See also Adler, "Anti–Child Labor Movement," NCLC 70.

22. Hine, "Child Labor in Gulf Coast Canneries," NCLC 158, pp. 5–6. Adler, "Child Labor and Its Great Attendant Evils," NCLC 11, pp. 9–10. The Mississippi factory owner was quoted by Hine in Creel, Lindsey, and Markham, *Children in Bondage*, p. 352.

23. Alan Trachtenberg, "Ever the Human Document," in *America and Lewis Hine*, p. 131.

24. Francis Walker, "Restriction of Immigration," p. 828. Walker is probably referring to Riis's description of Italian rag and garbage pickers in his *How the Other Half Lives*, pp. 50–52. For an analysis of how Riis viewed slums and their problems, see Hales, *Silver Cities*, pp. 167–80.

25. Pictorial photographers of the time, as Trachtenberg has pointed out, avoided this kind of frontality because they feared it would make their pictures look like snapshots; but Hine seems to have emphasized it because it connected the children to the viewer emotionally and visually. Alan Trach-

tenberg, "Ever the Human Document," in Hine, *America and Lewis Hine*, p. 124. Hine's picture and comments on the Portuguese boy are in Verna Curtis, *Photography and Reform*, p. 66.

26. For the sources of the terms "popular prejudices" and "national traditions," see below, nn. 30 and 39 of this chapter.

27. Greeley is quoted in Henry Smith, *Virgin Land*, p. 221; the statistics on farm tenancy are on p. 222. Commager, *The American Mind*, p. 51; for the agrarian reaction to this decline, see p. 220; and for a study of the political rise and fall of the rural Populists, see Goodwyn, *The Populist Moment*. Considered as a myth, the family farm is the descendant of the "garden of the world" described by Smith, and its European equivalent would be the sentimental pastoralism of the eighteenth century, which achieved its apotheosis in Marie Antoinette's *Le Hameau* at Versailles.

28. The Coolidge picture is in "News Pictures," p. 61. See chapter 4, below, and William Adams, "Natural Virtue," pp. 695–712, for additional comments on the iconography of the family farm relative to actual farm conditions.

29. Beveridge, "Child Labor and the Nation," NCLC 55, p. 3. See also Henry Smith, *Virgin Land*, p. 213. The 1900 census report is cited in Trattner, *Crusade for the Children*, p. 149.

30. The statistics regarding children who were "working out" are from Clopper and Hine, "Child Labor in the Sugar-Beet Fields," NCLC 259, p. 6. Lovejoy, "Cranberry Sauce," p. 605. The Lovejoy article was illustrated by Hine photographs. Another reformer made a criticism similar to Lovejoy's in 1922, when he argued that farm "conditions, now beginning to be recognized as harmful to children and even to adults, have been pictured as most attractive in song, story, verse, and from the platform, so that those away from this field have not suspected the truth." Walter Armentrout, "Child Labor on Farms," in National Child Labor Committee, *Rural Child Welfare*, p. 53.

31. Hine, "Roving Children," no pagina-

tion. For similar comments on migrant farm laborers' housing, see Lovejoy, "Cranberry Sauce," pp. 607, 608. Hine's child labor pictures from farms and canneries are on microfilm lots 7475 and 7476 in the Hine Collection of the Library of Congress.

32. Clopper and Hine, "Child Labor in the Sugar-Beet Fields," NCLC 259, pp. 10–13. Hine's field notes for these pictures are in Verna Curtis, *Photography and Reform*, p. 82. In other Hine photographs of the beet workers, adults are present, but they are always working separately and never pay any attention to the children working around them. These pictures illustrated NCLC pamphlet 259.

33. Lovejoy, "Cranberry Sauce," p. 606. Hine, "Child Labor in Gulf Coast Canneries," p. 4. Hine's comments on cannery working conditions are from McKelway, "Child Labor in Mississippi," NCLC 169, p. 17; Hine, "Child Labor in Gulf Coast Canneries," p. 5; and Hine and Brown, "The Child's Burden," NCLC 193, p. 9.

34. Garfield, *President Garfield on Education*, pp. 326–32. Scharnhorst and Bales, *The Lost Life*, pp. 64–77.

35. Alger, *Ragged Dick*, p. 203. For additional comments on this novel and Alger's formula for his rags-to-riches stories, see Scharnhorst, *Horatio Alger, Jr.*, pp. 67–68, 75–76.

36. Commager, *The American Mind*, p. 231. Kenneth Lynn, *The Dream of Success*, pp. 252–53. Also see Goodfriend, *What Is America?*, pp. 46–47. Scharnhorst and Bales, *The Lost Life*, pp. 152–53, 155. The image in the *Fortune* ad was credited to the Library of Congress but not to Hine. "Fortune: How to Succeed," p. D24. The original picture is item no. 1403 in the Library of Congress collection. According to the caption, the boy's nickname was "Little Fatty," and Hine made the picture in 1910 in St. Louis. Hine's pictures of newsboys, messenger boys, and other children in "street trades" are in microfilm lot 7480 of the Library of Congress collection.

37. Scharnhorst and Bales, *The Lost Life*, pp. 129, 150. Scharnhorst, *Horatio Alger, Jr.*,

pp. 66, 76, 107, 134. Hodges, *Social Stratification*, p. 271. See also Ingham, *The Iron Barons*, p. 79.

38. Boyer, *Urban Masses*, pp. 94–107. "Street-Workers," NCLC 246, p. 3. See also Riis, *The Children of the Poor*, p. 254.

39. Trattner, *Crusade for the Children*, pp. 110–12, 193–95. *New York Sun* quoted in Browers, *Beveridge and the Progressive Era*, p. 253. Clopper, *Child Labor in City Streets*, pp. 6–8.

40. Clopper, *Child Labor in City Streets*, pp. 132–34, 63–65. Hine, "The High Cost of Child Labor," NCLC 241, p. 5.

41. The picture of the messenger boys first appeared in McKelway, "Child Labor in Tennessee," NCLC 150, p. 15. Four years later, the NCLC used it for the cover of another pamphlet with the ominous caption, "The Finished Product." "Street-Workers," NCLC 246. The information about the Wilmington boy is in Verna Curtis, *Photography and Reform*, p. 59. The Savannah and Macon boys are described in McKelway, "Child Labor in Georgia," NCLC 138, p. 19.

42. "Moral Dangers" poster in Hine, "The High Cost of Child Labor," NCLC 241, p. 5.

43. The Waco and St. Louis photographs are in Gutman, *Lewis W. Hine*, pp. 81, 83, 101. Alan Trachtenberg, "Ever the Human Document," in Hine, *America and Lewis Hine*, p. 131. See also Verna Curtis, *Photography and Reform*, p. 59.

44. Emphasis added. Rosalind Williams, *Dream Worlds*, p. 89. See also Lears, "Some Versions of Fantasy," p. 393; and Ewen, *Captains of Consciousness*, pp. 82–86. In the context of this study, I use the term "consumerism" as Ewen does, describing a vague but very pervasive "dream of human happiness" or "idiom of daily life with a matter-of-fact status within American culture," which gives the economic and industrial system "a kind of passively accepted legitimacy" (pp. 108, 187.) I am not referring to the other basic meaning of "consumerism," which refers to the attempt to inform consumers about the moral significance of their consumption or to protect them from inferior or dangerous

merchandise.

45. Ward, *The Psychic Factors of Civilization*, p. 320. Riis, *How the Other Half Lives*, pp. 140–45. William Hard, "Making Steel and Killing Men," in Weinberg, *The Muckrakers*, pp. 342–58. Perkins, *The Roosevelt I Knew*, pp. 22, 17. For a good commentary on the muckraking novelists of the Progressive Era, including Upton Sinclair, David Graham Phillips, and Ernest Poole, see Conn, *The Divided Mind*. Many of the muckrakers devoted their investigations primarily to political corruption and corporate chicanery; those I have mentioned were concerned mainly with industrial working conditions.

46. C. C. Regier, "The Balance Sheet," in Shapiro, *The Muckrakers and American Society*, p. 47. Hofstadter, *The Age of Reform*, pp. 194–96. Mumford, *The Golden Day*, p. 122. Chalmers, *The Muckrake Years*, p. 62.

47. Beard, *The Rise of American Civilization*, vol. 2, p. 718.

48. Fox, *The Mirror Makers*, pp. 32–34. For the extremely rapid and profitable rise of pro-business magazines that depended on advertising, such as the *Saturday Evening Post* and the *Ladies' Home Journal*, see Goulden, *The Curtis Caper*, pp. 26, 27, 31–32. For the increasing importance of newspaper advertising and the growth of consumer culture in this period, see Schudson, *Advertising*, p. 152; Potter, *People of Plenty*, pp. 172–81; and Trachtenberg, *The Incorporation of America*, pp. 135–39. Woodward and *Printer's Ink* are quoted in Ewen, *Captains of Consciousness*, p. 80.

49. Hine, "Social Photography," pp. 355–56.

50. Grape Nuts Flakes ad, p. 46; Eskay's and Nestle's ads, pp. 58, 61. Quaker Oats ads (in *Saturday Evening Post*, p. 78, and *Ladies' Home Journal*, no pagination).

51. Hine's posters are in Hine, "The High Cost of Child Labor," NCLC 241, and microfilm lots 7482 and 7483 of the Library of Congress collection.

52 The South Carolina captions are in Ronald Hill, *Lewis W. Hine*, p. 9.

53. Hine, "Social Photography," p. 356. Hine presumably was showing slides of child workers as he spoke, since his talk was described as "illustrated by the Stereopticon."

54. Ronald Hill, *Lewis W. Hine*, p. 2.

55. Gutman, *Lewis W. Hine*, p. 49.

56. Hine and Brown, "The Child's Burden," NCLC 193, p. 7.

57. Ronald Hill, *Lewis W. Hine*, p. 2

58. Van Gennep, *The Rites of Passage*, pp. 3, 11, 19–25, 60.

59. The interview quotation is from "He Photo-interprets Big Labor," pp. 42–43.

60. Naomi Rosenblum, "Biographical Notes," in Hine, *America and Lewis Hine*, pp. 20–25. See also Gutman, *Lewis W. Hine*, pp. 14–15, 45–46. Rothstein, *Documentary Photography*, p. 24.

61. Hine, "Social Photography," p. 358. In 1938 Hine told Elizabeth McCausland that, after World War I, "I thought I had done my share of *negative* documentation. I wanted to do something *positive*. So I said . . . , 'Why not do the worker at work?'. . . At that time, he was as underprivileged as the kid in the mill." McCausland, "Portrait of a Photographer," p. 503.

62. Rothstein, *Documentary Photography*, p. 24. Gutman, "The Eyes of Lewis W. Hine," in *Lewis Hine 1874–1940*, p. 43. Trachtenberg has sympathetically analyzed Hine's intentions and the virtues of his pictures of adult workers, but he, too, is troubled because "to our present taste, the message of the pictures may be too transparent, too preconceived, too much of a theme superimposed on an otherwise interesting subject." Alan Trachtenberg, "Ever the Human Document," in Hine, *America and Lewis Hine*, pp. 135–36. See also Seixas, "Lewis Hine," pp. 381–409.

63. The "inferno" woodcut of the Covey mural is in a Norton Company ad, p. 41. For a portfolio of Gerrit Beneker's portraits, see "American Workingman," pp. 66–67. Trachtenberg has commented on Stella's drawings in Alan Trachtenberg, "Ever the Human Document," in Hine, *America and Lewis Hine*, pp. 126–27. For more examples of the romantic treatment of industry and labor, see Hurley, *Industry and the Photographic Image*, particularly Alvin Langdon Coburn's Pitts-

burgh industrial images and Robert Mottar's 1960 Chase Manhattan Bank construction pictures; the work photographs in Steichen, *The Family of Man*; and Eugene Smith's Pittsburgh portfolio in Maddow, *Let Truth Be the Prejudice*, pp. 175–77, 192–95.

64. *New York Evening Post* story on Hine is paraphrased and quoted in "Treating Labor Artistically," p. 32.

65. Hine, "The Railroaders," pp. 159–66.

66. "American Workingman," pp. 62–65. Although the skilled workers in Bourke-White's pictures concentrate as carefully on their work as Hine's subjects do, it is significant that she and *Fortune* selected skilled workers—a glassblower, a cooper, and a silversmith—who had rather archaic skills that were part of the old handicraft tradition. They ignored the skilled industrial workers, who were becoming an increasingly important part of the work force. Acknowledging that workers like machinists and mechanics were an essential part of the industrial process would have weakened the aura of magic so common in the Luce magazines. Moreover, such an acknowledgment would have implicitly contradicted *Fortune*'s usual approach to industry and big business, which heavily emphasized the importance of managers, financiers, and executives.

67. "He Photo-interprets Big Labor," p. 43.

68. Hurley, *Industry and the Photographic Image*, p. 76. For analyses of the "cult of the machine" and American attitudes toward technology, see Chase, *Men and Machines*; Marx, *The Machine in the Garden*; and chapter 2 of Trachtenberg, *The Incorporation of America*. Perhaps the most eloquent statement of this cult's faith was Charles and Mary Beard's finale to their 1927 *The Rise of American Civilization*, vol. 2, p. 800, which concluded, with Wagnerian solemnity: "It is the dawn, not the dusk, of the gods."

69. Castro is quoted by Marichal, "Some Intellectual Consequences," p. 41.

70. Pound, *Industrial America*, p. 9. The chapters on the Continental Can and Standard Oil of New Jersey companies are the only sections of this book in which there are no workers in any of the photographs; however, there are similar pictures of machines or mills running themselves in the chapters on the Libbey-Owens Glass, General Mills, Norton Abrasives, and Kimberly-Clark corporations. When they do appear, the workers are always shown from back or side views, and they are never shown in control of the machinery they are operating. On the other hand, all of the chapters are illustrated with full-face studio portraits of the corporation's top executives—usually the president or the chairman of the board.

71. See Nye, *Image Worlds*, for a good study of how one important corporation (General Electric) used photography to view itself.

72. *Fortune* prospectus quoted in Marquis, *Hopes and Ashes*, p. 114. In the late 1920s and the early 1930s, Modernism was seen as a dramatic new force capable of revitalizing cultures and societies. As such, it also became a salable commodity, as Marquis has pointed out in "The Marketing of the Modern" (the subtitle of her chapter on the founding of the Museum of Modern Art), in *Hopes and Ashes*. Young and Rubicam ad, p. 105. See also Vicki Goldberg, *Margaret Bourke-White*, pp. 81–83.

73. John Hill, the man who started Bourke-White on her career as an industrial photographer, was a public relations consultant for Otis Steel who wanted to use her pictures for advertising. Vicki Goldberg, *Margaret Bourke-White*, p. 83. See also Callahan, *The Photographs of Margaret Bourke-White*, p. 29.

74. Macdonald quoted in Vicki Goldberg, *Margaret Bourke-White*, p. 104. Bourke-White used a variety of photographic styles in the 1930s. Some of her *Fortune* images of unskilled workers follow the conventions of sooty romanticism; but when she photographed Russian industry in the early 1930s, she used a more documentary style, rather similar to Hine's, which emphasized the workers.

75. Walter Rosenblum, "Foreword," in Hine, *America and Lewis Hine*, p. 13. Hine, letter to Florence Kellogg, 17 Feb. 1933,

quoted by Alan Trachtenberg, "Ever the Human Document," in *America and Lewis Hine,* p. 136. "He Photo-interprets Big Labor," pp. 42, 43.

76. Hine, *Men at Work,* no pagination.

77. Hine, "Power Makers," pp. 511–18. Hine used this "Heart of a Turbine" image in both his 1926 *Mentor* interview and *Men at Work,* which suggests that he considered it an important illustration of his viewpoint. Bourke-White's Niagara Hudson dynamos are in "Niagara Hudson," pp. 42–49. Her skyscraper pictures are in "Skyscrapers," pp. 32–36. (In another skyscraper article—which was not illustrated by Bourke-White—*Fortune* pictured the building's structural steel workers in essentially the same way that Hine photographed them for *Men at Work.* "Skyscrapers: Builders and Their Tools," pp. 85–94.)

78. Chase, *Men and Machines,* pp. 210, 147. Chase, "Danger at the A. O. Smith Corporation," pp. 62, 63.

79. The excerpts from the Kipling poem are in "He Photo-interprets Big Labor," p. 41. The complete poem is in Kipling, *Rudyard Kipling's Verse,* pp. 380–81.

80. Trachtenberg, "Camera Work," p. 210.

81. Walter Benjamin, "A Short History of Photography," in Trachtenberg, *Classic Essays on Photography,* pp. 213–14. Walter Benjamin, *Understanding Brecht,* pp. 94–95.

82. Hine, "Social Photography," p. 356.

83. Hine, "Three Bits of Testimony," p. 663.

84. Vicki Goldberg, *A World History,* p. 469.

85. Hine, "Hiding Behind the Work Certificate," p. 691.

86. Vicki Goldberg, *A World History,* pp. 464–65.

87. Hine, "Roving Children," no pagination. Hine, "The Construction Camps," no pagination.

88. Leslie Katz, "Afterword," in Friedlander, *Factory Valleys,* no pagination.

CHAPTER 4

1. Stryker is quoted in Hurley, *Russell Lee,* p. 18. The quotes from people who saw the FSA's Grand Central exhibit are from Steichen, "The F.S.A. Photographers," pp. 46–47. Steichen's review, without these comments, is in Newhall, *Photography,* pp. 266–70.

2. The "hard times" letter is quoted in Rowell, *Mountains,* p. 113. Ratcliffe, "Hard Times in America," pp. 702, 709.

3. Chase, *Prosperity,* p. 134.

4. "Cycles of Human Experience," quoted in Warren, *Herbert Hoover,* p. 116.

5. McElvaine, *The Great Depression,* p. 53. Or, as Lloyd pointed out, Hoover's "rise from the status of impoverished waif to multimillionaire, all within the space of three decades, makes the tales of Horatio Alger seem almost prosaic by comparison." Lloyd, *Aggressive Introvert,* p. 3. Also see Lipsitz, "The Meaning of Memory," p. 81.

6. Warren, *Herbert Hoover,* p. 23. Lloyd, *Aggressive Introvert,* p. 161.

7. Herbert Hoover, *The New Day,* pp. 41, 16, 179–82, 199–200.

8. A. Fenner Brockway, *Can Roosevelt Succeed?,* quoted in Bergman, *We're in the Money,* p. 24.

9. Hopkins hired Hickok, who had been an Associated Press reporter, to be his "confidential investigator" of the living conditions of persons on relief, because—even though Hopkins was receiving all kinds of statistics—he wanted to understand "the human dimensions of the situation." Hickok reported on these conditions in letters to Hopkins and to Eleanor Roosevelt. Hickok, *One Third of a Nation,* pp. 68, xxiii. As William Stott has commented, it was possible for many people to ignore the depression in the 1930s; for, as Marquis Child said in 1941, "horrors were just around the corner, any corner, if you cared to look. Most people never looked." Quoted in Stott, *Documentary Expression,* p. 68.

10. Naturally, as Lawrence Levine has pointed out, Stryker and the FSA photographers did share many of the values (or "ide-

ology") of the prevalent culture of the 1930s, such as belief in the individual, voluntary cooperation, a "harmony of interests," the "virtues of the agrarian/small-town way of life," and "the possibilities of peaceful, progressive reform." However, as Levine emphasizes: "What needs to be remarked upon is the extent to which the most widely known photographs . . . went beyond comfortable consensus to show crisis and breakdown. What is equally important is the extent to which the photographers were able to rise beyond a simplistic rendering of their ideological concerns to create a record of American life and culture that were generally ignored or downgraded by most cultural and artistic agencies." Lawrence Levine, "The Historian and the Icon," in Fleishhauer and Brannan, *Documenting America*, p. 37.

11. Lewisohn, *Expression in America*, pp. 295–96.

12. Hoover is quoted in McElvaine, *The Great Depression*, p. 78. Edward L. Bernays, "The Fine Art of Advertising," in Susman, *Culture and Commitment*, p. 135. An anthology of writings from the period, *Culture and Commitment* is also one of the best interpretations of the 1930s. Susman's "Album of Images" from the 1930s and the 1940s, at the end of the book, is a good introduction to the "iconography" of the decade.

13. Hays is quoted in Bergman, *We're in the Money*, p. 167.

14. For the plot of *Mr. Deeds*, see Bergman, *We're in the Money*, pp. 140–44.

15. Lange's photograph and caption are in McElvaine, *The Great Depression*, p. 170.

16. Mast, *A Short History of the Movies*, p. 276.

17. Agena, "U.S. Policy and the Third World," p. 303. One of the interesting aspects of her subject, which Agena does not mention or analyze, is what people in the United States may have in common with the "populations of the developing countries," since they seem to find the same kind of music and television shows so entertaining.

18. Hearn believes that these versions of the Dream became an ideological defense for conservatives against the New Deal and the values it represented: "The Depression itself, as well as the New Deal efforts to combat it, threatened to erode such venerable ideals as individualism, self-help, and entrepreneurial daring. . . . But the myth of success was tirelessly invoked to buttress the conventional faiths. Whereas the New Deal offered welfare programs, the apostles of success preached self-help. . . . While the Depression, the New Deal, and other developments contributed to an increasing emphasis on security, the old-line advocates of success strove to revitalize the waning entrepreneurial spirit. While New Deal Agencies imposed regulations on business and industry, the cult of success advocated rugged individualism and laissez-faire." Hearn, *The American Dream*, pp. 4, 20, 78, 79.

19. Nevins, *James Truslow Adams*, p. 68. The phrase "American Dream" was also used as the title of a play by George O'Neil in 1933, but it was probably Adams who popularized the term, since his book appeared earlier and was so successful. For a bibliography of works on the Dream between 1931 and 1965, see Curti, "The American Exploration," p. 391.

20. Nevins, *James Truslow Adams*, pp. 48, 68.

21. James Adams, *The Epic of America*, pp. 347, 126, 45–46, 333, viii. See also p. 174.

22. "Speaking of Pictures," pp. 12–15.

23. Marling, *Wall-to-Wall America*, pp. 170, 133, 113, 190. As well as contrasting the visual styles and compositions of the murals with FSA hard-times depression images, such as Lange's U.S. 66 photographs, Marling also contrasts the murals with more pessimistic paintings of the 1930s, such as those by Moses and Raphael Soyer.

24. The critic's comments on Curry are by Malcolm Vaughan, quoted in "New York Criticism," p. 16. Also see, "John Curry," pp. 34–37. The phrase "hallowed ground" is from Craven, "John Steuart Curry," p. 41.

25. Elizabeth McCausland, "Rural Life in America as the Camera Shows It," quoted in Hurley, *Portrait of a Decade*, p. 134.

26. Baldwin, *Poverty and Politics*, p. 108.

For additional information on the farm crisis of the 1930s, see Conrad, *The Forgotten Farmers*; Shover, *Cornbelt Rebellion*.

27. Hurley, *Portrait of a Decade*, pp. 34–35. Edward Steichen, "The F.S.A. Photographers," in Newhall, *Photography*, p. 267. In addition to Steichen's and McCausland's reviews, the best contemporary account of the FSA photography unit is Howe, "You Have Seen Their Pictures," pp. 236–241. For examples of FSA publicity pictures, see Walker Evans's series on the FSA housing project constructed near Eatonton, Georgia. Evans, *Walker Evans Photographs*, nos. 185–190. Or see Arthur Rothstein's "FSA Migratory Labor Camp," and Gordon Parks's "Ella Watson, U.S. Government Charwoman," in Fleishhauer and Brannan, *Documenting America*, pp. 188–205, 226–39.

28. Vachon, "Tribute to a Man," p. 96. Evans used the terms "documentary," "documentary in style," and "typical documents" in a 1 Nov. 1935 memorandum to Stryker, in which he described a photographic field trip he intended to make. Evans, *Walker Evans at Work*, p. 113. Also see chapter 1, above; Hurley, *Portrait of a Decade*, pp. 14–15; and Howe, "You Have Seen Their Pictures," pp. 236–37.

29. "In documentary photography," Stryker wrote, "*people* and *things*—their clothes, houses, land—should never be separated." Stryker, "Documentary Photography," p. 1364. Rothstein is quoted in "Publisher's Note," in Rothstein, *The Depression Years*, no pagination. Vachon, "Tribute to a Man," p. 97.

30. Vachon, "Tribute to a Man," p. 97. Hurley, *Portrait of a Decade*, p. 50.

31. Evans, letter to Hanns Skolle, 28 June 1929, in Evans, *Walker Evans at Work*, p. 24.

32. Dorothea Lange, "The Assignment I'll Never Forget," in Newhall, *Photography*, p. 264. See also James Curtis, "Dorothea Lange," pp. 1–20; and Paul Taylor in Janis and MacNeil, *Photography Within the Humanities*, pp. 38–41.

33. "The Flood Leaves Its Victims on the Bread Line," p. 9. Telephone interview with Arthur Rothstein, Feb. 1985.

34. Vachon's pictures of the Dubuque NAM billboards are in Susman, *Culture and Commitment*, facing p. 336, and in McElvaine, *The Great Depression*, p. 3. For other examples of these ironic pictures of billboards, see the Library of Congress, FSA Files D223 (Rothstein), D631 (Lee), D9684 (Locke), E223 (Rothstein), E9684 (Post Wolcott), F441 (Vachon), J503 (Lange), and J4407 (Lange); and Rothstein, *The Depression Years*, p. 71. Lange's still photograph of the two migrant workers and the Southern Pacific billboard was used as the basis for an episode in the film version of Steinbeck's *Of Mice and Men*.

35. For a summary of these NAM families' "life-style," as it would now be called, see the discussion of the American way of life in chapter 5.

36. John Walker, "Reflections on a Photograph," pp. 148–49.

37. "The N.A.M. Declares War," p. 9. "Business Prepares to Tell Its Story," p. 29.

38. "Industry Looks Ahead," p. 14.

39. Hirsch, "What Is Big Business Up To?," pp. 5–8.

40. Steichen, "The F.S.A. Photographers," p. 269.

41. Telephone interview with Arthur Rothstein, Feb. 1985. Rothstein, *Documentary Photography*, p. 31.

42. Stryker letter, quoted in Evans, *Walker Evans at Work*, pp. 118–19. Some of Evans's pictures of soil erosion in Mississippi are reproduced in Evans, *Walker Evans Photographs*, nos. 91–106, 118–22.

43. Rothstein, *The Depression Years*, p. 16. For examples of other pictures of soil erosion, see Library of Congress, FSA File E165 (Rothstein, Delano, Evans, Post Wolcott).

44. The captions in *You Have Seen Their Faces* are confusing. They are presented as direct quotes, so they give the impression that they were spoken by the people in the photographs and transcribed by Caldwell; however, the book begins with a disclaimer: "The legends under the pictures are intended to express the authors' own conceptions of the sentiments of the individuals

portrayed; they do not pretend to reproduce the actual sentiments of these persons." Caldwell, *You Have Seen Their Faces*, no pagination. For additional negative (and a few positive) comments on this book, see Stott, *Documentary Expression*, pp. 218–24. For a contrast between Bourke-White's and the FSA photographers' techniques, see Peeler, *Hope Among Us Yet*, p. 69.

45. University of Wisconsin President Charles Kendall Adams is quoted in Hearn, *The American Dream*, p. 14. For similar comments during the 1930s, see Bernard Baruch's remarks quoted in Arthur Schlesinger, Jr., *The Coming of the New Deal*, pp. 201–2; and James Truslow Adams's comments in Nevins, *James Truslow Adams*, p. 250.

46. Lee's Iowa photograph and the comment on it are in Hurley, *Portrait of a Decade*, pp. 81–82. The 1938 quotation is from Steichen, "The F.S.A. Photographers," p. 47.

47. Stryker is quoted by Kytle, "Roy Stryker," p. 6.

48. William Stott, "Introduction to a Never-Published Book," pp. 25–26. In some cases, as David Peeler has pointed out, the FSA photographers selected their subjects carefully; and occasionally they also "staged" some of their pictures for better composition or to convey the photographer's "vision" of the truth about a situation. Peeler, *Hope Among Us Yet*, pp. 58–59, 92–96.

49. Beech, "Schools for a Minority," p. 615. For a slightly different interpretation of Lee's picture, see Jussim, "Propaganda and Persuasion," pp. 106–7. Lee's other picture of the Transylvania woman is in Library of Congress, FSA File E3612. See also Rothstein, *The Depression Years*, pp. 46, 47; and Library of Congress, FSA Files E37565 (Post Wolcott), E6675 (Post Wolcott), H375 (Lee), and H37565 (Collier) for more pictures of "sub-standard" schools.

50. Hurley, *Portrait of a Decade*, p. 66.

51. Lange and Taylor, *American Exodus*, pp. 47–48. The reason these photographs have a "bitter edge" can be deduced from some of the men's comments that Lange and Taylor recorded: "None of us vote. It costs

us $3.50 poll tax for a married man and wife to vote in Texas." "We used to go to church when we had better clothes. These are our Sunday clothes." "We were born at the wrong time. We ought to have died when we was young." "I'd be happy with a job at $1.50 a day." Quoted by Meltzer, *Dorothea Lange*, p. 174. A sequence of four of Lange's photographs of these men is in Meltzer, *Dorothea Lange*, pp. 218–19. Her picture of the sharecroppers, whom Steichen called "scare crows," is in Steichen, "The F.S.A. Photographers," in Newhall, *Photography*, p. 266.

52. Evans made the photographs of the cross overlooking Bethlehem and the auto junkyard on the same day, 8 Nov. 1935. It may be significant that the name of the junkyard was "Joe's Auto Graveyard." For an analysis of how he used his lens to foreshorten and compress the landscape, see Jerry Thompson, "Walker Evans," pp. 11–12. See also Jerry Thompson, "Walker Evans," pp. 69, 122; and Stryker and Wood, *In This Proud Land*, p. 129. The Birmingham picture is in Library of Congress, FSA File E222.

53. Rothstein's Birmingham and mining pictures are in Library of Congress, FSA Files E223, E2588, and G573. Rothstein's coal mine pictures are in D278, and F2588. See also Post Wolcott's pictures of the barren, eroded land near a Tennessee copper mine in E165.

54. Lee's and Shahn's pictures are in Hurley, *Portrait of a Decade*, pp. 103, 31. Vachon's is in Library of Congress, FSA File F441.

55. Stryker is quoted by Nancy Wood in Stryker and Wood, *In This Proud Land*, p. 17.

56. Lee's picture of the couple with the radio is in Stryker and Wood, *In This Proud Land*, p. 77.

57. These pictures are in Stryker and Wood, *In This Proud Land*, pp. 158, 102.

58. The reference to the FSA photographers as "Crusaders with Cameras" is in Editors of Time-Life Books, *Documentary Photography*, p. 65, where they are linked with Riis and Hine. Vachon, "Tribute to a Man," p. 98.

59. Susman, "The Thirties," p. 184.

60. Chase, *Mexico*, pp. 14–17. Hearn points out that in several of the best-selling didactic books of the 1930s—Pitkin's *Life Begins at Forty*, Link's *The Return to Religion*, and Lin Yutang's *The Importance of Living*—the authors proposed alternative values to "the frantic pursuit of material success," which characterized mainstream American values. Hearn, *The American Dream*, pp. 148–55. For an analysis of how this interest in vernacular nonindustrial societies and their arts influenced photography in the 1920s and 1930s, see Pitts, *Photography in the American Grain*, pp. 10–21.

61. The 1936 FSA shooting script by Robert Lynd, the coauthor of *Middletown*, is reprinted in Stryker and Wood, *In This Proud Land*, p. 187.

62. For pictures of blacksmiths, see Library of Congress, FSA Files E64632 (Post Wolcott) and H64632 (Collier); and Rothstein, *The Depression Years*, p. 91. The comment on Rothstein's cumulus clouds is in Vachon, "Tribute to a Man," p. 97. Evans's pictures of churches and vernacular architecture are in his *American Photographs*, particularly the second part. Peeler has commented on this tendency by the photographers, which he calls their "preservationist" impulse. Peeler, *Hope Among Us Yet*, pp. 97–101.

63. Lee's photograph is in Stryker and Wood, *In This Proud Land*, p. 95. Vachon's pictures of Emile Riche's signs are in Library of Congress, FSA File E9684. Evans was so fond of certain Coca-Cola, barber shop, and tobacco signs, particularly if they were rusty and picturesque, that he literally collected them—pried them off walls and fences—and took them with him after he photographed them. See Evans, *Walker Evans at Work*, pp. 226–231.

64. Auden, "September 1, 1939," pp. 57–58.

65. Evans, unfinished letter to Ernestine Evans, Feb. 1934, in Evans, *Walker Evans at Work*, p. 98.

66. Lincoln Kirstein, "Photographs of America," in Evans, *American Photographs*, p. 192. For a somewhat different reading of the structure of *American Photographs*, see Alan Trachtenberg, "Walker Evans' America," pp. 56–66.

67. Lincoln Kirstein, "Photographs of America," in Evans, *American Photographs*, p. 192.

68. Lee, "Pie Town, New Mexico," p. 41. See also Hurley, "Pie Town, N.M., 1940," pp. 76–84. For another important example of how a FSA photographer portrayed people who were outside of mainstream American culture, see John Collier's study of the Lopez family in Fleishhauer, *Documenting America*, pp. 294–311.

69. Lee, "Pie Town, New Mexico," pp. 42, 88.

70. Ibid., p. 107. It seems likely that many of the Pie Town people were sharecroppers who had raised cotton before they came to New Mexico, because when "one farmer grew a cotton plant and brought it to the fair," someone told Lee, "the folks got real mad and made him take it away."

71. Ibid., p. 41.

72. For these quotes and pictures, see Lee, "Pie Town, New Mexico," pp. 41, 46, 47; and Library of Congress, FSA Files H416, H4412, H5318, and H53104. Lee's note about Hutton is in Library of Congress, microfilm lot 639M, item no. 36715 D.

73. Stryker, "Documentary Photography," p. 1368. Lange's picture is in Stryker and Wood, *In This Proud Land*, p. 126; Post Wolcott's is in Hurley, *Portrait of a Decade*, p. 101; Lee's is in Library of Congress, FSA File H9684.

74. The Evans pictures are in Evans, *Walker Evans Photographs*, nos. 197, 198; and his *American Photographs*, p. 51.

75. Roosevelt, "Special Message to Congress on Farm Security," in Roosevelt, *Selected Speeches*, p. 170.

76. Halleck, "Connecticut," pp. 96, 98.

77. Embree, "Southern Farm Tenancy," pp. 149, 153. For additional background on the agricultural crisis of the 1930s and FSA policies, see Arthur Schlesinger, Jr., *The Coming of the New Deal*, pp. 361–81; Baldwin, *Poverty and Politics*, pp. 157–227, 262–84.

78. Lange and Taylor, *American Exodus*,

pp. 153–54.

79. Howe, "You Have Seen Their Pictures," pp. 236–38.

80. Baldwin, *Poverty and Politics*, pp. 347–56. Stephens, "FSA Fights for Its Life," pp. 479–81. Hurley, *Portrait of a Decade*, p. 166.

81. Howe, "You Have Seen Their Pictures," p. 237.

82. Stryker, 12 Sept. 1940 letter to Delano, quoted in Hurley, *Portrait of a Decade*, p. 148. Conversation with Jack Delano, July 1985.

83. Stryker, 19 Feb. 1942 memorandum, reprinted in Stryker and Wood, *In This Proud Land*, p. 188.

84. Vachon, "Tribute to a Man," p. 99. For good (or perhaps ironic) examples of these smiling workers, see Lee's pictures of Shasta Dam construction workers in Stryker and Wood, *In This Proud Land*, p. 70; and Library of Congress, FSA File J329157.

85. Pictures of these exhibitions are in Library of Congress, FSA Files C964273 (*Way of a People*) and C964276 (*Road to Victory*).

86. Lee's picture is in Library of Congress, FSA File G96452. Meltzer, *Dorothea Lange*, p. 242.

87. Hurley, *Portrait of a Decade*, pp. 166–70.

88. Howe, "You Have Seen Their Pictures," p. 238; Hurley, *Portrait of a Decade*, p. 143.

89. "Senator on Warpath," pp. 40–41. Judge, "F.S.A. Attacked," pp. 4–8.

90. Clurman, "The Frightened Fifties," pp. 120–21.

91. Photo League, *Photo Notes*, pp. 1–8. This untitled special issue included the League's protests against being placed on the Attorney General's list, Strand's speech attacking this action, and letters and telegrams from Adams, Lange, and other supporters of the League. See also Gee, *Photography of the Fifties*, pp. 2–4.

92. Palfi, *Invisible in America*. Interestingly enough, a documentary style did flourish in the late 1940s in the Italian film industry when it was dominated by neorealism. See Mast, *A Short History of the Movies*, p. 283.

93. Doherty, "Farm Security Photo-

graphs," p. 9.

94. Hurley, *Portrait of a Decade*, pp. 173–74.

95. Hurley, *Russell Lee*, p. 29.

96. Ibid.

97. Evans, *Walker Evans at Work*, p. 112. Evans, "Walker Evans on Himself," p. 25. In another interview, Evans emphasized the influence that Baudelaire, as well as Flaubert, had on him. Katz, "Interview with Walker Evans," p. 122.

98. The quotes from Evans are in Ferris, "A Visit with Walker Evans," p. 29; Katz, "Interview with Walker Evans," p. 123; and Evans, "Walker Evans on Himself," p. 26.

99. Ferris, "A Visit with Walker Evans," pp. 34, 33.

100. Evans, "People and Places in Trouble," pp. 110–17. For examples of the kinds of portfolios Evans suggested to the *Fortune* editors, see Evans, *Walker Evans at Work*, p. 185. Evans's visual sensibilities were so close to Atget's that he felt "insecure" when he saw the French photographer's work: "I am too close to that in style myself. I didn't discover him until I had been going for quite a while," he said, "and when I did I was quite electrified and alarmed." Evans, "Walker Evans on Himself," p. 25.

101. The subway pictures are in Evans, *Many Are Called*; the Detroit pictures are in "Labor Anonymous," pp. 152–53. For the other *Fortune* photoessays and portfolios mentioned in this paragraph, see the second section of the Bibliography, under Evans.

102. Evans, "Beauties of the Common Tool," pp. 103–7. Evans, *Walker Evans at Work*, pp. 185, 208. Robert Frank interview in Janis and MacNeil, *Photography Within the Humanities*, p. 65.

103. Meltzer, *Dorothea Lange*, pp. 293–98. "Family of Man," *Life*, pp. 132–43.

104. "Irish Country People," *Life*, pp. 135–43. Meltzer, *Dorothea Lange*, pp. 291–92.

105. Edey, *Great Photographic Essays*, p. 154.

106. "Three Mormon Towns," *Life*. Meltzer, *Dorothea Lange*, p. 291. By an unpleasant irony, the isolation of the town of St. George—enabling the Mormons to maintain their way of life earlier in the twentieth cen-

tury—made them victims of the American government, which arranged atom and hydrogen bomb tests in the 1950s so the fallout would occur in their region of Utah rather than over Las Vegas. See Fuller, *The Day We Bombed Utah*, pp. 29–37.

107. Meltzer, *Dorothea Lange*, pp. 298–99.

108. "Revolving Door Court," pp. 69–73.

109. Meltzer, *Dorothea Lange*, pp. 301–2. For examples of the Berryessa pictures, see p. 267.

110. Ohrn, *Dorothea Lange*, pp. 189, 195. White is quoted in Meltzer, *Dorothea Lange*, pp. 302–3.

111. W. Eugene Smith, "One Whom I Admire," p. 88. There was little evidence, Ohrn has concluded, "that Lange's work had an impact on the golden age of photojournalism [in the 1950s]. . . . Despite her dedication to extending the use of photography and communicating her concerns to a wide audience her work was curtailed in both respects by her loss of energy [due to illness] and by the view of photography that dominated the decade. By not seeing the kinds of reports Lange made during the 1950s, Americans missed an opportunity to look inward, to reflect on the quality of their lives, . . . and on the direction their world view was taking them." Ohrn, *Dorothea Lange*, p. 195.

CHAPTER 5

1. Cornell Capa in Danziger and Conrad, *Interviews*, p. 62. Gevaret film ad. (The sentence I have quoted was originally in French: "La photographie, oeil magique et miroir fidèle, jouet et instrument entre les mains de l'homme moderne, conquiert le monde!"

2. Hamblin, *That Was the Life*, pp. 48–52, 265.

3. Ibid., p. 290. The picture published in *Life* in 1956 contained twenty-one airplanes. "Air Age," pp. 154–56.

4. Attwood, "A New Look at America," pp. 48, 50–51. Attwood, *Most Exciting Country*, pp. 13, 28, 34. See also Oakley, *God's Country*, pp. 228–30.

5. Williamson, "Life Magazine's 'Country Doctor.'" Moffett, "Dust Bowl Farmer," pp. 91–92. USIA, *Progress on the Land*, p. 32. Goodfriend, *What Is America?*, p. 94. *Life* and the USIA brochure printed the photograph of the prosperous farmer standing in his wheat field juxtaposed with Rothstein's "Dust Storm," which, by the late 1940s, had become a symbol of the depression. Rothstein's picture is also in Goodfriend, *What Is America?*, p. 86 (a different page than the *Life* image appears on). Officially, the USIA was not created until 1953, when it took over and expanded programs begun by the Office of War Information in World War II and continued by the Department of State later in the 1940s. However, in this study I use "USIA" as a generic reference for all of these agencies' activities during the 1950s and to refer to their publications—though some have the imprint of the United States Information Service (USIS), the overseas arm of the USIA, which distributed their publications in foreign countries.

6. William Graves, "Introduction," in Editors of Time-Life Books, *The Best of Life*, p. 4. "Wanted: An American Novel," p. 48. See also "Fiction in the U.S.," p. 24.

7. One of the chief reasons *Life* and *Look* had different visual styles was that *Look* was printed in gravure, which has a relatively soft, impressionistic look, and *Life* was printed in letter press, which has a higher gloss and a harder, crisper quality. As for the contents of these magazines, many of the advertisements they published during the 1950s were similar: they proclaimed that Americans had a wonderful way of life, and that the product advertised was an essential or important part of it. However, since most of these advertisements were illustrated with drawings rather than photographs, I have not dealt with them in this study.

8. Schudson, *Advertising*, p. 215.

9. Peale, "Norman Vincent Peale Answers Your Questions," p. 43. "Leisure Could Mean a Better Civilization," p. 62. Millikan and Rostow, *A Proposal*, pp. 149–50. See also Lipset, "The End of Ideology?," p. 73.

10. Kahler, *The Tower and the Abyss*, pp. 92–95.

11. Hopkinson, " 'Introduction' to Scoop, Scandal, and Strife," pp. 295–96.

12. Garland, *Roadside Meetings*, pp. 341–42. Edmund Wilson, *I Thought of Daisy*, p. 170. See also Dewey, *The Public and Its Problems*, p. 139.

13. Karl, *The Uneasy State*, p. 77

14. Hopkinson, " 'Introduction' to Scoop, Scandal, and Strife," pp. 295–96. Or, as Henry Luce promised in his prospectus for *Life*, readers would be able to "see the world; to eyewitness great events; . . . to see strange things—machines, armies, multitudes . . . things thousands of miles away, things hidden behind walls and within rooms . . . to see and be amazed; to see and be instructed." Henry Luce quoted in Edwards, "One Every Minute," p. 20.

15. Clare Booth Luce, "America in the Golden Age." Luce's recollection was not entirely accurate, since *Life* did report on both the 1942 and 1943 Detroit race riots: "Detroit Has a Race Riot," pp. 40–41; "Race War in Detroit," pp. 93–100. For a very good analysis of how *Life*'s editors could trivialize or slant news stories about serious social issues, see Squiers, "Looking at *Life*," pp. 60–66.

16. Edwards, "One Every Minute," p. 23. A poll conducted by George Gallup for the Des Moines *Register & Tribune*, which was published by the Cowles family, revealed that what most newspaper readers noticed were not lead news stories or editorials, but picture pages (85 percent), favorite comic strips (70 percent), and editorial cartoons (40–50 percent). Fox, *The Mirror Makers*, p. 138.

17. Henry Luce was quite blunt about this matter in a 1937 speech to the American Association of Advertising Agencies, when he asked them to put their clients' advertising in *Life* so it could survive: "I stand before you as before a court. Your court is also the Appropriations Committee of the American press: you are the Commissars, you exist as an alternative to the People's Commissariat of Public Enlightenment. Here today I make application . . . that you shall appropriate over the next ten critical years no less than $100 million for the publication of a magazine called *Life*." Henry Luce, *The Ideas of Henry Luce*, p. 40.

18. Edwards, "One Every Minute," p. 23.

19. "When will the American fight?" Margaret Mead asked in 1942, and answered, "When the game is fair; when he can't be told that he started the fight, nor that he is pushing around someone smaller than he is. . . . His best position is in a fight which somebody else started . . . for which no one else can blame him." Mead, *And Keep Your Powder Dry*, p. 152. Also see Goodfriend, *What Is America?*, p. 98.

20. Elson, *Time Inc.: 1923–1941*, pp. 284–85. Elson, *Time Inc.: 1941–1960*, pp. 188–89. Edwards, "One Every Minute," p. 102.

21. Gans, *Popular Culture*, p. 34.

22. "The Cruel Chinese," pp. 50, 51. "The American Newsfront," p. 15. "A Dying Moose," p. 31.

23. Capa's picture was in "Death in Spain," p. 19. The New Guinea picture was in "Three Dead Americans," p. 35, and "Tenth Anniversary Issue," p. 119. "The Cruel Chinese," pp. 50–51.

24. "*Life* was full of pictures of busty, bare-legged girls, but their exposure had its limits. The deeper cleavages and wholly transparent nightgowns were touched up with an airbrush . . . by a man with the nickname of 'the nipple obliterator.' " Edey, "Introduction," p. 8.

25. Elson, *Time Inc.: 1923–1941*, p. 305. "The Most Famous Legs," pp. 18–19. "What America Thought in 1937," p. 13. "The Nightgown Becomes an Evening Dress," pp. 56–57. "The Camera Overseas," pp. 50–51. "Hollywood Keeps Fit," pp. 24–25.

26. Melot, "Landscape of the Body," pp. 73, 74. Several FSA photographers, particularly Lee and Rothstein, also tried to have this "effect of the real" in some of their images. Peeler, *Hope Among Us Yet*, pp. 92–96.

27. Hamblin, *That Was the Life*, pp. 49, 51. Edwards, "One Every Minute," p. 17.

28. "A Small Town's Saturday Night," pp. 63–70.

29. This sense of order was equally significant in the editing of the social "problem" photoessays published by *Life* and—some-

what more frequently—by *Look* in the 1930s and 1940s. These photoessays often started with a large picture, often a news photograph, showing some kind of disorder—for example, a riot or a father sobbing after losing the custody of his child in a divorce case. But the editors followed these disorderly images with pictures illustrating the nature of the problem, with captions or texts giving expert opinions, and then with an emphatic solution—illustrated by calm pictures—showing how the problem would be solved by a return to traditional, middle-class American values or a reliance on middle-class institutions. See, for example, my analysis of *Look*'s photoessay about racial prejudice later in this chapter, and Squiers, "Looking at *Life*," pp. 64–65.

30. Hodding Carter, "How Come Huey Long?" *New Republic* 82 (13 Feb. 1935): 11–14, quoted in Winslow, *Brother Can You Spare a Dime?*, p. 111.

31. Leyburn, "The Problem of Ethnic and National Impact," p. 60.

32. Ma Joad's speech is quoted in Susman, *Culture as History*, p. 212. "Ballad for Americans" is in "The Battle for America," p. 73. Wallace, "America Tomorrow," p. 13. McLuhan, "Time, Life, and Fortune," p. 33. "The 30,000 Managers," p. 73.

33. Barthes, *Mythologies*, p. 100. Sandeen, "The Family of Man," pp. 367–91.

34. Lerner, *America as a Civilization*, p. 274.

35. Karl, *The Uneasy State*, p. 185. See also Beard, *The Rise of American Civilization*, vol. 2, p. 800. Tugwell, Munro, and Stryker, *American Economic Life*, pp. 588–90. Moreover, this "promised land" would be cultural as well as economic, since Tugwell and his colleagues attacked Sinclair Lewis because he had "entirely overlooked the promises of a rich [cultural] future beneath the surface ugliness of our industrialism" (p. 591).

36. "The World's Fair," p. 56. "*Life* Goes to the Futurama," pp. 79–85.

37. Berle, "And What Shall We Do Then?," pp. 102–3.

38. "An American Proposal," p. 59.

39. This New Deal for the whole world was part of a "Manual for the Motion-Picture Industry" written in 1943 by a group of liberals in the Office of War Information. Black and Koppes, "What to Show the World," p. 89.

40. "Eisenhower Visits Capitalism Show," p. 20. Miller and Nowak, *The Fifties*, p. 112. The organization of the *People's Capitalism* exhibit was itself a good example of how the consensus system worked. The Advertising Council represented big business; it held its discussions of "people's capitalism" at symposiums sponsored jointly by the Council and Yale University; and the exhibit was sent abroad by USIA. The participants in the Council's symposiums were a revealing cross-section of the American "establishment" of the 1950s. (See Goodfriend, *What is America?*, pp. 13–17.)

41. USIA, "People's Capitalism," no pagination. Nevins, "The Audacious Americans," p. 85. See also Marcus Nadler, "People's Capitalism" (pamphlet), quoted by Perlo, "'People's Capitalism' and Stock Ownership," pp. 333–34.

42. "American Workingman," p. 54; USIA, "Consumer Capitalism in Action," p. 5. USIA "People's Capitalism," no pagination. Sitompoel, "Capitalism in America."

43. Allen, "What Have We Got?," p. 55.

44. Lipsitz, *Class and Culture*, pp. 120–21.

45. Lipsitz, "The Meaning of Memory," pp. 82–83.

46. Elson, *Time Inc.: 1941–1960*, pp. 256–58.

47. "Dreams of 1946," pp. 57–60.

48. Attwood, *Most Exciting Country*, p. 6.

49. Attwood, "A New Look at America," p. 50. "An American City's Dream," p. 24. Just to make sure that foreigners had the opportunity to be inspired by such examples, both *Time* and *Life* had international editions by the 1940s, and in 1946 *Life*'s editors referred to these two magazines as a "pair of useful and hard-working American diplomats," whose jobs were "to tell the candid, undistorted news of America to thinking people of other lands," and "to carry to buy-

ers everywhere the sales message of American industry." "The American Ambassador," p. 139.

50. Chahroudi, "*Twelve Photographers Look at US.*"

51. *Printer's Ink* (16 May 1929), p. 137, quoted in Lemagny and Rouillé, *A History of Photography*, p. 160.

52. "U.S. Growth," p. 2. Livermore, *Building the Community*, pp. 28–29.

53. "Tenth Anniversary Issue," pp. 29–152. "This Pleasant Land," pp. 46–58. "American Production," pp. 15–92. "The American and His Economy," pp. 7–102. "U.S. Growth," pp. 6–94. "American Life and Times," pp. 3–95. "America's Assets," pp. 8–87. "Food," pp. 2–89. Some of these special issues had brief news sections in which black people (for example, athletes) might appear; but they were almost totally excluded from the photoessays glorifying America's prosperity and power.

54. "Presenting," pp. 8–15. Herberg, *Protestant, Catholic, Jew*, p. 88.

55. Nevins, "The Audacious Americans," p. 85. Attwood, "A New Look at America," p. 51. Richard Nixon quoted in May, *Homeward Bound*, p. 18.

56. James Adams, *The Epic of America*, pp. 342–44. Lange's picture is in Stryker and Wood, *In This Proud Land*, p. 94. Miller and Nowack, *The Fifties*, p. 111.

57. These photoessays are in "The American and His Economy," pp. 8–15, 84–85, 29–39.

58. "Industry's New Frontier," p. 92. See also Nash, *The American West Transformed*, pp. 201–13.

59. Attwood, "A New Look at America," p. 51. Cowles, "What the Public Thinks," pp. 19–21. Also see Oakley, *God's Country*, p. 289.

60. Nash ad. Congoleum ad.

61. "Atom Power for Homes," p. 64. "How to Make Money," pp. 24–25. "Atomic Miracles," p. 27. "Leashed A-Bombs Do Tricks," pp. 144–45.

62. "A Wand Wave, A New Era," p. 141. The idea that atomic energy was a dangerous force that could be kept under control was also expressed by metaphors relating it to female sexuality. May, *Homeward Bound*, pp. 92–93, 108–12.

63. Colton, "Man's New Servant," p. 71. Woodbury, "The Utopian Promise," p. 26. See also Boyer, *By the Bomb's Early Light*, pp. 291–302.

64. USIA, "The Atomic Revolution," no pagination. Sarnoff, "The Fabulous Future," p. 18. Von Neumann, "Can We Survive Technology?," p. 37.

65. "They Live with Atomic Food," pp. 31–33.

66. Millikan and Rostow, *A Proposal*, pp. 149–50.

67. Advertising Council, *Basic Elements*, p. 17. Goodfriend, *What Is America?*, p. 87

68. "Prejudice," pp. 47–51. Stegner, *One Nation*, pp. 197–269.

69. Goodfriend, *What Is America?*, pp. 81, 92–93.

70. Attwood, *Most Exciting Country*, pp. 6, 64, 73.

71. "An American City's Dream," pp. 23–27.

72. "All-America Cities," p. 51. Star, "All-America Cities," pp. 73–77.

73. Carr, *Puerto Rico*, pp. 57, 202. Conversation with Jack Delano, July 1985. Also see Tugwell, *The Stricken Land*, pp. 34–43.

74. "Puerto Rico," p. 23.

75. Carr, *Puerto Rico*, pp. 203–6. "Thank Heaven for Puerto Rico," p. 24. "Operation Bootstrap Score," pp. 38–43. The "before" picture of "Coki" Lozano was made in 1949 and published in "A New Puerto Rico Shows Off," p. 24.

76. "Operation Bootstrap Score," p. 38. USIA, "A People Moves Ahead," pp. 3, 14, 20.

77. Wells, *The Future in America*, p. 151.

78. Millikan and Rostow, *A Proposal*, p. 1. As Harold Macmillan—who worked almost continuously with American policymakers and diplomats during World War II—complained in his diary in 1944: "They [the Americans] either wish to revert to isolation combined with suspicion of British imperial-

ism, or to intervene in a pathetic desire to solve in a few months by the most childish and amateurish methods problems which have baffled statesmen for many centuries." A year earlier he had decided that "of course the Americans do not read—or at any rate comprehend—history." Macmillan, *Politics and War*, pp. 446, 150.

79. MacArthur, "A Fourth of July Message," p. 34.

80. Kennedy, "Inaugural Address," in Linkugle, *Contemporary American Speeches*, p. 368.

81. FitzGerald, "The Shah Discovers His People," p. 9.

82. Henry Wallace was more accurate in 1947 when he warned that loaning money to dictators would mean "our banks will give dollars; our arsenals will give weapons. When that is not enough our people will be asked to give their sons." Both his and Dulles's statements are in Challener, *From Isolation to Containment*, pp. 163, 181. Henry Luce, *The Ideas of Henry Luce*, p. 120.

83. Butler, "America's Armed Forces," p. 8. See also Inman, "Imperialistic America," pp. 107–9; Rosenberg, *Spreading the American Dream*, pp. 155–59. Moon, *Imperialism*, pp. 412–14.

84. LaFeber, *Inevitable Revolutions*, p. 81.

85. Guimond, "Exotic Friends," pp. 48–61.

86. Thomson, Stanley, and Perry. *Sentimental Imperialists*, p. 24.

87. "U.S. Gets a Look," pp. 20–22. "The Presidency," pp. 15–16. LaFeber, *Inevitable Revolutions*, p. 69.

88. Dorman, "Peripheral Vision," pp. 427–38.

89. Pictures of the Shah's 1949 visit are in the National Archives and the Associated Press files. Diem and Eisenhower are in "Foreign Aid Repaid," p. 25. Osborne, "Tough Miracle Man," pp. 156–57. The picture of Diem waving from a convertible is in Karnow, *Vietnam*, p. 211.

90. "A Modern Monarch," p. 41. For details of how the Shah and his government manipulated the American media and policy-makers, see Bill, *The Eagle and the Lion*, pp. 367–71.

91. Willkie, *One World*, pp. 181, 158.

92. "The Vice-Presidency," p. 14.

93. Dean Tipps, quoted in Dwight Hoover, "Modernization Theory," p. 409. Richard Jenson is quoted on pp. 424–25.

94. Cyril Black, *The Dynamics of Modernization*, p. 11. For a bibliographical survey of modernization theories, see pp. 175–99. For the intellectual background and origins of these theories, see Nisbet, *Social Change and History*, p. 211. Also see Potter, *People of Plenty*, pp. 134–39.

95. "The Cost of Being an American," p. 53.

96. These images and examples are from USIA, "Partners in World Progress," a brochure that was an abridgment of an ICA (International Cooperation Administration) booklet entitled "Technical Cooperation: The Dramatic Story of Helping Others to Help Themselves."

97. "New Latin Boom Land," pp. 122–31.

98. "Iran," pp. 32–34. See also "A Mideast 'Victory,'" pp. 46–50.

99. Griffith, *The Waist-High Culture*, p. 111. Heikel, *Iran*, p. 109. Graves, "Iran: Desert Miracle," p. 12.

100. Peress, interview with Miriam Horn, p. 89.

101. Oakley, *God's Country*, pp. 198–200.

102. Barthes, *Mythologies*, p. 101.

103. "A Historic Week of Civil Strife," pp. 43–47.

104. "A Segregated Life," pp. 101. *Life* did not actually use the phrases "American Dream" or "American way of life" in this photoessay, but all of the themes in it were related to those concepts as they were presented at other times in the magazine.

105. Hamblin, *That Was the Life*, p. 283.

106. "A Segregated Life," pp. 105–9. Hamblin, *That Was the Life*, pp. 281–82.

107. Martin Luther King, Jr. statement quoted in "Lord of the Doves," p. 46.

108. Cargill admitted the United States did not seem to have the traditional imperial goal of seizing new territory, since it had only

annexed a few islands in the Pacific after World War II, but he pointed out it had acquired the use of a great deal of "choice acreage for bases and airstrips all over the world." Cargill, "Gift to the World," pp. 209–11.

109. Morley Safer quoted in Corry, "T.V.'s Legacy," p. 29. However, as Hallin emphasizes, such critical (or even skeptical) comments by American journalists were very rare until after the Tet Offensive in 1968. Hallin, *The "Uncensored War,"* pp. 132, 167–80.

110. For an analysis of the patterns and frequency with which certain kinds of images appeared in the media, see Hallin, *The "Uncensored War,"* p. 177.

111. Shana Alexander, "What is the Truth of the Picture?," p. 19.

112. "An Editorial," p. 33.

113. Fulbright, *The Arrogance of Power*, pp. 132–34.

114. Evans, "People and Places in Trouble," pp. 110–17.

CHAPTER 6

1. Henry Luce, *The Ideas of Henry Luce*, pp. 44–45; Arbus quoted in Bosworth, *Diane Arbus*, pp. 130, 175. Klein, *Photographs*, p. 16. Frank, "Robert Frank," no pagination.

2. Frank quoted in "Return of a Classic," p. 104.

3. According to Maitland Edey, at least seven people were involved in the production of a *Life* photoessay: departmental editor, picture editor, the photographer, negative editor, graphics designer, managing editor, and researcher. Edey, *Great Photographic Essays*, pp. 5–6. Irving Penn quoted in Janis and MacNeil, *Photography*, p. 127.

4. Klein, *Photographs*, p. 16. Bosworth, *Diane Arbus*, p. 175. Tucker, *Robert Frank*, p. 94.

5. Henry Luce, "A Prospectus for a New Magazine," quoted in Szarkowski, "Understanding Atget," p. 14.

6. Robert Frank, "A Statement," in Tucker, *Robert Frank*, p. 31.

7. "Not for nothing were pictures of Atget compared with those of the scene of a crime. But is not every spot of our cities the scene of a crime? . . . Does not the photographer—descendant of augurers and haruspices—uncover guilt in his pictures?" Walter Benjamin, "A Short History of Photography," in Trachtenberg, *Classic Essays*, p. 215.

8. "Wanted: An American Novel," p. 48.

9. "Our Country and Our Culture," pp. 283, 295, 298–99, 302.

10. I have pointed out how some of Hine's and the FSA photographers' images may be interpreted as general social criticisms, but these images were buried in files and archives during the 1940s and 1950s: it is uncertain that the photographers in the 1950s could have known much about the FSA photographers beyond what they saw in Evans's *American Photographs* and Agee's and Evans's *Let Us Now Praise Famous Men*, or that they knew more about Hine and Riis other than that they had tried to reform slums and child labor conditions. As for photojournalism, most of the picture magazines' problem-solving photoessays were very mild exercises in social criticism, since they chiefly emphasized how quickly America's problems were being (or were about to be) solved by better technology, education, or a few civic reforms.

11. Robert Frank, "A Statement," in Tucker, *Robert Frank*, p. 31. The extent to which Frank was influenced by Evans has been much debated. See Papageorge, *Walker Evans and Robert Frank*, and also items 1661, 1664, 1666–68, 1675, 1678, and 2277, in Stuart Alexander, *Robert Frank*.

12. Weegee, *Naked City*. Brassaï, *The Secret Paris of the 30s*.

13. For additional comments on the political implications of Frank's images, see the end of this chapter. See also Evans, "The Congressional," pp. 118–22 (photoessay with pictures by Frank and text by Evans). It is significant that, in the few pictures in *The Americans* in which Frank's subjects were powerful men, he photographed them as speaking to one another in a covert way and excluding others.

14. Robert Frank, Guggenheim Application, in Tucker, *Robert Frank*, p. 20.

15. Stott, *Documentary Expression*, pp. 245, 253–56. For comments on Attwood and *Life*'s special issues, see the previous chapter. Contemporary examples of this "America the Beautiful" genre are available on calendars sold in bookstores or given away by banks and savings-and-loan companies.

16. Frank commented on this image that it was the first time he was in the South and saw segregation, and he "found it extraordinary that whites would give their children to black women when they wouldn't allow the women to sit by them in a drugstore." Quoted in Editors of Time-Life Books, *Documentary Photography*, p. 171. Also see his remarks in William Johnson, *The Pictures Are a Necessity*, p. 172.

17. Bosworth, *Diane Arbus*, pp. 29–54. "Telling It As It Is," p. 110. For Arbus's brief comments on her childhood and upbringing, see "Daisy Singer's" remarks in Terkel, *Hard Times*, pp. 98–99.

18. "Cuckooland," pp. 50–57. The Melchoir story and other "screwball" photoessays are reprinted in Mich and Eberman, *The Technique*, pp. 148–49, 152, 156–57. Diane Arbus, "The Full Circle," reprinted in Arbus, *Magazine Work*, pp. 14–23.

19. Bosworth, *Diane Arbus*, pp. 33, 169, 231.

20. Arbus, *Diane Arbus*, p. 4.

21. There might have been some outsiders or other isolated people in the picture magazines—"troubled" children who needed foster homes, for example—but these magazines always emphasized how this isolation, like other social problems, could be solved by the proper functioning of middle-class institutions. See, for example, "Richard Gets His Chance," pp. 121–27. "From DP to College Queen," pp. 87–90. "Coed from the Hills," pp. 95–100.

22. Beloff, *Camera Culture*, p. 137. Similarly, see Sontag's comment on Arbus quoted later in chapter 6.

23. Klein, *Photographs*, pp. 15–16, 11, 13. Klein was probably influenced by dadaism (see p. 13) as well as by Léger, but America has so much homegrown, semiconscious dadaism that that side of Klein's sensibilities could have been sharpened merely by his growing up in a city like New York.

24. Léger quoted in Kotik, "Léger in America," p. 42.

25. Klein, *Photographs*, p. 16.

26. Ibid.

27. Klein might have seen Riis's pictures in " 'The Battle with the Slum,' " pp. 11–18.

28. Letter in Tucker, *Robert Frank*, p. 14.

29. Klein, *Photographs*, p. 13.

30. Frank quoted in Janis and MacNeil, *Photography*, p. 56.

31. Arbus, *Diane Arbus*, pp. 2, 5.

32. Sontag, *On Photography*, p. 47.

33. Bosworth, *Diane Arbus*, p. 234. Klein, *Photographs*, pp. 15, 7.

34. "An Off-Beat View of the U.S.A.," reprinted in Tucker, *Robert Frank*, pp. 36–37. For an additional, and negative, reaction to the French edition of *The Americans*, see White, "Les Américains," p. 127.

35. The Magnum pictures by Capa, Stock, Arnold, Miller, and Glinn referred to in this chapter are in Magnum, *The Fifties*.

36. Victor Turner, "Comments and Conclusions," in Babcock, *The Reversible World*, p. 280.

37. The *Glamour* text and pictures are reprinted in Bosworth, *Diane Arbus*, facing p. 274.

38. Bosworth, *Diane Arbus*, p. 121. Diane Arbus, "Fashion Independents on Marriage," reprinted in Arbus, *Magazine Work*, pp. 62–63. For examples of gender stereotypes, see Goffman, *Gender Advertisements* .

39. Sontag, *On Photography*, p. 35. See also Southall, "The Magazine Years, 1960–1971," in Arbus, *Magazine Work*, pp. 167–68.

40. The title "mother and child" is mine, not Arbus's.

41. For Arbus's published comments on the Tarnapols, and for her picture of them, see Arbus, *Magazine Work*, p. 107. For her private comments on them, including the remark, "I think all families are creepy in a way," see p. 168.

42. Brassaï, *The Secret Paris*, no pagination. See Arbus, *Magazine Work*, pp. 122–25;

Bosworth, *Diane Arbus*, pp. 295–97, 314–15.

43. "Telling It As It Is," p. 110. The Arbus quotes are from Arbus, *Diane Arbus*, p. 3, and Sontag, *On Photography*, p. 39.

44. Diane Arbus, "Tokyo Rose Is Home," reprinted in Arbus, *Magazine Work*, pp. 120–21.

45. Goodfriend, *What Is America?*, pp. 30, 25. What girls and women learned about the United States is not mentioned. *What is America?* was inspired by the Advertising Council and distributed by the USIA at approximately the same time that these organizations were sponsoring the *People's Capitalism* exhibit; and, like that exhibit, the book is a good example of a consensus version of the Dream, since it combined motifs from both conservative (the Horatio Alger, Jr., myth) and liberal (the melting pot myth) versions.

46. Klein, *Photographs*, p. 15.

47. Schuh letter to Frank, reprinted in Tucker, *Robert Frank*, p. 32.

48. Klein, *Photographs*, pp. 52–53.

49. Ibid., p. 7.

50. Frank letter in Tucker, *Robert Frank*, p. 28.

51. Ian Jeffrey, "Robert Frank," in ibid., pp. 58–59. Edwards letter quoted in ibid., p. 34. The references to Frank as a "poet" are in *"Life* announces the winners," p. 21, and Dobell, "Feature Pictures," p. 77. John Szarkowski commented, on the back cover of the 1968 Aperture edition of *The Americans*, that Frank's pictures took "us by ambush" in the late 1950s, because "We knew the America that they described . . . but we knew it as one knows the background hum in a record player, not as a fact to recognize and confront. Nor had we understood this stratum of our experience was a proper concern of artists. The fact that Frank's America was not in conventional terms edifying was beside the point. The shocking thing was that it was not in conventional terms tragic, but merely untidy and triv[i]al. Yet Frank recorded with such clarity and purity his own sense of what was basic to us that the trivial was transfigured, and became symbol. Robert Frank established a new iconography for contemporary America, comprised of bits of bus

depots, lunch counters, strip developments, empty spaces, cars, and unknowable faces." Quoted in item 701 of Stuart Alexander, *Robert Frank*, p. 56.

52. Perhaps because of the extensive interest in the question of how much Frank was influenced by Evans, there has been little or no interest in how he may have been influenced by his reading. In workshops and conversations he has expressed his admiration for T. S. Eliot's poetry and remarked that he "read all the early books by Sartre, the 'Roads to Freedom' novels." And, according to William Johnson, Frank still reads Camus's works, particularly his novel, *The Plague*. William Johnson, *The Pictures Are a Necessity*, pp. 27–28, 160–61.

53. Wilson, *Axel's Castle*, pp. 105–6.

54. Philip Brookman, "In the Margins of Fiction," in Tucker, *Robert Frank*, p. 82

55. For examples of cowboys in the picture magazines, see "Want to Meet Real Cowboys?," pp. 66–71; and "Champ Rider," pp. 123–29.

56. Koether, "The Great American Automobile," p. 40.

57. For Frank's comments on this picture, see Editors of Time-Life Books, *Documentary Photography*, p. 174.

58. Tucker, *Robert Frank*, pp. 90, 92, 94

59. Frank and Evans, "Conversation," p. 3. See also, Tucker, *Robert Frank*, p. 95.

60. Frank letter in Tucker, *Robert Frank*, p. 72.

61. Frank's comment on the New Orleans picture ("I wasn't thinking about segregation when I shot it. But I did feel that the black people were more dignified.") is in Editors of Time-Life Books, *Documentary Photography*, p. 167. However, it is likely that Frank could have been thinking about segregation when he composed his book, since the French edition was published in 1958, after the Montgomery bus boycott of 1955 and 1956. In a workshop he described the United States of the 1950s as a "terrifying country, especially going to the South. . . . But I didn't want to make propaganda. I wanted to say it in a subtle way." William Johnson, *The Pictures Are a Necessity*, p. 172.

62. There is one more flag sequence (with pictures of one flag in a bar in Detroit and another in a backyard in California) approximately halfway between the Jay, New York, flag picture and the tuba player picture; the concept in this sequence is unclear to me—though it may be related to eccentricity or individualism.

63. Walker Evans, "Robert Frank," reprinted in Tucker, *Robert Frank*, p. 30.

64. Frank letter in Tucker, *Robert Frank*, p. 14.

65. Attwood, "A New Look at America," p. 48.

66. For good examples of these stereotyped images of women, see *Life*, *Look*, and the Magnum anthology, *The Fifties*. It is significant, because of his sympathetic interest in women and blacks in the 1950s, that Frank remarked in a 1981 letter, "I think my sympathies will always be with people who are weaker and will almost certainly be loosers [*sic*]. It might be romantic to feel that way—unless I would believe in Justice—and I don't." Letter in Tucker, *Robert Frank*, p. 68.

67. "Wanted: An American Novel," p. 48.

68. Tucker, *Robert Frank*, p. 95. Edwards letter to Frank in ibid., p. 34.

69. Klein, *Photographs*, pp. 10, 16, 22.

70. Frank letter to Smith in Tucker, *Robert Frank*, p. 16. Stuart Alexander, *Robert Frank*, p. vi.

71. Quote from *The Lines of my Hand* in Tucker, *Robert Frank*, p. 10. After his Guggenheim trip, Frank's career began to have certain similarities to Evans's after *American Photographs*. Both were based in New York and worked mainly for prestige publications—Evans for *Fortune* and Frank for the *New York Times*. Both made increasingly detached photographs—Evans from train windows and Frank from city buses. Frank, however, broke out of this pattern: he gave up still photography, for a decade, to make films, and he moved to Nova Scotia.

72. Frank letter in Tucker, *Robert Frank*, p. 73.

73. Philip Brookman, "In the Margins of Fiction," in Tucker, *Robert Frank*, p. 80. This dialogue was in the filmscript; however, it was not in the film itself. Frank's friend Rudy Wurlitzer, who wrote the screenplay for *Candy Mountain*, has described Frank as a person who "has always left things. . . . He has always moved on, at great cost and suffering and great renewal." Quoted by Tucker, *Robert Frank*, p. 94. Similarly, John Heilpern has written about Klein that "he appears to have made of his career what amounted to a willful noncareer. Everything he worked at over the years, from his paintings to his later political films, he abandoned eventually to start afresh." Klein, *Photographs*, p. 9.

74. Edward Weston, "Random Notes on Photography," in Newhall, *Photography*, p. 225. Klein, *Photographs*, p. 22. Also see Frank's comment on "beautiful photographs" in Janis and MacNeil, *Photography*, p. 61.

75. Frank and Evans, "Conversation," p. 2.

76. As I mentioned earlier in this study, Hine was trained as a social scientist and worked with sociologists and economists on the *Pittsburgh Survey* and with caseworkers for his child labor pictures; Evans and the other FSA photographers had gone into the field with directions from sociologist Robert Lynd, assigned readings in J. Russell Smith's economic geography book, plus plenty of information from Stryker himself about the economic history of the United States.

77. Klein, *Life Is Good*, p. 190.

78. Tucker, *Robert Frank*, p. 90. Robert Frank, "A Statement," in ibid., p. 31.

79. Avedon quote in "Telling It As It Is," p. 110.

80. Lincoln Kirstein, "Henri Cartier-Bresson," in Cartier-Bresson, *Henri Cartier-Bresson*, pp. 10, 8, 9. See also Beaumont Newhall, "Cartier-Bresson's Photographic Technique," in ibid., pp. 12–14.

81. "Memorable and Beautiful," p. 137.

82. Burgin quoted in Lemagny and Rouillé, *A History of Photography*, p. 193.

83. Frank in Janis and MacNeil, *Photography*, p. 56. Klein, *Photographs*, p. 16, 18–21. Klein parodied this kind of photographic "objectivity" in *Qui êtes-vous, Polly Maggoo?*, when a cameraman tells a model, "Just pretend I'm not here. Just be yourself. Be completely *normal*" (p. 9). See also Beloff's com-

ments on Cartier-Bresson in her *Camera Culture*, pp. 217–19.

84. Edey, *Great Photographic Essays*, p. 50. McCombe's photoessay was published in the 3 May 1948 issue of *Life* .

85. Morris in Janis and MacNeil, *Photography*, p. 22.

86. Arbus, *Diane Arbus*, p. 2. Klein quoted in Lemagny and Rouillé, *A History of Photography*, p. 194.

87. There are, moreover, just enough similarities between the people in the two pictures to suggest that Frank and Glinn might have photographed some of the same politicians—though probably not the same conference.

88. Frank quoted in "Return of a Classic," p. 104. Lemagny and Rouillé, *A History of Photography*, p. 193.

CHAPTER 7

1. Louis Aragon quoted in Adereth, *Commitment in Modern French Literature*, pp. 33–34. Evans, "Walker Evans on Himself," p. 26.

2. Boffey, "Space Agency Image," p. 1. In a poll of Americans aged eighteen to forty-four, 32 percent of those surveyed "said the shuttle disaster was the event in the past 20 years that had had the greatest impact on them personally," even greater than the Vietnam War (29 percent) or the AIDS epidemic (22 percent). Collin, "Anxiety," p. 13. Also see Brummer, "America's Space Dream," p. 10.

3. Haynes Johnson, "Resurrection of Coolidge," p. A3a.

4. Bouchier, "The Great Greed of 1987," p. 16. Kopkind, "Films," pp. 251–52. For analyses of how this Great Greed was "sold" to Americans and implemented politically by conservatives, see Fisher, *Let the People Decide*, pp. 121–26; Edsall, *The New Politics*, pp. 107–40.

5. Bidwai, "Reaganism's Impact," p. 44. Zuckerman, "Dreams, Myths and Reality," p. 68. See "Middle-Class Squeeze," pp. 36–41, on the stagnating fortunes of middle-class Americans during the 1970s and 1980s.

For a similar sense of shocked surprise that many Americans were not prospering, see Lardner, "Rich, Richer; Poor, Poorer," p. A27.

6. Hamrin, "Sorry Americans," p. 51. Also see Edsall, "The Return of Inequality," pp. 86–88; and Tolchin, "Richest Got Richer," p. A1.

7. Schmidt, "Rise in Poverty," p. 20. "Texas Takes a Tumble," p. 21. See also Erlanger, "Atlantic City," p. 1.

8. A West German politician articulated the political principle behind this indifference to the poor and the unemployed when he said in 1987 that the "fear of unemployment" no "longer bothers people who now have jobs. The number of people unemployed has not diminished, but the fear of losing one's job has become remote in people's minds. And the fact is, more working people vote than unemployed persons." Rosenzweig, "Crash of Dropped Clangers," p. 14.

9. Franklin quoted in Goodfriend, *What Is America?*, p. 45. Hamrin, *America's New Economy*, pp. 136–38. In contrast, countries like England and Italy had savings rates of 12.2 percent and 23 percent, respectively (p. 138).

10. Hamrin, *America's New Economy*, pp. 94–97. Peter Peterson, "The Morning After," p. 49. "USA 'Selling Off Real Wealth,'" p. 1.

11. Stock, "New Home for the Homeless," pp. 16–17. "A Week in the Life," pp. 31–36. "More Young Women and Children," p. 1. "A High Tide of Homelessness," p. E6. Krauthammer, "How to Save the Homeless Mentally Ill," p. 24. Hooker, "Housing Outlook Dim," p. 1. The Chicago *Tribune* illustrated how difficult it was becoming for middle-class people to buy homes with an example of a Minneapolis family in which the parents had financed a $15,000 five-bedroom house with a $1,000 down payment in 1964: by 1988 their son needed $14,000 to finance a three-bedroom house, which would cost him $170,000. Sheppard, "More People Being Priced Out," pp. 1–2.

12. Attwood, "A New Look at America,"

p. 51. Lipset, "The End of Ideology?," p. 73.

13. Evans, "People and Places," p. 110.

14. Serrin, "Grim Holiday Spirits," p. 6. Maharidge and Williamson, *Journey*, p. 49.

15. "Dead Zones," pp. 20–31. For 1940s and 1950s comments on American cities, see above, chapter 5. "If greed was the predominant public quality of the early eighties," an English journalist commented about cities like New York, ". . . fear seems to be the most widespread public feeling now. . . . The methods of such [drug] gangs as the Jamaicans, the Colombians, and the Asians are often so openly violent that they make the declining Mafia seem old-fashioned." Weatherby, "Crack Downer," p. 11.

16. Even the Carter administration, however, was selective in its devotion to human rights, since it did not criticize certain dictators, like the Shah of Iran. For comments on American aid to Pol Pot, see Pilger and Munro, "U.S. Help to Pol Pot," p. 2.

17. A list of other dictators who had received aid and support from the United States during the 1970s and 1980s and later fell from power includes: President Ferdinand Marcos of the Philippines, Gen. Gustavo Alvarez of Honduras, Lt. Gen. Jorge Rafael Videla, Gen. Leopoldo Galtieri, Field Marshall Roberto Eduardo Viola of Argentina, President Anastasio Somoza Debayle of Nicaragua, Prime Minister Marcello Caetano of Portugal, President-for-Life Jean Claude Duvalier of Haiti, Col. Georgios Papadoupolos of Greece, Gen. Muhammad Zia Ul-Haq of Pakistan, and Gen. Alfredo Stroessner of Paraguay.

18. Henry Luce, *The Ideas of Henry Luce*, p. 120. Lippmann quoted in Steel, *Walter Lippmann*, pp. 416–17. See also Willkie's comments about America's influence and prestige in the 1940s in his *One World*, pp. 157–62.

19. Orwell, *1984*, pp. 14, 17. "Koch Joins the Barrage of Criticism," p. A13a. Mack, "Crisis in the Other Alliance," p. 447. See also Alterman, "Washington and the Curse," pp. 235–80. Patriotic wrestling fans would enjoy the spectacle of encounters between an all-American "Sgt. Slaughter," costumed as a drill instructor, and his opponents, who included "The Russian Assassin" and "The Libyan Sheik" (Sgt. Slaughter ads, pp. B3, D9). For a survey and analysis of some of the more crudely militaristic and xenophobic movies of the period, see Ryan and Kellner, *Camera Politica*, pp. 194–216.

20. Martin Walker, "Not So Evil," p. 9. " 'We Cut Loose,' " p. 14.

21. Tichi, "Jesters in Journalism," p. 22.

22. "A Week in the Life," pp. 31–36. Serrin, "Grim Holiday Spirits," p. 6.

23. Marcuse, "Why Are They Homeless?," p. 428. See also Swanstrom, "Homeless," p. A29.

24. Bill Owens, *Documentary Photography*, pp. 20–21.

25. Cronkite, "Echoes of Agnew," p. 29. For a good review of recent books describing how the U.S. media are manipulated, see Karp, "All the Congressmen's Men," pp. 55–63.

26. Klein, *Photographs*, p. 18.

27. Bill Owens, *Documentary Photography*, p. 21. See p. 20 for Owens's comments on how relatively unprofitable photography books are, including books, like *Suburbia*, that are "good projects" and receive "rave reviews."

28. Sischy, "Photography," p. 80.

29. "Our America," pp. 1, 13. Bill Owens, *Documentary Photography*, p. 20.

30. Bill Owens, "The Sun Belt," pp. 36–41. Bill Owens, *Documentary Photography*, pp. 20, 21.

31. Bill Owens, *Documentary Photography*, p. 15.

32. Bill Owens, *Suburbia*, no pagination. For the definitive 1950s stereotype of the barbecue picnic as the epitome of the American way of life, see the Spiegel ad, p. 53.

33. Bill Owens, *Documentary Photography*, p. 17.

34. Ibid., p. 15.

35. Owens's image of the bulldozer recalls Dorothea Lange's and Pirkle Jones's documentation of the destruction of the Berryessa Valley (see above, chapter 4). In addition, for

the student of American culture, Owens's picture also recalls Leo Marx's perceptive analysis of the episode in Twain's *Adventures of Huckleberry Finn*, in which the steamboat (of mechanism and necessity) smashes the raft (of nature and freedom) throughout American history. Marx, *The Pilot and the Passenger*, pp. 191–205.

36. Hare, *Interior America*, p. 18. Bill Owens, *Documentary Photography*, pp. 16, 15. Virtually the only comment Owens made about his *Suburbia* subjects that might be interpreted politically, was his remark that he was "truly interested in how the middle class lived and felt about themselves. And I felt that if people could become aware of their life styles in some way . . . they could change it [*sic*] for the better. I could hardly believe that an American family might spend as much as $350 a year on the care and feeding of the family pet" (p. 17).

37. Hare, *Interior America*, p. 9. For *Life*'s view of the chemical industry, see "Frontiers of Technology," pp. 82–105, a photoessay about Union Carbide emphasizing how young engineers were recruited and trained.

38. One of the rare documentary photographic studies of a major industry was, interestingly enough, the 1943 to 1950 Standard Oil of New Jersey project run by Roy Stryker after he left the government. Naturally, the photographers for this project saw the oil industry differently than Hare did.

39. Hare, *Interior America*, p. 16.

40. Evans, "People and Places," p. 110.

41. Hare, *Interior America*, p. 16.

42. Ibid., p. 10. See chapter 4, above, for comments on the FSA photographers' images of eroded farmland and industrial wastelands.

43. Hare, *Interior America*, p. 19.

44. The full title of *Life*'s study of Monsanto, "The Reign of Chemistry," photographed by Eugene Smith, was almost as revealing as the photoessay itself: "The Reign of Chemistry: Monsanto Company's Vast Operations Show How the Country's Fastest Growing Big Industry Has Become a Dominant Factor in the U.S. Economy

and Changed Every American's Daily Life," pp. 29–39.

45. Hare, *This Was Corporate America*, p. 14.

46. Ibid., pp. 16, 75.

47. The caption in the advertisement probably is a variation on a popular slogan of the 1960s and 1970s: "When the going gets tough, the tough get going," which was ascribed to football coach Vince Lombardi and supposedly inspired members of the Nixon administration.

48. The San Francisco *Examiner* would not give permission for a reproduction of its picture of the suicide, and therefore Hare had to use a drawing of it. Hare, *This Was Corporate America*, pp. 15, 24.

49. Ibid., p. 19.

50. Ibid., p. 91. MacLeish, *Land of the Free*, pp. 80, 83, 84, 88. Also see Sischy's very perceptive contrast between Hare's images and Dan Weiners's, made for *Fortune* in the 1950s. Sischy, "Photography," p. 79.

51. Harrison Salisbury, "Introduction," in Schlesinger and Kinzer, *Bitter Fruit*, p. xiv. See also ibid., pp. 153–54; Immerman, *The CIA in Guatemala*, pp. 128–60. According to one reporter, during the 1940s Somoza had decorated his office with no less than four photographs of Franklin Roosevelt. Krehm, *Democracies and Tyrannies*, p. 121. For examples of the propaganda published by Luce's magazines, see "Reds' Priority," pp. 8–13; "The End of a 12-Day Civil War," pp. 20–22. Earlier, *Life* had done a public relations piece for United Fruit and their operations in Central America: Kobler, "Sam the Banana Man," pp. 89–94. The conservatives' cooperation with the CIA and the region's dictators can be explained by their concern for the interests of certain multinational corporations, but the liberals' involvement was a little more complicated. For an analysis of their motivations, see Jules Benjamin, "The Framework of U.S. Relations," pp. 91–112.

52. Meiselas, *Nicaragua*, no pagination. Mattison, Meiselas, and Rubenstein, *El Salvador*, p. 103.

53. Susan Meiselas quoted in Snyder,

"Mixing Media," p. 34.

54. Edward Steichen, "The F.S.A Photographers," in Newhall, *Photography*, p. 267.

55. Snyder, "Mixing Media," p. 36.

56. "Babies and Biscuits," p. 112.

57. Maharidge and Williamson, "Dedication," *Journey*, no pagination. Telephone conversation with Michael Williamson, May 1989.

58. A. D. Coleman, "Introduction," in MacLeish, *Land of the Free*, no pagination. Maharidge and Williamson, *Journey*, pp. 8–9.

59. Maharidge and Williamson, *Journey*, p. 22.

60. Maharidge and Williamson, *Journey*, pp. 12, 20.

61. "GM to Close Framingham Plant," p. 1. SPX Corporation and Hardee's ads, p. 12D. Presumably, the irony in the Hardee's ad was not intentional.

62. Maharidge and Williamson, *Journey*, p. 35.

63. Ibid., pp. 100, 61, 138.

64. Ibid., pp. 109, 113. When he met Maharidge and Williamson, the welder had just quit his minimum-pay job because the Texans he worked with were so prejudiced against Northerners.

65. Lee quoted in Hurley, *Russell Lee*, p. 18.

66. Maharidge and Williamson, *Journey*, p. 77.

67. Ibid., pp. 107–9

68. Ibid., p. 140. See also Marin, "Hating and Helping the Homeless," pp. 39–47.

69. Maharidge and Williamson, *Journey*, p. 107. Sometimes, in the 1980s, this anger was expressed by the documentary photographers as well as their subjects. Jim Goldberg, for example, became "repulsed" by the hopelessness of the people he was photographing in welfare hotels: "Where once I had encouraged them to get up and fight, now I simply watched them get drunk and shoot up. The headlines in newspapers of the time were about cutbacks for the poor, tax breaks for the rich." Jim Goldberg, *Rich and Poor*, no pagination.

70. Maharidge and Williamson, *Journey*, pp. 188–90.

71. Kozol, "A Reporter at Large," pp. 66–67.

72. Newhouse, "Annals of Intelligence," pp. 80–81.

73. Trilling, "Reality in America," in *The Liberal Imagination*, p. 10. Trilling wrote his essay in two parts, which were published in 1940 and 1946.

Bibliography

Special Collections

Library of Congress, Washington, D.C., for the Farm Security Administration photographs discussed in chapter 4, for Frances Johnston's Hampton pictures in chapter 2, and for most photographs by Lewis Hine in chapter 3.

National Child Labor Committee (NCLC) Collection, Firestone Library, Princeton University, Princeton, New Jersey, for brochures and pamphlets published by that organization, which are illustrated by Lewis Hine's photographs, discussed in chapter 3.

United States Information Agency (USIA), Agency Historical Collection, Washington, D.C., for brochures, pamphlets, and other printed materials produced by the USIA and distributed abroad by the United States Information Service (USIS).

Books, Journals, and NCLC and USIA Publications

Adams, James Truslow. *The Epic of America*. Boston: Little, Brown, 1932.

Adams, William. "Natural Virtue: Symbol and Imagination in the American Farm Crisis." *Georgia Review* 39 (Winter 1985): 695–712.

Adereth, Maxwell. *Commitment in Modern French Literature*. New York: Schocken, 1968.

Adler, Felix. "The Basis of the Anti–Child Labor Movement in the Idea of American Civilization." NCLC 70. 1908.

————. "Child Labor and Its Great Attendant Evils." NCLC 11. 1905.

————. *The Moral Instruction of Children*. New York: Appleton, 1908.

Advertising Council. *The Basic Elements of a Free, Dynamic Society*. New York: Macmillan, 1951.

Agena, Kathleen. "U.S. Policy and the Third World." *Partisan Review* 49 (1982): 298–304.

Alexander, Stuart. *Robert Frank: A Bibliography, Filmography, and Exhibition Chronology*. Tucson: University of Arizona/Center for Creative Photography, 1986.

Alger, Horatio, Jr. *From Canal Boy to President*. New York: J. R. Anderson, 1881.

————. *Ragged Dick*. 1868. Reprint. New York: Bonanza Books, 1945.

Alterman, Eric. "Washington and the Curse of the Pundit Class." *World Policy Journal* 5 (Spring 1988): 235–80.

Anderson, James. *The Education of Blacks in the South, 1860–1935*. Chapel Hill: University of North Carolina Press, 1988.

Aptheker, Herbert, ed. *A Documentary History of the Negro People in the United States, 1910–1932*. Secaucus, N.J.: Citadel Press, 1973.

Arbus, Diane. *Diane Arbus*. Millerton, N.Y.: Aperture, 1972.

___. *Magazine Work*. Edited by Doon Arbus and Marvin Israel. Millerton, N.Y.: Aperture, 1984.

Armstrong, Samuel. "From the Beginning." In *Twenty-two Years' Work of the Hampton Normal and Agricultural Institute*. Hampton, Va.: Normal School Press, 1893.

Attwood, William. *Still the Most Exciting Country*. New York: Knopf, 1955.

Auden, W. H. "September 1, 1939." In *The Collected Poetry of W. H. Auden*, pp. 57–59. New York: Random House, 1945.

Babcock, Barbara, ed. *The Reversible World: Symbolic Inversions in Art and Society*. Ithaca: Cornell University Press, 1978.

Baldwin, Sidney. *Poverty and Politics: The Rise and Decline of the Farm Security Administration*. Chapel Hill: University of North Carolina Press, 1968.

Barthes, Roland. *Mythologies*. Translated by Annette Lavers. New York: Hill and Wang, 1972.

" 'The Battle with the Slum,' 1887–1897: The Early Documentary Photography of Jacob A. Riis." In *U.S. Camera 1948*, edited by Tom Maloney. New York: U.S. Camera Publishing Co., 1948.

Beard, Charles, and Mary Beard. *The Rise of American Civilization*. Vol. 2, *The Industrial Era*. New York: Macmillan, 1927.

Beech, Gould. "Schools for a Minority." *Survey Graphic* 28 (Oct. 1939): 615–18.

Beloff, Halla. *Camera Culture*. New York and London: Basil Blackwell, 1985.

Benjamin, Jules. "The Framework of U.S. Relations." *Diplomatic History* 11 (Spring 1987): 91–112.

Benjamin, Walter. *Understanding Brecht*. Translated by Anna Bostock. London: NLB, 1973.

Bennett, Alice. "The Italian as Farmer." *Survey* 21 (3 Oct. 1908): 57–60.

Bennett, Edna. "Black and White Are the Colors of Robert Frank." *Aperture* 9, no. 1 (1961): 20–22.

Bergman, Andrew. *We're in the Money: Depression America and Its Films*. New York: New York University Press, 1971.

Beveridge, Albert. "Child Labor and the Nation." NCLC 55. 1907.

Bill, James. *The Eagle and the Lion*. New Haven: Yale University Press, 1988.

Black, Cyril. *The Dynamics of Modernization*. New York: Harper & Row, 1966.

Black, Gregory, and Clayton Kloppes. "What to Show the World." *Journal of American History* 64 (June 1977): 87–105.

Bosworth, Patricia. *Diane Arbus: A Biography*. New York: Knopf, 1984.

Boyer, Paul. *By the Bomb's Early Light*. New York: Pantheon, 1985.

_____. *Urban Masses and Moral Order in America, 1890–1925*. Cambridge: Harvard University Press, 1976.

Brassaï [Gyula Halász]. *The Secret Paris of the 30s*. Translated by Richard Miller. New York: Pantheon, 1976.

Browers, Claude. *Beveridge and the Progressive Era*. Cambridge, Mass.: The Riverside Press, 1932.

Brown, W. L. "Hampton School Record." *Southern Workman* 28 (Nov. 1899): 439–41.

Brownlee, Frederick. *Heritage of Freedom*. Philadelphia and Boston: United Church Press, 1963.

Butler, Smedley. "America's Armed Forces: 2. 'In Time of Peace': The Army." *Common Sense* 4 (Nov. 1935): 8–12.

Caldwell, Erskine, and Margaret Bourke-White. *You Have Seen Their Faces*. New York: Modern Age Books, 1937.

Callahan, Sean, ed. *The Photographs of Margaret Bourke-White*. New York: Bonanza Books, 1972.

Calloway, Thomas J. "The American Negro Exhibit at the Paris Exposition." *Hampton Negro Conference* 5 (July 1901): 74–80.

Capa, Cornell. "Cornell Capa." In *Interviews with Master Photographers*, edited by James Danziger and Barnaby Conrad III. New York and London: Paddington Press, 1977.

Cargill, Oscar. "Gift to the World." In *American Dreams, American Nightmares*, edited by David Madden. Carbondale: Southern Illinois University Press, 1970.

Carlson, Lewis H., and George Colburn, eds. *In Their Place: White America Defines Her Minorities*. New York: John Wiley, 1972.

Carr, Edward. *Puerto Rico: A Colonial Experiment*. New York: New York University Press, 1984.

Cartier-Bresson, Henri. *Henri Cartier-Bresson*. New York: Museum of Modern Art, 1947.

Chahroudi, Martha. "Twelve Photographers Look at US." *Bulletin of the Philadelphia Museum of Art* 83 (Spring 1987).

Challener, Richard, ed. *From Isolation to Containment, 1921–1952*. London: Edward Arnold, 1970.

Chalmers, David. *The Muckrake Years*. New York: Van Nostrand, 1974.

Chase, Stuart. *Men and Machines*. New York: Macmillan, 1929.

———. *Mexico: A Study of Two Americas*. New York: Macmillan, 1937.

———. *Prosperity: Fact or Myth*. New York: Charles Boni, 1929.

Claghorn, Kate. "Our Immigrants and Ourselves." *Atlantic Monthly* 86 (Oct. 1900): 535–48.

Clifford, Carrie. "The Atlantic Riots, II. A Northern Black Point of View." *The Outlook* 84 (3 Nov. 1906): 564.

Clopper, E. N. *Child Labor in City Streets*. New York: Macmillan, 1912.

———. "Child Labor in Indiana." NCLC 91. 1909.

———. "Child Labor in West Virginia." NCLC 86. 1908.

Clopper, E. N., and Lewis Hine. "Child Labor in the Sugar-Beet Fields of Colorado." NCLC 259. 1916.

Clurman, Harold. "The Frightened Fifties and Onward." In *The Nonconformers*, edited by David Evanier and Stanley Silverzweig. New York: Ballantine Books, 1961.

"Co-education of Races." *Southern Workman* 28 (Jan. 1899): 2–4.

Cohen, Hennig. "The Innocent Eye." *The Reporter* 34 (10 Mar. 1966): 45–48.

Commager, Henry. *The American Mind*. New Haven: Yale University Press, 1950.

Conn, Peter. *The Divided Mind*. Cambridge: Cambridge University Press, 1983.

Conrad, David. *The Forgotten Farmers*. Urbana: University of Illinois Press, 1965.

Copeland, Roger. "Photography and the World's Body." In *Photography: Current Perspectives*, edited by Jerome Liebling. Rochester, N.Y.: Light Impressions, 1978.

Creel, George, Ben B. Lindsey, and Edwin Markham. *Children in Bondage*. New York: Hearst's International Library, 1914.

Crèvecoeur, J. Hector St. John de. *Letters from an American Farmer*. New York: Signet, 1963.

Curti, Merle. "The American Exploration of Dreams and Dreamers." *Journal of the History of Ideas* 27 (July–Sept. 1966): 391–416.

Curtis, James C. "Dorothea Lange, Migrant Mother, and the Culture of the Great Depression." *Winterthur Portfolio* 21 (Spring 1986): 1–20.

Curtis, Verna Posever. *Photography and Reform: Lewis Hine and the National Child Labor Committee*. Milwaukee: Milwaukee Art Museum, 1984.

Daniel, Pete, and Raymond Smock. *A Talent for Detail: The Photographs of Miss Frances Benjamin Johnston*. New York: Harmony, 1974.

Danziger, James, and Barnaby Conrad III. *Interviews with Master Photographers*. New York and London: Paddington Press, 1977.

Dewey, John. *The Public and Its Problems*. New York: Holt, 1927.

Dichter, Ernest. *The Strategy of Desire*. Garden City, N.Y.: Doubleday, 1960.

Dorman, William. "Peripheral Vision: U.S. Journalism and the Third World." *World Policy Journal* 3 (Summer 1986): 419–45.

Du Bois, W. E. B. *The Education of Black People: Ten Critiques, 1906–1960*. Edited by Herbert

Aptheker. Amherst: University of Massachusetts Press, 1973.

———. *The Souls of Black Folk*. In *Three Negro Classics*, edited by John Hope Franklin. New York: Avon, 1965.

Edey, Maitland. *Great Photographic Essays from Life*. Boston: New York Graphic Society, 1978.

Editors of Time-Life Books. *The Best of Life*. New York: Time-Life Books, 1973.

———. *Documentary Photography*. New York: Time-Life Books, 1972.

Edsall, Thomas. *The New Politics of Inequality*. New York: W. W. Norton, 1984.

———. "The Return of Inequality." *Atlantic* (June 1988): 86–94.

Ellul, Jacques. *Propaganda: The Formation of Men's Attitudes*. Translated by Konrad Keller and Jean Lerner. New York: Knopf, 1965.

Elson, Robert. *Time Inc.: 1923–1941*. New York: Atheneum, 1968.

———. *Time Inc.: 1941–1960*. New York: Atheneum, 1973.

Embree, Edwin. "Southern Farm Tenancy: The Way Out of Its Evils." *Survey Graphic* 25 (Mar. 1936): 149–53.

Engs, Robert. *Freedom's First Generation: Black Hampton, Virginia, 1861–1890*. Philadelphia: University of Pennsylvania Press, 1979.

Evans, Walker. *American Photographs*. New York: Metropolitan Museum of Art, 1938. Reprint. New York: East River Press, 1975.

———. *Many Are Called*. Boston: Houghton Mifflin, 1966.

———. *Walker Evans at Work*. New York: Harper & Row, 1982.

———. "Walker Evans on Himself." *New Republic* 175 (13 Nov. 1976): 23–27.

———. *Walker Evans Photographs for the Farm Security Administration*. New York: DaCapo Press, 1973.

Ewen, Stuart. *Captains of Consciousness*. New York: McGraw-Hill, 1976.

Exhibitions Staff, National Archives and Record Service. *The American Image*. New York: Pantheon, 1979.

"The Family of Man." *Les Beaux-Arts* (Brochure in French for the Exhibit), no pagination. USIA Historical Collection, [1955].

Farrison, W. Edward. "Booker T. Washington: A Study in Educational Leadership." *South Atlantic Quarterly* 41 (July 1942): 313–17.

Faulkner, William. *Essays, Speeches and Public Letters*. New York: Random House, 1965.

Felt, Jeremy. *Hostages of Fortune: Child Labor Reform in New York State*. Syracuse: University of Syracuse Press, 1965.

Ferris, Bill. "A Visit with Walker Evans." In *Images of the South. Southern Folklore Reports*, no. 1. Memphis: Center for Southern Folklore, 1977.

Fisher, Robert. *Let the People Decide*. Boston: Twayne, 1984.

FitzGerald, Frances. "The Shah Discovers His People." *New Times* 11, no. 12 (1979): 9.

Fleishhauer, Carl, and Beverly Brannan, eds. *Documenting America, 1935–1943*. Berkeley: University of California Press, 1988.

Fox, Stephen. *The Mirror Makers: A History of American Advertising and Its Creators*. New York: William Morrow, 1984.

Frank, Robert. *The Americans*. New York: Grossman, 1969.

———. "Robert Frank par Robert Frank." In *Robert Frank*. Paris: Centre National de la Photographie, 1983.

Frank, Robert, and Walker Evans. "Conversation." *Still /3*. New Haven: Yale University Program in Graphic Design, 1971.

Franklin, John Hope, ed. *Three Negro Classics*. New York: Avon, 1965.

———. *From Slavery to Freedom*. 4th ed. New York: Knopf, 1974.

Friedlander, Lee. *Factory Valleys: Ohio and Pennsylvania*. New York: Callaway Editions, 1982.

Fulbright, William. *The Arrogance of Power*. New York: Random House, 1966.

Fuller, John. *The Day We Bombed Utah*. New York: New American Library, 1984.

Gans, Herbert. *Popular Culture and High Culture*. New York: Basic Books, 1974.

Garfield, James. *President Garfield on Education*. Edited by B. A. Hinsdale. Boston: Osgood, 1882.

Garland, Harland. *Roadside Meetings*. New York: Macmillan, 1930.

Gassier, Pierre, and Juliet Wilson. *The Life and Complete Work of Francisco Goya*. Translated by Christine Hauch and Juliet Wilson. New York: Harrison House, 1981.

Gee, Helen. *Photography of the Fifties*. Tucson: University of Arizona/Center for Creative Photography, 1980.

Gilman, Daniel. "A Study in Black and White." In *Occasional Papers*. Baltimore: Trustees of the J. F. Slater Fund, 1897.

Goffman, Erving. *Gender Advertisements*. Cambridge: Harvard University Press, 1979.

Goldberg, Jim. *Rich and Poor*. New York: Random House, 1985.

Goldberg, Vicki. *Margaret Bourke-White: A Biography*. New York: Harper & Row, 1986.

———. *A World History of Photography*. New York: Abbeville Press, 1984.

Goodfriend, Arthur. *What Is America?* New York: Simon and Schuster, 1954.

Goodwyn, Lawrence. *The Populist Moment*. New York: Oxford University Press, 1978.

Gossett, Thomas F. *Race: The History of an Idea in America*. Dallas: Southern Methodist University Press, 1963.

Goulden, Joseph. *The Curtis Caper*. New York: G. P. Putnam, 1965.

Grierson, John. "The Story of the Documentary Film." *The Fortnightly* 152 (Aug. 1939): 121–30.

Griffith, Thomas. *The Waist-High Culture*. New York: Harper & Brothers, 1959.

Guimond, James. "Exotic Friends, Evil Others, and Vice Versa." *Georgia Review* 42 (Spring 1988): 33–69.

———. "Toward a Philosophy of Photography." *Georgia Review* 36 (Winter 1980): 755–800.

———. "The 'Vanishing Red': Photographs of Native Americans at Hampton Institute." *Princeton University Library Chronicle* 49 (Spring 1988): 235–55.

Gunn, Giles. *The Culture of Criticism and the Criticism of Culture*. New York: Oxford University Press, 1987.

Gutman, Judith Mara. *Lewis Hine 1874–1940: Two Perspectives*. New York: Grossman, 1974.

———. *Lewis W. Hine and the American Social Conscience*. New York: Walker, 1967.

Hales, Peter. *Silver Cities*. Philadelphia: Temple University Press, 1984.

Halleck, Fitz-Greene. "Connecticut." In *The Poetical Works of Fitz-Greene Halleck*. New York: Appleton, 1850.

Hallin, Daniel. *The "Uncensored War."* New York: Oxford University Press, 1986.

Hamblin, Dora. *That Was the Life*. New York: W. W. Norton, 1977.

"Hampton School Record." *Southern Workman* 28 (Dec. 1899): 496–98.

Hamrin, Robert. *America's New Economy*. New York: Franklin Watts, 1988.

———. "Sorry Americans—You're Still Not 'Better Off.'" *Challenge* 31 (Sept.–Oct. 1988): 51–52.

Hare, Chauncey. *Interior America*. Millerton, N.Y.: Aperture, 1978.

———. *This Was Corporate America*. Boston: Institute of Contemporary Art, 1984.

Harlan, Louis R. *Booker T. Washington: The Wizard of Tuskegee*. New York: Oxford University Press, 1983.

Hearn, Charles. *The American Dream in the Great Depression*. Westport, Conn.: Greenwood Press, 1977.

Heikel, Mohammed. *Iran: The Untold Story*. New York: Pantheon, 1982.

Herberg, Will. *Protestant, Catholic, Jew*. Garden City, N.Y.: Doubleday, 1955.

Hickok, Lorena. *One Third of a Nation: Lorena Hickok Reports on the Great Depression*. Edited by

Richard Lowitt and Maurine Beasley. Urbana: University of Illinois Press, 1981.

Hill, Paul, and Tom Cooper. "Camera-interview, Eugene Smith [part 2]." *Camera* 8 (Aug. 1978): 39–43.

Hill, Ronald J. *Lewis W. Hine: Child Labor Photographs*. Washington, D.C.: Lunn Gallery, 1980.

Hine, Lewis. *America and Lewis Hine*. Millerton, N.Y.: Aperture, 1977.

―――. "Child Labor in Gulf Coast Canneries." NCLC 158. 1911.

―――. "The Construction Camps of the People." *Survey* 23 (1 Jan. 1910), no pagination.

―――. "Hiding Behind the Work Certificate." *Survey* 31 (7 Mar. 1914): 691.

―――. "The High Cost of Child Labor." NCLC 241. 1915.

―――. "Illiterates in Massachusetts." *Survey* 32 (18 Apr. 1914): 69.

―――. *Men at Work*. New York: Dover, 1977.

―――. "Power Makers." *Survey* 47 (31 Dec. 1921): 511–18.

―――. "The Railroaders: Work Portraits." *Survey* 47 (29 Oct. 1921): 159–66.

―――. "Roving Children." *Survey* 23 (1 Jan. 1910),no pagination.

―――. "Social Photography: How the Camera May Help in the General Uplift." In *Proceedings of the National Conference of Charities and Corrections, Thirty-Sixth Annual Session*. Edited by Alexander Johnson. Fort Wayne, Ind.: Fort Wayne Printing Co., 1909.

―――. "Three Bits of Testimony for the Consumers of Shrimp and Oysters." *Survey* 31 (28 Feb. 1914): 663

Hine, Lewis, and Edward Brown. "The Child's Burden in Oyster and Shrimp Canneries." NCLC 193. 1913.

Hodges, Harold. *Social Stratification: Class in America*. Cambridge, Mass.: Schenkman, 1964.

Hofstadter, Richard. *The Age of Reform*. New York: Knopf, 1956.

Hoover, Dwight. "The Long Ordeal of Modernization Theory." In *Prospects*, vol. 11, edited by Jack Salzman. Cambridge: Cambridge University Press, 1987.

Hoover, Herbert. *The New Day: Campaign Speeches of Herbert Hoover, 1928*. Stanford: Stanford University Press, 1968.

Hopkinson, Tom. "'Introduction' to Scoop, Scandal, and Strife." In *Photography in Print*, edited by Vicki Goldberg. New York: Simon and Schuster, 1981.

Howe, Hartley. "You Have Seen Their Pictures." *Survey Graphic* 29 (Apr. 1940): 236–41.

Hurley, F. Jack. *Industry and the Photographic Image*. New York: Dover, 1980.

―――. *Portrait of a Decade: Roy Stryker and the Development of Documentary Photography in the Thirties*. Baton Rouge: Louisiana State University Press, 1972.

―――. *Russell Lee, Photographer*. Dobbs Ferry, N.Y.: Morgan and Morgan, 1978.

Immerman, Richard. *The CIA in Guatemala*. Austin: University of Texas Press, 1982.

Ingham, John. *The Iron Barons*. Westport, Conn.: Greenwood Press, 1978.

Inman, Samuel. "Imperialistic America." *Atlantic* 134 (July 1924): 107–16.

James, Henry. *The American Scene*. New York: Horizon, 1967.

James, William. *The Varieties of Religious Experience*. Cambridge: Harvard University Press, 1985.

Janis, Eugenia Parry, and Wendy MacNeil, eds. *Photography Within the Humanities*. Danbury, N.H.: Addison House, 1977.

Johnsen, Julia, ed. *Selected Articles on Child Labor*. New York: W. W. Wilson, 1925.

Johnson, Daniel, and Rex Campbell. *Black Migration in America*. Durham, N.C.: Duke University Press, 1981.

Johnson, William, ed. *The Pictures Are a Necessity: Robert Frank in Rochester, N.Y., November 1988*. Rochester: University Educational Services at George Eastman House, 1989.

Johnston, Frances. *The Hampton Album*. New York: Museum of Modern Art, 1966.

Judge, Jaquelyn. "F.S.A. Attacked." *Photo Notes* (Fall 1948): 4–8.

Jussim, Estelle. "Propaganda and Persuasion." In *Observations: Essays on Documentary Photography*, edited by David Featherstone, pp. 101–14. Carmel, Calif.: The Friends of Photography, 1984.

Kahler, Eric. *The Tower and the Abyss*. New York: George Braziller, 1957.

Karl, Barry. *The Uneasy State*. Chicago: University of Chicago Press, 1983.

Karnow, Stanley. *Vietnam*. New York: Viking, 1983.

Karp, Walter. "All the Congressmen's Men: How Capital Hill Controls the Press." *Harper's* 279 (July 1989): 55–63.

Katz, Leslie. "Interview with Walker Evans." In *The Camera Viewed: Writings on Twentieth Century Photography*, edited by Peninah R. Petruck, vol. 1. New York: E. P. Dutton, 1979.

Kipling, Rudyard. *Rudyard Kipling's Verse: Definitive Edition*. Garden City, N.Y.: Doubleday, 1946.

Klawens, Stuart. "Films." *Nation* (30 Oct. 1989): 505–7.

Klein, William. *Life Is Good and Good for You in New York: Trance Witness Revels*. Paris: Editions du Seuil, 1956.

―――. *William Klein: Photographs*. Profile by *John Heilpern*. Millerton, N.Y.: Aperture, 1981.

Kopkind, Andrew. "Films." *Nation* (1 Mar. 1986): 251–52.

Kotik, Charlotta. "Léger in America." In Fernand Léger, *Fernand Léger*. New York: Abbeville Press, 1962.

Krauthammer, Charles. "How to Save the Homeless Mentally Ill." *New Republic* (8 Feb. 1988): 23–25.

Krehm, Richard. *Democracies and Tyrannies of the Caribbean*. Westport, Conn.: Lawrence Hill, 1984.

Kytle, Calvin. "Roy Stryker: A Tribute." In *Roy Stryker: The Humane Propagandist*. Louisville, Ky.: Photographic Archives, University of Louisville, 1977.

LaFeber, Walter. *Inevitable Revolutions*. New York: W. W. Norton, 1983.

Lange, Dorothea, and Paul Taylor. *American Exodus*. New York: Reynal & Hitchcock, 1939.

Lears, T. J. Jackson. "Some Versions of Fantasy: Towards a Cultural History of American Advertising." *Prospects* 9. Edited by Jack Salzman. Cambridge: Cambridge University Press, 1984.

Leech, Margaret. *The Garfield Orbit*. New York: Harper & Row, 1978.

Lemagny, Jean Claude, and André Rouillé, eds. *A History of Photography: Social and Cultural Perspectives*. Translated by Janet Lloyd. Cambridge: Cambridge University Press, 1987.

Lerner, Max. *America as a Civilization*. New York: Simon and Schuster, 1957.

Lewisohn, Ludwig. *Expression in America*. New York and London: Harper & Brothers, 1932.

Leyburn, James. "The Problem of Ethnic and National Impact from a Sociological Point of View." In *Foreign Influences in American Life*, edited by David Bowers. Princeton: Princeton University Press, 1944.

Liebling, Jerome. *Jerome Liebling Photographs*. Amherst: University of Massachusetts Press, 1982.

Linkugle, Will, ed. *Contemporary American Speeches*, 4th ed. Dubuque, Iowa: Kendall/Hunt, 1978.

Lipset, Seymour. "The End of Ideology?" In *The End of Ideology Debate*, edited by Chaim Waxman. New York: Funk & Wagnalls, 1968.

Lipsitz, George. *Class and Culture in Cold War America*. South Hadley, Mass.: A. J. F. Bergin (Praeger Scientific), 1981.

―――. "The Meaning of Memory: Family, Class and Ethnicity in Early Network Television Programs." *Camera Obscura* 16 (Jan. 1988): 79–116.

Livermore, Charles. *Building the Community through Family Life*. Buffalo, N.Y.: Board of Community Relations, n.d. USIA Historical Collection.

Lloyd, Craig. *Aggressive Introvert: A Study of Herbert Hoover.* Columbus: Ohio State University Press, 1972.

Lovejoy, Owen. "The Cost of the Cranberry Sauce." *Survey* 25 (7 Jan. 1911): 605–10.

———. "In the Shadow of the Coal Breaker." NCLC 61. 1907.

Luce, Clare Booth. "America in the Golden Age." Transcript of Interview by Bill Moyers. In PBS Documentary "A Walk Through the Twentieth Century."

Luce, Henry. *The Ideas of Henry Luce.* Edited by John Jessup. New York: Atheneum, 1969.

———. "Prospectus." In Editors of Time-Life Books, *The Best of Life.* New York: Time, Inc., 1973.

Lynn, Kenneth. *The Dream of Success.* Boston: Little, Brown, 1955.

McCausland, Elizabeth. "Portrait of a Photographer." *Survey Graphic* 27 (Oct. 1938): 502–5.

McElvaine, Robert. *The Great Depression: America, 1929–1941.* New York: Times Books, 1984.

Mack, Andrew. "Crisis in the Other Alliance." *World Policy Journal* 3 (Summer 1986): 447–72.

McKelway, A. J. "Child labor in Georgia." NCLC 138. 1910.

———. "Child Labor in Mississippi." NCLC 169. 1911.

———. "Child Labor in Tennessee." NCLC 150. 1911.

———. "Child Labor in the Carolinas." NCLC 92. 1909.

———. "Declaration of Dependence." *Child Labor Bulletin* 2 (Aug. 1913): 43.

MacLeish, Archibald. *Land of the Free.* 1938. Reprint. New York: DaCapo Press, 1977.

McLuhan, Marshall. "Time, Life, and Fortune." *View* (Spring 1947): 33–37.

Macmillan, Harold. *Politics and War in the Mediterranean, January 1943–May 1945.* London: Macmillan, 1984.

Madden, David, ed. *American Dreams, American Nightmares.* Carbondale: Southern Illinois University Press, 1970.

Maddow, Ben. *Let Truth Be the Prejudice: W. Eugene Smith, His Life and Work.* Millerton, N.Y.: Aperture, 1986.

Magnum Photos, Inc. *The Fifties: Photographs of America.* New York: Pantheon, 1985.

Maharidge, Dale, and Michael Williamson. *Journey to Nowhere.* Garden City, N.Y.: Dial Press/Doubleday, 1985.

Malmsheimer, Lonna. " 'Imitation White Men': Images of Transformation at the Carlisle Indian School." Paper presented at a conference, The Photograph and the American Indian. Princeton University, Sept. 1985.

Mangold, George. *Problems of Child Welfare.* New York: Macmillan, 1924.

Marcuse, Peter. "Why Are They Homeless?" *Nation* (4 Apr. 1987): 426–29.

Marichal, Juan. "Some Intellectual Consequences of the Spanish Civil War." *Texas Quarterly* 4 (Spring 1961): 39–47.

Marin, Peter. "Helping and Hating the Homeless." *Harper's* 274 (Jan. 1987): 39–49.

Marling, Karal. *Wall-to-Wall America.* Minneapolis: University of Minnesota Press, 1982.

Marquis, Alice. *Hopes and Ashes.* New York: The Free Press, 1986.

Marx, Leo. *The Machine in the Garden.* New York: Oxford University Press, 1964.

———. *The Pilot and the Passenger.* New York: Oxford University Press, 1988.

Mast, Gerald. *A Short History of the Movies.* Indianapolis: Bobbs-Merrill, 1981.

Mattison, Harry, Susan Meiselas, and Fae Rubenstein, eds. *El Salvador.* New York and London: Writers and Readers, 1983.

May, Elaine Tyler. *Homeward Bound: American Families in the Cold War Era.* New York: Basic Books, 1988.

Mead, Margaret. *And Keep Your Powder Dry.* New York: William Morrow, 1943.

Meiselas, Susan. *Nicaragua.* New York: Pantheon, 1981.

Melot, Michel. "Landscape of the Body." Review of *Le Corps et son Image*, by André Rouillé. *Radical History Review* 38 (1987): 72–77.

Meltzer, Milton. *Dorothea Lange: A Photographer's Life*. New York: Farrar, Straus and Giroux, 1978.

Mich, Daniel, and Edwin Eberman. *The Technique of the Picture Story*. New York: McGraw-Hill, 1945.

Miliani, Dom Lorenzo. "Letter to Dom Pierre." *Texas Quarterly* 4 (Summer 1961): 175–96.

Miller, Douglas, and Marion Nowak. *The Fifties*. Garden City, N.Y.: Doubleday, 1977.

Millikan, Max, and W. W. Rostow. *A Proposal: Key to an Effective Foreign Policy*. New York: Harper & Brothers, 1957.

Moon, Parker Tyler. *Imperialism and World Politics*. New York: Macmillan, 1926.

Moore, Michael. "In Flint, Tough Times Last." *Nation* (6 June 1987): 753–56.

Mumford, Lewis. *The Golden Day*. Boston: Beacon, 1957.

Nash, Gerald. *The American West Transformed*. Bloomington: Indiana University Press, 1985.

National Child Labor Committee. *Rural Child Welfare*. New York: Macmillan, 1922.

Nevins, Allan. *James Truslow Adams: Historian of the American Dream*. Urbana: University of Illinois Press, 1968.

Newhall, Beaumont. "A Backward Glance at Documentary." In *Observations*, edited by David Featherstone. Carmel, Calif.: Friends of Photography, 1984.

———. "Documentary Approach to Photography." *Parnassus* 10 (Mar. 1938): 3–6.

———, ed. *Photography: Essays and Images*. New York: Museum of Modern Art, 1980.

"New York Criticism." *Art Digest* 9 (15 Feb. 1935): 16.

Nisbet, Robert A. *Social Change and History*. New York: Oxford University Press, 1969.

Nye, David. *Image Worlds: Corporate Identities at General Electric, 1890–1930*. Cambridge: MIT Press, 1985.

Oakley, J. Ronald. *God's Country: America in the Fifties*. New York: Dembner Books, 1986.

Ohrn, Karin. *Dorothea Lange and the Documentary Tradition*. Baton Rouge: Louisiana State University Press, 1980.

Orwell, George. *1984*. New York: New American Library, 1961.

"Our Country and Our Culture." *Partisan Review* 19 (May–June 1952): 282–326.

Owens, Bill. *Documentary Photography: A Personal View*. Danbury, N.H.: Addison House, 1978.

———. *Suburbia*. San Francisco: Straight Arrow Books, 1973.

Owens, Craig. "The Discourse of Others: Feminists and Postmodernism." In *The Anti-Aesthetic*, edited by Hal Foster. Port Townsend, Wash.: Bay Press, 1987.

Palfi, Marion. *Invisible in America*. Lawrence: University of Kansas Museum, 1973.

Papageorge, Tod. *Walker Evans and Robert Frank: An Essay on Influence*. New Haven: Yale University Art Gallery, 1981.

"The Paris Exhibit." *Southern Workman* 29 (Jan. 1900): 8–9.

Peeler, David. *Hope Among Us Yet*. Athens: University of Georgia Press, 1987.

Perkins, Frances. *The Roosevelt I Knew*. New York: Viking, 1946.

Perlo, Victor. "'People's Capitalism' and Stock Ownership." *American Economic Review* 48 (June 1958): 333–47.

Peterson, Peter. "The Morning After." *Atlantic* 260 (Oct. 1987): 43–69.

Petruck, Peninah R., ed. *The Camera Viewed: Writings on Twentieth Century Photography*, vol. 1. New York: E. P. Dutton, 1979.

Philbrick, Thomas. *St. John de Crèvecoeur*. New York: Twayne, 1970.

Photo League. *Photo Notes: Special Issue* (Jan. 1948): 1–8.

Pitts, Terence. *Photography in the American Grain: Discovering a Native American Aesthetic, 1923–1941*. Tucson: University of Arizona/Center for Creative Photography, 1988.

Potter, David. *People of Plenty*. Chicago: University of Chicago Press, 1954.

Pound, Arthur. *Industrial America*. Boston: Little, Brown, 1936.

"Racial Self-Restraint." *The Outlook* 84 (3 Nov. 1906): 308–10.

Rahv, Philip. *Literature and the Sixth Sense*. Boston: Houghton Mifflin, 1969.

Ratcliffe, S. K. "Hard Times in America." *Contemporary Review* 137 (June 1931): 702–9.

Render, Sylvia Lyons. *The Short Fiction of Charles W. Chesnutt*. Washington, D.C.: Howard University Press, 1974.

Riis, Jacob. *The Children of the Poor*. In *Jacob Riis Revisited*. Garden City, N.Y.: Anchor Books/Doubleday, 1968.

———. *How the Other Half Lives*. New York: Scribners, 1892.

Roosevelt, Franklin D. *Franklin D. Roosevelt: Selected Speeches*. Edited by Basil Rauch. New York: Holt, Rinehart and Winston, 1957.

Rosenberg, Emily. *Spreading the American Dream*. New York: Hill and Wang, 1982.

Ross, Edward. *The Old World in the New*. New York: Century, 1914.

Rothstein, Arthur. *The Depression Years as Photographed by Arthur Rothstein*. New York: Dover, 1978.

———. *Documentary Photography*. Boston: Focal Press, 1986.

Rowell, Galen. *Mountains of the Middle Kingdom*. San Francisco: Sierra Club Books, 1983.

Rudwick, Elliott. *W. E. B. Du Bois: Propagandist of the Negro Protest*. New York: Atheneum, 1968.

Ryan, Michael, and Douglas Kellner. *Camera Politica*. Bloomington: Indiana University Press, 1988.

Sandeen, Eric. "The Family of Man at the Museum of Modern Art: The Power of the Image in 1950s America." *Prospects* 11. Edited by Jack Salzman. Cambridge: Cambridge University Press, 1987.

Sarnoff, David. "The Fabulous Future." In Editors of Fortune, *The Fabulous Future*. New York: E. P. Dutton, 1955.

Scharnhorst, Gary. *Horatio Alger, Jr.* Boston: Twayne, 1980.

Scharnhorst, Gary, and Jack Bales. *The Lost Life of Horatio Alger*. Bloomington: Indiana University Press, 1985.

Schlesinger, Arthur, Jr. *The Coming of the New Deal*. Boston: Houghton Mifflin, 1959.

Schlesinger, Stephen, and Stephen Kinzer. *Bitter Fruit*. Garden City, N.Y.: Doubleday, 1982.

Schudson, Michael. *Advertising: The Uneasy Profession*. New York: Basic Books, 1984.

Seixas, Peter. "Lewis Hine: From 'Social' to 'Interpretive' Photographer." *American Studies* 39 (Fall 1987): 381–409.

"Self Help and Self Activity." *Southern Workman* 28 (Jan. 1899): 5–7.

Shapiro, Herbert, ed. *The Muckrakers and American Society*. Lexington, Mass.: D. C. Heath, 1968.

Shover, John. *Cornbelt Rebellion*. Urbana: University of Illinois Press, 1965.

Sitompoel, Harris. "Capitalism in America: An Indonesian View." USIA pamphlet, n.d.

Smith, Henry. *Virgin Land*. New York: Vintage Books, 1950.

Snyder, Don. "Mixing Media." *Photo-Communiqué* 9 (Spring 1987): 28–36.

Solomon-Godeau, Abigail. "Beyond the Simulation Principle." In *Utopia: Post Utopia*. Boston: Institute of Contemporary Art, 1988.

Sontag, Susan. *On Photography*. New York: Farrar, Straus and Giroux, 1977.

Spargo, John. *Child Slaves in Free America*. New York: Comrade Publishing Co., 1906.

Squiers, Carol. "Looking at *Life*." *Art Forum* (Dec. 1981): 59–66.

Steel, Ronald. *Walter Lippmann and the American Century*. Boston: Little Brown, 1980.

Stegner, Wallace. *One Nation*. Boston: Houghton, 1945.

Steichen, Edward. *The Family of Man*. New York: Museum of Modern Art, 1955.

_____. "The F.S.A. Photographers." In *U.S. Camera 1939*, edited by T. J. Maloney. New York: William Morrow, 1938. Partially reprinted in Newhall, Beaumont, ed. *Photography: Essays and Images*. New York: Museum of Modern Art, 1980.

Stephens, Oren. "FSA Fights for Its Life." *Harper's* 186 (Apr. 1943): 479–87.

Stott, William. *Documentary Expression and Thirties America*. New York: Oxford University Press, 1973.

_____. "Introduction to a Never-Published Book of Dorothea Lange's Best Photographs of Depression America." *Exposure* 22 (Fall 1984): 22–30.

Strand, Paul. *Paul Strand: Sixty Years of Photographs*. Millerton, N.Y.: Aperture, 1976.

"Street-Workers." NCLC 246. 1915.

Stryker, Roy. "Documentary Photography." In *The Encyclopedia of Photography*, edited by Willard Rouse. New York: National Educational Alliance, 1949.

Stryker, Roy, and Nancy Wood. *In This Proud Land*. New York: Galahad Books, 1973.

Suchen, June, ed. *The Black Man and the American Dream*. Chicago: Quadrangle, 1971.

Suntop, Lionel. "Lewis Hine: 1874–1940." *Creative Camera International Year Book 1976*. London: Coos Press, 1975.

Susman, Warren. *Culture as History*. New York: Pantheon, 1984.

_____. "The Thirties." In *The Development of an American Culture*, edited by Stanley Coben and Lorman Ratner. Englewood Cliffs, N.J.: Prentice-Hall, 1970.

_____, ed. *Culture and Commitment, 1929–1945*. New York: George Braziller, 1973.

Szarkowski, John. *Mirrors and Windows: American Photography Since 1960*. New York: Museum of Modern Art, 1979.

_____. "Understanding Atget." In *The Work of Atget*, vol. 4. New York: Museum of Modern Art, 1985.

Ten Years' Work for the Indians. Hampton, Va.: Hampton Normal and Agricultural Institute, 1888.

Terkel, Studs. *American Dreams Lost and Found*. New York: Pantheon, 1980.

_____. *Hard Times*. New York: Pantheon, 1986.

Thompson, E. P. *The Making of the English Working Class*. London: Victor Gollanz, 1963.

Thompson, Jerry. "Walker Evans: Some Notes on His Way of Working." In *Walker Evans at Work*. New York: Harper & Row, 1982.

Thomson, James, Jr., Peter Stanley, and John Perry. *Sentimental Imperialists*. New York: Harper & Row, 1981.

Torrence, Ridgely. *The Story of John Hope*. New York: Macmillan, 1948.

Trachtenberg, Alan. "Camera Work: Notes toward an Investigation." In *Photography: Current Perspectives*, edited by Jerome Liebling. Rochester, N.Y.: Light Impressions, 1978.

_____. *The Incorporation of America*. New York: Hill and Wang, 1982.

_____. "Walker Evans' America: A Documentary Invention." In *Observations*, edited by David Featherstone. Carmel, Calif.: Friends of Photography, 1984.

_____, ed. *Classic Essays on Photography*. New Haven, Conn.: Leete's Island Books, 1980.

Trask, David. "A Note on Fitzgerald's *The Great Gatsby*." *University Review* 33 (Spring 1967): 197–202.

Trattner, Walter. *Crusade for the Children*. Chicago: Quadrangle, 1970.

Travis, David. *Walker Evans: Leaving Things as They Are*. Chicago: The Art Institute of Chicago, 1987.

Trilling, Lionel. *The Liberal Imagination*. New York: Viking, 1951.

Tucker, Anne, ed. *Robert Frank: New York to Nova Scotia*. Houston: Museum of Fine Arts, 1986.

Tugwell, Rexford. *The Stricken Land*. Garden City, N.Y.: Doubleday, 1947.

Tugwell, Rexford, Thomas Munro, and Roy Stryker. *American Economic Life*. New York: Harcourt, Brace, 1925.

Twenty-two Years' Work of the Hampton Normal and Agricultural Institute. Hampton, Va.: Normal School Press, 1893.

USIA (United States Information Agency). "Atomic Power for Peace." n.d.

————. "The Atomic Revolution." n.d.

————. "Consumer Capitalism in Action." [ca. 1953].

————. "Partners in World Progress." n.d.

————. "A People Moves Ahead/Puerto Rico: The Land and the People." Typescript, n.d.

————. "People's Capitalism: the United States Economy in Evolution." Supplement to *Free World* 6 (Jan. 1957).

————. "Progress on the Land." n.d.

Vachon, John. "Tribute to a Man, an Era, an Art." *Harper's* 247 (Sept. 1973): 96–99.

Van DerZee, James. *The World of James Van DerZee*. New York: Grove Press, 1969.

Van Gennep, Arnold. *The Rites of Passage*. Translated by Monika Vizedom and Gabrielle Caffee. Chicago: University of Chicago Press, 1960.

Von Neumann, John. "Can We Survive Technology?" In Editors of Fortune, *The Fabulous Future*. New York: E. P. Dutton 1955.

Walker, Francis A. "Restriction of Immigration." *Atlantic Monthly* 73 (July 1892): 822–29.

Walker, John. "Reflections on a Photograph by Margaret Bourke-White." *Creative Camera* 167 (May 1978): 148–49.

Wallace, Henry. "America Tomorrow: Common Man Economics." *Vital Speeches* 9 (Aug. 1, 1943): 610–13..

————. *New Frontiers*. New York: Reynal & Hitchcock, 1934.

Wallis, Brian, ed. *Art After Modernism: Rethinking Representation*. Boston: David Godine, 1989.

Ward, Lester F. *The Psychic Factors of Civilization*. Boston: Ginn & Company, 1893.

Warren, Harris. *Herbert Hoover and the Great Depression*. New York: Oxford University Press, 1959.

Washington, Booker T. "The Successful Training of the Negro." *The World's Work* 6 (Aug. 1903): 3731–51.

————. *Up From Slavery*. In *Three Negro Classics*, edited by John Hope Franklin. New York: Avon, 1965.

Waxman, Chaim, ed. *The End of Ideology Debate*. New York: Funk & Wagnalls, 1968.

Weegee [Arthur Fellig]. *Naked City*. New York: Essential Books, 1945.

Weinberg, Arthur, and Lila Weinberg, eds. *The Muckrakers*. New York: Capricorn Books, 1964.

Wells, H. G. *The Future in America: A Search After Realities*. New York: Harper & Brothers, 1906.

Whelan, Richard. *Double Take: A Comparative Look at Photographs*. New York: Clarkson N. Potter, 1981.

White, Minor. "Les Américains." *Aperture* 7, no. 3 (1959): 127.

Wilcox, Walter Francis. "Negroes in the United States." *Encyclopedia Britannica*. 11th ed. New York, 1910–1911.

Williams, Raymond. "Literature *in* Society." In *Contemporary Approaches to English Studies*, edited by Hilda Schiff. London: Heinemann, 1977.

Williams, Rosalind. *Dream Worlds*. Berkeley: University of California Press, 1982.

Williamson, Glenn. "Life Magazine's 'Country Doctor': The Photo-essay as Ideological Tool." Paper presented at the 1987 American Studies Association annual meeting.

Willis, H. Parker. "The Findings of the Immigration Commission." *Survey* 15 (7 Jan. 1911): 571–78.

Willkie, Wendell. *One World.* 1943. Reprint. Urbana: University of Illinois Press, 1966.

Wilson, Edmund. *Axel's Castle.* New York: Scribner's, 1931.

———. *I Thought of Daisy.* New York: Farrar, Straus and Giroux, 1967.

Wilson, Woodrow. *History of the American People.* 5 vols. New York: Harper & Brothers, 1902.

Winslow, Susan. *Brother Can You Spare a Dime?* New York: Paddington Press, 1976.

Wise, Gene. *American Historical Explanations: A Strategy for Grounded Inquiry.* Homewood, Ill.: Dorsey Press, 1973.

Wolters, Raymond. *The New Negro on Campus: Black College Rebellions of the 1920s.* Princeton: Princeton University Press, 1975.

Woodward, C. Vann. *Origins of the New South, 1877–1913.* Baton Rouge: Louisiana State University Press, 1951.

Zangwill, Israel. *The Melting Pot.* Rev. ed. New York: Macmillan, 1914.

Newspapers, Advertisements, and Mass-Circulation Magazines

"Air Age." *Life*, 18 June 1956.

Alexander, Shana. "What Is the Truth of the Picture?" *Life*, 1 Mar. 1968.

"All-America Cities." *Look*, 9 Feb. 1954.

Allen, Frederick Lewis. "What Have We Got?" *Life*, 5 Jan. 1953.

"The Amenia Conference." *New York Age*, 7 Sept. 1916.

"The American Ambassador Sailed in the Hold." Advertisement. *Life*, 25 Nov. 1946.

"The American and His Economy." *Life*, 5 Jan. 1953.

"An American City's Dream." *Life*, 7 July 1947.

"American Life and Times." *Life*, 2 Jan. 1950.

"The American Newsfront: Negro Killed in Row over $10." *Life*, 7 Feb. 1938.

"American Production." *Life*, 4 Oct. 1948.

"An American Proposal." *Fortune*, May 1942.

"American Workingman." *Fortune*, Aug. 1931.

"America's Assets." *Life*, 1 Jan. 1951.

"Atomic Miracles We Will See." *Look*, 25 Aug. 1953.

"Atom Power for Homes in Five Years." *U.S. News*, 25 June 1954.

Attwood, William. "A New Look at America." *Look*, 12 July 1955.

"Babies and Biscuits in the Jungle." *Look*, 26 Nov. 1957.

"The Battle for America." *Fortune*, Aug. 1941.

Berle, Adolf. "And What Shall We Do Then?" *Fortune*, Oct. 1941.

Bidwai, Praful. "Reaganism's Impact." *World Press Review*, Aug. 1985.

Boffey, Philip. "Space Agency Image: A Sudden Shattering." *New York Times*, 5 Feb. 1986.

"Bosses Murdered Worker, Judge Rules." Trenton *Times*, 15 June 1985.

Bouchier, David. "The Great Greed of 1987." *New Statesman*, 12 June 1987.

Brummer, Alec. "America's Space Dream Turns into Nightmares." *Manchester Guardian Weekly*, 10 Jan. 1986.

"Business Prepares to Tell Its Story." *Literary Digest*, 22 Aug. 1936.

"The Camera Overseas: 'A Week of Hell' in Nanking." *Life*, 10 Jan. 1938.

"Champ Rider." *Life*, 22 Oct. 1951.

Chase, Stuart. "Danger at the A. O. Smith Corporation." *Fortune*, Nov. 1930.

"Coed from the Hills." *Life*, 13 Oct. 1952.

Collin, Dorothy. "Anxiety Unknown Factor in Election." *Chicago Tribune*, 31 July 1988.

Colton, F. Barrows. "Man's New Servant, the Friendly Atom." *National Geographic*, Jan. 1954.

"The Company of Smiling Employees." *Life*, 5 Jan. 1953.

Congoleum advertisement. *Look*, 29 May 1956.

Corry, John. "T.V.'s Legacy from the Vietnam War." *New York Times*, 21 Apr. 1985.

"The Cost of Being an American." *Fortune*, Jan. 1952.

Cowles, Gardner. "What the Public Thinks about Big Business." *Look*, 8 Feb. 1955.

Craven, Thomas. "John Steuart Curry." *Scribner's Magazine*, Jan. 1938.

Cronkite, Walter. "Echoes of Agnew." *Christian Science Monitor*, 11 May 1982.

"The Cruel Chinese." *Life*, 28 Dec. 1936.

"Cuckooland: Screwy California May Be the Future Athens of America." *Life*, 21 Nov. 1938.

"Dead Zones." *U.S. News*, 10 Apr. 1989.

"Death in Spain." *Life*, 12 July 1937.

"Detroit Has a Race Riot." *Life*, 16 Mar. 1942.

Dobell, Byron. "Feature Pictures: Robert Frank: The Photographer as Poet." *U.S. Camera*, Sept. 1954.

Doherty, Robert. "Farm Security Photographs of the Depression Era." *Camera*, Oct. 1962.

"Dreams of 1946." *Life*, 25 Nov. 1946.

Drew, Elizabeth. "A Political Journal." *New Yorker*, 13 Aug. 1984.

"A Dying Moose Makes a Great Hunting Picture." *Life*, 28 Nov. 1938.

"An Editorial." *Look*, 14 May 1968.

Edwards, Jackson. "One Every Minute." *Scribner's Magazine*, May 1938.

"Eisenhower Visits Capitalism Show." *New York Times*, 14 Feb. 1956.

"The End of a 12-Day Civil War." *Life*, 12 July 1954.

Erlanger, Steven. "Atlantic City: Failure Behind the Facade." *New York Times*, 29 Aug. 1988.

Eskay's and Nestle's baby food advertisements. *Ladies' Home Journal*, Apr. 1910.

Evans, Walker. "Beauties of the Common Tool." *Fortune*, July 1955.

———. "Before They Disappear." *Fortune*, Mar. 1957.

———. "The Congressional." *Fortune*, Nov. 1955. (Text by Evans; 10 photographs by Robert Frank.)

———. "Downtown, A Last Look Backward." *Fortune*, Oct. 1956.

———. "Imperial Washington: A Portfolio by Walker Evans." *Fortune*, Feb. 1952.

———. "Labor Anonymous." *Fortune*, Nov. 1946.

———. "People and Places in Trouble." *Fortune*, Mar. 1961.

———. "Those Dark Satanic Mills: A Portfolio by Walker Evans." *Fortune*, Apr. 1956.

———. "The U.S. Depot." *Fortune*, Feb. 1953.

———. "Vintage Office Furniture." *Fortune*, Aug. 1953.

"Family of Man." *Life*, 14 Feb. 1955.

"Fiction in the U.S." *Life*, 16 Aug. 1948.

"The Flood Leaves Its Victims on the Bread Line." *Life*, 15 Feb. 1937.

"Food." *Life*, 3 Jan. 1955.

"Foreign Aid Repaid." *Time*, 20 May 1957.

"Fortune: How to Succeed." Advertisement. *New York Times*, 6 Apr. 1982.

Freitag, Michael. "Thousands of Children Doing Adult Work." *New York Times*, 5 Feb. 1990.

"From DP to College Queen." *Life*, 15 Dec. 1952.

"Frontiers of Technology." *Life*, 7 Oct. 1957.

Furey, Edward. "What American Dream?" *New York Times*, 8 Feb. 1983.

Gevaret film advertisement. "The Family of Man." *Les Beaux-Arts*, special issue. (French brochure for the exhibit.) USIA Historical Collection.

"GM to Close Framingham Plant." *Boston Globe*, 5 Nov. 1987.

Grape Nuts Flakes advertisement. *Ladies' Home Journal*, 1 Oct. 1910.

Graves, William. "Iran: Desert Miracle." *National Geographic*, Jan. 1975.

"He Photo-interprets Big Labor." *Mentor*, 14 Sept. 1926.

Hersey, John. "A Reporter at Large: Homecoming." *New Yorker*, 17 May 1982.

"A High Tide of Homelessness Washes over City Agencies." *New York Times*, 25 Mar. 1984.

Hirsch, Alfred. "What Is Big Business Up To?" *Forum*, July 1938.

"A Historic Week of Civil Strife." *Life*, 7 Oct. 1957.

"Hollywood Keeps Fit." *Life*, 10 Jan. 1938.

Hooker, Jim. "Housing Outlook Dim in N.J." Trenton *Times*, 28 Apr. 1988.

"How to Make Money out of the Atom." *U.S. News*, 13 Aug. 1954.

Hurley, F. Jack. "Pie Town, N.M., 1940." *American Photographer*, Mar. 1983.

"Indo-China: Another Place Where Reds Are Losing." *U.S. News*, 1 Mar. 1957.

"Industry Looks Ahead." *Business Week*, 12 Dec. 1936.

"Industry's New Frontier." *Life*, 4 Oct. 1948.

"Iran: Revolution from the Throne." *Time*, 6 Oct. 1967.

"Irish Country People." *Life*, 21 Mar. 1955.

"I've Been to the Mountain." *Life*, 12 Apr. 1968.

"John Curry." *Life*, 18 Dec. 1939.

Johnson, Haynes. "Resurrection of Coolidge." *Washington Post*, 7 June 1981.

Johnston, Frances. "Through the Coal Country with a Camera." *Demorest's Family Magazine*, 26 Mar. 1892.

———. "What a Woman Can Do with a Camera." *Ladies' Home Journal*, 11 Sept. 1897.

Jordan, William. "The Greatest Nation on Earth." *Ladies' Home Journal*, July 1897.

Kilborn, Peter. "Playing Games with Labor Laws: When Work Fills a Child's Hours." *New York Times*, 10 Dec. 1989.

Kobler, John. "Sam the Banana Man." *Life*, 19 Feb. 1951.

"Koch Joins the Barrage of Criticism against UN Delegates." *Washington Post*, 27 Sept. 1983.

Koether, George. "The Great American Automobile." *Look*, 27 Nov. 1956.

Kozol, Jonathan. "A Reporter at Large: The Homeless." *New Yorker*, 1 Feb. 1988.

Lardner, John. "Rich, Richer; Poor, Poorer." *New York Times*, 19 Apr. 1989.

"Leashed A-Bombs Do Tricks for Atom Tamers." *Popular Science*, Oct. 1953.

Lee, Russell. "Pie Town, New Mexico." *U.S. Camera*, Oct. 1941.

"Leisure Could Mean a Better Civilization." *Life*, 28 Dec. 1959.

"*Life* Announces the Winners of the Young Photographers Contest." *Life*, 26 Nov. 1951.

"*Life* Goes to the Futurama." *Life*, 5 June 1939.

"Lord of the Doves." *Newsweek*, 17 Apr. 1967.

MacArthur, Douglas. "A Fourth of July Message." *Life*, 7 July 1947.

Maddocks, Melvin. "It's Fantastic to Be an American." *Christian Science Monitor*, 29 Jan. 1981.

"Memorable and Beautiful." *Life*, 13 Oct. 1952.

"Middle-Class Squeeze." *U.S. News*, 18 Aug. 1986.

"A Mideast 'Victory' for U.S.—The Boom in Iran." *U.S. News*, 27 Jan. 1969.

Mintz, John. "Complaints Pursue N.J. Building Empire." Trenton *Times*, 15 June 1980.

"A Modern Monarch on the Peacock Throne." *Life*, 14 Jan. 1966.

Moffett, Hugh. "Dust Bowl Farmer." *Life*, 28 July 1947.

"More Young Women and Children Joining the Ranks of the Homeless." *Philadelphia Inquirer*, 22 Nov. 1985.

"The Most Famous Legs in History." *Life*, 3 Jan. 1938.

"The N.A.M. Declares War." *Business Week*, 14 Dec. 1935.

Nash advertisement. *Life*, 30 Jan. 1956.

Nevins, Allan. "The Audacious Americans." *Life*, 2 Jan. 1950.

Newhouse, John. "Annals of Intelligence (Terrorism)." *New Yorker*, 10 July 1989.

"New Latin Boom Land." *Life*, 13 Sept. 1954.

"A New Puerto Rico Shows Off." *Life*, 24 Jan. 1949.

"News Pictures Ignore Profits and Loss." *Fortune*, Sept. 1930.

"N.Y. Officials Say Crack Now Their Top Drug Problem." Trenton *Times*, 7 Aug. 1986.

"Niagara Hudson: Exhibit A of Superpower." *Fortune*, June 1931.

"The Nightgown Becomes an Evening Dress." *Life*, 3 Jan. 1938.

Norton Company advertisement. *Fortune*, Feb. 1930.

"Operation Bootstrap Score: 400th New Factory." *Life*, 21 May 1956.

Osborne, John. "The Tough Miracle Man of Vietnam." *Life*, 13 May 1957.

"Our America." *Newsweek*, 4 July 1976.

Owens, Bill. "The Sun Belt." *Newsweek*, 4 July 1976.

Peale, Norman Vincent. "Norman Vincent Peale Answers Your Questions." *Look*, 5 Apr. 1955.

Peress, Gilles. Interview with Miriam Horn. *U.S. News*, 9 Nov. 1987.

Persico, Joyce. Review of *Scarface*. Trenton *Times*, 20 Jan. 1984.

Peterson, Iver. "Congress Is Urged to Help Homeless." *New York Times*, 16 Dec. 1982.

Pilger, John. "Frogmarched into Slavery." *New Statesman*, 20 Aug. 1982.

Pilger, John, and David Munro. "U.S. Help to Pol Pot." *Manchester Guardian Weekly*, 14 Dec. 1986.

"Prejudice: Our Postwar Battle." *Look*, 1 May 1945.

"Presenting: The $15,000 Trade Secrets House." *Life*, 5 Jan. 1953.

"The Presidency: Wonderful Turnout." *Time*, 15 May 1939.

"Puerto Rico: Senate Investigating Committee Finds It an Unsolvable Problem." *Life*, 8 Mar. 1943.

Purgavie, Dermot. "Flint's Bizarre Story on Film and in Real Life." Trenton *Times*, 15 Oct. 1989.

Quaker Oats advertisements. *Saturday Evening Post*, 19 Nov. 1910, and *Ladies' Home Journal*, 15 Nov. 1910.

"Race War in Detroit." *Life*, 5 July 1943.

"Reds' Priority: Pin War on U.S." *Life*, 5 July 1954.

"The Reign of Chemistry." *Life*, 5 Jan. 1953.

"Return of a Classic." *Newsweek*, 4 Dec. 1978.

"Revolving Door Court." *Life*, 23 Sept. 1957.

"Richard Gets His Chance." *Life*, 1 Dec. 1952.

Rosenzweig, Luc. "Crash of Dropped Clangers Leaves Kohl Unperturbed." *Manchester Guardian Weekly*, 11 Jan. 1987.

Sgt. Slaughter advertisements. Trenton *Times*, 29 Aug. 1986, 26 Sept. 1986.

Schmidt, William. "Rise in Poverty Is Grim Side of Minneapolis Boom." *New York Times*, 15 Sept. 1988.

"A Segregated Life." *Life*, 24 Sept. 1956.

"Senator on Warpath." *Life*, 7 June 1948.

Serrin, William. "Grim Holiday Spirits in a Steel Town." *New York Times*, 24 Dec. 1984.

Sheppard, Nathaniel, Jr. "More People Being Priced Out of the American Dream." *Chicago Tribune*, 29 July 1988.

Sischy, Ingrid. "Photography: Belief." *New Yorker*, 22 May 1989.

"Skyscrapers." *Fortune*, July 1930.

"Skyscrapers: Builders and Their Tools." *Fortune*, Oct. 1930.

"A Small Town's Saturday Night." *Life*, 2 Dec. 1940.

Smith, W. Eugene. "One Whom I Admire, Dorothea Lange." *Popular Photography*, Feb. 1966.

"Speaking of Pictures: This is Mural America for Rural Americans." *Life*, 4 Dec. 1939.

Spiegel advertisement. "Shining Examples of the Brighter Life." *Life*, 18 June 1956.

SPX Corporation and Hardee's advertisements. *Muskegon Chronicle*, 31 July 1988.

Star, Jack. "All-America Cities." *Look*, 8 Feb. 1955.

Stock, Dennis. "New Home for the Homeless." *Life*, 26 Nov. 1951.

Swanstrom, Todd. "Homeless: A Product of Policy." *New York Times*, 23 Mar. 1989.

"Telling It As It Is." *Newsweek*, 20 Mar. 1967.

"Tenth Anniversary Issue: The U.S. in 1946." *Life*, 25 Nov. 1946.

"Texas Takes a Tumble." *U.S. News*, 21 Apr. 1986.

"Thank Heaven for Puerto Rico." *Life*, 15 Mar. 1954.

"They Live with Atomic Food." *Look*, 7 Feb. 1956.

"The 30,000 Managers." *Fortune*, Aug. 1941.

"This Pleasant Land." *Life*, 7 July 1947.

"Three Dead Americans." *Life*, 20 Sept. 1943.

"Three Mormon Towns." *Life*, 6 Sept. 1954.

Tichi, Cecelia. "Jesters in Journalism." *Christian Science Monitor*, 14 Nov. 1980.

Tolchin, Martin. "Richest Got Richer and Poorest Poorer in 1979–87." *New York Times*, 23 Mar. 1989.

"Treating Labor Artistically." *Literary Digest*, 4 Dec. 1920.

"USA 'Selling Off Real Wealth.' " *USA Today*, 28 July 1988.

"U.S. Gets a Look at Fulgencio Batista." *Life*, 21 Nov. 1938.

"U.S. Growth." *Life*, 4 Jan. 1954.

"The Vice-Presidency." *Time*, 31 Aug. 1962.

Walker, Martin. "Not So Evil, Very Much an Empire." *Manchester Guardian Weekly*, 11 Oct. 1987.

Wall Street Journal advertisement. ("It Was Called the American Dream.") *New Yorker*, 17 June 1985.

"A Wand Wave, A New Era." *Life*, 20 Sept. 1954.

"Want to Meet Real Cowboys?" *Look*, 6 Jan. 1959.

"Wanted: An American Novel." *Life*, 12 Sept. 1955.

Weatherby, W. M. "Crack Downer." *Manchester Guardian Weekly*, 17 Apr. 1988.

" 'We Cut Loose.' " *U.S. News*, 14 July 1986.

"A Week in the Life of a Homeless Family." *Life*, Dec. 1987.

"We Still Believe in American Dream." *USA Today*, 13–15 Jan. 1984.

"What America Thought in 1937." *Life*, 3 Jan. 1938.

"Where We've Been and Are Now." *Life*, 4 Jan. 1954.

Whirlpool Corporation advertisement. ("The American Dream Is Our Dream, Too.") *New Yorker*, 9 Jan. 1984.

Woodbury, David. "The Utopian Promise of the Peacetime Atom." *Look*, 9 Aug. 1955.

"The World's Fair." *Life*, 3 July 1939.

Young and Rubicam advertisement. *Fortune*, Feb. 1930.

Zuckerman, Mortimor. "Dreams, Myths and Reality." *U.S. News*, 25 July 1988.

Index